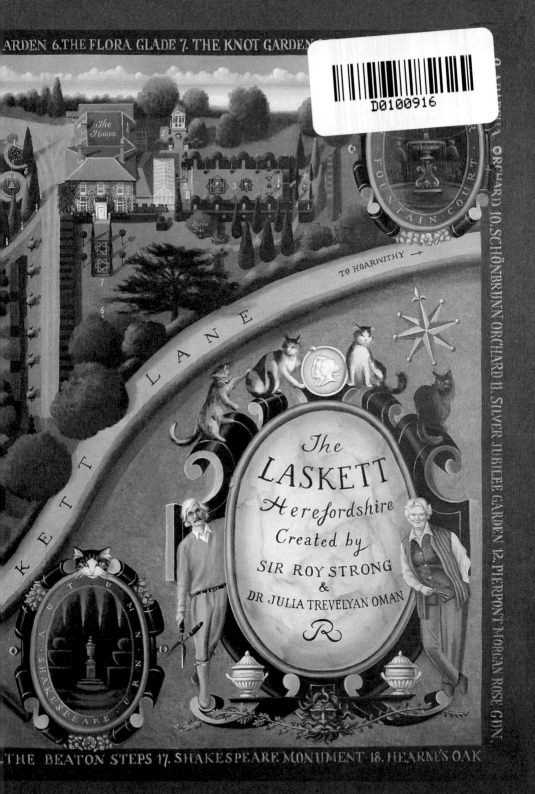

GARDEN 6. THE FLORA GLADE 7. THE KNOT GARDEN

GARDEN 9. ORCHARD 10. SCHÖNBRUNN ORCHARD 11. SILVER JUBILEE GARDEN 12. PIERPONT MORGAN ROSE GDN.

TO HOARWITHY →

THE HOUSE

FOUNTAIN COURT

K E T T L A N E

The
LASKETT
Herefordshire
Created by
SIR ROY STRONG
&
DR JULIA TREVELYAN OMAN

AUTUMN · SHAKESPEARE · URN

THE BEATON STEPS 17. SHAKESPEARE MONUMENT 18. HEARNE'S OAK

'A bird's eye view (by Jonathan Myles-Lea, 1995) of the garden we created over twenty years, a paradise into which I could escape from the dolours of public life. All our cats

THE
ROY
STRONG
DIARIES

THE
ROY
STRONG
DIARIES
1967–1987

Roy Strong

Weidenfeld & Nicolson
LONDON

First published in Great Britain in 1997 by
Weidenfeld & Nicolson

The Orion Publishing Group Ltd
Orion House,
5 Upper Saint Martin's Lane,
London, WC2H 9EA.

Extract from *The Virgin in the Garden* by A. S. Byatt
reprinted by permission of the
Peters, Fraser & Dunlop Group

A catalogue reference is available
from the British Library

ISBN 0 297 81841 4

Typeset by Selwood Systems, Midsomer Norton

Printed in Great Britain by Butler & Tanner Ltd, Frome and London

For Julia
who saw me through

CONTENTS

List of illustrations xi–xii
Introduction xiii

PART ONE: SIR PORTRAIT: 1967–1973

1967 Enter Stage Left 3
1968 A Star is Born 10
1969 Apotheosis 32
1970 Icarus 52
1971 The Elopement 83
1972 Crest of the Wave 97
1973 Goodbye Baby and Amen 116

PART TWO: MUSEUM PIECE: 1974–1987

1974 Into the Lions' Den 133
1975 Stormy Weather 144
1976 Disaster Strikes 160
1977 Darkest Hour 184
1978 Scenes and Apparitions 210
1979 Silver Lining 231
1980 Friends at Court 248
1981 Splendours and Miseries 273
1982 All Change 298
1983 State of the Art 329
1984 Carry on Carrington 355
1985 Trapped 375
1986 The Decision 391
1987 Exit Stage Right 407

PART THREE: POSTSCRIPT: 1996 435

Acknowledgements
Index

ILLUSTRATIONS

Between pages 176 and 177
Child Star: Cecil Beaton, 1967[1]
Sixties Icon: David Bailey, 1970[2]
Bride and Groom: Michael Leonard, 1972[3]
Textile Apotheosis: Polly Hope, 1985[4]

Between pages 208 and 209
Homage to the Queen: The Beaton Exhibition, 1968[5]
The National Portrait Gallery, before and after[6]
My First Rescue: Handel with *Messiah*, 1968[7]
Miniature Monocle: Sir Francis Drake, 1971[8]

Between pages 256 and 257
The Field of Cloth of Gold Ball: Antonia Fraser as Queen, 1970[9]
Garden Idyll at Reddish: Eileen Hose, Timothy White the cat, Cecil
Beaton and myself, 1977[10]
Remarkable Women: Frances Yates[11]; Diana Cooper[12]; Ann Fleming[13]
Pamela Hartwell[14]

Between pages 304 and 305
The Eternal Begging Bowl: The Chellini Madonna, 1976[15]
Patriotic Dolls: Lord and Lady Clapham, 1974[16]
Going for Broke: The Lomellini ewer and basin, 1974[17]
Cleopatra's Nightmare: Wellington's Egyptian Service, 1979[18]
The Shock of the New: Robert Welch's Candelabra, 1980[19]
Trendsetter: The Biedermeier Exhibition, 1979[20]
Milestone: The Destruction of the Country House, 1974[21]
Millstone: The Henry Cole Wing[22]
Glamorous Knight: The Princess of Wales leaves the Gonzaga Exhi-
bition, 1981

In text

Frontispiece Tenth wedding anniversary –
Laurence Mynott's Capriccio

 1 Caricature, *The Times* 1974: Richard Cole
 39 Sketch, 1969: David Hockney
 60 Pocket cartoon, *The Times*, 1970: Marc
 81 Pocket cartoon, *Daily Express*, 1970: Osbert Lancaster
 99 Pocket cartoon, 1973: Osbert Lancaster
 107 Pocket cartoon, *Sunday Times*, 1972: Heath
 109 Cartoon, *The Spectator*, 1972: Horner
 114 Drawing, The Laskett, 1973: Hugh Casson
 131 Caricature, *Sunday Times*, 1986: Gerald Scarfe
 243 Cartoon
 389 Cartoon, *Evening Standard*, 1985: Jak
 435 Caricature, *Sunday Times*, 1996: Gary
 438 The Reverend Wenceslas Muffby: Michael Leonard

INTRODUCTION

This book draws on two sources, the first my personal diary, the second a series of letters to a Dutch friend. Together they span the two decades during which I directed two of the country's most prestigious art institutions, the National Portrait Gallery and the Victoria and Albert Museum. As an historian I feel bound to declare and describe my sources, so that the reader may understand the nature of the material which is printed here. Let me begin with the diary.

The diary begins on 9 November 1967, five months after my entry into office, on 1 June, at the Portrait Gallery. At a dinner given by the collector Sir Brinsley Ford at his treasure house in Wyndham Place I sat next to Esmé, Lady Carlisle, a widow who had embarked on a second professional career working for the Museums and Galleries Commission. It was she who suggested to me, an extremely young museum director, that I should keep a diary because I would meet so many interesting people. She was right. I did. Home I went and began on a few loose sheets of typing paper and continued until Christmas, writing about a dozen lines a day. These juvenile jottings can be virtually discounted, but the following year the diary went in a totally different direction, and that was due to the friendship which had sprung up with Cecil Beaton.

Beaton's diaries were in the process of publication at that time and I was hypnotised by his ability to conjure up characters or a scene. His diaries were not daily but occasional, made up of set pieces describing particular events and people or retrospective miniature essays. They were concerned, too, with a social panorama and certainly not with the day-to-day technicalities of his professional life. It was that type of diary which I decided to keep.

In doing so I am all too aware that the impulse ebbed and flowed. In going through the entries I am more than conscious of everything I could have written about but failed to. This was often due to exhaustion, but also to the fact that so much of my daily life was consumed in writing letters and memoranda and, at the weekends, books and articles. The diary could so easily slip into oblivion. After marriage I stopped for a year or so and it was only my wife who urged me to pick up my pen again. During the late sixties and early seventies the entries are scattered through lined notebooks. Then from 1975 to 1981 they

are on the reverse of old BBC scripts and photocopies of my wife's costume designs. At the beginning of the eighties I suddenly looked back at the entries and was taken aback by how interesting some of them were. I then went over to blank notebooks.

Most of the contents of these diaries are printed here, so the reader need not be left wondering what else lies locked up in my archive. Not that much, although for personal reasons certain things are omitted and, on the whole, I avoided printing anything which would upset too much. But in the case of those in public life like myself, I have felt that they could take it on the chin, as I have done over the decades. As the years passed my literary abilities developed and from the mid-seventies on the entries are virtually verbatim, apart from editorial tidying up to make sense. Some of the earlier entries inevitably called for a little more tidying.

Interspersed with diary entries there are extracts from a series of letters I wrote to Jan van Dorsten, who was a lecturer and eventually a professor at the University of Leiden. He was two years my senior and we first met at Cumberland Lodge in Windsor Great Park in the summer of 1958. Our shared interests were academic, concerned with England and the Low Countries in the late sixteenth century, and together we produced in 1964 a book called *Leicester's Triumph*. The letters are continuous until Jan's sudden death in 1985, which came as a great shock. He too was a good letter-writer, but the heart of our exchange was what is omitted here: academic information centring around the books which we were writing. But over the years these missives developed almost into an alternative form of diary as I recounted to him everything which had happened since the last letter. Indeed one letter actually acknowledges that fact and asks for photocopies of my earlier letters for my own files. In addition, as Jan was a foreigner, I was always putting into context the things about which I wrote, letting down the backcloth of the period as it unfolded through the seventies and eighties. What these letters capture is the essence of my existence, which has always been domestic. They record a married life and the creation of a house and a garden which were to be one's rock. They still are.

I could not have published this material ten, or even five, years ago. It called for space, distance from the events and people described. Much at the time was deeply painful. I now read it as though I was reading about someone else. Why the decision to publish? Well, I am not immortal and the reader will discover that I have a special line in describing memorial services. Who knows what will be one's allotted

span? Somehow my antennae tell me that the time is right. Within my make-up the compilation of some kind of memoir of one's life and what one set out to achieve is an act of reconciliation, for it has been littered with failures as well as triumphs. The publication also had to await the right editor. I was not far into writing *The Story of Britain* when I knew that I had found that person in Julia MacRae, so much so that in a sense the dedication of this book can be read in two ways. To make such an act of revelation about oneself calls for utter confidence in the person receiving such material. That I have had in abundance. What follows owes an incalculable debt to her skills, her friendship, and her belief in what I was doing.

PART ONE

SIR PORTRAIT

1967–1973

1967

Enter Stage Left

'GOT IT. I feel humbled in exultation as it is a fantastic achievement at thirty-one, beaten only by Sir Kenneth Clark at the National Gallery. I apparently swept the Board. But the tasks ahead are terrific and daunting and exhilarating ...'

It was in this way that I announced my appointment as Director of the National Portrait Gallery (which I had joined as an Assistant Keeper in 1959) to my Dutch academic friend, Jan van Dorsten. For me it ended months of anguish, which had begun the previous October when David Piper, the then Director, accepted the directorship of the Fitzwilliam Museum, Cambridge, and I wrote: 'I have a very good chance of getting it but my extreme youth may be my undoing ... 1967 will either be a year of triumph or disaster ...' Then followed the months of waiting but I had allies. David Piper was one, so was Francis Wormald, one of the 'kingmakers' of academe at that period, who had presided over my earlier advancement. To these I was able to add as referees the future Dame Frances Yates, who had supervised my doctorate, and Sir Oliver Millar, Surveyor of the Queen's Pictures. Not a bad line-up, but I had a narrow miss when the advertisement for the post specified that candidates had to be over thirty-five; David Piper and the Chairman, Lord Kenyon, struck that out and replaced it with thirty.

D-Day was 16 March. There was a short list of six and a formidable interviewing board with a battery of high-powered Civil Servants, Trustees, and, from without, the great scholar E. H. Gombrich, Director of the Warburg Institute (where I had learned so much), and E. K. Waterhouse, the waspish doyen of British art historians. It was a gruelling interview but I went in fully prepared. I still have what I wrote as my dossier of what had to be done to the Gallery, a ten-year strategy covering everything from establishing an education department to rearrangement and redecoration, from cleaning pictures to staging exhibitions. The Chairman told me afterwards that my answer to one question had nearly cost me the job, for I suggested that the Portrait Gallery should have a relationship with the National Trust and decentralise some of the collection. The idea of one square inch of canvas

leaving St Martin's Place was viewed as anathema. Later Lloyd Kenyon was to eat his own words and bathe in the success of branches at Montacute and Beningborough Hall.

The announcement, which was a Prime Ministerial one, became public on a Saturday when it appeared in small print in the Public Appointments column of *The Times*. I recall that it was my day to do Saturday duty at the Portrait Gallery and I sat there feeling rather lonely and unloved. It all seemed such an anticlimax. Then the phone rang and the fruity voice of Richard Buckle, the ballet critic of the *Sunday Times*, came through, thrilled at the news and asking whether I was doing anything for lunch. 'No,' I replied. Although he had to dash off early to review a matinée at Covent Garden, he regaled me with champagne and smoked salmon in his skyline flat in Henrietta Street. I'll never forget that spontaneous gesture. At the time the directorship of the National Portrait Gallery was certainly not the stuff of the news columns. All that, however, was to change. But no one, not even I, could have foreseen just how dramatically and in how short a time.

There is no diary for this year until its closing months and even then it is frankly an uninspiring read, a dozen lines a day recording this and that with only occasional flashes. Nor are the letters to van Dorsten much better. Fluency in both had yet to come. (I have always been a late developer, even now in my early sixties.) In a way this allows me to set the stage for what was to be the biggest transformation scene of my life. For those who have encountered me during my decades on the public stage, where and how it all began may come as something of a surprise. But it should not, for I belong to a sharply defined group of people still active and creative within the Arts, a group which includes Peter Hall and Harold Pinter, for instance, whose origins were in the main quite far down the social scale. My career, like theirs, is the progress of a child of lower-middle-class roots who, thanks to the Education Acts and a dedicated mother, was able to climb the educational ladder and enter another world.

I was born in the north London suburb of Winchmore Hill in a late-1920s terrace house on 23 August 1935, the youngest of the three sons of an impoverished commercial traveller, George Edward Clement Strong, and his wife, Mabel Ada Smart. The marriage was not a good one. My father had no sense of responsibility whatsoever for any of his children. As is so often the case, it was my mother who was to be the driving force to secure for them what her father had told her was the

key to their future, their education. To achieve that she worked hard, taking every kind of job and leaving behind her a debt which no son can ever adequately repay.

Shy and introspective, I felt alone in this unhappy, riven household, creating instead my own secure world of toy theatres and through wielding the paint-brush. Early on I became fascinated by the past, and although what I would like to have done most was to design for the stage (later I had the good fortune to marry into that) it was deemed safe for me to go on to read History at the university with perhaps a career in teaching in mind. That came at the end of important formative years at the local grammar school, Edmonton County, where there happened to be one other boy, slightly older, who was also to achieve public distinction, Norman Tebbit. I reminded him of that fact decades later and it makes me smile to think of our two faces looking down from the school's walls today.

There I owed much to dedicated teachers who responded to what was an optimistic era of opportunities for those for whom advancement through education until then had not been possible. Joan Henderson, my history teacher, fired me with a love of the Elizabethan age which has never left me. Doris Staples not only taught me Latin but also instilled into me the disciplines of unremitting hard work. The year in which I was appointed Director of the National Portrait Gallery she sent back to me a letter which I had written her in 1954 in which I wrote: 'I realise that one degree is not really of much use – interesting jobs are so difficult to get. All I want to be is something like the Director of the National Portrait Gallery or the Head of a Department at the Victoria and Albert Museum!' My art master also once said to me, witheringly, as though it were a fate too appalling to contemplate, 'You'll end up Director of the National Portrait Gallery.' It is fascinating that those two institutions, with which I fell in love in my early teens, should have already been formulated in my mind as ambitions. The likelihood of someone from my background ending up as Director of both by the age of thirty-eight was, at that time, pure fantasy. But I am fortunate in that I have always known the direction in which I wanted to go and followed it with unswerving tenacity and application. That, I now realise, is a rare attribute.

So I read History under S. T. Bindoff at Queen Mary College in the Mile End Road from 1953 to 1956, not a particularly happy period of my life, achieving a First Class Honours Degree much to everyone's surprise and securing the vital scholarship I needed to proceed to research for a doctorate under the great Renaissance scholar, Dame

Frances Yates (who will appear later in this book). I had been passion-
ately interested in the portraiture of Elizabeth I while still in the sixth
form but that topic was to become a sideline while I wrote a thesis on
Elizabethan court pageantry. To the Warburg Institute and to Frances
Yates I owe an incalculable debt in restructuring my mind. Unbeknown
to me, an interest in early English portraiture was exceptional at the
time and, in 1959, I joined the staff of the National Portrait Gallery.

The Portrait Gallery then was a very different place from the vibrant
institution which we know today. There were just over thirty staff
including the Director, Kingsley Adams, and three Assistant Keepers,
of which I was the most junior. It was a pretty drear place with the
portraits, uncleaned and glazed, hung virtually frame to frame over the
acres of wall space. David Piper always used to cite the entry in one
guide to London at that period which read: 'National Portrait Gallery.
No lavatories.' It was in fact a great institution which had gone to
sleep, presided over by a Board of Trustees headed by Lord Kenyon
which was certainly conservative in stance, not to say almost reac-
tionary. None of the waves of innovation which stemmed from the
United States had yet reached it, although they had already trans-
formed, for instance, the Victoria and Albert Museum under the aegis
of Leigh Ashton.

I recall early on, at a dinner party, being asked where I worked and I
said the National Portrait Gallery. My neighbour snapped back at me:
'Oh that dreary place!' I swore that if it was the last thing I did I would
change that perception of the institution. But it wasn't easy being the
junior member of staff buried in the basement and in my second year,
by now deeply unhappy, I almost left for academe. During this period I
steadily built up a reputation as a scholar in the field of English Renaiss-
ance studies, publishing my earliest books and a long stream of articles.
I did my first exhibition in 1963, *The Winter Queen*, when my frustrated
theatrical bent was able, for the first time, to find public expression.
Then, from 1963–4, I became involved in the Shakespeare exhibition
at Stratford-upon-Avon. Richard (Dicky) Buckle, who organised that,
was already a hero of mine from his incredible Diaghilev exhibition.
What this experience exposed me to for the first time was the creative
arts of the present, having up until then lived wholly in the past. It was
also a great turning-point in my mental make-up. I fell in love with
today, and I remember having a barber cut my hair back to front to
project a new image of myself.

By 1967, within the small world of museums and art historical
scholarship, I was beginning to impinge on public consciousness. In

1966 my face appeared on the cover of the *Illustrated London News* and there was coverage within on this new young museum lion. This was not regarded with favour by David Piper, who by then had become the Gallery's Director, but he did give me my head, allowing me to begin rearranging the public galleries. By then too I was writing both for *The Times* and the *Spectator*, recruited by Hilary Spurling, the latter's arts editor at the time.

The year 1967 finds me in a flat in Lancaster Gate, having escaped the suburbs three years before. I shared it with the future head of the British Library's Manuscripts Department, Michael Borrie. It was London in the late swinging sixties and I loved every minute of it, one long revel of entertainment and dressing-up in velvets and furbelows. Everything had seemed set that this should continue for the coming years with the hope that, in an era when 'dead men's shoes' still pertained, I would end up one day, unless I blotted my copybook, as Director. All that changed when, on 1 June, I precipitately began what could have been a reign of thirty-four years.

For the first few months I decided that I had to conform to some preconceived directorial image, so I had two wardrobes, one of which, made up of safe suits and sober ties, was for the Gallery. It wasn't long before the strain of being Dr Jekyll and Mr Hyde began to tell and I thought they must have appointed me for what I am, warts and all, and decided to be myself. Another of life's great turning-points had been achieved. From that moment everything took off, and Dr Strong of the fedora hat and maxi-coat, the Regency velvet jacket and ruffled shirt, stepped into the media limelight.

The friendship with Cecil Beaton began this year and that too was another watershed. That introduction I owed to Dicky Buckle. Shortly after I came into office I had lunch with Dicky, who knew Beaton, and I asked him if Beaton would ever consider an exhibition of his portrait photographs at the Gallery. Within a matter of days we found ourselves lunching with Beaton at his elegant house in Pelham Place, South Kensington. This was virtually my first entrance into a world with which I was to become all too familiar. I wrote to Jan van Dorsten on 3 June: 'He has agreed to present prints of any of his portrait photographs that we want, 1927–1967. They are ravishing and brilliant and of all the greats. To mark this, Buckle will design a Beaton show in the autumn of '68 which ought to cause a furore! Beaton is thrilled.' In fact Beaton was rather in eclipse at that period. He was, however, someone whose work had hypnotised me since I was a teenager. On this first visit, when he took us up to the top floor to look at his files, he was

astonished at how excited I was about his early work – all those pictures of Edith Sitwell as a Gothic tomb effigy or Tilly Losch emerging from a cloud of cellophane. I was in fact rediscovering him.

Meanwhile someone who was to become another great friend, the remarkable and reclusive editor of *Vogue*, Beatrix Miller, decided that something must be stirring down in St Martin's Place and commissioned Cecil to photograph me. 'The 12 September issue of *Vogue* contains me by Beaton,' I wrote to Jan. 'He chose a sane photo, not one of the ones where I was reclining full-length under Queen Victoria or embracing a showcase containing General Wolfe.' To my eyes I stare out of that picture like a retarded undergraduate floating in an ocean of beruffed Jacobean grandees. Beatrix said that it was the best photo Beaton had taken for her for years. She also began to ask me to write for *Vogue*, which was in one of its great periods: 'Just the sort of thing an NPG Director ought to do to brush away the dowdy cobwebs,' I recorded at the time.

But I'd inherited problems. The Gallery was poor and I was suddenly faced with two major portraits to save. The first was Thomas Hudson's full-length portrait of the composer Handel with *Messiah* open before him, a picture which had been on loan to the Gallery for years but which was now snatched away to be sold. Then there was the self-portrait of the painter George Stubbs. Up until then Portrait Gallery directors accepted that expensive works of art were not for them. That was not to be my policy. I wouldn't take it lying down, and over the Handel we launched an appeal. It owed a huge debt to Hugh Leggatt, the dealer who acted for the Portrait Gallery in the saleroom and who never charged commission and was one of the institution's most loyal supporters. He also became a firm personal friend and together we were able to achieve much for the Gallery.

The saga of the Handel portrait went on for a year. In December I had lunch with the singer Joan Sutherland's agent who indicated that she wished to help with the appeal. On 10 July of the following year she sang in a performance of *Messiah* in the Albert Hall with the portrait as a backdrop. Princess Alexandra graced the occasion. I went on stage and presented Joan Sutherland with a framed print of Handel, something which I reminded her of twenty years later when I met her again at the opening of the Twentieth Century Gallery. Over the Stubbs I was lucky too. One of the Trustees was Carola Oman, Lady Lenanton, the aunt of my future wife. She twisted the arm quite sharply of a rich member of the racing fraternity and all was well. But both these successful campaigns signalled what my future life was to be, epito-

mised when I wrote: 'Another endless, relentless, soul-destroying battering of the Government for money.'

The diary begins on 9 November and the only entry I can bear to print records going to lunch at Buckingham Palace on 28 November. This was important, for it was the beginning of the saga which led to Pietro Annigoni's second portrait of the Queen.

'I was summoned to lunch at Buckingham Palace. The other guests were Julie Christie (the mini-girl of the moment with a tiny sensuous face), Max Rayne (Rayne Foundation, money), Robin Mackworth-Young (the Royal Librarian, a great relief for me), Jonathan Aitken (I did not chat to him), Professor Richard Guyatt (Royal College of Art) and Dr Graham Booth (a very nice physician). Twelve of us in all sat down to lunch.

'I arrived at 12.50 p.m. and was shown to the Bow Room which looks over the terrace on to the grounds and where drinks were served and introductions made. The entrance of the Queen and Prince Philip was heralded by an onrush of corgis and we were rounded up and presented. I then got stuck into a four-cornered conversation with the Queen about the Galapagos Islands. The food was well presented but indifferent, the Queen extremely relaxed and very intelligent, more so, I thought, than Philip as she is more considered in her judgements. As instructed by Lord Kenyon I tackled her about a new royal family group for the Portrait Gallery. She denounced the James Gunn and also went on to say that she wouldn't allow a portrait, which had just been finished, to go to Scotland as it was too awful. Another made her into a midget. Annigoni was the only artist whose name passed her lips. Do I tackle the possibility of her sitting to Annigoni again? The party broke up at 2.45 p.m. and Max Rayne drove me back to the NPG.'

The lunch at the time got quite a lot of newspaper coverage, being regarded as wildly trendy. The next day Oliver Millar told me that it had been 'divided between the yahoos and the intellectuals with RS amongst the latter'. I wrote to Max Rayne suggesting that he might like to present the Gallery with a new portrait of the Queen by Annigoni but that led nowhere. Hugh Leggatt was to step into the breach on that one.

1967, therefore, was really 'Overture and Beginners, please'. A number of the cast had already made their entrances on to what was to be the stage of my life. The first six months had seen the blue touch-paper put into place. It did not have to wait long to be ignited.

1968

A Star is Born

If 1967 had been extraordinary, 1968 was to be even more so. Lloyd Kenyon, in a speech at a farewell dinner given for him as Chairman of the Trustees of the National Portrait Gallery by Sir Hugh Leggatt in the eighties, recalled: 'And then came Roy. It was like being attached to the tail of Halley's comet.' Suddenly I was everywhere. Cecil Beaton swung wide for me the door into the *beau monde* and, after his exhibition opened at the end of the year, both the Gallery and its young Director epitomised a new energy in museums, reflecting the era we now categorise as the 'swinging sixties'. Quentin Crewe wrote in November: 'It is simply incredible that the Trustees of such a fuddy-duddy organisation should pick a witty, zippy, mischievous man of thirty-two to look after the likenesses of the figures of British history.' In retrospect, incredible it was.

I was, of course, initially entirely seduced by it all. Suddenly I was thrown into a whole new world. London society in the late sixties had its old guard and its young, with some, like Beaton, who traversed both. The latter was also true of the young Dufferins, Sheridan[1] and Lindy, whom I first met at a dinner in June. Droll and saturnine, with the face of a depressed if affectionate basset hound, Sheridan was the perfect foil for his wife's insouciant explosions. With her superb bone structure, halo of curly hair and almost mad laugh, Lindy seemed to exude energy, so much so that she often generated it in other people. Into their house in Holland Villas Road, with its two huge rooms hung with vast pictures by David Hockney, everyone who was brightest, most creative, or just plain beautiful frequently gathered. Sheridan's annual birthday party, which floated on an ocean of champagne with about two hundred guests scattered through the candlelit garden, became one of the great events of the year. In September I went to stay with them in Ireland at their house, Clandeboye, for the first time, for a shooting party which

[1] 5th and last Marquess of Dufferin and Ava; later a Trustee of the Wallace Collection; died 1988 aged 50.

included Patrick Plunket,[1] Lizzie Spender[2] and Christopher Gibbs[3] who appeared dressed for dinner in a caftan festooned with shells. I was given a gun and told to point it upwards. At the crack of dawn a gamekeeper rowed me out to an island to shoot duck. I wrote afterwards: 'I'd never handled a gun in my life before then, but the ground was soon littered with empty cartridges.' It is an experience I have not repeated.

This was the period too when Lady Antonia Fraser was making her mark as a writer and also as a hostess, presiding over gatherings at her house in Campden Hill Square. Antonia came into my life through her mother, Elizabeth Longford. When my wife's aunt, Carola Oman, came off the Portrait Gallery Board we needed a replacement, preferably another female biographer. Lloyd Kenyon tended to be a snob and I knew he'd love a countess, so I suggested Lady Longford. Elizabeth, who had published a superb biography of Queen Victoria, said that I must meet her daughter Antonia. Her gatherings followed the pattern of those during this period, beginning with a dinner, after which a second tide of guests arrived. It was difficult to get to bed much before 1 a.m. and it is hardly surprising that a recurring theme in my diary for this year is one recording tiredness and exhaustion. Other key exponents of this kind of entertainment were Judy Gendel,[4] George Weidenfeld[5] and Ann Fleming.[6] All were sooner or later to recruit me to their ranks. One was at full pelt.

These were occasions which called for male sartorial display – another characteristic of the late 1960s. In May I wrote to Jan van Dorsten: 'I have just bought the most outrageous black damask skirted jacket with a high-standing collar like Beau Brummell.' A dandy museum director must have been another eccentric phenomenon at the time, for until then convention had dictated all. Beaton was an influence, and I adopted a broad-brimmed fedora. The advent of this

[1] Lord Plunket, Equerry to the Queen and, previously, to George VI; Deputy Master of the Royal Household from 1954 until his death in 1975.

[2] Daughter of Stephen and Natasha Spender; married the comic performer and satirical writer Barry Humphries.

[3] Art dealer and man of taste.

[4] Formerly Judy Montagu, daughter of H. H. Asquith's confidante, Venetia Stanley; wife of the publisher, Milton Gendel.

[5] Founder and Chairman of the publishers Weidenfeld & Nicolson; created a life peer in 1976.

[6] Formerly Ann Charteris; wife in succession to Lord O'Neill, Lord Rothermere and the novelist Ian Fleming. A discerning hostess and astringent and witty letter-writer, whose collected *Letters* were published in 1985.

apparition did not pass unnoticed for the fashion journalist Alison Adburgham, when writing in the *Guardian* in June about an 'evening suit in black Venetian cloth trimmed with Russian braid ...' went on to say: 'One could well imagine it being worn by an aristocratic poet at a soirée, or by the Director of the National Portrait Gallery.'

Lunch parties even then seemed to belong to another age. They betokened arriving at 12.45 p.m. and not leaving until nearly three. They epitomised leisure, an elegance and an intimacy. Usually they were of about eight or two tables of eight, rarely more. Cecil always gave lunches. They were in impeccable taste. I went to many but the most memorable occurred this year on 10 April when I was bidden to meet the Queen Mother. 'The Queen Mother always meets the same old boring people,' Cecil drawled down the telephone, 'so I'm asking you.' My record of it is deficient but I recall the actress Irene Worth extolling the virtues of Fortuny dresses which she always wore for solo performances, and Diana Cooper[1] arriving with a tiny dog which she deposited on her lap during lunch. Knowing of this encounter I was dragooned by Lloyd Kenyon to ask Queen Elizabeth whether she would open Cecil's exhibition (which she did), but Beaton's own account in which I appear is far more graphic: 'Roy Strong in a psychedelic tie ... Introductions: I suddenly found myself nervous and stumbling over my words. Roy calm-headed [I wasn't]. The topic was the lack of painted portraiture today. Would Graham Sutherland be good to paint the Queen?' I do remember Cecil cursing Edith Sitwell who had been a guest the last time the Queen Mother had come, and whose arrival had been heralded by an ambulance, a gangplank and male nurse outriders gliding her wheelchair to rest.

Lady Waverley[2] was another lunch-giver. She was a great snob. It was only after I married that she was finally put in her place because my wife remembered that she had been her grandfather's secretary during the First World War. There was something vaguely sinister about Ava Waverley, who lived a somewhat rarefied existence in Lord North Street, Westminster. What was striking about these occasions was that at thirty-two I was usually half the age of everyone else present. On 25 April, for example, the gathering was of Isaiah and Aileen Berlin,[3] John

[1] Lady Diana Cooper, widow of the diplomat and writer, Duff Cooper, 1st Viscount Norwich. Indestructible beauty and author of three entrancing volumes of autobiography, she died in 1986.

[2] Widow of Sir John Anderson, created 1st Viscount Waverley in 1952.

[3] Isaiah Berlin, philosopher, historian, essayist, diplomat, academic and man of influence, knighted in 1957.

Sparrow,[1] John Betjeman,[2] Nin Ryan[3] and Duncan Grant[4] who at eighty-three flouted every convention, arriving in crumpled jacket and trousers. The dining-room was white, the tablecloth and napkins pink, the flowers pink and white. Only Lady Waverley could have a trophy of oranges, each one of which contrived to have a stalk and leaf attached, arranged as a still life to reflect in a mirror. As I left that lunch party she stared at me and said, 'I do like you because you have illusions.'

Looking back I was an innocent, learning the ropes of a scene in which one either sank or swam. I swam. The whole drift of what I was being swept into I put in a letter to Jan van Dorsten:

'One is fascinated, looking back over the last couple of months, by curious, grand occasions and one's chance to meet the great ones of the 1918–39 era: Beaton's lunch for the Queen Mother (who was a duck), legendary Diana Cooper ('I only appeared on the stage once in Max Reinhardt's *The Miracle* ...'), the Royal Academy Dinner, everyone hung with orders and glittering with tiaras ... How strange to think that life in England at its core is still like this in 1968. The rich encrusted circles linked to the literati, intelligentsia, elegant and witty, a world of surfaces. Somehow I go down with them like a bomb, which I haven't fathomed out yet.'

This strange new world took that moribund Gallery right to the heart of where everything was happening during those years, and that had never occurred before. The retrospective exhibition of Beaton's portraits was to be the culmination of the year but by now there was much else happening as my vow to put the Portrait Gallery on the map began to move from a paper dream to reality. Pictures began to be cleaned by Clifford Ellison and there was the thrill of seeing the great full-length of Gloriana, the 'Ditchley Portrait', stripped of crude overpaint. The first great suite of redecorated rooms on the Regency and Victorian period opened, and a series of lunchtime readings entitled *People Past and Present* began.

That series was something of a landmark and was the idea of John Carroll, who had a string of theatrical dames in tow. Margaret Rutherford was his aunt and he organised the readings at the Shakespeare

[1] Warden of All Souls College, Oxford, 1952–77.

[2] Poet, broadcaster and writer who became Poet Laureate in 1972.

[3] The American Mrs John Barry Ryan, wealthy daughter of the financier Otto Kahn.

[4] Painter, designer of textiles and pottery, and a prominent member of the Bloomsbury Group.

Festival at Stratford each year. He was a benign owl-like figure whose features showed the permanent agony of someone on the pathway to total deafness. The idea he mooted to me on 22 May, and we began that autumn with the first, Dame Flora Robson as Elizabeth I. I wrote to Jan: 'I'm inundated with Dames – Dame Margaret Rutherford and Dame Sybil Thorndike come to them all.' Eventually the programmes went on to disk, thanks to Harley Usill, in the Argo series. The one which remains in the forefront of my memory is Sybil recalling Ellen Terry, whose beetle-wing cloak she had worn as Lady Macbeth in 1918. But the series was to be immortalised in 1978 by A. S. Byatt (whom I first met through Antonia Fraser) in her novel *The Virgin in the Garden*. My copy of this book lies open before me as I write, with its inscription: 'For Roy with love. And with gratitude for many things, inside and outside this book.' The Prologue was 'The National Portrait Gallery: 1968' and the occasion was Dame Flora as the Virgin Queen. That chapter captures the heady excitement and atmosphere of that year at the Gallery:

> The long gallery, in which they took their seats for the recital, was full of a different kind of people. Alexander amused himself by counting powerful women: there was Dame Sybil Thorndike, graciously accepting a throne-like chair from Dr Roy Strong, at that time Director of the Gallery, and an iconographer, possibly even an idolater, of the Virgin Queen. There was Dame Helen Gardner, head up, face benignly severe, Merton Professor of Renaissance Literature in the University of Oxford. There was Lady Longford, biographer of Queen Victoria, and in the background he thought, he hoped, he discerned the large, contemplatively vague figure of Dr Frances Yates, whose writings on the images of Elizabeth Tudor as Virgo-Astraea had, as it turned out, signally changed the whole shape of his life.

This was a gathering of women all of whom in one way or another were to have a place in my life too.

Perhaps the most important development for the Gallery, however, was the Trustees' decision, taken at their June meeting, to collect portraits of the living, although they could not be exhibited within the sitter's lifetime. That was one battle won, a bloody one at that, but the crack was there upon which to build. For the first time there was the possibility that the Gallery would not be an array of images of the decrepit. A surprising six-foot-high head of Lord Mountbatten by John Ullbricht was acquired for £300, so I was well pleased. But I sensed I couldn't push it.

Even as early as February I wrote: 'The NPG Directorship is about

one thing – CASH, BLOODY MONEY. The Gallery is miserably, terribly POOR.' So 1968 was spent impressing on Government our bankruptcy and our inability, previously accepted, to acquire portraits which might enter the category also of being great art. With only £8,000 p.a., Purchase Grant acquisitions of any significance could never be anything other than rarities. I was determined to reverse that. The appeal for the portrait of Handel by Thomas Hudson reached a triumphant conclusion and we successfully purchased the then only certain portrait of Catherine Parr.

1968 opened with me moving from Lancaster Gate to a mid-Victorian mansion flat in Morpeth Terrace overlooking the length of Westminster Cathedral. It had once been lived in by the painter Hercules Brabazon Brabazon, a number of whose watercolours of views from its windows are in the Victoria and Albert Museum. I was told that he used to descend the stairs, hail a hansom cab and say 'Cairo', and the obliging cabby took him to the appropriate railway station. But the rooms were spacious, with marble fireplaces, and even though I had no money to install central heating, I decorated it as best I could in the prevailing deep colours: olive green, ochre and mulberry. It was the first time that I had ever had a place of my own, even though it was rented, and the first time, too, that I had room to write in. That side of my life, once central, began to become peripheral as the pressure to run and promote a great but forgotten national institution made it increasingly difficult to keep up with any kind of scholarly writing. But the year as a whole was one long whizz.

11 March. The Lawsons.

Nigel and Vanessa Lawson gave a dinner in great style. Nigel is editor of the *Spectator*, to which I owe much, having made in its pages my first significant journalistic debut, thanks to Hilary Spurling. How she got on to the magazine was quite extraordinary. She told me that they wanted a boxing correspondent so she immediately volunteered. True or not, a foot was firmly secured in a door which was eventually prised open to let me in as a reviewer of art exhibitions twice a month, one piece of 750, and the other of 1500, words. Oh, how welcome those cheques had been to me struggling along on £750 p.a.

I don't really know Nigel but he always reminds me of George IV *en profile* by Sir Thomas Lawrence, elegant, handsome in a way with his tousled curly hair. Vanessa is a petite dark beauty, this evening looking like a porcelain figure in transparent furbelows. An evening like this

betokened a wish to make a mark but to what end, I wondered?[1]

But the real event was to find myself placed between the two beauties of two eras, Diana Cooper and Antonia Fraser. Diana's pale blue staring eyes rather terrify me and recall the basilisk glance of Lady Waverley. But Diana was very funny about Paul Getty,[2] from whom she had been trying to extract some money for a charity. 'He's so mean, he even had his face lifted on the cheap.' Eventually Getty had produced his wallet and pressed a five-pound note into her hand. She smoked incessantly and ate little, pecking at a trout. Nureyev,[3] she said, was a far better dancer than Nijinsky, which I thought interesting.

Antonia was in frills and I think I rather frightened her with a blaze of historical erudition. She has made herself a beauty by application rather than through attribution. Helen Vlachos, the Greek exile, was also there. I shared a taxi home with someone I hadn't met before, Peter Coats,[4] who seems to know everybody and appeared deeply curious about this young man who had been accorded the placement of the evening.

May. Henrietta Maria comes and goes.

The great excitement of the season for the NPG was the De la Haye sale on 27 May which included a huge miniature of Henrietta Maria wearing what looked like a masquing costume with a bejewelled ostrich feather in her hair; it bore the monogram of Samuel Cooper on the reverse. It was stunning and Van der Dort had recorded it in the Cabinet Room of Whitehall Palace where it was given to John Hoskins. This is one of the great portrait miniatures and I was determined that the Gallery should have it. That meant eliminating any possible competitors where one could and the V & A signalled their disinterest. It then boiled down to us versus the Royal Collection, and Oliver Millar made it very clear that he would be furious if the Queen failed to get it.

In order to enter the saleroom I had somehow to cobble together £6,000. Our solitary charitable fund produced £2,500 and I petitioned the historian Veronica Wedgwood, who promised £500, while there

[1] Nigel Lawson was to become MP for Blaby in 1974 and Chancellor of the Exchequer 1983–9. Created a life peer in 1992. Vanessa was his first wife (she died 1985).

[2] John Paul Getty, American oil tycoon and multimillionaire art collector.

[3] Ballet dancer and choreographer who defected from Russia in 1961 and made his Covent Garden debut with Margot Fonteyn in 1962.

[4] Socialite, garden adviser and writer who had been a close friend of the politician and diarist, 'Chips' Channon.

was £1,000 from our own Purchase Grant. I whammed in a ferocious letter to the DES [Department of Education and Science] demanding £3,000 which would mean that we would enter the saleroom with £7,000 but that I had to know by 22 May. I really can't bear this hand-to-mouth existence, not helped by being conscious that a portrait of Henry VIII's last queen, Catherine Parr, is in the offing.

The day before the reply from the DES was due the Queen expressed her personal wish to buy the miniature. That means we had to climb down in deference to the royal will. Robin Mackworth-Young, who is a gent, at least had the decency to come and explain the position to me in person. It was an agonised conversation and I was dreadfully upset. Then came the final blow, that the DES anyway would not consider giving a Special Grant. With all the nervous energy, work and hysteria which had gone on around this single object I began to see why David Piper had moved on. I wonder whether I ought to throw in the job if it's going to be like this.

The miniature was purchased by the Queen. I felt that the palace had behaved pretty badly, overruling the national interest which Hugh Leggatt had pleaded in a letter which was not even acknowledged. I felt that the Queen had been wrong but there was nothing to be done.

18 May. A tour of Northamptonshire seats.

I rose early and caught the 9.15 a.m. train to Northampton, where I was picked up by Desmond Fitz-Gerald.[1] Our tour began at Althorp where we were ticked off at length by the portly and extremely tetchy Lord Spencer.[2] Loathed by the county, as we were to learn at our other ports of call, his lordship has never recovered from not being made a KG. The house was freezing cold and we hung on to our coats as we were soldiered past the serried ranks of ancestors culminating in a grand gallery of Lelys and Van Dycks. We ended up in the lived-in part of the house where a decanter of sherry and two glasses stood on a silver salver in the middle of an oak table. Made to feel like servants we drank the ritual glass which betokened aristocratic hospitality before moving on to Brockhall, which turned out to be an entrancing, somewhat tumbledown small Jacobean house with a surprising interior in the Gothic mode but whose decoration otherwise left much to be desired.

[1] 29th Knight of Glin; a pioneer historian of Irish art and architecture who was then an Assistant Keeper at the V & A and later Irish agent for Christie's.
[2] 8th Earl Spencer. Father of the future Princess of Wales.

The Hesketh house, Easton Neston, beckoned next. What a stunner, fit to be a trianon for Louis XIV. Here Desmond's new girlfriend 'Spider' Quennell surfaced, dark-haired and vivacious, and the temperature began to rise. With the Heskeths, mother and son, the atmosphere became even more electric, she like the Princess Eboli with one eye concealed by a black patch and sporting a huge baroque jewel. There's an inspired wildness about Kirsty Hesketh but firmly held in by a taut intellect. Alexander, at seventeen, was already huge and his pale puffy face and blond hair put me in mind of portraits of George IV's brothers by Liotard. Today he was dressed all in virgin white with at least three silk scarfs fluttering around his neck. Here there was much dwelling on the evils of Lord Spencer, whose dislike of Lady Hesketh could be taken to extremes, as when he individually rang up every member of a committee she had asked to lunch to persuade them to decline. Here indeed was cool baroque splendour maintained still at full pelt with no sign of fraying at the edges, which probably explains the green eye beaming from icy Althorp. Desmond told me that the house was very haunted and how someone once passed the night in a room where no dog could ever have been. In the middle of the night there was an eerie pitter-patter of paws around the room and, extending his hand from the bed, the luckless sleeper found it licked. The room was in fact empty.

No rest for us and on we went to Lamport and Gyles Isham, one of my Trustees, a great charmer, gentle and avuncular. It is difficult to think of him as an actor or that Cecil Beaton told me that while up at Cambridge he had driven miles to see Gyles as Hamlet: 'He had the most beautiful back view I'd ever seen.' Looking at him now the 'glass of fashion' would be my last description of the man. But Lamport's a friendly house with no great pretensions and, as befitted him in his new role as antiquarian and chronicler, Gyles had scrupulously documented every picture and piece of furniture in the house from the family archive.

Our last port of call was Drayton, a quite wonderful house with an approach as though to a castle in *The Faerie Queene*. Here was a huge contrast to what had gone before and we were in a sense back where we had started at Althorp only more so, a freezing interior with crumbling walls and disintegrating décor. The owners, one felt, were feeling the struggle to be an unequal one. Colonel Stopford-Sackville, a large jolly military gent, and his husky-voiced wife poured us out gin by the tumbler load. Drayton was filled with treasures and I longed to linger. There was the Mary I I'd had for the Eworth exhibition and an amazing

tapestry that had belonged to Elizabeth's first favourite, Leicester. But the owners' real pride was their new kitchen. With all their problems I was hardly surprised.

24–27 May. Cecil Beaton at Reddish.

The dramas over Henrietta Maria had left me exhausted but I'd been asked by Cecil Beaton to Reddish for the weekend. Not knowing the form I felt nervous. Young and dull would perhaps have better described me; whether I was or not I don't know but I was often hopelessly out of it in conversations about the great and the fashionable of the 1920s and '30s. But I adored the house. I'd thought that it would have been larger than it was but instead it reminded me of the Mauritshuis, a small rusty red-brick late-seventeenth-century villa, grandeur in miniature. It was set back only a little from the road and held in by bulging clipped yews. A short elegant flight of steps led up to the front door, over which presided a solitary, rather grubby, bust of a Roman emperor in a niche. The door opened on to a flagstoned hall with grey marble columns and pilasters and it was only then that I realised that the house had begun its life only one room thick.

No detail in terms of decoration ever escapes Cecil's eagle eye. It was after all the stage-set upon which he acted his life and never more so than in what he called his 'Lady Windermere's Fan' room. That was off to the left, up a few steps leading to double doors which swung wide, revealing a room which evoked the shades of Lillie Langtry rather than those of William and Mary. Here was splendour and clutter in the Edwardian manner, so that I would not have been surprised to have glimpsed his beloved Queen Alexandra pottering among the explosion of palms and silver-framed photographs at the far end of the room. The wainscot and ceiling were a greyish-white highlighted with gold and the walls were covered in crimson velvet and banked with pictures. Either side of the double doors there were gilt console tables with huge gilt mirrors reflecting a large pair of busts of Louis XVI and Marie Antoinette. But this theatrical richness was overlaid with cascades of flowers, roses, not only real ones which were in vases everywhere but across the Aubusson carpet, the fabric of the loose covers and the curtains. Flowers were the key to this house. No room was without them, nor dining table devoid of a bouquet.

Off 'Lady Windermere' there was another accretion, a Gothic conservatory where I suppose Cecily and Gwendolen might have bantered, white but filled with Chinese blue-and-white containers and censers and embowered with a profusion of climbing geraniums and pink

mallows. At its centre there was a tiny pond with goldfish. Here the air was moist and scented.

Cecil always opened up as he strode around the garden. There were the palest pink roses swagged on to garlands, long ropes worthy of a Gaiety Girl, climbers all over the house, a terrace which led on to a broad swathe of lawn and further gardens, the whole held in by rising land on which grew a concealing curtain of mature trees. There was an orchard, a wild garden with spring flowers, a broad walk to a seat flanked with wide herbaceous borders, a kitchen garden and a new little abstract lavender garden around an old sundial.

The more I see of Cecil the more extraordinary he becomes. In a way his mind is filled with nothing, in another way it's filled with everything. The former observation comes from the academic in me, for disciplined intellectual knowledge is a foreign country to him, quickly revealing horrendous gaps in even at times the most rudimentary facts about the past. But as an observer of surfaces and essences I think he remains unsurpassed. He fascinates me with his pale blue eyes, quite steely at times, and fluttering eyelashes set into a delicate expanse of pale pink skin. His lips are always firm-set and when displeased or angry take on the quality of being frayed at the edges. His gestures are feminine and there is that wonderful mannered voice with its calculated and cultivated drawl. But, over all the rest, his manners can never be faulted.

I felt a bit like Daniel in the lions' den. The other guests were the actress Irene Worth and John and Gillian Sutro.[1] The Sutros I never worked out but he had been at Cambridge with Cecil; there was much talk of Merle Oberon and he was forever disappearing to the telephone, but he was intelligent and perceptive. The real star was Irene with her deep-throated voice and swooping enthusiasms. After dinner one evening she surprised us all by imitating Bernhardt taking a curtain-call, lower, lower and even lower, ending up flat on the floor.

There was an expedition to Toby and Marianna Marten at Crichel, which they are restoring foot by foot, a vast Adam-Wyatt type neoclassical house with stucco work by Rebecca Biagio. They had a tame estate carpenter who I must say was a whizz at *faux*. There we all sat lamenting the fate of John Profumo. It was said that on the night he

[1] John Sutro, film producer (Alexander Korda's London Film Productions); died 1985.

was forced to go down to the House he was drugged on sleeping tablets, and gave himself away.[1]

Before I left for London Cecil, chortling a line or two of 'We'll gather lilacs', took his secateurs and strolled round the garden piling my arms high with huge branches of lilac. I sat in the train engulfed in its fragrance, a happy man. I had glimpsed another world and had drunk deep of its delights.

18 June. A visit to Duncan Grant at Charleston.

Duncan Grant picked me up in his decrepit Morris Minor from Lewes station. One has to admit that he's a rather astounding 83-year-old, with his soft blue eyes which now and then water a little, and untidy hair which must once have been fair. He must have been rather beautiful, I thought, in his day. In appearance he was untidy, wearing a navy-and-white striped T-shirt, a check sports coat, old brown trousers and canvas shoes. There was a slightly feminine quality to his manner but he was a gentle soul with a great twinkle in his eyes and an innate sense of fun and humour. And he drove the car remarkably well for an octogenarian. All the time I thought that through this man I have contact with, amongst others, Odilon Redon and Jacques-Emile Blanche, as well as Wilde's darling 'Bosie'.

The house, adjacent to a farmyard, is entrancing, with a lake in front of it jammed full of pond irises and its façade festooned with climbers. What struck me most was the way it was the quintessence of a period. All the colours, for example, were not harsh but broken and transparent: lemon, white, black, brown and green. A huge vase of ragged pink blooms was placed on top of a chest of drawers looking exactly like a Duncan Grant/Vanessa Bell still life. The dining-room had a well-worn round table decorated with typical Omega spots, lines and rounded shapes in black, white and lemon. There we had a simple lunch off their own pottery. Everything was all of a piece. I then took in all the pictures: Vanessa Bell, Roger Fry, Keith Baynes, Augustus John, Matthew Smith, copies of a Vlaminck, a Gainsborough and ones by Duncan himself.

There was a marvellous flint-walled garden full of crab-apple trees, Canterbury bells and giant poppies (which, he said, he loved). We then went through the portraits in his studio. There were not many. There were some of Vanessa (whose studio above enjoyed a sweeping view of

[1] The Cabinet Minister John Profumo had resigned in 1963 following the disclosure of a notorious liaison with a model, about which he had initially lied to the House.

the Downs and was stacked with canvases) and a number of interesting self-portraits. There was one in particular of himself, dated 1910, nude and wearing a turban. This he was about to sell. The later ones were far less good, although those in which he wore a hat were rather fascinating. But it was the early, rather academic ones, two of them, which most caught my eye and I angled after one of them for the NPG. Nearby there was a pottery studio where he and Quentin Bell made pots, very nice ones, and where Duncan Grant was doing sculpture for the first time.

All the walls, fireplaces and furniture in the house were covered with painted decoration. Charleston really ought to be preserved as a totally unique environment, impossible in a way to pass on.[1] I remember most how lunch had been laid, a perfect Grant–Bell still life with its loaf and coarse roughly glazed pottery patterned with bold lines in blue, red, green and yellow.

20 July. To Jan van Dorsten.
Wonderful rest in appallingly hot Vermont ... Ten days here with their Elizabethan Institute. Ten one-hour lectures and five one-hour cross-examination sessions. Ten lectures have proved a heavy load and I don't think that I would do so many again, but when they wrote in January I needed the money badly. Still do, as it will pay for my library table and any back income tax. Very hot, 103° one day and very humid ... generous hospitality but in-between-times I stay in my sordid little room in the dorm reading *Bleak House* and sleeping. Got up at 2 p.m. today and still feel languorous.

This ought to have done me some good as the previous weeks in London were ones of fantastic exertion centring on the two great galas. Needless to say yours truly ended up doing most things. Gala 1: the Minister for the Arts, Miss Lee [Jennie Lee], came to open the newly decorated suite of rooms (which I long to show you. They are rather good). I had a children's party for the occasion. No adult was admitted without a child. The Chairman and I received them at the entrance with a little boy aged seven announcing them. They were then given a huge tea in the Tudor Room, little lecture tours and a dramatic reading. And we dined Miss Lee after – valuable – the whole a ploy to get her into the Gallery and I knew she *loved* children. I pinioned her on the fact that we would have to close one day a week if the

[1] Charleston *has* been restored and preserved, and is now managed by the Charleston Trust. It is open to the public on certain days.

economy measures went through. I await the result. I was impressed by her, although she is a bit clogged up with *vieux jeux* socialism.

Gala 2: The day before I flew here, Joan Sutherland sang in *Messiah* at long last and saved the picture of Handel. What work and what worry. A rail strike hit the sale of tickets so some areas were 'papered' ... And then there was all the fuss of Princess Alexandra coming: the decoration of the Royal Box, the correct seating of people in it, the exact timing of everything, the number of bars of the national anthem which she was allowed to have, who could come in for drinks in the interval, etc. At any rate it was all a great triumph, the Princess adorable, everyone in the box a-glitter with gems and me cavorting around in a black velvet Regency jacket.

So I think that event rounded off year one as Director. Oh, I forgot, on top of all that we saved the only known portrait of Catherine Parr for the nation – more in-fighting. I have reason to be pleased and reason also to be tired.

21 October. Dinner at Campden Hill Square.

Antonia [Fraser] was in folk dress *à la polonais* at a shot with a skirt guarded with braids and a bolero but she looked fair, fresh and pretty. She's a born hostess and I sat next to Violet Wyndham, whose profile resembled that of a benevolent vulture and who wore a wig. Attired in a brightly coloured caftan and sporting a large amount of jewellery she was, I later learned that she was the daughter of Ada Leverson, Oscar Wilde's beloved Sphinx. For years Violet used to tell people she could remember Wilde because she had sat on his knee as a child but with advancing years that story was dropped. But tonight she regaled me with stories of the novelist Louise de Vilmorin staying with Diana Cooper while she was having her face lifted in the hope of marrying Monsieur Malraux and of the shock that a guest to dinner had at finding her with her face still pinned at the perimeters. There was Auberon Waugh, a plumpish softened version of his father, and George Weidenfeld, fat really but very very clever and whose beady eyes miss nothing. After dinner we all careered off to Hugh Thomas's[1]

[1] Historian and author of many books, most notably his classic *The Spanish Civil War*. Created a life peer in 1981.

birthday party in Ladbroke Grove where there was Noël Annan,[1] the Gatacres[2] and Ben Nicolson.[3]

Costume, Byron and Doris Langley Moore.

Doris Langley Moore entered my life in connection with the establishment of the Costume Society, of which I was the first chairman, the stress being on the word 'man', for my task was to keep the female scholars of the history of dress from tearing each other limb from limb. Doris was a remarkable woman, the founder of the Costume Museum in Bath and a passionate Byron scholar. Indeed I recall an astonishing lecture she gave at the Victoria and Albert Museum on the occasion of the Byron exhibition in 1974. It began with her in South Africa (where she had been born and convent-educated) going to her first dance where a man tried to kiss her. Drawing back, she asked him, 'Have you read Childe Harold?' *From there on she never looked back, eventually writing a book on Byron's marriage in a house in Portland Place where Lady Byron had lived, although not at that number. Only after she had finished her text did she discover that the house had been renumbered and that she had been writing in the room in which many of the events she described had actually taken place.*

Doris, like me, was a great believer in trivia as being revealing, saying that Byron's laundry bills alone painted the man. She lectured once at the Portrait Gallery on his dress (she had discovered the famous Albanian costume) where, as her coup de théâtre, *she swung open the lid of the Victorian lectern and held up one of the poet's shirts which she had whizzed in the washing machine the previous evening.*

Large of feature and definite of tongue with the manner of a latter-day Lady Catherine de Burgh she was in her era advanced in terms of emancipation, telling me once that she had written the first novel which actually took the reader through the bedroom door. Doris had total recall and I tried to persuade her to write her memoirs. I recall her telling me of an encounter with E. M. Forster when he kept on wanting her to go and see his collection of ladies' hatpins. Fearing the worst she declined, at that time blissfully unaware of what a homosexual was.

[1] Provost of University College, London, 1966–78; Chairman of Committee on the Future of Broadcasting, 1974–7, and of the Trustees of the National Gallery, 1980–5. Created a life peer in 1965.

[2] P. V. Gatacre, husband of Teresa ('Tizzy') Chancellor, was Director of Madame Tussaud's at the time; owner of a noted Dutch country house and garden, De Wiersse.

[3] Son of Sir Harold Nicolson and Vita Sackville-West and brother of Nigel Nicolson, distinguished editor of the *Burlington Magazine*, from 1947 until his death in 1978.

*The Corporation of Bath, to whom she eventually gave her col-
lection, was the bane of her life. I gave her the best suit I ever had
made, in about 1970, by Blades at the top of Savile Row. It was blue,
double-breasted with six buttons, tightly waisted and with side vents
seemingly to the armpits, very narrow sleeves and straight-cut trou-
sers, just pre flares coming in. With them went a black fedora hat from
Herbert Johnson, a pair of glasses, a shirt and tie from Turnbull &
Asser in raspberry ripple stripes and a pair of black shoes. I recall my
mother visiting the museum and turning a corner to be confronted by
her son staring at her from a glass showcase.*

24 October.

I must be one of the few people to get on with Doris. I've never really
had any difficulty with her but I'm not sure that I'd like to work for
her. Today she was in purple, except for her gloves which were grey
and she was very conscious of the fact. That she lamented, recalling
that no woman before 1945 would ever appear in London without
wearing a hat. Somehow it was back to face-lifting again, this time its
early days when the surgeons could only do half at a time. A friend had
called on Marie Tempest at the halfway stage to be confronted with
the mask of comedy and tragedy. But the real point of the lunch was
for me to sign her passport photograph as a true likeness. Extraordinary
what vanity does to people but I cheerfully scribbled my signature on
the reverse of photographs seemingly taken through a gauze screen.

Doris is a great barometer of changes in social mores. 'I was Philip
Hendy's mistress,'[1] she suddenly announced. 'Now it can be said,'
reflecting the movement of the times. She now hated him and I won-
dered what had happened. Doris is South African, which she tends to
conceal, and started her life married to a doctor in Harrogate before he
ran off with the nanny. I really wish she would write her autobiography.
Every time we meet some other weird crumb falls my way. This time
it was the problem of getting Fred Ashton[2] out of the RAF during the
war. The only way was to devise the scenario for a patriotic ballet,
which she did: *The Quest*, based on Spenser's *Faerie Queene*. Not Fred's
best I gather but the décor by John Piper must have been striking. I
remember it being reproduced in a King Penguin, *English Ballet*, which
came my way when I was in my teens.

[1] Sir Philip Hendy, Director of the National Gallery 1946–67. Knighted 1950.
[2] Frederick Ashton, dancer and principal choreographer to the Royal Ballet. Knighted
1950.

Beaton Portraits: 1928–65.

This exhibition dominated my thoughts all through the year, and I have put all the entries connected with it into one sequence.

29 February.

Trustees' Meeting day. There was a mind-boggling confrontation between Lloyd Kenyon, Cecil Beaton and Dicky Buckle. I don't think that Lloyd knew quite what had hit him. There stood the model of the exhibition with 'walls' which in fact floated, stylised William Kent mirrors with tin-foil glass on to one of which had been glued a picture of Greta Garbo. I waited to see what would happen but Cecil flattened Lloyd.

That evening there was a Trustees' dinner at the Chairman's club, the Cavalry, a faded, rather shabby institution in shades of unutterable green. The evening began badly with Miss Lee cancelling at the last minute which made us all furious. Gerald Templer[1] told Richard Ormond[2] and me to get our hair cut! I was seated between Cecil and Elizabeth Longford. Elizabeth said, 'Cecil, I thought you were a "Sir".' 'No, only in Paris,' he replied. 'I was paged in a hotel "Soeur Cécile, Soeur Cécile", and kept on thinking, who the hell is this nun, and then I realised it was me that they wanted.'

17 October.

Cecil described to me how he had achieved a new portrait of the Queen posing in a plain black cloak. He said that he was very pleased with the results and that the Queen had been in a very giggly mood. He remarked how plain she looked but, after a little retouching, the photographs were fine.

25 October.

Cecil flew in to see progress on the exhibition after having been to Princess Marina's memorial service. He was exquisitely dressed in a six-button double-breasted morning suit with a huge black hat and kid gloves. He was thrilled with it. I took him to lunch at the Ivy to which he said he hadn't been since the 1930s.

[1] Field Marshal Sir Gerald Templer, formidable soldier, later founder of the National Army Museum and a Trustee of the National Portrait Gallery.

[2] Assistant Keeper, National Portrait Gallery; since 1986 Director of the National Maritime Museum, Greenwich.

29 October.
The Beaton exhibition really looks marvellous. He was in it photographing Dicky [Buckle] in a black silk blouse festooned with necklaces of sharks' teeth. He insisted that I join the group.

29 October. To Jan van Dorsten.
And now one is on the eve of the great Beaton show and the whole of London agog for it. It is *marvellous* and I long to show it to you. No one will ever be able to do a photographic exhibition again in the same way. The programme is like a play: Act I: A drawing-room pre-war with a great frieze of beauties, the Queen Mother seen in the distance through a Venetian window flitting across sunlit lawns, Beaton himself looking out of a tin-foil mirror as the 'Observer', thirties popular music playing. Interlude: the war, a corridor of sailors, bomber pilots, etc., hung like banners; a bombed-out room; and the vista closed with St Paul's arising from smoking ruins. Prelude to Act II: the Coronation. Act II: A studio today, a huge studio stove, vast Beaton hat, postcard stand ten feet high with twenty photos of Marilyn Monroe on it slowly revolving, a model theatre with projections, great racks of portraits, a new one of the Queen on an easel (to be released on the day of the opening), Elizabethan music playing and, as one leaves, Beaton today taking one's photo with a flash-lamp bursting every few minutes. Incense burnt in the last room and a lot of psychedelic light. It ought to cause a furore!

30 October.
Vogue's launching party. I think that this must have been the most dazzling assemblage I'd ever been in. Noël Coward, with coarsened features and looking very decayed, arrived with Gladys Calthrop[1] on his arm. The photographer David Bailey appeared ashen in velvet rags with Penelope Tree,[2] sporting a long black skirt to match her equally long black lanky hair. She wore an Indian bandeau and her eyes were painted around with alternate green and black lines. The painter Patrick Procktor gangled in, seemingly eight foot high in elegant velvet undress. Lindy Dufferin wore a dark crimson suit, Evangeline Bruce in black, Lee Radziwill stunning in Courrèges black and white, Diana Cooper in turquoise. The *beau monde* floated by like the waves of the sea: Peter Coats, Frederick Ashton, Lord Harlech, the Channons, Stephen Spender, Lady

[1] Designer of many of Noël Coward's productions.
[2] Model and epitome of late-sixties style.

Rosse, Mrs Ian Fleming, the Tynans, Mick Jagger, Pamela Colin, the Weidenfelds, Jocelyn and Jane Stevens, the Glendevons and David Hockney with a beautiful blond Jewish boy. I find it difficult to write about today. It was so terrific, so glamorous. And I loved every minute of it.

31 October.

I was exhausted but exulted. This was the day of the royal launching and our own private view. It began well with over thirty reporters at the press view, an unheard-of record for us. The Queen Mother arrived ten minutes late at 6.40 p.m. with Lady Jean Rankin and Captain Aird in attendance. I recognised the favourite pink ostrich feather hat. Although this was billed as a private visit, the cameras of the press flashed as she arrived to be greeted by Cecil, who took her round. For her it was full of nostalgia but what was so striking was her fascination not with things gone but with the present. After the tour of the exhibition she went to the boardroom, which had been transformed with flowers and spots. She was sweet to all the Trustees and, as she left, she was presented with a bound copy of *Beaton Portraits*. Then it was back to the private view which followed and the evening wound up with a dinner in my office for Cecil, the Kenyons, the Longfords and Dicky. Dicky very sweetly presented me with a pretty cup and saucer but I fear that the dinner was a bit staid.

Beaton gives a far fuller account of this opening in his diary, including that I had said as we waited under the awning for the Queen Mother, 'Oh, the excitement! I think that this is the most thrilling thing that has ever happened to me!' Up until then it was.

3 November.

The most amazing article on me by Quentin Crewe in the *Sunday Mirror* in which I was billed as 'The man who is giving history a face-lift' and putting Trad and Mary Hopkin (No. 1 in the pop charts) into the NPG. One hopes that one can fulfil what the piece said: the man of the future who cares for the past. It does make one hanker for the British Museum, Tate, etc. Is that too awful of me? I hope not. One must recognise one's limitations but I do seem to have a talent for getting things moving...

19 November. To Jan van Dorsten.

The Beaton opening came and went ... 16,000 through in fourteen days. I have suddenly found myself shot into the limelight as a kind of

messiah of the London museums. Very dangerous this pop idol stuff. I was celebrity of the week on *Woman's Hour* (whatever does that bode?), a whole page in the *Sunday Mirror*, a long profile in the *Guardian*, etc. I wonder where it will all lead? I do seem to get rather involved with smart people these days. Difficult but interesting. I shall obviously be the museum monster of all time by the time I'm forty!!

27 November. Judy Gendel.

I felt really exhausted and slept most of the day. In the evening there was dinner with Lloyd, who really is so conventional that he's becoming a bore. I didn't dare reveal that after I'd escaped from him I was pounding off to a new venue, 84 Maida Vale. Milton and Judy Gendel had only recently entered my life. I'd met her first being placed next to her at Antonia Fraser's. In a way she's almost hideous to look at, her face heavily lined and masked by perfectly enormous spectacles. Tonight she was wearing a disastrously lurid caftan. Whatever virtues she had, dress sense was not one of them, but she was intelligent and a delight to talk to with her deep hoarse voice. She sets the pace and Milton just seems to be there, a permanently smiling American.

Her taste in clothes was reflected in the interior decoration. It could only be described as anti-décor, a Victorian house gutted and filled with a mixture of modern furniture and junk, items like a chesterfield upholstered in black shiny leather and a table painted bright purple. But here was gathered the scene I was becoming increasingly familiar with, the same people transposed to another location, among them Diana Cooper, the Gatacres, Stephen Spender, John Craxton, Julian Jebb, not to mention a sprinkling of dim-witted debby girls with blanched faces and kohled eyelashes. Elfin-like Julian Jebb in a black velvet frock coat and frills was being always so funny, so witty, so amusing and, I felt, such a bloody bore.

30 November. Christabel, Lady Aberconway.

I was bidden to lunch by Brinsley Ford to that treasure house, 14 Wyndham Place. Joanna Ford was ill so it turned out to be *à trois* with Christabel, Lady Aberconway. And what enchantment that proved to be. For one thing she knew how to make an entry to effect, even though she's short in stature, arriving with one hand engulfed in a vast fur muff and the other resting on the gold and onyx handle of her walking-stick. I'm not sure that she was ever beautiful but certainly vivacious, her face a pale oval lit by a pair of sparkling grey-blue eyes. Her white hair was in marcel waves secured by combs. The absence of Joanna

must have pleased her for she had two men all to herself.

'Here I am at seventy-eight,' she began, 'still in love with life, every minute of it. The only thing I dread is eternity.' What about reincarnation? Yes, she'd like that. 'But, Christabel,' Brinsley interrupted, 'you might be a char.' 'Yes, but I'd be your char and think how interesting that would be.' Her speech was accompanied from time to time by girlish giggles, particularly when she was a little *risqué*, which was most of the time. This is a lady who loves a tipple and she cheerfully nosed her way through two large gin and Dubonnets. 'Not much Dubonnet,' was the instruction, 'but I do not mean that comment to apply to the other ingredient.'

Over lunch she held forth on Douglas Cooper.[1] Whenever she saw him she loved him. Whenever he wasn't there she disliked him. His new friend was Michael Fish, who must give him 'a little love', and from there her thoughts ranged on to stories about Lord Spencer and the Duke of Wellington.

Afterwards she took us back to her house in North Audley Street, a monument to thirties neo-classical romance. There was an oval staircase, quite small really, but with urns carved in false perspective in niches on the ascent, a Rex Whistleresque apparition. Shortly after, one was to learn just how heavily his ghost hung around the place. She used as her drawing-room a garden room which ran the length of the back of the house and opened on to a small pretty paved garden with trees, statuary and a pond with a fountain. The garden room was dominated by a handsome William Kent fireplace over which hung an entrancing Renoir of a nanny with two little children looking at ships from a river-bank. At either end of the room there was a niche containing an urn designed by Rex Whistler. Around one processed all the Samuels – Pepys, Richardson, the Prophet, Rogers, not to mention Courtauld – around the other danced the Muses, all nine, according to Brinsley, being Christabel.

She had turned the room into her drawing-room because she loved it so much, although, she confessed, she felt naughty for having done so. Rex's designs for the urns were there, as indeed was much else. A huge scrapbook was opened filled with photographs and letters decorated in his inimitable manner describing work at Plas Newydd and for the Sassoons and others. There was a book of his of which only three copies were ever printed, number one for Christabel, number two for Sam Courtauld and the third for the writer Osbert Sitwell. What visions

[1] Art collector, especially of Picasso, writer, and perennial *enfant terrible*.

this evoked of a world now gone: pretty pictures of shells (including our hostess as one) and Winterhalter ladies gliding through woods. On one of the walls hung Rex's drawing of Osbert, a crisp medallic profile, destined for the NPG.

And then came a great surprise. We were taken upstairs in a little lift, something Brinsley had never achieved. Stepping out, the walls were banked with photographs of her family, whom she loved, and also of cats, which she also loved. Then came her bathroom, half an oval made whole by a wall of mirror glass. This, she announced, was a bathroom for Venuses. It was good to see oneself. It reminded you to eat less. Finally came her bedroom decorated with chinoiserie wall-paper. Next to the bed there was a pair of shutters resembling a hatch. I asked her what it was. She replied that behind the doors was a portrait of someone who was now dead. I dared not ask who, perhaps the beloved Sam? She preferred, she said, not to open it. From this room another door led to a winding staircase: 'For lovers,' she said with a sigh, 'but no more.'

So we began to make our descent, first to her own sitting-room where, over her desk, there was a wonderful Picasso of a little girl clasping a bird and, nearby, a Sickert of a group on a beach, very small and bright with an inscription on the reverse. And so to the ground floor and the dining-room. Another breathtaking Renoir over the fire-place but the best one of all on the wall opposite, indeed the finest picture in the house, in which a distant figure moves almost waist-deep through a haze of blooming grasses. To its right there was a Cézanne of a wood. This for her was *A Midsummer Night's Dream* and she began to point out where each character made its entrance and exit. The Seurat sketches on cigar boxes seemed almost an anticlimax. What a day. I hope that I meet her again.

1969

Apotheosis

Looking through the events of this year I seemed to be heading either towards an early apotheosis or being a rather sad essay in pride before the fall. It appeared that I could do nothing wrong. Everything I touched took off, and was acclaimed. Dangerous stuff, but for a heady year I floated along on a cloud. The year opened with the extension of the Beaton exhibition no less than twice (it went on to New York). London at weekends became accustomed to the extraordinary sight of queues stretching around the Gallery into Trafalgar Square. 'It's done something terrific for us,' I wrote, 'It's associated the Portrait Gallery with the land of the living instead of being an artistic morgue.' Attendance figures shot up. The place was on the map and, copying a notorious V & A publication, I introduced a pamphlet entitled *Six Famous Portraits in Fifteen Minutes* to hook the casual first-time visitor. Moves were made now towards film: '... portraiture isn't exclusively to do with painting. Our business is with the living image. We should be making films. We should have our own cinema. People today like historical fact. They don't want fiction.' All that year the work of the Gallery went on, cleaning and restoring pictures, putting in order the archive, redecorating the galleries. The NPG never looked back. What leaves me proudest is that never once did I ever sense any disloyalty. There was no hint of any resentment from the staff as their Director strode the public and social stage. For them I was the revived Gallery incarnate. My success was their success.

So the media never left me during 1969, but I had already begun to realise that such coverage had its dangers. By November the *Daily Mail* did 'a day in my life' as Britain's most unlikely Civil Servant and I was photographed standing beneath the statue of Irving at the bottom of Charing Cross Road, looking like a demented suffragette in a huge fedora hat and coat to my ankles. I was, it seems, 'a startlingly mod figure', but then this was after all the apogee of the swinging sixties, the heyday of the King's Road and of the Beatles. I recall saying to Beatrix Miller, then editor of *Vogue*, 'I'm not going to give another interview,' to which came the reply, 'Darling, that's great. That means

you'll survive.' And I did, but it was a lesson to be learned and at times one teetered perilously near the edge.

Looking back it must sometimes have been quite difficult for the Trustees to stomach but the wind was taken clean out of their sails as it was all so very successful. But I sensed the frost. It was difficult to cut down to size a Director who could spot a major portrait of Anne of Denmark in the saleroom unrecognised, and buy it for £700, which we did in the Craven sale in January. Let alone one who could raise the overall grant for the Gallery from Government so substantially in his first two years. There is no trace of that hard bargaining in what I wrote in my diary, for I continued my path of recording essentially, but not always, a panorama of social life.

The diary reads as though that life was an endless party, which in a way it was. But even my records of those are patchy. One of the most remarkable was given for George Weidenfeld's fiftieth birthday. The invitation card read 'exotic dress'. That was misread by one recipient as 'erotic dress' and promptly thrust into the wastepaper basket. I went as Aubrey Beardsley's idea of the Regency in black velvet and silver spangles swagged in purple sashes and carrying a huge fur muff.

In spite of what seems one long tide of frivolity all I had intellectually striven to achieve reached its culmination in the exhibition at the Tate, *The Elizabethan Image*, in November. That event coincided with the publication of both *The English Icon: Elizabethan and Jacobean Portraiture* and the two-volume catalogue of the Gallery's early portraits, *Tudor and Jacobean Portraits*. In a sense, academically, my work there had already reached its logical end.

The exhibition was conceived from the outset to convert, to win over, beguile, dazzle and stun a public with the magic of an era of painting which I had fallen in love with as a teenager. I set my face against producing an academic tome as a catalogue, far better something inexpensive, manageable and seductive. The show, too, was to be a narrative spectacle on the grand scale with sunshine and shade. Through the gloom of mid-Tudor iconoclasm, replete with the shattered images of saints, the visitor wended his way towards the shrine of Gloriana, in the midst of which stood a golden obelisk bearing her imagery, rainbows and spheres, sieves and crowned columns. Then, all of a sudden, as a *coup de théâtre*, there was a vast long gallery lined with flower-coloured full-lengths of worthies in gala costume, a phantasmagoria of bristling ruffs and farthingales, spangled shoe rosettes and jewel-besprinkled hair. Lute music hung in the hair and the exhibition-goer found himself assailed by visions of tournament and

revelry and, later, by the melancholy of the end of an age, young men shrouded in black with their arms criss-crossed, along with ladies enveloped in veils mysteriously half-smiling in the shadows. And then as a finale came a fanfare heralding the world of Inigo Jones, Rubens and Van Dyck. It was unashamedly romantic but also highly disciplined, in exhibition terms a realisation of Sir Philip Sidney's phrase, 'the riches of knowledge upon the stream of delight'.

This was an exhibition done from the heart with passion. Only two critics carped, Denys Sutton and Terence Mullaly; the rest responded beyond even my wildest dreams. Bryan Robertson wrote that it was 'the most revelatory spectacle of its kind I can recall seeing in London', and John Russell joined him, saying '... what we see at the Tate is not so much installed as argued: set out complete with music and the written word, with many an artful twist and turn of the terrain. Against all expectations it has a headlong emotional drive.' The year 1969 ended on an even greater high than 1968, if that were possible.

20 January. Duncan Grant's 84th birthday party.

Duncan Grant will be eighty-four tomorrow but today the Dufferins gave a *fête* in his honour. Lindy presided, dressed in a brown velvet trouser suit with silver buckles on her shoes, her hair curled as though she were a gangster's moll. There was dinner for about thirty at four round tables in the 'gallery room' with Hockney's *Splash* and a bloody Bacon on the walls. It was quite a gathering with Alexander Dunluce[1] Ossie Clark,[2] Ralph Kitaj,[3] Pauline Vogelpoel,[4] Cyril Connolly,[5] David Hockney,[6] Raymond Mortimer[7] (very wrinkled and in a polo-neck) and Bryan Moyne. David Garnett, author of *Lady into Fox*, now seventy-eight, stood large, white-haired and solid. Patrick Procktor was, as always, languorously elegant in grey with a blood-orange-red open-necked shirt and gaudy waistband. Also the publisher Hamish Hamilton and his Italian wife, she wearing black, trimmed with ostrich feathers.

[1] Lord Dunluce, picture restorer and Keeper of Conservation at the Tate Gallery since 1975; succeeded his father as Earl of Antrim in 1977 but continues to use his courtesy title.

[2] Brilliant and feckless fashion designer, immortalised in David Hockney's painting, *Mr and Mrs Ossie Clark and Percy*.

[3] R. B. Kitaj, American born painter, long resident in London.

[4] Innovative and stylish Organising Secretary of the Contemporary Arts Society.

[5] Author, critic and editor of the literary magazine *Horizon*.

[6] Painter, portraitist, stage designer and photographer whose work epitomised an era.

[7] Benign writer and literary critic for the *Sunday Times*.

I sat between Rhoda Birley and Quentin Bell with Fred Ashton and Peter Schlesinger, David Hockney's new friend, and a beautiful girl whose name I never caught. I dropped a clanger with Fred, saying how much I missed the old Messel *Sleeping Beauty* with things like the second-act hunting party, dancing and slashing away with their riding-crops, the peasants as though lifted from a Boucher intertwining with them, which he considered an awful bore. I didn't twig that Lady Birley was Oswald's widow until later in the evening. She is still strikingly beautiful with the whitest of complexions, expressive eyes and a great deployment of bangles and jewels which sparkled. Peggy Ashcroft, dressed in black, told me she intended to leave her portrait by Sickert to the Gallery, but oh that voice![1]

29 January. A visit to David Hockney's studio.
At Lindy Dufferin's party for Duncan Grant I'd chatted to David Hockney and suggested what a marvellous subject Fred Ashton would make for him. At the time Fred was perching on the arms of a sofa with his fingers exquisitely arranged – the only word for it – around a cigarette. From afar *en profile* he looked like some exotic parakeet. David was clearly excited by the possibility. At the time he was drawing W. H. Auden so I thought that I ought to go and look.

Number 17 Powis Terrace is one of those late-Victorian stucco ter-races in Notting Hill Gate with a vast columned portico and every sign that gentility had long since fled. The houses were now tatty tenements and I climbed up what can only be described as a squalid staircase-well to be met by David. Original is the only word one could ever apply to him with his bleached blond hair and owl spectacles. But I couldn't help loving him and admiring his quick logic and unique perception. He's rather large and square, getting fat in fact, and somehow terribly conscious of it. The whole time I was there he kept on feeling beneath his shirt as though checking up on the expansion of the wedges. We sat down in his kitchen together with his slim blond American boy-friend, Peter Schlesinger, and lunched off consommé, toast and pâté washed down with red wine. After it we went into the studio.

I don't think that I'd ever before encountered anyone so overtly homosexual. Against one wall rested two blown-up photographs of Peter, one in bikini underpants, the other in jeans with his flies left undone. All over the floor were scattered magazines with male nudes.

[1] Classical actress of supreme distinction, who was as good as her word over the Sickert. DBE, 1956. Died 1991.

David picked one up and complained how it had been seized by the Customs and then returned. On its cover was stamped 'Nudes – semi-erect'. He works from photographs but not when he draws people. He showed me some of Angus Wilson, one of which was very good, although he didn't think so. He agreed to draw Fred Ashton for me, although I warned him about the Trustees. The phone rang. It was a Spanish waiter who wanted to come round and strip for him to draw. The time had come to leave.

Every surface was white. In the sitting-room stood a Mackintosh chair, a rococo sledge, a divan bed with some cushions scattered across it and some coloured cut-out trees like those in a child's toy theatre. In the studio I noticed a frame containing a collage of newspaper cuttings of the Rolling Stones. Both David and Peter live for the opera and ballet and, oh, David said, how he longed to draw the pretty boys in the ballet school. Perhaps, I thought, Fred might pave the way.

9–16 February. Moroccan interlude.
'We must have a painting expedition!' yelled Lindy Dufferin. That was several months ago when I had taken my painting things to Clandeboye and done a rather wishy-washy watercolour of the house. Notionally we agreed on February but would this dotty idea ever actually happen? I doubted it and then, all of a sudden, we were off to Morocco. There were three of us: myself, Lindy, buoyant and pop-eyed as ever, as though in a permanent state of amazement at everything and everybody, and her 'newly discovered' cousin, Bryan Moyne.[1] Now he was a bonus, a tranquil, tolerant, lovable person, although he was so soft-spoken that I only ever could catch half what he said. At the airport he presented each of us with a notebook because notebooks would definitely be needed.

We stayed a night in Rabat, which had few delights, but we ambled through the old town, the *medina*, with its narrow medieval streets lined with booths in which the vendors stood or crouched, their goods spread before them. But, oh what colour! Cinnamon, black pepper, turmeric, the spices in their huge sacks ravished the eye.

On the Monday we went by bus to Fez via Meknès. The coastal scenery was dull and then suddenly we climbed up into the hills which were verdant, the almond groves in full bloom. Everywhere one looked there were orange trees, hard-pruned vines, cactus hedges and woods

[1] Bryan Guinness, 2nd Baron Moyne; poet, novelist and playwright whose first wife, Diana Mitford, later married Oswald Mosley.

of eucalyptus with the soft haze of mountains in the distance. The Palais Jamai at Fez lived up to its name. It had indeed been a palace and our rooms looked out on to a courtyard full of palm trees, brightly coloured nasturtiums and flowering shrubs. That was what I would paint, I decided.

One day our very smart guide took us around the *medina*, just as well as we would never have come out of it on our own. Up hill and down dale we trundled through this partly roofed maze along cobbled and muddy streets, pushing past donkeys with huge panniers slung across them, making our way through one district after another, metalworkers hammering away like blazes, vat-dyers the colour of their own dyes, an area for textiles and caftans and another which I wish I had missed, an abattoir with its end product, skins for leather.

Our only introduction was to Angelica Garnett. Very Bloomsbury as indeed was the whole scene which greeted us. Angelica was separated from her husband and was here for four months alone in a capacious one-room studio whose facilities could only be described as basic. Here she was painting away like a mad thing, producing abstracts of local scenes of no great moment but her drawings showed that she had real talent. Poor thing, she had a lovely face but it was crow's-footed and careworn. She was tired and desiccated and for most of the time she subjected us to lengthy lectures on local vice and unreliability.

Julia Trevelyan Oman first entered my life when her father, Charles Oman, Keeper of Metalwork at the Victoria and Albert Museum, gave her a small engraving of Elizabeth I. Wishing to know more about it he had directed her to 'young Strong' at the National Portrait Gallery. That happened shortly after the phenomenal success of her ballet The Enigma Variations, *choreographed by Sir Frederick Ashton in 1968. Later I recall asking Julia what had been her first impression of me. She said it was of my back view disappearing down the Kafkaesque corridor at the Portrait Gallery with one leg dragging slightly behind. Looking at that lonely figure receding into the distance, she thought: He needs looking after. She was right and in the end she did. My only regret is that I took so long to propose to her.*

25 February. The First Night of Aubrey's Brief Lives.
I had been sent seats by the designer, Julia Trevelyan Oman. I took Hermione Waterfield and we sat in the third row with Fred Ashton, who had a glamorous boy in tow next to us. In front there was John Betjeman and alongside him the actor Richard Johnson, Princess

Margaret and Tony Snowdon. From afar I glimpsed Cecil Beaton. The ladies wore acres of false hair.

Julia's set was really a Victorian vision of the seventeenth century, an amazing clutter-bespattered lodging dominated by a huge four-poster surrounded by a dust- and cobweb-laden phantasmagoria of dried flowers, old furs, stuffed animals, pictures, carved fragments, tassels, pieces of armour, pewter plates filled with spices and nuts, bottles and jars. In the interval, members of the audience ambled down to the stage just to look in greater detail at the huge pile of props. Roy Dotrice's performance was a *tour de force* with its touching evocation of the England of Gloriana before the terrible Civil Wars, and how everything since had been just plain awful.

4 March. The première of Isadora.

The invitation bade those who came to wear 'gems and flowers'. I couldn't think what to do but my barber persuaded me to go wearing a false moustache which looked very fetching but kept falling off. The film, directed by Ken Russell, turned out to be pretty feeble but there was a great party afterwards at the Coliseum. The only drama of the evening occurred when the star of the film, Vanessa Redgrave, in a scarlet and gold sari, her hair encircled with flowers, fainted. Mark Lancaster and David Hockney, in green, both appeared wearing garlands of flowers and Patrick Procktor wore a bouquet of enamelled ones in his lapel.

24–25 May. David Hockney draws Cecil Beaton.

Cecil gives an account of this weekend in his diaries, which rightly concentrate on David producing drawings of him 'looking like a bloated, squat, beefy businessman', noting that '... poor Roy Strong did not seem to have much attention given to him, and he had recourse to doing watercolours in the conservatory.' I still have that rather bad watercolour. David did a couple of quick profile sketches of me looking like a seedy Regency buck while we all sat watching television. I have one, which he gave me.

The other Cecil pasted in one of his scrapbooks and twenty years later I was able to reidentify myself for its purchaser. Much to my surprise, in a Hockney exhibition in the late 1980s, one of David's photographic albums was open at a page where I saw myself sitting in the conservatory.

This was what Cecil had categorised as a quiet weekend. David

David Hockney's sketch of me.

Hockney was to draw his portrait so David arrived along with Peter. Cecil is nothing if not vain so there was much coming and going with piles of hats from which David could make a choice for Cecil to wear. David's early attempts didn't go down at all well, hardly surprising for his graphic style highlighted every wrinkle on Cecil's face.

One afternoon while David drew Cecil in the studio and I lolled on the grass behind the house, a woman suddenly strode up and asked where he was. I said he was sitting for David Hockney and it was up to her as to whether she should interrupt or not. The intruder was Lady Mary Dunn, I learned later, and David gave a wonderful account of Cecil glimpsing her through the window and screaming, 'It's that fucking woman!', then jumping up and opening the door with 'Mary, darling, how wonderful to see you!'

On one day we went to a lunch party for about thirty at Michael Pitt-Rivers's house at Tollard Royal. There stood A. J. Ayer[1] and Dee Wells.[2]

[1] Philosopher and writer. Wykeham Professor of Logic at Oxford, 1959–78. Knighted 1970.

'Notice how I cut her dead,' murmured Cecil. [He hated her.] We were also driven as near as he could get us to his first Wiltshire house, Ashcombe, virtually over a ploughed field. We got out and stared down a slope but we could see little. What one did learn was that this was the house he really loved. There was the obligatory expedition to Crichel for drinks with the Martens. Cecil knew we formed a somewhat striking quartet. David was into wearing socks of two different colours. 'I think we were strong medicine for them,' Cecil drawled with satisfaction as we left.

13–15 June. Kelvedon and the Channons.

I'd been asked by Paul and Ingrid Channon[1] to Kelvedon for the weekend and travelled down with the Dufferins by train, stupidly making them get out at the wrong station and finding ourselves hurtling miles by taxi across country. The house is red-brick Georgian done over in the best style by David Hicks but full of the kind of things 'Chips' Channon would have purchased in the thirties like the flamboyant gilded German rococo saints which flanked the entrance in the hall, evoking the Sitwells' rediscovery of that style. The house was apparently converted back from being a convent for a time and now the bedrooms have different names like Empire, Victorian and Austrian. The weekend was *grande luxe* as bags were unpacked, bathwater run, clothes laid out and, luxury of luxuries, everyone, including the men, was brought breakfast in bed with *all* the Sunday newspapers. The Victorian room came my way hung with a Dutch East India Company pattern and a white half-tester bed and curtains and a view out to the lake at the front.

This was an idyllic country-house weekend with clear blue skies, the temperature in the upper seventies, and while I painted others swam, played tennis or bridge and we lunched alfresco. Ingrid is a born hostess, with great attention to detail, breaking through what could have been a frosty and formal set-up with refreshing gaiety. The Channons are new friends I'd met through the Dufferins. Everyone else staying was new to me: Mark[2] and Arabella Boxer, he immensely clever with an early fifties look about him, but the real event was Ann Fleming. This is a stunning, chic, caustic and witty woman who doesn't

[2] Journalist; wife of A. J. Ayer.

[1] Conservative MP for Southend West (succeeding his father Henry 'Chips' Channon in 1959); Opposition Spokesman for the Arts, 1967–70; Minister for the Arts 1981–3.

[2] Mark Boxer, cartoonist, who signed his drawings 'Marc' (died 1988). Arabella, his first wife, made her own reputation as cookery writer.

suffer fools gladly. The twin attributes of power and the desire to dominate run in her veins.

21–22 June. The Bath Festival.

This, I must say, was complicated. It went back to overtures being made to me by someone I have now come to regard as battleaxe number one, Barbara Robertson of the jam factory. I had been asked by, and stayed with, the Strathconas at 20 Lansdowne Crescent with the idea of helping the poor old Bath Festival. After Yehudi Menuhin had been replaced, the whole affair seems to have sunk into a frightful footling mess. It was now run, rather unsatisfactorily one thought, by a tri-umvirate with Jack Phipps as the impresario–administrator together with Michael Tippett, the composer, and Colin Davis, the conductor, as honorary unpaid artistic directors. Not one of them agreed with the other. Phipps is frankly genial but uninspired, Colin Davis moves with the mood of the moment and this particular moment was focused on youth and its response to music, while Michael Tippett seemed just all over the place. Tippett, who had his friend Karl, a painter, with him, I took to hugely. He's a funny, nice, profound man in his way, given to girlish whoops and giggles when he suddenly slaps his thigh and curls up in a heap on the sofa. The weekend was spent trekking from concert to concert and from lunch to dinner with endless soul-searching. There was just too much music, too much snobbery and too little sense of overall direction. It left me extremely tired and depressed.

24 June. Lunch at Victoria Square.

This is the first time I'd been asked to lunch by the formidable Mrs Fleming. The house is on the corner of Victoria Square, one of those innocuous stucco jobs but with a pepperpot tower. It is very pretty inside with a little library/drawing-room on the first floor lined with Gothic bookcases in bamboo with Gothic wallpaper hung with a col-lection of Victorian silhouettes in brass. Large brass arms of the same era hold back the curtains. We lunched off fish, chicken salad and crème caramel and strawberries served by the hired butler. There was the usual gathering of the clans: David and Evangeline Bruce, Stephen and Natasha Spender, Diana Phipps, and Patrick Procktor, who swept in and, on seeing Natasha Spender in a startling outfit patterned with really awful bright red squares, rushed up and said, 'How perfectly lovely!'

That evening I was asked to the Lord Mayor's Midsummer Banquet, which I thought was a great compliment to the NPG. I was flanked by

two people of unutterable dreariness and the whole event was marred by J. B. Priestley getting up and giving a speech about the iniquities of taxation in respect of authors, his own income tax in particular, and quite wrong for the occasion.

3 July. The British Museum celebrates the reinstallation of its classical collections.

The great and costly soirée at the British Museum seemed at a shot to be for something like three to four hundred guests. It was beautifully done in what I would categorise as 1950s Metropolitan Museum of Art style. The dinner was served in the Duveen Gallery with its fabulous Elgin Marbles, with clusters of round tables surrounding a large one at the centre. The Queen had been meant to come but couldn't as she had a cold so that must have been a blow. Philip came on his own. The dinner was somewhat surprisingly served by girls in ochre-coloured classical mini-dresses, wildly way-out for the BM. Whatever next? As there were no speeches and no press was present I couldn't see the point of the evening, a view shared by the farouche and fascinating writer Dame Rebecca West who kept on asking me, 'What is it all about?'

Annigoni paints the Queen.

The Trustees' desire for a portrait of the Queen and her preference for Pietro Annigoni expressed at the Buckingham Palace lunch I went to in 1967 came to fruition. The donor was the Gallery's most loyal supporter, Hugh Leggatt. Annigoni gives a long account of his sittings in his Diario *and there is another in the catalogue of the Annigoni exhibition at the National Museum of Wales in 1977. The portrait was to be unveiled the following February but the sittings ran all this year, and I have put the four relevant entries together, before returning to chronology.*

25 February.

Annigoni has started painting his portrait of the Queen. I gather that the first sitting is over. Annigoni is very pleased. The costume is under discussion and so far he's been offered a cloak but somehow I feel we need a revamped image of her *à la chasse* as a countrywoman. But it's under way and very exciting.

31 March.

I went with Hugh Leggatt, the donor, to Annigoni's studio at 56 Edwardes Square. There, on the easel, sat his pastel and tempera head-and-shoulders of the Queen looking extremely serious, in concept simple and monumental. But the real excitement came when he showed us a series of suggested compositional sketches, one of which I dived at. Against a huge overcast sky the Queen arose like a vision in a red cloak, lonely, majestic, timeless, formidable, the CROWN embodied. An alternative, which had far less background, was discarded. He blew fixative over the compositional formula we liked best at once. And then he raged on about the *Daily Express* trying to get into the studio.

24 October.

Went to see the picture of the Queen by Annigoni. Hugh Leggatt and I drove to the Palace and went in through the Privy Purse entrance. A footman took us up in a lift and then along miles of carpeted corridor covered with crimson and banked with pictures to a chinoiserie room. The portrait is stunning, hugely grand and majestic. I can't say how thrilled we were with it. Annigoni is an engaging rogue, dreamy and funny at the same time.

8 December.

Saw Annigoni again at the Palace. The portrait is very advanced, indeed almost finished. For a moment it looked dull and then Hugh uttered the word, 'Varnish.' Annigoni seized a wide brush and dipped it in the water of a flower vase and applied it to the picture as we shrieked, 'Marvellous.'

15 July. Godfrey Winn's birthday party.

The journalist Godfrey Winn had come my way as a result of the Annigoni portrait, having been asked to write it up. He's a perfectly nice man but everything was said when, as I took him round the Gallery, he stood in front of a Lawrence portrait of a strikingly handsome young man and with a grotesque grimace exclaimed, 'Why can't I look like that?'

I arrived early at 115 Ebury Street where he lived in a flat painted all over in a particularly awful shade of 1940s green. But he did have good pictures by Matthew Smith and Graham Sutherland. It had never crossed my mind what kind of party this was to be but that began rapidly to dawn on me as not a woman appeared and twenty men

gradually filled the room. I left as soon as I could decently extricate myself, appalled at the sight, amongst other things, of all those bottles of cosmetics ranked above his dressing-table.

31 July–4 August. Weekend at Clandeboye.

The occasion was the Kasmin Gallery's exhibition at the Arts Council of Northern Ireland's Art Gallery in Belfast. A whole battery of artists were flown over for the opening, some put up at Clandeboye, others in hotels. The three interlopers were Catherine Pakenham, Chrissie Gibbs (his hair sprouting nicely again after having had his long blond locks shaven in Cairo) and me. When it came to the artists and their hangers-on it was impossible to work out who was married or living with whom and whose children were whose. I gave up, but among them there was lovely David Hockney, Robyn Denny and his wife, he head-to-toe in dolly-mixture corduroy and an absurdly broad-brimmed red hat, Ken Noland and his wife, to neither of whom I spoke, Anthony Caro, who was a disappointment, Howard Hodgkin and some Americans called Orlitsky whom I didn't take to, rather a monster with a dreary wife, a girlfriend in tow and also a repellent child called Laura with no neck and long hair. The unsinkable and predatory Kasmin spent most of the weekend pursuing Catherine Pakenham. *Quelle galère!* Lindy Dufferin summed up the whole event with characteristic panache while she was lolling behind me near the tennis court: 'The trouble with all of them is they're common.'

On the Thursday the opening took place followed by a party for a hundred at Clandeboye with a discothèque in the music-room. 'Belfast hasn't seen anything like this before' was the oft-repeated comment as the frenzy of the dancing escalated. Nymphet and go-go girls had been imported to keep the scene swinging, one of whom had to be rescued from Kasmin's bedroom. The butler took one look at the girls and retreated. At 1.30 a.m. I went up to bed and then decided to come down again, changing into a Victorian black and brown velvet frock-coat with a frothing cravat in pink and white stripes. The party ended at 3 a.m. Later that weekend David Hockney, catching me in the same garb standing outside the library about to go in, sidled up and said in his beguiling north-country accent, 'Have you done your act yet?'

Just about everyone was on drugs except me, who declined even a puff. David was busy 'cleaning' Kasmin's hemp over breakfast: 'No wonder you have headaches, you've left the seeds in.' The butler was sent to get a tea-strainer but none could be found. On Friday we were all taken fishing at sea. I was terribly seasick and crouched in the

boat in a huddle clasping Dido, the Dufferins' dog. Apart from David Hockney, the artists were a dull lot. I stayed on an extra day and rehung most of the pictures.

16 October. A Trustees' Meeting.
This was a perfectly horrible meeting. Their ignorance utterly appals me. Many congratulations showered on Richard Ormond, who had produced an excellent booklet on portraits of poets; pointedly none came my way. Lord Euston raised the point that the Trustees should be consulted and approve of all schemes for redecoration in the Gallery. That swipe boded ill and was followed by the Field Marshal [Templer] who demanded that the Trustees should decide whether or not on principle engravings should even be included in the display. This was a frontline attack on the newly opened Regency rooms. Not one line of gratitude was expressed for what had been a massive face-lift to the top-floor galleries. I was saved by Elizabeth Longford, who said decoration by committee was decoration by the lowest common denominator. In the old days the Trustees chose the wallpapers. God protect us from that. I was left deeply disillusioned.

23 October. Lambeth Palace.
I was asked to one of the Archbishop of Canterbury's press lunches. The faded architectural pomp of the palace is bizarrely at variance with the lower-middle-class lifestyle lived within it. Sherry and orange juice were followed by a utilitarian lunch of stew, apple pie and cream, and cheese.

Archbishop Ramsey is a huge man with no neck, a sweet face and smile and marvellous eyes, all of it arising from a mound of pink and purple. After we'd eaten he held forth, rather apologetically I thought, predicting a further decline of the Church of England, the saving grace being that Christian attitudes were still important in society even if they were no longer connected with belief. This sounded a pretty grim scenario to me.

25 November. Harold Acton again.
I went to John and Gillian Sutro at 25 Belgrave Square for a buffet supper in honour of Harold Acton.[1] I had met him before at a lunch given by John Pope-Hennessy [Director of the V & A] which was a

[1] Harold Acton, author, aesthete, gossip and owner of the villa La Pietra, near Florence. Knighted in 1974.

disaster. I was wrong about him. He's a large friendly mandarin pussycat exuding charm and full of stories and nostalgia. This was his first day out, having been confined to the Ritz. The gathering included George Weidenfeld and the actress Glenda Jackson, star of D. H. Lawrence's *Women in Love*. David Bailey and Penelope Tree came later, she very beautiful with her head encircled by a trailing bandeau, with long greasy hair and wearing crushed brown velvet.

The Elizabethan Image *at the Tate Gallery*

I had been asked to do this exhibition, the first in a series surveying the whole development of British painting, by Sir John Rothenstein, the Director of the Tate Gallery. It came to fruition under his successor, Sir Norman Reid. The designer was Christopher Firmstone, whose work I had first spotted at Birmingham and who had designed the exhibition on Drummond's Bank for me at the NPG.

22 October. To Jan van Dorsten.

The Tate Gallery show has been hit by so many disasters that it quite worries me. I know I shall be glued there throughout the last three weeks of November. I feel slightly cross with Christopher Firmstone, who has never really thought through the costings with the result that there was a heart-rending session when the garden went, the graphics went, the theatre went, etc. and I tipped in my fee to aid with the mounting. I am slightly more cheerful now as the Berlioz show at the V & A is so theatrical in the Buckle–Strong tradition that I am for being a step ahead and doing *The Elizabethan Image* with a staggering, austere grandeur and no gold fringe.

27 November. The opening.

The great day began with the biggest press conference that the Tate Gallery has had since the vast Picasso exhibition. About one hundred and twenty came including what seemed to me oddities like *Der Spiegel*. I buried the hatchet with Norman Reid, who seemed to totally ignore the exhibition, even allowing for the fact that he had been away a lot. Christopher Firmstone and I took Tate staff members Judith Jefferies and Will Vaughan and the scenery painter Pauline Whitehouse out to a silly lunch to celebrate, and in the afternoon there was a blockbuster private view with so many people there I knew it would be pointless to list them. And then came the evening marathon.

That began with a dinner given by Pamela Colin on her way to being

the new Lady Harlech. Pamela is a tough New York cookie with the face of Nefertiti. Her flat was at 15 Bolton Gardens, where the inevitable hired servant opened the door. The decoration was very New York too, the drawing-room bright green with vast sofas sunk beneath a cornucopia of huge cushions. The gathering was a distinguished one: John Gielgud, pink and healthy, in a red velvet jacket with, I assume, his boyfriend in ruffles, the Channons (Paul went off to the House to vote and came back), Irene Worth dazzling in pale green *à l'antique*, the draperies held at the shoulder by a gold BC clasp, adorable Beatrix Miller, Jill Weldon in floating veils, Tony Snowdon, his arm in a sling having pulled a tendon, and Princess Margaret with her hair piled high and wearing a sheath dress in creamy white with a bolero lined in pink.

There is a rule with royals that no one sits till they do, which this time was hard on Ingrid Channon, who was pregnant and was kept standing for three-quarters of an hour. Princess Margaret was not pleased by her placement. I was placed to her right but she was seated along the side of the table with Pamela seemingly at its head. That, I gathered in retrospect, was a blight. I'd never sat next to Princess Margaret before and she ignored me until it came to the pudding. Then she wiped her plate slowly with her napkin at which point Beatrix leaned over and said, 'The food here's great but let's face it the washing-up's rotten.' Princess Margaret is a strange lady, pretty, tough, disillusioned and spoilt. To cope with her I decided one had to slap back which I did and survived.

We then all drove to the Tate, where batteries of cameramen flanked the steps as I escorted Princess Margaret into the Gallery and took her on what turned out to be largely a social tour. *En route* Jennie Lee offered her congratulations. The Tate was stuffed with a glittering throng of some five hundred and it all ended at 1 a.m. when HRH got up from the table and departed, asking me to come back to Kensington Palace for a drink. Somehow in the confusion of it all I never tagged along and I ended up with two old friends at Morpeth Terrace laughing till 3 a.m. The exhibition is the best one I have ever done.

11 December. Queen Elizabeth makes a visit.

I was rung up in a panic by the Tate. The Queen Mother was on her way from Clarence House, could I drop everything and come at once. I hopped in a taxi and arrived in time to guide her round three-quarters of it. She loved it for its Englishness and, coming across a warder slumped asleep, tiptoed by, whispering to me, 'We mustn't wake him!'

12 December. The Royal Box.

I'd never been in the Royal Box at Covent Garden before but John and Gillian Sutro asked me to join Garrett Drogheda's[1] party, which was an interesting one, with Steven Runciman,[2] Fabia Drake the actress, Patrick Garland and, from the second act onwards, Arnold Goodman[3] and Ann Fleming. The group in fact boxed and coxed between the box and the grand tier during what proved to be a somewhat star-crossed revival of *Coq d'Or*. Garrett Drogheda sits with a tiny little torch to hand making notes of anything which goes wrong. At one point a singer's crown came off and not knowing what to do with it she handed it to her attendant. Worse followed, for when the attendant had to move she promptly handed it back, much to the former wearer's surprise. A great carpet was then meant to be unrolled but that too met with disaster.

18 December. Carols at St James's Palace.

The event of the day was Lady Adeane's drinks party. There is a custom that once a year just before Christmas those who have grace and favour residences all give parties on the same evening or at least those who have windows which look out on to the inner courtyard of St James's Palace. In the middle blazed two coke-filled braziers supplied, I was told, free of charge by the gas company, while an ancient lamplighter lit the gas lamps surrounding the courtyard. At seven promptly the Bach Choir entered in procession carrying candles and singing carols. Within, the chatter and clink of glasses stopped, and everyone moved towards the windows to look down and listen. It was enchanting.

I knew very few people there but I was glad to see Elizabeth Longford, lovely in a black caftan with gold embroidery at the neck and sleeves. Another lady leapt across the room and effused about the Tate exhibition, which made me happy. Michael Adeane[4] was anxious as to whether all the arrangements were as we would wish for 25 February, the day the Queen was coming to unveil the Annigoni portrait of herself.

[1] Lord Drogheda, Chairman of the Royal Opera House, Covent Garden, 1958–74, and of the *Financial Times*, 1971–5.

[2] Steven Runciman, historian, writer and traveller. Knighted in 1958.

[3] Solicitor, friend and *éminence grise* to many in the political and arts worlds. Chairman of the Arts Council 1965–72. Created a life peer in 1965.

[4] Private Secretary to the Queen from 1953 until 1972, when he was created a life peer.

22 December. Nicholas Georgiadis.

I took the painter and theatre designer Nico Georgiadis round the exhibition. He's a massively built Greek with a face akin to that of a Pharaoh with black hair and piercing eyes, a bit of a noble savage in a way. He speaks English with a hint of his native Greece overlaid by France, where he lived for two years. Nico I enjoy, although one does realise that he likes to cultivate the 'right people'. One also senses an acute business acumen. Every scrap of paper he's ever touched in his studio I suspect is rescued to be sold at some time. Yes, *Romeo and Juliet* had been a triumph in Stockholm. He had modified, he said, the original sets and improved them. But he'd returned utterly exhausted and was in bed recovering when I initially rang him. Now he wants to paint again but is not in the mood for it.

It is always interesting to go around an exhibition with a practising artist. What excited Nico most were the patterns. He couldn't get over the dress in the Ditchley portrait of Elizabeth with its pattern of gauze puffs secured by jewels. His knowledge of history seemed patchy as he hadn't even grasped that England was Protestant in the sixteenth century.

Christmas Day.

I am writing this entry at 1.15 a.m. on Christmas morning at home at 23 Colne Road, having returned from Midnight Mass. How strange it is to be sleeping in this back bedroom again after so long. I was the youngest of three brothers. Until I was twelve or thirteen I shared the back bedroom with my brother Brian, at least from about 1944 when he came back from evacuation. We started in one double bed and then, as the war ended, that was exchanged with someone nearby for two black iron Victorian ones. Mine was that nearest the door and the light switch, which I had to get out of bed to turn off, treading on the cold linoleum square which was all that covered the stained floorboards. There were no points and no bedside tables. The room was distempered and there was a small cast-iron fireplace which was never lit. In winter it was so cold that each morning the windows were a flowery pattern of thick frost which one would scrape off to see what it was like outside.

In the eccentric manner of childhood the room was divided down the middle, the left-hand side being assigned to me. The solitary piece of furniture which was mine was an old wooden chest of drawers painted green. Alas, it had no drawers and a curtain was stretched across it on a wire. Behind that lurked the shelves on which resided what little one had. But it was better than what preceded it for the double bed had

during the war been moved to the room below and sat beneath an Anderson shelter, the centre of the room being jacked-up by wooden joists in case the ceiling fell in due to bombing. The back room in which I now lay had housed our neighbour's furniture piled high for the duration of the war. It wasn't till my mid-teens, when my eldest brother Derek married, that I had a room of my own, the tiny boxroom at the front of the house about nine by eight. How remote all this now seems.

26 December. Boxing Day. Father.

How old Father seems, and sad and irritating. He will be seventy-five next year. I look at him and find it difficult to believe that he was apparently quite the life of the party when he was young. Occasionally there's a flicker of what might once have been but what I see now is a slightly bent figure with an enormous bloated stomach, which protrudes resembling a cushion tied on, for a straight line could otherwise be drawn from his chest down to his feet, which are now swollen. He left school at twelve and seems to have forgotten what little he ever learned there. I find it difficult to have any communication with him, worse now because he sleeps all day, waking only for meals, and has become terribly forgetful. His life has been a monument to the lack of will-power. No one should be like that. I think in a funny kind of way he loves my mother, in spite of having ill-treated her for forty years. He wanted a housekeeper, not a wife. He wanted someone to cook, sew and trot round while he just sits. His attitude to women is basically pre-war working class. He still resents her reading a book because he regards that as lazing, but also because through it she is demonstrating her relative literacy over him.

27 December. To Jan van Dorsten.

Yes, the year ended in a blaze of glory with the *Image* exhibition (queues at the weekend to get in) the talk of London (rave notices except two), the *Icon* getting good reviews (a breathtaking one of all the books in the TLS), I am doing *Desert Island Discs* (the ultimate radio recognition) and have been acclaimed Arts Personality of 1969 by the *Sunday Times* with my photo, mysterious with hat, on the front page and again further on with the Kennedys, Bernadette Devlin,[1] Barbara

[1] A civil rights activist, elected in 1968, at twenty-one, as MP for Mid-Ulster and the youngest in the House of Commons.

Castle[1] and the Queen! They hailed me as the social lion of '69, the well-known figure striding in huge hat and maxi-coat like an actor-manager or making an entrance at a party in black velvet and silver, bearing a huge muff. At any rate one can relax now. Of course there are detractors. The ultimate compliment was to be attacked by A. L. Rowse[2] in a review verging on hysteria in *History Today*. Five years ago it would have upset me but now one sweeps on with a good chuckle.

The *Image* is undoubtedly the best exhibition I have ever done and scholastically? well, it made its point but the great thing was to have given a great section of the general public a happy and joyous hour-and-a-half. I have never before been quite so overcome over this aspect – it has come back again and again from various people . . .

The Tudor Room is being redone and will be finished mid-February. On 25 February the new Annigoni of HM will be unveiled amidst a blaze of world publicity . . . I cannot believe 1970 can be more marvellous than 1969. Oh, you asked about the Speech Day [at my old grammar school, Edmonton County]. It was apparently a triumph and I have not had such a prolonged ovation since the USA. The kids were marvellous and all the sixth-form girls fell for me. It must be my new John Lennon Victorian gold-rimmed glasses I suppose . . . With TV and the *Daily Mail* having done 'a day in my life' I feel that I must build up a defence. TV has to be kept to a minimum of exposure but radio is OK and I should like to do more. But to capture the public imagination means one can achieve so much for the NPG and the arts in general. At any rate we shall see what we shall see . . .

[1] Forthright Labour politician who was Minister of Transport, 1965–8, and Secretary of State for Employment and Productivity, 1968–70. Created life peer in 1990.
[2] Fellow of All Souls College, Oxford, 1925–74, and a prolific writer on English history, in particular of the Elizabethan age.

1970

Icarus

A few spokes began to be thrown into the wheels of the rollercoaster during this year, one of extraordinary activity, the media hype showing no signs of going away, although I tried hard to put a damper on it. It was already storing up enmity and envy amongst those, like Denys Sutton,[1] anxious for Icarus to plunge from the skies. Early in January the pre-recorded *Desert Island Discs* was broadcast, and I owe my membership of the Garrick Club, where we ended up drinking too much, to Roy Plomley.[2] *Private Eye* began to cast me as Dr Strange and an apogee of a kind was reached when a photograph of me, clutching a glass, appeared uncaptioned at the head of the Pseud's Corner column. I don't like to think in retrospect what the poor Trustees thought but the public poured in to the Gallery as never before. Everything that happened became national news: the Annigoni portrait of the Queen in February, the one of Princess Margaret by Bryan Organ in August, and two notable exhibitions, one of cartoons under the aegis of the *Sunday Times* and the other on Samuel Pepys. The fact that all these events attracted a torrent of abuse from the established art press made absolutely no difference to the public's increasing affection for a much neglected institution.

Within the Gallery I was pressing on with the programme of cleaning and restoring pictures, rehanging the collection and, above all, shifting its terms of media reference: 'The painted portrait was the device of the Renaissance but today we have a whole range of mechanical means for capturing the personality of an individual.' A nascent department of film and photography was on its way. Dr John Fletcher entered my life, a dendrologist whom I let loose on the Gallery's early panel paintings to remarkable effect. He never seemed to look at them as works of art but as lumps of wood which could be dated by their tree-rings. Behind the hype the main struggle of the year was with the National

[1] Editor of the art magazine, *Apollo*.
[2] Presenter of the enduringly popular radio programme *Desert Island Discs* for over forty years.

Gallery which, for the first time, had met its match in a Director of the Portrait Gallery who wouldn't take it lying down.

Only towards the close of 1970 did a cloud appear on the horizon, a harbinger of what the seventies were to become. The Conservative Government, with Lord Eccles in charge of the arts portfolio in the role of Paymaster-General, announced its intention of introducing museum charges in an attempt to recoup some of the £7.9 million the national collections cost. It was, said Lord Eccles, a sprat to catch a mackerel. Looking back, one could argue that Eccles presaged what for many institutions was to become inevitable in the eighties, but as a once impoverished grammar-school boy who owed everything to free access to museums I was implacably opposed. The Trustees, usually glad to keep their heads below the parapet, this time rose to the occasion and issued a statement against the proposal at their October meeting.

I seemed to be lecturing and appearing everywhere, including a British Council tour of Switzerland and the USA in the autumn. Somehow I kept going with my academic work but it was not easy. The project to catalogue Inigo Jones's masque designs got off the ground thanks to Andrew Devonshire (Duke of Devonshire) allowing me to have the lot at the National Portrait Gallery. I gave a lecture on the image of Charles I as fashioned by Van Dyck at the Society of Antiquaries, which led to a small book, but I felt hard pressed. John Pope-Hennessy tried to bully me into doing theatre design for the mammoth Council of Europe's neo-classical exhibition but I managed to dodge it.

The social round of the late sixties continued as though the sun would never set. My appointments diary reveals a whirl, most of which I never recorded, but the diary covers enough to catch the scene. Merely multiply what follows below and more, frankly, would have been simply repetitive. Perhaps David Bailey's photograph of me in a haze of cigarette smoke, velvet, and glinting black silk cravat, a kind of bespectacled museum Dorian Gray, might be said to sum up where it had all got.

4 January. Pauline Vogelpoel.

Everything about Pauline Vogelpoel exudes style. Her wardrobe alone would fill a pantechnicon and her flat in Little Boltons certainly lived up to expectations. The drawing-room was carpeted in white with white tiles as a surround; white curtains in abundance were festooned across the large bay window, swagged back with white ties. Virtually everything else was brown, apart from the occasional artfully placed tables shrouded in green tablecloths trailing to the floor, on each one

of which *objets* were arranged as though for a still-life painting. This was a small drinks gathering consisting of Guy Roddon, the portrait painter, Ernestine Carter of the *Sunday Times* with her husband, Jake, of Sotheby's, Laurie Lee the author, and another *Sunday Times* journalist whom I really didn't take to. Through him I was given a glimpse into the old queens' world of the Reform Club amongst whom figured that arch-snob, Robert Cecil of the Wallace Collection. I always remember going there to help him with an Elizabethan portrait, when he was perfectly polite if spiky. Not long after that he came to the National Portrait Gallery; seeing him and thinking that he'd forgotten my name I extended my hand and said 'Roy Strong.' 'No, I'm not Roy Strong,' he replied, and turned his back on me.

On the spur of the moment I took Pauline out to dinner at the Terrazza and couldn't help being struck by the new openness with which people talked in lines like 'He was not a boyfriend or lover'. No love there for Norman and Jean Reid at the Tate, the former categorised as Austin Reed to his wife's Swan and Edgar. Pauline's problem is that she created a new kind of arts friends' organisation in this country with the Contemporary Arts Society, which was the first in the field to give candlelit dinners and organise tours abroad. With the creation of the Friends of the Tate she has found herself suddenly demoted to a remote part of the basement of the Tate Gallery and understandably resents it.

6 January. The Field of Cloth of Gold Ball.

This was the event of the winter season, the great charity ball at Christie's over which Lady Antonia Fraser was to preside as the Queen of the Field. The evening started with a buffet at her house in Campden Hill Square whither the costumed assembled. I had exploited my new-found friendship with the opera at the Coliseum and went dressed as a Regency antiquarian carrying a large folder with a label on its outside reading: *An Exact Inquiry Concerning the Antiquities of the Field of Cloth of Gold*. That soon proved to be a sorry burden, having to lug it around for the rest of the evening. But the green velvet jacket with gold frogging, satin knee breeches, and black stockings raided from the Wells production of *The Queen of Spades* looked fetching enough.

This indeed was an odd assemblage. Antonia had decided to don a headdress of golden rays as some kind of *Reine Soleil* but she resembled rather the Statue of Liberty. Her costume was vaguely medieval in orange and gold with trailing sleeves and a mass of brilliant orange ostrich-feather trimmings. Here they all were in a range of costumes from the Middle Ages to yesterday, not one of which Henry VIII would

remotely have recognised. The satirist John Wells was loping around as Richard III with a cushion stuffed up his back, Teresa Gatacre had raided the tableau of the Princes in the Tower at Tussaud's and came as one of the luckless victims, while Hardy Amies arrived as Richard of Bordeaux, oblivious to the fact that the king would have been long dead by his age. The Tynans were in medieval scarlet, Jonathan Aitken in a caftan lent him by Antonia, George Weidenfeld in another, but this time gold and magnificent, while Michael Pakenham made a wonderfully thin Elizabethan gallant. Lord Blandford, I mused, must be one of the few people who can dress up as Henry VIII without any need of padding. The Reginald Maudlings, never ones to miss a party, appeared for some inexplicable reason dressed as Arabs.

After much mutual admiration we all set off in convoys for King Street, where the Great Rooms had been dressed overall by David Mlinaric, huge sixteenth-century tapestries swagged along the walls which, much to my surprise, had been lent by John Lewis. The newly married Harlechs made an entrance, David as another Henry VIII (this time with padding), Pamela having decided not to wear costume and realising that she had made a terrible mistake. So it all raved on amidst the gloom but the prize of the evening must go to the wicked David Carritt.[1] There he stood engulfed in artificial grass with two plastic bumblebees pinned as nipples. When I asked him what he was he replied, 'The Field.'

This marked my first appearance in Private Eye: *'Another eye-catching outfit was that of the curator of London's Unnatural History Museum, Dr Roy Strange, who came dressed in a see-through wedding gown and Rabbi-style moustache. "I came straight from the office," he confided. "I didn't have time to change. I do hope no one will notice." No one did.'*

8 January. 'A load of old women.'

Beaton had sent me a card saying come to lunch and that it was to be just him and 'a load of old women'. The 'old women' turned out to be Loelia, formerly Duchess of Westminster, now Lady Lindsay, and Lady Hambleden. Cecil was in terrific form: 'I just flew in and went straight to the doctor for a couple of injections and slept for a week at Reddish.' Both *grandes dames* turned out to be highly engaging, Loelia Lindsay particularly so. She had a wonderful eye for changing social mores,

[1] Art dealer and director of Artemis Fine Arts Ltd.

recalling the blatant snobbery of the twenties when she was a deb when, if you had danced with a man the night before and had found that he was socially inferior, if you happened to see him the following day you would just look through him.

She recalled how once she went out to dinner, and returned explaining to her mother how wonderful the food had been, how delicious in particular the consommé with sherry had tasted. She was never allowed there again. For her first weekend away, her mother had insisted that she took gloves up to the elbow to wear in the evening. On descending the staircase with them on she found herself an anachronism, and, taking them swiftly off, tucked them behind a silver-framed portrait of Queen Ena of Spain. The trouble with Loelia Lindsay is that I keep on recalling Diana Cooper's account of how she came to marry Martin Lindsay. It happened, if I remember rightly, in Austria, where he proposed. Loelia didn't know what to do and so asked Diana, who said: 'If anyone else asks you between now and when you see him next say, "Yes." '

After lunch I took Cecil around the Elizabethan exhibition at the Tate, which he clearly hugely enjoyed.

14 January. Dangers ahead.

I sense danger with over-exposure to the press. In the morning the *Christian Science Monitor* and the *Daily Mirror*, in the evening photographed for *Harper's* by Barry Lategan. I went to his studio in Chelsea and was pictured pensive, resting my chin on my right hand with my new moleskin-collar coat draped around my shoulders.

22–25 January. Pietro Annigoni.

The studio of Il Maestro is in the Borgo degli Albizzi, a narrow Florentine street with little traffic and unsmart shops selling inexpensive clothes and shoes, flowers and radios, horrible ornaments and household provisions. I clambered up dark flights of stairs and rang a bell. A bearded youth poked his head out of an indoor window. 'Il Dottore Strong per Signor Annigoni,' I yelled. The door opened. I climbed more stairs and was confronted by Il Maestro silhouetted in a doorway.

Annigoni is now in his sixtieth year. A little over five feet in height, burly rather than fat, with clothes less worn than hung on him. His large face reminded me of a Brueghel peasant, his brown eyes have a piercing glint but they also harbour humour. His hands are not the delicate stems one associates with a painter, but rather the large strong square ones ideal for gardening. His hair, straight and black, is brushed

away from his forehead, slightly thinning on top, and worn a trifle long, the only concession I felt to artistic effect. Sticking-plaster marks where his left ear had been lost in a terrible car crash. I tried hard not to think of Van Gogh. Today Il Maestro was dressed for warmth: a brown corduroy jacket with knitted collar and edges zipped up the front, dark baggy trousers and, later on, a long green knitted scarf. He smoked Gauloises, which he always broke in half and popped into a holder, continuously. I was here to interview him for *Vogue*, a new departure in my life.

In this apartment Annigoni lives and works while he is in Florence. The studio is about twenty-five feet square, a typical cream-painted, red-tiled Tuscan room with views across a clutter of rooftops. In the corner opposite the door stands his easel with a sketch in black chalks of a beautiful model and pinned to it a paper inscribed: *Non toccare*. Behind the easel is a battered rocking-chair and a pile of paints, pastels, papers, a bottle of whisky, a broom, and a stuffed marmoset. Against the wall opposite are two more easels and a rack containing two views of Edwardes Square, one in a blizzard, the other autumnal, two studies of girls' heads and an unfinished portrait of a middle-aged American lady with a troubled, shadowed, masculine face and wearing a string of pearls. Later Annigoni told me he had had to abandon the commission as he could not face the rejuvenation demanded by the sitter. Everywhere I looked there were piles of stuff: paper, paint, dirty old chairs, a battered dais, a torn antique lay figure, old curtains. And there was the inevitable studio stove.

The studio was to the right of the entrance staircase; to the left Il Maestro lives. Up a rickety wooden staircase there is a lumber room and a roof terrace. No plants or flowers are to be seen anywhere. His study was another essay in clutter. On the wall there were two drawings of his mother and father, an oil of himself when young by a friend and a row of portrait heads along a bookcase containing sixteen volumes of the *Enciclopedia Universale dell'Arte*. Another is jammed full of books on Ingres, Tiepolo, Constable, Persian architecture, Michelangelo, Leonardo, and more surprisingly the works of Daniel Defoe, *The Churchill Years*, *The Best of O. Henry*, *The Agony and the Ecstasy*, Durrell's *Alexandria Quartet*, the *American College Dictionary* and *L'Arte come Investimento*. We sat and talked by his desk. Over his shoulder there hung a Beaton photograph of Princess Margaret cut out and stuck on to his own portrait of her, both of which had been signed. While we talked people kept coming and going. The ravishing model brought us coffee and all the time an old man pottered around as a studio assistant.

The conversation ranged round the portrait of the Queen and his concept of her as 'a rather lonely person', the thrill of his first picture of her about which even the taxi-drivers were excited, his love of Rembrandt, his ruthless censoring of his own work, his admiration (and hate) of Francis Bacon ... Annigoni emerged as no intellectual but he is deeply serious about his art.

When we went to dinner that evening it was *en famille* to a modest trattoria on the edges of Florence. Eight of us sat at one long table, Il Maestro at one end, his son, Benedetto, at the other. There was an abundance of red wine and simple good food served on thick white plates: fresh fennel, coiled anchovies, sliced salami, Parma ham, *risotto con pesce*, minestrone, veal and chicken, and masses of fresh fruit. His other guests were fellow artists with their wives and the conversation was essentially ordinary and domestic – about children, travelling, exhibitions and lettuce-leaf cigarettes.

On the Sunday he took me to Ponte Buggianese, near Montecatini. There in the church of San Michele was what he considered to be his most important recent commission. The church was nondescript and the inside filled with polychrome images in lit-up glazed boxes. To the right and left of the transept were frescos by two of his pupils, one an Annunciation by someone suffering from a nasty overdose of Perugino, the other a stark *Supper at Emmaus*, rather splendid but wrecked by the dolly-mixture window over it. Annigoni's own work covers the entire length of the nave, forming a progression which begins at the west end by the door where a man and woman sit, the latter a gargantuan, morose, downcast figure contrasting sharply with the man who looks, astonished, up at the events which are unfolding. Over the door there is a cross and angels heave upwards in embalming cloths the slumped corpse of the dead Christ while more angels in a rose-brown heaven blow trumpets. Above, lit by the clerestory windows, is the risen Christ, a monumental figure haloed in white, heavy in clouds heightened with gold leaf. In the vestry there were the cartoons for the major figures and Annigoni expressed concern about the effect of the damp on them.

The priest bought us a drink (it was his birthday) after which we all piled into the car again and went off to the nearby restaurant. Once again Il Maestro was saluted and once more we were stuffed with *antipasti*, *minestre* and *carne*. We floated on a sea of conviviality and as we left an extra bottle of very special Sicilian wine was wrapped up for us to take with us, to drink on the occasion of the launching of the portrait of 'La Regina d'Inghilterra'.

25 February. Annigoni's portrait of the Queen.

The day of the unveiling of the Annigoni portrait of the Queen at last came. It began very simply with me arriving early to check that everything was in order. Nothing, however, had quite prepared me for the screaming mob of journalists that fell through the Gallery doors when they were opened. For an hour it was nothing but cameras flashing. Annigoni was a positive saint as he posed for them, even agreeing to stand on a chair by the picture and frankly look somewhat idiotic. That was only the photo-call. He was battered by this onslaught and I rescued him, taking him behind the scenes for twenty minutes before the next onrush, the press launch, which was from 11.30 to 12.30. The hard work on the media over the last two years certainly paid off in terms of the vast turn-out.

After lunch at Gay Tregoning's[1] flat in St James's with Hugh Leggatt I went back to prepare for the final fray. Hugh had brought in Kenneth Turner to do the flowers. The place was unrecognisable. The entrance staircase was flanked with cascades of spring flowers. On the first landing the portrait was hung against a light blue fabric and lit from beneath, while on either side there were silver-birch trees soaring up to the ceiling. On the Royal Landing swags of flowers thirty feet deep trailed down the damask either side of the great Lavery group of George V and his family. I don't think that the Gallery had seen anything quite like this party. Lloyd Kenyon and I met the Queen and escorted her amidst a barrage of flashing camera lights, up to her own portrait. The news reel cameras whirred while she stood and looked at herself, commenting on how varnishing had improved the picture, and then she said: 'It looks very different with a frame,' a masterpiece of evasion. Next to the portrait stood the entire Leggatt family, who were duly presented.

The party seemed to go with a swing and without incident, apart from Lloyd presenting Dame Helen Gardner to the Queen as Lady Summerson, which cannot have gone down at all well. On the way out he nobbled the Queen in the hopes of getting the Prince of Wales as a Trustee, while all through the evening, on the side, I was getting nods and winks from Sir Martin Charteris[2] and Lord Plunket. Nothing further disastrous happened beyond the *Daily Mail* critic being thrown out for being drunk.

[1] Secretary to the art dealers Leggatt Brothers; later married Sir Hugh Leggatt.

[2] Distinguished courtier. Served the Queen first when she was Princess Elizabeth; then Assistant Private Secretary 1952–72; Private Secretary 1972–7.

Marc's cartoon on the Annigoni

The portrait produced an explosion of press for the Gallery on a scale it had never before experienced. Crowds flocked to see the picture and I was this time sent up in Punch. *The art critics, of course, put the boot firmly into the portrait, John Russell writing that it was the 'worst ever portrait of the Queen', Terence Mullaly that it was 'a bitter disappointment ... clumsy ... an insult'. Whatever it was, it was certainly controversial and* The Times *seemed to sum it all up: 'Sad, severe, too stern, lonely, its critics alleged. Dignified, serene, respectful, its admirers replied.' Mark Boxer did a witty cartoon with a warder holding a newspaper with the headline* Sad, Sad Picture, *saying to me: 'I thought She looked rather more like it after She had seen it.'*

3 March. Peter Coats.

Peter Coats is a consulting editor of *House & Garden*. He lives at A1, Albany, rooms once occupied by Lord Byron. In his youth he had looked after the Viceroy's gardens under the Raj and he was, I gathered, 'Chips' Channon's boyfriend during his latter years and responsible for pub-

lishing the diaries. He is now sixtyish, rather well preserved with a choleric reddish face, today wearing an elegant double-breasted suit with wet-look shoes. Here was a figure who had been flitting across my path from time to time and all that I did know about him was that he was the most appalling snob. Talk for him was all about people, the right people, and certainly not about either things or ideas.

The flat was decorated with some grandeur. The entrance hall was covered in green baize, the pale drawing-room looking out towards Piccadilly was hung with a huge crystal chandelier stuffed with black candles. At the end of the room there was a large eighteenth-century French picture, in the Boucher manner, of children dancing. Along the wall opposite the window a Louis XV marquetry commode was flanked by Dresden vases on plinths and two huge sofas were on either side of the chimneypiece. On his desk rested a silver rose made by Oliver Messel for *Der Rosenkavalier*, encased in a cellophane box, a beautiful prop composed of tinsel, pearls and spangles which Peter lent out from time to time to a very privileged few.

The other guests were Sacheverell and Georgia Sitwell,[1] he with the celebrated family face with its small eyes set back into the sockets and bird-like nose, she with a large hat on, bulbous protruding eyes, and a voice deep enough to be taken for a man's. The dining-room was in the basement, the table marble and the walls *faux marbre*. Most of the conversation was at the expense of the poor Annenbergs,[2] he apparently attracting his wife's attention by banging a glass with a spoon and yelling, 'Mothur'.

5 March. Tussaud's Bicentenary.

The celebration of two hundred years of Madame Tussaud's was the occasion for a vast fancy-dress dinner in their Hall of Fame to which a huge contingent of the diplomatic corps had been bidden, suitably festooned with sashes, ribbons and orders. The lead-up to this event was more than trying, as the press for some mysterious reason had got it into their heads that I was going either in drag as Madame Tussaud or as Dr Crippen. In the end I plumped for 'Sea-Green' Robespierre and decked myself in 1790s green satin with black frogging hired from Bermans. I resisted painting a thin red line around my neck as perhaps going a bit far, but it did cross my mind. However, on arriving at Baker

[1] Sir Sacheverell (Sachie) and Lady (Georgia) Sitwell. Sachie was the brother of Dame Edith and Sir Osbert Sitwell whom he succeeded as Baronet in 1962.

[2] Walter Annenberg, American Ambassador in London, 1969–74.

Street I was assailed by a battery of photographers and as a consequence must be the first national museum director to figure on the front page of the *Daily Mail*. Bringing up the rear was Elizabeth Longford in a crinoline as Queen Victoria while her daughter, Antonia, was busy within, masquerading as Mary, Queen of Scots.

Great but wholly unnoticed energy had gone into the menu, which worked its way through *Filets de sole Nelson*, *Noisettes d'agneau Victoria* with *Bombe Gladstone* as a finale. Too much drink flowed and I vaguely remember clambering into the tableau of Madame Tussaud modelling the severed head of Marie Antoinette, grabbing the head and being photographed nursing it by *Time*, something I later regretted. As an evening, however, it all fell curiously flat.

10 March. Lunch at 11 Downing Street.

I first met Jennifer Jenkins[1] at Ann Fleming's. She struck me as an intelligent Barbara Castle type of socialist lady, but her great project was to redecorate the staircase of Number 11 with portraits of all of her husband's predecessors as Chancellor. This lunch was of the type I'm worst at, totally political, with people who eat and drink nothing but politics morning, noon and night. I'd also lost my voice, which didn't help. Jo Grimond came out of it best as having more than a degree of wit and warmth, but Lady Gaitskell really is a bore of the first order followed closely by Michael Astor, who is at least clever. He brought his latest wife and there was also Lord O'Neill, who was rather sweet if unforceful. And what, I wondered, was Roy Jenkins actually like or about?

16 March. Sybil Cholmondeley.

Sybil Cholmondeley is a Sassoon by birth, a woman who, though short in stature, more than compensates for her lack of height with features which command. This is an enormously intelligent woman whose kindly, inquiring and twinkling eyes now shelter behind large glasses. Unbelievably she lives at No. 12 Kensington Palace Gardens. Friends ask her, 'Where do you live now, Sybil?' and are rightly astounded to discover that she still inhabits this minor palace. On the front door hangs a notice which reads *This is not the Nepalese Embassy* with an

[1] Chairman of Consumers' Association, 1965–76, and of numerous bodies concerned with the Arts and conservation, including the National Trust, 1986–90. Created DBE in 1985. Her husband, Roy Jenkins, was Chancellor of the Exchequer and shortly to be Deputy Leader of the Labour Party.

arrow pointing to No. 12A. This is the last of the great aristocratic houses in the road still to be lived in as it was intended, enormously comfortable, even if now a little grubby.

I was ushered through to the drawing-room at the back of the house overlooking the gardens, a huge room in discoloured green with a chimneypiece at either end in both of which a log fire blazed. Over one hung the famous Oudry of a dead swan, over the other a portrait of the hostess by Sargent, in the guise of an Infanta by Coello. From this one gathered that in her day she had been a great beauty. The room was filled with fine French furniture and tapestries.

The other guests were the Duke and Duchess of Devonshire, William Plomer, the poet, and Lady Fermoy.[1] The dining-room was hung with huge sea-pieces by van de Velde and other pictures of birds and fruit. There was also an abundance of porcelain and fans while huge marble swans nestled on console tables between the windows, which looked out on to the road. The Duke was twitchy as usual, the Duchess complaining that she only had an hour-and-a-half to choose fabrics for clothes at Liberty's. They formed a great contrast, he somewhat shambling, she with not a hair out of place. She hates plays, opera and most ballet and anything which in any way constrains her. He, in sharp contrast, admitted to loving them all.

I didn't get anywhere with William Plomer, who was large, rectangular and very white, but we did talk about his libretto for the opera *Gloriana* and he said that he would leave his watercolour portrait of Benjamin Britten to the National Portrait Gallery. Lady Fermoy, however, is a charmer and told me how her grandfather had always brought his own cow to London for the Season for milk.

23 March. The Royal Box.

I had been asked to the opera by the Droghedas to see *Wozzeck*, not my favourite opera, and the party turned out to be a decimated one, Pamela Harlech having been carted off to hospital all of a sudden, which was a loss. But there was Joan Drogheda looking as usual ravishing in a black skirt with a white blouse which had vast frills of *embroiderie anglaise* at the wrists and neck which she wore with baroque pearl earrings and brooch. Garrett, who always looks distinguished, had lost his voice and there were two other guests, Leopold de Rothschild and Aly Forbes. But I had the best time with Diana Cooper, tonight in

[1] Ruth, Lady Fermoy, lady-in-waiting and lifelong friend of Queen Elizabeth, the Queen Mother. Grandmother of Diana, Princess of Wales.

purple and green, but with the inevitable unicorn brooch in gold and pearls.

She leaned across the dinner-table towards me and said, 'I do admire you.' She always came, she said, to the National Portrait Gallery to see the portrait of the dead Duke of Monmouth. Alas, I had to tell her it was not him. Her mother, Violet Rutland, and her sister, Marjorie, were in the Royal Academy group but she said that their dresses couldn't possibly be right because they were terribly 'greenery-yallery Grosvenor Gallery'. Her grandfather adored opening Belvoir to the public but as children they hated it because of the awful smell they left behind. But the old Duke just loved to ride amongst them all graciously acknowledging their gratitude.

27 March. To Jan van Dorsten.

... I have turned down everything that is showered on me in the last two months and it is a great decision. One could have been ruined by the end of the year. I had no idea that being successful was so difficult to handle. However, 'No' has been firmly said to all projects, and a curtain has come down on any requests for personal coverage. I've done all that and I'm not cheapening myself. So 'No' to the *Sunday Times* colour supplement article on me, 'No' to the *Evening Standard* – would I be photographed with three favourite objects? – 'No' to radio panel games ... I have no desire to go down in history as the young man who went around with a funny hat and wrote a few books in the early seventies. I intend to have a long, immensely hard-working and distinguished career.

16 April. The Aesthete returns.

At the Trustees' Meeting today they purchased the wonderful Capel family group by Cornelius Johnson with its mysterious garden view and the Sickert portrait of Jacques-Emile Blanche. The lunchtime readings coincided with the meeting and I had to cope with Alan Bennett as Augustus Hare, he striking me as a gawky, overgrown schoolboy. At the meeting the National Photographic Record was laid to rest without any major débâcle. But the real event of the day was the Rosses'[1] party for Harold Acton in honour of his new book, *More Memoirs of an Aesthete*. No. 18 Stafford Terrace must be one of the best surviving

[1] 6th Earl of Rosse was, among many things, Chairman of the Museums Commission, 1956–78, and of the National Trust, 1971–6. Anne, Countess of Rosse, was sister of Oliver Messel and mother, by her first marriage, of Antony Armstrong-Jones.

domestic interiors from the 1880s in London, with a drawing-room on the first floor which is quite spectacular, the walls lined edge to edge with framed prints and photographs, above that a shelf for pots and plates and the whole capped by a golden ceiling. Lindy and Sheridan Dufferin were there, she in that blue wool dress which has seen her through thick and thin lately and he deliciously remarking, as Princess Margaret and Lord Snowdon arrived. 'One has to ask the relations.'

The ability of the Gallery to buy that great family group for the sum of £23,350 was a milestone. This was the first time that it had ever managed to raise itself into the big-time league in terms of major pictures. Until then it was always tacitly accepted that anything remotely expensive was not for us. I remember being galled when the Goya portrait of the Duke of Wellington, on permanent loan from the Duke of Leeds, was suddenly removed from the walls and sold to the National Gallery. To me it was a mortal affront. That portrait was of one of England's greatest heroes by one of the world's greatest artists and it should have stayed in the Portrait Gallery, but no one raised a voice in protest. This was an attitude I vowed to change. The spectacular increase in our Purchase Grant from £8,000 p.a. to £40,000 p.a. for the next quinquennium, announced in January, moved us for the first time up the museum purchasing league. Since then any repetition of such an incident as the one over the Goya would be unthinkable.

To Russia with love.

Julia Trevelyan Oman was to design Eugene Onegin *for the Royal Opera House, which occasioned a Russian journey.*

15 May.

We flew from London to Leningrad by Aeroflot in a half-full plane, plied *en route* with an abundance of sweet things: Russian champagne, little chocolate cakes and bars of chocolate. On arrival the chaos and disorganisation began. After a totally unexplained delay of half-an-hour in Customs, a blonde student appeared in a red-and-white-striped T-shirt, speaking perfect English, and escorted us, together with a professor of English, to a waiting car. It was a long drive into Leningrad, chilly with a sharp breeze, but the sky was rose-tinted and crystal clear. The roads were wide and everything was on a monumental scale. Everywhere the decorations for May Day were still in place, including vast statues of Lenin in tin-foil. As we got towards the centre the streets began to narrow, which made the squares in contrast look absolutely

enormous. By the time that we reached the Astoria Hotel it was dark and we ran into language difficulties with the receptionist, but eventually got our rooms, which were nowhere like as primitive as we had anticipated. Much to our surprise there were bath-towels, plugs, soap and loo-paper. Trying to get anything to eat was another matter. After a lengthy battle we ended up in the bar where a snack was reluctantly produced: four pieces of dry bread and a tin of low-grade salmon for which Western currency was extracted.

17 May.

The map of Leningrad we were given had no indication of scale, so that by the time we reached the Marly Theatre we were late for *Le Corsaire*, which must be ballet's answer to *The Desert Song*. The scenery and costumes were decades old, with old-fashioned side-wings and cut cloths. The theatre, however, was a dream, everything in silver and grey with splashes of tangerine drapery. I suppose this production must be close to what we would have seen a century ago, a kind of hopelessly over-the-top melodrama with moments of supreme kitsch like the hero being pushed on from the wings atop a cut-out rock, and the *corps de ballet* surfacing in the last act bearing flower-spangled canes, attended by little girls carrying baskets of blue plastic roses. By now I began to realise that not knowing a word of the language is a strain and little things began to irritate, like going into a restaurant with our coats on and being ticked off by the waitress with: 'That is bad.'

18 May.

Today we tried the mineral water instead of the lemonade and concluded Narva water was the nearest thing to Alka-Seltzer without the tablet that we knew. It was opera that evening again at the Marly, a rare collector's item by Tchaikovsky, *Iolanta*. I think that it must have been set in Scotland as something vaguely resembling the Scott memorial appeared on stage. The female chorus wore high-heeled court shoes and the page-boys were played by plump women in tights and knickers and yet more high heels. Things began to go badly wrong like a balustrade, a cut-out, falling over, and the lighting kept on changing from luminous pink to blue in a trice. As on the previous evening plastic roses were everywhere, this time bushes of them sprouting all over the set. But redemption came in the pretty ballet which followed, rounding off a good day during which we were overcome by the splendour of the miles of biscuit-coloured neo-classical architecture.

19 May.

Quite early on during the visit we had begun to lose faith in what the British Council had told us that they would arrange as no one so far had even been informed that we were coming. Mercifully the shower of introductory letters we had sent, and brought, opened doors. A call to the cultural attaché at the British Embassy got me nowhere, being told to ring a Mr Laskin at the Ministry of Culture. I then began to see a similarity between how the Russians and the British Council worked.

In the morning we walked for miles around the city just looking at its architecture, but we got back to the hotel promptly at 2.45 p.m. for a trip to the Pushkin. Once everyone had got on to the bus the guide announced that the trip was off and that instead we were to be taken to Pavlovsk. The protest movement by those who had already been there was ignored and off the bus set. Pavlosk is quite incredible, a broken semicircle in the neo-classical style, to the eyes of the visitor seemingly as it had always been but in fact totally rebuilt after being destroyed in the war. Each room had a photograph of what it had looked like before the bombing. It was as though Brighton Pavilion had been flattened and then put back as if nothing had happened. No expense had been spared, with scagliola rooms in shades of ochre, raspberry-ripple and icing-white and everywhere marquetry floors and *trompe l'oeil* ceilings. Dining-tables were laid with services of Imperial porcelain, crystal and silver. In one room they had an allegorical ceiling for which the design existed but which had never been carried out. 'Now,' we were told, 'we can do it.'

There was, however, a great surprise on the top floor, an exhibition of Imperial costumes. Many belonged to Peter the Great, Peter II, Catherine the Great and the family of the last tsar. There was an extraordinary fashion doll sent by Rose Bertin, Marie Antoinette's dressmaker, as a design for a dress for the Order of St Catherine. Doll and resulting dress stood side by side, something I have never seen, huge panniers of green silk shot with silver with borders and puffs of green velvet and masses of gold embroidery. There were the dresses of Tsar Paul's widow, Marie Feodorovna, evening costumes of white net over white, blue silk and silver, yellow silk with lace flounces and, best of all, a little Empire dress of Egyptian cotton striped in beige. There were dresses by Worth and the last and most touching items were outfits for a lady and her daughter, about 1880, of knitted swansdown like a configuration of snowflakes with bursts of swansdown trimming at the hem and huge muffs and bonnets. There were also the gowns of the last empress in net over shades of pink, blue and white scattered

with bead embroidery. And the Grand Duchess Olga's riding habit in blue and crimson like that for an hussar.

20 May.

By now we had resigned ourselves to the food. As Second World War children we stoically consumed the powdered milk and egg, the stacks of bread and butter which came with everything, the clear soup and the gobbets of tough meat. This morning we went to check our return flight with Aeroflot, only to be told to our horror that we were on the waiting-list. Perhaps, they said, if the list gets longer a bigger plane might be laid on. Panic-stricken at the thought of being marooned here, we made our way to Finnair, who assured us that if the worst came to the worst they would get us out via Helsinki.

Today we finally got into the Kirov after endless telephone calls and when we arrived we were greeted by the Deputy Director, the chief scenic artist and an interpreter-secretary. It is a beautiful theatre with a vast stage and enormous proscenium arch. Together we then proceeded to tour the scene-painters' studios where they paint the cloths, as they do in Europe, laid flat on the ground. On we went to the workshops which supply all the theatres in Russia except those in Moscow. The costume design was poor, the quality of cut depressing, but there was also a lot of extremely fine craftsmanship. In the evening we saw *The Legend of Love* with Feydecheva dancing in the usual archaic production, notable mainly for the spotlights always falling in the wrong place.

22 May.

Pushkin and Tsarskoe Selo came on agenda for today. The Germans had wrecked the latter and no one to this day knows where the famous Amber Room is. As in the case of Pavlovsk everything has been put back in a manner which can only be described as incredible, like rebuilding Buckingham Palace from scratch. This is a place of delights: the great hall 'wallpapered' with pictures, the external staircase by Cameron leading to a gallery built for Catherine II with a huge rusticated ramp up which to take a carriage, the ravishing little neo-classical Trianon erected for Catherine II's grandson. The park began as formal in the French manner and then was converted to *un jardin anglais* with a picturesque irregularly shaped lake and Gothic follies. In the middle of the lake there was an island with a pavilion on it used for *fêtes* while musicians played floating on the waters. What is so strange is that everything is seen at a glance because the terrain is totally

flat, resulting in an optical effect in which all the garden buildings and ornaments seem in a row: a Turkish minaret, a Palladian bridge, a small obelisk and a vast column.

24 May.

We stumbled by accident upon a working church. These are not even acknowledged to exist or figure on any map. But in the case of St Nicholas there was no concealing the steady stream of old ladies making their way towards it. We followed them, climbing up the stairs and encountered for the first time the real Russia, overpowering as the people repeatedly crossed themselves and kissed the holy icons. Incense wafted in clouds as the liturgy was sung. I could see no one young there but it was packed, really jammed. We weren't challenged but we didn't belong. It was a time capsule from the past, deeply moving and quite overwhelming, a glimpse of what had gone. In the afternoon we finally got to Petrovorets, only to be told that the palace was closed and that we could only see the grounds with its pretty little baroque house used by Peter the Great. But it was worth it for the golden fountains.

8 June. Quentin Crewe marries again.

Quentin Crewe, once cruelly described as 'meals on wheels', gave a party at the Barracuda in Baker Street to mark his latest marriage to Susan Cavendish. Princess Margaret is said to have remarked, 'This is the last time that we do this for Quentin.' Susan was dressed like a cavalier.

9 June. Mélange.

I went to the Buckingham Palace garden party in memorably idyllic weather until shattered by a violent downpour, by which time I had already made my exit. As he surveyed the sea of mayors and mayoresses in their chains Steven Runciman remarked to me, 'So few distinguished-looking people these days.' The Dickens exhibition opened at the Victoria and Albert Museum, a disappointing affair with far too many items and no visual excitement. Someone said that it was like having the footnotes without the book. I went on to a party given by Ann Fleming for Angus Wilson which attracted a droll assembly: Noël Annan, Charles Ritchie, Elizabeth Bowen, Iris Murdoch, the Stephen Spenders and, most remarkable of all, Patrick Procktor with silver toenails.

16 June. An unsinkable hostess.

Diana Cooper's Warwick Avenue house always seems solidly 1930s romantic in mood. The drawing-room and the dining-room run into one as an L-shape, but the latter's the thing with its *trompe l'oeil* decoration by Martin Battersby, a celebration of Diana wending its way round the walls but allowing room to set within it a kind of reliquary display of *objets* from *The Miracle*, arranged as a still life. Diana is one of the few originals that I have ever met. Somehow she has a timeless magic which cuts across the generations and makes differences in age irrelevant. She's still beautiful with that delicate bone structure and those huge pale aquamarine eyes which always slay me. It is difficult to put one's finger as to where the magic lies. Rather it stems from a delight in life and people and taking things as they are and never looking back. I'd put her high on my list of the least snobbish people I have ever met.

She was making one of her specials when I arrived, that lethal mix of vodka, grapefruit juice and mint of which I have learned to beware. Before I could say anything she grabbed me by the arm saying, 'Such a disaster. At 12.30 p.m. I went to check that everything was in order and found that the cook was coming tomorrow and ...' she added with a grimace, '... such a distinguished luncheon party.' Just how distinguished was shortly to emerge as the guests assembled. But there she stood in her summer outfit, one she seemed to wear non-stop this year, a silk dress in a printed snakeskin pattern with a straw hat on her head concealing her hair, which was in curlers for the evening. On the hat paraded her unicorn gold brooch.

The result of this catastrophe was that the party ended up in the Maida Vale Steakhouse, a typical hostelry of the late sixties with tartan on the walls, plastic table-tops and imitation-leather banquettes. The manager was taken aback by this invasion headed by Diana and Harold Macmillan[1] or 'Horse' as she calls him, bent double over a stick, deaf and complaining of a cataract. The manager said that he was used to having all the pop stars but not the politicians. So there we were, an ex-Prime Minister, a marquess and marchioness (Salisbury wearing a straw hat engulfed in white net), an ex-American ambassador, myself and Diana Phipps, who had just bought a foot (sic) by Rubens in the Portobello Road for £25. By the evening news of this bizarre gathering had reached the *Evening Standard*. What it showed was that Diana was unsinkable.

[1] Prime Minister, 1957–63, and later 1st Earl of Stockton.

18–19 June. The general election.

The social event of the day was Pamela Hartwell's[1] *fête* at the Savoy. It was something which could only happen in this country as people from *le monde* on both sides of the political divide gathered together in the same room, about sixty at dinner and far too many ambassadors. I spotted the Salisburys, Diana Cooper, the Littmans, George Weidenfeld, Ann Fleming among the foray. Kenneth Tynan[2] sat looking at the large television screens as though he prayed for them to be smashed into a thousand pieces. Alun Chalfont[3] nearby was betting Elizabeth Jane Howard that the Conservatives would get in, which they did.

I got up late the next morning and recovered enough from the previous evening to go to Ann Fleming's post-election-day lunch. There was a widespread belief that the loss of the World Cup football match had doomed Labour and even more Marcia Williams[4] giving Harold Wilson the wrong campaigning advice.

24 June. Viscount De L'Isle strikes.

Lord De L'Isle rang. Why, he demanded, hadn't he received the notice of the emergency meeting of the Board of Trustees on 2 July? I said that I thought that he had and was most apologetic. This was the preface to an appalling personal tirade against me which in retrospect he probably regretted. 'We know that you think nothing of the Trustees. We run the Gallery. You are egocentric. Everything is you. I've watched what you've said in the press and I'm watching out for you ...' And so he went on in an unnerving outburst. I never replied but was extremely abject and polite.

Immediately after the call I went to check and found, of course, that he had been sent the papers at the same time as everyone else and also a reminder. He obviously has a pathological loathing of me. I remember David Piper telling me that he had it in for me, and that it went back to the attribution of a picture of his at Penshurst: I fancy that it was telling him that the one said to be Queen Elizabeth I dancing with the

[1] Celebrated political hostess and wife of Michael Berry (created Baron Hartwell, 1968), proprietor of the *Daily Telegraph* and *Sunday Telegraph*.

[2] Journalist and theatre critic, notably for the *Observer*; Literary Manager for the National Theatre, 1963–9.

[3] Noted Defence correspondent for *The Times* and frequent broadcaster on foreign affairs. Created a life peer in 1964 and joined Harold Wilson's Government as Minister for Disarmament.

[4] Private and Political Secretary to the Prime Minister, Harold Wilson; created a life peer in 1974, taking the title Baroness Falkender.

Earl of Leicester was in fact of the French court. This was a gloomy day. Just to make matters worse the bank told me that I had an overdraft and my secretary forgot to tell me that I had accepted to go to the Lord Mayor's Midsummer Banquet and I failed to turn up.

Deadlock with the National Gallery.

The whole of 1970 was coloured by the future of the building. That went back to something mysteriously referred to as the 1964 Agreement whereby the National Portrait Gallery would surrender its existing building for a new one to be erected next to the National Gallery where the present Sainsbury Wing now stands. Relations between the two galleries were never easy. We were regarded as some kind of poor relation at the back, certainly not one to be given any kind of consideration.

The Director of the National Gallery, Sir Philip Hendy, never acknowledged my existence, except once. On the day he retired I stepped off a No. 24 bus in front of the National and he was walking towards me. We said 'Good morning' to each other and that was that. This caught the prevailing de haut en bas attitude, and no one at the National Gallery can have welcomed the sudden glamorous renaissance inaugurated by the young Director of the poor relation, which had produced phenomena-like queues around the corner into Trafalgar Square to see the Beaton exhibition.

What little harmony remained between the two institutions was not helped either by the arrogance of the National Gallery's Chairman, Lord Robbins. I argued vociferously against the adequacy of the new site, which was far too small to take the Portrait Gallery's collections if we were forced to build no higher than the present façade of the National Gallery. I recall Robbins saying to me, 'With your kind of picture what does that matter. You can build the galleries underground.' In 1970, wholly without any reference to us, the National Gallery produced its Report in which it announced its Trustees' decision to demolish the National Portrait Gallery and expand backwards. I remember my utter rage, which was matched by that of the Gallery's Trustees. This time, I vowed, we would not be kicked around.

John Cornforth, the architectural writer on Country Life, was a great friend, and he was instrumental in Peter Fleetwood-Hesketh writing the first-ever article on the existing NPG building. It appeared in the issue of 20 August and opened with a salvo throwing the gauntlet down to our neighbours:

The models and diagrams on view at the National Gallery ... leave one in considerable doubt as to what will happen to its younger sister, the National Portrait Gallery, to whose character and traditions no thought seems to have been given...

Having outlined its architectural merits and fitness for its task he turned to a consideration of the proposal to demolish it and move to the new site:

Whatever merits this scheme may seem to have had at that time ... circumstances have altered since then in a way that would make such a change less desirable than ever ... The solution is surely to leave the National Portrait Gallery alone, admirably fulfilling the purpose for which it was built, while the plans that have been drawn up for enlarging both galleries are once more very radically considered.

In order to obstruct the National Gallery's ambitions it was crucial to get the Portrait Gallery listed. At that time the historic-buildings orbit of the Greater London Council fell within the domain of the then Lady Dartmouth.[1] My first encounter with her was in some grim cafeteria in County Hall. Raine Dartmouth remains a remarkable apparition but I couldn't at the time reconcile this diamond-bespangled fashion plate with anyone remotely effective. In that I was to be proved immediately wrong. In the middle of our conversation the division bell rang and she got up to vote. Her aide, left at the table with me, said after she had gone, 'You won't believe this but she's absolutely marvellous. If we feed her with the right information she never gives up.' Shortly afterwards the National Portrait Gallery building was listed, so that even if the National Gallery did take it over they would not easily be able to demolish it.

Having kept my diary in the main social, it is deficient on all the twists and turns in this saga, but on 2 July the Trustees held an extra meeting, an unheard-of event when, between the end of June and the beginning of October, no one of the established classes was to be glimpsed save on the grouse moors or sightseeing abroad. The meeting was an extremely heated one and Field Marshal Sir Gerald Templer stormed over the fact that he had been deputed as a member of a joint sub-committee of the Trustees of both galleries to sort out the problem. He barked that the committee had never even met once.

[1] Raine Dartmouth, daughter of the prolific novelist Dame Barbara Cartland; later married Earl Spencer, father of Diana, Princess of Wales. After his death in 1992 she married the Comte de Chambrun. They divorced in 1996.

There followed widespread exclamations around the table on the subject of the arrogance of the National Gallery, and Elizabeth Long-ford voiced the opinion of several that what the place most needed was a totally new site and identity away from the National altogether.

I never recorded the Trustees' Meeting of 2 July and these events are only covered in two short entries in late June and a letter to Jan van Dorsten, which catch some of the frenzy.

23 June.

The whole future of the NPG is now up to the Trustees. I have done all that I can and will not be involved any more only to be denounced by everyone. They have been presented with a huge dossier of facts as to the impracticability of the new site. I have seen the DES, the architect, the GLC [Greater London Council], the Royal Fine Art Commission and the Museums Commission.

26 June.

The final meeting with the National Gallery on the subject of their extension on our site took place in London Bridge House. I kept quiet and let Lloyd Kenyon do the upfront at which he was this time not bad. As long as the NPG Trustees hang on to what is rightfully theirs we will be all right. As soon as they give in to the National Gallery and say that we will evacuate the site we are sunk.

I went on from that to visit Shirburn Castle at Watlington to inspect the Macclesfield collection for an Estate Duty Office valuation. No one had been able to get into the place for years and the family had a reputation for eccentricity. The castle was, it seemed, Regency Gothic with moat and drawbridge but it left me totally unprepared for the pile-up of tat and junk within. Lord Macclesfield made a brief appearance in a plebeian cloth cap and overalls, carrying a cardboard box, for all the world like a removal man. I was taken around by his son, Lord Parker, and the pictures were staggering, the dining-room lined with seven Stubbs and a great Hogarth. Later I learned that the Macclesfields were so disliked that the locals burnt down their model farm.

15 July. To Jan van Dorsten.

On return [from Russia] I fell straight into the most hideous crisis the Gallery has had for years, the struggle to preserve our future in the face of a militant National Gallery ... I cannot describe the work and mental and nervous erosion of the last few weeks, collecting data, struggling from one Government department to the next. Now it is all over,

frankly we've had it. It is clear the path which one must tread, thanks to those bloody Trustees. So I am now landed with drawing up a new specification for our non-existent building and how many staff, etc. we shall need in the year 2000. I must say that I feel pangs of disappointment and regret over it all, but there is no going back. Which in a way has put me back on top again. It is no use flailing around in the past, so I immediately began to think in terms of a vast new building and staff ... Somehow now the wrench has been made eventually to go from the old building one has got a sense of direction. But I'll never forgive those BEASTS, the National Gallery, as long as I live.

28 June. Patrick Plunket.

Patrick Plunket deserves a note, for I wrote little about him although in a way he was a key figure. I met him through the Dufferins. He was an immensely beguiling man and close to the Queen, being perhaps one of the few who could give her a glimpse of the real world outside, which he savoured to the full. Patrick was behind some of the innovations in the Palace at this period which brought the new wave of post-war meritocrats into the orbit of the monarchy. He was terribly funny recalling, for example, an evening when the Queen discovered that she had to wear a tiara and the Palace safe was locked and how he scooted off and brought her back the Plunket one to wear. He took great pride in arranging the décor for parties, chortling, for instance, over seeing en tableau three crowned heads nestling beneath a complete tree he'd had brought in for a party at Windsor. From time to time I would find myself alone with him at Mount Offham and he would look at me and say, 'What do you think of them?', 'them' being the royals, and I would think how extraordinary it was that he should be asking me and I would tell him. The last time we saw him was at a dinner given by the Lord Mayor for the Queen. Patrick was bringing up the rear, looking over her shoulder at us and winking.

I was bidden for the day to Patrick Plunket at Mount Offham. The house is double-fronted Edwardian painted pink and garlanded with wisteria and roses. The drawing-room was also pink and hung with some very good pictures, a Bonington seascape over the fireplace, three by Rubens – an abbot praying, the fall of Hippolytus and the Emperor Theodosius warned by St Ambrose – and a portrait of Richard Brinsley Sheridan by Reynolds. The room opens on to a conservatory inspired by Beaton's at Reddish, white, with wicker chairs with blue and white

cushions and an explosion of bloom. In the book-room there was a late Gainsborough of gypsies cooking in a Gothic ruin.

That day Patrick was keeping open house and people just seemed to come and go. Patrick must be in his early forties, upright and military in his bearing, once, I would have thought, very good-looking but now his hair is receding and middle age is setting in. He's an amazingly debonair, funny and generous man. But like all courtiers a certain impenetrable wall exists which one doesn't try to cross.

30 June. Kelvedon **en fête.**

The most brilliant event of the season must have been the ball at Windsor in Ascot week to celebrate the Queen Mother's, Lord Mountbatten's, and the Duke of Gloucester's seventieth birthdays. Ted Heath [the Prime Minister], after saying that he was definitely not going, did, and made a triumphal entry, I was told, kissed by the duchesses. The *fête*, given at Kelvedon by the Channons, came next, to which I drove across country with Julia Trevelyan Oman from Glyndebourne, not an easy journey.

A great pavilion had been built on to the back of the house with polythene windows, a massive use of glistening tin-foil, white balloons and pyschedelic lighting effects. One's ears were obliterated by the pop music. Inside the house was banked with sweet-smelling white lilies and all the doors had been taken off their hinges except where to do so would have involved taking the architrave too.

Seven hundred and fifty guests gobbled salad, strawberries and cream, danced, talked and strolled from 10.30 p.m. until dawn. Just about everyone was there...

3–5 July.

Viewing Boughton from the road the average person would wonder what kind of institution this vast pile now was. But, oh no, every bit of it is lived in still. The front is late seventeenth century, very French in style, and there's a huge stable-block to the left with a cupola. Avenues of elms radiate out from it across the landscape, yet at the back the house is rambling, cosy Elizabethan. In the middle there's a grass courtyard with beds of lavender and sweet-smelling climbers up the mellow stone walls and encroaching across the mullioned windows. I concluded that it was the smell, or rather fragrance, of the house which was so magical, the white morning-room scented with lilies, the unforgettable ancient linen (I saw sheets dated 1811), the curious

faint odour of the tapestries, one of which was tossed across my bed as a counterpane.

Mollie Buccleuch [Mary, Duchess of Buccleuch] would be a bonus to any great house, for both her energy and her enthusiasm appear to be unending. A complete tour of the house is obligatory and that includes the attics, where sixty tapestries exist rolled in bundles and where Catherine of Braganza's marriage furniture is stored. It takes three hours non-stop and there's no sympathy for stragglers. Those that didn't make it, like John Pope-Hennessy, who spent one weekend there in a dark suit looking like some sort of beetle, aren't asked again. Mollie leads with her sing-song voice with its 1930s inflections. Walter Buccleuch lets it all wash over him, a P. G. Wodehouse duke in baggy tweeds, but noble in his way and extremely sweet-natured.

This weekend I was enormously struck by Evangeline Bruce, one of the most elegant women I have ever met, tall with perfect bone structure and who moves beautifully. On Saturday evening she appeared looking as though she had stepped out of Botticelli's *Primavera*, wearing a dress of transparent floating blue. There was, however, one difficult, ironic moment. 'Bill De L'Isle's coming,' Mollie announced, at which point my heart sank as I recalled that ghastly telephone conversation. But when the moment came neither of us batted an eyelid and I certainly never thought that I'd end playing charades with him. Harold Christie, a tycoon, and his wife flew in by helicopter and mercifully flew off again, bound for Patrick Plunket.

One loves the idiosyncratic traditions of a house like this, offering, for instance, cold ham and sauce as an extra course after the main one and the way that all the Paul Lamerie silver is always used for tea. There's something engagingly dotty about Mollie. As she drove us to church on Sunday she put her hat on at the same time as trying to drive the car. We went into a wall.

10–12 July. Cecil Beaton and a small rout at Cranborne.
Cecil sent me a postcard saying that it would only be me and, therefore, a quiet weekend, apart from 'a small rout at Cranborne'. None the less I changed on arrival, much to Cecil's delight, into my latest sartorial trophy, a Regency frock-coat in brown velvet with black velvet lapels which I wore with a froth of silk cravat, all run up for me by Turnbull & Asser.

On the Saturday we went first to dinner with the Heads[1], whose

[1] Antony Head (created 1st Viscount Head in 1950) and his wife Dorothy.

small manor house [Bishopstone] is populated by monkeys and exotic parakeets and whose comforts are sustained by a retinue of Malaysian servants. Dot Head spends most of her time painting bad pictures. This was the prelude to the rout. By the time that we left for it, it was bucketing down with rain but even that did not diminish the beauty of Cranborne floodlit from afar, nor that of our hostess, Mollie Cranborne,[1] who appeared like the Woman in White, presiding over what were clearly somewhat dimly lit and dampened revels. As Cecil was tired we thankfully didn't stay long.

Indeed Cecil was tired most of that weekend, taking himself off to rest in the afternoons while I read or attempted to paint watercolours of the house. On Sunday morning I sat *cap à pied* in white with a straw hat on my head on the terrace. Cecil appeared and said that he wished he had his camera with him but he didn't so that picture was not to be. Off we went to lunch with Raymond Mortimer. The house, shared jointly with Patrick Trevor-Roper and Desmond Shawe Taylor, is now more than a little faded from its great days when Eddie Sackville-West presided. The pictures and decoration were pure Bloomsbury. On return Prince Michael of Kent and a girlfriend came for drinks.

20 July. An oration at Liverpool.
Delivered my oration at Liverpool. I was a great success.

This was given at the Museums Association's dreary annual conference and got much press coverage thanks to providing them with the almost irresistible byline of 'Martinis with the Bellinis'. Rereading it, it seems the usual harangue which any present-day museum director might still deliver: 'Enjoying our national heritage should not be a foot-slogging day of dedication, fighting to find a place to park, nowhere to get a drink when one gets there, and restaurant facilities – if there are any – often of an appalling squalor...' And so I ranted on, but it made amongst other things the sharp point that museums were not only for education, 'a kind of cultural soup-ticket from the Government...' (something stressed like blazes at the time as, in Government terms, museums came under the aegis of that department) but '... are supposed to be places of enjoyment, although judging from most of them you would not know it.'

[1] Mollie Cranborne, wife of Viscount Cranborne, later the 6th Marquess of Salisbury, and a remarkable gardener.

21 July. Oh! Calcutta!

A preview of Kenneth Tynan's much heralded *Oh! Calcutta!* at the Round House in Chalk Farm turned out to be an occasion notable for the boredom of it all. I have never been so aware how anti-erotic nudity could be or, when it came to the nude *pas de deux*, of the accuracy of Fred Ashton's observation that there were some parts of the anatomy over whose movements the choreographer had no control. There it was, a vast pile-up of sketches on wife-swapping, masturbation, knickers, lesbianism, *et al.* Joe Orton's sketch on country-house perversions was the only jewel in this tarnished crown, but even that needed cutting.

24 July. Farewell to Ashton.

Julia Trevelyan Oman took me, and I went wearing a black velvet frock-coat and trousers, with a pink-and-white-striped cravat, and sporting a quizzing-glass on a chain. This was Fred's farewell to the Royal Ballet with Robert Helpmann as narrator. It opened with a projection which listed Fred's ballets over forty years, which I thought would never come to an end. Margot Fonteyn was the star of the evening, seemingly eternally young. I loved some of the very early ballets, including part of one on the theme of the Wise and Foolish Virgins with the Rex Whistler décor recreated and Margot in a ravishing gauze dress. At the close it was she who led him on stage to take curtain-calls in a way only he knows how to, upstaging absolutely everyone else.

The diary fades away for much of the rest of the year but the middle of August was punctuated by the exhibition of Bryan Organ's portrait of Princess Margaret for Lincoln's Inn. There was yet another mass-media explosion and the inevitable denunciation by Terence Mullaly: 'As a portrait it is unrecognisable, the handling of the paint is clumsy, the concept unoriginal, and it symbolises nothing but the wilful eccentricity of the artist.' But Bryan Organ is a considerable painter; working on the thesis that there is no such thing as bad publicity he shot to a stardom which was to lead to him painting the Prince and Princess of Wales under my successor and to becoming one of Prince William's godparents.

2 September. Lesley Blanch.

Beatrix Miller, the redoubtable editor of *Vogue*, gave a party for Lesley Blanch of *The Wilder Shores of Love* fame. She turned out to be an English lady with soft features and curly grey hair who cast me as 'Sir Portrait'. Beatrix's flat in Mulberry Walk basically consists of one large

room, all of it painted or wallpapered, including the ceiling, in shades of russet. This was a small select gathering for the chief guest's delectation and was notable, I thought, for its panorama of fashion. This was a real cavalcade. There was Susan Crewe in black velvet eighteenth-century knee-breeches with diamond buttons and black silk stockings, Marina Warner *à la turque*, the textile designer Bernard Nevill in a muddy white tunic and trousers and, unbelievably, orange-pink shoes, Jill Weldon *à la paysanne* to the floor, Barney Wan in a leather jerkin and brown velvet trousers tucked into his boots and, finally, Tony Snowdon in a balletic white shirt with billowing sleeves and plunging neckline, his black velvet trousers held up by a broad belt with a large buckle, and wearing a huge gold bracelet and oversize watch.

David Bailey arrived with Penelope Tree in tow. He announced he was to do a film on Cecil Beaton, his life and loves. His latest photographic book, he said, would have no text, no publisher and no date.

22 October. Beaton stages a party.

Cecil staged a party for the benefit of David Bailey's film on him. I arrived late, having dined elsewhere first, but into Pelham Place was gathered what in twenty years' time will be looked back on as the in-set of the era. Once again this was a costume parade on the grand scale: Peter Ayer, the actor, in brown velvet, Ossie Clark in plum velvet edged with ribbon, his wife Celia Birtwell tousled and pretty in black, Edna O'Brien voluptuous also in black, Beatrix Miller in a navy-blue dress by Jean Muir, Patrick Procktor in a cream and white shirt over which he sported layers of little waistcoats, Dicky Buckle in white, Patrick Lichfield all hair and embroidered shirt, Mick Jagger in purple, and Penelope Tree wearing an astonishing leather hat whose brim went halfway down her back, a fringed shawl and crumpled green leather boots which reached her navel. Others gathered into the fold whom I took in were the Weidenfelds, Hugh and Antonia Fraser, David Hockney with Peter Schlesinger, Diana Phipps, the Channons and Ann Fleming. It wasn't much fun being an extra, all of us pushed to one end of the room so that the cameras could roll.

On 10 November the Pepys exhibition opened, this time with plaudits from Mullaly: 'All done with rare panache ... a memorable display'; while Denys Sutton, taking up from his vitriolic attack on The Elizabethan Image, *wrote: 'The show was hardly worth arranging.' And yet it was hugely popular and innovative, for it was the first occasion on which a theatre designer, Julia Trevelyan Oman, was used in a*

museum. No one who saw it will forget her miraculous recreation of rooms in Pepys's house with real objects plundered from the museums and dealers of London. We had only one casualty, a pewter plate, which was eaten into by the game pie cooked by the show's organiser, Richard Barber, which sat on it for months. Hardy Amies faulted Julia on one thing, a huge bouquet of dried hydrangeas, a flower which did not arrive in this country until the eighteenth century. Julia was dismissive. They looked, she said, absolutely right.

'Instead of charging us to see good pictures why doesn't Lord Eccles
tax filthy pictures!'—Osbert Lancaster's cartoon in which I
encounter Maudie Littlehampton.

25 November. Juan de Pareja.

The sale of Velásquez's *Juan de Pareja* from Longford Castle has been the art crisis of the autumn. I went to the late-evening viewing at Christie's and had a long talk with Margaret Radnor.[1] I couldn't help feeling an admiration for these poor owners, faced with the dilemma

[1] Dowager Countess of Radnor.

of 'keeping it going'. Saddled as they were with a castle and crippling death duties which had to be paid, the only way out was to sell what they regarded as almost part of themselves. How awful that we allow this to happen. She hoped that it would go to the National Gallery and yet one knows that the Government is bankrupt and nothing will save it.

The picture is now in the Metropolitan Museum of Art, New York. That entry, and the erupting struggle over museum charges, were setting the scene for what was to come.

1971

The Elopement

This year was dominated by two themes, museum charges and marriage. The latter was to be extremely deleterious to diary-keeping in the initial stages, although it was to inaugurate another chronicle, a joint one, in the scrapbooks which begin as from 10 September, the day on which I eloped and married the designer, Julia Trevelyan Oman, at Wilmcote Church near Stratford-upon-Avon. These scrapbooks now run to some eighty volumes and are a monument both to my wife's sense of order and to her belief in capturing the fleeting moment. For far too long those fleeting moments seemed to consist of me, for it was not until after 1980 that I acquired a camera and was able to redress the imbalance. The scrapbooks are a mine of information, for into them go invitation cards, menus, letters, newspaper cuttings and other printed ephemera, as well as our own photographs. My wife has an extraordinary eye, snapping details which would never concern the average person; things like the breakfast tray or the bathroom, if we went away, would be firmly recorded. Looking through them now I am aware that they contain much that is already history.

But that is to anticipate, for by 1971 I was into year five as Director of the National Portrait Gallery and things were becoming a little repetitive. Nothing seemed to impede my progress and, indeed, marriage seemed to propel it along at an even faster rate. But there were the detractors on the sidelines. One such was Denys Sutton, editor of the prestigious art magazine *Apollo*. Quite why I was the object of his venom, apart from envy, I have never been able to divine, but in January he felt that he had at last secured my disgrace. On 2 January he wrote the following letter to *The Times*:

Whether or not the nation should purchase the portrait of Pereja by Velásquez, which was recently sold at Christie's, is a matter of opinion. It is surely unprecedented for a civil servant and the Director of a national art institution to publicly voice his opposition to the considered view of the Trustees of the National Gallery ... that this masterpiece should be

acquired for the nation. This is what Dr Roy Strong, the Director of the
National Portrait Gallery, has done.

Surely it is a function of the Trustees of the National Portrait Gallery to
ensure that their servant should adhere to the correct and proper con-
stitutional procedure and refrain from public statements that do not have
the explicit approval of the Board...

It was Hugh Leggatt, a loyal friend, who rang me that Saturday morning
and told me of this shaft to the heart. I dropped everything and rushed
round to see him. Brilliantly, he did the obvious thing: rang the BBC
and asked them for an exact transcript of what I had said on television
in a context which had in fact nothing to do with the Velásquez. Armed
with that, a letter from a 'Stephen Fitch' appeared in *The Times* three
days later:

Mr Denys Sutton in his criticism of both the Trustees and the Director of
the National Portrait Gallery does not state precisely what Dr Strong said
in connection with the possible export of the Velásquez. These were his
actual words:

'I mean, this is entirely a personal view: I mean I think it is very sad to
see it go: it is a very very great painting but when our museums are in such
a state that a charge has been made for entry I mean it is very difficult to
make out a case to spend more than what is supposed to come into the
Exchequer from entry charges in one year on a single painting.'

'Stephen Fitch' then went on to lambast the 'sanctimonious, anti-
quated attitudes' embodied in Denys Sutton. We had lived to fight
again. But I was shocked as to just how dirty that fighting could become.
As the seventies progressed it was to become even worse, as art and
museum politics progressively sank deeper into the media mire.

By 1971, too, the structure which I was to bequeath to my successors
at the Portrait Gallery was to all intents and purposes in place. Now
they are so taken for granted that it would probably not occur to any
visitor that things had ever been otherwise. But they were. Every year
there were two exhibitions, perhaps supplemented by the display of a
recently completed portrait, always good for controversial press cover-
age. These exhibitions were professionally designed and mounted, fol-
lowing in the wake of the Beaton. Caroline Brown, who began her life
like me, shelving books, continued to wave her wand over the public
galleries, turning them into a visual history of the country. There had
been incredible rules, such as that no engraving should ever be exhibited
in proximity to a painting. These were all swept away. The use of

period wallpapers, the introduction of period artefacts, lent by the Victoria and Albert Museum, and the occasional indulgence of theatrical set pieces, like the vast canopy over the full-length portrait of Queen Victoria, would have been viewed with horror by my predecessors. Pictures continued to be cleaned, a perpetual revelation. At first that had been undertaken by outside restorers, but the aim was to set up our own conservation department and not live off the reluctant charity of the National Gallery. The readings, *People Past and Present*, continued to be acclaimed, and a nascent education department was launched under Angela Cox. I look back to the energy of those years and to the small group of staff, minute in comparison with any other national collection, that made such a renaissance possible. The number of senior curators never exceeded five. Looking back, Richard Ormond was to become Director of the National Maritime Museum, Colin Ford (who was appointed to the Gallery this year) was to create the National Museum of Film and Photography at Bradford and then become Director of the National Museum of Wales, and I was to become Director of the Victoria and Albert Museum. Not, I think, a bad achievement. But I gave them their heads and they repaid it with total loyalty.

The first exhibition of the year was *Snap: Instant Image '71*, done in collaboration with the Welsh Arts Council; the second was on the portraiture of Sir Godfrey Kneller, put together by Douglas Stewart. *Snap* had a four-week run at the Portrait Gallery in the spring but was closed for being pornographic when it reaches Wales. That was due to David Bailey's series of photographs of Helmut Berger and Marisa Berenson running along stark naked and full frontal together, a beautiful picture. I cherish the memory of Lloyd Kenyon, the Chairman, ushering the royal personage who opened it past these images. But there was no pressure exerted to take them down. Otherwise the year was notable for an unsung and unseen rescue operation. We were unexpectedly offered the *Daily Herald* photographic archive covering the years 1920 to 1970. In a sudden flurry the Department of the Environment found us space in a refrigeration plant at Hay's Wharf. I never actually saw that archive but more than a decade later recall seeing pictures from it used in a major photographic exhibition at the Hayward Gallery, and noting with pleasure that the rescue had been worth the effort.

Early in the year I settled into a tiny Gothic house in Brighton which had taken far more than I could afford to restore. It was the first house I owned and I loved it, going down every weekend and being far too social. But by the autumn of 1971 I was to be a married man and, as everyone who has crossed that Rubicon knows, also a changed one.

19 January. Kingsley Adams, the Museum of Theatre Arts.

Kingsley Adams died of cancer peacefully in the Royal Homoeopathic Hospital, Great Ormond Street. Heroically his wife had never told him, but she had known for a year that it was incurable and that no more surgery could be done. Kingsley was a dear, good man, self-effacing, modest, not blessed with great imaginative powers but endowed with many solid virtues. He knew an immense amount but wrote little. With his death an era in the National Portrait Gallery's history draws to its close, for he came as an Assistant Keeper in 1919, eventually becoming Director in 1951. His wife, I always thought, was trying and silly, but when the end came she was really rather marvellous. That morning he rang, unbeknown to me from his deathbed, to tell me of my election to the Athenaeum, congratulating me and saying how sorry he was not to be able to take me there for my first lunch. That gesture, I knew, was one of reconciliation, because I was keenly aware that so much that I had done must have come as a shock to him.

In the afternoon I went to my first meeting of the committee of the Museum of Theatre Art, a project of Dicky Buckle's, with George Harewood and Arnold Goodman as joint Chairmen. Goodman rightly sat on Dicky's scheme to spend £40,000 over three years on Astrid Zydower, who would sculpt figures for the Diaghilev costumes. Sensibly we drew up a constitution, decided to register as a charity, and set about approaching Government for an available, suitable building.

20 January. Bryan Organ.

Bryan Organ recounted how he had had a melancholy lunch à deux with Princess Margaret over his portrait of Tony Snowdon. She said the picture caught his ruthlessness. How long can that marriage go on? Bryan is busy on his portrait of me, two images against a sea of 'Somerset House' faces.

I had stayed with Bryan and Elizabeth Organ the previous autumn at their Bedfordshire farmhouse, when he asked me whether I would sit. The ensuing portrait was unveiled to the public in an exhibition of his work at the Redfern Gallery late in May. It was purchased by Charles Gordon and eventually found its way to the National Portrait Gallery in the late 1980s. Looking back, the image seems an appropriate one for its era. Bryan subsequently gave us a sketch of my head as a wedding present. I am, however, puzzled by the reference in the diary entry to 'two images' but that must have been the plan at one stage in the evolution of the composition.

13 January. **Eugene Onegin.**

Fred Ashton and I were Julia's guests for the first night of her production of *Eugene Onegin* at Covent Garden. It was even richer, lovelier and more lyrical than on the gala night, the ballroom scene magnificent. We began by having drinks with John and Patsy Tooley[1] with David Hockney and Peter [Schlesinger] butting in. Now Fred is a great personage but, oh, how he hates being old. He was planning a ballet based on Turgenev's *A Month in the Country* with Julia designing but had postponed it due to MacMillan's *Anastasia*, which was also Russian. The Opera House seems in a bad way. John Field, the ballet co-director, went before Christmas, MacMillan was off somewhere in the regions and there were no more new ballets except Jerome Robbins's *Dances at a Gathering* and the botched-up *Swan Lake*. There was also very little new opera and rows brewing over Peter Hall's desire to have *Figaro* sung in English.

19 February. **Farewell to Kingsley Adams.**

This morning there was a service of thanksgiving for the life of Charles Kingsley Adams at All Souls, Langham Place. It was a touching yet happy occasion. His school contemporary at Winchester, the Dean of Gloucester, read part of a sermon by John Donne and Taylor Milne of the Institute of Historical Research gave a short, good address. It was very full. Christine Adams was so grateful for all we'd done that she gave me a kiss. I was quite taken aback. I took David Piper out for a very funny lunch. He thinks that I will be Director of the National Gallery next. The plot thickens. The art scene is in such a mess at the moment with the Velásquez gone and now the Harewood Titian coming on to the market.

22 February. **Museum charges and the Harewood Titian.**

Hugh Leggatt said that the Treasury had told Lord Eccles that museum charges would not work. If this is true then Eccles will have to pressurise the Cabinet to force the Treasury to accept that. We are in the midst of George Harewood flogging his great Titian, *The Death of Actaeon*, evoking screams of anguish. Whatever is going on at the National Gallery?

The Death of Actaeon *ended up in the National Gallery. The museum-charges debate wended its weary way through the year. That the*

[1] John Tooley, appointed General Administrator of the Royal Opera House, Covent Garden, the previous year, and his second wife, Patricia. Knighted in 1979.

campaign against their introduction remained so vigorous owed much to Hugh Leggatt's never-ending war in the media. The national collections rather had their hands tied, being obliged to Government for their funding. In February the Portrait Gallery Trustees opted for the minimum entrance fee allowable, two shillings, with a one-pound season ticket and a long list of exemptions. The charges were to be introduced, we were later told, as from 3 January 1972.

25 February. A new National Portrait Gallery?

Something very important happened today. I had drinks with David and Nancy Perth. David, in his role as first Crown Commissioner, has immense influence on the development of the Crown Estates. To him I owe Carlton Terrace as an outstation for the reserve collection and as a hoped-for gallery of modern British history. Now the entire area adjacent to the Hampton Site through to the Haymarket is to be redeveloped. David Perth and Hugh Casson want a grand new National Portrait Gallery to stretch from the Hampton Site right across to Suffolk Street, obliterating Whitcomb Street. If it comes off, the NPG's salvation would have been achieved and the National Gallery routed. How important it is to go out and meet people. If I hadn't known Perth and Casson this would never have occurred.

The plan as it now stood was that the premises acquired in Carlton Terrace would release the Duveen Wing for a lecture-room cum cinema, a restaurant and offices. This year the offer of 13 to 15 Carlton Terrace began to move towards being a fact. Government had decided that the building of a new National Portrait Gallery was now at the head of its priorities list, aiming to start in 1976 with an opening in 1980. The cost was to be £3 million. Westminster Council had also conceded that the new gallery could be two storeys higher than the existing National Gallery façade. The problem was to centre on the cost of buying out those already occupying premises in Whitcomb Street.

2 March. The Prince of Wales.

Elizabeth Longford asked me to a small drinks party for Prince Charles. There were about a dozen of us. Antonia was there, pretty beyond belief, back from the Bahamas, with Hugh. Frank Longford,[1] Jack

[1] Lord and Lady Longford were both significant writers and historians and also parents to a dynasty of authors including Thomas Pakenham, Antonia Fraser and Rachel Billington.

Plumb,[1] Martin and Gay Charteris, the odd deb girl and the writer Marina Warner in appliqué hot-pants beneath a coat which went down to her ankles. All Marina could think of was that HRH was twenty-two and had he been to bed with anyone? He's a pleasant young man, earnest, with a boyish grin and a non-sophisticated sense of humour, prankish, thoughtful, kind and shy. He dresses in a very middled-aged way with narrow lapels and tiny shirt collars and narrow ties. I couldn't help being impressed by his sheer 'niceness'. We talked mostly about the NPG and Charles I.

10 March. Lunch at the American Embassy.

A lunch was given by the Annenbergs at the American Ambassador's residence for Nancy Hanks, in her own country a cross between Arnold Goodman and Hugh Willatt of the Arts Council. The USA has at last begun official subsidy of the arts. Winfield House is an amazingly pretty place with eighteenth-century green chinoiserie wallpaper, a Van Gogh over the fireplace and marvellous flowers everywhere. The toasts were drunk Philadelphia fashion, seated. Raine Dartmouth proffered her cheek to me for the first time and there was the usual rallying of the clans, including Arnold Goodman and Pamela Hartwell. Much talk of Princess Margaret at the moment who now sits at home on her own in the evenings, with no one ringing her. A friend told Bryan Organ, 'Ring HRH and take her to the flicks,' but he couldn't bring himself to do it. Pamela Hartwell's niece, Juliet, gave HRH an *intime* dinner party for six but found herself stuck with her.

24 March. Buckingham Palace en fête.

This was the day of the great *fête* at Buckingham Palace arranged by Patrick Plunket, a party of a new kind bringing into the royal orbit all sorts and conditions of people they never usually bothered about. It began strangely with a Mr Wild coming to the Morpeth Terrace flat for a drink. He is the world's expert on the painter Hercules Brabazon Brabazon, who lived in my flat for forty years, from 1864 to 1904. During that period the whole Victorian arts world came here, including Philip Wilson Steer, Sickert, John Singer Sargent and Franz Liszt.

All that was but an eccentric preliminary to what followed, which began with dinner at the Charterisesy apartment in St James's Palace. There were about sixteen of us including the Hamiltons (heirs to the

[1] J. H. Plumb, Professor of Modern History at Cambridge, later Master of Christ's College, Cambridge. Knighted in 1982.

Abercorns), Vic Feather[1] and wife, the Eshers, the Longfords and Lady Diana Cooper. It was a great stroke of luck to be placed next to her, dressed this time in a beautiful flowing medieval robe. We discussed the motive for the party. Diana said, 'It's because the aristocracy are in revolt.' We had, as usual, a fascinating conversation in which she told me of her regret that she had never helped anyone in her life, and how she had been turned down as a prison visitor, how she had known Cecil [Beaton] all his working life from his early days when he was pushed into the pool at Wilton for wearing make-up (which indeed he still was very noticeably at the last party I saw him at, and in the Bailey film) and of the awful time she'd had with Ted Heath at the *Onegin* gala.

After dinner we all moved on to the Palace, up the grand staircase, into the Picture Gallery off which the other grand rooms open. The royals were there in force and we were received by the Queen, Charles and Anne, Princess Margaret and Tony, Princess Alexandra and the Queen Mother. The latter, sweet as always, was in her inevitable tiara and Hartnell crinoline, one of white net sprinkled with sequins which, however, had seen better days. Princess Alexandra hauled me off to see the Canaletto drawings. Patrick Plunket in black velvet was preening himself on the success of it all, the whole event based on what the Spanish and French embassies did. Not before time it replaced the cocktail party, and what was clear was that everybody likes an excuse to dress up. In one of the rooms there were tables and gilt chairs and light refreshments, in another the band of Guards playing the dreaded Palm Court music.

This was one of those occasions more remarkable for who wasn't there. Among those who crossed my path were Lord Clark of *Civilisation*, Raine and Gerald Dartmouth, she in green, Ted Heath with whom I exchanged a desultory word, the banker, David Airlie minus Ginnie, who had given birth to number six that day, Robin Mackworth-Young who had arranged pretty and interesting things for us to peer at, Dame Flora Robson with wig, the Bishop of Chichester with gaudy pectoral cross, the French and Spanish ambassadors, Pamela Hartwell, the Rev. Austen Williams of St Martin-in-the-Fields, and Peter Wilson from Sotheby's who had auctioned off that day the Dulwich College Domenichino to cries of 'Illegal!' There was Norman Hartnell, Bryan and Nanette Forbes, and Hardy Amies [the Queen's dressmaker] who said that this was the first occasion that he had ever come in through the front door.

[1] General Secretary of the Trades Union Congress; created a life peer in 1974.

7 June. A Weidenfeld fête.

Sandra[1] was not there. It was intellectuals night with a sprinkling of those from other layers of the cake like the Frasers, Diana Phipps, the Lawsons, Harmsworths and me, I suppose. As an evening it was a real killer, sixty of us at a shot and the food ran out. There was no pudding except a small macaroon. David Hockney took the opportunity to tell me how feeble he thought Bryan Organ's portrait of me was.

The Earls of Derby had a remarkable cache of early English portrait miniatures which for years had been on loan to Manchester City Art Gallery. Then, as so often happens, they were snatched from their cases and put into the saleroom. This was a unique opportunity for the Portrait Gallery to acquire some major works, with Nicholas Hilliard's miniature of Sir Francis Drake and the miniaturist Isaac Oliver's self-portrait at the top of the list of desiderata, with what was then believed to be an unfinished miniature of Elizabeth's favourite, Essex, lower in the pecking order. Years later, when I was working at the Victoria and Albert Museum on these early miniatures, its status was redefined as Oliver's original ad vivum *sketch of the Earl. Had I known that in 1971 I would perhaps have revised the list of priorities, but that research was yet to be done. This was one of those rare occasions when the Trustees put in their all and Government behaved impeccably.*

8 June. The Derby miniatures.

Up betimes and to Leggatt Bros. This was the day of the sale of the Derby miniatures at Christie's, the climax of a long campaign. The Trustees had thrown in every penny of the Gallery's purchase fund, there was £5,000 from the Wolfson Foundation and £2,000 from our own Trust Fund. The Treasury, via the Paymaster-General's office, had given us leeway to bid up to about £80,000 for the Sir Francis Drake and the Isaac Oliver self-portrait. This in itself was a triumph. Hugh Leggatt, however, played his trump card in taking me into the saleroom, much to the discomfiture of the Agnews, who circled round the room half way through the sale for a conference. Drake was secured for 32,000 guineas. Then a woman on my right had an epileptic fit and moaned horribly through the succeeding lots. We secured the Isaac Oliver self-portrait for 38,000 guineas with Agnews as the flabbergasted underbidders. We failed to get the miniature of Essex which was on our list but purchased for 3,500 guineas the Peter Oliver self-portrait.

[1] Sandra Payson Meyer, George Weidenfeld's third wife.

At the end of the sale the purchases for the National Portrait Gallery were announced and there was a burst of applause. Cameras clicked and I departed in a haze of triumph, carrying the miniatures back in my hat in Leggatt's van. We put them on view on the morrow. Only Lloyd Kenyon didn't utter a word of gratitude but instead complained that the glass over them was dirty.

That evening Diana Phipps gave a *fête*.[1] There assembled the painter James Reeve in velvet, Diana Cooper in off-the-shoulder black feathers, George Weidenfeld and a whole crew of Greek shipowners and Portuguese dukes. Diana Phipps has real style. It may be makeshift, which it often is, but she always has style. The first-floor drawing-room is a monument to her love affair with a staple-gun, the walls lined with brown velvet across which she's scattered any picture she can rally as long as it has a gilt frame. Then there are the odd eccentric touches, like the sculpted head on the floor close to the hearthrug, or the epergne-like antlers hung with little glass phials, into each one of which she had placed a different flower.

10 June. Further fêtes.

This was the worst day for weather of the decade. It rained all day, all the time, sad really because it was the day for *fêtes*. Firstly there was Raine Dartmouth's luncheon for about twelve, done with all the silver plate, and the servants in white gloves. This was filled with people I hadn't met like Lady Kinnaird and Lady Freyberg, but the most interesting person there was a brilliant young man of twenty-four named Robert Jackson, a Fellow of All Souls. He's one of those old-fashioned gangling young men with short hair and ears sticking out, with a parting and glasses. But one felt the sharpness of the intellect. Then, in the evening, there was Ava Waverley's dinner. I really wish that I understood about her. I arrived late because it was Corpus Christi and I'd gone to Mass at St Matthew's. The other guests were the Queen Mother's right-hand man, Martin Gilliat, Nin Ryan and Diana Cooper, ravishing in gold and deep turquoise.

At this point my diary really does falter, for I was on the lead-up to 21 July when I proposed to Julia in St James's Park after having taken her to a perfectly awful film of King Lear. *From then on, and with all the machinations to achieve a wholly private wedding, everything else went out of my mind. What happened can be caught only in retrospect.*

[1] Mrs Harry Phipps, daughter of Countess Cecilia von Sternberg.

3 September. To Jan van Dorsten.

August began with the usual trip to the Frasers, then to Italy – to an amazing house party in a vast rambling villa at Este run by Diana Phipps with the eccentric London social scene arriving and departing – the Weidenfelds, Lady Diana Cooper who came with six trunks of luggage and a box labelled *Hats – British Embassy*, Antonia [Fraser] ... and her children, the Bruces, a clan of Countesses Sielern, the odd author or Greek shipowner. So, life by the pool being burned dark kipper, Scrabble non-stop, lazy days, pretty in the evening when we sometimes dined in the eighteenth-century ballroom which stood apart from the house, guttering candelabra reflected in vast faded Venetian mirrors, crumbling rococo cherubs and flowers and swags. Occasional expeditions to Verona or Monselice but mostly walks into Este to see bad horror films or buy kitsch postcards ...

On the week beginning 12 September you will receive some amazing news. As you are not in this country I can hint at the great secret. No one knows here, not even the most closest, and no one under any circumstances must know until after the event, so if you see anyone don't even let them know the little I have told you in this letter. I know it will give great pleasure to you both when it is publicly known. For me it brings untold happiness and life as it were starts again ...

9 September. To Jan van Dorsten. The Elopement.

... now I can tell you, as by the time this reaches you it will have happened. I will have eloped with Julia Trevelyan Oman! Unbeknown to practically everyone, to parents specially, I asked Julia to marry me on 21 July. I can't tell you how thrilled and happy I am about it all ... No one knows. It has been a vast operation doing it so [that] no one does and very romantic. In the church at Wilmcote near Stratford-upon-Avon lies locked in the safe a huge special licence from the Archbishop of Canterbury. Gerard Irvine, a very good friend, is marrying us and David Hutt, his curate, is my best man – the old lady sacristan of 91, sworn to secrecy, is witness. Today the characters in the plot start descending on Stratford. Julia is there already putting the finishing touches to her production of *Othello*. Gerard and David arrive in a car provided by us. I go this a.m. and then with Julia to the church which is very Oxford Movement for me and much reminds J of her ballet *The Enigma Variations* and her Oxford background and the dynasties of Omans and Trevelyans. Meanwhile others descend who are going, as we all are, to the first night of the play. But tomorrow morning an elaborate operation begins when the vital parties proceed to Wilmcote

Church. Gerard will be waiting in his best vestments, David in a cassock, Julia is going to wear a huge black velvet hat and beautiful skirt and blouse with masses of tucks and folds made by the wardrobe at Stratford (who didn't know what they were making) ... I will be in a beautiful pale grey velvet suit ... The service begins with an exchange of gifts ... then the marriage and exchange of rings, then the communion service. Then off to the Wellcome Hotel for lunch and on to Brighton ...

Part of the lead-up to this event had been our collaboration on a pretty stocking-filler, Elizabeth R, *which came out in October. The dislocation to domestic life left little time for writing and one of my earliest tasks was to ring Mary Rothermere and tell her that I now had a wife. Cecil Beaton had been asked to stay at Daylesford that weekend, along with the actress Gayle Hunnicutt and the actor David Hemmings, to photograph the Rothermeres, but he went on to photograph the newly-weds both singly and together. The old Duke of Marlborough came over and I recall Cecil drooling at the sight of 'that old celluloid kewpie doll'. When the photographs of us arrived from Cecil a note was enclosed which read 'Remembrance of things still continuing – in spite of Harold Wilson et al.'*

23 November. Mary Tudor and Holman Hunt.
Lunch at the French Embassy for Mr Burden, a Trustee of the Museum of Modern Art in New York. There were the Annenbergs ('We adored your book') who collared Julia to talk at the Embassy, Bobby and Gay Scott, Norman and Jean Reid. I sat next to Polly Lansdowne, Lord Eccles's daughter, a pretty enough Courtauld-trained girl. The French are bad at decorating tables and we had to stare at *biscuit* groups of animals indulging in rape or violence.

Lord Eccles rang to say we would get the money for the Mary Tudor portrait, amazingly, and then seemed to ramble on about absolutely everything. In the evening we went to the new production of *Poppaea* at the Coliseum which had sets of plastic marble and was bad, going on after to a gathering given by Diana Holman Hunt at 50 Onslow Gardens. She's middle-aged, vague and very 1930s to look at. The place was full of Holman Hunts. She gathers around herself the middle range with the occasional star (a bewildered Diana Cooper). There was Christopher Wood of Christie's and Pauline Vogelpoel and Teddy Wolfe, the painter, bloated, cheery, ancient, and heavily cosmeticised.

The purchase of the exquisite portrait of Mary I by Hans Eworth was not a straightforward one. At her neck she wore a jewel from which hung one of the world's most famous pearls La Pellegrina, the one which Richard Burton had given to his wife, Elizabeth Taylor. There was great fear that the Burtons would wish to purchase the portrait but, after much coming and going, it was acquired with their assistance. Today, in the Portrait Gallery, it remains as something of a monument to that ill-starred match, the label reading: 'Purchased with the help of the National Art Collections Fund, Pilgrim Trust, H.M. Government, Miss Elizabeth Taylor and Richard Burton.'

1 December. Prince Richard of Gloucester.

We were asked to the Foyle's Literary Luncheon for Prince Richard of Gloucester, who had taken the photographs for a book entitled *On Public View* by Paul White. The book was on London statues, and at £8 was expensive. Prince Richard is a charming boy just down from Cambridge, slightly owlish with glasses and a stoop. Except for the waxworks at the high table tickets could be purchased for the lunch: £3 worth of cardboard food. Julia came off better in the placement with Norman Hartnell on one side, explaining to her how awful it was to get the Queen to wear anything properly, and the Duke of St Albans on the other, a Colonel Blimp type descended from Nell Gwyn. I was enmeshed between mountain-climbing Chris Bonington and an Edwardian *grande dame*, Walter Buccleuch's sister, Lady Sybil Phipps. Moira Lister, as the chairwoman, gave a completely inappropriate address followed by Prince Richard, who did well for a young boy.

4–5 December. John Fowler.

We went to stay with John Fowler, the celebrated interior decorator. After a drive through mist we came to this remote little Gothic hunting lodge at Odiham. It is literally a façade of beautiful brick with three gables inset with pretty Gothic windows behind which he has created a house. John is now seventy-ish, very red in the face and jowly and, at the moment, easily tired having recently had cancer of the jaw. Two young men were in attendance: Peter Hood, who had been destined for the clergy, and a second who was working on the V & A's neo-classical exhibition.

But the garden is the thing. An avenue of pleached limes leads to the brick façade. There are little lead statues of shepherds flanking it, pretty flower-beds with wire obelisks, and in the middle of the garden there are two Gothic gazebos of trellis which face each other. And then

there's John's latest addition, a large garden room, both beautiful and comfortable, with windows looking on to a lake and a box-hedge garden.

John Fowler's entertaining is by no means grand but warm and generous, with the young men butling a bit. The food is English but given a twist through the use of herbs from the garden. Sunday was enlivened by Emmanuel and Elizabeth Kaye coming to lunch whom John was trying to get interested in West Green House, 1720s, run-down and romantic and with a secret walled garden with box topiary. After lunch we all went over to see it. John is busy drawing up rules for the restoration of National Trust houses. He screamed about the ignorance in this country over restoration. At Chiswick the painters had been sent up to the cupola and came down with a scraping which was bright orange. This was actually the colour of the stuff which was used for stopping in plasterwork in the eighteenth century. The Ministry of Works architect flicked through the British Standard colours swatch and matched it, saying, 'Right, paint it marigold.'

This is the first time in my diary that I ever wrote about a garden and reading it I sense how stirred I was by this creation and that it had been entirely achieved by John Fowler. The impact was far greater than Beaton's Reddish and sowed the seed for the furor hortensis which was to seize me more and more in middle age.

1972

Crest of the Wave

This was a year when much entered the pipeline in the National Portrait Gallery's history which was only to reach fruition after my departure. One of the most significant plans came out of a visit by the Standing Commission on Museums and Galleries which was chaired by Lord Rosse, who also held sway at the National Trust. The moment seemed apposite to raise the matter which had almost cost me the directorship when I had been interviewed in 1967: that the National Portrait Gallery should have a relationship with the Trust, and use some of its houses to display its reserve collection. This time the idea took off and was welcomed by the Trustees at their October meeting. The scheme was for a display of Tudor portraits at Montacute, which I first visited on 29 November, to be followed by a parallel display of northern worthies at Beningborough.

The second development was the establishment of a Contemporary Portrait Collection. The importance of collecting portraits of the famous while they were still alive was always guaranteed to arouse quite irrational passions in the Trustees. The list of people whom they had rejected as ineligible during this period makes almost unbelievable reading twenty-five years later: among them Francis Bacon, Princess Margaret, Elizabeth Bowen, William Golding, Lord Snow, Malcolm Arnold, Sir John Barbirolli and Sir David Webster, whose picture by David Hockney was swiftly thrown out. I did, however, persuade them to accept a head of Henry Moore by Marino Marini donated by Moore, but what was said about Moore's art by Gerald Templer was unprintable. During the discussions about these people one sensed the undercurrents, as judgements were made almost in code with much eye-contact across the table. An advisory group was also instigated to establish who ought to be photographed amongst the living. I had inherited something called the National Photographic Record whereby the Gallery paid a photographer to produce dull studio head-and-shoulders images of worthies. There had been few problems as it worked to safe categories, like all High Court judges automatically being asked to sit. This I was at last able to persuade them to sweep away in favour

of a new system. Now, with the new meritocracy in the ascendant, there was much cause for breast-beating as to who should or should not be photographed to join the national pantheon.

The saga of the new building continued, the architects Casson Conder producing a report in which yet again we were told that the Gallery could not be got on to the Hampton Site. We were presented with three options: another site in central London, acquiring the land in proximity to the Hampton Site or, thirdly, to opt for a phased development, moving half the Gallery to a new Hampton Site building and following with the rest when the United Universities Club lease ran out in Suffolk Street in 1992. The last was the preferred route.

The greatest rescue drama of the year centred around the album of photographs by Hill and Adamson which the Royal Academy, strapped for cash, decided to place in the saleroom. As its President, Sir Thomas Monnington, was a Trustee there was dismay that they had not been offered to the Gallery. Poor Tom Monnington was an honest man and was so shamefaced at the next meeting, admitting that the Portrait Gallery had never entered their heads. The album was withdrawn from the sale and offered to us in March of the following year for £38,178.50 with the condition that there would be no public appeal. I had the great good fortune to have a benefactor walk into my office and offer to buy them outright for the nation anonymously. Osbert Lancaster celebrated the event with a characteristic cartoon of two dowagers looking at the portrait of General Burgoyne, one saying to the other: 'General Burgoyne looks jolly smug this morning.'

That autumn the heir to the Suffolk and Berkshire collections, Mrs Greville Howard, opened negotiations to give the Suffolk collection to the National Portrait Gallery. It included the most famous series of early full-length English portraits ever painted, those by William Larkin, icons of splendour on the grand scale. The drawback was that we would have to display all of them in perpetuity, a request impossible to meet. If our relationship with the National Trust had progressed further we may well have reached an accommodation but it was too early. The Suffolk Collection today hangs at the Rangers House, Greenwich.

Even with what is recorded below I am conscious of everything that passed without record, like the extraordinary dinner given by Tony Palmer for Liberace. There was much travelling: our belated honeymoon in Tuscany in January; I was delivering the Ferens Lectures at the University of Hull in February; and in April I was a visiting professor at Yale. Julia was designing *Un Ballo in Maschera* for the Staatsoper in

'General Burgoyne looks jolly smug this morning!' Osbert
Lancaster's cartoon on saving the Hill–Adamson Albums

Hamburg and there was much weekending all over the country. But
the great change in our private lives came towards the middle of this
year when we were within reach of buying part of a seventeenth-
century house at Culworth in Northamptonshire. That signalled an
intent that our married life should be based not in London but in the
country.

Immediately after Christmas, exhausted, we set off for Italy to spend
a belated honeymoon in a farmhouse at Castellina in Chianti, near
Siena, lent to us by the businessman Sir Ronald Grierson.

7 March. To Jan van Dorsten.

The Italian month was heaven ... the villa was in the midst of the
Tuscan hills, very remote but with central heating, lots of plumbing
and ravishing walks and views in every direction. And a couple to cook
and launder and care for us. In the first week we just slept 15 hours a
day and from then on gradually revived ... It was so wonderful being
alone together and we saw as few people as possible, apart from a trip
to Lucca to see [Hugh] Honour and [John] Fleming, the obligatory dinner
at the Berenson villa, I Tatti, and luncheon with divine, lovely Harold
Acton ... It was cold and it could rain but the country was so much
prettier than in the summer, the colours softer, more transparent. So
that was all good and I managed to write two out of the five lectures
on *Princely Magnificence* for my role as Ferens Professor of Fine Art at
the University of Hull...

New Year's Day. Lunch with Harold Acton.

The Acton villa, La Pietra, has a number, 120, and is on the Via
Bolognese as one leaves Florence. On arrival two vast iron gates are
flung open, leading on to the customary avenue of cypresses to the
house. Either side we caught glimpses of the clipped yew hedges and
statuary of the legendary garden. No luck so far as that was concerned.
It was raining. We were late so it was difficult to take in the house. As
we drew up, two white-jacketed servants rushed out with umbrellas to
protect us from as much as a splash.

I felt as though I was walking into a setting from a novel by Henry
James, or perhaps Edith Wharton. There were vast rooms whose walls
were painted a grubby cream stuffed with Italian primitives, chairs of
faded, ragged velvet, mottled mirrors, pieces of classical sculpture and
dusty curtains swagged back and secured by gargantuan tassels. And,
of course, every other thing was gilt. All right, one had to admit that it
was a little run-down but it was still definitely grand. There was no
time to take any of this in as we were quickly ushered into the *salone*
to meet the other guests, who included George Kaftal, the iconographer
of the Tuscan saints, his wife, an ancient New York lady of untold
means (Nancy Perth's aunt), Richard Freemantle, a young man who
was cataloguing Harold's pictures, his dull pretty wife, Chloë, whom
he had married on 6 September four days before us, and the retired
American consul in Florence and his wife, Jean and Merritt Coote.

The dining-room must be unique for being hung seemingly entirely
with 'Last Suppers'. There was a round table beautifully laid with
scarlet and purple flowers in a large florid silver bowl at the centre,

pale blue long-stemmed wineglasses, and cutlery with spade-like handles. To the left of each place *grissini* and a tiny round of toast had been elegantly laid. Lunch consisted of a risotto of *rognoncini*, turkey with artichokes and soggy sprouts, salad and cream cheese, followed by a vast chocolate soufflé.

The conversation was *louche* and flowed thick and fast, thriving on gossip and scandal. It began with a story about Mrs Keppel, Edward VII's mistress, arriving for lunch somewhere in Italy, demanding gin, and, finding that there was none, sending for her chauffeur to go out and buy it. From there it moved on to Violet Trefusis, whom Harold remembers as a magnificent Edwardian dowager. No, she had not been the King's mistress, but she had had a tumble with him on the sofa. Wallis Simpson, she said, owed her hold over the Duke of Windsor to the fact that she had learned the 'Chinese Clutch' in Shanghai. Notice the way, she used to say, that he couldn't keep his eyes off her, reducing himself to the level of a ventriloquist's dummy. No, Harold did not like James Pope-Hennessy. No, he couldn't cope with someone who always turned up beaten black and blue, covered in weals, with beefy soldiers, sailors or anything else of that ilk that he could lay his hands on. Yes, he was an embarrassment to his brother, John. Wasn't it clever of Cecil Beaton to say on arrival in New York that the wealthy Mrs Harrison Williams, an extremely angular woman, was the most beautiful woman in the United States and that everyone else was dowdy and plain beside her? And so it ran on, and all of it in that wicked, extraordinary voice.

Julia was placed on Harold's right and was told that the lunch was in our honour and we were charmed. He told us that he had given our little book *Elizabeth R* to Oliver Messel in the London Clinic, who was enchanted by it. As we left he gave us an inscribed copy of his book on the Bourbons of Naples.

8 March. Marie Rambert.

We were bidden to dinner. That went back to Astrid Zydower's sculpture of Marie Rambert[1] for the National Portrait Gallery. On the day that it went on display Mim Rambert took up her place next to it as though she had entered paradise. But to return to the dinner. 19 Camden Hill Gardens sounds a smarter address than it really is, for it is that part of the street which slides down rather seedily into Notting Hill

[1] Ballet dancer and teacher who promoted collaboration between painters, musicians and choreographers and founded the Ballet Rambert in 1935. Created DBE, 1962.

Gate. From the moment we saw the run-down exterior we knew that we were overdressed for the occasion. No matter, we pressed the front-door bell and Mim swung it open, one leg raised while she kicked the other one forward. Not bad, I thought, for eighty-four. There she stood eyes a-sparkle, her white hair immaculately coiffured, her nose a cer-tainly noticeable one. She was dressed in a black suit with slacks, black shoes with jet buckles and with a brilliantly coloured scarf knotted around her neck. We were the first people to be given dinner there for twelve years since her husband died, which was certainly a piece of information upon which to ponder.

This was modest living, a ground-floor front room, cream-painted and now really rather grubby. Whatever she lived for it was certainly not for comfort. The room in fact narrowly missed being spartan. In the middle of it stood a refectory table, there was a sofa in the window, two armchairs either side of a gas fire and that was it, bar two good pictures, a still life over the fireplace and a Teniers-like genre painting in a large ebony frame to the left as one came in. Here there was no pretension. Although Mim has a housekeeper, Astrid Zydower had in fact cooked the dinner. They are like mother and daughter, bound by their Lithuanian Jewish origins. As Astrid is only able to cook one thing, roast lamb, which is in fact excellent, it was to be regretted that she had decided to try her hand at a stew. It was awful but down it went, to be followed by baked apples and cream, Brie and home-made bread.

We sat facing each other across the refectory table. There is no doubt but that this woman is endowed with a wonderfully larger-than-life quality. Her energy is extraordinary and every so often she would make extravagant gestures with her arms. After dinner we looked and giggled at bundles of old photographs of Frederick Ashton in *The Tragedy of Fashion, Cinderella* and other ballets, all put on the tiny eighteen-foot stage of the Mercury Theatre in the thirties. Then followed ones of Pearl Argyle, Andrée Howard, Willy Chappell, Alicia Markova, all those I had first seen in pictures in those endless books on ballet which appeared just after the war.

Fred she always remembered as fun. She recalled how he used to come to Dymchurch when she had the children, diving into the pool and popping up having arranged himself in silhouette, holding his hand up in blessing and crying out, 'St Luke.' She had taught Fred to dance. The first thing that she did was to make him lift the female dancers to develop his muscles. He is, as we all know, lazy. Yes, she had guessed that Julia was responsible for *The Enigma Variations*. The idea wouldn't

have crossed Fred's mind. How Mim hated the new *Sleeping Beauty* at Covent Garden (designed by Lila de Nobili and much misunderstood). When the Diaghilev Ballet had been in London she had gone to every performance, although they had danced to an almost empty theatre. No, she loathed MacMillan's *Anastasia*. *Triad* was nothing, but she adored Balanchine's *Apollo*. She had never had time for Fonteyn until Nureyev came on the scene, when she said Margot's dancing suddenly improved. She told her so. The reply was, 'Yes, now that they look at him instead of me I can relax, and really dance for the first time.'

12 March. Life in NW1.

Keith[1] and Susan Kyle gave a party in their house on Primrose Hill. This is living NW1 style which has no respect for a period house. At the bottom of the stairs a gate had been fixed to cage in the child, the walls vanished beneath swathes of paperbacks, the kitchen cum dining-room was scrubbed pine, the drawing-room lined with a particularly hideous gold-striped wallpaper. Everything was very NW1 including the dress of the guests. There was Peregrine Worsthorne[2] in cuddly woollies buttoned down the front and baggy trousers. A. J. Ayer in a tatty suit desperately in need of an expedition to the dry cleaners with Dee Wells, all cleavage, like a vampire on her night off. Vanessa Lawson was like a nymph gone mad in a dress of black nothing while Nigel, thicker than of yore, frustrated and clever, told me he had a constituency waiting for him in the coming election. The food matched the ambience: piles of cold meats, salad and cheese, washed down with rivers of cheap wine.

6 May. To Jan van Dorsten.

... We are really set here for the summer, getting up early each morning to start work for there is so much to do. By early July two 40-minute radio scripts, six 15-minute TV scripts on royal faces [the television series *Six Faces of Royalty*] and the Mary Queen of Scots Christmas Book [the companion to the *Elizabeth R* of the previous year] ... We work hard and economise for the reason that we have seen the house of our dreams in Northamptonshire. Brighton will be sold this summer for a vast profit and jointly we will buy, if we can – the gods and heavens and surveyor's report allowing – Danvers House, Culworth, near Banbury. It is in the middle of a marvellous village near Sulgrave and

[1] Journalist, author and broadcaster.
[2] Columnist and later editor of the *Sunday Telegraph*. Knighted 1991.

Canons Ashby and in glorious countryside yet not isolated ... It is really like buying a small country house. One enters through a wall from the village street into a gravelled courtyard and before one's eyes arises this beautifully aged yellow stone Georgian house with huge sash windows, very Dutch in a way, rather Mauritshuis. I suspect basically Elizabethan or earlier but with an eighteenth-century layer in front. To the right runs a red-brick Victorian stable block closing in the right-hand side of the courtyard. Beyond that is another vast range of buildings, including a saddlery, hay loft, carriage house and rooms for grooms! I don't know what we will do with that block but it is sound and will stand even if we eventually demolish it...

We have unfortunately fallen in love with it and are quite obsessed, which is fatal because it is expensive, but we have decided that we would rather live as decayed gentlefolk in grandeur than in bijou smartness in Brighton. The interior is ideal: a large panelled dining-room which would easily sit twenty people for dinner, the grand salon with a door on to the garden or terrace, the winter drawing-room, eighteenth century, panelled and with a corridor outside which could become a library corridor, a little closet leading off ... A beautiful broken staircase winds up to the first floor: two bathrooms, four bed-rooms, apart from five more rooms over the stable block. Outside what could be a little herb knot-garden with a garden house overlooking it, grass, shrubs, trees and beyond a small paddock which would turn into an orchard. To the right a secret garden, decayed but restorable to Edwardian romance with a trickling stream.

This has all happened in a rush by a series of accidents. Brighton was simply not big enough and we needed a house for life, a statement about us together, a joint creation and we would live there always ... we looked at the churchyard and it was very old and beautiful and English and simple and the sort of place to end up in. This may sound silly but one must form a pattern to life and this is it.

20 June. Charlie Wrightsman on the Windsors.

Charlie[1] and Jayne Wrightsman take up residence for the season in their 21 St James's Place apartment, its walls panelled and hung with their trophies, the Van Dyck *Henrietta Maria* which I failed to get, a Gerhard David *Madonna*, a Vermeer in the library and that marvellous Renoir of a lady with a pussycat stretching upwards in the drawing-room. The other guests were Cecil Beaton, Nin Ryan, George and

[1] Charles Wrightsman, American multi-millionaire, oil magnate and art collector.

Sandra Weidenfeld and Pamela and Michael Hartwell. I sat between Pam and Nin at the round dining-table which seated ten and which was unusual in that each guest had his own carafe of wine.

But the really interesting information of the evening came from Charlie on the subject of the Duke of Windsor, whom he had known since the Duke had first visited the States. They had played polo together and had seen a lot of each other when the Duke had a house at Antibes. The Duchess was, however, the 'bad lot', a chronic insomniac who needed only three hours' sleep and demanded that people talk to her till four in the morning. She sponged off everyone and had boyfriends, in particular Jimmy Donohoe whom she had times with on her own at Palm Beach, the Duke arriving later. Charlie Wrightsman categorised her as the 'nurse'. He was like a child of ten. The Duchess ran the whole show, embarking on memoirs and television for the money. She had invested in jewellery which was a mistake because on his death her income collapsed as certain revenues from Wales ceased to come any more. She had been virtually doped for his funeral and it was thought safer to take her into the Palace rather than having her freak out at Claridge's.

26 June. A Weidenfeld fête.

'Who could do it, even in the eighteenth century?' Jack Plumb remarked to me as sixty people sat down to dinner at Cleeve Lodge, George and Sandra Weidenfeld being seemingly together again for a brief period. These occasions always begin in the hall with drinks, move on into the dining-room and thence to the library. The décor of the place cannot be described as anything other than expensive but impersonal, except for the library which reflects George's genuine interest in his subject. He's an extraordinary, larger-than-life man, with a brilliant intellect, seeing a book in practically everyone he claps eyes on. The trouble is 'clap' is the word, for he's looking over one's shoulder the next minute. The food is always rich if institutional, the staff hired, and at least one of the waiters is always drunk. I had the misfortune to be placed next to Mrs Peter Quennell who spent most of the dinner denouncing everyone else at the table and screaming about the ceiling spotlight which fell upon her. In the end she stood to her feet storming about it, and asking George to get it turned off. I did not enjoy myself.

28 June. Cecil Day-Lewis.

Today I had a long conversation with Cecil Day-Lewis's beautiful widow, Jill Balcon, about her husband's portraits. The best one was that

by Lawrence Gowing which had been commissioned by Rosamond Lehmann, with whom Cecil had lived for ten years. At the end of the relationship she had crated it up and sent it back to the author's first wife and now it was jointly owned by Jill's stepchildren. She was so sad and tragic. All she wanted out of life was the Gowing portrait and a shelf of his books. She said that the Kenneth Green portrait which had been offered to us was appalling, that the artist had behaved terribly, painting Cecil when he was ill.

29 June. 'Darling Daisy' and the Annenberg ball at the Ambassador's Residence.

This was rumoured to be the Annenbergs' farewell spectacle due to their imminent replacement by the Heinzes or, as rumour had it earlier, Ronald Reagan. The evening began with dinners elsewhere, in our case with Jack and 'Babe' Steinberg at 74 Portland Place. This was interior decoration of the money speaks variety, sumptuous and instant, the walls hung as though to order with one Utrillo, one bad Renoir and a number of other third-rate Impressionist paintings. There were twelve of us in all and everything was done in great splendour with at least two menservants and many maids.

I sat between Estée Lauder and Mrs Peter Thomas, wife of the Secretary of State for Wales. Estée Lauder was cosmetics from New York, fat, swathed in classical drapes, her necklace of real jewels so vast that they looked false, and a blonde thirties wig. Mrs Thomas, who had a face like a Pekinese, was a granddaughter of Frances Warwick's youngest child (i.e., one of those whose father, according to Anita Leslie, was other than the Earl). She remembered having quite a bit to do with 'Darling Daisy' [Frances Warwick] in old age when she was ostracised from her own set for turning socialist. She recalled her taking a bath, huge and devoid of her wig. To the end she continued to dress in Edwardian feather boas and floating veils and wear hair 'transformations'. She was also a compulsively greedy eater, wolfing back pats of cheese and butter in the dairy.

The ball was done on a vast scale recalling a vanished era. The place was filled with the most incredible flowers, huge vases of arum lilies, white Canterbury bells and trailing pink fuchsias. Two pavilions had been added to the house; the second, which was octagonal and open at the sides, was for dancing. The roof and walls were festooned with garlands of roses. In the supper room there was a vast sugar subtlety with the American eagle sitting on a mountain of spun sugar.

The Masque of Beauty *was an exhibition done in a hurry to fill the gap caused by the collapse of the Graham Sutherland retrospective due, if I remember rightly, to the exiled artist's relationship with the Inland Revenue, and also because negotiations for a show of British portraits from Florence failed to come off. Happily it was staged by my successor, John Hayes, in 1977. The Masque was never designed to be anything other than entertainment, but was regarded as just a bit too frivolous by some for a national collection. Keith Roberts of the* Burlington Magazine *used a review of it as a vehicle for lampooning what he regarded as the trivialities going on at the bottom of the Charing Cross Road. None the less the media had a field day on my choice of the nine reigning beauties to include in the exhibition. I was prevailed upon against my wishes by Colin Ford, our recently appointed Keeper*

'I thought Roy Strong was the prettiest' –
Heath cartoon on *The Masque of Beauty*

of Photography, to include Diana Dors. The Spectator *printed a cartoon of me as Paris giving judgement upon the three aristocratic beauties parading before me with a balloon above inscribed: 'What I always say is: Beauty is in the eye of the reader of Debrett.' The* Sunday Times *cartoon showed two women leaving the show, the one saying to the other: 'I thought Roy Strong was the prettiest.' My main memory is of*

Dame Sybil Thorndike coming in a wheelchair, everything clearly by
then a great effort, and every time we lifted her up a flight of steps she
burst into the verse of a hymn. And the fact that because Kenneth
Turner, the brilliant flower arranger, had banked the place with dried
flowers and carpeted the floor with beech leaves, visitors suffering
from asthma had occasionally to be carried out feet first.

4 July. The Masque of Beauty.

The private view of *The Masque of Beauty* was a triumph. Christopher
Firmstone's sober décor for the exhibition of Sir Godfrey Kneller's
portraits was obliterated by Kenneth Turner's flowers, trees and leaves
which engulfed the place, and Chris Bazeley's lighting. Julia and I wore
white and brown, Julia in a dress of those colours and me in a white
suit with a brown-and-white spotted Yves St Laurent bow-tie. Cecil
Beaton, wearing a dinner-jacket with a camellia in his buttonhole,
complained that the photograph of the lady in the catalogue wasn't
Diana Cooper as she never did her hair in that way (he was right). The
costume parade included Antonia Fraser in a little black velvet jacket
and white lace, Elizabeth Longford in stiff grey satin, and Drue Heinz
dressed like an expensive, out-of-work gypsy. There was a huge press
turnout during the day, fifty or more fighting to get in. At the private
view the *Tatler*, *Vogue* and *Women's Wear World* clicked happily away.
Yes, it was a triumph but not without a fight.

8–9 July. Woburn Abbey and the Bedfords.

Ian and Nicole Bedford do create their own set. They are people who
really believe that because actors are interesting on stage, they must
necessarily be interesting in real life which, on the whole, they are not.
On the last Woburn weekend it was James Mason with a hair graft and
face-lift. This time it was Rex Harrison, who is a big bore and his wife
an even bigger one, weighed down by her false eyelashes. He has had
so many wives that I'm not sure which number this one was. Paul
Getty, who had in tow Penelope Kitson, we hadn't met before. There's
something really repellent about him, a kind of rich slug or amoeba, a
living, just about, monument to the equation of riches with misery.
There is obviously some strange rapport with the Bedfords as he
announced that he felt happy the moment he glimpsed Woburn from
the drive. All he quizzed me about was the value of early English
pictures and I must say that I found it odd to discover in our bedroom
a book written by him entitled *The Joys of Collecting*. The party was
rounded out with Nicole Sieff, Rosy d'Avigdor–Goldsmid, John and

Spectator cartoon on *The Masque of Beauty*, 1972

Caroline Ure (he about to be our No. 2 in Portugal) and Bevis Hillier.[1]
I've always had a soft spot for Bevis, a more sober wag these days
remembering his notorious byline in an early issue of the Friends of
the British Museum journal which he edited, 'Fairy Queen in Leather'.
After dinner one evening he entertained the company with a recital of
Victorian songs.

No other house can match Woburn for sheer comfort. If one arrived
nude nothing would be lacking. Everything is in one's room on shelves,
in cupboards or little baskets running to unusual items like whisky,
fruit, toothpaste, Alka-Seltzer, sanitary towels and cotton-wool balls.
The dining-room with the Canalettos is a knockout, along with the
food. After dinner there is the ritual tour of the candlelit state rooms
with Handel's *Water Music* pumped into them. I admire the Bedfords
a lot for their sheer brio. Ian adores droll badinage while she is just a
whizz at running everything.

[1] Editor of *The Connoisseur* and Antiques correspondent on *The Times*, who was later
to write a biography of John Betjeman's early life.

7 July. The Longfords.

This was a cosy dinner with Frank and Elizabeth, Hugh and Antonia [Fraser] and Jack Plumb. The Longford flat in Chesil Court in Chelsea Manor Street is wholly unpretentious with a tiny sitting/dining-room with the TV in the fireplace and filled with a mixture in no particular order of nice things and things indifferent. There were a few minor garnerings, that Andrew Bingham had left his wife, Caroline, the historical biographer, and that Frank Longford was having difficulties with his pornography report as it could be a best-selling piece of pornography itself!

6 August. The Sitwells at Weston.

We drove by car to see Danvers House again and then went on to have lunch with the Sitwells at Weston. This is a pretty house, the entrance hall rectangular with a round table at the centre with a blue-and-white tablecloth to the ground flung over it and Delft blue-and-white tiles lining the fireplace. The ceilings were on the low side but it's a happy combination of the domestic and stylish. The drawing-room was 1740s with portraits and clutter. There they were again, Georgia, husky-voiced, pop-eyed, angular, bright and efficient, Sachie sporting the family's bird-like features set into a sea of face, and wearing an over-buttoned-up tweed jacket.

Georgia confessed that Paul Nash had had a crush on her. Once, as he heaved her suitcase and his on to a luggage rack in a train, he said 'That's as close as we two will ever get.' I sat next to a Lady Benton whose first husband had been Condé Nast. The present magazine she regarded as a hideosity. She was so rich, paying 78% of her income in tax, that she had been forced out of England into exile and lived in a house in the deep south of Italy in total quiet and seclusion, much to the horror of the American hostess Kitty Miller, who said to her, 'Everyone near my house is in the Almanach de Gotha!'

Sachie recalled David Somerset's remark to Princess Margaret, who had been complaining bitterly of having to fight her way through the crowd: 'If it wasn't for them you'd be sitting in a restaurant in Estoril.'

9 August. Jackie Onassis.

Lunch at the Café Royal with the Wrightsmans and Jackie Kennedy Onassis. She's in her early forties with a cute, slightly lined, sixties face, dipped hair and the hands of an old woman, the flesh withered and with enormous knuckles, today covered with sticking-plaster. She was dressed with underplayed chic in trousers and a Hermès raincoat

Nervous, with eyes popping, she moved with almost teenage animation. The impression was of an intelligent, rich woman, bored with life marooned on a Greek island, envious of the Wrightsmans' London lifestyle, and longing for New York. In conversation she was a receiver rather than a giver.

Charlie Wrightsman is one of those large men whose neck is missing, with something disturbing about his face. He sports the perfect patina of the very rich and he addresses rather than converses, interjecting from time to time with a statement. Jayne is in a perpetual state of animation with a face like a parakeet nestling beneath a huge pile of bouffant hair. But she's well read and exudes enthusiasm.

31 August. To Jan van Dorsten.

The television series *Six Faces of Royalty* has been a stupendous marathon, and it fascinates me mastering a whole new field of technical experience and presentation. We have polished off Charles I, Eliza and Henry VIII so far and three more to go. I can't tell you how nerve-racking it is learning one's lines and doing them to camera as though they had just occurred to me – no help from autocue, as the great Lord Clark. We have been belting around Hatfield, the Tower and Wilton as locations, eternally driven mad stopping and starting due to planes, lawnmowers, sun going in, and a million other details. Careerwise the TV series is an important and judicious move but I don't want to do a great deal of it – scarce and occasional.

Now we have come to a disastrous end to getting the Northamptonshire house which has been a ghastly blow and very upsetting for us all. It means back to square one and we had hoped and planned and fallen in love with it. One is so desperate over inflation that we must get a house soon ... Tomorrow we go all the way to Herefordshire to look at Bishop's Frome rectory between Ledbury and Bromyard and Hereford and Worcester in Malvern Hills country. It is to be auctioned on 20 September so you can imagine the panic that this could engender if we like it.

11 October. To Jan van Dorsten.

We have failed to get Danvers House, Bishop's Frome Rectory and Priory Farm, Balscote. Each week we stagger from one part of the country to another, sometimes leaving the house at 5.30 a.m. in the morning to see things the moment that they come on to the market. What is important is that we have finally decided on the north of Oxford area and a good stone-built house, not a cottage. If I see the

inside of another peasant's hut souped up as a house for £30,000 I shall scream! At the moment there is still a remote chance of Priory Farm with its lovely courtyard and fourteenth-century doorway and nine acres of fields and orchard ... It is so TIRING and SO FRUS-TRATING.

8 November. Erté.

We were guests of honour at the Friends of the Israel Museum's very boring annual dinner. I was stuck next to Martin Davies[1] and Julia to Sir Philip Hendy. But the joy of the evening was the designer Erté, who was the shortest and most beautiful eighty-year-old I have ever seen. Pale of complexion with almost white wavy hair brushed back from his forehead, there he was nodding and sparkling away like some marvellous old aunt, wonderfully dressed in a short black slub silk jacket with lace collar and cuffs (J says lingerie lace) with little tabs below. He left wearing an enormous wild mink coat with a silk scarf tied with an indefinable chic. Erté has an extraordinary quality, like some exotic bird, quiet and beautiful in repose, but when speaking suddenly intensely animated, swooping as it were. A dowager duchess in drag, one almost expected him to use a lorgnette. He made every woman there with their false hair and acres of mink look common in comparison.

16 November. Judy Gendel.

Last week Judy Montagu, Mrs Milton Gendel, died of a heart attack aged forty-eight in John Stefanides' house in Chester Square. She had arrived back in England from Rome, she said to Patrick Plunket, to die. 'Nonsense,' he said. 'All you need is good old English cottage pie to erase all that horrible Italian food.' But, sadly, that was far from the truth. The funeral was near Oddington where her brother lived, quiet, with Isaiah Berlin, John Sparrow, Patrick Plunket, HRH Margaret, Ingrid Channon and others that were close. Judy's daughter led HRH by the hand, a very touching scene.

Intelligent but lacking application, passionate and angular, Judy was as masculine in gesture as she was in mind. She had, however, a rare quality, that of intense involvement with anyone that she knew, and was endowed with wonderful gaiety and great generosity. Two years ago she suddenly became enamoured of clothes, and I remember her ceasing for a time to be an old bundle as day after day she appeared as

[1] Director of National Gallery, 1968–70. Knighted 1972.

some gorgeously apparelled cavalier with a vast hat. Her features, with their droop, resembled those of a bloodhound, but that was offset by the liveliness of her eyes and her sense of fun. When she was up she was up. We last saw her in July at a Weidenfeld party when she hardly wanted to recognise us. She was as thin as a rake, like an emaciated corpse, and her face was painted lead-white. I can remember then saying that the will to go on had left her.

29 November. Binkie Beaumont and others.

The evening began at 10 Downing Street with a party to celebrate the end of the Government's programme to clean Whitehall. I noticed that the Burton Gainsboroughs [which belonged to Baroness Burton] had been hung in the dining-room. The Prime Minister [Edward Heath] wasn't there, and then was, and in the end made a very good speech suggesting that through the cleaning of buildings we rediscovered our own architecture. The party was well organised and it was filled with an interesting cross-section including Peter and Tessa Walker, Hugh and Fortune Grafton, Ingrid and Paul Channon, Osbert and Anne Lancaster, Cynthia Gladwyn, *et al.*

We went on to dinner with the violinist Nathan Milstein and his wife Thérèse at 19 Chester Square with a strange and sparky assemblage: Jill Weldon in a yellow trouser suit, Beatrix Miller, in a sub-flu state, wearing a voluminously pleated Jean Muir dress in rust red, Cynthia Gladwyn (again) like a raddled doll with rouged cheeks and wearing a loose turquoise gown with gold frogging at the neck, Julian[1] and Marie Claire Amery, she delightful, he ill and antiquated, the pianist Moura Lympany in floating black with a pink chiffon rose at her breast, the Liberal leader Jeremy Thorpe looking like an innocent young man in an Aldwych farce, an explosion of Lord Goodman and that terrible old queen, Binkie Beaumont,[2] in a too small black bow-tie.

It wasn't to be Beaumont and Fletcher but Beaumont and Goodman who were to provide the fireworks of the evening at the table, in a furious exchange about the subsidised theatre. Binkie argued that art flourished on poverty but was firmly trounced by Goodman with an application of legal logic delivered in a witty, send-uppish kind of manner. Binkie Beaumont really hates Cecil Beaton. They had fallen out over *Coco* when Binkie was furious with Cecil for paying Joe

[1] MP for Brighton Pavilion who served in the governments of Macmillan, Douglas-Home and Heath.
[2] Theatrical manager and director of H. M. Tennent Ltd, he died the following year.

Predera £250 for doing all his work. The hatred goes back a long way. He recalled the Wiltshire of the 1930s, and the ball which the Alingtons gave at Crichel when Cecil in costume had danced on the table, of his fear when promised a quiet weekend with David Duff and then seeing about forty Rolls-Royces swing up the drive bearing the likes of Ottoline Morrell. He really is quite awful.

14 December. Paul Getty is eighty.

This was the Duchess of Argyll's dance for J. Paul Getty at the Dorchester. We arrived late, bumping into Nicole Bedford as we went in: 'Oh, oh, Ian is making a speech at midnight!' Within it resembled a scene from *The Godfather*. As midnight struck the orchestra played 'You're the Top' and a short procession wound its way across the dancefloor propelling a trolley draped in cloths on which sat a cake with eighty red candles. There was something really macabre about the whole scene, and if a man had jumped out from under the trolley with a machine-gun it wouldn't have surprised me.

The year ended on an up, for we found a house. We were rung up and asked to come to see The Laskett, Much Birch, between Ross-on-Wye and Hereford. If we liked the house, which belonged to a lady recently

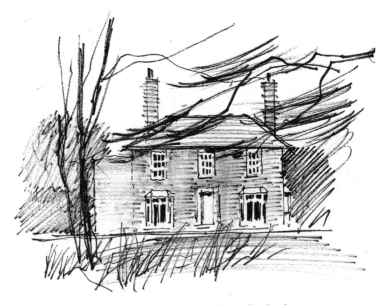

Hugh Casson draws The Laskett from Llandinabo Court 1973

widowed, and decided to buy, it would be a private transaction and the house would be ours as from May Day 1973. On 20 September we drove across country, a journey I will always remember, for as we crossed beyond Gloucester over the hills into what was to become our county I was acutely conscious of entering another land, rolling and golden, at that time rich in the autumn light with the trees laden with ripening cider apples. As soon as we glimpsed the great cedar of Lebanon which stood on the lawn before the house we knew we had come home. Only after we had purchased it did we discover that Elgar had visited the house and that his organist's widow was to be our neighbour. Bearing in mind Julia's ballet The Enigma Variations everything seemed somehow appropriate.

1973

Goodbye Baby and Amen

This was to be a year of huge changes, just how huge could not be anticipated as I entered it. Some years later Beatrix Miller told me that my life ran in seven-year cycles; in 1973 I had been just seven years as Director of the National Portrait Gallery. Before that I had been seven years as a junior curator in its basement, and after were to follow two seven-year cycles, rather contrasting ones, as Director of the Victoria and Albert Museum. And that touches upon the great event of the year, the unexpected move of Sir John Pope-Hennessy to the British Museum, leaving vacant a coveted post but one hardly likely, I felt, to come the way of a 37-year-old. In that I was to be proved mistaken.

I knew that I had already reached the end of what I could or indeed wanted to do in my present position. Ahead of me stretched years of monotonous repetition. The previous year, while I was at Yale, Jules Prown had offered me the directorship of the Paul Mellon Center for British Art, but I felt that would have been at best a step sideways. But I was restless. I realised that to display any overt interest in the V & A would be fatal. I was also conscious that I would in no way put in for the post, which again for the first time was to be advertised, unless a signal was given by the outgoing Director.

John Pope-Hennessy was a member of a dying species, the aesthete museum director. Today they are virtually an extinct breed. No one since his departure in 1976 for the United States has occupied quite his position of dominance, not in retrospect, I feel, a pleasant one. Even when only Keeper of Sculpture he would summon young museum curators to lunch at his house in Bedford Gardens to look them over. He regarded his own views as absolute, and even in his final years in Florence would bitterly opine that this or that Minister of the Arts had not consulted him on this or that appointment. His was museum-directing from the empyrean. No one below the rank of an Assistant Keeper was acknowledged to exist. His role as an international scholar was unassailable and he assiduously cultivated the art historical and museum circles of the United States. And, in the seventies, he had

become a member of the Wrightsmans' 'court', escorting them around the globe to this or that art mecca. He was always and invariably referred to as 'the Pope'. Pallid, cold and taut of feature, his fish-like eyes loomed behind thick rimless spectacles. His high-pitched voice, tending at times almost to an hysterical screech, was guaranteed to strike terror into those who dared contradict a single utterance. Few did. He was a commanding presence, always dressed the Establishment part with short hair brushed tightly back in the style of the thirties, black suits and unmemorable ties. There was no such thing as having a cosy domestic evening with John. Coming from the old-established intellectual and monied upper classes (his mother was Dame Una and his brother was James, the biographer) he lived in style with a housekeeper who waited at table.

The two of us could hardly have been more contrasted and yet I know, because people have told me, that he was fascinated by me. It was described to me how he would watch me circulating round a room. One could see him ask himself why it was that this self-made grammar-school boy from nowhere, flaunting a fedora hat and kipper tie, had come so far, had been so easily taken up by the whole of the Establishment. It puzzled him as much as it sometimes puzzled me. Early on he had reached the conclusion, if you can't beat it join it, so he decided as it were to 'adopt' me as indeed he 'adopted' so many, but in the end I was to prove to be, in his view, an ungrateful child. That lay in the future, in 1973. He began to copy things that I did at the Portrait Gallery, cultivating Cecil Beaton, who presented a collection of clothes (most of which the owners lent but all of which Beaton promptly gave to the V & A, including the Duchess of Kent's wedding dress, a 'gift' which later I had to unscramble). When I used a theatre designer to design an exhibition on Samuel Pepys, shortly afterwards John climbed on the bandwagon, employing Alan Tagg for Byron. When I married in 1971 he was one of the earliest to send us a wedding present, a beautiful design for an interior. The first crack only appeared when, as we both stepped out of a train to attend a conference at Ditchley, a few days after that event, his opening words to me were, 'I don't envy you your father-in-law.' The latter was Charles Oman, arguably the most distinguished scholar ever to head the V & A's Department of Metalwork, who was above all quiescent, timid almost, and spoke with a stutter. I found that comment unnecessary and tried to forget it.

Museum appointments inevitably attract intrigue. The national museum world thrives on gossip and as opportunities for elevation to its upper reaches are so few (there is no interplay with the regions as,

for example in France, where there is a unified museum service) the in-fighting is all the more intense as well as the bitchiness. In the old days everyone had merely stepped up one, but now the top jobs went out to open competition. That in no way impeded movement behind the scenes. The head-hunters were not to arrive until the close of the 1980s. Years later I learned that Lord Eccles had already made up his mind that unless I mucked up the interview I should be the new Director of the V & A. But I did not know that at the time and I felt isolated until the 'message' from the Pope came via Pamela Hartwell. Pam was a born intriguer and had moved on in later life from politics to art. On 20 June she asked me to lunch *à deux* at Cowley Street. Crouched over a card table she said, 'John expects you to put in, you know.' I was always a trifle wary of her diktats and felt that I needed to get that in writing from John himself, so I wrote to him at Bedford Gardens. I have not got that letter, but he quotes from it in the highly misleading account of my appointment that he gives in his memoirs. On 3 July he wrote to me:

> In my own mind I had assumed from the outset that you would apply, and I should be sorry if you did not do so ... I cannot, of course, predict the outcome. But I do not think it in any way discreditable if you applied and someone else were chosen, and it is very possible, depending on the composition of the Board, that the choice might fall on you.

The letter ended with exhortations 'publicly and privately to deny any interest in the post. Above all do not confide in Pam Hartwell; her energetic lobbying could well dish the whole thing.'

This was the sign from the heavens and much of that summer was spent covertly visiting the V & A and its numerous outstations in preparation for the interview, which took place in September. The announcement of my appointment was made public on 20 September and the earliest letter of congratulation I received was from David Eccles delivered by hand to the London flat and registering his 'delight' but ending with a swipe at Pope-Hennessy, who was dancing attendance on the Wrightsmans in Iran: 'Not a bad idea to take a trip that looks like wanting to learn something!' No love lost there, I thought. The letters of congratulation poured in. To set the record straight I quote from John Pope-Hennessy's:

> I have from the outset thought it the best appointment possible, as the one which would command most support from the area to which I myself

attach importance, the middle reaches of the staff, and which would represent progress not reaction.

Arnold Goodman summed it all up with characteristic perception: 'I was a little apprehensive that you would not be regarded as "stuffy" enough for the Establishment.'

I had, in fact, not told the NPG Chairman, Lloyd Kenyon. All my referees were sworn to secrecy for, if I had not been appointed, I did not wish either him, or even more the Portrait Gallery staff, in any way to feel that their Director was about to desert them. He was not pleased or particularly gracious about my exit. Inevitably that event dominated my year and accounts for my failure to keep a diary, a lacuna until the autumn of 1975 when it begins again.

For the Portrait Gallery 1973 was a year marked by Pamela Tudor-Craig's superb exhibition on Richard III, which has gone down as a minor classic. On 16 January Richard Avedon, the photographer, came to see me at the behest of Julia's New York agent, Robbie Lantz, but it was too early for an exhibition of his marvellous work. That was eventually to happen in 1995. My greatest regret was not to secure the portrait of Arnold Goodman which Graham Sutherland was busy painting for an anonymous benefactor. We would have been given it if we had been able to display it which, under the terms then prevailing, the Trustees would not agree to. We could now collect portraits of the living, which was a huge stride into the present, but only exhibit them when they were dead. The anonymous benefactor wrote to me on 13 July: 'The point you raise does not present a very serious obstacle, since I am certain Graham Sutherland would be seriously concerned if the picture were not to be on display ...' It was given to the Tate. Since then the Trustees have moved on and today the Portrait Gallery's exhibition of the living forms one of its major attractions. But it has been a long haul, held back all the way by its own Trustees.

The new building continued to grind its weary way onwards, the plans for fitting it on to the site in the Whitcomb Street area becoming ever more bizarre, so much so that in January I wrote to David Perth, the Crown Commissioner:

> The conclusion that I came to was that what was being proposed was in some ways ridiculous, i.e., a modern building the size of the National Gallery with a bridge over to offices in a converted United Universities Club, with a wing stretching out at the back. The mere shape of the building, let alone the prospect of running a Gallery with a road through the middle of it, seemed to grow progressively stranger.

That is in fact exactly how the Portrait Gallery was to end up under my successor, but the dividing road this time was to be Orange Street. However, by July the Commissioners came forward with a proposal to build a new gallery at Millbank to the south-west of Vauxhall Bridge, placing it in proximity to the Tate. This had the full support of Board and staff, both of which realised that our fortunes and identity would for ever be at risk by our proximity to 'big brother' next door.

For me 1973 was a year of significant publications, *Splendour at Court* and *Inigo Jones: The Theatre of the Stuart Court*, the vast two-volume catalogue of Jones's masques and theatre designs which I wrote jointly with Stephen Orgel, the distinguished American English Renaissance scholar. The latter received an ecstatic review by Peter Hall.[1] I recall sending him a postcard saying now he was qualified to direct *The Tempest*, which he did not long after. In addition I combined with John Harris, the architectural historian and curator of the RIBA drawings collection, and Stephen Orgel to stage a quatercentenary exhibition on Inigo Jones in the Whitehall Banqueting Hall (by then, and thanks to a campaign I launched with Simon Jenkins in the *Evening Standard*, emptied of military bric-à-brac). I had also come up with the idea, which I proposed via his publisher Jock Murray, that Osbert Lancaster should do a spoof portrait history of the Littlehamptons.[2] *The Littlehampton Bequest* appeared at the close of the year and I gave each Trustee a copy at my farewell dinner.

There was change too in my personal life, for we moved to The Laskett in May and began to create a home together and plant a garden. For the first time in my life I was to have a writing-room and a book-room. The summer was one of incredible beauty that year. Julia's production of *Un Ballo in Maschera* opened on 1 April at the Staatsoper in Hamburg. Set by John Dexter in the American Civil War period, it starred Pavarotti. All through the summer she was busy on *La Bohème* for the Royal Opera House, which was premièred in February. It remains, over twenty years later, still in their repertory as one of Covent Garden's great classic productions. But all that took place against a backcloth of tragedy for my mother-in-law died of cancer in November, adding family problems.

[1] Peter Hall, successively Director of the Royal Shakespeare Company and of the National Theatre. Knighted 1977.
[2] Osbert Lancaster, pocket cartoonist for the *Daily Express*, created the immortal mythical aristocratic family of the Littlehamptons. Maudie was the astringent Lady Littlehampton passing comment, in a brilliant series of cartoons, on the political and social scene of the era.

This was the year Britain entered the Common Market, an event signalled by extraordinary *fêtes*, in particular the great gala at Covent Garden on 3 January. I will long remember the encounter of the Dartmouth and Bedford tiaras, Raine's hair scattered with diamond stars and Nicole's dazzling eighteenth-century confection of sprays of diamond flowers *tromblant*. And then there was a magnificent party at Windsor on 19 June when again it seemed that the sun would never set on such display. Country-house weekends and lavish entertaining continued almost unabated, but in truth we were living a mirage, for 1973 was in fact the last year of the 1960s. I sensed that pall of gloom as the economic and political crisis intensified. The Labour Party had already signalled its intent of introducing a Wealth Tax. One of the burning reasons for wanting to direct the V & A was the passionate belief that a huge threat was on the horizon for everything which we now categorise as 'heritage', and that that museum under my directorship could play a crucial role as a vehicle in its defence.

30 January. Harold Macmillan.

We were bidden to a dinner with Olive and Denis Hamilton[1] given in honour of Harold Macmillan and turned out to be the only other guests and I'm still left wondering why they alighted upon us. Their flat is on the thirteenth floor of Roebuck House off Victoria Street. The decoration is Maples-modern with long curved-back settees, a lit-up showcase of treasures and a hideous Edwardian rococo screen. I suppose it was important and fascinating to meet the former Prime Minister, but I think that I would have to place him as one of the rudest men that I have ever met. He looks exactly like his own cartoons. Now about eighty, I would have thought, he's a bit geriatric with a runny nose, and his speech is a stream of consciousness interspersed with occasional lucid flashes. He was a pattern of memories, all of them political, and the Hamiltons kept on feeding him with memory questions. I was swatted down regularly if I ever attempted to open my mouth, never allowed to contribute one thing to the conversation, and if I even began a sentence he interrupted it. For most of the evening Julia and I sat in bored amazement. The only remarks tossed my way took the form of periodic incoherent denunciations of the Gallery's purchase of the Hill–Adamson albums: 'What do you want them for? Got drawer-loads of old photographs at home.' He really wasn't human and there was

[1] Chairman and Editor-in-Chief of Times Newspapers, previously Editor of the *Sunday Times*. Knighted 1976.

not a single comment he made which wasn't about himself. He was caricature arch-reactionary, enough to make me want to vote Communist.

Mercifully we went on to Ann Fleming's at 14 Victoria Square, for what was probably her last *fête*, for she has sold the house. I couldn't help thinking how extraordinary these gatherings had been with their mélange of politics, fashion, art and publishing. Within an hour it was possible to touch on so many aspects of life in '73. In this room there was gathered, some of them crouching in corners or perched on the stairs, the space being so tight, the French Ambassador and his wife, Lucien Freud the painter, the Annans, the Trevelyans, Francis Watson, John Wells, Lady Egremont, Garrett Drogheda, the Quennells, Mariga Guinness, Hugh O'Neill, George Weidenfeld, to name but a few.

These Victoria Square parties epitomise an era. They always had the same format, beginning with a dinner for ten downstairs and then adjourning up to the drawing-room over which Arnold Goodman's head by Angela Conner presided, where, from 9.30 p.m. on, everyone else assembled. They usually collapsed at about 1 a.m. This evening Ann looked as usual distinguished but thinner, and clearly had not been well. Ironically she always appears as though she doesn't really enjoy her own parties.

28 March. Arnold Goodman and Michael Foot.

Alfred Hecht is a very superior framer who lives over his shop in the King's Road. I climbed up the stairs, at the top of which I was astounded to see a superb head of Churchill by Graham Sutherland. This was a non-décor flat, a cream-painted space into which chairs had been placed rather than arranged. The dinner-table was laid with Habitat place mats and napkins and cheap cutlery, the china was plain white and the food was noticeably served by hired hands. But there were superb pictures. A huge Francis Bacon hung behind me, too large for the room, and, in the drawing-room, there was another marvellous Sutherland.

This was an extremely wearing evening, a non-stop flow of hard intellect and hard talk, and a contrary assemblage of guests. To my left sat Jennie Lee, her white hair immaculate, wearing an oatmeal-coloured trouser suit with a blouse in a perfectly dreadful shade of turquoise, and with quite a lot of make-up on when you looked closely. Then there was Michael Foot[1] and his wife. God, what doctrinaire socialists!

[1] Writer and journalist, first elected to the House of Commons in 1945; became Deputy Leader of the Labour Party in 1976 and Leader, 1980–83.

Indeed Michael Foot began by expressing his dismay that this dinner was not, as he had been led to expect, an International Socialist meeting. After dinner the two of them were unleashed. They harangued us, he raising his voice as though addressing a revolutionary mob. Poor Nin Ryan, the benign American millionairess, one sensed her shudder. And then, mercifully, there was Arnold Goodman.

Lord Goodman is huge, loving and logical. He is a fascinating character, contained, infinitely human and infinitely devious. He never contradicts himself and one can't help being struck by the utter uniqueness of the person, a jovial mound with huge hands, endlessly fondling and taking on and off his half-moon glasses. He never raises his voice and there is always a twinkle in his eye. He never either abuses anyone or loses his sense of humour. There was a furious, breathless row about the arts, the Foots on the old socialist theme of suppressed talent through lack of opportunity. They believed that there were thousands of undiscovered artists, poets and writers. There had been, Arnold argued, an explosion of interest and appreciation of the arts but what was striking about it was the fact that it hadn't produced this galaxy of new talent. Where, he asked, were all these new composers and painters and writers? This was an odd sort of evening.

17–18 March. Cecil Beaton.

While Julia was working in Hamburg I went to stay with Beaton at Reddish.

How can I describe Cecil? I have now known him since 1967, six years in all. He has aged and he hates it. He never gives up and he ought to. Yet he can still look marvellous and display great chic. As age has advanced he has grown progressively more malicious, relishing each hatchet-stroke as it is delivered. This weekend he was crowing over the Waugh memoirs. One senses his loss of orientation and there is no one to love. He tries writing plays which he is no good at. Baba Beaton [one of Beaton's two sisters] had died the week before. His secretary Eileen [Hose] told me that he was affected by unfulfilled ambitions like the one to paint. In a way he's a monument as to just how far a little talent in a lot of spheres can go.

March. Undated to Jan van Dorsten.

... I am in bed scribbling this to you with a terrible stomach upset and suffering from the most appalling over-tiredness. The last two months have been TOO MUCH. However my secretary and I fight off public

appearances I somehow end up to the eyelashes in them. I'm going to stay in and sleep all day in bed tomorrow. J gets back from Hamburg for 48 hours, thank heaven, and I miss her dreadfully.

Yes, we are all excited about The Laskett, as it is called, of Much Birch, although the full implications of making life work there we haven't discovered. We move on 3 May. There is such a queue for builders that the architect can't do the alterations until the autumn ... I long for you to see it and J adores it and is busy planning the décor, simple, unpretentious, rather New England in feeling, with lots of brown, beige, dried flowers, herbs and baskets, curtains gossamer-white, all light and pretty and domestic. I long for a job where I can be here ten days out of the fourteen. London is such HELL these days – the gas is on strike, the hospitals, the Civil Service, the railways. It's a bad period for people in these islands, full of deep unrest. So one creates one's place in the country, plants one's flowers and trees, watches over the kitchen-garden, cooks honest country dishes on the Aga and writes, looking towards the hills of an England which is disappearing.

One's career seems settled and I don't anticipate dramatic changes although there are those around pushing me for the BM or NG. Don't think either are likely and the former would be hell.

In April we left for a short holiday in Tuscany staying with various friends, including Hugh Honour and John Fleming near Lucca.

14 April. Georgina Masson, Harold Acton again and Violet Trefusis.
With an introduction from Julia's aunt, Carola Oman, we went to see 'Babs' Johnson, or Georgina Masson as the reading public know her, at her house at Impruneta, just outside Florence. Dressed in woollies and flat shoes she is permanently bent forwards when talking, perhaps in an effort to totally subject one to the monomaniac drone of conversation about herself. She must be in her early sixties and looks as though she has been transported hither from a rectory and a long-suffering rector. She was married briefly after the war to a Mr Johnson who was caught smuggling out a German girl dressed as a private, an offence for which he was cashiered. The great love of her life is her huge dog, about which she talks incessantly, that is when she is not talking about herself or republican Rome or President Jefferson's gardener or great courtesans of the Renaissance or whatever subject she happens to be working on at the moment. None the less one must admire the way that she has made a 'go' of it from nothing. It is, after all, pretty remarkable to write

a biography of the Emperor Frederick II, which was a bestseller in Germany, without reading a word of German.

In the evening we went once more to La Pietra and Harold Acton, this time for dinner. The huge gates were surprisingly not already open but had to be swung wide for us. Harold's chauffeur was ill and the second footman was standing in for him, we learned, so domestic life had been slightly traumatic. We sailed up the cypress avenue which had been planted by Harold's father, and looped around towards the house and parked. A light flashed on over the entrance and a white-jacketed servant stepped out and opened the car door: 'Buona sera.' Another stood at the front door to take our coats and there, in the central hall, stood Harold to greet us. This evening he was in a genial mood, his eyes having their customary sinister twinkle. This time the house seemed like a cross between an antique shop and a mortuary. In the middle of the hall a fountain trickled and at the bottom of the staircase sat a white marble rabbit. In the *salone* everything is discomfort: faded damask curtains appliquéd with ancient embroidery, and stiff upright chairs. I noticed a colour photograph of Princess Margaret, signed, framed in black. The six of us occupied a tiny corner lit by a pool of light like peas in an opulent pod, the six, apart from our host, made up of us, Hugh and John, and an Italian boy who was writing about Caserta.

It is difficult to capture Harold's wit, which is not one of repartee but rather one of performing, with a manipulation of cadence of voice able to insinuate a million naughtinesses. It is also impossible to recapture his skill at demolishing and encapsulating people. This evening he embarked on his loathing for Violet Trefusis, the embarrassment of the sale of the contents of her house which contained many things lent by his father which, by right, should have been his. He described his last visit to her. She had kept on asking when Diana Cooper was coming and Harold kept on assuring her that she *was* coming, which she eventually did. They were invited to dinner, Diana being duly fortified with gin. On arrival at the house a macabre scene then ensued. A maid suddenly entered the room bearing a cushion on to which jewels had been pinned and Diana was asked to choose a piece which would be left to her and so she selected a ruby bracelet. Violet Trefusis then entered, propped up on two sticks and further supported by two male acolytes. She sat down and handed Diana an envelope. Diana proceeded to open it and finding that it contained a hundred pounds popped it into her handbag as covering the expenses of coming. Diana is someone who has absolutely no time for ill-health and has

always made a point of never going to funerals. So the evening had consisted of Diana bellowing at this emaciated corpse to speak up, which eventually the poor lady did.

Violet Trefusis was a lesbian and one of her great amours was Vita Sackville-West. At one point both husbands had pursued their wives to Venice in order to recover them. At the moment Nigel Nicolson was about to publish Vita's love letters to Violet, which Harold regarded as highly shocking and unfilial, Nigel Nicolson believed them to be the love letters of the century. Hugh Honour told us how Nigel's brother, Benedict, had first learned about his parents. Apparently his grandmother told him when he was in his early teens. Ben had confronted his parents with the information next day at breakfast. They remained silent, and everyone continued to consume their eggs under strain.

At this point the diary stops until September 1975.

9 July. To Jan van Dorsten.
Our great excitement has been moving to Herefordshire at the beginning of May. This began disastrously with the pantechnicon bearing our beloved objects sailing off the road in a terrible crash with awful consequences for some of our treasures – 22 items smashed to firewood and 50 others badly damaged ... We have settled into Hereford very happily. I feel so much more relaxed ... One sits in the sun and watches the landscape unfolding in every direction for miles untouched, or contemplates the great 1812 cedar on the front lawn, or one gardens. I have really become a passionate gardener. Reclamation began with the kitchen garden, which is the size of two tennis courts and full of strawberry beds, raspberries, gooseberries, blackcurrants. Which area to save and which area to grass over and turn to orchard was the question. We persevere and I reclaim an area each week. We began creating our herb nursery near the garage and last week I planted no less than 80 sorts of cabbage, purple sprouting broccoli, etc., for winter veg. It is glorious picking pound after pound of fruit and deep-freezing it or making delicious fresh jams or J makes one of her rare appearances in the kitchen to make jellies, pickles and chutneys and other English farmhouse goodies, which are bottled and labelled and stood in neat rows in the cupboard. How happy we are! And the builders? Well, we camp in our rambling house with about three chairs, a trestle table and a bed. Gradually they have taken us over. But it is exciting to see the great breach made in the wall from what will be our hall into our new dining-room and watch the whole house gain a new dimension and fill

with light and landscape. Every week we arrive to find progress: windows are carted away, doors are removed and windows replace them, ceilings are taken down, cupboards are inserted and shelves added where we need them. We are months off any organised house but it is bliss.

Mid-September. To Jan van Dorsten.

By the time this letter reaches you it will be publicly known that I am to be the new Director of the Victoria and Albert Museum. I can still hardly believe that this is true, or grasp the import of such a momentous event. When it is released to the world this coming Friday evening it will cause a furore in the British art world. We have known each other too long for you to learn by opening a newspaper! And, of course, I couldn't let drop even a hint of my interest in the post in our correspondence. One leak on any side would have dished the whole project and my application has been surrounded with an embargo of total secrecy, even from the Chairman of the Board of Trustees, who will be having the most fearful shock this morning at breakfast when my letter arrives. Both of us feel that it is so right that this should happen and I am so happy for J whose family through two generations has been bound up with the history of the place and whose work is on exhibition there. There was a short list of six, including four V & A Keepers, so that I am walking into the lions' den when I eventually start on 1 January.

In many ways it is sad to leave the old NPG but I really couldn't have been Director for thirty-four years there till the age of sixty-five, and frankly I have had a really tough time trying to sustain enthusiasm and interest in the place over the last year or so. And I couldn't stand what it meant to put that new building up – I could have done so a few years ago but not now. It needs someone younger and still full of excitement and not boredom with it ... I shall be Director of the first museum I ever loved as a child, years before the NPG, and what could be more splendid than that and twenty years in which to really make a mark on the place.

11 November. To Jan van Dorsten.

I am now looking forward to the V & A enormously, although Sir John seems rather reluctant to hand it over and the pile of horrors there mount. He was so loathed that certain Keepers won't even go to his farewell dinner. Never since Moses came down from the mount has anything been so optimistically awaited as my arrival ... At any rate I

have great exhibition plans. I am already getting my clutches on the
'Byron' which will be the first one after my arrival and is in a terrible
state. I also plan a major English Gothic show, a Festival of Britain
show, a shock show on the destruction of the English country house...

In the country we are gardening furiously. I pruned a hundred rose-
bushes last week and we have cut into our field two grand walks, one
called Elizabeth Tudor and the other Mary Stuart, both to be poplar
avenues backed by *leylandii* and yew. We love all our fancy names after
our books ... We planted hundreds of bulbs in the wilderness last
weekend so we shall see them carpeting the grass in the springtime.
Eight elm trees had to be felled which had the dreaded Dutch elm
disease. This leaves awful gaps which will never quite be filled in our
lifetime...

How strange it is to read one's planting mistakes! Within a year those
ghastly poplars had to be moved. The close of the year marked the end
of a phase of life. There was a terrible dinner given for John Pope-
Hennessy at the Rembrandt Hotel opposite the V & A, to which I was
bidden, by the heads of department of the V & A. I felt like Daniel in
the lions' den. Neither he nor they wanted it but the ritual was gone
through. It was a grim evening in a dour atmosphere. During dinner
the ceiling above started to leak and water began to trickle down on
to the table. Somehow that was symbolic of much that was to come.

All through these Portrait Gallery years I had been so busy that the
Annual Report, which had been the bane of my life as a lowly junior,
went unwritten. In 1976 a retrospective one appeared and I think I
might be allowed the vanity to quote what my successor John Hayes
wrote of my era:

Dr Strong served the Gallery for fifteen years. As Assistant Keeper he
produced the first of a new type of Gallery catalogue, in which the full
iconography of every sitter in the collection was discussed in detail: his
monumental Tudor and Jacobean Portraits *will always remain funda-*
mental for the work of succeeding scholars in this field. He cared deeply
for everything the Gallery stood for, and brought not only exceptional
energy and flair but a profound sense of dedication to his years as Director.
He revolutionised the permanent display, integrating the collections in
terms of the events in British history; he was determined that the Gallery
should come abreast of contemporary history; he recognised the increas-
ingly important role which photography, hitherto neglected, must play in
the Gallery's acquisition policy; he planned a splendid series of pro-

fessionally designed exhibitions, many of them highly original and adventurous in character; and, through extensive publicity, he made people aware that the Gallery had become a bright new star in the firmament of London's cultural life: he made the Gallery news.

Perhaps the reinvigoration of the National Portrait Gallery will go down as my greatest achievement, the right man in the right place at the right time when the money from Government was still there for things to happen. Only history will tell.

PART TWO

MUSEUM PIECE

1974–1987

1974

Into the Lions' Den

It is difficult to relive the culture shock of arriving in South Kensington on 1 January 1974. Before embarking on any coherent account of the Victoria and Albert Museum as I found it, certain incidents and scenes from these opening weeks still remain vividly logged within my mind. And this kaleidoscope of memory in fact presents a microcosm of what I had moved into. I recall summoning Mrs Oldham, Sir John's retiring secretary, into my office and saying, 'I'll just dictate a few letters.' Mrs Oldham stiffened, gestured to a table between the two windows overlooking Brompton Oratory, and said, 'I can't do shorthand. There is where Sir John typed his letters.' I looked at her and said, 'I've got news for you. Things are going to change around here.' There was no direct telephone line to the Director's office, no daybook, no proper filing system. I had brought my own secretary with me from the Portrait Gallery, something which was much resented. She at least could do shorthand, but the correspondence was huge. She spent her time coping with the telephone, the diary, arranging meetings and logging the unceasing flow of files in and out of the office. The unanswered post began to pile up. I sent for the Museum Superintendent, my administrative right-hand man, and asked him what I should do. 'Why don't you do what your predecessor did?' 'What was that?' I asked. 'You see the drawer there in your desk...?' 'Yes,' I replied. 'That is where Sir John pushed them.' In the end I got a shorthand typist from the pool, but I suddenly realised that I had stepped back into a bureaucratic dark age.

I arrived during the last weeks of the Heath Government. The miners were on strike and there was the three-day week. Lights had to be turned off and my secretary, Margaret Richards, and I sat with night-lights encircling the telephone, struggling to continue to work. Along the corridor the lights were ablaze as a demonstration by a communist member of staff of her solidarity with the workers. I had never encountered such lunacy before. Then came Geoffrey Squire, who had been appointed from the Education to the Textile Department to strike out a new policy for the costume collection, to beg that I would allow

him to return to his former department. He had been a year in Textiles. No one had spoken to him and he couldn't face any more of it. Back to Education he went, but I couldn't help pondering on what kind of atmosphere produced such cruel irrationality.

Sir John, I discovered, was also away a great deal, with an annual springtime American tour and from mid-July to mid-September, bar a few London days, in Italy. How ever did he run the place? Nor will I forget my first Keepers' Meeting when the Keeper of Prints and Drawings, Graham Reynolds (who hadn't got the top job), challenged my authority to my face, or the kindness of Norman Brommelle, Keeper of Conservation, who leaned forward with a sweet smile and said, 'I don't think Graham meant quite that.'

These were the barons, whose attitude to me was summed up by Peter Thornton, Keeper of Woodwork, who narrowed his eyes at me and said, 'You have to earn our respect.' Then there was that tour through the upper galleries where I kept on noticing buckets dotted across the floors collecting the rain seeping through from the roof. How, I thought, could roofs be left unrepaired while untold sums were being spent on redisplaying the collections? And then I claimed a taxi fare. No Director had ever done such a thing before. The salary was £8,500 p.a. and I was the first Director in the Museum's history without a private income. I made it clear that I had no intention of subsidising the place from my own pocket. The idea of 'expenses' or an 'entertainment' budget did not even exist. That was borne in on me when I instituted an after-dinner viewing of the Byron exhibition targeted at donors and lenders who, I discovered, had never been entertained before. Naturally I sent an invitation to the Permanent Secretary of the Department of Education and Science, of which the museum was part. A chilly call from them asked what I was doing giving out free champagne with the taxpayers' money. I replied that one single woman alone out of the guests coming that evening, Mrs Doris Herschorn, was leaving us half-a-million pounds' worth of Elizabethan miniatures. The matter was not raised again, and those miniatures were indeed in due time willed to the Museum.

All these fragments remain firmly entrenched in my mind even after two decades, for they were indicators of what I quickly came to realise – that I had joined an ailing institution. I had been taken in by the façade, the beauty of the exhibits, the stunning quality of its exhibitions (many in fact not V & A ones at all but Arts Council), the seeming vigour of its activities. These had set the pace in the museum world since the V & A reopened after the last war. Sir Leigh Ashton had waved his

wand over the place and it awoke as the first museum really to respond to everything which had happened in American museums. But, by 1974, it was living off its past. Entrenched within it was this deep and fundamental dichotomy between what was in fact its public mask, outgoing to the point where everyone always said to me, 'Oh, I *love* the V & A', and the reality of the face behind, far from joyous but sunk rather in an ocean of petty feuding. It was a view corroborated by my father-in-law, who joined the Museum in 1923. 'How did you survive?' I asked him one day. 'By keeping my head down,' was the reply.

The V & A, along with the Science Museum, stood apart from all the other national collections in being part of a Government Department, that of Education and Science. That had, for example, in the immediate post-war period brought untold advantages, having a direct line into Government denied the others. But it also had a downside, one which was to become progressively more and more apparent as my directorship continued. The Museum had no independence of voice. It had to be subservient to Government, even Sir John bowing to its will over museum entrance charges of which he strongly disapproved, but he never dared publicly to articulate. As a consequence the administrative staff were delegated from the Department. Loyal and hard-working, they were inevitably in the main people the DES wished to offload on to us. When, finally, independence was won in 1984 and the consultants went in I said, 'Don't tell me. They're up there still with abacuses.'

On the whole we were left to get on with it. Terence Hodgkinson, who was shortly to depart to become Director of the Wallace Collection and had been Keeper of Sculpture, besides propping up Leigh Ashton through his more inebriated period as Director, said to me: 'Remember you are absolute. If you decree black is white as from tomorrow that is what it will be.' That advice always worried me, being used to a far more consultative method of running a place, where policies and conclusions were reached by debate, mutual give-and-take, and trust. When I arrived, there were four Keepers' Meetings a year; these were held before meetings of the Museum's Advisory Council, which had few, if any, real powers and was rather a benign assemblage of the Great and the Good. Lord Gibson was Chairman and other members included Sir Denys Lasdun, Lord Clark, Sir Simon Hornby, Sir Steven Runciman, Lady Longford, Lady Hartwell, Lord Rosse and Michael Jaffé.

Under my predecessor, the Keepers' Meetings had consisted of him delivering a monologue for up to an hour, to which they listened with bowed heads and then departed. They were terrified of him and the basis of his rule was fear. It must have formed a marked contrast to

that of John Pope-Hennessy's predecessor, Sir Trenchard Cox. I was
told that he was so nervous of them that only one Keepers' Meeting
had been held during his entire directorship. Whether that be true or
not, I do remember vividly his assistant John Lowe's description of
working in his office, and having literally to force Trenchard Cox to
take a strong line against certain heads of department (like the one who
spent most of the day cataloguing for Sotheby's). John Pope-Hennessy's
policy had been based on divide and rule, playing off the one against
the other. But he made no really major changes. He had been in the
place since the 1930s and to him its structure was immutable. Coming
in from outside, I was quite bewildered and totally unprepared for the
internal hustle. Much of my time was spent trying to create some kind
of structure to carry dialogue right across the Museum. It was an
innovation that was not welcomed. Departments enjoyed their insu-
larity. They did not want to impart information to their junior col-
leagues, for, to a Keeper, information was power. The rivalries between
them could take on horrendous dimensions as they struggled for space,
money and staff. It was a closed, hermetic world. Once within it, it
was all too easy to believe that the fate of mankind hung on decisions
which were in fact positively trivial.

And so the scene was set. I knew too much of what had gone on
earlier in the place not to embark with three principles set in my mind
on which I was immovable, all of which had been violated in times
past. I would have no discrimination based on class, nor would I
discriminate against or for either women or homosexuals. My first year
was to be dominated by lack of money to buy works of art; the Theatre
Museum; what was to be called the Henry Cole Wing; and the exhi-
bition on the fate of the country house.

The Purchase Grant stood at £119,000 for 1974–5. By tradition that
was divided, with the bulk of it in a central fund to be spent on major
works at the Director's discretion and what were called departmental
grants, small amounts which enabled heads of department to acquire
more modest pieces, which were in fact part of the lifeblood of the
place. On arrival I was faced with the possibility of the most stunning
set of purchases, the ravishing ewer and basin which had belonged to
the Genoese Lomellini family, a second ewer and basin, this time
Jacobean and made for Sir Thomas Smith, a superb terracotta bust by
Pajou and, least important of the quartet, a bust of Isaac Ware by
Roubiliac. I am a great believer in going broke if items of great import-
ance are involved, and the only way to demonstrate the pathetic pur-
chasing plight of the Museum was to do precisely that. Every single

penny, including all the departmental grants, was tipped into the pool. The senior Keepers came in delegation to me and told me to my face that I was the most disgraceful Director that they had ever had. I was shaken but unmoved.

The first three items were acquired for a total in the region of £300,000 and I was successful in obtaining a Treasury Special Grant. I went on to get a second, this time for the Elizabethan miniatures belonging to the Earl of Radnor, a set which had descended as a group intact from the sixteenth century, but I had to pledge part of the next year's grant towards them, and I succeeded in getting a third for a Chelsea Chinoiserie Group, one of the key pieces of English eighteenth-century porcelain in the Museum, on the same basis. I failed in my outrageous bid for a Purchase Grant of half-a-million but came away with £289,000. And then came two jokers: Lord and Lady Clapham were two late-seventeenth-century dolls, perfect, with every detail of their dress complete. This time the Treasury wouldn't play ball, so we went to appeal, another novelty, and were successful. As Queen Elizabeth, a supporter of the appeal, wrote to me from Clarence House: 'Someone with the name of Clapham should never leave this country.'

By rights Lord and Lady Clapham should have gone to Bethnal Green which had the bulk of the V & A collection of toys and doll's houses. But as it fell within the domain of the Textile Department they ended up in the Costume Court as two of the Museum's most loved exhibits. Bethnal Green had, in fact, become a dumping ground for a whole mélange of stuff from South Kensington, including its fabulous Rodin sculptures and a collection of wedding dresses. It lacked definition and direction, so in 1974 I decided that it was to be the Bethnal Green Museum of Childhood, a process of transformation which was not to be immediate, largely due to the intransigent attitude of the incumbent member of staff there, but in the end it happened, and the long process of transferring to Bethnal Green the large collection of items connected with childhood began.

Photography had concerned me ever since the Beaton exhibition, after which I had become chairman of the Arts Council's first photographic committee, and I had also encouraged the remarkable Sue Davies to press on with her creation of the Photographers' Gallery. The V & A had, I knew, one of the world's great photographic collections, more by luck than design, for it was a Victorian inheritance and included items like the extraordinary photographs taken by Lady Hawarden. In 1974 these were housed as part of the Library, a pile-up of stuff kept in such a way (as I knew from people who had tried to use it) that it was chaotic.

Here was an area in which to leave a mark, for I was acutely conscious that we were in the last years during which early photographs could be purchased at a reasonable price and gaps in the collection could be filled and, even more, we could move into the contemporary field and make a killing with only a modest budget. And there was a brilliant young man already in the Museum, Mark Haworth-Booth, who was made for the job, so on the understanding that he would be answerable to me, the Department of Prints and Drawings took the collection under its wing.

Then there was the Theatre Museum. Before I arrived a resolution had been reached whereby under Government's aegis the Enthoven Collection of the V & A, the collections of the old British Theatre Museum at Leighton House and the projected Museum of the Performing Arts set up under the inspiration of Richard Buckle were to be amalgamated to create the Theatre Museum. A space had been made for them in the Fine Rooms at Somerset House, a marriage of architecture and artefacts which I found simply incredible, plus the fact that there were no storage facilities. This year we at least appointed a head of the nascent museum, Alexander Schouvaloff, but the fate of that museum was to dog my footsteps from then on.

The V & A already lacked space and now it was faced with all the problems of vast new collections arriving, including hundreds of costumes and items, like Picasso's backcloth for *Le Train Bleu*, whose fate was to be storage. I was told that the Library would run out of space by 1980. What else could one do but resort to what had been done before, and look towards introducing yet another mezzanine, thus destroying one more of the Museum's great Victorian spaces? Mercifully it was never built. Decentralisation seemed to be the key but everyone resisted it. All thoughts in that direction anyway were shortly to be blasted by the economic crisis then looming.

It is odd that this crisis did not already impinge on the museum world. Indeed, quite the opposite. The day after I started at the Museum the Deputy Secretary, Willy Wright, had summoned me to the Arts Office in Belgrave Square and given me the brief I was expected to fulfil. That was to establish an entirely new service for the regions by sweeping away the old Department of Circulation and creating something dynamic and new. I was promised any money and men that I should want. On that basis I began work, little knowing the *renversement* which lay ahead.

Some intimation that the good times had ceased to roll was already evident in the funding for the conversion of what was called the Huxley

Building along Exhibition Road. This was to be evacuated by Imperial College and fall to the V & A and the plan was to use it, renamed the Henry Cole Wing, to display the Indian Collections. In spite of its wonderful encrusted terracotta exterior, the interior was a nightmare, with some rooms only ten feet wide but twenty-four feet high. Its problem was the lack of any link with the main building and gradually during 1974 hopes of that, in the form of a bridge spanning the Aston Webb screen at an upper level, began to vanish.

But, on the whole, much was achieved in difficult circumstances. The introduction of the Craft Shop gave me enormous pleasure. After all, they were only selling what tomorrow, or rather today, the Museum should collect. Pamela Hartwell was busy trying to get her hands on some of the Duchess of Windsor's jewels and I was ready packed to go to Paris when it was all off, the Duchess's lawyer, the dreaded Maître Blum, having lowered the iron curtain. At any rate it saved us the embarrassment as to whether or not to bow and curtsy! I was warned that the Duchess would receive us in a dim, religious light to conceal her decay. Pam was also pursuing the Emery Reves Collection, Impressionists in the main and not really relevant, but that never deterred her. In the end, thankfully, it never came our way. But I loved the energy of the woman, and a weekend at Oving, of which we had many, was always an event to be treasured. Then there was the exhibition, *The Destruction of the Country House 1875–1975*.

This is now recognised as a landmark exhibition, changing people's perception, the first time, as far as I know, that a museum exhibition was an exercise in polemic; it was also the inspiration for Carter Brown's *Treasure Houses of Britain*, which he staged at the National Gallery, Washington, at the opening of the 1980s. Its genesis lay with John Harris and stemmed from the major report on the future of country houses which John Cornforth was then preparing for the Historic House Owners Association. These houses had made an extraordinary recovery in the post-war period but the new Inheritance Taxes and the proposed introduction of a Wealth Tax by the Socialist Government threatened their demise. The V & A never takes kindly to 'outsiders' coming in (which is why, for instance, the great English Gothic exhibition that I wanted happened in the end at the Royal Academy) so that it was quite a battle to get *The Destruction of the Country House* off the ground, which I did by including Peter Thornton, who used it as a vehicle to demonstrate his discoveries on room arrangement, important even if slightly irrelevant. But the driving force was Harris, and Marcus Binney of *Country Life*, who went on shortly afterwards to found SAVE, the

ginger organisation lobbying to preserve the heritage.

The Country House exhibition was produced with passion by us all. Nothing like it had ever been seen before. Robin Wade, the designer, had erected the vast façade of a country house with massive pillars, but it was tumbling down, falling on to the visitor. Each block of masonry was a photograph of one of the thousand homes which had been demolished in this century. In the background a tape conveyed the sound of burning timbers and crashing masonry, while a voice read the names of those houses like a litany. The impact on the public was overwhelming, for they alighted upon it turning a corner, having been wafted along by an opening section on country-house glories. And then they came face to face with this. Many was the time I stood in that exhibition watching the tears stream down the visitors' faces as they battled to come to terms with all that had gone. It was a brave exhibition to mount with a Socialist Government in power and I placed a press embargo on the opening dinner sponsored, like part of the exhibition, by the ever-generous Jack and Drue Heinz. I feared the newspapers caricaturing rich country-house owners quaffing champagne while the Museum pleaded their cause. Simultaneously the message was taken on to the television screen in a programme I made with David Cheshire, *Gone, Going, Going: The Fate of the Country House*. This was a battle bravely fought and in the end won. It was to be the first of the great series of heritage exhibitions which were to stir and form public opinion during these tumultuous, gloomy years when so much seemed at stake.

9 February. To Jan van Dorsten. First impressions of the V & A.

The first three weeks at the V & A were HELL. The dreary Civil Service-ness of it all, the terrible forms, files, signing, the filth, the smell of Jeyes fluid, the dirty loos, all the things I can't stand, but I will change it and I am. Revolutions happening on all sides, but one cannot win the affection of the staff in such a short length of time. My method of working is so radically different from anything that they have ever experienced. I am not daunted, although certain people have tried to daunt me, but I swiped them down, which is the only thing to do. Building programmes have been reordered, exhibition schedules shot around, activities spun into exuberant action. The canvas offers unlimited possibilities, and a few days ago I began to have very good days. There are some very good young people and the point is to draw out their talent, let them have their heads, and we ought to raise the roof within a year or two. I want to get the twentieth century into that place and make it alive and a comment on our times, to make the

Museum symbolise the care of a heritage in all its richness ... I want provocative exhibitions ... happenings in the quadrangle ... huge catalogues to appear, publications to take off...

The exit from the NPG was glorious. There was a party in the Tudor Gallery in the midst of which they wheeled on a trolley with gifts: a huge bay bush, an arbutus (strawberry tree) and two medieval *Rosa gallica* and a plant gift token with which we bought a John Downie crab apple and an Egremont Russet for the field. The garden really is exciting and we are nearing our first spring. Every minute here is precious, particularly after the rush of London and the awful gloom of the energy crises, the dreaded strikes and sinister disruption of society which seems at the moment to be happening. It really has been depressing and life in London gets more and more impossible – traffic, trains, soaring prices, the sheer effort to get anything of any sort done drives one mad.

28 May. To Jan van Dorsten. The Wealth Tax and Byron.

I know only too well the ghastliness of administration. At the V & A it is MOUNTAINOUS! So much time goes on unions, staff delegations, pay claims, warders' conditions, works programmes, frantic appeals for money, terrifying cliff-hanging negotiations with the Treasury, etc. And now, of course, as one thought, one occupies a central position concerning anything happening in England about the Arts and especially all things of historic interest. At the moment there are great controversies over church treasures and demolitions and other scandals. The threatened Wealth and Inheritance Taxes if applied to historic house owners will see ... the end of a thousand years of English history and culture, as pell-mell the contents are unloaded into the saleroom, the houses handed over to the Government or demolished. I can't tell you the horrors looming unless one fights and intrigues at every level behind the scenes.

The opening months of this year, in retrospect, were truly traumatic but I suppose that was to be expected. Now I feel calmer and can at least see them in perspective. I feel a new atmosphere and sparkle grow in the V & A. They are getting used to me. I know it's going to be fun too. *Byron* you must see, half my child but quite a spectacle. Let's hope that it draws the public. We gave a champagne party last night to launch it. This was an innovation and the first time that the V & A had ever made anything of donors, lenders, etc. We did our Mr and Mrs V & A stint very hard and it was worth it.

21 October. *To Jan van Dorsten*. The Destruction of the Country House.

Golly, how I know about compartmentalised museums. The V & A would drive you round the bend. Mercifully one has got to the stage in life where one is simply not going to get hysterical or too exhausted about it, and I put myself first for a change. Any *esprit* in that place is non-existent. They move in their own little worlds, totally uninterested in anything except their own wretched things and little thought for the public. My first major show, *The Destruction of the Country House*, opened amidst salvoes. It is one's first major statement made amidst a blaze of controversy and press and media coverage, a real challenge to those who wish to destroy everything England has created in the last 500 years. They queue to go into the show at weekends, and the book is a bestseller. The run-up and build-up for that was terrific and emotionally exhausting. It has wreaked havoc with getting on with the Walls Lectures [which I had been due to give at the Pierpont Morgan Library in New York that autumn], as indeed did the TV on the same, which dragged me the length and breadth of England through August. The weather has been foul, matching the economic and political situation. Like you, roaring inflation. In the country we till the land, eat our own veg grown from seed, stack high the deep-freeze with the fruits of summer ... it's just like World War II again.

Everything is in the doldrums. It is said that six theatres will close in the West End next year due to lack of money to put on shows. I don't see Julia getting the chance of doing anything at the moment, funds at the National and the opera houses being what they are. Seats at Covent Garden have just hit £9 a go [*sic*, for a seat in the back stalls] which makes one wince. We never go except to see something new. I live in dread of vast slashes to museum spending and facing 1975 with no money, the exhibition schedule in ruins, and the new Oriental wing stopped. The post is now on strike in WC1, so don't write to the British Museum. The Bakerloo and Circle Underground lines are so bad that they might just as well not exist. Sugar and salt are unobtainable. Olive oil, we discovered, has gone up 60% this year, the first of a long list of such rises. We did our winter shop in August, vast mounds of tinned and frozen foods, every sort of candle, matches, oil heater, oil lamp, Calor Gas, the lot. There's no exhibition to see (the big theatre one next year by the Arts Council has just been cancelled due to lack of funds), a Turner show opens at the RA on 12 November. Never mind, keep smiling...

Christmas Eve. To Jan van Dorsten. Farewell to 1974.
The V & A year I suppose ended in a haze of glory in some ways. The
Country House show caused a sensation and in the last week the
Queen, the Queen Mother, Princess Margaret, Lord Mountbatten and
the Ministers for the Environment, Housing and Conservation all came.
Quite a compliment and my BBC 2 TV [*Gone, Going, Going ... The
Fate of the Country House*] goes out on 2 January. So that is that.
Mercifully some of the most persistent opponents of RS are making
their exit from the V & A – too difficult to write about – and the union
problems surrounding the new appointments are truly horrifying. At
the moment I'm preparing an outline script for the *Spirit of the Age*
series, for which I'm doing the period 1500–1630 in fifty minutes flat.
Mainly it's architectural, but it's difficult to find the right locations. At
any rate it takes me away from the ghastly admin. scene. We are beset
with lack of funds and staff. Hideous purchase problems. It is awful to
be spending so much time on this, but these battles behind the scenes
are essential for survival.

I suppose Holland is as gloom-laden as here. It is so difficult to predict
what will happen. English society really seems to stand at a crossroads
and it is incredible how many dodge the issue. It is a very strange period
and worrying in its implications for many things one cares about. I
suppose a bit like the 1830s and '40s again.

*The storm clouds were gathering, the sky was darkening, but the rain
and, even more, the thunder and lightning lay ahead. I was not to wait
long for it.*

1975

Stormy Weather

The storm warnings did not take long to appear. On 23 January Lord Gibson, chairman of the Museum's Advisory Council, asked me to lunch at Pruniers and told me that the times were such that he had henceforth to give his whole attention to managing the Pearson empire, and no longer had the spare capacity to carry on with a role which was merely advisory. That was a blow. Pat Gibson then went on to say that he had persuaded another member of the Council, Lord Hood, to take over. Pat is usually nothing other than shrewd but in retrospect this was not to rank among his wisest moves, for it landed me with a chairman who had no fight in him. But I really had no choice. Sammy Hood was a delightful, lackadaisical English aristocrat, made for fair weather but hating even the sign of a squall. When a storm broke, as, in the end, it did, he ran for shelter.

This was a weird year. All the evidence suggested that the country was in a parlous financial state as inflation roared away, but in some areas cash continued to be scattered as in times past, while in others it suddenly dried up. There was no particular logic to the ebb and flow as yet. That was to come. The bad sign was that there was to be no Supplementary Vote allowed that year. These had become the norm to meet the demands resulting from inflation. A 40 per cent increase in postal, telephone and transport services had now to be met within our existing budget, but from where? In May the amount for the Henry Cole Wing was slashed from £2 million to £1.3, and along with it went the new restaurant and any substantial link block with the main building. None the less I clung on to some kind of corridor being built joining the two, even if it was only a covered way, otherwise the place would have been inoperable. And, although we were able to get the Theatre Museum out of the Fine Rooms at Somerset House (a ludicrous inheritance) and into the old Flower Market in Covent Garden, we were now told that there was no chance of opening it before 1979. Depression began to set in.

On the other hand, money became available for embarking on restoring the Museum as an exhibit in its own right. This began with the

restoration of the Old Refreshment Rooms, the earliest cafeteria in any museum in the world, with its glorious walls of Minton tiles (acoustically horrendous as I was soon to find out) and into which we added Alfred Stevens's magnificent fireplace from Dorchester House. The brick, terracotta and mosaic of the quadrangle was cleaned, starting a programme which was only to reach fruition under my successor when the exterior Brompton Road façade was at last cleaned.

And 1975 was a good year for acquisitions as my luck continued to hold. An anonymous millionaire came to see me wanting to give a substantial gift to the Museum on the condition that we took, along with it, a collection of Victorian musical boxes, which we did. He then proceeded to pay £250,000 for the Croome Court Library Room designed by Robert Adam and executed by the royal cabinet-makers, Vile & Cobb. On the death of the collector Mrs Doris Herschorn came her magnificent bouquet of Elizabethan miniatures, including ones by Nicholas Hilliard of Elizabeth I and Mary Queen of Scots. Joan Evans then decided to give us her collection of jewellery, some two hundred and fifty pieces ranging from the thirteenth to the nineteenth century. The first woman president of the Society of Antiquaries, Joan's life had been blighted by academic misogyny. I worked away to get her a gong and mercifully she was 'damed' shortly before she died, but the citation was for her charity work, which was really rather shocking. Then there was Donatello's *Chellini Madonna*. If my directorship is to be remembered for nothing else I would be happy for it to be associated with raising the money to save that one sublime piece of Renaissance sculpture for the nation.

The real task of the year was setting about creating the new Department of Regional Services, which had been my mandate from the Arts Office on appointment. There was not so much as a whimper as yet to suggest that the promised cornucopia of cash and manpower would not come my way. Quite the contrary, as £30,000 was proffered to set up a major exhibition for the regions to be held in two venues, but not in London. Much labour went into consulting regional museums and galleries and also the art colleges. And all of this reached a climax in June when I went public with our intentions at the annual Museums Association conference at Durham. Internally the creation of this new service had been a source of never-ending blood-letting which, had I known what was to be its fate, I would never have embarked upon in the first place.

But the sun did continue to shine, even if fitfully. The early months included filming for the BBC series *Spirit of the Age* under the aegis

of John Drummond. I covered the Tudors and early Stuarts and the programme, when eventually it was screened in the autumn, was well-liked, Michael Ratcliffe of *The Times* writing: '... Roy Strong stared down his nose at it [the camera] like a court official. Disconcerting at first, the grave tenacity of his approach is quite compulsive.' But I cherish most John Betjeman's postcard to me: 'It was like a great psalm in colour and sound.'

The age of festival had not quite vanished. Every evening in London was crammed with one or two social events. But the great spectacle of the year was the ball at Boughton on 12 July. We had the misfortune of our car breaking down and so arrived late, but the sight of that magical house floodlit, with vast fountains (courtesy of the local fire brigade) soaring up from the lake into the night sky, was one never to be forgotten. The Buccleuch tiara had started its life as a diamond belt and Jane Buccleuch had fasted herself into wearing it as it was originally intended. Occasions like this showed the stately homes of England putting on their brave face. If they were going to go under they would at least do so in style. My diary begins again in earnest on 20 September.

7 April. To Jan van Dorsten. Settling in and rabbits.
Nothing like a trip to the New World to restore the ravaged ego. We have just returned from four days in Canada and hideous snowstorms which made the journey home a nightmare. The expedition was for the launching of *High Victorian Design* at the National Gallery and Miss Oman and yours truly duly lectured to a substantial audience and there were the usual *fêtes* and speech-making. Glorious to be back and the spring early ... in spite of cold and frost, spring flowers, daffodils and primroses, scillas and hyacinths, carpet the glades, pretty beyond belief. I'm really rather enjoying this year after the horrors of last and getting an even firmer grip on the place, making my own strides forward and just letting everyone scream. God knows it needs it. I resign myself to the fact that it's not cosy and it's all gossip and intrigue and you just have to beat them at it ... We are not moving around much, except to Germany in late May for an official visit and to The Laskett for the whole of August and a bit of September. There are odd visits to chair conferences in Oxford, speeches in Durham, Bristol, York, etc., but nothing serious. It all takes so long, all this theorising and promoting of the museum philosophy, the museum idea, the museum crisis, all the usual controversial bits.

The garden stands poised and about to sprout, shortly to be coerced by Dr S's hand laying fertiliser on thick. Plagues of rabbits threaten the

future of the Rose Garden, squadrons of fat, beastly pigeons rip up plants for fun, and the rabbits have even learned to eat huge holes in our plastic netting and go through to gobble up our cabbages. I have gone mad in the Yew Garden and dug more beds with box hedging and pyramids and grey santolina. This year I mean to be tranquil. I'm tired of all the rushing and pushing and publishing and long to see my plants grow and sit under my vine.

Undated but probably June or July. To Jan van Dorsten. Heritage in danger.

Even though everything else in Britain is ghastly, the weather has been undiluted sunshine for weeks (not doing the garden any good though). I haven't touched research. I have been involved in speech-writing, vast administrative changes at the V & A with appalling scenes and hideous union trouble, and getting myself together to appear before the House of Commons Select Committee on the Wealth Tax. We've all gone mad here and I do hope we're not in 1640 waiting for 1642 but it feels like it. It is not helped by losing friends at 51 and other sadnesses. I feel glimmers of light – a museum assistant has been appointed to my office, a typist is promised and a filing clerk – all the result of an investigation. I'll win through. At the moment the heritage of Britain through the V & A comes first and everything else comes a long way back.

20 September. Eighteen months on at the V & A.

It has been a very tough eighteen months. I succeeded on a wave of optimism: the Pope had gone with his remote autocratic ways and ruthlessness to the staff. But it was a wave based on the notion that now he's gone we can all carry on as we did under Trenchard Cox and not be interfered with any more and certainly not directed. The whole set-up was archaic from the moment I arrived. It has taken me almost a year to create an efficient, loyal team around me. A streamlined office is essential. Now, eighteen months later, it is almost there. I move soon into the old boardroom redone as a committee/sitting/desk area. The room is pleasant, light and airy, and looks down on to the garden of Brompton Oratory with its calming grass and trees. It is being redecorated economically because questions have been asked in the House about Higher Civil Servants' accommodation! Everything I've chosen is, therefore, of British design and manufacture. The existing Director's office will divide to form areas for my secretary, typist, a museum assistant and an office for my right-hand-man, John Physick.

Everything at last begins to work: files are up to date and in order, there's a direct telephone line, I can dictate letters whenever I have five minutes and I have my entourage to hand. But what a ghastly battle to achieve it! It sounds so simple, but how can one achieve efficiency let alone implement policy when the machinery is not there.

Terence Hodgkinson suggested even before I arrived that I should make John Physick my personal assistant. I owe him a great debt. Eighteen months on he is Keeper of Museum Services and has proved the greatest bonus so far. It was a tentative relationship at first. I don't think that anyone there had been used to openness, critical thought, free interchange, utter confidence one in the other, undeviousness, let alone a bit of fun. He has his ear to the ground, has an unerring sense of rightness and of the history and mission of the institution.

But of all the battles those with the unions have been the most unbelievable. It has been a very hard ride. Under the Pope they were quiescent. Now in the hands of certain younger members of the curatorial staff they have become absolute HELL. Their great objective is to achieve a union closed shop. There is to be, in their view, no recruitment from outside except at the very lowest levels, otherwise Buggins' turn all the way. Above all there must be no changes, no new broom, no new ideas. The Director, in short, is there to follow the policy laid down by the unions. It has been total confrontation all the way and, if lost, the Director would be reduced to being merely a cipher of the unions. They were furious that the Keepership of Prints and Drawings was taken to open competition, although the wind was taken out of their sails when the internal candidate was appointed. They fulminated over the creation of the Department of Museum Services but how much better it is than the old one of Public Relations, drawing together under its wing a new alliance of slides and photography, press and information, exhibitions and design. They went mad over the creation of a Department of Education and Regional Services by merging Education and Circulation. The relationship of these two areas as branches of services to the community is so obvious that I cannot grasp the stupidity of the opposition.

We must now begin slowly to move positively on acquiring post-1920 artefacts or else the V & A will be a laughing-stock. The transference of emphasis on this task away from the old Circulation Department to the main curatorial ones is essential because otherwise Circulation will succeed, as it has tried to, in turning itself into a Department of Contemporary Art. Everything there has got fossilised: the design is static, the exhibitions haphazard, there's no follow-through and there's

a 'That's what you can have whether you like it or not' attitude. We must alter this. With the tremendous changes happening in Britain we must be a spearhead. People are crying out for art and information, often on a broader, less literate level than a century ago. We must pick this up and not look down our noses at it. The Regional Arts Councils are beating us already. The success of the Museum depends in a real way on demonstrating the classlessness and relevance of all art past and present. Art history and museology have got such a death-grip that any form of educational attachment is howled down as spoon-feeding! SPOON-FEEDING, when 90% of the population still think Botticelli is a brand of Chianti!

8 October. Intrigues for a new Minister.

There are intrigues going on for the replacement of Hugh Jenkins [Minister for the Arts], thank God. The man is an idiot, dangerous and dim. Harold Lever[1] has been appointed as someone to raise money for the Arts. Joanna Drew rang me. Did I know of a good up-front Labour lady? All I could think of was Shirley Williams and Shirley Summerskill, useless ideas. Joanna mentioned Alma Birk,[2] who would, of course, be marvellous and I urged her to push that idea. Let's hope.

13 October. David Eccles.

We dined with Polly Lansdowne, who lives in a pretty flat in Warwick Square. The others were John Cornforth and the Eccleses. David now very much assumes the role of the grand old man and held forth. The present divisiveness of society was, in his view, worse because it was between the literate and the illiterate. The Roman Empire had been united in its morals and aims up until the governing classes learned Greek. Then it divided itself off from the proletariat and, as a consequence, destroyed itself. Education, he said, was far more divisive than class. He admitted that he was to a degree culpable for this happening because, back in the forties, education seemed a necessary panacea. But, in fact it wasn't. Education was useless without character-moulding, which was far more important. Now there were no morals, ideas, or leaders for that matter, who were able to reunite what had become a fragmented society.

He was very pro Mrs Thatcher. He also said that he was responsible for Roy Shaw becoming Secretary-General of the Arts Council. He had

[1] Millionaire Labour front-bench spokesman for the arts. Created a life peer in 1979.
[2] Under-secretary of State, Department of the Environment. Created a life peer in 1967.

told Pat Gibson, when asked, that there was a need there for someone with an education background – workers' education – Shaw was the man. The interview, like others he said (the V & A?), had to be organised to ensure that Shaw got the job, particularly as the arts broadcaster Huw Wheldon was after it.

This autumn there was a great international conference at Ditchley on the future of museums. The directors flew in from all over the globe. John Pope-Hennessy was in charge of the British end and made his hostility to me apparent by inviting one of the V & A's heads of department as a deliberate snub. The colleague at least had the loyalty to decline the invitation. The assistant Pope-Hennessy used at the British Museum later told me that he had said, 'I'm deliberately not asking Roy Strong and I want him to know.' I have never discovered quite why there was this violent volte-face, although by then it was clear that I was not going to run the V & A as a branch of the British Museum.

19 October. The rift with John Pope-Hennessy.
Eight weeks before the Ditchley Conference we asked John Pope-Hennessy to dine with us after his lecture on Luca della Robbia at the V & A. He refused. The day of the lecture was yesterday. He came, we had drinks before the lecture and I gave him a glowing introduction and, after, we parted and went our separate ways. That evening we happened to have been asked to dinner by the German cultural attaché to meet the directors of the Künsthalle, Hamburg, and of Düsseldorf, who were both attending the conference. As we arrived we just missed the lift going up, but I caught an all too familiar screech emitting from it as it ascended. It was the Pope. Neither of us batted an eyelid but it was a gruesome evening, the six of us huddled around a small table with poor Birgitte Lohmeyer, the attaché, wholly ignorant of the cross-currents flying around. The magic moment came. The Hamburg director turned to me and said, 'We see you at Ditchley tomorrow?' to which I replied, 'What is Ditchley?' Pope-Hennessy now goes high on my list as one of the most calculating men I have ever encountered and someone to be avoided at all costs.

This week I decided to make a move towards creating a body of V & A benefactors and also began to think about creating a separate Department of Costume, detaching the whole collection from the moribund Textile Department. Someone in the place is still ringing up

the *Guardian* and *Private Eye* slurring the Director with any piece of garbled fiction which they can lay their hands on.

22 October. The all-party Heritage Group.
I went down to address the new all-party Heritage Group in the House, about ten of them in all, although Peter Walker and Lord [Geoffrey] Lloyd sat in to hear me. They seemed a dim lot, the Chairman, Ted Graham, is MP for Edmonton. From the moment you see him you know he probably wouldn't be able to tell a Rembrandt from a Picasso. The moving force is a Tory MP, Patrick Cormack, amiable, owl-like. Sir David Renton, an old Tory country gent, enunciated attitudes enough to drive one very far Left. Alan Beith, the young Liberal, ex-University of Newcastle lecturer in politics, showed a flicker at thirty-two. Really I wondered what use it had all been. They are such fringe people with no real influence up the line. I gave them the usual mix with a strong plea to keep art museums out of politics. It was depressing and the food was filthy.

Beaton had suffered a stroke which affected his right side. I remember going to see him shortly after he came out of hospital. Recalling his remark, that white flowers were the only chic ones, I arrived with armloads of white blossoms to cheer him. But he was a pathetic figure, having lost the use of most of his right side and prone easily to give way to tears.

23 October. Cecil Beaton after the stroke.
We drove down via Reddish, Sherborne Castle and Montacute to Bristol, where I gave the Hans Schubart Memorial Lecture. It was one of those glorious autumn days with marvellous colour, the sky and light brilliant. At Reddish the front door was opened by Eileen [Hose] and the first thing I saw was a clutter of tables and chairs and then I realised that Pelham Place had arrived. In the hall stood Cecil's London dining-room table and chairs which really looked quite out of place. In spite of a sale of vases, lamps and books to local dealers, much still remained including an attic stuffed with racks of pictures. Richard Buckle had the metalwork four-poster and Alan Tagg a load of tables, but it still looked wildly over-furnished.

Cecil didn't look as well as I remembered him in the summer. He had quite given up any attempt to reactivate his right hand in the hopes of a return to normality. Now there was, for the first time, an acceptance. One sensed the financial stress, hardly surprising really

with no money coming in and all of this to keep going. The wide herbaceous borders were to be grassed over and further areas of grass were to be left uncut. Everywhere one sensed retrenchment. Eileen admitted that she felt imprisoned. Officially she is supposed to get a day a week off but often she fails to. She is a wife *manqué* and does absolutely everything, shuttling between Cecil and her own 82-year-old mother who is also geriatric and forgetful.

Cecil pulls himself together for a front, but in off-moments he looks old and pathetic. The glimpse of him wearing a green cape-coat and a brown velvet cap waiting to go into the garden I'll never forget. He stood there, a furrowed, tragic bundle. Volume eight of the diaries is imminent. At least he doesn't break into sobs any more, but he can't deal with any complex conversation. I wonder how much Eileen has done on those diaries. One sensed the end of an era.

30 October. In Vogue *and James Laver.*

I went to see my episode of the TV *Spirit of the Age* series, which was considerably better than anything else of this kind I had done. In the evening we went to the launching of Georgina Howell's book *In Vogue* in the Orangery in Holland Park. Typically I glimpsed Beatrix Miller fleeing from the party as we arrived. Diana Cooper, at eighty-three, stunning in a huge brown hat and trouser suit. We had seen her earlier at the preview of my television film and we discussed Cecil: 'I'd like to kill him', she said, 'rather than see him in his present state.'

Ossie Clarke appeared, thin, ravaged and rather pathetic, I thought. Divorce proceedings with Celia Birtwell were in train although he still loved her and the children. He smelt of pot and seemed a tragic figure from the sixties, once so brilliant and now so battered. Perhaps all he will be remembered for is being the man in David Hockney's picture in the Tate, which now seems a reflection of a vanished idyll.

This week there was a memorial meeting for James Laver held in the Raphael Cartoon Court to which about two hundred came. He had been at the V & A for thirty-seven years and left when he didn't succeed Leigh Ashton as Director, something which I had not realised before. I knew him only very slightly. He produced two books a year from sixty on and what a lot of rubbish most of it was. Sad to see someone with so much charm, wit, urbanity and creativity degenerate into a hack. He needed the money, I suppose. He went into a sharp decline after his wife's death. She was scalded in the bath. After that he seemed two feet shorter and drank an awful lot. What a figure he must have once cut in the Museum in Prints and Drawings when Gertie Lawrence was

in his play *Nymph Errant*. I must read his memoirs, *Museum Piece*, some time, about which the *Times* critic wrote that it was like someone coming for tea and staying a month.

November. The Chellini Madonna.

This was undoubtedly the greatest single work of art to enter the V & A during my entire directorship, perhaps, it has been written, during the entire century: a bronze roundel by Donatello made in 1456 but thought lost. All I give below is what I wrote at the time.

The story of the *Chellini Madonna* is said to have started at Milton, the family home of the Earls Fitzwilliam, with the present Earl and his stepdaughter (Lizzie Hastings, wife of the MP) playing tiddly-winks. He expressed a wish to give her a wedding present and she indicated an interest in a bronze dish, which he promptly gave her. She later worked at Christie's and kept it on her desk for pins. No one recognised what it was but it interested David Carritt who mentioned it at dinner to John Pope-Hennessy who obviously twigged that it could be the missing roundel and suggested that it be brought to the V & A. That was in 1962. It was indeed brought in but on a day that he was not there. Everyone recognised it immediately. So did Pope-Hennessy, who confirmed the identification the next day, and Mrs Hastings was asked to give the V & A first refusal should she ever decide to sell. She didn't want to and popped it into her handbag and left.

Thirteen years pass and this is where the story gets doubtful. In the first place it was never offered to the V & A (Mrs Hastings said it should have been), which in the meantime had valued it at £250,000 and placed it second on their list of desiderata, next to the Academy's Michelangelo tondo. In the end Mrs Hastings needed the money and at this point Artemis enter the scenario, the London end of which is David Carritt and the American, Eugene Thaw. It seems that by one or the other of them she was persuaded to part with it. It was to be exported to the USA and go to the Frick Collection. This I did not know. All I was told from July on was that a Donatello was in the offing. An export licence had been applied for in which it was described as 'a bronze dish by Donatello' and the price given as £150,000. This suggests that although the description was meant to be 'accurate' it was meaningless, and therefore the object would slip through, particularly as the application arrived in the V & A on a Saturday morning in August when everyone was away. The friendship between John Pope-Hennessy and the Director of the Frick, Everitt Fahy, is too well known to be ignored and you

don't tell me Everitt didn't tell John, the Donatello authority. At any rate it came up before the Reviewing Committee on 11 November and was stopped and promptly offered to the V & A for £175,000. Because of the low figure put on the export application form the vendors dare not put it any higher for the Museum, although if it had ever got to America the price would have been hugely more. None the less it's high enough as far as we're concerned and the only way forward is to launch an appeal.

We did and it was successful. The roundel now occupies a key position in the V & A's Renaissance galleries.

18 November. Bridget D'Oyly Carte.

I took Dame Bridget D'Oyly Carte, a lively and distinguished lady, out to lunch to celebrate the gift of things to the Theatre Museum. She was fascinating on the subject of Harold Wilson [the Prime Minister] who was now a Trustee of the Company and had been asked to their hundredth anniversary at the Savoy Theatre. He loved it, made a speech on stage and now she needed him to help save the Company. So he keeps on ringing her up, much to her embarrassment, denouncing the élitism of Covent Garden as against the populism of Gilbert and Sullivan.

11 November. The State Opening of Parliament.

We sat in the Strangers' Gallery. Nothing surely could strike a more discordant or archaic note than this ritual. Pressing our way through the Lords one glimpsed through a doorway the peeresses assembling. What a sight! Eleven in the morning and in full evening dress, mostly of terrifying design and rarely fitting, their hair enmeshed into tiaras. Looking down from the gallery one meditated. It all seemed so out of key: in the centre serried ranks of peers in crimson with white fur, while, on the benches on either side, sat the peeresses twinkling away with diamonds, the only chic one Irene Astor in a sheath of plain purple, her piled-up hair held in by a small circlet of diamonds.

To our right sat Mrs Kenward, 'Jennifer', the social diarist, wearing a turquoise coat, diamond brooch and ostrich-feather hat, her face buried beneath powder. To our left were Gillian Wagner[1] and Denis Thatcher,[2]

[1] Gillian Wagner, wife of Sir Anthony Wagner, Garter King of Arms, distinguished for her chairmanship of Dr Barnardo's. DBE, 1994.

[2] Businessman and husband of Margaret Thatcher, at the time Leader of the Opposition. Created a baronet, 1991.

Mrs Carpenter, the wife of the Dean of Westminster, with her family, and behind the Duchess of Roxburghe. I discussed the scene with Gillian, who said that Princess Anne's wedding was the last occasion when all this seemed still to work. Everything since had seemed not to be quite right. Even the heralds were in difficulties. Their tabards cost £1,000 each and they had to be 'dressed', that is tied into their costume by a squad of men from Ede & Ravenscroft. Making their living by fees, they couldn't afford it.

Everything worked like clockwork. At 11.27 a.m. precisely the lights dimmed and the great candelabra on either side of the throne came on. The House rose and a cavalcade entered at both doors, a cascade of heralds, mace-bearers, court and crown officials, all taking up their places in a huge tableau like a waxworks. The Queen entered in white, the crown glinting with myriads of diamonds, her vast crimson velvet train borne by four pageboys, then followed the Duke of Edinburgh, the Prince of Wales and Princess Anne, wearing white. They sat down and arranged themselves in attitudes, the Duke and Prince resting their hands on their swords. Behind Princess Anne stood the Mistress of the Robes, the Lady of the Bedchamber, and one other in white and diamonds, and Captain Mark Phillips. Already in the House were the Duke and Duchess of Kent, the Duke of Gloucester and Lord Snowdon, but no Princess Margaret.

A long silence followed which seemed to last for ever as the House of Commons was summoned by Black Rod in Waiting. Then the Chancellor approached the throne, knelt, and presented the Queen with her speech. She read it in a clear voice but she sounded tired and the crown clearly weighed heavily on her. The motions were often very Left, which made the whole scene seem even more bizarre as they all sat there *en grand tenue* listening to measures designed to reduce them. This was Byzantine splendour. The speech over, the procession re-formed and swept out. One could take most of it but those peeresses in diamonds really ought to be stopped.

Paris, Versailles and Princess Margaret.

20 November.

We were in Paris for five days so that I could deliver the Churchill Memorial Lecture to the moribund Association France-Grande-Bretagne. We were in fact catching Edward and Gill Tomkins at the Embassy before they moved out next week to make way for the Hendersons. On arrival we were told that HRH Margaret and Colin Tennant

would come on Saturday to see the exhibition of Scythian Gold and for a visit to Versailles.

Edward Tomkins was extremely interesting on the state of Britain. Once, he said, we were the envy of Europe for our stability, our ability for evolution as against revolution. Now we were viewed as drifting. We were in a revolutionary state, a fragmented society of warring factions. He was adamant that inflation had heightened the situation but not caused it. Prosperity had covered it up, but poverty had now lifted the veil and the divisions, there all the time, had taken on a new sharpness. The basis of our society had gone. What kind of society did we want anyway, a meritocracy like Germany or a mixture like France? No one had made up their minds, so we looked feeble as we drifted and were dictated to by a handful of trade unionists. Possessions had corrupted. To possess had become the only measure of our society, therefore for all to possess, some had to be ruined, but everyone in the end would also be ruined. The speculators of the early seventies had brought money and 'get rich' into disrepute. Education was a disaster. Public-school education was the worst of all and should be stopped, although the option of private education should be maintained. He did not foresee a collapse of Government, but a moment would come when the majority would refuse to carry out the will of the small minority. Education alone could change things.

24 November.

Many calls to London about the Donatello. We had hoped to raise the money by doing a limited edition of casts from the roundel but Thaw, the dealer, wouldn't allow us [in the end he did]. Nothing, I discovered, had been done by the Arts Office to get us any form of Special Grant. Needing a question in the House, I got on to Hugh Leggatt to fix one. The *Sunday Times* wanted to disgorge more on the history of the Donatello. In the evening my lecture was a disaster and lasted two hours. A hideous day.

25 November.

Princess Margaret and Colin Tennant arrived, HRH in beaming mood, slimmer and wearing quite a weight of make-up, her thin hair heavily back-combed. She addresses rather than speaks to you, but she revels in tough conversation and anecdotes. She is, as we all know, tiresome, spoilt, idle and irritating. She had just come back from Australia which she hated and, worse, it rained. Colin said that it would surely be her last visit. The traffic lights were not even cancelled any more and there

was no escort for her, and no crowds either. Imagine the effect of that, he said, on someone who had known and expected all of those things. She smokes non-stop. In the evening we toured the Scythian Gold show and there was a dinner for forty-two at the Embassy. We went to bed at 1.15 a.m. much to our relief as we'd all expected to be up until 4 a.m. That evening she really looked rather marvellous in floor-length dark turquoise velvet with a string of diamonds close to her neck. How those royals must meditate on the vanishing magic. Colin Tennant said what did one expect of HRH? She had been deliberately brought up as the younger sister, not to be competition, taught only to dance and sing and that was that. She had been the first one to break out of the charmed circle and now it all seems against her. She has no direction, no overriding interest. All she now likes is *la jeunesse dorée* and Young Men.

26 November.

We assembled at midday and left for Versailles, HRH in purring mood, wrapped in mink and carrying practical walkabout shoes for the palace. Gill and I travelled in the back of the Rolls. At Versailles we were ushered into the apartment of M. and M. van der Kemp. He is the Conservateur en Chef and his wife Florence is an American, rich jet-set type from an earlier era. Monsieur van der Kemp is huge and grandiloquent and really thinks that he is Louis XIV but minus the wig. They represent money and smart/rich-set links to raise funds for Versailles, which he has done splendidly. Their apartment was over-decorated in the French *grande manière*, dark colours, hundreds of bibelots, candles ablaze even although it was midday, everything arranged on tables in patterns and an overall sense of the stifling. There was a ghastly lunch with a sprinkling of aristocracy. I sat next to the Duchesse de Rochefoucauld, who was caked in make-up and ate with her mouth open, was half-American, and of a selfish boredom enough to make me yearn for 1789.

After, there was a long tour through miles of rooms followed by a drive through the gardens to the Petit Trianon. Colin Tennant kept complaining the whole time how awful the lunch had been with men sitting next to each other and how he had been placed as a servant the night before next to HRH's detective.

In the evening there was a crashingly dull dinner to which the *Times* correspondent and wife came. It was agony. After dinner we sat and sat and sat. HRH and Colin wanted to go dancing but nothing in the end happened. All the time HRH slugged through the whisky and sodas.

She loved her house in Mustique, she told me. Oliver Messel had designed it for her, that is the outside, but she had done the inside. It was comfortable, modern, built on a promontory and surrounded by the sea. She lit up as she spoke about it. I said that I thought that she had a cottage at Nymans, but, no, that was Tony's. She then suddenly raved on about him. She had returned from Australia to find that he'd nearly driven away the chauffeur, he'd upset the nanny, he went away for weekends she didn't know where and she didn't know his friends or anything. It was bitter and sad. She looked lonely and soured by it all. But she'd enjoyed her day. It was 'lovely', as she would say in that slightly explosive drawl which indicated that she really had. She went to bed about midnight, glazed but happy, blowing kisses to us and promising reunions. On Monday Gill put her on the plane after she had bought £50 of *pâté de foie gras* and a £30 suitcase.

8 December. To Jan van Dorsten. Farewell to 1975.

Life has been hectic as always, with mammoth problems. One is the appeal to raise £175,000 to save a Donatello bronze which is almost finishing me. We have had a hectic four weeks with me doing no less than four major public appearances including the Winston Churchill Memorial Lecture in Paris. There we had a happy five days in the cold, but with brilliant sunshine, staying in the Embassy before the Tomkins family finally decamp. We had magical visits to Versailles and to Fontainebleau, which I had never seen and is essential for the Renaissance as you know. Not even having to cope with Princess Margaret the whole time marred our stay! Sir John Pope-Hennessy has taken violently against me, so I was deliberately excluded from the international symposium on museums held at Ditchley, but that is a saga of horror to tell you when we meet. In fact it was a good thing as it united the museum around me.

Life in England is full of so many problems. But the country offers hope and a peace which is important. Julia is deep into her new ballet for Covent Garden [*A Month in the Country*] and producing the most wonderful designs – quite extraordinary and romantic. We may have to go to Russia in May in the interests of détente but one can never get an answer from them! Nothing seems straightforward any more. Life in the museum is just as complex due to a million factors but better than last year because at least you know the hazards and the monsters.

I now know that the Country House show profoundly influenced the Government in respect of the Wealth Tax, so 1974 did achieve something. I put your tulips into the formal Yew Garden around the

stone urns and into the box-edged beds. They will look very seventeenth century in the spring ... in the meantime Christmas greetings and a Happy New Year amidst the gloom.

1976

Disaster Strikes

If I had to choose one year in my life which I would never wish to relive this would be it. That may not be so apparent from the diaries which kept, in the main, to their social domain, but some of the anguish seeps through in the letters to my Dutch friend. What happened took the most terrible physical, emotional, and intellectual toll of me. The golden boy was seen suddenly to be made seemingly of lead. The initial years at the V & A had been hard enough but I had through them the backing of Government, evidenced in promises of men and money to start a whole new department, besides the long series of Special Grants which had helped to acquire masterpieces for the nation. Now all of this was to go into reverse, and I was left alone, surrounded, it seemed, on all sides by a sea of troubles.

These began early in the year when I was summoned, together with Margaret Weston, Director of the Science Museum, which was the only other departmental one, to the DES. The meeting was of representatives of the entire Department. It was confidential. No one was to be told what happened there, which was a request that we were to do an exercise as to how we would cut our staff by up to 25 per cent. Both museum Directors were dispensed with quite early in the meeting as though we were irrelevant appendages. As far as the DES was concerned, we were. I came back to the V & A with my world shattered.

All through the summer months I had to work, cloaked in a blanket of secrecy, on that exercise with my senior administrative staff. Although even by the March meeting of the Advisory Council it was clear that some form of major surgery was the only way forward, we investigated every other avenue including, for example, handing over to the National Trust the two historic houses we ran, Ham House and Osterley Park House, but the Trust firmly rejected the proposal. Not a word was leaked to my colleagues, which in effect meant that I was living a lie, for I had to go on as though nothing had happened, in particular as though the new service to the regions, which had just been created and for which I had been promised every resource by Government, was going ahead.

It was not until the early autumn, after much heart-searching, that I reached the conclusion that those demands could only be met by shutting down a service which was over a century old. That decision, when it became public, was to be bitterly opposed by the Museum's unions. They demanded that there be equal misery for all ranks across the board. The decision to amputate I had reached on two counts. To me, knowledge and scholarship have always been sacrosanct. To destroy either in the great curatorial departments would be an act of vandalism for which I would never be able to forgive myself. An exhibition service to the regions could after all be done by another institution if the worst came to the worst. But I was aware that there was political mileage in it, that to close our service to the regions would throw the gauntlet down to a Socialist Government, for it would cut off something which had been the lifeblood of regional museums and galleries. If any threatened gesture would be likely to lead to a reprieve, this would be the one. It was playing for high stakes and in the end I lost, but looking back at it and in view of the Museum's subsequent fortunes I consider that my decision was not only brave but correct. It was not a view shared by senior staff at the time or, for that matter, by the majority of the Museum, but it was understood later when Mrs Thatcher renewed her decimation of the Civil Service.

What was so appalling was the utter hypocrisy of it all on Government's side. Because the V & A and the Science Museum were, alone of the national collections, part of Government, they alone were cut. None of the others. The motive behind this barbarity was that the size of the Civil Service had to be seen to diminish. It was not a decision in any way connected with money. In fact I remember that the day after I made this move public Willy Wright, still Deputy Secretary in the Arts Office, rang me and said would I like £100,000? That amount would have saved us in staff terms but it was the money that was offered, not the men. The V & A, not over-manned in the first place, has never really recovered from that blow delivered by the DES in 1976. What it established in my mind was that the historic link of the Museum to the Department was a fatal one, an accident of history which must now be brought to an end. I swore that if it was the last thing I did I would achieve that severance to ensure that never again would there be a repetition of such a ghastly scenario.

So support from on high had suddenly been taken from me. But it was the consequences of this which were so devastating, for that act inevitably would have a traumatic effect on the staff, who were naturally more prone to blame the Director than to grasp the wider strategy,

of which we were the hapless victims. Simultaneously the opposition to the new-broom directorship, which had found expression in unpleasant needling of me by way of the newspapers, now reached a crescendo. A young journalist called Liz Forgan, later to become head of BBC Radio, gained access to my office by saying that she wished to interview me about the Museum. I recall her sitting down, crossing her legs, and then looking at me and saying, 'Your staff don't like you, do they?' I could either have thrown her out or continued with the interview. I took the latter course, as I had nothing to hide. But it inaugurated a long period of hostility by the media which didn't finally vanish until the middle eighties. In view of what happened to my successor I suppose I have no reason to complain, but for someone who is essentially vulnerable it chipped away and was, above all, debilitating during a period of extreme stress.

On 2 November the entire staff of the Museum was gathered into the Raphael Cartoon Court. I entered from the English Primary Galleries down the stairs and stood upon them high enough to be seen and heard by everyone. I then read out what was to happen, my voice choked with emotion and the tears welling. Every member of staff was then handed a copy of what had to be done, which also included closing the Museum one day a week. I walked away alone, broken and defeated. My world seemed in ruins. Everything I had wanted to achieve for that great Museum now seemed to lie in tatters around me. How could I pull it back, how could I restore morale, how could I move the place forward again? It would take years to get the V & A back to where it had been before disaster struck.

All one was left with was the will to fight. And fight I was determined to do. It is sad that I felt that my colleague on the other side of Exhibition Road did not share my view. I swore that I would battle for the V & A up hill and down dale to avert, or at least ameliorate, this catastrophe. And so followed a bitter public debate. I failed, but I have no regrets.

9 February. The V & A, USA, and John Pope-Hennessy.

The craftsmen event [*The Makers*] in the V & A after Christmas was a triumph. It was jam-packed, so packed on the Friday that we had to close the doors to the Museum, and let a queue form. There were already 17,000 people in the building. All this means that the place is gaining in excitement and direction now after two years. The links with the Royal College of Art are happening. The Crafts Advisory Council too, their shows very fruitful, with their bias towards the

twentieth century: photography, jewellery, fashion. Change now permeates our graphics, shifting the Museum's image, making it more human, lively, progressive, unholy, contributing towards and celebrating contemporary creativity. All this is good and exhilarating. On the negative side we have the problems of overall Civil Service cuts in money and staff, but somehow this only sharpens the atmosphere and direction.

At the end of last week we arrived back from the United States from a bicentennial trip to Williamsburg, where I lectured to a lot of old crones, to Yale, New York, Richmond and back again to Williamsburg. Rumour was buzzing on return of the resignation of Sir John Pope-Hennessy. It reached the V & A direct from the British Museum, to be followed by the *Guardian* ringing my office and Hugh Leggatt being rung up twice. The reasons mooted were because of the Donatello, that he'd had a row with Lord Trevelyan over the appointment of a new Keeper, and his personal behaviour. One wishes scandal upon no one because it leads nowhere. At any rate we all now wait for the result of the emergency meeting of their Trustees.

15 February. More about Pope-Hennessy and Donatello.

The world continues to be full of gossip about John Pope-Hennessy leaving the British Museum. An emergency meeting of the Trustees was held, which suggests something serious as they meet monthly. An embargo on press comment has come down. No paper has carried the story. The reasons for his resignation are or have been suggested as being: (1) He's been offered a chair at Princeton (likely but why the rush?). (2) He lost a battle to appoint a lecturer from Newcastle as Keeper of Greek and Roman Antiquities. (3) He appointed a useless Keeper of British Antiquities and quarrelled with him. The Keeper then appealed over his head to the Trustees and won. (4) It was rumoured that he was involved in the Knightsbridge Barracks Guards case. He was involved in a similar scandal in New York. Whatever it is, it is a mighty fall by a mighty man. Rumour says that he goes by the end of April. One waits, fascinated.

This week with the Donatello facsimiles [they had been made with the assistance of the Royal College of Art] we will reach our target. This will be leaked to the press. I have no intention of telling the Minister for the Arts, Hugh Jenkins, who has hindered and been utterly useless and damned unhelpful. How dare he take the credit.

19 February. The Pope finally goes.

Yesterday the departure of John Pope-Hennessy was in every newspaper side by side with the election of Sir Hugh Casson as President of the Royal Academy. What the truth about his 'retirement' by the end of the year is, no one knows. It must have been bred of a crisis, as rumour ran rife and there was an emergency meeting of the Trustees. He and his plans were in full flight up until three to four weeks ago, so it must have been precipitated by something. He goes at the end of the year but the British Museum is unlikely to see much of him for the rest of this year. We glimpsed his back view sitting next to David Cairns at Covent Garden, a pathetic old figure. Defeat is not something he has ever publicly admitted before, and defeat this is. Now the speculation as to who next? Not me, if I can avoid it.

23 February. To Jan van Dorsten. The opening events of 1976.

The year was also ushered in by Fred Ashton's ballet A Month in the Country *based on the Turgenev play. Fred had told Julia while they were doing the* Enigma Variations *ballet years before that she was to design the next one. That that was about to be born was signalled at a dinner given by Moura Lympany on 4 June of the previous year. I recall the very long table with Fred and Julia at the opposite end from where I was placed. Suddenly I saw Fred moving around the salt-cellars and mustard pots. I learned later that he was telling Julia where the piano had to be, and also where the chaise longue for Natalia Petrovna should be sited. Fred had an early-Victorian print of a lady with diamonds entwined in her hair and this was how he visualised Natalia. Julia was determined to surprise the audience with a 'light' set which she did, after years of Stygian gloom had engulfed the stage of the Royal Opera House. The production was sponsored by the Linbury Trust and Anya Sainsbury produced the lace which went into making the pelisse for Natalia, the movement of which from behind was ballet costume at its most evocative. On the first night Anne (sister of Oliver Messel) and Michael Rosse with Harold Acton sat in a box opposite us, Anne gesturing across the auditorium as though to say to Julia that she had inherited the mantle of Messel in terms of theatrical magic. The blue on the set, christened by Julia 'Smolny Blue', was taken into our garden, and this was the year we planted what is still called the Ashton Arbour.*

The curtain went up on Julia's *A Month in the Country* at Covent Garden on 14 February. The sets and costumes were quite stunning,

the choreography extraordinary. As a production it had mixed reviews, from raves to gently hostile, but so did *Enigma* and that has become one of the Royal Ballet's great classics. So now we gently recover.

The craft programme over Christmas created a sensation, packed to the doors, and now, this week, I announce the successful completion of our Donatello appeal for £175,000. *The Land* photographic show broke new boundaries and, in March, *Fashion* opens, a nightmare show but with handling it could be a hit. The French Embassy are flying over the heads of the couture houses for the opening plus their top models. Internally it is on the whole peaceful, quiescent. We are reeling from vast cuts in Government expenditure which will involve serious cuts in activities and staff over the next few years. But I refuse to be gloomy about it. After all the Museum has lived through worse ... [It hadn't!]

The country is looking ever more marvellous. It is full of the promise of spring – snowdrops and crocuses along the drive, your tulips are pushing their heads up in the Yew Garden in formal patterns and the Elizabeth Tudor Walk is bursting with the five hundred daffodils which I planted flanking it.

25 February. An Attempt to save the Beaton archive; Kenneth Clark.
Michael Tree rang about Cecil Beaton. Things are bad. Money must be found. In all he must be guaranteed a net income of £20,000 p.a. till he dies. This means capital in order to bring in the income, which can only be done by selling the archive and the house. Cecil needs a cook, a manservant/nurse, Eileen, a gardener and charladies. The idea is that the house is to be purchased hopefully by some well-wisher who will let him have it for a peppercorn rent. The problem is how to save the archive, how to get £100,000 net for it. The sale of a lifetime's work, however, counts as income and is therefore taxable, so Cecil's one nest egg is vulnerable. I rang the Treasury to investigate and hope that perhaps it can be worked by getting exemption from Death Duty in retrospect. [I failed to persuade the Treasury or raise the money to save the Beaton archive and it was subsequently sold to Sotheby's.]

In the evening K Clark lectured at the V & A, the final scene of the Donatello Appeal. The lecture was on the level of a first-year art school. K has become very geriatric when not performing; when he does he suddenly pulls himself up and 'acts'. The first thing he did after the lecture was to ring his wife. Some of the slides were put in by him in the wrong order and there were some embarrassing moments of hesitation.

March. Princess Margaret and the National Theatre.

Princess Margaret and Lord Snowdon finally separated during the week of the 17th–18th. The National Theatre has opened. We went three times. The exterior is dull but the interior impressive with space, receding layers and varying levels. The sad thing is architects never make use of other designers and craftsmen, so not even the curtain was painted or embroidered or specially woven for it. We saw HRH Margaret in the interval on the second night (*Hamlet*). She was in very good form and she rang through and chatted away to me the day that the separation was announced as a coming certainty. One feels that she is relieved and it is the bitter end of the story recorded on our Paris trip. She will have a terrible time making a new existence for herself as she lacks application and has a bright but untrained mind. Jackie Onassis asked us to lunch at the Ritz which looked very run-down.

31 March. Princess Margaret's separation, 10 Downing Street, the garden, and E. Box.

I have been very lazy about keeping these records: Harold Wilson has resigned, HRH Margaret and Lord Snowdon have separated, and *Fashion* has opened at the V & A. In retrospect I record the most memorable fragments:

We were asked to lunch at 10 Downing Street for Mr Gromyko. We'd never been before. There was a large horseshoe table and interminable speeches in Russian and English, all of which had to be translated. I found myself between the usual two wives: one was Mrs Pentz, a very far Left wife of an Open University professor, and Mrs Stow, wife of Harold Wilson's Private Secretary. It was a dull lunch but I cornered Marcia Falkender as I left who said that she longed to be on the V & A Board but Harold kept on telling her she'd be too busy and won't let her.

10 Downing Street was *en fête* that week. Dinner for Cabinet colleagues one evening, dinner for the Queen the next. At the latter the *modus operandi* by the royals had certainly been thought through, Prince Philip being hail-fellow with Denis Healey and the Queen apparently bent on reducing the Foots to servile courtship.

At last the HRH Margaret separation came. Not a divorce. She said that put the papers down a bit as it eliminated the Archbishop of Canterbury. Frankly we're all relieved, although the hideous coverage really tarnishes. She looks better. At the French Embassy soirée for *Fashion* she complained bitterly about the press (on the day, Anne Tennant's nanny had rung her and said don't come back to the house

as it was besieged by photographers and reporters). She complained that Tony never stopped talking, and when I said that I had noticed on a newspaper billboard that someone had slashed Tony's pictures in his Australian exhibition she replied, 'Good.' In spite of all the efforts to shrink she looks very Hanoverian. Her dress was white trimmed with turquoise-blue embroidery and beading and totally uninteresting.

I have just started work on the circular Hilliard Garden. I want a pattern of box with autumn flowering plants to give the garden a lift in October. Last Friday the grass was cut and the garden for the first time looked a whole. We visited Michael Hartwell's and Hugh Johnson's gardens, both of which inspired us, but I think ours will be better! It is clear that we must plant more. We flung the builders out and the house and stables were complete the weekend of 2 April. At last!

Madge Garland told me a fascinating story about how E. Box (Eden Fleming), the painter, got her name. She saw an exhibition of primitive paintings and thought that she could do that sort of thing. Away in the north of England she did one on the lid of a cigar box and took it into a gallery who purchased it as by an anonymous north-country painter. They wanted more and rang her asking for the artist's name, so she replied, 'Box' (i.e., cigar box!) and added her own initial 'E' (Eden), hence E. Box.

5 April. Reddish and Cranborne.
We drove down to see Cecil Beaton. He looked older, or, rather, he has at last given in to age, accepts that he will not improve and regain the use of his right hand. It is the first time that I have ever known him to refer to his demise: 'I may last a year, two ...' Mentally he was better, able to remember what was said and pick it up again later. The visit was to sort out the collection. Frankly they had no clue as to its potential, no idea of vintage as against later prints, negatives, etc. As a long-term gold-mine, well handled, it could keep Cecil financially until he dies. What museums are after are purchases of 'vintage prints', hitherto regarded by Cecil and Eileen as the old reference prints but now very valuable.

Eileen said that he was fine as long as visitors came and he was 'lifted', but he had nothing to fall back on, no inner reserves and gave way to periods of depression. He could, with effort, read and should be made to, but he was spoilt by a friend coming once a week to do just that. The entourage is quite significant: Eileen, a manservant, a cook, two gardeners and charladies. He loved our visit, loved the gossip and obviously longs to get to London and the theatres. Sad.

We went on to see the Salisburys' garden at Cranborne. What a paradise. Perhaps the most perfect small-scale country-house garden I have ever seen, delicate, sensitive, English, wholly resistant of conifers and quick-growing effects. The setting of the house is idyllic, in a valley, with a pretty walled courtyard and red-brick gatehouse. There was an all-white garden at the back with dianthus and pinks used as ground cover beneath a walk of espaliered old apple trees, on one of which mistletoe had swagged itself to the ground. Beyond, gates led on to a noble avenue of elm leading the eye into the distance. There was an orchard with a tapestry hedge of beech, box and yew, planted with nothing but flowering crabs and carpeted with daffodils, which had walks cut through it. At the bottom ran a little stream, just created, with a walk on its further bank through trees, shrubs, primulas, etc. She [Lady Salisbury] had recently made a box garden into which she had planted all the flowers mentioned by John Tradescant. There's a formal garden with a mount, indeed a whole series of gardens away from the house including a marvellous herb garden and an apple tunnel. Perfect, personal, intimate, secret. And full of old-fashioned flowers: double primroses, Elizabethan primulas and old roses I'd never even heard of. We left plant-loaded, including the rose 'Cranborne', which I shall grow around the obelisk in the Yew Garden.

6 April. The Empress of Persia.
The Duchess of Kent gave a lunch for the Empress of Persia. Katharine Kent had been in hospital for an operation and looked pale and tired. It was a small gathering, the others being the Mosers, the Beaumarchais (Jacques and Julia united in being anti-Thatcher), Philip Hay, the Husseys and Edward Heath. I was surprisingly placed on the Empress's left. She is a woman of considerable glamour, immaculately dressed in couture clothes, simple, perfect and restrained, impeccably made up but not apparently heavily. I found her both intelligent and humorous. She is actively interested in the Arts, in preservation, heritage, crafts, theatre, ballet and museums. A remarkable woman with great poise, something revealed even more that evening when she opened an exhibition at the Science Museum with a raving mob of demonstrators at the doors.

7 April. Mrs Thatcher.
I went to the Minister of Education's office for the presentation of a medal. The Minister, Fred Mulley, is a north-country slob, coarse of feature, not very bright but affectionate and good in his handling of

the occasion. The office was still largely with Mrs Thatcher's décor, suburban hairdresser style: doors with panels of beading laid over and painted gold, and with a white carpet! The Permanent Secretary, Sir William Pile, was very funny about her, how she had slaved to learn French privately for her great visit to Geneva, got into the hotel and tried to order a drink, collapsing back into hopeless schoolgirl French. His most revealing moment with her, he said, was when (during the Jellicoe affair)[1] she had steeled herself up one day, when travelling in the back of a car with him, to ask 'Did men really pay that kind of money for that sort of thing?' She lives in a world apart, unaware how most of the population lived. He said that her law degree wasn't much, her command of facts terrific within a set area but beyond that nothing. Her knowledge of history was nil. When he went with her to Rumania she couldn't relate their past horizontally across to ours at all.

8 April. The Callaghans.
We dined at 10 Downing Street. The venue was moved from Lancaster House when Callaghan ceased to be Foreign Secretary and became Prime Minister. There is something terribly institutional about Government entertaining. I sat between the wife of the editor of the *Financial Times* who was boring and Lady Wright, a loquacious wife of an ex-ambassador who was now secretary of the Queen's Silver Jubilee Committee. The dinner was for the Empress of Persia who, as usual, looked stunning in her couture clothes, a sparkling embroidered top which hung over a skirt of plain silk of understated richness which moved marvellously. She made all the other women look ordinary.

Mrs Callaghan is tall and to the point. She is an intelligent woman with dark brown hair and a minimum of make-up. Her pale yellow evening dress did not sit happily upon her. She is no way a *grande dame* but a middle-class, educated, reforming mum. Callaghan strikes one as jovial, although I wasn't sure how bright he was; neither of us had an opportunity to speak to him properly. It was an odd gathering.

Easter. The Redcliffe-Mauds.
Down to The Laskett for a glorious twelve days ... but we travelled back via University College, Oxford, and dined *à quatre* with the Redcliffe-Mauds. There was much very sharp, bright, fast conversation.

[1] In 1973, during the Heath administration, Earl Jellicoe was one of two prominent Tory politicians who resigned after admitting that he had associated with prostitutes. The other was Lord Lambton.

As Sir John Maud, he had been Permanent Secretary at the DES backing Leigh Ashton at the V & A and Robin Darwin at the Royal College. The rooms were a comfortable clutter.

29 April. To Jan van Dorsten.

Everything here is roughly the same, but going much better. Easter was glorious. I made another garden on the far side of the field by moving about 800 old bricks and two or three tons of stone-chippings. At any rate it gave me a terrific break. At the moment we are in the grip of drought, the worst since 1821, no water anywhere and NO RAIN. It is extraordinary, and we may end up trudging with pails to get our water from a central pump so dire is the situation. The new department [of Regional Services] has just happened, so another major change has been achieved, and we hover on the rejigging of Textiles into Textiles and Costume, which should have happened thirty years ago. The fashion show at the Museum has been a tremendous success and the new charity I am establishing [the Associates of the V & A] ... is now legally through and poised for signing and RS is to approach what rich companies might be left in our ruined world of manufacture.

Julia is just about to do *The Importance of Being Earnest* for the Vienna Burgtheater and her ballet has just had its première in New York.

5 May. The Royal Academy Dinner.

Sir Hugh Casson's first dinner, with Hugh in a black high-collar three-quarter-length coat looking like a nonconformist cleric. He handled the proceedings along their customary lines but dexterously. The speeches were turgid: the Duke of Gloucester went on about design and chuntered into the tablecloth (the Duchess looked like a mini-Queen Victoria in a green crinoline and mini-tiara), Harold Lever said nothing about nothing in the most circuitous way that he could devise, and John Redcliffe-Maud opened and closed with ill-starred jokes. It was really embarrassing. I sat between Denis Hamilton and Ginnie Airlie so it was a good time. The food as usual was filthy, the flowers municipal, and the actual exhibition a disappointment.

22 June. The State Banquet for the French.

We'd never been to a State Banquet before, probably never will again. I assume we were asked because of the group of Constables sent in a rush to Paris from the V & A and, perhaps, Julia designing *La Bohème* which is arguably French of a sort. The bruit was that this evening was

to be of great splendour to impress the French with the magnificence of Britain, which certainly they wouldn't guess from the country's current economic plight. The whole affair reminded me of Catherine de'Medici, who did her most elaborate spectacles when Renaissance France was rent with civil war and the country broke, in order to give the illusion that all was well when patently it was not.

Now what struck me most was that it worked, as though automata had been set in motion once a knob off-stage had been pushed. In through that low awful entrance hall we went. A bevy of flunkeys and court officials solicitously urged us towards the Grand Staircase. That was quite something to see, as up it slowly ascended ancient aristocrats, ambassadors and government officials and their wives all *en grande tenue*, many of the men in knee breeches and silk stockings, their jackets and shirt-fronts festooned with orders. In the case of the women it was the best array of tiaras I'd seen since the gala at Covent Garden for Britain's entry into the Common Market. Two were outstanding: the Duchess of Northumberland's, with spikes of pearl like carbuncles, and Jane Stevens with *tromblant* diamond flowers. Both of them at least knew how their hair and tiara should be moulded into one, whereas most wore them like helmets soldered to their heads by a lump of false hair.

At the top of the stairs stood Hughie Northumberland in his role as Lord Steward of the Household, clasping a long white rod of office, one which in the past would have been used to clobber any who pressed too close to a royal presence. But today his mind was more on his silk stockings and how to keep them from falling down. Julia, practical as always, suggested a visit to Anello & Davide and a pair of tights. The great state rooms looked wonderful, a phantasmagoria of Edwardian opulence, gold on damask, damask on gold, a symphony of whites countered by green and blue, all of it overlaid by the fairy-tale glitter bestowed by the twinkling of huge chandeliers. For once the world of the state portraits on the walls and the reality of those who promenaded below were as one.

Everyone assembled in the Picture Gallery and then, at an appointed moment, another magic knob was pressed, a huge pair of doors was suddenly flung open, and the entire Royal Family stood like the Empress Theodora and her court, a tableau of Byzantine splendour which can go on nowhere else in the world, for all one was conscious of was the shimmering of countless diamonds as they caught the light when even one member of the Royal Family so much as slightly swayed. There they all stood, the Queen, the Queen Mother, the Duke of Edinburgh,

as suns around whom gathered the lesser constellations of Princess Anne, Princess Margaret, Princess Alexandra, the Kents and Gloucesters. There had obviously been a three-line whip for this banquet, I thought. Slowly we filed past, bowing and curtsying, and processed along a corridor formed by Yeomen of the Guard to the Throne Room.

The scene here was out of an aquatint of the court of George IV. The tables were an explosion of damask, silver gilt, glass and flowers: huge silver-gilt candelabra piled high with sweet peas and roses were interspersed with smaller gold vases of flowers, all the cutlery being silver gilt. Vast chandeliers lit the room, but what was quite extraordinary were the three great buffets with displays of plate done in a manner Louis XIV would have recognised. Behind each ascended boards upholstered in deep crimson velvet which were studded with huge pieces of gold plate and baroque wall sconces. Yeomen of the Guard in crimson and black, wearing chin-ruffs and holding halberds, lined the perimeters of the room. By the serving-tables stood batteries of footmen, some of them old retainers but most looked like out-of-work thugs hired for the evening, their faces arising out of uniforms which did not fit them and must have been dished out on arrival. None the less the impact on entering can only be described as dazzling.

Once more the automata were set in motion. Two huge doors were swung wide and as we were placed low down the table we could see this in all its detail. Slowly towards us along the corridor came the Royal Family and their principal guests ranked in hierarchy, preceded by yet more Yeomen. Then came the banquet, which resembled a ballet in which footmen bore and swept away course after course, two on gold plate and two more on Sèvres eighteenth-century porcelain of quality to make the French eat their hearts out, turquoise and gold for the pudding, dark blue and gold for dessert. The claret was a 1945 Château Latour, the like of which I am unlikely to encounter again. All the way through, the Guards' band played what was for the most part incongruous music, mainly 1950s musical-comedy numbers whereas Mozart would have been more appropriate. Before dessert was served the behind-the-scenes stage-management resumed its activity, as what can only be described as the house lights were dimmed and the double doors opened once more. This time bekilted Scottish pipers entered and slowly processed no less than twice all the way around the room. What the French can have made of this doleful sound I have no idea. Perhaps it was to recall the auld alliance. All it did was to call to mind the *bon mot* of a European lady who, on first hearing the bagpipes, remarked that she hoped that they did not smell as well.

Two boring speeches, one by the Queen and one by Giscard d'Estaing, and two national anthems were played. Then the royal party arose and left by a door at the top end of the room leading across into the great suite of drawing-rooms beyond, white, gold and blue. That was the signal for the general mêlée in which we talked a lot to royals and others about nothing in particular. One loves talking to Princess Alexandra and the Duke of Kent. The Duchess looked really ill. Princess Margaret, relaxed and tanned, was off the cigarettes for once and zoomed us round to show off this and that room. And we were touched to be spoken to and remembered by so many including Mary Wilson and the new Prime Minister [James Callaghan] and his wife. William Rees-Mogg and I were the only men without so much as an order to lighten our evening dress. The avuncular and plump 'Chips' Maclean was quite something to see in full fig as Lord Chamberlain of the Household clasping a white rod with a massive gilt key on a blue riband fastened to his coat-tail. So much grandeur, so much pageantry but I did wonder what it had achieved. But Ruritania was certainly alive and well.

23 July. The American Ambassador's Fête.

We went to the new American Ambassador's late-night supper party before which I launched the V & A's first ever display of modern jewellery by Gerda Flockinger, Roger Morris, David Courts, Bill Hacket and Wendy Ramshaw – beautiful. Incredible to think that ten years ago it would not have been possible to have gathered together talent of this sort.

The weather has been sweltering this week, 85 to 90 degrees during the day, but for the American party the evening was a perfect summer's one with pretty food, tables scattered across the terrace, dancing and a good gathering of people. Meanwhile over at the Opera House the gala for the President of France was going on with the Royal Box full of chairs shipped in from Buckingham Palace, a mirror hired from Partridge's and thousands of white flowers. Why we represented Britain with Verdi's *Un Ballo in Maschera* directed by a German I don't know.

24 June. Staff troubles and the final French fête.

Today I had an appalling confrontation with the head of the Indian Department, John Irwin, who I really think is getting a bit carried away. He accused me of telling him that he was redundant, which I certainly had not. Indeed I had just extended his tenure of office to enable him to secure his pension rights. There was a very bad scene. In retrospect

each of the old Keepers, on coming to the reality of their exit, have made things very difficult. None of them took at all kindly to the fact that they were going. There is to be a vast case against me put to the unions but I will sit it out. There is no written evidence.

In the evening there was a final glittering assembly of some eight hundred at the French Embassy for the State Visit. A vast pavilion had been erected covering most of the garden. It was lined with a trellis festooned with white arum lilies and with light sconces attached to pillars garlanded with white and pink flowers. Everyone was in uniform, orders and jewels. Notwithstanding all this splendour they succeeded in running out of champagne because, everyone having been told to arrive by ten, the royal entrée was not made until eleven. The Pope came over and said that he would like to dine with us. I had written and asked him. The feud has ended. He is a cruel beast, but I feel sorry for him. Tiaras, I concluded, look terribly wrong with 1976 dresses. They only look right on dowagers wearing old-fashioned ones.

26 June. Queen Elizabeth's picnic.

We were asked to lunch at Clarence House. The Queen Mother staged it in the grounds beneath two vast weeping plane trees whose branches touched the ground, creating two 'rooms'. She was in white and green, dressed as only she could be with false sleeves falling to the hemline of her dress and a large hat over her white-streaked dark brown hair. The hat was extraordinary, a helmet of green velvet beneath it and with a white velvet flower pinned at the back. The lunch ostensibly was for the new Apostolic Delegate, a Swiss Archbishop, but he seemed irrelevant to the gathering, which consisted of David and Nancy Perth, Michael FitzAlan Howard and wife, Lord and Lady Cranborne, Elizabeth Cavendish, David Bowes-Lyon, Lord and Lady Dalhousie and Lord David Cecil and wife.

The Queen Mother loves talking, loves being told what one is up to. If one starts up about the Museum or Julia about her *Earnest* production, she sparkles and just adores chatting as though one were catching up with some marvellous aunt. She told me that the President of France had never wanted to go to Edinburgh but that the Queen, bearing in mind devolution, had persuaded him.

The dining-room table had been carried outside with three vast bowls of flowers on it and two eighteenth-century *biscuit* figures of huntsmen which had been presented to her on the 1938 visit to Paris. William the page ('We plot together,' she says) obviously is the stage-manager. As he served me he said that he hoped that I had noticed the Gerald Benney

box in front of me. That had been presented in 1970 by the Fishmongers' Company and William obviously placed it there because he had read about RS and the crafts. He is a great theatre-goer and always compliments Julia on her work.

The Clarence House ritual is that of an Edwardian great house and the sight of eighteen people sitting at a dining-room table laid overall alfresco with three menservants ministering to their needs was pure 1890s. Her Majesty sits in the middle of the table and I sat between Lady David Cecil, who spent most of the time under the impression that I was the Director of the National Gallery, and Elizabeth Cavendish.[1] I asked her about the Poet Laureate [John Betjeman]'s sight. He has double vision which is why one lens is frosted over. The Queen Mother adores her lunch parties and that came through. The entourage of Gilliatt, Aird and Mrs Mulholland don't really control her. I imagine her forever plotting with her friendly page and breaking the rules! It was an extraordinary finale to a week of spectacle.

13 July. The American bicentennial exhibition.

Today the exhibition *American Art 1750–1800: Towards Independence* opened. It is the most beautifully designed and presented show, the objects each singing out with great purity. There was a great opening evening with all the protocol. Princess Alexandra came, adorable as usual, making everything easy and also having done her homework and devoured the catalogue, which is more than I had had time to do. We met her on the steps. Then followed the usual line-ups for presentation all the way through the exhibition but after that we were able to settle down to a lively look at the show. Thence we proceeded to the Cartoon Court filled with the Pilgrims and where the central Renaissance fountain had been banked with flowers. Then came a finale of great splendour. The Heinzes sponsored a dinner for eighty of the donors in the Old Refreshment Room. This wonderful room has just been restored and I cannot get over how incredible it looked in shades of gold, ochre and white, and decorated with flowers. There were about nine round tables with white tablecloths to the ground and the whole event was candlelit.

Everything was got through by 10.30 p.m. so that the Heinzes could get to Sir John Keswick's birthday party and we to HRH Margaret. Her gathering included the Beaumarchais, the Tomkinses, a *Sunday Times*

[1] Daughter of the 10th Duke of Devonshire. She was John Betjeman's close companion from 1951 until his death in 1984.

journalist and wife, Milton Gendel, Nicholas Soames, *et al*. A dreamy youth played pre-1945 numbers which they nostalgically belted out together. HRH did her Ethel Merman in *Hello, Dolly* and was in great form, not at all difficult.

July. Mrs Thatcher and the V & A.

I have been very remiss in not scribbling more. We have all been awaiting the announcement of the appointment of Michael Jaffé as Director of the British Museum. He looks so pleased with himself that it cannot be anyone else. Poor soul, little does he know the horrors ahead in that pit. Pat Jaffé turned up to the Heinz dinner dressed as though she ran a Japanese tea garden, carrying her latest infant aged four months, not a convenient or endearing spectacle.

On Monday 12 July we went to a huge dinner given by John and Aliki Russell in Chester Square for Mrs Thatcher for which we had been booked seemingly last year. I suppose that there must have been thirty for dinner and as many after. It was very ostentatious, with too many hired menservants. I counted six which is staggering for a London dinner. Mrs Thatcher was in floaty chiffon, an apotheosis of the boss's wife, with the appeal of cosmeticised putty. I cannot understand how she has ever got that far. Mercifully we were spared Mr Thatcher. It was a useful but totally unendearing evening, apart from happy encounters with the Tavistocks, Fleur Cowles and the Heinzes.

I am concerned at the moment with a hostile lady journalist [Liz Forgan] who 'got through' on the pretence of doing a leader for the *Standard* on the V & A but then proceeded to lunge into me. She had obviously been got at by the person or persons in the Museum who have kept up this press tittle-tattle over the last two years. I pray that it is not the damaging piece her attitude suggested.

The piece appeared on 15 July. Rereading it after twenty years perhaps I had far less need to be upset about it than I was at the time. The real shock had been Liz Forgan getting into my office for an interview for which I had been wholly unprepared. She was accurate when she wrote: 'The arrival of Roy Strong at the V & A has proved to be the occasion for one of the classic museum conflicts to be played out more publicly than usual – the clash between the role of the Director as impresario and that of the department Keeper as lord of his own particular domain.' Those who came out on my side included Cecil Beaton, Benedict Nicolson, the esteemed editor of the Burlington Magazine, *and the critic, Edward Lucie-Smith: 'What Roy Strong is*

Child Star

Cecil Beaton, 1967

Sixties Icon

David Bailey, 1970

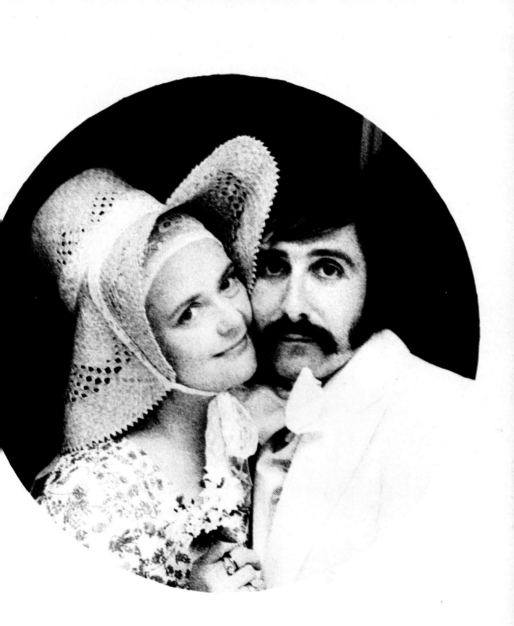

Bride and Groom

Michael Leonard, 1972

Textile Apotheosis

Polly Hope, 1985

doing is reverting to the Victorian concept of the V & A as a means of popular education and a centre of craftsmanship, whereas in recent times it has become a scholarly machine for research and discovering things ... Museum Keepers like to keep things, to work in ordered compartments. What they dislike about the Roy era is that things are no longer controllable. The ground, you see, begins to shift – and that makes everyone uneasy.'

Last week we turned a corner by inaugurating a new form of open forum Keepers' Meetings. Apart from Elizabeth Aslin [who ran Bethnal Green] and John Beckwith [Keeper of Sculpture], who continued to ignore, slam and snub, it was a great success. We were all suddenly beginning to think together, inconceivable a year ago, but not now. Two Keepers wrote separately and said that it was the best Keepers' Meeting they had ever attended.

14 September. A visit to Houghton.
Sybil Cholmondeley still reigns over Houghton. Her son has made her open it which she hates. It was a strange gathering: Julia and I, Sybil, George and Diana Gage, Mary Roxburghe and Raymond Mortimer. The house sits like the Bastille on the landscape and there is no garden. The guest rooms were very run down and the towels tattered. The husbands were expected to sleep away from their wives but I refused. A housekeeper/housemaid appeared each evening to fetch away any laundry, pressing or mending, a service we've only experienced at Woburn. Mercifully radios at least existed in the bedrooms, a sign of enlightenment, but the atmosphere was hieratic and ungiving. The food was quite awful. Any younger generation of country-house owner would have zoomed into the kitchen themselves and done better. The sight of that ancient gathering coping with corn on the cob is something I would like to forget. The age of the guests was after all something incredible: Lady Cholmondely eighty to eighty-two, Raymond Mortimer eighty-one, Lord Gage eighty – those three alone totted up two centuries and a half. Raymond Mortimer gave us a riveting description of a visit to Somerset Maugham shortly before he died and how he was so ga-ga that he was trying to eat the fruit painted on the plate.

14 September. Signs of the times.
I took Charles Williams[1] out to lunch. He said that it was evolution

[1] Banker and businessman. Labour spokesman on Trade and Industry, 1986–92. Created a life peer, 1985.

that we were going through not revolution. The next three years were crucial. From 1980 to 1990 we would be OK because of North Sea oil but what worried him was post-1990, by which time I would be fifty-five. We condemned the world of 'Jennifer's Diary'.[1] In the evening I took Beatrix Miller to *Don Giovanni* as Julia was in Vienna. Beatrix, on the contrary, said it was revolution, with whole classes being expunged.

The look for men changes: ears show, hair is shorter and straighter, suits are in, so is the well-turned-out look. Velvet is out, velvet bow-ties are out. The look is now precise. I have just bought a new evening suit which is plain, well cut, but with no frills or velvet.

5 October. To Jan van Dorsten. The Big Decision is taken.

Summer here began with ten days at The Laskett followed by a zoom into London for the opening of the Minton show at the V & A with brass bands in the quadrangle, back via staying at Houghton in Norfolk to The Laskett and then, finally, a week at Salzburg for the festival as guests. We suffered the most terrible drought this year which took much of the joy out of our break in the country because we looked out on a parched garden, pale yellow with dying trees and shrubs, and had to bale our bathwater out in buckets and cart them down to save a few precious things. I cannot tot up the plant obituary notices until next spring, but it looks dire, although not as bad as it could have been.

Salzburg was all smart glitter, but somehow it took one away from the gloom in a gorgeous hotel with every luxury, chauffeurs, waiters, the best seats, the lot – I adore the people who took us – and quite frankly we needed the break. Julia went straight on to Vienna, where she's doing Wilde's *Earnest* for the Burgtheater and she is there at the moment. It opens on the 16th and I ache for her to come back. She has been travelling to and fro the whole time and I selfishly hate her going away for a minute, particularly because I'm going through an agonising time. Now the Government cuts for the V & A have really started to bite with a savagery ... as Director I face the worst crisis since 1939. It is ghastly. I have to lose ninety-four staff out of seven hundred and at every level at an even percentage. I nearly go mad because the Keepers simply have not the practical administrative sense that I have, and their proposals, so tragically well meant, are pure fairyland. To meet what is asked for by Government I am going to have to do something which will set the institution back a hundred and thirty years. I must

[1] The social events column in *Harpers & Queen*, written for decades by the redoubtable Mrs Betty Kenward. It was frequently lampooned.

amputate. The last weeks have been agony, but I have reached my BIG DECISION. Now to find the way forward to do it. But the decision is made and that took hell out of me...

Everything here in Britain is so gloomy. I keep looking for GOOD NEWS – WHERE IS IT? The main theme is can we or can we not survive until the 1980s without a collapse of society as we know it. It all seems so incredible compared with five years ago that it is terrible to grasp. One is confused, bewildered, despairing. Well, one can only plough one's lonely furrow in as true a way as one can and that's that ... Private elysiums, as yet unshattered, bring peace and joy.

5 October. Elizabeth Longford is seventy.
Elizabeth Longford's delayed seventieth birthday took the form of a gathering of the clans at the Irish Club in Eaton Square. Awful rooms and filthy red and white wine. It was the first time that I'd seen Antonia [Fraser] for a year, worn but marvellous, wearing expensive black. She said to me something extraordinary, the drift of which was, now you have private happiness and public misery; before you married you had private anguish and public happiness. How true! She looked older, sadder, more impassioned, more remarkable.

25 October. The National Theatre opens.
This occasion was a washout in every sense of the word. It poured with rain, obliterating a street fair and entertainers for a start. We arrived at about 6.30 p.m. to struggle through a sea of people grabbing what they could of the free drink and food before getting into their seats at the mandatory 6.45 p.m. We had been assigned to the Lyttelton where we sat for three-quarters of an hour staring at a screen, watching yet more arrivals. At last the Queen actually turned up in floating apricot chiffon, quite hideous and with her hair another colour. Lord Cottesloe, the Chairman, looked as though he'd have apoplexy and launched into a disastrous speech which opened with the words: 'Your Majesty, when I saw you five years ago and asked whether you would honour us with your presence on this opening night you replied that you very much doubted whether you would still be Queen by then.' This clearly totally misfired and she was visibly not amused. After this the royal party vanished for a seeming eternity into some reception room. Eventually the Queen made her way to the Olivier and the proceedings at last got under way.

These began with a trumpet setting of the national anthem which nearly blasted Her Majesty and most of the audience out of their seats.

She afterwards said, I heard from Anne Tennant, that that was one arrangement of the national anthem which she never wished to hear again. Then Laurence Olivier decided to upstage everything and everybody as usual and made another speech. More delays followed while Princess Margaret made her way to our theatre. The national anthem was played again but, thank God, not that arrangement. At last Tom Stoppard's *Jumpers* began, a play of utter boredom. Michael Hordern gave a superb character performance but his stage wife was dismal. I guess that Diana Rigg might have been marvellous. Meanwhile in the Olivier Goldoni was played. Only the British, I thought, could open their National Theatre with plays by a Czech exile and an Italian.

At the close of it we were all marooned while the Queen came to view the Lyttelton. The dreaded State Trumpeters reappeared and there was another terrifying fanfare. The Queen collected her sister, who had been bored by the play but more by the fact that when she sat down the wall in front of her in the circle was so high that she couldn't see over it. Thus opened our long-awaited National Theatre.

The first week in November.
This week saw the climax at the V & A of the staff cuts programme. After a tremendous battle with the DES I was allowed graciously to rally my troops. It was quite a day, seeing the Keepers, the unions, and addressing the assembled staff from the steps of the Raphael Cartoon Court. The decision to close Regional Services was greeted by hysteria, wholesale press leaks, newspaper tirades and correspondence. There was bitter union opposition.

15 November. Enter Shirley Williams.
The Standing Commission on Museums and Galleries visited the V & A. Lord Rosse and his colleagues supported my plan to disband Regional Services as being the only possible way to cope with the cuts and also the most embarrassing from Government's viewpoint. The situation was midstream and could still jump either way. There has already been a bitter *Times* correspondence and the proposal has certainly placed both Ministers [of Education and Arts] in a fix as to what to do, because cutting the Department will be denounced and equally any reprieve would lead to trouble with the unions and other grades in the V & A and the Science Museum as well as in the Civil Service. It will be fascinating to see what they come up with.

Ironically we went that evening to the Royal Box at Covent Garden as guests of John and Anya Sainsbury with Shirley Williams [the new

Secretary of State for Education] and Professor Anthony King as the other guests. It is difficult to see Mrs Williams in 10 Downing Street which was disappointing because so many hopes are pinned on her good sense and directness, both of which qualities are certainly there, plus warmth, affection, a sparkle and a certain hesitancy. But toughness and ruthlessness seem lacking, and these seem essential ingredients for the top. She must be about fifty-nine. She strikes one as oddly short, but that is because she seems to have no neck. Her brown hair is simply dressed and she has a pleasing, friendly but not a striking face, far less so than photographs would suggest. She moves awkwardly and I noticed that she held her cutlery in her fists and gesticulated with her knife and fork as she spoke.

Anthony King, with whom she lives, is an overweight provincial academic from the University of Essex. She clearly needs him as a prop whereas Mrs Thatcher could manage without Denis!

16 November. An appeal and a collection.
I helped compose a letter from Lord Rosse to Shirley Williams asking for a reprieve for the V & A and for a reconsideration of the whole service of the national collections to the regions. Today the last instalment of Cecil Beaton's collection of dresses arrived [this donation had begun under Pope-Hennessy] and my office was a sea of tulle, sequins and lace by Givenchy, Balenciaga and Dior, all snatched off the backs of Mrs Wrightsman and Mrs d'Erlanger.

25 November. Harold Acton again and 'A Tonic for the Nation'.
Pamela Hartwell gave a lunch for Harold Acton, who was looking better than I'd seen him look for years, denouncing Martin Green, a seemingly dull academic, for insinuating his way into his house and then writing *Children of the Sun*, a scabrous and inaccurate book. Victor Rothschild took out a writ against him which stopped it appearing in England. Green had described his house during the last war almost as a homosexual brothel. The other guests were Aileen and Isaiah Berlin, John Betjeman, Ann Fleming (a rare phenomenon in Pam's house) and Robin Birkenhead.

I sat next to Ann, whom I had not talked to for a long time. She was thinner, more nervous, smoking endless cigarettes, and did a repair job with a battery of cosmetics through lunch. She stays in Arnold [Goodman]'s flat while she is in London, had indeed seen him in bed that morning chortling over having rescued the *Observer*, which had been purchased by some unheard-of American oil-tycoon. Betjeman

was off to look at Brunel's window in the Abbey, led there by a biography of Norman Shaw who had thought it his best.

In the evening there was the opening of *A Tonic for the Nation* [the exhibition to mark the twenty-fifth anniversary of the Festival of Britain in 1951]. It began with a press reception at the Royal Academy, after which the press clambered on board the only one of the four surviving London buses built for the Festival and careered through the streets, arriving at 6.5 p.m. promptly. There was a real sense of occasion. Crowds gathered. The Queen Mother's car eventually swung to its rest and out she stepped amidst spontaneous applause (which she is so good at acknowledging) both outside the Museum and in the entrance hall. It was a marvellous progress. Hugh Casson took her round the show, a feast of memories, and every presentation was full of 'Do you remember – I took you round Lansbury/Dome of Discovery, Campagnia – you planted that tree!' We presented her with a copy of the book, beautifully bound and signed by all the 'survivors', including the architect Basil Spence who had died at the end of last week. She loved every object. I couldn't get her through the Museum because she wanted to look at everything and she was stunned by the Gamble and Poynter Rooms [the Old Refreshment Rooms]. She'd seen Julia's *A Month in the Country* and loved it, was worried about Benjamin Britten,[1] who had sent her a record on her birthday, and she had had a reunion with John and Myfanwy Piper.[2]

It was a marvellously happy evening and we ended with dinner for the doers in my office: Bevis Hillier, Mary Banham and the Firmstones. And the press turnout was fantastic.

Early December. The cuts saga continues.
Meanwhile I am saddled with the trauma of the cuts. The problem is that if the Minister of State [Shirley Williams] is not prepared to push we've had it. Donaldson [the Arts Minister] has failed to move her. He is stuck. This means that devolution – total – must be achieved.

17 December. A year of misery ahead.
The truth of the matter over the savage cuts imposed on the V & A is that months ago Fred Mulley, then Secretary of State for Education, did

[1] Britten was in poor health and died later that year.

[2] John Piper, the painter, and his wife Myfanwy often collaborated with Benjamin Britten, she writing his libretti, he designing the scenery and costumes for Britten's operas.

not lift a finger. Jack Donaldson admitted that nothing could be done. Shirley Williams said that the figures were unalterable. This only shows to me the utter wretchedness of Civil Servants. We were just written off months ago without anyone taking any notice at all of the appalling implications. It means the end of Regional Services. The letters of protest from places as far as Aberdeen and Portsmouth have made no difference at all nor lobbying MPs, the Lords, the Standing Commission, nor the Henry Moore–David Hockney petition. 1977 is to be a year of misery as one inflicts the cuts.

So we sat in Jack Donaldson's office trying to find a way forward and the only way was the one that I had indicated, to summon a meeting in the New Year of all interested parties to solve the crisis. A preliminary to this would be a meeting of national museum directors. There is a logic to this, and if it happened that a central exhibitions system could be set up it would be an enormous step forward, relieve the V & A of a burden and also free up space for the modern collections.

Jack Donaldson gave me lunch quietly and we had a very open chat. He was not enjoying being Minister. All he did was to say 'No'. He could see no policy. In fact it was better not to have one. A melancholy day. Weak, tired, sweet and affectionate, Jack Donaldson is a good man. At least he's a healer.

1977

Darkest Hour

The diaries henceforth begin to speak for themselves, calling for far less preamble. None the less, I can't help noticing that I never wrote about some things which have remained entrenched in my mind ever since. Perhaps that was the reason. One was the confrontation between the unions and the management within the Museum itself. It took place in what was called the Demonstration Room, used by the Education Department. I arrived and sat on one side of the table, flanked by the Museum Superintendent and by officers from the DES and the Arts Office. Opposite sat members of the Museum staff, acolytes attendant upon a central figure, a full-time Civil Service union official called Sheldon dressed in an expensive well-cut suit. This was the period when union spokesmen were trained to deliberately harass the 'enemy'. I had never encountered this type of verbal assault before, and I never wish to again. He started to taunt me in front of my own staff. I remember that I looked down at the table preserving a dignified silence. I had been totally unprepared for this, and my option was either to keep that silence or to sink to his level and return like for like. That I would not do.

As my side left the meeting we walked back through the Northern Renaissance Galleries and came across a group of schoolchildren listening intently while a teacher excited them about one of the objects in the showcases. I turned to those who were with me, emissaries of the DES, and cried out in a trembling voice: 'This is why I came here. Look what you have reduced me to.'

It was indeed the implementation of those cuts in human terms which was to be so terrible. The careers of colleagues were cut short. Others found themselves moved into jobs for which they had little, if any, grounding, let alone inclination. The colleague who was most affected, Madeleine Mainstone, head of the defunct new department, died of cancer. My own hair turned white that year. But the unions were unremitting and unforgiving. Such attitudes might have been forgivable for those on the workshop floor; for educated curatorial staff to argue for a closed shop was unbelievable, but they did. They even

demanded that I appoint someone who knew no Japanese as a curator of the Japanese collections, rather than go outside. On that one I stood my ground, but the atmosphere was poisonous and deeply deleterious to any forward thinking. All one was concerned about was damage limitation. It remains a mystery to me to this day that staff of the Museum should have continued throughout to naively retain faith in the DES as their ally and friend. The Department, in fact, was the source of their misery, but they would not believe it.

There were short darts abroad, one to Brazil to negotiate an exhibition which never happened. During these years I was walking through the dark part of the wood but I was lucky. Two lifelines saw me through. One was the beauty of a contented domestic life, the other was the continuing voyage of the mind. I think of 1977 as the year I learned to write. Although I had produced a succession of books since 1963, *The Cult of Elizabeth* crossed a literary bridge, one I find also reflected in the letters and diaries which become far easier and more relaxed in style. Even in my darkest hour I could go into my writing-room, sit down at my desk and look out of the window at the great cedar tree on the front lawn which held the house in its arms. A tortoiseshell cat would be near or on me, and I would tread the paths of another age, that of Gloriana's England.

15 January. To Jan van Dorsten. A ghastly year ahead.

I am sitting typing this in my writing-room looking out at the sun melting the snow off the garden in front of the house. Your number-one fan, Miss Torte de Shell [our cat] is on my lap. She had a marvellous Christmas with a mint mouse from Harrods with a bell on the end of its tail and another felt catnip mouse from my secretary, but she spurned both and really prefers playing goalie under the kitchen table while I kick ping-pong balls at her.

I was so wretched and exhausted before Christmas and, knowing what hell these opening months of 1977 would be, I cancelled speaking engagements and collapsed down here for a fortnight. It did us both so much good ... We were utterly quiet, only went out to dinner once and regretted it, and only by chance had some old friends for a picnic lunch on Boxing Day, which was glorious because it was all on the spur of the moment. Otherwise I rested and rested.

Everything at the Museum is as gruesome as usual. We are still stuck with no news on the cuts as yet because the Secretary of State is on holiday. At any rate I know that the pronouncement will support my policy (they have to because in this country we are now reaching a

stage where Civil Servants are going on strike or blockading anything which they object to, so that they cease to be the arm of elected Government ...). It is the task of finding ways forward out of the mess which is so awful because it ought never to have happened. On top of this we are having to cope with negotiations on devolving the Museum and, having expressed intent to do so, they are now backtracking which I find sinister, and I find the whole Ministry as it were dedicated against my struggle to get free of them. Oh dear, when will it end? I was put in to run a museum and I am sunk without trace in these endless wrangles.

The cuts saga culminated with the museum unions demanding a face-to-face meeting with the Minister.

1 February. The cuts finale.

At last the day of the meeting of the unions with Mrs Williams. Before that I had precisely seven minutes with her on my own at 3 p.m. at the DES while she hung on to a doorknob wanting to go down to the House. It was hopeless to answer all the problems which could come up, but she was bright and to the point and she grasped what I was able to say in the time. We all reassembled in Committee Room 15 at the Commons at 4.45 p.m. She entered at 4.50 p.m. and we were all out of it at 5.35 p.m. I sat to her right while on her left were John Spence of the Arts Office and John Cowan of the Establishments Division of DES. Opposite sat the unions, who embarked on their familiar litany, defying the percentage of the cuts that the Museum had to sustain, refusing to admit any possibility of closure or of the winding up of Regional Services, in short all the usual stuff. I was quiet which, I am sure, was tactically right. Needless to say it was utterly nauseating to hear those V & A union people trotting out that the cuts would be met horizontally, a tactic we had abandoned as a possibility six months ago.

Mentmore was one of the four Rosebery houses within reach of each other, the others being Tring, Ascott and Waddesdon. It is a vast pile in the Victorian neo-Jacobean style and early on Neil Primrose, now the new Lord Rosebery, whom I had first met doing the electrics at the Shakespeare exhibition at Stratford in 1964, asked me down. I never wrote about that visit but it was quite extraordinary. There was old Eva Rosebery with bright orange hair, a colour, as was said of the first Elizabeth's, unknown to nature. I recall that the Servants' Hall was still in use, that two white-gloved footmen waited on us at lunch and

that when I idly asked what that bejewelled baton was on a console table nearby, I was told that it was the King of Poland's sceptre! Everything was faded and dusty. A door was flung open into a tiny room lined with velvet, the walls of which were hung thick with superb French Renaissance Limoges enamels. Some had fallen off the wall on to the floor and Neil Rosebery just casually picked them up and popped them on a window-ledge. Everywhere one looked there were hidden treasures but I did not warm to the place.

February. The end of Mentmore.

It may well be that people in the future will want to know why Mentmore went under. This in the first place was a saga of appalling delays, but it needs to be made clear that the Roseberys never did offer *everything* in lieu to the State. They offered only the house, a little land and a small selection of its contents, the rest being either removed to Dalmeny or only lent to Mentmore. Secondly, the crisis over Mentmore came at a very bad time. The Minister for the DOE [Department of the Environment] avoided the issue for months. He felt that he couldn't make a move during the summer of 1976 because of appalling inflation and massive unemployment. Mentmore called for £3 million of Government funds plus £75,000 p.a. to run it, apart from any money needed for its restoration.

The delays were such that they got us into 1977, the period *after* the International Monetary Fund had bailed Britain out with a massive loan. All along it was hoped that a foreign industrial concern would step forward and pay one or two million towards the acquisition of Mentmore during the last week of January. From the point of view of the V & A it also came tactically at a very difficult time. If it had been acquired for us, the contrast between that and the closure of the Museum and its service to the regions would inevitably be cause for hostile comment. Now the protests begin to roll into *The Times*, and the other newspapers are also full of it. There is a strong push for some saving action to be taken, but it is difficult to believe that the Inland Revenue will agree to forgo their money for six months. Denis Healey [Chancellor of the Exchequer] has been got at and is not interested. But none the less we await a miracle.

7 February. More on Mentmore.

All day was spent on Mentmore. There was a scabrous piece in the *New Statesman* by Andrew Saint writing under the name of Leo Plendell. It was clear that appalling muddles have gone on. The DOE package to

the Treasury had been too late and was no good because private support fell through and no provision had been made for the maintenance of the house. There was no difficulty over delaying payment of Capital Gains Tax by Lord Rosebery but for what? There was in fact no definite package on offer. Today he came through with a new upped offer of £2,860,000! Sotheby's, he says, have to be paid off.

I saw Alma Birk, who was in a state because of Lord Glendevon's question in the Lords and also because of the piece in the *Statesman*. Everyone decides to play it cool and say that as there was no money the best that could be done was done, and to await further developments. The Land Fund turns out to be a myth with only £17 million left in it, £30,000 p.a. a year of that being eaten up for the maintenance of Heveningham Hall. Also the Roseberys have hardly been monuments to generosity. The old Lord Rosebery left £9.5 million, of which admittedly £4.5 million has to be paid in Death Duties, but on their side there has been no public-spirited gesture to help in any way or contribute to some sort of endowment. Compared with what happened over Arundel Castle the will of the owner was far from helpful.

10 *February. Mrs Williams pronounces on the cuts.*

Today came the culmination of the cuts saga. At 3.30 p.m. Mrs Williams gave a written statement in the House and at 4 p.m. it was released to the unions (who knew the night before anyway). The drafting of that statement was a hair's-breadth escape for me. I had to *insist* that it was altered to read that the Secretary of State had accepted the proposals 'of the Director of the Victoria and Albert Museum' and 'although the Department of Regional Services will be disbanded ...', which meant it was accepted by Government as a *fait accompli* and no longer to be argued about. It was appalling that it had not been in the initial draft. Without it my position as Director would have been utterly untenable. Jack Donaldson had to be reached in a train in order to achieve these revisions.

John Spence at the Minister's Office admitted that it had all been Fred Mulley's doing. Jack Donaldson had thought that it was possible to find a way out of it and failed. Above all, it was recognised that it had been unfair to me. I had taken the rap from everyone. It had shown to the DES the utter lunacy of their running a museum which they did not understand. Jack Donaldson and Mrs Williams now really wished to devolve the V & A away from Government to avoid this ever happening again. It has been a sordid affair and not done my image or career any good. But I've stood firm and, as they said, my gesture upset

the whole system. They were stuck. Perhaps there may be benefits ahead. Certainly it will help the Museum reform itself.

6 March. Mentmore again.

If only the Government had purchased Mentmore for £2 million when it was offered two years ago! The saga drags on with SAVE campaigning away like blazes. The truth of the matter is, there is NO money. At long last this coming Wednesday there will be Peter Shore's[1] *dictum* that £1 million may be forthcoming from the Land Fund if at least £2 million is raised privately. It's a dead duck. I was summoned last Friday and asked to go to Mentmore and see what we could get for half-a-million, £1 million and £1.5 million respectively in the way of contents. I was then handed what turned out to be the probate valuations, which are useless! Donaldson went on to ignore the fact that three or four items alone out of the eight or nine great pieces would come to £1 million and they would have to be paid for out of the Land Fund and not separate from it as he believed. So the Civil Servants at the DES and DOE are furious with their ministers.

Alma Birk, sweet and well intentioned, never seems to be able to grasp the facts. So at long last Mentmore looks like going. But so much of it has already gone, in the great sales between the wars, in what has been already sold since the last lord's death or removed by Neil Rosebery to Dalmeny or by Eva Rosebery to her house in Aylesbury. There has been a really shocking lack of organisation over this one. The procrastination by the DOE for ten months through 1976 was a disaster, also their inability to put together any viable scheme to save the house, let alone their failure to bring in the necessary personnel like the National Trust and V & A who would know how to put together such a scheme. The Treasury regard the DOE with jaundiced eyes as well they might.

Meanwhile the newspapers are covered with the news that the V & A may close on a Saturday with me of course denounced as the villain. It really is cruel. There was no choice in the matter. For the unions there's a mass of mileage in spiting the public.

In the end we were forced to allow the Warders' Union to vote for which day to close and it was Friday. Even when we were open we

[1] Labour MP for Stepney and Poplar, 1974–83; Secretary of State for the Environment, 1976–9.

couldn't ever open all the galleries. The public, of course, complained bitterly but there was nothing to be done.

18 March. Althorp and the Spencers.

Lecturing at Northampton we visited Marion Brudenell at Deene and stayed at Althorp. Raine, ex Lady Dartmouth and now the new Lady Spencer, reigns triumphant. Johnnie [Spencer] is about fifty, rather dull but very well meaning and hugely affectionate. It is a great *amour* and they clasp hands at every opportunity. Raine has in many ways grown up. This time she actually took notice of Julia and didn't, as she normally does, concentrate on the men. Althorp is now totally transformed by her from a museum into a home again. Her own niche, thanks to the hand of Colefax & Fowler, is resplendent with a vast canopied bed, gilded mirrors, tables draped to the ground with heavily fringed cloths and everything arranged, dusted and polished to the nines. Her own little sitting-room has walls of thick striped damask. Much of the Hill Street furniture and all the bronzes are not only here but scattered all over the house. The bedroom is so splendiferous that Johnnie Spencer said that the only thing out of keeping in it was himself. She is marvellous at supporting him and deferring to his views, forever saying: 'Oh Johnnie, you must tell this or that story, you're *so* wonderful.'

How to pay off the Death Duties much preoccupies them. Crates of ceramics were got off to the V & A, one of the Van Dycks had gone to the National Gallery and I arranged for three others to be transported to the Tate. None the less the place is STUFFED with the furniture and pictures from five great houses: Athenian Stuart torchères, endless sets of chairs, banks of pictures, even the bedrooms are hung frame to frame, thick with them. Raine, a monument to creature comforts, has put in double glazing and uses all the great rooms, all rearranged by her. Thirty were sitting down to dinner on Saturday. She has created a new small sitting-room, again by Colefax & Fowler, in shades of cream, lemon, blue, grey and gilt, for Johnnie's collection of Edward Seagos, which hang there very well. As with the rest of the redecoration it was light and sumptuous.

Over in the stables she has opened a shop selling Dior phoney jewels and Floris products, created a banqueting area and, Johnnie's particular pride, a wine shop selling near plonk adorned with a Château Althorp label. Well, Raine will certainly give the county a run for their money.

So many houses in this area – Burghley, Boughton, Deene, Easton, Rockingham – and all lived in still. Marion Brudenell at Deene said

that the Ancasters at Grimsthorpe went on in a house which was never opened as though the sun would never set. Even in 1977 the maids ironed the loo paper and laid it out in fans! Milton too is hard by, unopened and magnificent.

10 May. The garden in spring.

The Laskett garden begins to look lovely after the horrors of the dry summer of 1975, and equally dry winter of 1975–6 and then the great drought. That took its toll. The great beautiful beech tree near the house is dead and many other small trees and shrubs have gone. One great loss was a catalpa given us by Patrick Plunket. Lovingly we watered it all through the summer when we could, out of memory of him, but it went. We'll plant another, and it will be known as the 2nd Lord Plunket! This year for the first time the Rose Garden actually looks like a Rose Garden. I cut the central bed into a circle and filled it with senecio and lavender and other grey foliage plants. The four amelanchiers in the spandrels have flowered for the first time this spring and the yew hedge is now four feet high and sprouting to take it up even higher. The great project for this year is a flight of steps down into a new garden before the Rose Garden.

17 May. The Royal Academy Dinner.

This was a very dull evening with speeches by Shirley Williams, theatre director Jonathan Miller and Princess Anne which were all appalling. Jonathan Miller forgot to toast the health of the Royal Academy which displeased Hugh Casson [the President]; HRH Anne did a defensive speech, a fatal mistake, as she tried to shift her horsey image, while Hugh Casson just twittered. Poor Mark Phillips, HRH's husband, sat looking dim, his hair thinning. Mrs Williams's speech was deplorable, making it out that funds were now available to save the nation's treasures when clearly they're not. HRH is much more becoming in the flesh than in nearly all of her photographs, but she needs far more training in speech-making. She has nothing like the sweeping *de haut en bas* of her Aunt Margaret who rightly has the knack or nerve to sail on, indifferent to criticism.

To meet the crisis over the collapse of a regional exhibition service the Arts Office summoned a conference of interested parties in an horrendous hotel on the outskirts of Leicester in late July. It got nowhere, but during the months before it happened it much pre-occupied the thoughts of the national museum directors. They, of

course, remained untouched by our miseries and kept their heads down. The only one who rang me and offered to do what he could to help me was Norman Reid, Director of the Tate. That gesture I have never forgotten.

23 May. After the cuts and the Mentmore sale.

I had an interesting meeting with Norman Reid, Michael Levey[1] and David Wilson[2] at the National Gallery. At last they have the wind up over the Leicester conference. I said: 'Over to you.' They, fearing the worst, want to postpone Leicester and call their own conference of regional art museum directors but with another end in view, that of 'replacing' the Museums Association. It will be interesting to see how all of this progresses.

At the moment things are, *pace* a few difficulties, looking up. This is merely an instinctive feeling, but now we are past the crisis of a near warders' strike and a lockout, one feels a wave of hope. The policies are laid down and being followed through. There is no more struggle about what should happen. It now *is* to happen somehow, which is quite a different situation.

Mentmore. What a saga! The sale prices have been fantastic. We have the Marie de'Medici cabinet and the Augustus of Saxony bureau in the building. These at least Lord Rosebery parted with to the nation in lieu. He also agreed to us and a few other museums acquiring more things and so we're the richer by a marvellous Flemish table and a 'bureau Mazarin'. British Rail purchased the genuine one of the pair of two superb commodes, so that we have that too, on loan. But we lost the Marin terracotta, the *pietra dura* statues of saints and all the Limoges enamels. Although I authorised a bid of up to £50,000 for one of the damaged milk pails which had belonged to Marie Antoinette we still failed to get it.

June and July. The Queen's Silver Jubilee.

We spent the Silver Jubilee weekend in the country keeping ourselves to ourselves while the village indulged in a turkey lunch, games, watching a coloured TV set up in the village hall, followed by tea and a Jubilee Cake. One can't help reflecting how enormously the stature of the Queen has increased in the last two or three drear years. Shy,

[1] Director of the National Gallery, 1973–87. Knighted 1981.
[2] Director of the British Museum, 1977–91. Knighted 1984.

thoughtful, inscrutable, she remains an enigma to me which, I suppose, is just as well.

Julia was in Vienna working on Bunbury [German title of *The Importance of Being Earnest*] on the day of the great firework display. I had travelled up to London to see Nureyev's *Romeo and Juliet*, which was patchy but not devoid of moments of splendour. As I left the Coliseum at about 10.45 p.m. the night sky thundered and crackled with fireworks. I strolled across Trafalgar Square, awash with people, and then down the Mall, where it was surprisingly thinner on the ground. The decorations in scarlet, turquoise and silver I thought were common. Having a cheap Jubilee was one thing but bad taste another. I stood opposite the Palace watching a huge crowd gradually assemble. It was shot through with plain-clothes policemen directing each other hither and thither. The crowd itself was basically middle-class British. Educated voices could be heard. Men in suits passed by with union jacks tied to the end of their umbrellas. From time to time cheering broke out followed by the singing of the national anthem or 'Rule Britannia' and then more cheers. The crowd was a young one. As I looked down I suddenly realised that it must have rained, for it was wet underfoot and the night air had a decided nip in it.

Then came the moment everyone had been waiting for. The vast TV lamps suddenly beamed down. At last the coaches swept by with their postilions in scarlet and their interiors somewhat ludicrously lit up. The surge of emotion and the lump in the throat was almost tangible. More cheers, waving and clapping and then followed a long wait. The Guards played military music in front of the Palace. At last the centre window opened and out the Royal Family stepped on to the balcony. The roar below was deafening. The Queen only had to lift her hand a little for a tide of fervour to ripple through the masses looking up. Close to me a group started to sing the national anthem, which was taken up across the tides of humanity. One could not help finding it deeply moving, as indeed was the cry of a cockney nearby who yelled up to the Queen: "Ave a good sleep.'

In my strange role as Civil Servant I had been issued an invitation for a reception to be given for the Civil Service at Buckingham Palace on 10 June. Only ten people were to go from the Department of Education. I dreaded it, but there was no way out. Alone, no Julia, and with a flock of zombies. And so it was to be.

It was an odd evening for I knew members of the Royal Family and the Household better than the Civil Servants. I talked at length to the Duchess of Kent, who described how her young son Nicholas, totally

misreading the event, on returning to the Palace on Jubilee Day from the carriage procession had exclaimed, 'I am so glad that Elizabeth and Philip are now married!' and how she had thrown her arms around the Queen, kissed her, and said, 'They *really* love you!' The Queen, she explained, had been totally bewildered and overwhelmed by this huge flood of affection directed towards her.

'What are you doing here?' said Princess Margaret. 'Don't laugh,' I said, 'I'm a Civil Servant.' We sat down in the great White Drawing-Room and talked. Tony, in a fit of pique, had just removed vast tracks of furniture from Kensington Palace. The piano had gone and all the nursery chairs. We discussed Nureyev's *Romeo and Juliet*, which we agreed was patchy, when she caught the eye of the Queen who was just about to disappear through the magic door in the wall with a console table attached to it. 'You're not going, are you?' yelled Princess Margaret. Her Majesty turned, looking, I thought, rather skittish in tiara, jewelled necklace and mini-crinoline and said, 'Yes. I've done all I can. I ask them what they do. They're DES or TUC or whatever and that's that.' Then, turning to me, 'It's the first time we've ever had the Civil Service. I was surprised to see you.' 'Well,' I explained, 'I *am* a Civil Servant!' I then went on to tell her how marvellous the balcony appearance had been the previous night and about the crowd below. I felt somehow that she ought to know. Apparently there was a second appearance after midnight, just the Queen and Prince Philip. Princess Margaret said that she had to more or less push them out as they failed to grasp the fervour of the crowd.

The Victoria and Albert Museum's contribution to this event was the Fabergé exhibition arranged in a hurry by, and thanks to, an old friend, Kenneth Snowman, who is the world's Number One on the subject. That was opened on 21 July by the Queen Mother, who arrived in blue, wearing huge pearls and a sapphire brooch but minus a hat. Looking for someone she knew I rescued Diana Cooper from the mêlée, wearing a black feather hat, questionably of New Look vintage. I'd seen it before, when she told me that someone had left it to her. Later the Queen Mother did her stuff with Kenneth Snowman's American millionairesses and *soi-disant* archdukes and duchesses.

One thing I have discovered is that you can't go wrong with Fabergé. For some extraordinary reason it just grabs people. Of course, it fits into my definition of the three ingredients essential to any successful exhibition: death, sex and jewels. Plenty of the latter, not much sex but they all got shot in the end. There they all were, largely thanks to emptying the vitrines at Sandringham: jewel-encrusted Easter eggs,

gold baskets with lily-of-the-valley in pearls, little crystal vases with sprays of flowers in precious and semi-precious stones. Suddenly the Queen Mother spotted a cigarette box enamelled in blue with a serpent of diamonds winding its way across the lid. Mrs Keppel had given it to Edward VII, she said. On his death, Queen Alexandra gave it back and, at the right moment, Mrs Keppel gave it back in her turn to Queen Mary.

The Queen Mother's own things had mostly been the latter's, but a crystal vase with a spray of enamelled cornflowers had been given her by George VI about the time that the war broke out. She said that she kept it on her desk all through the war. The Royal Family seem besotted with Fabergé. Over two hundred pieces in the exhibition came from them, leaving Princess Anne bereft of her riding-crop and Prince Charles minus his cuff-links.

The following day there was another viewing, this time for the lenders and Princess Margaret, sharing the family's obsession with the jeweller, arrived early in a good mood. At one moment she pressed forward and said in her characteristic drawl, 'Roy's right. It's what you'd call a good egg.' The next morning I arrived to find a queue already stretching from the Museum's front entrance to Exhibition Road. We had a major success on our hands. Julia and I decided to plant a garden in memory of the Jubilee. It will be of white flowers.

June. Museum miseries.

The doldrums continue ... The DES is filled with a beastly, unsympathetic lot of people. We now learn that the cuts package was never in their eyes accepted as a 'package' at all, much to our horror, and whole tracks of it have to go back to Ministers again with parliamentary questions and statements. The July conference on the regions causes much fur to fly. The National Gallery, British Museum and the Tate have implored Donaldson to cancel it. He, however, refuses. They wish instead to hold their own conference of the major regional art museum directors. I agree but point out the illogicalities of including the National Portrait Gallery which is an historical museum, etc. in a firm but polite letter which only succeeds in evoking a page and a half of unnecessarily strong reaction from Michael Levey.

There was no need for him to have worried. It all led nowhere.

6 July. Party time.

Today we went to the last lunch which the Beaumarchais will give at the French Embassy for they leave at the end of July. Both were a delight to know, a mixture of acute intelligence and warm affection. The last year had taken its toll: the State Visit of the French President, London as the capital of the EEC [European Economic Community] with its never-ending flood of visitors, and the French turning anti-British again. There was a not uncharacteristic line-up, about twenty-eight in all at three tables arranged with all the usual taste in flowers and napery and elegant cuisine. No gossip or information of moment.

In the evening we went for the first time for years to a Weidenfeld *fête* and, oddly enough, I rather enjoyed it. Compared with the grand era of the late sixties in Cleeve Lodge, Chelsea Embankment is far more modest. The flat in fact looked a bit worn. There were holes in the carpet and it was very sixties, with its dark red walls and lighting by spots on to busts. All of the objects, apart from the serried ranks of books and a few drawings, seemed devoid of personal association. This was a decorator's job in every sense of the word. I find it difficult to believe that the bouquet of Ecole de Magnasco over the fireplace was ever George's taste, or that vast painting opposite of a late-seventeenth-century church interior, peopled by a court at its devotions.

There were fewer people and far simpler food and wine, in fact just cold beef and mutton with salad followed by a fruit salad served in bowls or silver platters. There was the usual round-up with some repetitions from lunch. I was able to thank Isaiah Berlin for my invitation to the British Academy Dinner and had an exchange with him on the subject of Frances Yates. He was the one who had got her her DBE.

George floated and burbled as people ate, drank and moved around. Julia and I had a long mutual moan with John and Marina Vaizey[1] about the hopeless situation in which people like us found ourselves. We worked ourselves into the ground for little and yet were expected to give all the free services expected of a nineteenth-century gentleman of means, sit on committees, make speeches, give prizes and lectures. The system had made no adjustment. John wanted an October election, a Labour defeat and the reign of Mrs Thatcher. Only in opposition, he said, would Labour reorder itself, split into two and cease being wholly enslaved to the trade unions. His condemnation of unions indeed knew

[1] John Vaizey, economist, was created a life peer in 1976. His wife Marina was art critic of the *Sunday Times*, 1974–91.

no bounds. The raving rent-a-mob at Grunwick repulsed him.[1]

30 June. The British Academy Dinner.

I went for the first time ever to the British Academy Dinner. I knew that I would never be asked until Neville Williams, the Secretary, and Sir John Pope-Hennessy had gone. Both have, the latter to the USA, the former died sadly early. I gave the illustrations of one of his very thin books on the Tudors a pasting in *The Times*, for which I was never forgiven. However, it turned out to be an affair of aged grandeur held beneath the sombre if stirring roof of Middle Temple Hall. I sat between a major Ethiopian scholar (covered in honorary degrees but fairly hard going) and William Watson of the Percival David Foundation, an affable sinologist. But there were some nice explosions opposite with the Rev. William Baddeley of St James's, Piccadilly, and brother of Hermione. Harold Macmillan gave the upstaging speech of the decade, a major theatrical performance of pauses and flourishes, with much bringing up of his notes to his eyes. He in fact said little that we had not heard before, the general drift of which might be summed up in a quote from Talleyrand in the aftermath of the defeat of Napoleon. 'Let gigantic France return to being merely great.' This, he said, now applied to Britain in its decline. Poor Shirley Williams, who also had to perform, never got a look in.

25 July. To Jan van Dorsten. Into the summer.

Can't think where I left you. Actually things are picking up, although I am extremely tired and exhausted and aching for next Thursday when we decamp for the whole of August, barring going up one day to welcome the Queen to the V & A. It has just been solid slog. Very tiring. The cuts have begun to wend their dreadful course in action but the worst of all crises with the unions has now faded away. We are closed one day a week, Fridays, and the demolition of our Department of Regional Services is now happening, but not without political and provincial rumblings. Well, this Government brought it on themselves, so that's that. Julia is busy doing *Die Fledermaus* for Covent Garden, too big a job in too short a time. The Museum has hit the jackpot with Fabergé and they are queuing all day and every day as far as Exhibition Road. It is the success of the year, a legendary show of nine million

[1] Earlier in the year violence had broken out between police and demonstrators outside the film-processing company Grunwick, whose refusal to introduce trade unions had sparked massive protest.

pounds' worth of imperial Easter eggs and Royal Collection *bijouterie*. A few nice pieces but rather like the contents of a superior cracker. Playing to the gallery really, but the public love it, pure escapism and half the Royal Family have asked themselves. *Change and Decay: The Future of our Parish Churches* has opened. Very good, better than the *Country House*, so a balance in shows is there. The Brazilian exhibition collapsed so frantic telegrams have got us the Ludwig II of Bavaria show for next spring. Let us hope that the autumn is calmer. The last year has really been too much to bear...

Change and Decay: The Future of our Parish Churches *should not pass unremarked upon. Over twenty thousand people went to it and it was instrumental in Government at last coming through with grants, via the Historic Buildings Council, for churches. That was a major achievement. Peter Burman and Marcus Binney were the two main-stays of this exhibition. This was the really important exhibition, empty for much of the time while the mobs fought to see the jewels.*

Frances Yates has been made a Dame. Oh, she loves it. There was a touching cheese and plonk party at the Warburg [Institute] and I arrived in time to hear most of her speech. She really is remarkable. At any rate there, at last, is recognition for pure learning. I worked at getting her her first gong and Isaiah Berlin pushed the DBE. That was about the only thing worth celebrating in the Jubilee Honours List. The Jubilee, oddly, has been an enormous success. Somehow one senses that the British are trying to say through it that they want evolution and not revolution, or maybe it's just nostalgia for vanished glory. The crowd cheering was British and young – I stood amongst them and noted that and was deeply moved by it. In fact I told the Queen when I saw her, just in case she thought that she was now only a tourist idol...

In honour of the Jubilee I'm busy digging a new garden here, just before the Rose Garden in the other half of what was the tennis court. It will have a little brick path across it and a sundial in the middle, a couple of phoney statues flanking the entrance to the Rose Garden and a huge circular bed embracing it backed by shrubs. And all the flowers will be white.

The summer.

We had the happiest of summers, a break of five weeks through August into September, coming up to London only once in the first week of

August when the Queen came to see Fabergé. The following day she left on her tour of the south-west and on to Northern Ireland. It is curious the magic which she exerts and how one can never remember a thing that she has said after. There was a lovely flicker, though, when I was laying down the law about how the Americans had gone about attempting to get their hands on the show. 'You're getting pompous,' she said.

The builders came to The Laskett, the gutters were all taken down and realigned, a new downpipe was inserted at the front of the house, the porch and the front door were rebuilt and the stables finally lined with shelves. What an achievement! And we seriously discussed with the builder roofing over between the house and the stables. The tree man came and we arranged for the great beech tree to come down, the four chestnuts up the drive, and a vast branch off the cedar on the front lawn, all very sad. I laid a brick path across the Jubilee Garden and a mass of garden ornaments arrived from Chilstone which I dotted round the garden. It all looked very fine and the plan very developed after only four years. The yew hedges were up to four feet with constant feeding and I began to prune them to form hedges. The great *leylandii* hedge along Elizabeth Tudor was cut off at eight-and-a-half feet. After almost drought till mid-August the rains came and everything grew incredibly, a foot to a foot-and-a-half in two or three weeks, or so it seemed.

Workwise Julia was busy on *Die Fledermaus*. I had to footnote my book *And When Did You Last See Your Father?* and rewrite, yet again, sections of it. Work began in earnest on a book on gardens in England, 1500 to 1700. It was a blissful break, the longest since 1973 I think, and so very much needed. I returned feeling positive, rested, constructive, energetic and refusing to dwell on past woes.

September.

The grind on return was very much as before. We must complete by Christmas the run-down of our staff numbers, a process prolonged solely by union intractability. The Fabergé continues to be a rave...

Everything now hangs on how we can achieve independence of Government. The real nub of the matter lies in the upper echelons of the DES, with Hamilton, the Permanent Secretary, I feel, and possibly also with Walter Ulrich in the Arts Office. I must, therefore, start building up a powerful political lobby to achieve the disestablishment of the V & A.

Edward du Cann[1] came to lunch. This was the first of my feelers. He agreed to sound out MPs in certain areas. At the moment it looks as though the present Government will remain in power and be returned at the next election, so it is no use wholly working for a Tory pledge. I need both parties. This is going to be a lonely and treacherous path but I have set my mind very forcefully on to it.

17 October. Lord Goodman.

We drove back from the country early in order to have dinner with Arnold Goodman. By chance he had hosted a reception at the V & A for the Association for Business Sponsorship of the Arts and I was able to draw him to one side and say that I wanted to see him about disestablishing the Museum. He didn't bat an eyelid. After supper, therefore, Arnold and I disappeared into his study, a room lined with glass-fronted bookcases, Angela Conner's bust of him as well as Sutherland's portrait, and a picture by Forain. Arnold indeed has always collected Forain and his is the largest collection in England. The legal references in them clearly pleased him. There was also a marvellous drawing by Daumier, but otherwise the decoration was comfortable, rather cluttered in fact, with over-large chairs and tables.

He warned me of the dangerous position in which I was putting myself. I was not to be seen to be pushing the cause and must opt out from now on until it could be brought into the open. First of all he suggested a dinner at University College, by chance as it were, one Sunday evening at which, again by chance, Isaiah Berlin, Pat Gibson, Edward Boyle and Lionel Robbins would be present. We talked of those who could influence such a move: John Vaizey, Harold Lever, David Eccles (who might betray it to the DES), Norman St John-Stevas (who might do the same), Lord Clark, Henry Moore. However, he progressively began to think that a letter to *The Times* could be written signed by the key names. Would I write a draft? (This I did and delivered by hand the next morning on the way to the V & A.) The present Minister [Lord Donaldson] was weak and helpless and had no power or influence up the line or over Civil Servants. The Civil Servants were treacherous, so that external influence of a very powerful nature would have to be brought on to the DES. A letter could get it into the open. This could then be picked up by the Press and by Parliament. A lobby could then be formed and a bill launched.

[1] MP for Taunton Division of Somerset, 1956–87; Chairman of the Conservative Party, 1965–7, and of the 1922 Committee, 1972–84. Knighted in 1985.

19 October. The Sleeping Beauty Gala.

The new production of *Sleeping Beauty* at Covent Garden is a very boring one, back to 1946 virtually in its entirety with uninspired Bibbiena-type Messel scenery but *sans* the Messel magic. But there was some marvellous dancing. HRH Margaret presided in a white and gold dress which fell virtually straight from her shoulders to the ground. We were rounded up for her table afterwards. Carl Toms was in attendance and we fetched up the dancer Wayne Sleep for further entertainment. HRH bet that we didn't know who designed the dress. It had been made for a party. Yes, Carl had designed it and Bermans had made it up from saris. She was off to New York and then to Mustique. She was in her best playful mood, nicking bits of food off Wayne's plate, generally chortling, and wishing to polish off the cats in Act III. I said that I wanted to shoot the Bluebirds. The picture was the usual one: seated at a table holding court waving a cigarette holder with a glass of whisky and slightly giggly. Julia was embraced by her, which was a new departure.

27 October. Meals out.

A newspaper man told me that it was Lord Donaldson's greatest boast that in being Minister for eighteen months Lady Donaldson had never had to cook one dinner.

2 November. John Sainsbury's half-century.

John Sainsbury[1] is fifty. The house in the Boltons had a pink and white pavilion added to it, swallowing up the entire garden. There were about a hundred and fifty guests at round and oval tables, each seat carefully numbered. Everything was done on a large and lavish scale, the tent banked with flowers and lit by brass chandeliers, the food from the lobster onwards superb. Three worlds mingled: arts, politics and business. We seemed to know most of the first two. We had rather a dull table with Rosamond Lehmann, Wagnerian in size and hung with diamonds like pieces of coal, Pat Lousada, Ken Davidson, Sir Robert and Lady Sainsbury, David Wall, the dancer, and Lionel Robbins, the last decidedly getting on in years. I had quite a good session with Robbins, extolling the virtues of the Trustee system. Earlier a lot of them had been at publisher Jock Murray's over-crowded party for

[1] John Sainsbury, chairman of the family business, 1969–92; served on many committees including the V & A Advisory Council; he was chairman of the Royal Opera House, 1987–92. Created a life peer in 1989.

Betjeman's *Archie and the Strict Baptists*, Reynolds Stone's collected works and K Clark's second volume of autobiography. K Clark is getting married again and going to live in France. Rab Butler told me he told K that he hoped he's used 'I' less in Volume Two.

All the world seemed to be at the Sainsburys. The dancer Lynn Seymour came late wearing a looped-up dress with no skirt, her hair frizzled, her eyes saturated in kohl, disagreeable. She sat next to Nureyev, also looking rather raddled and disagreeable. The Mosers came on after having had the Queen Mother in the box for *Beauty*. She had gone privately but once the audience caught a glimpse there was a burst of applause and affection. I discovered that Arnold Goodman had done nothing about the V & A and broached the subject with Noël Annan. The Poet Laureate and Elizabeth Cavendish then entered. I said, 'I hope that Archie was an Anglo-Catholic bear.' 'No,' came the reply, 'he was Low Church,' and we commiserated and agreed to have an evening together.

16 November. K Clark's memoirs: Graham Sutherland and Henry Moore.

I had been asked to chair the Foyle's Literary Luncheon for K Clark's second volume of autobiography, *The Other Half*. The top table was the usual Madame Tussaud's. I was flanked by K and Graham Sutherland and the other stars present were Cecil Beaton and Henry Moore. I did an *hommage* from a younger generation to an older one.

There was, I gathered, to be an Order of Merit rally at the Palace tomorrow for the new OMs, Fred Ashton and J. B. Priestley. Graham Sutherland said how awful Priestley was with his put-on Yorkshire accent and third-rate writing, bar *The Good Companions*, K was deep into Walter Pater and his speech was full of 'I': 'I think that bit of the book is good ... is less good ... is more perceptive ... is less ...; I like describing people; I can't help it if all my friends happen to be NAMES.' Oddly enough one does like the man. He's not really vicious, certainly not in conversation. There is a marvellous urbanity about him, but it is very noticeable that his interest in other people is nil. I have never known him ask how one was or what one was doing. One makes conversation at him and he, in reply, makes statements. I suppose that must be the virtue or the shortcoming of the great.

Graham Sutherland is, however, a thoroughly nice man with a twinkle in his eye and such a pleasure to talk to, that is away from his wife Cathy – hard as nails with her tight-pressed lips and her little Chanel suit, exuding the warmth of a tiger about to claw. What a shame

he never found a Myfanwy Piper! And yet the marriage works. She is his keeper, his defender, his protagonist. No, he knew that the recent Portrait Gallery exhibition of his portraits had not worked and I said that it should have happened ten years ago when I did the first correspondence with him. He was very sweet and said that I was right but taxation had intervened. George Weidenfeld was after him for his memoirs but he was instead going to write for an Italian publisher a short book on his art.

Henry Moore at seventy-nine would beat anyone on the rugger field, a tough northern lad, revelling already in his eightieth next year with a show at Bradford (his home town) and all over Hyde Park by the Arts Council. It is all such an interruption, he kept on saying, but, oh, how one knew he loved it.

23 November. The new American Ambassador.

We went to dinner with the Kingman Brewsters at Winfield House, still minus their possessions which are stuck on a dockside somewhere. She is delightful, warm, affectionate and unpretentious, providing the atmosphere for a husband who is impressive, dignified, intellectual, funny and canny. But their arrival certainly heralds a very different style, an absence of duchesses and social whirl. It was a small dinner party with no twits, just Freddie and Rosemary Fischer (*Financial Times*), Dr David Owen and his wife Deborah.[1] I liked her very much. It will be interesting to see where he ends up. As Freddie remarked, if he has the Foreign Office at thirty-eight he can only move to being Chancellor, so the likelihood is, if Labour are returned, the team will stay the same. They were a good, clean-cut professional couple. Freddie admired the way he had coped with Rhodesia, unlike his predecessors who turned their backs on the problem and hoped that it would go away. David Owen said that if the Government went to the country now they would lose.

24 November. Farewell to John Fowler.

Today there was a memorial service for John Fowler at St George's, Hanover Square. It was sad but happy, packed with worthies, grand ladies from the shires in broad-brimmed black hats, representatives of Colefax & Fowler, the National Trust, owners of great houses, boys

[1] David Owen, at this time Labour MP for Plymouth (Sutton) and Foreign Secretary since February 1977, was to be one of the founders of the Social Democratic Party in 1981; he was created a life peer in 1992. Deborah Owen is a prominent literary agent.

that he had trained and inspired. There were great baskets of flowers, white and green, flanking the chancel steps, very John, and clipped bay trees at the back. Rachel Kempson,[1] not in black and looking marvellous, read 'Fear no more the heat of the sun . . .' from *Cymbeline* and James Lees-Milne,[2] looking thinner and older, gave the address. It was a simple, loving one, how he'd first known John in 1944 when he had invited him to share his air-raid shelter in Chelsea, how John had gone off some evenings to dress the most terrible wounds of blitzed people, his taste and his care, the way he'd lift his thick glasses and look at a Georgian nail, his early privation and poverty (about which he couldn't bear to speak), his mother's scraping to educate him, his misery as a bank clerk, until he went from being an assistant in an antique shop to working at Peter Jones. The rest was history. Decoration is such an ephemeral art. As things now stand with the gloom encircling the great houses his work is literally the last in a line stretching back to Inigo Jones.

28 November. Heritage in crisis and Harold Acton at Kensington Palace.

Today I had a melancholy visit from John Spence of DES. No, there would not be a triennium. Purchase Grants for museums, due to inflation, would continue to be annual until financial stability was regained. The million for the heritage wrenched by Shirley Williams in Cabinet in the aftermath of Mentmore would be made over to the museums and taken out of the hands of the politicians. He said that the regions and works of art other than pictures should be better provided for. The National Land Fund didn't exist, but £3.5 million p.a. did. This should also be made over, he thought, in the same way, that is, out of the hands of the politicians. Government could do nothing in the present circumstances but salvage what it could until some measure of maintenance relief could be given to owners of houses. He could see no way of saving Kedleston. It was hopeless. All that could be done was to rescue the contents. There was no money to maintain it. Burghley, Wilton, Chatsworth all loomed as the old generation died off and the new couldn't any longer face going in, nor face the kind of life it meant. Spence is always the apostle of gloom. He foresaw more cuts to the V & A unless we could get clear of Government and rued the stupidity

[1] Actress, wife of Sir Michael Redgrave.
[2] Writer, architectural historian and diarist, largely responsible for involving the National Trust in rescuing country houses.

of the V & A staff side who fought for continuing to remain part of the DES.

That evening we dined with Ingrid Channon at Lindsay House prior to HRH Margaret's round-up for Harold Acton. It must be one of the largest private houses in central London, everything done to decorator's taste and Ingrid must spend all day banking it with flowers. The dinner consisted of the Rory McEwens, the Lichfields, Norman St John-Stevas, Davina Woodhouse and Derek Hart.

The drawing-room at Kensington Palace presented its usual scene. HRH in plummy red with a gold belt, smoking and drinking whisky, in good form surrounded by a motley crowd, some of whose identity we never established but included the Harlechs, the Rosses, the Tennants, a young Bacon boy, a Ramsay and Roddy [Llewellyn]. We'd never met him before. He was like Tony round again, thirty-ish, rather dapper, but very polite and assigned to a kind of 'host' role getting drinks and ferrying them to people. HRH showed no overt interest in him, although he would spring up and actively join in anything that she wanted.

Anne Rosse, in her usual low-cut dress with a slit hemline and manacled in diamond stars, was very unhappy. It did seem rather tactless to ask Anne and Michael with Roddy there. She was in fact shocked and confided her embarrassment at being present at a party where her own son was replaced before her eyes by Roddy. HRH's trip to the US had been a great success. She had stayed in Drue Heinz's house with fleets of hairdressers and chauffeurs in attendance. I asked the million-dollar question, 'Does Roddy stay here?' 'Yes,' was the reply. He's agreeable, not nearly as bright as Tony, rather silly and giggly, but kind, and she hasn't had much of that.

At one moment we were about to safely plunge for the exit when HRH clapped her hands and poor Harold Acton, seventy-three and overtired, had to sing two songs in Chinese and then she headed for the piano. I knew that we were stuck and it was Scottish ballads until 2 a.m. with Rory McEwen bearing the brunt of it, poor soul. HRH only wielded her sceptre once on poor Leonora Lichfield. They arrived at midnight and HRH told them that they'd been bidden for 10.30 p.m. HRH and everyone else had been thrilled with the gala the night before and Julia's beautiful *Papillon* costumes for Fred's *pas de deux*.

6 December. Lunch at Clarence House, the new Lady Clark, and the Royal College of Art.
We were bidden to lunch by Queen Elizabeth. There were the usual

welcoming corgis backed this time by the sight at the rear of the famous 'drunken' hired butler we'd once seen fall backwards on a sofa with a trifle at George Weidenfeld's. Aird and Gilliat[1] as usual were doing the introductions. Clarence House is really like a very grand country house in London. The drawing-room has the Augustus John portrait of Queen Elizabeth, purchased after his death, over the fireplace. Someone else had sat for the body wearing her dress and jewels. To the right of the door as one goes in hangs Millais' *St Agnes Eve* for which Queen Elizabeth had recently bought a sketch for the central figure, rather cheaply she said to me, at a sale at Christie's or Sotheby's. On the wall opposite the fireplace there is a huge full-length of Charles I and his son, Charles II, after part of Van Dyck's vast family group, flanked by Lely portraits of ladies. In a corner by the window there is a tranquil *quattrocento* Italian Madonna and Child which, she said, always radiated peace and quiet to her.

The Ritz crackers as usual were handed around in the packet to what was a formidable line-up, too large for cosiness really, about twenty-five in all, and too many old people. It included a marvellous Czechoslovak couple, Prince and Princess Clary, she eighty-one, he ninety-four. They had had to leave their country with nothing, and now lived in Venice, but what a life and what memories! Their movements belonged to the Edwardian age. I sat between the Dowager Lady Hambleden and Ruth Fermoy, who is a thoroughly good no-nonsense sort. I'd never realised that her daughter was the displaced Lady Spencer and all the troubles when Raine [Dartmouth] literally 'moved in'.

The lunch was held in the dining-room, although in this house what is the dining-room seems to change. This one was hung with portraits of George III and his family. The table seemed enormous with banks of flowers and the *biscuit* eighteenth-century hunting figures which she loves upon it. The food was really bad; a deep-fried rissole, frozen Brussel sprouts and mashed potatoes, even if they are served on silver, don't rank in my running as even good plain food. But Queen Elizabeth was in good form. She'd loved *The Sleeping Beauty*, full of nostalgia for her, and was thrilled to be presented with *About the House*[2] with Julia's portrait of Kiri te Kanawa as the *Fledermaus* Rosalinde on the cover.

The day ended with a late-night supper given by Fleur Cowles[3] in

[1] Sir Alastair Aird and Sir Martin Gilliatt of Queen Elizabeth's Household.

[2] Magazine of the Friends of Covent Garden.

[3] American painter and hostess, formerly an editor and journalist. Married earlier to Gardner Cowles, and later to Thomas Montague Meyer.

honour of the new Lady Clark, a woman who farms near Dieppe. K was really geriatric, entering the room like Betjeman clutching invisible banister rails and placing one foot before the other in tiny steps. It was quite an effort to talk to him. Obviously he'd been bewildered by the dinner before, to which Fleur had invited no one he knew.

Recently I was twice offered the Rectorship of the Royal College of Art, first by John Hedgecoe[1] and secondly by a more 'official' emissary, the Deputy Pro-Rector, Dick Guyatt. It was immensely flattering to be thought of as the only person who could lift that place out of the mire into which it had sunk under Esher. I did toy with it, but it is a step sideways, slightly downwards. I could do it, yes, but why leave the V & A when some achievements at last are in sight?

14 December. Warwick Castle begins to go under.

So the Warwick Castle Queen Elizabeth I was purchased by the National Portrait Gallery for £75,000! A bargain, marvellous! How sad to see the dismemberment of Warwick Castle. For years David Brooke has popped pictures and filled the gaps from Bonhams. He now lives in Paris and attends lectures at the Sorbonne, springing up and spouting apparently over-the-top right-wing views. This is deeply sad and his father's comment that he had as much right to sell the contents of Warwick Castle as the owner of a council house was deeply damaging to the battered cause of country-house owners. I am not optimistic.

22 December. Rebecca West at eighty-five.

Last night we went to Rebecca West's eighty-fifth birthday party. It was given by Gwenda David, a 'scout' for the New York publisher Viking, in a tiny house, Trellis Cottage, off Hampstead Square. It was a funny NW line-up, all literary: Kingsley Amis and his wife Elizabeth Jane Howard, Robert Lacey, author of *Majesty*, the Owens (Foreign Secretary); his wife Deborah, had started her career with Nicholas Thompson [our old agent]), Kaye Webb, a large lovely lady who had been Ronald Searle's wife until he upped to Paris, and Anthony and Sally Sampson. There were about twenty of us in all, crammed into this small space waiting for food from eight until ten which, when it eventually came, was sparse.

Dame Rebecca sat on the sofa in her Yuki dress, occasionally donning spectacles like ice cubes, with ankles and feet like balloons and with a stick at her side. Everyone did *hommage* and for a moment she stood

[1] Pro-Rector and Professor of Photography at the Royal College of Art.

up and the old sparks blazed again in gratitude. I earned my keep by cutting the cake. It was a pure *Lucky Jim*[1] scene: virtually nowhere to sit, bad wine decanted into minute glasses, and a scream as someone who was starving attempted to get a mouthful more. I don't honestly think that we enjoyed ourselves. But I enjoyed talking to Elizabeth Jane Howard, who must be past fifty and was wearing too much make-up. She probably has an awful time with him. They've moved house four times and now she has no real garden, something which she loves. We mostly spoke about cookery, about which she knows a great deal.

30 December. To Jan van Dorsten. The end of a difficult year.

I can't think where I left you in the Strong saga. The autumn has in fact been very GOOD. Somehow the tensions in the V & A have subsided, the deep-rooted hostility to an outsider has almost gone after four years ... and I found myself invited to no less than seven different Christmas parties. Never been asked to any before. My ego was also buoyed up by being offered the Rectorship of the Royal College of Art in succession to Lord Esher – £2,000 a year more, academic holidays and a flat. Apparently I was regarded as one of the two people who could do it – rather amazing isn't it? I also learned that they had seriously considered me in 1967. Rumour ran rife in the V & A, which really echoed to one's credit as I turned it down. I could do the job BUT I really couldn't face another four-year battle getting to know people again, establishing contacts from scratch. As Julia said, why the hell should someone else reap the benefits of all the drudgery and dirty work that you've been forced to do? I feel sure that I took the right decision and once made I've never reconsidered it. So I don't feel that I shall be moving until my early fifties, if at all, and then where?

The first night of *Die Fledermaus* is tomorrow. Yesterday we went up for the dress rehearsal. I cannot tell you how lovely it is. Julia's ball scene is simply magical, evoking Tissot paintings of the seventies, the most wonderful ball dresses, and a set which unfolds its spectacle throughout the act. There was a burst of applause when the curtain arose – unprecedented at a dress rehearsal which is hard business. And it really looks mid-European.

I am busy planting the Jubilee Garden with white flowers. How you will love it when you see it. And masses more planting to come. You will see how the Great Plan is developing and the bits of statuary really give it an architectural feeling pending the growth of those yew hedges

[1] A comic novel by Kingsley Amis satirising post-war provincial university life.

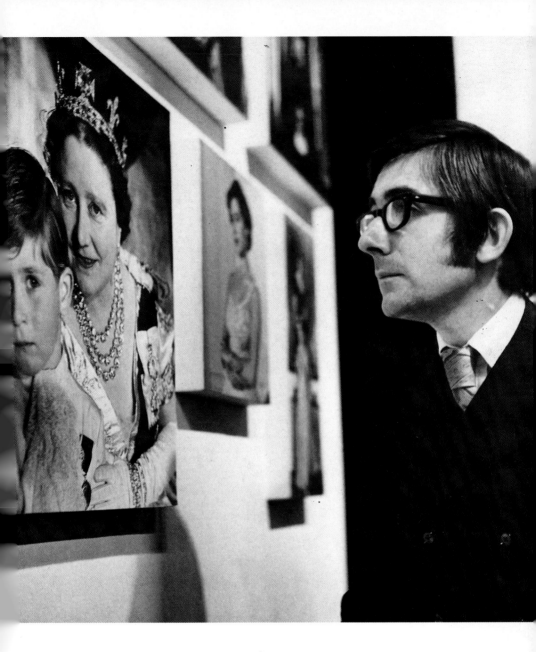

Homage to the Queen

The Beaton Exhibition, 1968

The National Portrait Gallery

before (above), and after (below)

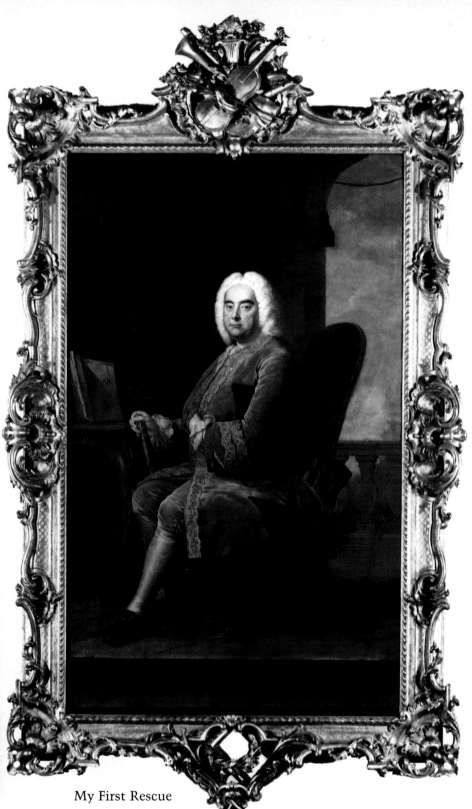

My First Rescue

Handel with *Messiah*, 1968

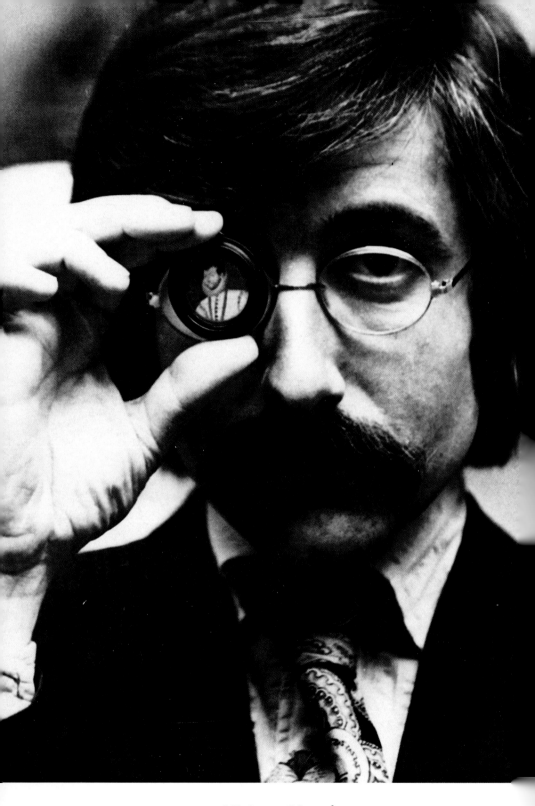

Miniature Monocle

Sir Francis Drake, 1971

and obelisks which I fertilise so frantically each spring.

I hope 1978 will be less horrid than 1976 and 1977. I really couldn't endure it. There will be a terrific battle to disestablish the Museum which I really want to achieve, but the unions are against and they, as you know, run everything (into the ground I feel like adding). How lucky I am to have Julia and our blissful working loving professional existence, and this glorious house and garden which I love more than any other patch of earth in the world and which yearly becomes more and more US. Count one's blessings ...

The end of 1977.

This has been a strange year, one of problems and mirages, of pageantry and nostalgia, of the stirrings of radical discontent. How enormously complex the broad perspective seems. The middle and the professional classes have had their incomes and their values seemingly flung to the wall. The virtues of talent, hard work, and reward are in disrespect. Taxation is crippling. Any money made in excess of my salary is taxed at the rate of 87 pence in the pound. The only point of doing any extra work is, therefore, for tax claims not for income. And yet we end the year seemingly on a more even keel, North Sea oil promising untold millions and the stock market rising fast but we are still faced with unemployment, vast cuts and strikes. The Wealth Tax rides again, hitting anyone whose property or income exceeds £100,000, a figure easily reached by vast tracks of the educated section of the community: a house, a cottage, some shares, a couple of pictures and you are there. The levelling would be achieved but farewell to houses, gardens, collections, patronage – or perhaps not – perhaps the tax will mean spend, spend, spend.

Not an easy year for us. Deep unhappiness in handling the V & A cuts. None the less in the autumn I felt more at home in there ... The great battle of '78 will be the status of the V & A. How lucky one is to have the security of The Laskett, its gardens growing, a private loved Arcadia.

1978

Scenes and Apparitions

On 19 January Lord Goodman's promise to launch a campaign to get the V & A out of the clutches of the DES was set in motion. It took the form of a joint letter written from him and Lord Gibson to *The Times*. A huge media battle then took off, with endless letters from both sides, which spilt over into other newspapers and from there on to the news and editorial pages and eventually on to television. The DES were not pleased, and I certainly must have ceased to be loved by them in any sense of the word. Civil Servants after all were paid to be faceless zombies whose prime task was to carry out unquestioningly the will of their masters. But what they had not reckoned on was that the arts world was, and still is, a volatile one. Whereas not a line of printer's ink was worth expending on the fate of the Science Museum, the V & A has never ceased to attract media attention, heightened, I suppose, by being landed during these years with what must have been the country's first media-oriented Director. In going out and challenging Government I was fully aware that I was laying my head on the block. It certainly delayed the customary bestowal of a knighthood, but what was that worth in the face of betraying the institution I had been appointed to direct?

The strength of being a director of any institution depends not so much on support within as on powerful friends in the larger world outside. Without those I would never have been able to defy Government and with such allies I knew that however much the DES tried to gag me, and they did, I was in a sense untouchable. We, in fact, won our case, for on 5 October Shirley Williams instituted public consultations on the future of the two departmental museums, thus inaugurating the tortuous pathway which was to lead nearly six years later, in April 1984, to the Museum's first Board of Trustees.

The greatest pleasure of the year for me, however, came from the exhibitions of contemporary artefacts which moved the Museum's image firmly into the present. I recall asking the Department of Prints and Drawings shortly after I arrived where their contemporary design collection was. The reply was that they were terribly worried about

what they had from the twenties and thirties. I replied that I was more worried about what they had *not* got from the fifties and sixties, items which could be had for the asking. This was the year that the Archive of Art and Design was established (with the usual opposition from the staff), one which grew rapidly and is now recognised as a major source for this country's design history, housing a wide variety of media from paper and photographs to film and magnetic tape.

1978 was a curious in-between year but things were beginning to pick up again. Work actually began on the conversion of the Henry Cole building, although how we were ever to man it when it opened no one had a clue. There was a strange trip to Japan to negotiate the exhibition of Japanese post-war industrial design which I had had in mind when I arrived in 1974. For the Japanese it was extraordinary that someone so young was Director of a national institution. Learning that, as one achieved one's forty-fourth year, was some comfort at least.

Into the New Year.
1978 began with a BANG, Julia's production of *Die Fledermaus* at Covent Garden! Christmas and New Year were entirely spent in moving to and from the opera house. After all the cuts, trials, difficulties and deceits, when the curtain finally went up, as is so often the case, it was marvellous. It was televised throughout Europe and America, a great triumph for Julia with appreciative reviews. How proud of her I felt as she took her curtain bowed under bouquets of flowers.

11–12 February. The Royal Lodge Arts Festival.
We were asked to 'The' Royal Lodge (as one is supposed to call it) for the weekend, bidden to arrive at 6.30 p.m. on Saturday. By some miracle we got there from Herefordshire on the dot without losing our way in the Great Park which we usually succeed in doing. As we stepped out of the car in the dark we spotted what seemed like familiar figures emerging from the next vehicle who turned out to be Elizabeth Cavendish (in the middle of a crash diet and half the size) and the Poet Laureate [Sir John Betjeman] (eyes now OK, double vision having been cured, but with Parkinson's, but all the same looking better than we had seen him for some time). Well, we then knew that we weren't in for the stuffies. The line-up was Norman St John-Stevas, David and Rachel Cecil,[1] David Mackenzie and wife, both delightful, Fred Ashton,

[1] Lord David Cecil, critic and literary biographer of, amongst others, Jane Austen and Lord Melbourne, and his wife Rachel, daughter of Desmond MacCarthy.

Ruth Fermoy and Martin Gilliatt. Princess Margaret, of course, in good mood.

It is essentially a modest establishment. A large rambling Wyatt house of quite undistinguished architecture, painted bright pink, surrounded by hedges and gardens planted in the thirties. Within, that late thirties taste and comfort is still evident, the era when bathrooms had no pictures on the walls or carpet on the floor. The bedroom we had had the classic dressing-room leading off it where the man could sleep. The bedroom was pink and hung with watercolours by cords suspended from a picture rail, again thirties. Flowers were still taken out of the room at night. All life, however, centred on the great room. I'd forgotten that I'd lived with that at the National Portrait Gallery for fifteen years, the famous Wyatt Green Gothic Room in the Sir James Gunn tea-party group of George VI and family! It was marvellous to exclaim about that fact to Queen Elizabeth on arrival. It is a huge room whose robust Gothic panelling is subtly painted in shades of green and lit by wall lamps and two vast chandeliers. George IV presides over the chimneypiece flanked by two huge Wootton hunting pieces. At one end of the room there is a large verdure tapestry with a console table before it, covered in blue-and-white vases. At the other end there is a grand piano. There were sofas and chairs and desks at which to write and an atmosphere of solid comfort and warmth. All along the wall opposite the fireplace were Gothic french windows opening on to a terrace and a landscape park.

The staff consisted of a battalion of men dressed in what looked like World War II Civil Defence Corps uniforms. The routine was that of a country-house weekend: drinks, change, dinner, talk. No prizes would be awarded for the food, which was safe English: plain fish with a butter sauce, roast beef and apple pie. Because there were two women, Queen Elizabeth and Princess Margaret, who had to be at either end of the table, the placement concentrated on getting new men to sit next to them and everyone else was placed pell-mell in between. As a result Julia got stuck with Norman and Martin Gilliatt at two meals running. On Sunday the men were obliged to appear for a cooked breakfast, which I loathe doing. Exchanging badinage with Norman at 9.15 a.m. on Mrs Thatcher is trying. I retreated to Julia and stayed put until we went with Princess Margaret to the chapel in the park for Holy Communion at 12 p.m.

We stood outside the church waiting for matins to end, after which the locals trooped out bowing and curtsying, and then suddenly round the corner came the Queen on her own, in a horrid fur hat and looking

very tired. After communion we walked back, myself guiding the tottery Sir John. By the time that we arrived the great room was wholly given up to frivolity, so much so that one really felt sorry for the Queen who had to go, as she said, and dish out New Year's Honours to those who got them in Windsor. After lunch we went in a party to look at the Royal Library, bowling right down the Great Walk, a marvellous drive, and straight into the castle courtyard. The Royal Library is always a mystery as there is no catalogue, so one is always spotting something else one had never seen before, this time a poem of Elizabeth I, an embroidered box belonging to Charles I, Charles II's Bible, etc. The rooms are like some tremendous filmset between shots, roped off for visitors with the furniture pushed to one side, and flowers.

Back again to Royal Lodge for a rest for, at 6.30 p.m., we all had to reassemble for drinks and a reading by David Cecil with piano pieces played by Joan Drogheda. For this performance others came: Garrett Drogheda in his brother's 1932 dinner-jacket, very Bertie Wooster, Gay and Martin Charteris,[1] now dug into Eton, a handful of Eton children and Robin Mackworth-Young and wife. We all sat and listened to Ravel, Rachmaninov and Schubert, interspersed with readings by David from Hardy, Tennyson and Anon. One can hardly hear what he says any more, but somehow it doesn't matter. Dinner followed and then a frenzy of toasting: to our hostess, to HRH, in memory of General de Gaulle, prefaced by the Marseillaise, to music and literature, to Pope Paul and Donald Coggan, all interspersed with songs like 'If You Were the Only Girl in the World' belted out or hummed. Elizabeth Cavendish warned me that this could last till 4 a.m. Thank heaven it didn't and we adjourned.

There is something marvellous about Queen Elizabeth, always utterly unflustered and a true merry widow. Crises seem not to affect her. Warmth of friendship flows freely, together with an intense interest in everyone, and in what they are doing. When we talked of what, if the place caught fire, we would rush in and save, her answer unashamedly was the photographs of the grandchildren, just as we would snatch up the memories of our scrapbooks. She said that she knew when she looked a fright when her page didn't exclaim how marvellous she looked!

[1] The Queen's former Private Secretary had become Provost of Eton; he was Chairman of the Trustees of the National Heritage Memorial Fund, 1980–92. Created a life peer in 1978.

13 February. Sybil Cholmondeley and Roddy Llewellyn.
We went to dinner with Princess Margaret, one given in honour of Sybil
Cholmondeley, who apparently arrived at 8.10 p.m. on the dot. It was
a funny line-up: the actor Paul Scofield and wife, David and Rachel
Cecil, Rose Cecil and some other young ones that HRH was match-
making with – and Roddy. Roddy sits opposite her at table in the
role of host, which is rather unnerving. Lady Cholmondeley was very
intrigued and rather shocked by it. After dinner we were taken on a
tour of the upstairs including the bathroom with the vast Gothic door
Tony and HRH had found, which had led to Carl Toms designing a
Gothic bathroom. In the middle there was a table with a showcase on
top of it for her shell collection which, considering the amount of travel
she does, struck me as very small. In the bedroom there was a fine head
of George VI by James Gunn ('Awful snob, Gunn,' she said. 'Loved
coming to Balmoral') and a head of Elizabeth Tudor by Oliver Messel.
It was a large room with an enormous double bed with a canopy over
it.

The dinner was rather lavish, I thought, starting with lobster and on
through the usual game birds, the table heavy with silver and glass.
HRH is an extremely good hostess and moves people around so that
everybody speaks with everybody including her. Her dress was virtually
topless, apart from two thin shoulder-straps, and the top was entirely
made of glitter beads. Julia had Roddy come and tell all, totally un-
prompted, a long saga of operations on nameless parts and his singing
career. What upset her were his purely selfish motives. It wouldn't last
long and he should get as much out of it as possible. He is, after all,
fifteen years younger at least than HRH. Derek Hart, a loyal and loving
friend to HRH (would that she'd marry him!) saw the picture. Roddy
is a pretty young blond man but, unlike Tony, not bright. She seems to
have thrown all discretion to the winds. He apparently stays at The
Royal Lodge and shortly afterwards he flew off quite publicly with
HRH to Mustique, where he was carried off to hospital due to internal
bleeding and HRH rushed to his bedside. It is all rather sad and pathetic
and deeply embarrassing for the Queen surely? During this period Peter
Townsend[1] published his memoirs of their attachment, an act in the
worst taste. Derek Hart said that she never did love him. One does feel
rather sorry for her but she does so very little to help herself.

[1] In 1955 Princess Margaret had publicly stated that she would not marry the divorced
Group Captain Peter Townsend, who had been equerry to King George VI.

3 March. Queen Elizabeth again.

Julia was ill in the country this week so I came back, not well either, and soldiered through events on my own. This was the evening of Ingrid Channon's dinner for Queen Elizabeth. Lindsay House was decorated in splendid fashion for the occasion and banked with vast vases of spring flowers and bowls of hyacinths. No less than three menservants appeared, one holding an umbrella over guests as they arrived in the rain.

I was placed on Queen Elizabeth's right with Diana Cooper on my right. Diana at eighty-three or -four still fabulous in yards of Indian glitter fabric with those huge blue eyes lustrous as ever, although she can hardly see where she's going any more. At seven next morning she was off to the United States to stay with Nigel Ryan, 'the last attachment'.[1] Diana was sad about Enid Bagnold,[2] Lady Jones, now in a nursing home in Brighton, her family never going to see her. If only she were in London...

Queen Elizabeth was in one of those floating creations which she wears on informal occasions, this time in blue, as against the state crinolines. I noticed her shoes which were straps of rhinestones with peep toes; most of the stones were missing and they were very old but very comfortable. How typical! No, she didn't care for the ballet *Mayerling*. Fred Ashton at the other table kept on raising his glass to her to which she responded. It was a game which they had played for years. Poor Fred was not pleased that the ballet had been dedicated to him. As Queen Elizabeth remarked, the Empress Elizabeth would never have danced in front of the court. She too was to be up early in the morning, off to see horses. Her energy is remarkable. I know for a fact that she had been to Thelma Cazalet's for lunch that day and the previous evening had gone with Lord Donaldson and his wife to the whole of *Don Giovanni* at ENO. After dinner we sat at her feet while Fred described a ballet in which she would descend in a cloud.

7 March. The battle for the V & A.

So much has happened in the last few weeks and one is so TIRED. The battle raged over the V & A, reaching a crescendo, and then subsided. It was begun by Arnold Goodman and Pat Gibson, with prompting,

[1] Nigel Ryan, Editor and chief executive of Independent Television News, 1967–77, and with NBC News in New York, 1977–80, was so referred to by Lady Diana Cooper.

[2] Novelist (*National Velvet*) and playwright (*The Chalk Garden*), the widow of the former head of Reuters, Sir Roderick Jones.

and, with more of the same, continued with letters from Henry Moore, John Piper, Peter Lasco, Brinsley Ford, Hugh Leggatt, etc. culminating in an editorial in *The Times*. There were scabrous union letters in opposition, and a particularly dreadful one from Hugh Jenkins.

But one is faced with the tortuous paths of the Civil Service and what happens is really locked up in the inner recesses of Elizabeth House [DES] and in particular with the Minister's henchmen, John Spence and Walter Ulrich. Donaldson's for it. Shirley Williams is too tired to care. The Permanent Secretary, Jim Hamilton, is not against it – the lunch I had with him made it clear to me that he was not against. So now we have come to a standstill, with a phalanx wanting this to happen: the Standing Commission on Museums and Galleries, the Advisory Council, me, Donaldson and a mass of the staff. Against it happening stand Spence, Ulrich and the union activists. We have allies in high places and in the House politically on both sides. It was appalling when the DES tried to stop me speaking on TV on the V & A. In the case of Thames TV I was forbidden outright, although they denied it. In the case of the BBC I fought right the way up the line to Mrs Williams's office and she overruled them and I appeared.

It has been a murky saga with a violent smear on me in the *New Statesman* to which I wrote a reply. Sammy Hood mercifully decided that he didn't want to go on as Chairman and Alexander Glen[1] is to be appointed. He hasn't even got the letter asking him yet and anyway he will use his acceptance as another card to play in the game. On the whole I am optimistic that played quietly we will get what we want.

6–7 April. Overnight at Windsor Castle.

These one-night stays at Windsor are a kind of up-the-line version of the Palace lunch. Inevitably, as in the case of the lunches, the mix of people can be somewhat bizarre.

We arrived in our decrepit vehicle at Windsor Castle. It was a glorious spring day, the hedgerows had suddenly burst into green and the sky was cloudless. I think that it must have been a long time since such a battered and dusty vehicle had arrived at the Castle. There was a flurry of footmen and the Master of the Household, Sir Peter Ashmore, greeted us and then, inside, Lady Abel Smith, a woman in her sixties, practical and easy, a typical lady-in-waiting. Up the stairs into the Grand Corridor

[1] Sir Alexander Glen, explorer, businessman, writer, banker and committee man. KBE, 1967.

and into one of the York Tower guest rooms, all of which overlook Royal Mile down to The Royal Lodge.

The bedroom was like sleeping in the Wallace Collection, polished but impersonal somehow. We warded off a small army of valets and maids who always, in an excess of zeal, want to unpack and press everything so that you can find absolutely nothing as a result. The bathroom had Hugh Casson drawings. The sitting-room was comfortable with a lovely Landseer of a dog, a sketch of Victoria and Albert for one of the great pictures of them, and the back view of one of Albert's sisters standing on a terrace. There were a few books on a chest of drawers. I opened one, it was inscribed 'Elizabeth 1943' and another had a small bookplate which read rather sharply 'The Queen's Book'.

After ten minutes we were fetched by another posse and taken down the Grand Corridor to the White Drawing-Room, which Princess Margaret said the Queen had made 'squashy', i.e., down-filled sofas and armchairs. This was the only room which seemed a little domestic. The *TV Times* was visible on a side-table and a 'squashy' large stuffed animal by the fireplace, which did strike an incongruous note sited as it was beneath the marvellous Gainsborough of Queen Charlotte in her vast paniered skirt.

We did the rounds, which included the Prime Minister [Jim Callaghan] and his wife, the Turkish Ambassador and the Australian High Commissioner. The dinner, however, was mainly in aid of Kurt Waldheim, Secretary-General of the United Nations. As at The Royal Lodge the footmen endlessly circulated silver trays laden with drinks. Princess Margaret looked ill (which she was, with 'red' flu), sun-tanned and wearing green, obviously pleased to see us amidst a bevy of people she probably regarded as 'heavies'. I found myself talking non-stop to Prince Philip, who really looks remarkable for his age. He seemed in a way more muted and less aggressive than I last remember him, but just as opinionated, full of the woes of Britain, groaning on about the evils of Capital Gains Tax, VAT, the stifling of patronage, and enunciating all the other reactionary attitudes one rather suspected.

Her Majesty entered the room with the Prime Minister. They, of course, had been closeted having their weekly audience, although this time surrounded by a blaze of publicity over HRH and Roddy which had reached its peak in the press that day with 'would she or would she not retire to private life?' and, also, coincident with the revision of the Civil List with its royal allowances. In fact rarely can Windsor Castle have been surrounded by such a blaze of publicity. The Queen, as we all know, is intensely shy and I don't think that we exchanged a

word beyond salutations. Julia did talk about the dogs, one of which rolled over, at which point HM radiated. She really loves those dogs and at that fleeting moment the character behind the layers came shining through.

Changing for dinner was a flat-out twenty-five-minute break. This time we reassembled in the Green Drawing-Room, very 'unsquashy' and formal. More guests arrived, mostly Household like a Windsor canon and his wife and the Royal Librarian. More drinks followed. HRH appeared in white, surely by Hartnell, with sparkling embroidery at the neck and hem. HM wore something floating in shades of violent orange and salmon pink with a vast diamond bracelet, necklace and earrings (one of those dresses designed to be 'seen' a mile off) and Prince Philip was in his Windsor uniform with its red collar. HM later put on her specs in the Royal Library which, like those worn by American blue-rinse ladies, hung on a cord around her neck. 'Where's your specs?' yelled Princess Margaret.

At that moment the children surfaced. Prince Andrew, tallest and thinnest of the boys, is now seventeen and living up in his butch appearance and sensuous lips to his 'Randy Andy' image, and David Linley,[1] the duplicate of Tony Snowdon. He is as tiny as his parents and about the same age as Prince Andrew. A tutor was with him to coach him to get through his O-levels. When asked by the Prime Minister what he wanted to be, Princess Margaret replied, 'A carpenter,' to which she added, 'Christ was a carpenter.' We then proceeded to the State Dining-Room and sat at a vast table, everyone placed according to precedence, all the surplus men relegated to a horseshoe at one end. I sat between Audrey Callaghan, a cosy lady, and the canon's wife. The table was lit by four vast silver candelabra interspersed with bowls of spring flowers, the usual printed menu card and printed statement as to what porcelain was being used. At the end the Queen led out the ladies, the gentlemen remaining for about ten minutes and then we all moved off for a tour of the State Apartments.

This, I felt, was a regular feature and reminded me of Woburn where, after dinner, the Bedfords led the way through the Abbey lit by a thousand candles. There is something magical about Windsor, especially that Grand Corridor which curves its way around the court-yard and, therefore, seems to go on for ever. And then one passes

[1] Lord Linley, son of Princess Margaret and Lord Snowdon, later trained as a furniture designer and cabinet-maker; he established his own business, David Linley Furniture Ltd., in 1985.

picture after picture one has known for so long, the Zoffanys, the Gainsboroughs of George III's daughters, the framed phalanx of the whole family, the Wilkies and Leslies from Victoria's early life, the pictures of her coronation and first Privy Council meeting. We pressed on through the redone chapel, all white and gold, seemingly an ante-chamber but behind a curtain lurked the altar. This now has its double doors restored which, flung open, led into St George's Hall. Before those were reinstated the Hall had here James Gunn's state portrait of the Queen in her coronation robes beneath a canopy of state. The Hall had animal pictures, Stubbses and Landseers, pushed behind the chairs ready for a Wildlife Fund rally, for which an exhibition was being mounted in the Waterloo Chamber.

So we swept on in a dilatory, dawdling manner through room after room, past the Wests of George III's family, Vermeer's *Lady at the Virginals*, hung too high, on through the State Bedroom where the bed badly needed repairing, through the Charles II rooms with their ceilings by Verrio and carving by Grinling Gibbons. The tour culminated in the Royal Library, where Robin Mackworth-Young [the Royal Librarian] had mounted the usual exhibition with a bouquet of manuscripts for me on the founding of the Victoria and Albert Museum, including the Duke of Devonshire's memo to Queen Victoria asking that the Museum should be called not the Albert Museum but the Victoria and Albert Museum!

We wended our way back at last to the Green Drawing-Room. We then talked to Princess Margaret, who just obliquely referred to herself as being under scrutiny for 'not being worth her salts'. Then the Queen and Prince Philip retired amidst a flurry of bows and curtsies and the party broke up except for Princess Margaret, who wanted us to stay up but who let us go on learning that I was off to Scotland at the crack of dawn.

I hate sleeping on soft beds and I loathe being unable to open the windows, so it was not a good night. We were called at 7.15 a.m. Breakfast was laid on a table in our sitting-room at eight with flunkeys in attendance. The three-minute egg arrived hard-boiled as no one had bothered to tap the top but the coffee, as in all royal establishments, was good. We were asked to sign the visitors' book. Each page was of thick white card and it weighed a ton. Flicking back through it what surprised me was not how many, but how few, people ever stayed here. Christmas, Easter, Ascot, the shoot – Kents, HRH Margaret and children, no sign of the Gloucesters, a sprinkling of foreign royals, Prince George of Hanover, Mountbatten, the PM, the Healeys ... One

was back at 1971–2 in ten pages, back to our friend Patrick Plunket. It all works like clockwork but everyone is so unaccustomed to servants these days that it is unnerving to be descended upon by so many.

7 April. Bowhill and the Buccleuchs.

Julia and I left Windsor Castle and I was dropped at Heathrow and went, shuttle service, to Edinburgh. There the Duke of Buccleuch's chauffeur picked me up and we drove for an hour-and-a-half through Edinburgh to the Border country. It was a marvellous spring day, at last, after an interminable winter, the sky clear, the light almost dazzling in spite of the fact that the trees, hedgerows and flowers were three weeks to a month behind the south.

At last Bowhill, the only one of the three great Buccleuch houses I had not visited and whither I now voyaged to make an oration for the seventy-fifth anniversary of the National Art Collections Fund. It is architecturally totally undistinguished, an early- to mid-Victorian conglomeration of rooms but what marvellous things within. The Buccleuchs are sweet people, Jane so very different from what one would be led to expect from her fifties deb portrait by John Merton as a lacquered New Look beauty. She is still a beauty but even more so in character and as a person. She has a loving sympathy, a kindness and a gentleness. Entirely unpretentious, she seems to hit it off with Dowager Mollie whom one knows found it difficult not being Duchess when Walter died. Jane and Johnnie have opened all three houses to the public with all that that entails.

Jane has delved into attics and cupboards and opened up, above all, the Buccleuchs' Victorian treasures. Two duchesses, with only a short break, virtually covered the entire reign of Queen Victoria as Mistresses of the Robes. There, in the boudoir, was a trunk stuffed with every letter and piece of ephemera, all neatly labelled and packaged. I picked some of them up. One was labelled 'A poem by Queen Alexandra on the young Dalkeith who had bled to death'. Jane told me that so upset had everyone been that Queen Victoria had actually paid a visit of condolence to the Duchess of the day, almost unprecedented. Then there were the letters telling the Duchess how the carpet had had to be widened for the royal visit!

At lunch on the Saturday I sat next to Mollie Buccleuch, who recalled how Colin and Anne Tennant had endlessly brought over Princess Margaret and Roddy Llewellyn to Bowhill and Drumlanrig. Mollie and Queen Elizabeth were greatly at variance, going back to the days of the 'romance' between Johnnie [Dalkeith] and HRH. For months it was

touch and go but, thank heaven, it didn't happen. She then gave an hilarious description of her sister, Diana, and Princess Alice Gloucester at Drumlanrig being confronted by HRH, Roddy and Bianca Jagger on a visit. They were all mystified. Who were these people, both ladies living an existence totally oblivious to *le monde*? HRH and Prince Philip didn't hit it off – all those jokes about the navy irritated her.

The Buccleuch houses are still incredibly run. There's a butler, unpacking, clothes laid out, though no shutters, and curtains drawn back in the morning. There are at least three people in the kitchen, which is sparkling and spotless, besides odd-job men and gardeners. At Drumlanrig the napkins still used are from the 1840s. Jane Buccleuch was still discovering stores: the stationery cupboard with its piles of notepaper edged in black for mourning and its packets of quill pens. On Saturday morning we went down into the basement to the safe, two rooms lined with glass-fronted cupboards. There was a set of 1568 engraved dessert plates, the Garter jewels of the Duke of Monmouth, enamelled gold thick-set with diamonds, vast silver candelabra and firedogs, case after case. Later I got into the Smoking-Room with Richard Dalkeith, a dumping ground for books, many of them from Dalkeith but such treasures: phalanxes of tomes of engravings after Rubens, Teniers, Chardin, Boucher, Raphael, not to mention one of the best Grangers I've ever seen.

The glory of the house, however, is its landscape setting. At the front the ground rises sharply. At the sides and back it sweeps away down to a lake set in a valley. There's no real garden near the house beyond a flower border, close-mown grass and a few huge old clipped yews. A fair distance away there was a walled kitchen- and flower-garden but the most spectacular of all were the several greenhouses, beautifully in order, with pots of gloxinias, geraniums and carnations for the house and two huge tomato trees, fifteen feet high, grown from seeds from Lord Mountbatten at Broadlands.

24 April. A. S. Byatt.

A. S. Byatt came to lunch. We had lost sight of each other, both unwittingly. I had married and gone off to another routine of life. She, at about the same time, lost her son, Charles, in a motor accident. Now, six years on, life's disasters have been overcome through applying herself to work and she is now a lecturer in the English Department of University College. Another child had come, Miranda, a wistful Shakespearian allusion. She looked inevitably older, much more openly withdrawn and introspective. Earlier she would be silent and then burst

into conversation. Now it flows easily and just as highly intelligently. She is no beauty with slightly higgledy piggledy teeth, of which she is conscious, and scruffy brown hair but marvellously alive eyes.

She had just finished the first volume of the novel containing the Virgin Queen, a tome in itself nearly five hundred pages long. I had helped her with the cover, trying to get a Magritte-like fantasy quality of Elizabeth Tudor advancing through a 1950s garden. The novel begins, as she always told me, about ten years ago with a prologue set at one of those readings at the National Portrait Gallery. The particular one, of course, was Flora Robson as the Queen and RS appears and Frances Yates is thought to be seen. We talked about the mirror images of history, I from the discoveries of the Victorian book [*And When Did You Last See Your Father?*], Antonia in relation to an edition she was doing of *The Mill on the Floss*. She had met Julia's aunt Carola [Oman] when doing the piece on the writer Georgette Heyer for the *Sunday Times*. Georgette Heyer, she had suddenly realised, was not nice and she therefore stopped probing further. Once again mirror images, because people who wrote or read that type of novel were escaping into a neo-fascist society, a turning-back of the clock to the vanished hierarchies of birth and privilege. An interesting interpretation of those novels, even if rather speculative.

She still saw Antonia Fraser who, with Harold Pinter, now lives a kind of shadow existence in the old Campden Hill house of hers. Now roses replace the strawberries of the Frasers on everything. Dinners are for four and intense conversation, in which he switches on only when he is interested. Proust turned him on and Antonia was taken by him upstairs to his study and he showed her the two books on Proust which, as a penniless youth, he had stolen from a public library, so passionately did he need them. Antonia was rather touched by both the passion and the honesty. Pinter, however, still remains divorced and will not marry Antonia which she would like him to do.

8 May. To Jan van Dorsten. A review of the first half of the year.
1978 seems to be better than 1977. It opened with me, behind the scenes (never tell anyone this please), launching the most fantastic correspondence in *The Times* to get the V & A free of the bloody Department of Education and Science. To say that it opened with a salvo from Lords Goodman and Gibson and Henry Moore and John Piper and from then onwards never looked back will give you an index of the organisation it represented and of the friends in high places who will run to one's aid in a righteous cause. It led up to an editorial in

The Times, questions in the House, etc., and RS refused to sign the report on the Museum to go to the Minister as it did not recommend disestablishment. It was turmoil – you can imagine it. But the Minister has now asked us to prepare an alternative form. All this means that Government is moving towards what I want and it should happen, but it needs to save face. If it doesn't, the row has to be rekindled, which I pray not. It took years off my life.

I am suffering from having no shorthand typist because the Civil Service salaries are so low. My salary has been frozen for four years, a 50% cut, and I am frantic for money. Thank God Julia works and I am doing a monthly column in the *Financial Times* because we need the cash. It is disgraceful. A typesetter in Fleet Street earns what I do. It erodes one's will towards public service.

Julia is busy on Tussaud's, which is a bore but pays well. The garden looks marvellous. The yew hedges are now five feet high and the new Jubilee Garden of white flowers just coming into its first year. Everything is becoming more and more 'there'. The walls of the hedging are really going up.

My utterly ruthless routine is the only thing which keeps us going. I need a rest from people more than work. They drain one dry. One has to give out all day every day as some kind of star turn and I just can't take it as I used to. A place in the country, a hovel, is ideal as long as you don't make it a scene with endless people coming and going. Virtually no one ever comes to The Laskett. It is an inaccessible mystery to 99.9% and long may it remain so.

31 May. Objects: The V & A Collects, 1974–8.

The Queen Mother, always a generous supporter, came to open the exhibition which was designed to give one's colleagues a lift and also to let the world of twentieth-century art and design know that we had responded with a vigorous contemporary collecting policy. Here they could see the fruits for the first time.

Somehow it is cheering to see fourteen hundred out of the hundred and fifty thousand objects which have entered the V & A since one's arrival in 1974: the Lomellini ewer and basin, the *Chellini Madonna*, the Herschorn miniatures, Lord and Lady Clapham, Picasso's *Train Bleu* backcloth, the Mentmore treasures, the Ades and Garner collections. And to see the first room of the exhibition filled with things made in the last five years. One was staggered by the brilliance and the variety

of treasures! Now it seems we are definitely in a moving-forward period again.

Poor HRH Margaret was carted off to hospital with hepatitis. What a tragedy it has all been and needlessly. And now the divorce with Snowdon is announced. How little people will understand the agonies which she has gone through as a practising Anglican to let the divorce happen. How silly but understandable to fall for Roddy and what an inevitable end. The loneliness of it all for her must be terrible.

11 June. Carola Oman.

Julia's aunt, Carola Oman, died peacefully at six o'clock on a glorious summer's morning at Bride Hall. She had never been quite the same since she had fallen down and broken her leg some years before, but she was indomitable to the end and really only began to go downhill sharply after Christmas. In between the two strokes which killed her she sharply looked around to check that she was still in her beloved Bride where she had sworn to die. She was. It was a rounded life; her last work, not her best, was one we had suggested that she write, *An Oxford Childhood*.

She was a prolific writer of novels, children's stories and biographies, almost thirty I would have thought. She was also a formidable, rather daunting, woman, not easy to talk to, always attired as 'the lady' and with a strong sense of duty which perhaps came out more forcefully than any real affection behind it. To the end she lived attended by a chauffeur–butler and cook way beyond her means, liquidating jade, china and jewels to pay for it. Bride by the end was slightly in retreat, with areas of the garden abandoned, but only slightly. On the day of the funeral we returned there for tea. There it stood bathed in the June sunshine, Tudor red brick and E-shaped (as she once said to me years before with her odd sense of humour – 'I'm your period, E-shaped'), roses and clematis clambering up the walls, tubs of fuchsias flanking the path to the door and a view the other way across seemingly untouched countryside for miles.

I always remember Julia making me tell her of our elopement, to which the reply on the telephone immediately was 'And about time too. You may call me Carola,' delivered in her typical *grande dame* manner. When, shortly after, we went to stay she pointedly gave us the works of Browning which had belonged to Whistler's solicitor, James Anderson Rose (together with his coat of arms and the famous print of the artist's mother).

It is always sad to see a house go. The writing-room with its desk

and papers were still there, and its shelves of novels, which struck one as odd because the reference books she would have used were on the other side of the house. The dining-room with its tapestry chairs, all by her, with views of Bride and favourite dogs, dalmatians, all very personal, the drawing-room with its cabinets filled with Worcester porcelain. Now it will all be dismantled and become just so many things and so many memories. With Carola's death my father-in-law suddenly lost his past.

19 June. David Hockney's Flute.

We always go once or twice a year to Glyndebourne, a great, pure 1930s treat, with all the paraphernalia of black tie at noon, the drive down, the stroll in the garden, the long dinner interval and the champagne picnic. The audience is always extraordinary. Not in the least Covent Garden or the Coliseum, mainly stockbroker young couples in ridiculous dresses and worse dinner-jackets, together with masses of tottery old ladies.

David Hockney's *The Magic Flute*, contrary to the reviews and build-up, was our first disappointment for years. Technically the scenery moved better than for *The Rake's Progress* but then it ought to have done, being dozens of painted cloths. All flute and no magic. It was a series of flat, hard pictures with costumes in colours screaming at each other. Nor did they know any more how to light a painted cloth. They are so used to lighting a set as night that when an artist paints it as night they are defeated. Redeeming features, however, were the utterly delightful and witty Hockney animals with almost but not quite human faces. Sad, because the opera was obviously meant to be carried by its designs as, apart from Ben Luxon, there were no singers in it of importance and a noticeably feeble Queen of the Night.

11 July. Benedict Nicolson and a godchild for Julia.

It was Julia's forty-eighth birthday and a day of contrasts. There was Benedict Nicolson's memorial service at St James's, Piccadilly, at noon. He was a curious, lovable yak of a man, shambling and crumpled, melancholic but with a streak of humour. He made the *Burlington Magazine* the papal encyclical of the art history world. He was always kind to young people. When I had discovered an approach towards identifying Elizabethan painters by means of grouping the scripts of the inscriptions on the pictures, the series of articles I wrote jumped the queue. He was really interested in what one had discovered.

The church was packed with the art history, art trade, museum world

with, to a degree, a sprinkling of the social scene. K Clark gave a very short and very bad address with a good swipe or two at Berenson and his 'court'.

After lunch we went to the crypt of St Stephen's Hall for the christening of Peter Walker's[1] new child, Robin, Julia being godmother. What a marvellous Pugin interior! The Cardinal had said Mass there the day before, the first time since the Reformation, and given a very uninteresting embroidered frontal, which looked like a throw-out from a side chapel at Westminster Cathedral. John Sandford[2] in clericals did the honours and Robin Caspar Walker behaved impeccably. Back at the Walkers' house in Cowley Street he went to sleep on a chair, his arms arranged around his head and with a trail of christening robe falling to the floor, looking like a Winterhalter of one of Queen Victoria's children. Peter had provided an extra cake for Julia which was sweet of him.

After a private view at the V & A we went to Drue Heinz's dance at Whitfield for Jack's birthday. At least this had the virtue that one was able to get away instead of being imprisoned on a boat as we had been one year. A vast, too large, tent had been erected at the back of the house. Hordes of waitresses wearing straw boaters and ribbons stood around doing seemingly nothing. There was no food, just a mass of cutlery on empty buffets. Drue was a bit short on princesses this year, only HRH Margaret looked relaxed and rather marvellous in white, and complaining that her summer arrangements had gone awry. We processed, circulated, registered with our hosts, and made an exit shortly after midnight.

The summer.

This year was exceptionally good for growth in the garden. The Jubilee Garden looked marvellous for a first year, a sea of white. The orchard had real fruit, apple trees bent low with the weight of it. August was an uneventful month but rather hard work [writing]. The urn which had stood on the front lawn at Bride was placed at the end of the *Die Fledermaus* Walk [it ended up in the Rose Garden]. It was always called 'John Taylor's Monument' and we found out why when we moved it. The slab of stone it sat upon when turned upside down was his head-

[1] Conservative politician who was Secretary of State for Trade and Industry, 1972–4, and holder of several Cabinet posts in Mrs Thatcher's Government. Created a life peer in 1992.

[2] The Rev. John Edmondson, 3rd Baron Sandford took the Conservative whip in the House of Lords.

stone! No time for great garden works. Within The Laskett we assim-
ilated the Bride furniture and I still have to shelve the books (I was left
half Carola's library); her writing desk has happily also become mine
and was obviously pleased to have more books written at it.

30 October. To Jan van Dorsten. The autumn.

We are back from Copenhagen, most unenjoyable treatment by the
Anglo-Danish Society, and from Japan (yes) which was rather horrid if
interesting, marvellous gardens and ancient architecture amidst a sea
of uncontrolled urban sprawl. No more travelling which is a relief. The
museum has a hit with *Giambologna* [the exhibition]. It also has
running Ludwig of Bavaria, Frank Pick, Samuel Palmer and *The Way
We Live Now* – interiors post-1950 – so that's good and the public are
fighting to get in.

Otherwise here I am at The Laskett recovering from Japan. I've
cleared my writing-room and I'm typing at Carola Oman's desk. I've
shelved all the books she left me, which was a grind, so I feel clearer
than for ages. Odd articles have to be written but one is slightly between
books...

1 November. Julia becomes a Royal Designer for Industry.

Julia received her scroll at the Royal Society of Arts as an RDI. It
was a grand and rather moving occasion, the first time that they had
honoured photography and so duly honoured Bill Brandt and Tony
Snowdon. Moving, because the furniture designer Sir Gordon Russell
made what surely must be his last public oration on 'Skill', which was
a reflection on his own life and its ideals, stretching back to Ashbee
and the craft movements at the turn of the century. He is eighty-six,
recently afflicted with creeping muscular atrophy, so that his angular
green-eyed daughter Kate stood by him to point to words, remove pages
of the script, and wipe his nose. He's a truly splendid, brave old man. I
was ticked off by him afterwards for running 'Capability' Brown[1] down
in the *Financial Times*, which shows that there is life in the old boy
yet. The hall was packed and the lecture was relayed to an overflow in
another room. After there was a rather bad supper and I had Mrs Bill
Brandt number three, going on about the high cholesterol count in her
blood, on my left and Lady Masefield, the President's wife, on my right.
Just hard work.

[1] Lancelot Brown, known as 'Capability', the great eighteenth-century landscape gar-
dener.

Esmond and Mary Rothermere entered my life shortly before I married. He was a formidable man and, apart from Sybil Cholmondeley, was the only person still living in the pre-1918 manner with a country house, Daylesford, in the Cotswolds, and one of the aristocratic London houses, Warwick House, in St James's. Entertainment was on the grand scale. Daylesford was on one of our early routes to and from the country and one of the first donations of plants for our garden came from there. In old age he was power diminished, but the old flames flickered to life from time to time. His was a fund of memory which should have been recorded. I recall stray remarks like how he employed the out-of-work during the Great Depression to plant the grounds of his earlier house, Mereworth, with thousands of bulbs, and how, after the Second World War, he had sold this house because he realised that 'servants would no longer live in the basement'. Or when, at the christening of Prince Charles, he had said, 'I have been present at the christening of the last King of Britain.'

2 November. Farewell to Esmond Rothermere and enter Princess Michael.

Odd that it should have been All Souls Day for Esmond Rothermere's service of thanksgiving at St Margaret's, Westminster. It was strangely impersonal as though those who organised it hadn't been near a church for years, which they probably hadn't. Lord Blake gave a disappointing address, mostly on the personal side, but I think it failed to give anyone in the packed congregation the sense of the end of an era, which in a way he epitomised. One never felt that he brought out the passions and contradictions of the man strongly enough. Ahead of me I saw Hugh Trevor-Roper shuffling the whole time, and my eye caught Ann Fleming, Lady Rothermere number two, coming in late with a large black hat and veil, looking ill and, as usual, disagreeable. The widow processed down the aisle also swathed in veils and mourning, dwarfed by the new lord. I can never fathom why people always wear black at what is supposed to be a service of thanksgiving.

That evening we, and apparently most of the population, had been invited to St James's Palace for the party after the service of blessing for the marriage of Prince and Princess Michael of Kent. The queue was endless until one at last ascended the staircase into the state rooms, which did look marvellous. Arcades of roses decorated the buffet tables, an Austrian practice, which was delightful even though the colour of the flowers was too hectic for the rooms. The newly-weds, he in a lounge suit and she in a dark red velvet jacket and skirt, stood receiving

in a room hung with tapestries. The Duchess of Kent made an early exit through a side door, and the Queen had already gone by the time that we got there. We caught a jovial glimpse of the Duke of Kent, *en route* to play tennis, and had our usual happy encounter with the Queen Mother, holding court in the corner of the room. No champagne for her. Martin Gilliatt had nipped through the back door back to Clarence House to bring her a stiff dry martini. In the blue dress with that huge diamond brooch which one has seen so often she presided over her friends, who were sought out by Martin and Ruth Fermoy and brought up. Only Lady Russell managed to push her way in when no one was looking.

9 November. Oliver Messel.

Another service of thanksgiving, this time for Oliver Messel at St Martin-in-the-Fields. As I remarked to Peter Coats as we went in, we seem to meet weekly at memorial services these days. I suppose that as I wrote the *hommage* in the *Sunday Times* Julia and I were swept up to the front right. Fred Ashton was behind and, in the pew ahead of us, sat Dame Ninette de Valois,[1] 'Madame', grim and as though in pain, with an old turban hat on her head. Anne Rosse looked very drawn in black fur hat and veils. HRH Margaret and Anne Tennant arrived, also with the obligatory black hats. The altar and altar steps were appropriately decked in Messel white blossoms and, unlike the Rothermere service, this one did seem to reflect some knowledge of the Church of England and also had a degree of human warmth about it. Esmond Rothermere's was totally anonymous. The lessons were read by Thomas Messel and Tony Snowdon (rather badly). Madame then ascended the pulpit and bereft of a single note delivered a remarkable tribute.

It began with her being in a French theatre in the Diaghilev Company as one of four dancers who had to take a step forwards, bend down and pick up a mask. She did so and, admiring its beauty and design, asked, 'Who made this?' The reply came, 'A young Englishman called Oliver Messel.' She recalled his passion for perfection, his understanding of the craftsmen in the workshops, his ability always to improvise to spectacular effect when in the midst of rationing just after the war he created *The Sleeping Beauty*. Perhaps the most touching memory of all was when that production was taken to the Kirov and both she and the

[1] Founder and Director of the Royal Ballet, 1931–63; created DBE in 1951, but always referred to as Madame.

1979

Silver Lining

We first met Margaret Thatcher in the summer of 1974 the year before she was elected Leader of the Opposition. Esmond Rother-mere asked us for a drink, just nine of us in all, standing on the terrace of Warwick House on a warming June evening. It was during the lead-up to the Country House exhibition and I recall going at her about the scenario that loomed ahead if Labour's proposed Wealth Tax became a reality. I got nowhere. She failed to grasp the point, or rather she had an *idée fixe* about museums, that they were dead things, piled-up lumber from Britain's past which was now holding the country back, and she twittered on about her Worcester porcelain collection. When, after the 1979 election, she went into 10 Downing Street the V & A lent her a caseload of the stuff and I also gave advice on how to cheer up the gloomy dining-room without spending any public funds. A more significant and fruitful encounter with her was to come later, but for most of her premiership the Press Office spent time trying to prevent her using the expression 'the museum society', which said a great deal about how she thought of such institutions.

At the time it was clear that the 1979 election would be a turning-point. As the seventies ground to their dreary close I am conscious of the lack of social events to fire my pen. Everyone and everything was in retreat, concerned most of the time with just keeping going as society battled against the endless dislocation of basic services. Few, from personal resources, could afford to entertain any more on the grand scale; perhaps what I have recorded earlier was the tail-end of a way of living which went with the war. Pamela Hartwell's legendary election-night *fêtes* at the Savoy, for example, contracted and were relocated in her own house in Cowley Street, albeit with a small tent added on the roof of the dining-room. But they were diminished, killed off by inflation and by a change of social mood.

What stood poised to take off, but was as yet only in its infancy, was the corporate entertaining born of sponsorship which was to become the leitmotif of the coming decade. The wooing of the private sector, which was to form such a central part of Thatcherite arts policy, went

back to the early seventies when, under the aegis of Arnold Goodman, the Association for the Business Sponsorship of the Arts was formed. Museums in the early stages moved on the fringes of this, the main thrust being in relation to the performing arts, which could offer far more glamour as a package. By 1979 that was shifting. *Vienna in the Age of Schubert: The Biedermeier Interior, 1815–48* was sponsored by the Austrian Bank and *The Garden: A Celebration of 1,000 Years of British Gardening* by a number of sponsors. Earlier the Heinzes had supported both the Country House exhibition and the one to mark the American bicentennial. But that was exceptional. I was fortunate to have lived through an era when either I or a colleague could still conceive of a show and do it, not having to think of raising the funds as a first premiss. The shift away from that, which admittedly imposed a discipline, changed the nature of exhibition-making, driving it ever harder into the market-place towards the spectacular. In 1979 it was also still taken for granted that it was Government's duty via the Property Services Agency to maintain the fabric of the building and refurbish the Museum's galleries. Within five years it had become axiomatic that up to 50 per cent now had to be raised from the private sector.

The idea of fund-raising was slow to get off the ground and the meetings of the Associates mainly seemed to consist of rows of pairs of eyes looking at me to do it. In its early days it owed much to such enlightened businessmen as Sir Duncan Oppenheim, Robin Holland-Martin and Sir Alexander Glen. The age of the development office lay in the future. None the less change was in the air, a fact signalled by the long liaison with Mobil Oil, which was the first company to take a dedicated interest in the V & A.

The role of a museum director likewise began to change fast as the 1980s unfolded. In the post-war period the attributes necessary were adherence to Establishment values, a sense of vision and purpose for the institution, and scholastic credentials. By the later 1960s, with the creation of an Arts Office, political acumen began to be needed, the ability not only to know one's way around Government departments but also the Lords and Commons, as the Arts became politicised. In the coming decade two new attributes came to be demanded which were in the long term to relegate the others to the status of a second eleven: knowledge of modern business management techniques and, above all, the ability to raise money. Both, in moderation, are desirable attributes but, in excess, as they became, they began to erode my reasons for wanting to be Director, which centred on the ability to

orchestrate an institution and to say what needed to be said to the public, and to maintain the primacy of knowledge. The present incumbents of our national collections have hardly a book to show between them. The age of the scholar–director is dead.

This change of mood and direction at the turn of the decade was reflected in the exhibition *The Garden*. It was to be the last of the great didactic polemical shows. Another had been planned on cities and towns but it was never staged as the climate changed. That was caught in the subtitle: 'A Celebration', very different from its predecessors: 'Change and Decay' and 'Destruction'. *The Garden*, however, like the others, had a huge impact. It owed much to an unsinkable team headed by John Harris. After it, Government initiated the first listing of historic gardens and garden history and restoration took off. All the major books on British garden history appeared after that exhibition.

Nor should the Biedermeier exhibition be forgotten. It was Julia who first introduced me to the delights of that style. When I asked the Austrians for an exhibition of it they were horrified. They regarded Biedermeier as the nadir of bourgeois taste but I persevered and we got it. As with so many influential exhibitions, very few people went to it but it was to be the fount from which flowed the cult which was to follow and dominate the decorating magazines through the eighties.

This was also the year in which the Friends of the V & A was set up. A large file on this subject existed, going back to Sir Trenchard Cox in the early 1960s. The staff had always been bitterly opposed to the notion of Friends. Cox got as far as organising the launching event with a lecture by Kenneth Clark and with Princess Marina as its patron, but it never happened. He gave in to the Keepers. The file resurfaced under John Pope-Hennessy and he too was defeated. This time we proceeded on the pledge that not one member of staff would be asked to lift a finger. Initially they didn't. The Museum messengers wouldn't even collect the mail from the Friends' out-tray, so that they had to lug it to the post themselves. The Friends were, of course, viewed as unpaid voluntary labour that had somehow got in through the back door, taking jobs from union members. The intrepid Julie Laird, the first Secretary of the Friends, sat it through. For that the Museum in retrospect should be grateful, for it was an unpleasant beginning.

As part of *The Garden* exhibition Russell Page had designed a garden for the quadrangle. As far as the staff were concerned the ghastly pink cherry trees planted by Sir Leigh Ashton in the immediate post-war period were sacrosanct. I lost that particular battle. I look back with regret, for it would have given the Museum a garden designed by one

of the great designers of the century. In most ways 1979 was a grey non-year. The signals of all that was to come were not yet in place.

21 February. The Winter of Discontent.

It is a long time since I wrote. The winter of 1978–9 has been the coldest since 1947. The Laskett has been under snow from virtually before Christmas until now. Locals say that the cold has far exceeded their memories of the celebrated '47 winter and, in our case, the water-pipes actually froze. As if that were not enough to cope with, after Christmas we entered a period of turmoil and dislocation which made life increasingly difficult. The tanker drivers went on strike with consequences for getting any petrol. Then the lorry drivers went on strike which resulted, locally, in the police being brought into a supermarket to break up the scramble by women for food. The railways have been on and off striking throughout this period, something which mercifully has not affected us. At the moment the National Union of Public Employees is on and off striking too – hospital porters, ambulancemen, school porters, dustmen, mortuary workers, etc. In the streets of London the rubbish is piled here and there, spilling out from its bags all over the place. Leicester Square is one large dump and every restaurant is approached through rubbish. We now even divide our refuse in London into different bags and take it down to the country for disposal. In some areas even the Water Authority has been on strike.

So far the V & A has not been affected, although on Friday one of the Civil Service clerical unions will go on strike, which will affect but not close us totally. It is difficult to see where all this will lead to as it spirals ever onwards. Everyone is being paid more and more for shorter and shorter hours and producing less and less. Our image abroad is deeply distressing, 'The British Disease' as it is called. Neither political party seems to present any remedy and the next election will be the most bitterly fought since 1945. It surely will be a turning-point again about the direction of the structure of society.

Meanwhile the V & A curiously flourishes. Its status remains completely in mid-air and will do so until after an election. The unions issued a statement refusing to contemplate any severance with the DES. It was all, as usual, very nasty and made an unpleasant preface to Christmas. Still, the exhibitions – *Giambologna, Vienna in the Age of Schubert*, Eileen Gray and Samuel Palmer – have all been critical and popular successes. We must have had two million visitors by now but we discovered that the automatic counter on the revolving door

was only notching up one visitor for every eleven that went through it! So we don't really know.

Building projects move ahead. The Henry Cole Wing is on schedule. The plans for the redevelopment of the North Court [home of the defunct Regional Services Department] are advanced, aiming, eventually, to form an Oriental complex. By 1982, at a shot, we shall be in the middle of the biggest move-around since 1909. The Theatre Museum, however, remains a worry. The lease is not yet signed for the Covent Garden site. In which Minister's office is that locked up, I wonder? The old Post Office Building in Blythe Road, Hammersmith, is up for grabs for all of the museums with a consequent savage jockeying for position. Staff remains the central problem. On some Fridays there are only seven warders over the whole twelve acres. And there is no way to remedy this. The DES is immovable. All one can say is that the Arts Office actually admits that the cuts to the V & A should never have been allowed and the regional exhibition problem perpetually humiliates them. Lawrence Brandes, who replaced Spence there, holds out some hope of staff for the year 1980–81 by the devious means of categorising them as 'new projects'. This apparently is the only way round the problem.

We have been busy in the garden. The Ashton Arbour [planted while Julia was working with Fred on *A Month in the Country*] has been paved and a walk created to the orchard. This ought to look marvellous when it grows up.

15 May. After the election.

We are now in a state of post-election euphoria. As one predicted, there is a complete *renversement*. At the Conservative arts election conference I got someone to get up and ask Norman St John-Stevas if he would give us the resources to open the V & A again on Fridays if they got in. This produced a commendable diatribe against the Labour Government's treatment of the Museum and a pledge to reopen us. So here we are back in business again. Norman is in the Cabinet, Chancellor of the Duchy of Lancaster, Leader of the House (less onerous as they have a working majority) and Minister with responsibility for the Arts. The latter are to be removed to the Duchy of Lancaster Office and a small Arts Ministry is to be created. The V & A is to reopen and Regional Services is to be put back, so we will be reinstating everything that was dismantled from 1976–8. Norman at the moment seems unaware of the practicalities of turning the clock back. We will need forty-five warders and a staff of about seventy to establish Regional

Services in the Post Office Building, let alone that needed to open the Henry Cole Wing and the Library again to the public on Fridays. All of this sums up to me a particularly futile few years, so easily it seems that everything has now been turned around...

5 June. Sir Robert Mayer's Century and the Wellington Egyptian Service.

We were invited to Sir Robert Mayer's[1] 100th Birthday Concert at the Royal Festival Hall. So were the Queen, the Duke of Edinburgh and the Prince of Wales. The Queen obviously enjoyed herself and had the unerring ability to sit back and let the limelight fall where it should, on to the centenarian, who made a brave speech from the Royal Box. Such wonderful music: the Tallis 40-part motet, the violinists Yehudi Menuhin and Isaac Stern playing Bach in a way that was thrilling to a degree, the singer Dame Janet Baker, wearing the most perfect drapes by Yuki, superb in *Les Nuits d'été*, with the triumphant blast of the *Hallelujah Chorus* as a finale. These evenings can all too easily become an embarrassment but this one was not, nor over-sentimental or ill-pitched or badly chosen. The world of the Arts as we know it was on parade.

On the reverse of the coin we await the drift of the new Government on the Arts. Arriving, as they did, with such optimism, disappointment is bound to follow. Norman St John-Stevas is in the Cabinet, in one sense a triumph for the Arts, in another it could work in reverse. Mrs Thatcher was busy this week and last, preparing her budget, with swingeing cuts in the public sector. Norman was asked to cut the Arts by £2 million! So far the greatest victory has been the exclusion of the V & A from the freeze on all Civil Service recruitment, the first time ever that the Museum has been recognised as in any way different. That we were excluded can only be put down to the dramas of the last three years and one's policy of cutting where it showed. If I had cut horizontally as the unions demanded I doubt very much if we would have been exempted. So Norman finds himself in a very difficult position. Too much promised, too much expected. As far as the V & A is concerned I would doubt if things could get any worse than delays on, or the cancellation of, all building projects.

One of the V & A's branches was Apsley House at Hyde Park Corner

[1] Philanthropist and musician, especially active in promoting musical activities fo the young. He died in 1985 aged 105.

Relations with the Wellingtons were never easy. They got off to a bad start in 1974 when I allowed the Byron Society in for a glass of sherry after they had laid wreaths at the statue of Byron close by, on a freezing winter's day. That prompted a very long letter from the Duke saying how his ancestor, the first Duke, had not approved of Byron and that these poor members of the Byron Society should never have been allowed in. Apsley House in fact belonged to the nation and the Wellingtons were merely tenants, a fact which from time to time one had to remind them of.

We are just about to purchase the famous Wellington Egyptian Service for £350,000. The saga began with Valerian Wellington being asked for a boar-hunt weekend with the President of France. After this he had the nerve to ask for one of the military banners, taken by the first Duke from Napoleon's army and hung at Apsley House, to give as a 'thank you' present to the President. I put him down rather forcefully on that one. At any rate it was during that weekend that the service was apparently sold to the French. The Reviewing Committee for Works of Art, of course, stopped it, much to his fury. That transaction then became public, also to his fury, as he is now seen as someone thoughtless of the national heritage, selling it abroad. It will mean that as a result of the purchase the Museum will be broke again as usual, but it will be worth it.

Meanwhile Hugh Casson was prevented from sending the Michelangelo tondo from the Royal Academy to either Japan or Russia, likewise much to his irritation. He, like the Duke, blew up and stated that works of art, like people, should live 'dangerously', hardly an encouragement to those who lend their works of art to Academy exhibitions. When we stopped it going to the United States six million was the figure put on it but twenty-five is now bandied about in the newspapers. No doubt all this forms good PR for the final ransom price when it is sold.

24 July. The Foreign Secretary's residence.
I went to help Caroline Gilmour rearrange the Foreign Secretary's residence at 1 Carlton Gardens. Much of it had been done over at a cost of £95,000 for the Callaghans, who never lived there, because no sooner was it completed than he became Prime Minister. Because the Carringtons have no need for it, the Gilmours have the flat instead. It is really very nice and Caroline has rearranged the furniture, imported pictures, and expurgated horrors. It was pure Peter Jones, all except the

Callaghans' bedroom which had been transformed into a motel room with units, ceiling lowered with lights on a dimmer set into it, a screen set into the middle of the room with the bed pushed against it, while behind the screen there were clothes-racks.

Ian came in looking more than usually exhausted and haggard. Caroline had been telling me that he had only taken the Lord Privy Seal post because of Peter Carrington and because Carrington cannot be Foreign Secretary without Ian in the Lower House. He'd in fact had a yen for Environment. I don't get the impression that they like Mrs Thatcher much. The latter had gone up to Caroline at lunch at Chequers the previous Sunday and said, 'Oh, Ian and I quarrel like mad with each other.'

25 July. Conservative cuts.

Today we decamp to the country for August, give or take a day or two. So much has happened so quickly. The Government has kept its pledge on vast public spending cuts. The moderates in the Cabinet like Ian Gilmour, Peter Walker, Jim Prior, Norman St John-Stevas, *et al.* were defeated. Placing it in the V & A terms we now stand on the brink of total disaster. The Civil Service is to be reduced by 10, 15 or 20%. Mercifully the Civil Servants refused even to do a return on the V & A and I sharpened up a letter, drafted by Walter Ulrich, the Deputy Secretary, for Norman, stating that catastrophe lay ahead if such cuts were imposed and seeking exemption or immediate Trustee status. We must now wait and see.

This, of course, does not exclude the financial cuts. For this year, 1979–80, I have had to axe £230,000 from £6.5 million and I sat down all yesterday doing the chopping. It will be worse next year. I have already done an estimate for something like 7, 12 and 17% over the next five years. This can only be met by chopping away at the Purchase Grant. The Museum otherwise will be a corpse.

3 August. Queen Elizabeth comes to Ham House.

We retreated to The Laskett for six weeks, apart from returning on Friday, 3 August, when Queen Elizabeth had asked herself to Ham House. Needless to say she was late and it was rather rainy. Pat and Dione Gibson,[1] Julia and I waited on the steps. She arrived with Hugh

[1] A past Chairman of the V & A Advisory Council, Patrick Gibson had also been Chairman of the *Financial Times*, 1957–78, National Trust, 1963–72, and Arts Council 1972–7; he was created a life peer in 1975. His wife Dione, a Pearson, was a collector of early Victorian paintings.

and Fortune Grafton[1] and Oliver Millar[2] in tow. Only Queen Elizabeth could cheerfully open up a transparent bell-shaped plastic umbrella and peer through it! I had arranged lunch in Catherine of Braganza's bedchamber, Her Majesty enthroned in a seventeenth-century chair facing the window with all the lines of perspective of the garden radiating from her. She was in great form, and longing for the Queen's return from Africa on the morrow, her seventy-ninth birthday. I proposed a toast and, as we all know, she loves toasts.

Cleverly she had sent William Talon,[3] now elevated from page to steward, ahead. Martin Gilliatt promised that Her Majesty would provide the 'liquid refreshment' and so a fruit cup to be served in the ante-chamber and wine for the lunch was carried in.

5 September. To Jan van Dorsten. Résumé of miseries and joys.

We are back in London on Sunday on the old 'milk round'. I wish that I could say that I looked forward to it. All I know is that autumn and winter brings a gruesome load of problems – cuts, cuts and more cuts and more and more union unrest. All I know also is that I enter it with a better attitude than the first time around. I really can't keep on nearly breaking down over it. The last round aged me terribly. My hair went white. This time I'm determined to let it wend its way and that's that. There's little I can do except fight the good fight. But there will be complicated and controversial decisions to be made which are only mine and for which I will have to take the rap. Unfairly we are locked still in this misery of the Civil Service. Hopefully we will escape staff cuts, but there will be big financial ones which I can only meet if I'm given the financial flexibility on the lines of the Trustee museums, and there's the rub. Will they? I'm playing my cards close to my chest and being very cool, and not screaming yet, unlike everyone else in the Arts who seems to be marching all over the place in protest at the moment.

So it's a lousy autumn and I only wish that one was getting more calm out of the job than one is. Still, that's life. I'm so glad that you saw *The Garden* [the exhibition]. Now that was a bonus and a fabulous

[1] The Duke and Duchess of Grafton. Hugh Grafton sat on an unending list of heritage committees, especially those connected with historic buildings, and was for decades a Trustee of the National Portrait Gallery. Fortune Grafton was appointed Mistress of the Robes to the Queen in 1967.

[2] The distinguished historian of British art and Surveyor of the Queen's Pictures. KCVO, 1973.

[3] A long-serving and trusted member of Queen Elizabeth's Household.

success. That will carry one through the next year. Without doubt, like the Country House exhibition and Fabergé, it has gone down as one of RS's legendary shows with the public. I felt very cheered by all the fan mail and eulogies and lovely reviews of the garden book [*The Renaissance Garden in England*]. Also I did a series of six five-minute radio talks on taste and fashion in dress, manners, the new puritanism, etc., which went down a treat. They were called *Strongpoints* and two got repeated on *Pick of the Week* and, on top of all that, they were printed in the *Listener*. They were me back on form – nothing to do with museums or art history or anything boring like that – but I hope witty and trenchant observations of social minutiae on the general drift of contemporary society.

Apart from one week the weather has been adverse. Great garden works. I demolished the rockery in the Rose Garden and moved there the eighteenth-century urn which came from Julia's aunt's house, Bride Hall, to act as a focal point. It looks marvellous and I've underplanted it with cuttings of pinks bordered with lavender. Everything has grown and grown. The orchard is to have a yew hedge around it this autumn. I finished the Yew Garden with sand and gravel, making a small seventeenth-century embroidered parterre which will amuse you. The orchard is hung with fruit and we have an abundance of vegetables. We have also had the builders the whole time coming and going. Frankly when they're finished the house will be a third again in size. We have now had the house six years and it is really beginning to look like a well-run and comfortable small English country house with what is increasingly becoming an extraordinary garden which staggers everyone who sees it.

Next Monday we will have been married eight years and my only regret is that it were not longer. We wish you both [Jan van Dorsten had just married for the third time] all the loving happiness that we have had and have every day together, all the eating together, the cooking, the washing-up, the planting and weeding, the shopping, the working, the everything – it is the most precious thing ever to be given.

9 October. An Ashton evening.

This evening we went to the triple bill at Covent Garden of Fred's ballets, *The Dream*, *Symphonic Variations* and an exhumation of *Wedding Bouquet*. The latter was first performed in 1937 with plot music, costumes and scenery by Gerald Berners. As archaeology it would be understandable but as a production to take its place in the repertory decidedly not. Anthony Dowell, with his hair smarmed down

sat to one side and spoke the lines which no one could hear as the amplification did not work. As a ballet it was between-the-wars experimental, and one could see how the Royal Ballet descended as a cross between echoes of Diaghilev interlaced with elements more typical of a C. B. Cochran revue. It is sad that they cannot move on, the three ballets that evening being 1937, 1946 and, I think, 1960 respectively.

Fred really ought to be kept off the stage. For one of the most creative, lazy and mean-spirited people one has ever met, he thrives on adulation. His curtain-calls now are a complete act in themselves. He always begins by slowly sauntering on from one side, his hands moving in controlled balletic flipper-like gestures, saluting members of the cast with a kiss. But the big moment is always his own curtain-call when he deliberately walks out of the wings from the back of the stage down towards the footlights, a journey which he protracts to last as long as possible. I really feel sorry for poor Kenneth MacMillan being perpetually saddled with the ghost of Christmas past. It was a real Fred *fête*. Madame [Ninette de Valois] went down the aisle swerving neither to the left nor the right, her body erect as though held in iron clamps. Mrs Ian Fleming's pallid vulture-like profile I caught as she swept up the grand staircase in flaming sari-red. Princess Margaret was in a most unbecoming orange-pink Chinese package patterned in gold, along with Roddy Llewellyn, who hid his face for most of the evening either behind opera glasses or buried in his programme.

We spoke to John and Marina Vaizey in one of the intervals, he gobbling on an ice-cream and, at the same time, hatcheting into socialism hard. He was behind everything that Thatcher was doing. Axe the armies of Government officials and this time really do it, for nothing as yet has really happened, although so many believe that it has. No other cuts have been made yet, apart from that to income tax. He thought it would not be such a turbulent winter. The unions are still in disarray, the socialists are wallowing in a blood bath of recriminations. So 1980–81 will probably be very difficult. It has become so much a pattern of life since 1973 for misery to set in from November onwards, reaching a crescendo in February, that one really wonders whether it will continue to be the pattern for the eighties, which are to be with us in fourteen weeks' time. The seventies have been a very unpleasant decade.

0 October. A reflection.

am forty-four this year. It is quite difficult to even think what lies head because it seems so much a period which might be categorised

as the years between. I am neither the brash young swinging-sixties museum director, nor the doyen of the art establishment. On the whole one is content. Privately I have been blessed with abundant happiness in Julia and our life together. That has been the most precious and miraculous gift of all, stabilising and consoling through every crisis. The Laskett, my writing-room, the garden and its changing seasons give perpetual joy. I have kept going at writing. Doing a monthly column for the *Financial Times* keeps my hand in journalistically and frankly I enjoy it. There's quite a lot of radio on and off which, again, I like. More to the point I have continued to produce books. I still feel guilty about my poor languages, only reading French and Italian. I had a bash at teaching myself German and I find that I haven't the energy to do it on top of everything else. Still, during the summer, I had a good try at brushing up my Latin. The voyage of the mind is the most important and sane one. So I do think that I've lived down any charge of being trivial, but the latter is probably an important self-ingredient. There should always be room and a response for fun and the dotty.

I feel myself totally settled in and accepted at the V & A, perhaps even rather liked. There are still several years of work ahead there in a more peaceful atmosphere. In spite of cuts, it has been a creative period. I work hard as I always have. The physical energy of one's twenties and early thirties is not there any more but the mental drive is, and one is no longer battling. One is there, experienced, with little to learn in running a place. I don't feel any drying-up in ideas or in excitement and response to what is happening. I don't mind buying things which I loathe for the V & A or staging exhibitions filled with things which I don't like as long as they relate to now and succeed in provoking the public. As one gets older one must protect oneself, create bastions into which to retreat. One must set new targets intellectually always, for what follows career-wise either will or will not happen. It can no longer be worked at in such a direct way. Yes, I wouldn't be thirty-four again or twenty-four and certainly not fourteen. I hope that I'm nicer than I was but I hope that I haven't lost my edge. One must watch slipping into sloppy middle age. I've been vain enough to remove twenty-eight pounds in the last year and restructure my food intake. I've also had a year of hell with contact lenses and ended up wearing bifocals. 'Oh I'm so glad you've gone back to wearing glasses,' they all say.

31 October. Reddish and Longleat.
I hadn't seen Cecil Beaton for over a year. I sensed economy in the air as we sat together with Eileen in the small library rather than in his

'I've made it, Mum – Roy Strong wants to
buy me for the Victoria and Albert Museum.'

vast 'Lady Windermere's Fan' drawing-room. He seemed about the
same, I thought, pale certainly, no signs of any physical improvement
and with the odd mental lapses and losses of train of thought. A bright
pink cravat added the usual note of chic.

Now nothing gives Cecil greater pleasure than doing people down,
so to cheer him up I played to the gallery like crazy. No, he drawled,
he couldn't say that the great ball at Wilton for eight hundred, and for
which everyone had been bidden to wear their tiaras, was a success.
The rooms were overlit, Lady Pembroke looked funereal in deepest
purple and the tiaras weren't much good either. A redemptive accolade
was tossed however to the garden urns which had been treated as
torchères and stuffed with candles. Then he applied his scythe with
customary relish. Down went Kitty Miller, who had just died at eighty-
three, Pamela Hartwell, 'awful' (the *Telegraph* this week had referred
to him as 'the late Mr Cecil Beaton'), Snowdon, 'awful' (he had Tony's
latest book and denounced all the blown-up faces from the sixties),
Princess Margaret, 'awful', and so on.

The momentum of Cecil's life was clear from the evidence around.
He had just returned from a walk when I arrived and paints were visible
tumbled into a corner of the room. He uses his left hand but, as Julia

says, anyone who has manual dexterity can adapt. Now he only comes to London about once a month and obviously misses the theatre and the chatter. Nor is he any longer really working on anything. I had heard from *Vogue* that his last sitting for them of Georgiana Russell and child in the conservatory had been a nightmare.

Longleat I had not visited since 1960 when, as a young Assistant Keeper, I had been locked for the whole day in the muniment room to work on the Devereux manuscripts. There it sat in the golden light of autumn amidst its 'Capability' Brown park, the house now soft and romantic but built originally as a four-square symbol of the aggression of a new family, the Thynnes. I had a curiosity to see it all again and the country-house cause had made me say 'Yes' to taking part in a fifty-minute film on the present Lord Bath.

Now he was an encounter to remember. Tall, thin, with a beak-like nose which had been squashed in, he was a splendidly narcissistic seventy-four-year-old. Brains can never have been one of the leading attributes of the Thynne family. He crowed at length that he had 30,000 books but had not read one of them. These admittedly included collections of theological treatises and the odd incunabulum. 'Not even the ones you purchased?' I said. 'No,' came the reply, not even one from the vast Churchill collection he had formed.

Longleat itself now looks sadly institutionalised with dowdy vases of chrysanthemums and dahlias, a bit like a Victorian railway hotel. I made my way through room after room littered with rather badly made costumes from some television spectacular. Love had fled the place long ago. In one wing lives the eldest son and heir, rarely if ever spoken to. The rift between him and his family is total. In his part of the house the family portraits have been thrown out and the walls covered with murals painted by him of scenes from the Kama Sutra. A large notice warned that this part of the tour of the house was not for the delicate of either mind or eye. Outside he had made a curving, symbolic garden. 'Phallic, phallic,' said Lord Bath, gesturing in disgust down at it from the roof, which I had never been on before and which, with its pretty Elizabethan pepper-pot pavilions and views across the country, must rank as one of the great experiences.

In the evening we all took part in a televised dinner party of a kind which can only be categorised as caricature. It was given in Job's Mill, the pretty, practical house in which the Marquess and his present wife live, the atmosphere of which cannot be described as anything other than bourgeois, certainly not aristocratic. An assembly of Thynnes had been garnered for the occasion, plus the television interviewer Clif

Michelmore. There, beneath a battery of arc lamps, we bantered while Christopher Thynne from time to time drove one mad with country-house jokes using his napkin or a pepper-mill. After it was all over and the cameras had left, out came the 1930s gramophone and everyone danced until 1 a.m. in a scene straight out of Evelyn Waugh. Next day we had to pull to, and I did my piece on the glories of the house.

10 *November. Country wedding.*

John Bulmer and Angela Conner have lived together longer than we have been married, some eleven years. However, today, at long last, they wedded. I was rung early a.m. by John. Had I got a black hat with a broad brim that I could bring with me? No, I hadn't. It was in London. Whatever was that wedding going to be like?

We arrived at Monnington which, even beneath a grey autumn sky lit only by fitful flashes of sun, looked breathtakingly romantic. It is the perfect English combination: old rambling country house, stable block and parish church, all cheek by jowl. John had bought it for nothing years before and bit by bit they have made it habitable, although Angela's domestic instincts are limited. There is never a Kleenex in the place, the dining-room table is a salting-stone for a pig, and dinner generally tends to be constructed after the guests have arrived. However, today it had an 'all the fun of the pageant' atmosphere.

At about three, bride and groom appeared and the wedding *fête* began. What can be said in its favour is that the couple certainly did enjoy it and it looked marvellous in an eccentric kind of way. Angela and John, attired in black and white, mounted horses caparisoned (rather badly) in the same colours, Angela's dress being an approximation to eighteenth-century hunting attire. At this point various stable-hands surfaced in guises fit for the *Palio* ... and then Angela's sister, Penelope Gilliatt, entered in ankle-length black and white with a little hat perched on the front of her auburn hair, together with Edda, Angela's half-sister, both as it were in-waiting on the bride. Penelope looked ill but animated.

Opposite the house John had dug a lake with an island in the middle and thence the cavalcade, headed by a child bearing a casket holding the wedding rings, wended its way while some musicians marooned on the island tootled. Arriving over a wooden bridge at the church they were met by a cleric, a handy bishop, and a choir, which sang, somewhat surprisingly, 'Now Is the Merry Month of May'. The church, which is tiny, was packed and then followed what I can only describe as a concert in the middle of which two people just happened to get married. Long

choral pieces were performed and candles were lit, the chancel as it were becoming a concert platform. Afterwards everyone went back to the house. The *fête* went on and on: tea, a dance, dinner and finally fireworks. It made me so glad that we had decided to elope.

28 November. Anthony Blunt and the Bishop of London.

This was an incredibly social day. First we were bidden to the reception for the marriage of Laura Legh to Simon Weinstock. Unlike the fracas and queue to get in and out of St James's Palace for the Michael of Kent wedding, we were quickly up the stairs and in, encountering a mixture of Jew and Gentile spread through the State Apartments leading to the Throne Room. Queen Elizabeth held court as usual by her favourite window. She was in sparkling form and clearly is going to enjoy every minute of being eighty next year. And she was, as ever, anxious to know the news, about Julia doing *Swan Lake* for Boston and what's on at the Museum, etc. Princess Margaret, in a velvet suit, pushed her way characteristically towards us to complain of a great brick dropped by Garrett Drogheda during the fund-raising tour of the USA.

We then moved on to have drinks with Caroline Gilmour at Carlton House Terrace to view the face-lift. Well, it did look much better. Vast pyramids of dried flowers by Ken Turner, at my recommendation, arose from the torchères in the entrance hall, flanking a fireplace over which there was a looking-glass from Boughton. Buccleuch tapestries were being restored to hang on the grand staircase. In the great blue, white and gold drawing-room upstairs there were grand full-length portraits, rearranged furniture, and V & A loans, all of which transformed the place from *école de* Peter Jones. If only Caroline can win the battle and get rid of the DOE chrysanthemum floral tribute which is delivered once a week at vast cost to the taxpayer, it will all be marvellous.

Willy Rees-Mogg was delighted to be back in business (*The Times* started up again last week).[1] I am afraid that I said how thoroughly I disapproved of a lunch being given for Anthony Blunt[2] after the press conference he gave. He shared my view of Blunt. After a very careful reading of both the press conference and the TV interview Blunt emerged with more suave condescending deviousness than any of them. Above all, as everyone says, no single word of regret, no expression of

[1] After a long and bitter dispute with the unions *The Times* was published again on 12 November, after a closure of almost a year.

[2] The Queen's eminent art adviser, Sir Anthony Blunt, had been exposed as a long-time Soviet spy and stripped of his knighthood.

sorrow for having conceivably exposed the Queen to any embar-
rassment. All this is reflected in the fact that no one of significance has
raised a finger of support for him, although the Establishment, if it had
seen any glimmer of repentance, would, as usual, have tried to lift him
back. Willy and I agreed that Blunt was a character out of some Jacobean
drama where untruth piled up upon untruth, so that everything became
blurred by deceit and deviousness. And yet he is a good scholar.

Then came dinner with Gerald Ellison, Bishop of London. The Elli-
sons are the first to live in the new episcopal residence in Barton Street,
Fulham Palace having been made over, I believe, to the Borough of
Hammersmith. The house is pre-1914 Queen Anne and hung with
episcopal worthies in rochet and chimere. Apart from that, as with all
ecclesiastical residences, it felt a bit sparse. Although the dining-table
was laden with silver, the actual table was a group of plastic-topped
ones pushed together to form a single surface and surrounded with
modern metal and wooden chairs. In other words, the room was pre-
sumably used for committees.

The dinner was in honour of the Kents. It was the first time that we
had seen her for nearly a year. She looked so much better but older,
with less hair, which in fact was an improvement on the inflated sixties
look which she had clung on to for far too long. She wore tartan in
shades of blue and green with some rather inferior lace trimmings
which spoilt what would otherwise have been a pretty dress. Music
was now her thing and she had been going to rehearsals with the Bach
Choir. We enjoyed her account of Denis Thatcher asking her to arrange
for him to meet the Duke of Edinburgh privately so that he could
discuss how he should handle being married to a woman at the centre
of affairs!

The Bishop had back in the basement chapel from the V & A (which
is why we were there, I suppose) Bishop Sheldon's splendid silver-gilt
plate and there was also a marvellous modern cope appliquéd with a
pattern of all the domes and steeples of the great churches of the
diocese. It can only be worn, however, by a tall bishop.

The other guests were Sir Hugh and Lady Griffiths (lawyer), Lord and
Lady Runciman, Matilda Edwards (Foreign Office), the Norfolks and
Edward Heath. Julia was next to the last. He really does not like women
and, like nearly all politicians, can only ever talk about himself. Even
Julia found this very hard work.

1980

Friends at Court

In the long run the Conservative Government was to work in the Museum's favour. At no other time in my career had I known so many people in power. In fact there were only two people in the Cabinet we didn't know, and that network of friendship and political connection was to be used to full advantage when the new Government accelerated what its socialist predecessor had begun, the massive reduction in size of the Civil Service. As far as I was concerned this was a rerun of all that I had gone through in 1977–8, although this time, in the interests of self-preservation, I decided that I must not get so emotionally entangled in it. In this round the only serious loss was the closure of the National Slide Library. On the whole benign ministers protected the V & A although, for the first time, the other national collections began to feel the axe which until then had only been wielded on the two departmental museums. But 1980 was to include an important chance encounter with the Prime Minister which lit the blue touch-paper which was to gain the V & A its liberty.

The exhibition of Renaissance jewels, *Princely Magnificence*, is the one which figures in the diary entries; I oddly never wrote about *Japan Style*, which the Queen opened on 12 March. This was a disastrous opening event as the Chief Warder countermanded my instructions that those invited to the private view were to be in the exhibition at the same time as the Queen toured it. The result was an empty exhibition with me taking Her Majesty around while everyone else was confined to a neighbouring gallery. Betty Kenward, 'Jennifer' of the famous Diary, was rightly upset and I only retrieved my reputation with her by sending a bouquet of red roses round by hand immediately, with a letter of apology and explanation. Such things may sound trivial but the smooth running of such events can make or break a directorship.

The idea for the exhibition went back to my arrival at the V & A. I came as it were with it in my ideas knapsack. In the post-war era Japan had forged the way in industrial design but there had been no exhibition on the topic. It took years to get this off the ground and the fact that it happened at all was owed, amongst others, to the Japan Foundation and

enthusiasts like our former ambassador Sir Fred Warner and his wife, and to my colleague Joe Earle. What is striking was the hostility and criticism that the exhibition provoked. There were even questions in the House saying that it was a disgrace that Dr Roy Strong should show Japanese mass-manufactured goods like motorcycles in one of our national collections. But, in an odd way, that exhibition, although never a public success, was a turning-point: within two or three years there followed the massive Japanese exhibition at the Royal Academy which was received with rapture and from then on, of course, everyone was after Japanese sponsorship money.

By 1980 I was trying, after the dramas, to lift the place forward again and returned to the subject of redoing the Museum's British Primary Galleries, a project which is still in hand as I write seventeen years later, which is some indication both of the financial implications of any such scheme and also the amount of internal feuding which such proposals to change anything always gave rise to. Much energy was expended wooing the Wolfson Foundation but that failed. It was, however, the first time in the Museum's history that part of its permanent display, hitherto maintained and refurbished at Government expense, was to be paid for partly by the private sector. Until then sponsorship had been a feature only of exhibitions. So it was that however decrepit some of the departmental galleries were when it came to raising money, one inevitably had to look for the most attractive packages, and the Primary Galleries, containing our finest and most famous objects, were an obvious choice. At this stage it meant that anyone financing a scheme from outside would be faced with working with the Property Services Agency of the Department of the Environment, an organisation with which I had struggled for over a decade and about whose efficiency and economy the less said the better.

More significantly, this year saw what was called the Boilerhouse Project get under way, a temporary exhibition space built behind the Aston Webb Screen on Exhibition Road at the expense of the Conran Foundation whose purpose was to stage shows designed to stimulate contemporary design. These were to be a preliminary to what was later to be the Design Museum at Butler's Wharf. Here again there were problems, as the Treasury tried to veto it on the grounds that outside interests should not be housed on Government premises. They did, however, in the end authorise the scheme on the basis that it was a 'temporary' exhibition.

And this was the year too that the groundwork was done which led to the joint MA course with the Royal College of Art in the history of

design and the decorative arts. The aim was to establish design history as a serious academic discipline and that it was set up at all was due largely to the support of Professor John White and to Christopher Frayling at the Royal College. From my perspective all I knew was that these areas of knowledge were looked down upon by the fine arts lobby. Certainly the Courtauld Institute of Art had ignored both design and the decorative arts as a kind of lower form of life and my aim was to rectify this. But, although naturally it remained unarticulated at the time, it was also aimed at gingering up complacency within the V & A, where curators too often believed that they alone 'knew'.

The purchase of the Balfour ciborium, one of the most important and famous pieces of English late-Romanesque goldsmith's work dating from the end of the twelfth century, was reason for rejoicing but I confess that I was more excited by the decision to commission a collection of contemporary plate for the Museum. Robert Welch made a magnificent pair of silver candelabra for use on ceremonial occasions with a Latin inscription composed by the Keeper of the Library, Ronald Lightbown. Ablaze with candles, these were henceforth to adorn the many fund-raising and other functions which were to be the pattern of the eighties. After I left, this tradition sadly went into abeyance.

18 January. Cecil Beaton.

This was the day Cecil Beaton died. I was rung that day by Beatrix Miller, editor of Vogue, *and asked to write a pen-portrait of him. That request pre-empted what had become an increasing practice of writing a pen-picture in my diary. What appears below was published in the 1 April issue of the magazine. It seems appropriate to include it here as I wrote in the immediate aftermath of hearing of his death.*

I shall miss him. I shall miss that pale face and the blue eyes, that elegant figure which never sat but composed itself into a chair. I shall miss the gaiety, the drawl and inflexion of his voice, the way his eye would turn on a scene, the lid blinking like a camera's shutter taking it into eternity, the rakish manner in which he put his sombrero on his head, defiant in style to the end. The perfection of a luncheon party in the old days at Pelham Place, the grand style in miniature with its double doors, classical columns and walls of black velvet edged with gold. In the country it was the same but different: the gatherings before lunch and dinner in what he called his 'Lady Windermere's Fan' room his own recreation of the *belle époque*, crimson velvet and gold and white, rose-covered chintz covers and curtains, and layer upon layer o

lace, and flowers, flowers everywhere. White flowers, I recall him saying, were the only chic ones. His white willow herb now grows in our garden and the Reddish rosemary for remembrance.

What a treasury within the mind those weekends were! His entrance carrying at least four hats in which to sit for his portrait to David Hockney. The expedition across a field until the car sank virtually immovable into the furrows so that he could give us a glimpse of Ashcombe, his first love, down in the valley below. Or darting around the room spraying it with *eau de toilette* before the arrival of the local repertory company, come to pay homage. And always one's return to London laden with flowers. Once I left with a Birnam Wood of lilac to the astonishment of Waterloo Station and the taxi-driver.

And his energy, zest and response to everything. Always wanting to see everything new in the theatre, to see what other photographers and designers were up to, eternally rearranging and redecorating the house, forever embarking on new garden projects with a magic that made plants and trees grow faster than anyone else's. The walk round the garden was the thing, to see what was new. One visit it would be a colonnaded summerhouse at the end of a vista of lawn, on another a chequered paved garden of lavender and box, or roses trained flat over frames. And, his finale, the island and wild garden with its ducks and wildfowl and spring flowers.

The measure of an artist is his ability to make others look through his eyes so intensely that his vision becomes unique and immediately recognisable. This he had. I cannot ever believe that he was a great technician and I have seen him bewildered, trying to understand a scale model, but when the prints came or the curtain went up it was pure Beaton. I know of no one else with an eye so attuned to the visual nuances of an age, who recorded them so brilliantly in his own work from neo-Edwardian to surrealism, from neo-Baroque to op and pop. For over half a century he distilled the essential images of successive decades through his camera's lens and by this means shared them with us.

Like so many others, he almost despised what he did best, photography. But that is what posterity will cherish most, the multifaceted images that he gathered into the camera's lens, recording the essence of twenties fashion, the romance of royalty in the thirties. He went on to arrest us with the cruel reality of war and his eye was reborn to the arts of peace. But he would have preferred to have been a painter. I was always aware of the oil paints and brushes lurking somewhere waiting

to ambush a sitter. I dreaded being asked what I thought of those portraits of his victims. Mercifully I escaped.

As a writer? I wish that he had been more careful of his prose. I wish that he had been a little less slapdash and hurried. No, those books were pure *pièces d'occasion* but the diaries are different. Yes, we will always need those diaries, at least the early ones, and certainly some of the later. No other source is so compelling in its pen-pictures of the *beau monde* of two generations. No one else has written down so much acute visual detail about people's looks, mannerisms and physical surroundings. His pen exactly drew the world in which he moved, not that of politics or of the intellect, but of international society, of theatre and films and of aristocratic country life in England in its muted decline.

I don't think that I would have liked to have been in the wardrobe or the paint shop trying to interpret one of his designs, but then that wasn't the point. In fact, when the curtain actually rose it was always on a visual spectacle that could only have been conceived by him. Its key was an exaggeration and a heightening of every detail of a period to an extreme. He transferred to the stage the fashion plates of Heideloff or the portraits of Boldini and Helleu as though they recorded a reality which they didn't. In the post-war years those sets and costumes for the revivals of Edwardian plays were a miracle. They gave me, as a schoolboy up from the suburbs looking down from a remote part of the theatre, a glimpse into a sumptuous world, a vivid contrast to the grimness of austerity, rationing and utility. Up went the curtain on Edwardian opulence, rooms with windows curtained with yards of material, tables with heavily fringed tablecloths, huge chandeliers, *grandes dames* in jewels, tiaras and silken trains. However did he do it and wherever did the materials come from? For three hours he swept us away. In fact, for half a century he swept us magically away. Although history will recall him most in his brash, assertive heyday, I admired him most at the end. The stroke was terrible, but it gave him a greater humanity, an honesty, a courage and a bravery in the face of adversity which vanquished the old often brittle surface. One felt true friendship and every visit to Reddish left one filled with poignancy and affection. Perhaps it is not how he would like to be remembered, but I shall always recall him as he had no wish to be, a marvellous old man, gentle and warm, with his thick caped winter coat and woollen scarf, walking in the chill golden sunshine of the garden he loved most of all.

What one couldn't say then but can now is that I remember him too

as a great hater. Somewhere there still lurks something which I never saw, his book of caricatures which remain unseen to this day, so cruel they are. Snobbery, untold ambition, together with envy, were sad defects which marred this remarkable man. Hugo Vickers, his biographer, told me that I was one of the few people to survive in his diary unscathed by his pen. At his memorial service later that year I acted as one of the ushers.

23 January. A crown for Cecil.

I drove down amidst glorious bright winter sunshine with Beatrix Miller and Felicity Clark in the *Vogue* limousine to Cecil Beaton's funeral at Reddish. The pathway up to the church was lined on either side with wreaths and as I walked up the path I caught a glimpse of some of them, those from Mary Rothermere, Irene Worth and Irving Berlin. Diana Cooper had sent a crown of flowers – a crown, as she said later, for Cecil. Inside, the church gradually but quietly filled up with Dicky Buckle, Hugh Smiley,[1] Hal Burton[2] and Henry Pembroke[3] acting as ushers. The coffin lay in front of the altar flanked by two huge candlesticks with two arrangements of white flowers, and wreaths had been garlanded across the sloping window-ledges along the aisles. The atmosphere was very 'village' with the organist softly playing 'Jesu, Joy of Man's Desiring' and, more poignantly, 'Nimrod' from the *Enigma Variations* with its theme of friendship. The mood was *piano*, in spite of the presence outside of the press snapping away.

At 2.30 p.m. promptly the 'family' appeared, Eileen in a pixie hood and green coat, Grant the factotum, Smallpeace the gardener, and others. Diana Cooper arrived, marvellous, in a long mink coat but wearing a white sombrero with her unicorn brooch pinned firmly to it. She sat front left and the others I spotted were Pam Hartwell, George Weidenfeld, Diana Phipps, Chrissie Gibbs, Patrick Procktor, Marianna Marten, the David Cecils and Mollie Salisbury.

When it came to it the service had that empty feeling that they tend to have for non-believers. There was something appallingly banal, although inevitable, about it. The coffin was carried out and lowered into the grave, which was decked with awful bright green artificial grass. Dicky Buckle came up and asked us to come back for tea at Reddish. We went. How extraordinary it was to be in that house and

[1] Sir Hugh Smiley, married to Cecil Beaton's sister Nancy.
[2] Television producer and personal friend of Beaton.
[3] Earl of Pembroke, owner of Wilton House (Inigo Jones), near Salisbury.

have tea with no host. It was eerie. I saluted Diana and said, 'Thank you for wearing that white hat and for wearing the unicorn too.' But she clearly needed something stronger than tea and made her way towards the gin. It was a strange, sad gathering with the threads of various aspects of a life brought, for once, together. Everything was fine until we left and I said, 'I must go into the library for the last time.' We pushed the door open and walked in. Everything suddenly flooded back and it was too much. The result was Beatrix and Felicity in tears. Yes, Cecil would have loved it all. He had always adored publicity and he went out in a blaze of it with a small army of reporters in attendance and photographers and the cameras whirring. What more could he have wanted?

At the sale of the contents of Reddish Christopher Gibbs purchased for me the sundial from Cecil's tiny lavender garden which he had just laid out when I first knew him. It stands as the focal point to the garden we planted to mark the Queen's Silver Jubilee.

30 January. The Shakespeare Prize and allied thoughts.
One very nice thing has happened to me. I have been awarded the Shakespeare Prize by the FVS Foundation in Hamburg. It is a prize given annually to the British person who is considered to have done most for the Arts in the country and my immediate successors include Peter Hall, Tom Stoppard, Harold Pinter, Graham Sutherland and Margot Fonteyn. There is a cruel irony in this, for my work has all stemmed from being a schoolchild in a war against Germany, brought up on King Penguins and *Britain in Pictures*[1]. How odd, after so many years, so much work, so much giving and caring, to receive one's first gong from the 'enemy'. The British system is cruel. If you stand up for a place, like I did for the V & A, against the appallingly unjust treatment of it by the Socialist Government, you are slapped down ... the sweet letters of congratulation on the Shakespeare Prize have greatly touched me.

So I feel at forty-four in a clouded period, during the summer of 1979 almost in eclipse, but, thanks to *The Garden* exhibition, perhaps the clouds are parting. I hated the feeling of bitterness left within me from

[1] King Penguins, published by Penguin Books, and *Britain in Pictures*, published by Collins, were two enormously influential series of illustrated books. Small in format, competitively priced and popular in tone, they introduced a wide range of subjects to a huge public during the war and post-war periods.

1977–8, all the rows and all the horrors. Now it recedes ... I sense a new beginning. Perhaps the greatest pleasure at the moment is to see the Heritage Bill go through with its various amendments which epitomise all that I fought for in the great series of exhibitions I did from country houses to churches to gardens. It was a great triumph to achieve leaving artefacts *in situ* in the great houses and seeing the Government indemnity system extended to regional museums and galleries.

30 January. To Jan van Dorsten. Into the eighties.

How marvellous of you to find out that I was awarded the Shakespeare Prize, rather glittering and it quite made the advent of the eighties exciting ... We have been busy as usual. Julia is doing *Swan Lake* for Boston, *Hay Fever* for the Lyric, Hammersmith, the Orangery at Warwick Castle, besides a book together. We have also just finished putting together a very pretty guide to Madame Tussaud's. We are still in the throes of builders but the large room is finished and we were in it at Christmas. It is gorgeous and looks as though it has always been there. The joining of the house and stables goes on and we have had dramas all through the late autumn with the roof off and ceilings collapsing, which drove us mad. The end is in sight and the house looks HUGE, more like a manor and less like a rectory. I've planted a yew hedge around the orchard and I'm trying to redo the vast serpentine herbaceous border into a new wild extravaganza. On the whole things are very calm and this Government has been a treat for me after the bloody horrors of the last. I just want calm and peace and good straightforward work. Nothing could have been so horrible as the late seventies, so I feel fairly optimistic in contrast to everyone else who is now having to cut for the first time.

14 February. Norman St John-Stevas.

Having lived through four changes of Minister for the Arts since 1974 one gets used to them coming and going. I was not heartbroken to see Donaldson make an exit. He had stood by limp while the V & A was lacerated. He clearly loathed the job, knowing that it had not turned out to be the bed of roses that he thought it would be. But he was good at going places, all over England, and appreciative of ordinary people. In other words, a nice man but too feeble to fight and produce the goods.

Norman St John-Stevas is far more complex. It is too simplistic to say that he's a nasty man but one who will produce the goods. Having

promised all for the Arts, he's got it along with the Duchy of Lancaster Office and also being Leader of the House. It is too much for one person, but he won't relinquish any of it. All the problems start and finish with his personality. There is no great family fortune and he likes the hired domestic grand style and having Princess Margaret to dinner. Indeed he's obsessed with HRH, with whom he makes a not uninteresting parallel. Like her he has a sharp, quick mind and wit but, unlike her, his has been trained by education. Like her he is a person of total irrational caprice. The day that his marvellous assistant Mary Giles came to have lunch with me he had not spoken to her for three days. Some letters he answers, others disappear in boxes where no one can get at them. Some people are in, others out, some just come and go. Young men are in, unfeminine women are in. People like Michael Levey or myself are in only as a temporary alliance, for he doesn't like hints of other stars in the firmament and, worse, we are both married. His way of doing things could be, and is rapidly proving, fatal. His only concession to the plebs is going to English National Opera, for he refuses point-blank to go to the regions. When he does things, like HRH, he can suddenly switch off and brush past all the loyal workers, leaving them unthanked. At the moment the last stages of the Heritage Bill are giving him a secure lull. But I would predict that by the autumn those that have held back won't hold back any longer. *Private Eye et al.* will shoot their darts. Up until now all he's done for me is to maintain – only just and with a dip – our *status quo*. With that I'm content, because stability is desperately needed. But his petulance, his endless craving for adulation and his failure to hearten the workers spell disaster unless he can be got to gracefully retire and pass it all on to a member of the Lords, which seems the only way out. Cuts in the arts budget, still as yet unknown, the failure to legislate on tax concessions on sponsorship or the removal of VAT, and unfortunate appointments to the new Heritage Memorial Fund Trustees lie ahead. Unless a radical change of attitude sets in I can't see anything ahead but the rocks. Sad really.

24 April. The National Heritage Memorial Fund is launched.
Yesterday the National Heritage Memorial Fund was launched at the V & A. I arranged the drink and the flowers, which were appropriately red, white and blue, and it was staged in the Gamble Room. The occasion was a bouquet for the Museum as Norman could have held it in any of a number of other places. All the heritage–arts lobby and their press appeared plus a few of Norman's socialites, like Charles Harding,

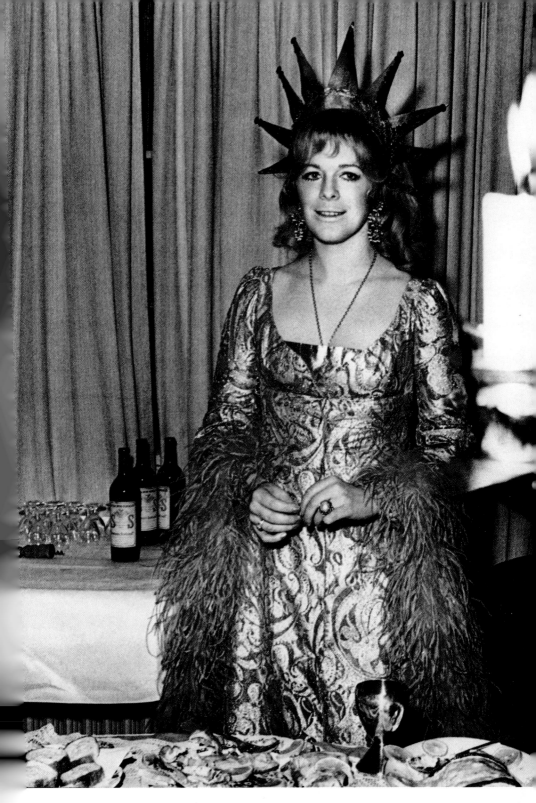

The Field of Cloth of Gold Ball

Antonia Fraser as Queen, 1970

Garden Idyll at Reddish

Eileen Hose, Timothy White the cat, Cecil Beaton and myself, 1977

REMARKABLE WOMEN

Diana Cooper

Pamela Hartwell

Frances Yates

Ann Fleming

Margaret, Duchess of Argyll, and Lady Rupert Neville. Raine Spencer was there with Johnnie, not seemingly deflated by Norman's failure to get her the chairmanship. Alma Birk was more embittered on the subject and stated that if she had known who Mrs Thatcher was going to have appointed she would have fought harder in the Lords. The appointment of Martin Charteris (who was my idea via Hugh Leggatt) everyone has greeted with great respect. But what of the others so far announced? John Smith (Landmark Trust), a worthy soul and ex-Tory MP, Sir Robin Coke, another ex-Tory MP (his constituency refused to readopt him) and country-house owner, Lord Balfour of Burleigh representing Scotland (don't know about him) and someone I've forgotten for Ireland. But what a disappointing lot of people, all buildings-orientated. No one whose focus is the fine arts or industrial archaeology or the natural environment. And all oldish. At any rate basically it's a good thing. No brains or real eyes apart from the Chairman. I despair. Norman was quite open about his disappointment.

17 May. To Jan van Dorsten. Italy and more cuts.

We are here in the midst of Mediterranean weather, day after day of blue sky and sun which in one sense is glorious but, in another, disastrous as the garden wilts and a fortune in shrubs, trees and hedging slowly dies. The seasons have gone mad again.

You must try and go to Florence. The Medici exhibitions are fascinating and a muddle. I took about twenty Friends [of the V & A] and we had a hectic time. I worked till I dropped. Out at the dot of 9 a.m. each day for nine hours of sightseeing; even had to entertain them in the evening. But the exhibition on theatre was wonderful, and I'm hoping to get it for the V & A. I staggered back from that and got to The Laskett on Good Friday, three days together, and then Julia went off for four days to Boston with her *Swan Lake* designs. She looked exhausted before she went. I virtually slept while she was away and she caved in with tiredness on return. Her *Hay Fever* opened at the Lyric, Hammersmith. Lovely notices for her, but the miscasting of the central character, Constance Cummings, has meant no transfer to the West End which financially is irritating.

The Civil Service is faced with another round of staff cuts as I predicted, so God knows what will happen. I fought so hard and cared so much last time that I simply cannot go through all that again. So I have composed my mind to tranquillity. If it happens to us and we are not protected they will have to come in and do it themselves, as I will refuse to make any recommendations at all, regardless ... We're off to

Hamburg for the [Shakespeare] Prize next week and I've literally just this afternoon finished the speech. My salary again is lower than my heads of department and it is essential to keep doing journalism to pay the bills. The report on museum directors' pay has been locked in the Civil Service Department for a year and has never reappeared. I am frankly non-stop in agitating about it as I have nothing to lose.

28 May. A significant encounter.

It was rather a *piano* Royal Academy Dinner. Hugh Casson, however, just seventy, was looking spryer than ever, Princess Margaret was in transparent virgin white and Mrs Thatcher in black and white. There was the usual gathering of the Establishment and the art mafia. Many more of the men than usual were wearing dinner-jackets rather than white tie. The food was filthy and the speeches very dull. Princess Margaret's speech was written by Hugh Leggatt via Norman's office (he wasn't there as he'd gone to see the Pope!) and Mrs Thatcher's, I guess, was compiled by Robin Coke.

The latter asked before dinner whether I would like to meet the Prime Minister. I said that I'd already met her but would love to meet her again. It was quite an encounter, for I am afraid that I seized my chance and stood my ground, saying that the poor V & A mustn't be sacrificed yet again because of Civil Service cuts. She sailed on, saying that she had given the Arts masses of money. I said to her that that wasn't the point. After I said to Robin Coke, 'I hope I didn't go too far.' 'Well, she'll certainly remember you,' was his reply, asking me to write to him about our woes in order to reach her ear.

Then, during her after-dinner speech extolling her munificence in terms of cash to the Arts, she interjected 'In spite of what Dr Roy Strong says,' and gestured down the table towards me. I wanted to sink through the floor but afterwards she came up to me and rather sweetly put her arm through mine and said, 'What is the problem?' and we talked. That I thought rather marvellous of her and I told her exactly what our problem was. It was not so marvellous, however, that poor Mr Thatcher entered as part of the high-table procession only to find himself demoted halfway down a table. That wasn't very tactful handling by the Academy.

Royal Academy Dinners are strange, increasingly run-down occasions that you can set a stopwatch by. Everyone fled early. The designers Zandra Rhodes and Jean Muir at least added zip, Zandra with two eyebrows for a change and Jean impeccable in a little immaculate

black number with sequins. No other woman had a dress worth looking at. They were upholstered...

June. Bevis Hillier's attack.

The British never love the middle-aged. They love their stars, if such they be, either in youth or old age. Liz Forgan had begun that chipping away and now it was to accelerate. At about this time the press officer reported to me the words of a major art critic, still writing for one of our broadsheet egghead Sundays: 'We created Roy Strong. Now we're setting out to destroy him.'

I confess myself to be bitterly upset by the slanderous attack on me by Bevis Hillier in the *Sunday Times* colour supplement. It slammed into me as a failure whose course had run into mishandled disaster and who would leave for the United States as soon as I could get my clutches on a knighthood. It was the most envious and cruel piece, deliberately placed on the page at the bottom below a profile of a lowly museum assistant just to rub in my public demotion. I have heard since that Bevis has been belaboured good and proper for doing it and, in fact, as a consequence, lost something that he very much wanted. The attack would have been hard enough to take from any journalist but worse from someone who has been a friend for fifteen years, who had eaten at my table, visited my house in Brighton, been given work in the V & A, for whom I had been a referee for a job, and who, never at any stage, had been given anything but help by me. There was also no way that I could publicly reply. And now he writes to me saying that he is sorry and that he made a mistake. Yes, of course I do forgive him but, no, I can't wipe out of my mind the hate and venom that poured out into newsprint. Something terrible had happened. Friendship and trust had been violated ... And one cannot glue glass back together again. It is always broken.

June. The cuts saga continues.

I am slowly realising that nothing short of an Act of God will prevent the V & A being cut again. I look on this with gloom, but it fulfils what I predicted the previous time when I fought for the disestablishment of the Museum which the Labour Government refused to grant in the face of union opposition. As a preliminary canter and skirmish the first Report on the V & A during my directorship is now stuck in the Office of Arts and Libraries. It covers the years 1974 to 1978 and, although the text has been sugared to distortion, they have indicated to me that

the Minister will not allow its publication unless distortion is moved into untruth and the end-result reads as though in 1977–8 nothing actually happened which was out of the ordinary. I can't stand the beastly hypocrisy of it. Having rewritten the Report twice I now wash my hands of it and leave it to them to do what they will with it. So much for truth in public service.

Nothing so far indicates that we will be exempt from the 75,000 further Civil Servants due to go. In our case it means another sixty posts. At the moment we have a report on the warders which states that we need twenty-two immediately to ensure that even the basic security of the collections on display is maintained. If I opened the V & A on the basis of that report and placed warders as they indicate, the whole Museum would close in perpetuity bar the ground floor. The Advisory Council mercifully agreed to take joint responsibility with me for continuing to go on as we do, with the hope that nothing untoward would in fact go wrong. So there is no way of axing further warders without closing the place.

Somehow the sixty staff to be chopped have to be found elsewhere. If all this happens, the Museum will have lost 190 staff in seven years. The only hope tempering this is to gain the flexibility that disestablishment from Government would bring. As long as we are part of the Civil Service we are stuck with their dogmatic pronouncements on numbers. I have no flexibility between salary and administrative funding, which would alleviate some, if not all, of the problems. So I continue to press for disestablishment. As part of the campaign I wrote to Sir Robin Coke in the hopes that he could influence the Prime Minister and I also lobbied Paul Channon, the Minister responsible for the Civil Service, while we were in the Royal Box with the Duke of Kent watching *Parsifal*! There seem, however, to be no exceptions and no mercy, something made worse by the fact that the Civil Service Department is now faced with potential abolition by this Government and is therefore zealous to prove itself by acting in the cause of these massive reductions. I am to see Norman St John-Stevas in the hopes of appealing for the option of disestablishment from Government.

14 July. Erté's Der Rosenkavalier.
Last week I heard that Paul Channon actually had written to Norman and today the under-secretary, Lawrence Brandes, saw him about it. The outcome was that Norman won't let the V & A go as it would be a diminution of his own empire.

The weather is awful this summer. For six weeks now it has been cool to cold with leaden skies and torrential rain. Glyndebourne for our annual trip was afloat and made worse by Erté's ill-conceived *Der Rosenkavalier*, a kind of art deco illustrators' mid-Victorian chocolate-box lid that had nothing to do with the opera. Very dull singing apart from Octavian.

15 July. The Queen Mother is eighty.

Into morning dress and off to St Paul's. It was a cool, grey day but there was no rain. We walked up to the cathedral from Blackfriars Station through the gathering crowds. Inside there was a flurry of arrivals, a kaleidoscope of grey toppers, summer dresses and hats, and marvellous military uniforms. We were directed to the nave and placed very well, halfway down. The entire waxworks was there. The cathedral was very brightly lit which gave it an added sparkle and glitter, which was spectacular when it fell on to the swords and braiding of the gentlemen ushers and the halberds of the Beefeaters. There was a hideous banner hung at the crossing into the north transept donated by the Friends of St Paul's in turquoise and yellow, very strident and incorporating a quotation from Dame Julian of Norwich. We waited for an hour but it was not in the least tedious as the throng of *tous les grands* commanded our constant attention, all 2,700 of them. The *corps diplomatique* were swept to the front.

There were so many people and so many friends. Jim Callaghan looking weary, white and worn, the ebullient Edna and Denis Healey, Diana Cooper on her son John Julius's arm wearing her 'hereditary' hat of black ostrich plumes, Fred Ashton, his jaw fallen and looking very old, and Jack Donaldson in a crumpled lounge suit with Frankie [Frances Donaldson] in a hat which made her look like a char. Maureen Dufferin looked an apparition in ankle-length black with a tiny sequined cap with sprays of osprey feathers jutting out of it (a caricature out of a Busby Berkeley musical). Wave after wave went by: Droghedas, Caccias, De L'Isles, Mollie Buccleuch, Bernard Norfolk. Then came endless processions of yeomen, gentlemen-at-arms, aldermen, vergers, the Dean and clergy. The organ continued to boom out Wagnerian marches which added hugely to the feeling of expectation. Cardinal Hume in electric pink took a seat in the choir.

Then came the great main processions. The west door was flung open and there was a sudden glorious glimpse of sky and the surge of the crowds outside cheering. The Bishop of London wore his wonderful cope embroidered with all the City churches. Archbishop Runcie,

however, was in rather a nasty modern gold one. Down the aisle came the Royal Family, mostly rather badly dressed with Princess Michael in baroque flounces and the Duchess of Gloucester with a hemline a decade out, it was so high. Princess Alexandra, however, passed with flying colours. There followed a long pause and then came the final procession which was signalled by a shattering blast of trumpets from the gallery of the dome. It opened with all the clergy with their processional crosses, the vergers with their silver wands, then Black and Silver Stick in Waiting, the Lord Chamberlain, then the Queen, the Queen Mother, Princess Margaret, Prince Philip and the Prince of Wales. There was happiness everywhere.

We all rose and sang the first hymn. And so it proceeded with lessons, hymns and prayers, all 1662 Prayer Book stuff which she loves and a good address by Runcie. 'Not A +,' Martin Charteris remarked, but I thought it very good. A bit suburban in a way but a treat I would think for the TV viewers. The whole service was very static. I cannot think that it lasted more than forty minutes and it ended with a blessing, after which we all sang the national anthem fervently with trumpets blasting again.

The royal procession moved back towards the west door, very slowly with lots of happy smiles as familiar faces were registered, bows and curtsies in tidal waves as they advanced. Then the ushers let out a second wave, the *corps diplomatique*, an untidy lot, then the Government. It was to be noted that Mrs Thatcher walked up the nave eyes downcast and pensive as was indeed correct. All in all the old magic worked, thank heaven. But who could we have to make it work better than the Queen Mother, instant joy and happiness for all?

25 July. To Jan van Dorsten. The Shakespeare Prize is given.

The weather here has been vile until last Monday, really cold and rain and rain and more rain. Really depressing. However, hopefully it will be nice for our August stay [in the country]. We come down on 5 August, the day after the Queen Mother's eightieth Birthday Gala at Covent Garden for which HM has chosen one of Julia's ballets, which is a great honour and thrill. So we go to that which will be a marvellous occasion, all jewels and happiness I'm sure. One of the nice things was to be asked to the service to mark the occasion at St Paul's and to be placed with her friends right in the middle near the nave aisle halfway down. Gloriana herself would have loved it. All went like clockwork, wonderful state uniforms and pretty dresses and gents in morning clothes. Simple and dignified and loving and she walked out smiling

and acknowledging us all. What a privilege to have known her and what a capacity for friendship that extraordinary woman has.

So that was nice. Our other treat was the Hamburg trip. A great success. My getting the Shakespeare Prize had more coverage than they had had for years. We were so well looked after – the best hotel. A charming party was given by the British consul on the evening that we arrived, with two of Julia's theatrical friends, who run a dancing school in Lübeck, presenting, as a surprise, two children in perfect eighteenth-century clothes who danced in our honour. The party went very well but we only learned after that the Turkish waiters didn't know what whisky and soda was, so tumblers eight inches deep were dished out! Then on the great day a ceremony in the town hall of the type you must know about, but which is very un-English. There was a quintet playing Mozart in one corner. About two hundred and fifty guests were crammed into a grand room. There were eulogies from the Minister for Culture, a long one from the Director of the Kunst und Gewerbe Museum, then the presentation, then I finally got up to give my address – homage to Hamburg and the Warburg family and a statement of my philosophy of work. A great lunch followed, with more speeches and I was able to make an informal one saying that I'd make a Shake-speare Grove in my garden, which apparently touched them much.

The citation and medal presented were handsome and the words of the former very cheering to one's ego. Well, I've ordered an enormous urn for the end of the great avenue in the garden which will be the Shakespeare Grove.

So lovely bonuses. Now for the boring and nasty side. We still struggle on not knowing what the Government cuts will do. One week they are on, the next week off. Never mind, everyone this time is working together as a team. At the moment I think that we shall survive untouched, if we keep our heads down and be quiet. But it is touch and go. It has been so tiring lately. Four weeks running having to go out four evenings a week, which so exhausted me that I had to go to bed for a day. Now all I have to do is to struggle through the next ten days and then collapse.

Well, the garden here, after the drought of April and May, has made great strides and it is quite spectacular. A lot of growth and many alterations. The hedge around the Rose Garden is nearly everywhere six feet high and one can sit within it enclosed, a *hortus conclusus*. So we will be here until 8 September being quiet and working, which is pleasant, with occasional expeditions. I have to go in and assist the launching of a treasury for Hereford Cathedral for which I have been

the prime mover and money-raiser. Apart from that nothing official, thank heaven. So we'll start up again in late September.

4 August. The Queen Mother's Birthday Gala.

We came up from the country for the gala at Covent Garden. Julia's *A Month in the Country* was one of the ballets chosen by the Queen Mother for her birthday tribute evening. As we drove early to the Opera House we passed Clarence House, which even at 6.30 p.m. was still besieged with crowds and the new great banner was fluttering from the mast.

Gala audiences tend to be made up of the rich and seemingly ugly, for I have never seen so many overweight, badly dressed people and worse, poor things, overlit, for television had moved in. Outside the Opera House there was a white canopy and inside a box had been constructed in the Grand Tier by curtaining off a section and throwing a swag of braided and tasselled crimson velvet over the front, overlaid with garlands of flowers. The flowers, which had been donated, were mean in scale and one sighed at the poverty of invention and lack of money when one recalls the famous boxes created by Oliver Messel. However, the audience had a good sprinkling of old friends: C. V. Wedgwood behind us, Paul and Ingrid Channon in a box with Peter Coats, Ingrid stunning in a strapless fifties revival dress, then the Robbins, Droghedas, Levers, Gibsons, Lord Goodman *et al*. Very little jewellery, however, was worn.

The curtains parted and the state trumpeters in crimson and gold were revealed standing *en tableau*. The audience hushed the moment that the trumpeters lifted their instruments to their lips for the fanfare. Everyone stood and turned towards the Royal Box to discover that the Queen Mother had brought the entire family with her. She looked so happy, all smiles and waves, glittering in a diamond tiara and silver bespangled white dress. The audience applauded and applauded in a deafening salute of affection. Princess Margaret looked radiant, at home in the theatre which she loves most. Flashes of pleasure also came from the Queen, whose face set into one of grimness from time to time. Tough to have the competition of her mother but she was a genius at stepping back on this occasion. Tough also for her and some of the others to be saddled with three hours of ballet without a horse in sight, which must have been a work of supererogation.

Queen Elizabeth had chosen the programme. *Mamzelle d'Angot* was a real exhumation, a jolly romp by Massine with sets by Derain dating from 1943 but it must have been dated even then and seemed pure

1930s. It was danced, however, *con brio*, and the comedy was wrung out of it making it seem like an early Osbert Lancaster cartoon brought to life. *Month*, with Dowell and Porter, was even more lyrical and poignant, every detail touching and beautiful. How wonderful for Julia to have had this chosen for the great day.

And then, after the interval something happened. There was a delay. Then the Queen and Princess Margaret appeared in the Grand Tier alone. No Queen Mother. What had happened? All of a sudden huzzas swept the auditorium. Typically, she had noticed that no one in the amphitheatre or gallery would see her and so this silvery vision gradually made its way to the front of the old Royal Box to the right of the proscenium, this evening assigned to ladies-in-waiting. No spotlight had been allowed for this eventuality but it was lit by her own radiance. Everyone turned. The audience lifted the roof with hurrahs and applause and the gallery sang 'Happy Birthday'. It lasted seemingly for ever.

Then came the new Ashton ballet, *Rhapsody*, to music by Rachmaninov with Collier and Baryshnikov and choreographed in honour of the Queen Mother. Lyrical dancing, ever flowing and inventive, with an abundant use made of the Russian dancer's mighty frame with astounding turns and leaps which no British dancer has the build to do. Not a great Fred ballet but good, marred by a horrid set by himself and unbelievably bad costumes by William Chappell, all glitter in the wrong places, chokers and garters for the men and headdresses for the girls.

There was the usual riot of applause at the end, flowers, flowers, and yet more flowers, although the Opera House had obviously purchased a job lot of about a hundred Victorian posies which were relentlessly thrown on. Fred bowed low to the Queen Mother, sweeping his arms to the ground in homage. And then followed one final spectacle. The curtains parted for the last time to reveal the whole Opera House staff on stage. A vast cake was wheeled on, candles ablaze, and everyone stood and sang 'Happy Birthday'. Once more there were stupendous cheers and applause as this twinkling figure waved acknowledgement. And from the ceiling it rained down glitter, swirling like silver snow all over the auditorium. A great and moving evening. What shall we do without her? Princess Margaret loves the ballet, but only the Queen Mother ever *asks* to come to a museum just for sheer pleasure.

7 September. To Jan van Dorsten. Back to 'school'.

I go back to horrors. It looks as though the Government will lop another sixty staff from the V & A and my last week here [at The Laskett] has been overshadowed by trying to think HOW ever to do it. I dread all the rows, all the problems, all the denunciations, all the unpleasantness, etc. So that's bad. All I know is that I've made up my mind not to get so passionately involved this time because the last fracas nearly finished me. So I've kept the decks clear for a ghastly time and have been turning down invitations to perform left, right and centre.

We went to Stratford for my birthday and saw two horrors. The worst *As You Like It* ever: Rosalind was old enough to have been Orlando's mother and awful leaden sets. No magic, no romance. And a terrible Beaumont's *Maid's Tragedy* in The Other Place which we abandoned in the interval. I don't know how they get away with such rubbish. The day was saved by the weather and by oodles of smoked salmon for picnics and a bottle of champagne. The first fortnight down here we were too tired and too laid flat by hay fever to attempt much. And it rained non-stop.

The Shakespeare Prize lifted me through 1980 but any swipe that can be given to Dr Strong is sure of applause. But I do have faith in a certain unsinkability to beat them all and no one is going to get me to conform just for them, so there . . .

A rococo column and a bronze sphere arrived for the White [Silver Jubilee] Garden and looks good. I got it in the Cecil Beaton sale. It seemed sad not to buy something to remember that house by which one knew so well. And I've slaved, weeding and heaving lumps of paving and whatnot everywhere. And I've slept. No visitors to stay except my father-in-law.

Next Wednesday we'll have been married nine years which is incredible because it only seems like yesterday that I wrote to you before the event, which was quite a surprise for you. Off we'll go to our favourite Greek restaurant for a cosy dinner together.

6 October. Cuts averted and the V & A postgraduate course mooted.

During the last few days I have heard that the V & A is stabilised. It is not to be publicly referred to but it came through to me in a telephone call from Lawrence Brandes. Norman, I was told, had gone out of his way to master the facts, taking my letter in detail (the one I had spent the last week of my holiday drafting on the consequences of a cut of sixty staff which this time meant a decimation of the upper ranks because the warders could take no more). Paul Channon too had been

on and off the phone to the Office of Arts and Libraries (OAL). I fought a good tactical battle and it was worth all the efforts in respect of Norman, Paul, *et al*.

I am now trying to struggle towards establishing the Royal College of Art/Victoria and Albert Museum MA in the History of the Decorative Arts and Design. There is the usual violent opposition from a lot of the Keepers who have a withering dislike of the RCA, clamouring that if such a thing ever should happen it should be jointly with the University of London. John White[1] has been an enormous help and basically it should work. In fact it should lift the level of work on the decorative arts, a Cinderella subject as far as art historians are concerned. And do the same for design, now at a low level, and thus provide informed staff for museums and to teach design. It has so far been a bloody saga.

14 October. Gainsborough opens at the Tate Gallery.

Princely Magnificence has proved to be a wondrous spectacle to cheer us through the winter. Gainsborough at the Tate Gallery, however, proved to be something of a disappointment. We went there last night to a dinner given for about sixty. There was a degree of disorganisation and lack of taste attendant upon it. For example, to be received before we had reached the cloakroom was a mistake. We were all coats and hats in a bundle greeting the Hutchinsons[2] and Bownesses[3]. The dinner was in the Whistler Room, now very discoloured but still enchanting, but there was a lack of those elegant touches that used to exist under the Reids. Horrid chrysanthemum table centrepieces in strident colours, oval dinner plates, hard unrelenting electric light and no candles. The wine was good but the food not: melon on the table when one sat down, over-cooked lamb, crisp beans, parsleyed potatoes with no parsley and a diabolical-looking lemon cream pie.

There was something leaden about the show. The green walls killed the pictures, especially the landscapes which, as a result, looked flat. Obviously the money had run out or been scarce for the décor, which had set out to create a suite of eighteenth-century rooms. I feel that

[1] Professor of History of Art, University College, London.

[2] Jeremy Hutchinson, leading criminal barrister, was first married to Peggy Ashcroft and then to June Osborn. Created a life peer in 1978, he was Chairman of the Trustees of the Tate Gallery, 1980–84.

[3] Alan Bowness was married to Sarah, daughter of Ben Nicholson and Dame Barbara Hepworth. He was Director of the Tate Gallery 1980 to 1988, when he received a knighthood.

was so wrong for Gainsborough. This is how we always see him in endless country houses. What it needed was a sharp modern display to kick us into a new way of looking at him. Many of the great portraits were missing, only going to the Paris end of the exhibition, which was a mistake. No, it was really dull.

But from time to time one could focus on glories which even the hideous lighting could not suppress, pictures like *The Morning Walk* or the lady with the flaming red hair from Ascott. At the dinner I sat between an ancient coiffured Tate benefactress, hung with mink and diamonds and with pads and false additions to her hair, and Frankie Donaldson who, as always, was a treat. We both downed the Erté *Rosenkavalier* as bad taste and a mistake.

David Wilson and I went into a long conference with Lawrence Brandes of OAL. Once again the wheel turns. Ten days ago I believed that the V & A was stabilised thanks to Norman's personal efforts. Now I'm not so sure. Apparently endless meetings go on. The devils in the Cabinet are Joseph, Howe, Biffen and Nott who clobber Mrs Thatcher and feel that all ought to be sackcloth and cut-back and misery in the Arts and that the £380 million overall budget should be slashed. They don't approve of the Arts continuing to flourish, of operas being produced, or exhibitions staged. Never, I said, have I felt it more important to give people a lift, a vision, two hours of happiness, than now. All very deeply depressing. I felt that the whole evening was flat and rather dowdy. No sparkle, definitely none.

28 October. Mollie Buccleuch is eighty.
We went to Mollie Buccleuch's eightieth birthday party at the Gilmours' flat in Carlton Gardens. I must say that she looks a marvellous eighty, bright-eyed as ever, with her droll attitude and sing-song voice. The royals were there in force: Queen Elizabeth, Princess Alexandra (who rushed up and poked Julia in the back), the Gloucesters and Princess Alice.

The Buccleuch retainers had been imported for the party. There was a solid phalanx of the old gang: Mary Roxburghe, Fred Ashton, who had given up smoking and looked years younger, Ann Fleming, who did a ridiculous sweeping curtsy to Princess Alexandra, Johnnie and Raine Spencer, her hair like an exploded balloon, masses of make-up and black lace, Diana and Yehudi Menuhin, the Droghedas, Channons, John Cornforth, larger than ever, the Brudenells, Mariann Marten, the Dacres, Norman St John-Stevas – 'Look what the lift has brought up!,' yelled Lord Thorneycroft – Diana Gage, David Hicks

Hardy Amies ... All very happy, the old guard going on seemingly for ever.

All of this made a great contrast to the lunch I had with Beatrix Miller that day, the main theme of which was the sadness of it all. The Government policies are too tight. She had been to Newcastle and been horrified by the filth on the streets, drunken youths, the violence and the policing. If these policies continue and sharpen, the tumbrils will roll. In her world we lamented that Yuki had gone bankrupt, Bill Gibb ditto and now John Bates in liquidation [all fashion designers]. The British fashion and textile industry was ruined. It had been dismantled beyond recall. Last year she had written to the Prime Minister with Jean Muir, predicting all of this, and had had only a secretary's acknowledgement. She would, she said, write again. *Vogue* are to set up an annual Beaton prize for the best young photographer or illustrator.

29 October. The Boilerhouse and the Balfour ciborium.

We now seem to be in a better state! The pendulum of OAL swings to and fro and now I am told by Lawrence Brandes that the staff situation is stabilised after all! I do wish that I knew where we were. Now, I gather that there are to be cuts instead in finance, certainly to the Purchase Grants. The Cabinet meets tomorrow for the final hatchet job. But this is a period of success for the V & A. The exhibition *Princely Magnificence* is a rave with queues soon I am sure [there weren't]. The Conran Boilerhouse scheme has been announced, although as usual preceded by leaks to the papers. It seems a forward move. We get a phase of our building programme, costing £700,000, done in return for a five-year concession of space for a series of temporary exhibitions on mass manufactured design. There are, of course, the usual groans from the V & A staff.

Next week we will announce the purchase of the Balfour ciborium, a quite complicated transaction involving Lord Balfour, OAL, the Tax Office, us, and the National Heritage Memorial Fund. It cost one million, in fact £800,000 to us, made up of two-thirds from the NHMF and a third from us. The Wolfson Foundation's decision over paying for redoing the Primary Galleries is deferred until February next, but there has been much coming and going. How much, however, seems to vary from the view that Leonard Wolfson really ought to pay for it all this time (there is £50 million in the funds) to making a grant of between one million and half-a-million for a period of six years. I have Solly

Zuckerman[1] to court last. Probably the whole thing will collapse but I hope not. Meanwhile the V & A/RCA course has produced a real storm in a teacup but I am determined that it shall go ahead. The Keepers as usual are in a state of hysterics. Very boring.

6 November. *Princess Margaret comes to* Princely Magnificence.

Princess Margaret asked herself to *Princely Magnificence*. It was a private party for about twenty with dinner at Kensington Palace afterwards. Julia and I stood on the steps as usual in the bitter cold. It's a curious set she attracts in some ways. Colin Tennant rushed in wrapped in a shawl looking very middle aged. Anne now appears as though she had no connection with him. The Channons came and Derek Hart and Roddy Llewellyn, his hair coiffured and behaving as a royal *manqué*. Then there was a new Italian recruit, Luigi d'Orso, tall and thin and working for Colnaghi, and his very chic French wife. There was the usual top-up of members of the Household, the de Bellaigues and the Mackworth-Youngs, groaning as they had to be on a dawn flight to Los Angeles. And there was Ned Ryan – who is this man? HRH was, as usual, straight on to the whisky and the cigarettes. At any rate she loved it all and we all went back to Kensington Palace for a buffet supper. I said to Jane Stevens that we had to drive to Hereford and she said that I should tell HRH. I did and we escaped at 10.15 p.m.

Kensington Palace I thought looked grubby and run-down. The dining-room had a console table between the windows by Lord Linley which he had made while at Bedales. It was rather marvellous, a real Messel. It was awful to hear HRH droning on about how wonderful Anthony Blunt was but I've endured worse evenings with her.

8 November. *Bill Brandt.*

Bill Brandt came to photograph me at The Laskett. At 12.30 p.m. he arrived up the drive with his wife at the wheel. Brandt is an old man with wispy white hair and extraordinary eyes. I opened the car door 'Oh,' he said, 'I've lost two buttons from my overcoat.' I said that didn' matter. Did he want to take the photograph before or after lunch 'NOW,' he said and paced round the exterior of the house. That ide was vetoed for security reasons. I therefore took him to a garden vista No good. I then whizzed him through my library and writing-room. N

[1] Chief Scientific Adviser to the Government, 1964–71, and an influential figure i education. Created a life peer, 1971.

good either. Then he alighted *en passant* on the plant-embowered bay window in the hall and that was it.

It was a curious experience. The camera shutter got stuck. The lighting consisted of a bulb inside a metal helmet on a rod with a plug so old-fashioned that it would only fit into a socket in the hall chandelier. Both his film and camera were packed loose in a suitcase in which they just rattled around. He carried no fall-back camera. His wife stood by him holding this primitive lighting apparatus while he yelled at her where to position it. From time to time he just yanked physically to where he wanted her. He snapped but the camera didn't work and he couldn't understand why! It took ages and it became more and more surreal. They were both frozen and sat and had lunch in their overcoats. It was really weird as the house wasn't that cold at all. Throughout they both behaved like refugees from Eastern Europe.

The photograph was included in his book of portraits but of all the photographers who have snapped me, and they range from Beaton to Parkinson, Brandt was the most chaotic experience.

29 November. To Jan van Dorsten. End of the year.

We have been working fantastically hard. Julia's *Wild Duck* at the Lyric was wonderful and she's just back from Boston and working on *Swan Lake*, which opens next March. She's also done some pretty costumes for a *pas de deux* Ashton is doing for some charity gala for Sibley and Dowell. So that's nice. The V & A has got the marvellous jewellery exhibition, *Princely Magnificence: Court Jewels of the Renaissance*, which is a great and breathtaking spectacle. It is a huge success with 1,000 a day going through, which is cheering. I am still, after eighteen months and absolute agonies and dramas, in pursuit of one million from the Wolfson Foundation to redo our Primary Galleries and I am almost within an ace of getting it. This is confidential because it could all collapse, but I've done my best. And there's an oil company which wants to sponsor early opening on Sunday, so we've not done badly. On top of that the Balfour thirteenth-century ciborium was purchased for a million for the V & A, and a lost Bernini sketch model. And I've got the Theatre Museum through, a very delicate operation in dark times but I've got it, and the Minister and I are going to be photographed on site in the next couple of weeks. All of this has been achieved at great cost by me politicking as never before, pulling every string I have with the Tory Party and now I don't give a damn. It's sink or swim ...

Princely Magnificence brought a lot of state occasions, endless

openings and now I seem to do nothing but welcome members of the Royal Family round it. That's good for the V & A. But there have been too many late evenings and they don't let up for the next fortnight. Everything here is so expensive, one is terrified of a restaurant bill and I've just passed out from shock doing the Christmas shopping. We have been to quite a lot of theatre and I mention this because we saw last week the greatest and most glorious experience we have had in the theatre, we think, for a decade, the RSC's *Nicholas Nickleby*. It went on for two evenings and lasted nine hours and not a minute too long. It was a triumph, wonderful, leaving one spellbound, laughing, crying, with a lump in one's throat. Everyone in the audience left totally annihilated and hardly able to talk to each other because it was so amazing, so deeply moving. What a contrast to the terrible things we saw them do at Stratford in the summer. Pure joy. Oh, how I wish you could have seen it. It made one so proud of them and somehow this country, amidst the misery and gloom.

So we settle in for the winter. The leaves have left the trees. Miss Torte de Shell [our cat] is on my lap having scolded me for being a day late. It is a bright sunny day but bitterly cold and I look out on the great avenue we call Elizabeth Tudor and long to see the daffodils appear. There is so much to do in the garden. Whole bits to recast and be cleared up as a result of the building. Well, the latter we now recognise to be a great success. The house is so much warmer and it rambles, and it's lovely to have what we call the garden room with its row of deep-freezes and racks of stored fruit from the orchard to see us through the winter. And the big room, which we call Bride Hall after Julia's aunt's house which really made it possible to build, is the heart of the house with books, plants, sewing to hand, and comfortable chairs.

P.S. I don't think you had a garden book [*The Renaissance Garden in England*], did you? I'll try and let you have a copy of the paperback next year. I am loath to post it. It costs a fortune now, the post. Letters in England in January go up from twelve to fourteen pence! The Tube is crippling! Queues everywhere because there are hardly any 50p machines and virtually everything is 50p upwards. It is 30p from Victoria to South Kensington. It was 5p in 1974. Where will it end?

1981

Splendours and Miseries

One image summed up the year. It was of the new Princess of Wales at the opening of the exhibition *Splendours of the Gonzagas* on 4 November. Stunningly dressed and enthroned like a shy Renaissance princess on a chair of crimson velvet, the pictures circled the globe. It was her most spectacular early public appearance after her wedding and the following day it was announced that she was expecting Prince William. This was the most glamorous opening ceremony staged within my directorship. As far as the public was concerned it was the one and only event that year at the Victoria and Albert Museum.

Behind the scenes, however, the institution was creaking its weary way towards Trustee status through the usual morass of reports and committee-speak. The agent to effect this change was to be a report compiled by Gordon Burrett under the aegis of Sir Derek Rayner's[1] office, work on which began in October. Their brief was to save public money, cast a fresh eye on the Museum's functions and to identify tasks which we need not do, besides finding more cost-effective ways of carrying out those that we did. All of this was a very far cry from the Victorian idealism which had established the Museum in the first place. The document set the tone of what were to become the two leitmotifs of the eighties: money and management. We were on the road which led to departments being cost-centres, and to targeting and assessment, critical path analyses, mission statements, and five-year strategies. All this was to accelerate through the decade under Government pressure, but in the Rayner Scrutiny we see it in embryo. In its early phases it was largely to be welcomed for stirring the somnolent and putting the inert on their mettle. I was painfully aware, however, that it was to be the prelude to the most fundamental reconstitution of the V & A since 1909.

[1] Derek Rayner, Joint Managing Director and later Chairman of Marks & Spencer, had been given a special brief to improve efficiency and eliminate waste in Government. Created a life peer in 1983.

Until April I have only brief notes, for, on 9 December of the previous
year, I had passed out in public, a terrible warning sign, and was
effectively out of action and devoid of energy for some months. What
follows below is a summary of these staccato notes.

The end of March.

The fall of Norman St John-Stevas was very sudden. It happened late
on a Monday, coming on to the evening news. I had guessed ages before
that his successor would be Paul Channon and I was right and it was a
great relief. Norman had done well by the Arts but he was tem-
peramental, unpredictable and capricious. Before Christmas Donald
Sinden and a whole group of theatrical worthies had waited for two
hours in the Covent Garden Flower Market for him to be photographed
signalling the inauguration at long last of the Theatre Museum but, in
what appears to have been a fit of caprice, Norman never turned up.

The V & A now has to be submitted to a Rayner Scrutiny, an
efficiency investigation, and much work has gone into preparing a
concise document for them which would encapsulate the full range of
our problems. That report was accomplished by the close of March
when it was presented to the Office of Arts and Libraries. Meanwhile
the MA course was quietly sailing forwards and the Slide Library, about
to be closed, was saved by the sleight of hand of transferring it to the
Standing Commission on Museums and Galleries. They decreed that
it should stay put with us while they went about preparing a report
which would no doubt say that it should be returned to the V & A.
Princely Magnificence closed with a final gate of just under 80,000.
The Wolfson scheme for the Primary Galleries finally collapsed and
Julia's *Swan Lake*, done in the style of Ludwig of Bavaria, opened in
Boston.

21 February. To Jan van Dorsten. Collapse and recovery.

I have been meaning to write for ages but the reason that you have not
heard is that shortly after having written my glowing letter on having
middle age under control I fainted in public and was carted off to rest
for a month, so there must be a moral somewhere. It happened at one
of those endless parties. I just said to Julia, 'I must sit down,' then I got
up and Julia said, 'You ought to go home' and I said 'Yes.' I got as far as
the hall and passed out, turning bright green apparently. A doctor was
there when I came round and Julia drove me home and put me to bed.
As soon as we could, everything was cancelled and we came down here

for virtually a month, creeping back by stages. It was all an awful shock, but certainly it was a red light to be heeded.

Although I felt bouncing with energy when I returned after the summer, we did (as always) have a ghastly autumn – work piled on work – a crisis with more cuts to the V & A and a public row and questions in Parliament about my decision to close the National Art Slide Library, also problems with the Minister!! On top of that I was landed with work for our vast ballet exhibition, 8,000 words on *ballet de cour* dress and fifty long catalogue entries, then with work on the catalogue of our exhibition [of miniatures] going to the United States. TOO MUCH, TOO MUCH. Well, I saw the doctor a fortnight ago and he gave me a clean bill of health. A good result is that neither the V & A nor my office take it for granted that I am immortal and that I can bear every burden laid upon me. But I have to cut back on public commitments.

At least one enters 1981 minus a really difficult head of department who has retired, minus my administrative right-hand man, and with the Wolfson Foundation definitely not, in the end, coming through with a million. All these have been terribly taxing matters. So one draws a breath. We had four blissful days at a hotel on Dartmoor, cold, but bright blue sky, sun, and gorgeous food and service. A real tonic. The central battle of 1981 will be the status of the V & A. All my energies have gone into preparing a masterly document on the terrible state we are in in readiness for a Government investigation early in the summer. This I pray – we all pray – will settle the terrible dilemma under which I – we all – have worked for the last five years and which has rendered the direction and workings of the Museum almost inoperable. This time the Council, the Civil Servants, etc., all are united in sorting it out. We cannot go on and on and on in this constitutional mess.

Julia is off to Boston next week to see her production of *Swan Lake* through. I go out for the première on 11 March and we both come back weary on the 13th. Julia then goes straight into Dekker's *Shoemaker's Holiday*[1] at the National for June and work in Germany for next year. As I look out of the window the great avenue of beech and yew now culminates in the Shakespeare Prize monument, an urn atop a pedestal approached by steps, some nine feet high, which looks suitably grand in our mini-Versailles. Awful to hear of the cuts [in Holland] but it is

[1] Thomas Dekker, born *c.* 1570, English dramatist, author of plays, masques and entertainments.

like that everywhere. It is a very difficult period and now Mrs Thatcher
has dished out millions to the miners and the steel industry and the
water-workers her policy stands in ribbons. Inflation has very much
declined but at an appalling cost. I do not like the sharpening drift
towards two nations here. Julia and I represent the self-made middle
ground. It's an exhilarating period and one in which one can exert an
influence in the right way for good. But it is hard work. Thank God
that the new Minister for the Arts is a very old friend indeed.

Torte is curled up on my lap and tried to open your letter with her
claws . . .

24 March. A Weidenfeld gathering.

We went to dinner with George Weidenfeld, the first time for years as
it was given for the new French Ambassador, Bobbie de Margerie.
George as always is a warm but useless host who never introduces
anyone to anyone else so that we were left, as the others were, won-
dering who half of the people were. There were three tables of ten.
Before dinner I chatted with Antonia Fraser in a voluminous Jean Muir
dress and discovered that she was doing a book on seventeenth-century
women [The Weaker Vessel]. The Donaldsons appeared and I suggested
to Frankie, who is looking for a subject, that she write Rattigan's
biography. I sat between Hélène de Margerie and Marina Warner. Dinner
was dramatised by news coming through that President Reagan had
been shot. As our Ambassador in Washington was present there was
much coming and going from the table and, as a consequence, a subdued
atmosphere. After dinner Hugh Fraser appeared, and that was the first
time that I had seen him and Antonia and Harold Pinter all in the same
room together.

1 April. Mrs Thatcher at Clarence House.

The format was unchanged, although this time we were sent an invi-
tation card. On the dot of one the cars started arriving and we were
held up by the Heads embracing the Glendevons in the porch. There
was the usual flurry of equerries, a new one at the door and then the
familiar figure of Alastair Aird warding off the corgis. Julia said that
she always said 'Hello' to them but never touched them. One did
snuffle up to her at lunch, but Queen Elizabeth explained that that dog
had recently blooded Fortune Grafton. Further on, along the hallway,
there were more menservants, more than usual I thought, and William
Talon smiling.

It all works like clockwork. Queen Elizabeth stands in the doorway

of the drawing-room, all smiles, waving her arms in a slightly theatrical way, her hair as usual a pattern of combs, and wearing a green silk dress with trailing sleeves and turquoise silk shoes. She looked younger than ever and thinner. It had been too long, she said. I said that she had come to see the jewels when I was ill. 'Are you better?' and then turning to Julia, 'Are you *sure* he's better?' Yes, I was, and then followed the usual round of introductions. In addition to those we had spotted going in there was Rupert and Mikki Neville, Hugh and Reta Casson, the inevitable ancient lady-in-waiting, two large and portly men, one of whom was Coutts Bank, and, a surprise, Mr and Mrs Thatcher, but no Lady Diana.

The room looked the same as ever: with the Augustus John of Queen Elizabeth over the chimneypiece, the little portraits of Queen Victoria to the left, the Munnings of Queen Elizabeth to the right and mirrors in the bays. On the left of the doorway there was Millais' *St Agnes Eve* with, on the right, the sketch for it which she had bought a few years back and a huge Bassano of the Ark surrounded by animals. On the wall opposite the fireplace hung Charles I and his children after Van Dyck, flanked by Lely ladies. On the window wall there was a bust of Queen Elizabeth nestling behind the net curtains. A small grand piano was decked with silver-framed photographs, and there was the inevitable Fleur Cowles painting.

I swooped on Mrs Thatcher, saying how pleased we were with Paul Channon. She looked amazingly fresh considering the battering she'd undergone. Yes, she was pleased with Paul too. Yes, Norman was too much. Look at the way he'd done his office up, she exclaimed. No sense of economy. Not a penny had been spent on 10 Downing Street. Yes, she would have loved to have gone into Chevening, but there would have been dreadful public comment. At Chequers the money had run out and they were saddled with a vast swimming-pool which cost a fortune to heat and which she would not allow to be used.

In we went to lunch where Reta Casson explained to me how bitter Norman had felt at being thrown out. So much so that he had had to go into a retreat for a few days to calm his mind. It was lunch in the larger room, hung with George III and family, the huge table waited on by no less than five menservants. The food as usual was very indifferent: an over-decorated stodgy salmon mousse, meatballs, beans and potatoes and an ice-cream with black cherries. But the table looked as always marvellous with the familiar *biscuit* huntsmen, three huge bowls of flowers, and the silver candelabra alight. I sat between Reta Casson and Dot Head [Lady Head]. Hugh and Reta had been at the Royal Lodge last

year when Lady Diana had come over on the Sunday. Yes, we agreed, the match must have been fixed by Queen Elizabeth and Ruth Fermoy. Dot Head, wrinkled and deaf but idiosyncratic and rather splendid, was still painting away feverishly in Wiltshire. She spent her time denouncing the punks and the violence but went on to praise the 'gel' who did her hair, whose own was dyed punk plum.

We swept out after coffee back to the drawing-room. I sat and talked to Queen Elizabeth. Yes, she was off to France, for three days only, to Fontenay to see the tombs again, Richard I and Henry I. I said, oh yes, stretching my legs out and crossing them like a knight on a tomb while she pressed her hands together in the manner of an effigy at prayer. She always wants to know about the V & A, what's on and what's coming and also what's Julia up to. She loved hearing about *Swan Lake* in the manner of Ludwig of Bavaria. So, as usual, we left in a haze of happiness because her *joie de vivre* is an inspiration, always.

That evening we went to Sadler's Wells for the fiftieth anniversary of the company. The programme was MacMillan's *Danses Concertantes*, redesigned by Georgiadis with sleazy costumes; Fred Ashton's *Souspirs*, the *pas de deux* with costumes by Julia with Sibley making a brief comeback with Dowell, a ravishing five minutes; *The Rakes's Progress*, now very dated, and Rex Whistler's sets not fitting and looking like Hogarth cleaned up by the Georgian Society; and glorious *Pineapple Poll*, danced with a lovely bravura.

In the interval we saw Mim Rambert, now a very frail ninety-three, sitting in the front row with Colette Clark. She had her mink coat over her knees, her hair was uncombed, and she now seemed deaf. But she loved seeing us and we told her all about Astrid Zydower's sculpture for Warwick Castle [part of the scheme Julia did there for Tussaud's]. At the end Madame and MacMillan came on stage. But no Fred. He had had a fit of pique, Colette said. Madame made a brief speech of gratitude, then followed showers of flowers and that was that.

6 April. Sonia Melchett.

This was a buffet supper party given by Hugh Fraser and Sonia Melchett. She is a warm, strikingly handsome and intelligent woman, much concerned with her blonde and tanned appearance which was displayed to advantage in a black package supported by two tiny straps at the shoulders. Her energies are tied up with the Royal Court Theatre.

It was the first time that I had seen so many of the Fraser children now that they had grown up. Flora, now married, is finishing reading Greats at Oxford; Benjie, now twenty, whose face is pure Fraser, is off

to Scotland to start life as a journalist; and Natasha appeared like a bombshell in what was less a skirt than a stiffened flounce of satin from which descended endless legs into high-heeled shoes. Norman St John-Stevas came and went. Andrew Devonshire was all a-twitter over what the reserve should be for Poussin's *Holy Family*, which was being sold at Christie's on Friday to raise capital to form a trust for Chatsworth. Harold Lever was predicting worse disasters ahead for Labour, with Michael Foot being strong where he ought to give way and vice versa and seeing no solution to the problem. Tony and Lucy Snowdon[1] arrived, he very affable, although gunning for Norman because he had never answered his letter about the Messel Collection. He believed that he deliberately didn't so that he could keep in with Princess Margaret.

7 April. Spotlight.
The opening of the exhibition of ballet costumes, *Spotlight*, went off with aplomb. Princess Margaret in gold embroidered ethnic red did an hour's tour. We couldn't find Fred Ashton, who turned up after she'd gone, seated at the bottom of a statue quaffing champagne which he loves. There was a wonderful encounter between Marie Rambert and HRH, a rare occasion when the person being presented was shorter. *Spotlight* is a gorgeous spectacle and everyone loves it, apart from complaints either about the lights and/or the loudness of the music.

June. The Recession.
One notices the recession much. As you go down the escalator on the Underground the advertisement boards are either empty or carrying London Transport advertisements. When we had a drink and talked to the house manager of the National Theatre she admitted a half-sale of tickets for this booking period. Except for rare raves it is easy to get theatre seats, and in Leicester Square there is a booth selling them at half-price on the day. Sales are an all too familiar feature: pre-Christmas sales, January sales, pre-summer sales, summer sales. Shops also disappear.

13–14 June. Burghley and Woburn.
We drove up the A1, myself and two colleagues, to see the collection of miniatures at Burghley and, hopefully, that at Belvoir. The Duke of Rutland, however, never answers letters, or very rarely. So last week I

[1] Lucy Lindsay-Hogg who had married Lord Snowdon in 1978.

rang and then he rang back, rather ungraciously I thought, complaining that the V & A had ruined his Siberechts in the 1979 Garden exhibition. I tried to calm him knowing that we hadn't, and tried to get to see the miniatures. That, he said, would be difficult, so I said that we could go round with the public and just peer at them in their showcases. 'They're off show,' he said. 'Only I have the key.' So reluctantly an appointment was fixed for Monday at 2.30 p.m. By the time that we had got to Burghley the message came, 'Cancelled', because he had to go to Leicester as a JP to deal with rioters (last week being riot week). That was disagreeable but then, later, Henrietta Tavistock said that he was always a bit like that. Even Frances Rutland could be immobilised because her husband had gone off with the key. He always locked up the drink and she would have to make her way to the local pub off-licence for a bottle of wine.

However Burghley beckoned first. The encompassing railings were adorned with Union Jacks and in the tiny sentry-box at the wrought-iron gates there stood a man in a dark suit and bowler hat which struck an odd note. The butler, however, welcomed us and we swept in to see the Exeters. They belong to the 'Eat, drink and be merry' brigade because the title goes to a dotty cousin in Canada who is the focus of a religious cult. The house and its contents have therefore been made over to a preservation trust. The Marquess only has four daughters and no son.

Their own rooms are well kept and exude solid comfort. They are now both in their seventies, he leaning on a stick but otherwise in good shape, she upright and rasping behind tinted glasses. As usually happens I am addressed throughout as Sir Roy but I'm used to it by now and make no attempt to disabuse them. Their real living space is what they call the Mess Room, an engaging place piled high with magazines and papers. In the middle of it all Isaac Oliver's masterpiece *The Three Brothers Browne* stands propped up on Lord Exeter's desk amidst family photographs and, on a table to the left, stood dotted about a hundred Wade whimsy porcelain animals. Conservation, as the curator said, is not a word to be mentioned here.

After looking at the miniatures we went through the state rooms. Gloomy room after gloomy room, state bed after state bed, acres of Laguerre gods and goddesses sprawling across the ceilings, cabinets piled high with china, knick-knacks, miniatures and porcelain. There were so many pictures that they'd been screwed to the doors. The curator goes on and on: 'It's piled up in the basement and in the attic and in cupboards' – pictures, furniture, books, both whole and in pieces,

God alone knows what's there. I spotted a crystal and gold bejewelled object under a glass dome. 'What's that?' 'Queen Elizabeth's salt,' came the reply. I lifted the dome and picked it up. Perhaps it was, but it's left around for anyone's picking. Recently the archivist at Hatfield said that they had mislaid Saxton's *Atlas*, which the author had presented to Lord Burghley. Everything in the public part of the house was in crumbling chaos.

At last we came to the great hall. Here cases were filled with the Marquess's cups and medals as an athlete. There were also dresses dotted around on dummies and twenty-four clocks had been assembled as a further dusty sideshow. None of them worked, the curator said, although they'd all been repaired in Stamford. It was a depressing experience, but one can't blame them. No, they still hadn't found Elizabeth I's notebook, gold and decorated with Tudor roses in diamonds, or, for that matter, her agate gold-enamelled spoon and fork.

What a contrast to Woburn! It is always a delight to go there. Henrietta Tavistock had redone the long gallery as I had suggested to her years ago. Everything was cleared out. There was now rush matting, the ceiling and woodwork had been painted shades of white, there was a light paper on the walls with a large pattern, and all the early pictures had been banked on them with no furniture except chairs and benches pushed against the walls. Before it had had red walls and red carpet and just been a cluttered passageway.

Henrietta and Robin[1] are now thoroughly settled in and slowly making the place theirs. It's a quieter living style with none of the endless zip of Nicole and Ian.[2] But it's extremely well kept, both house and grounds. The Chinese Dairy has just been put in order and painted. I couldn't help being impressed. But problems loom with 20% down on visitors, which means a loss of £200,000 in two years, and with £2 million death duties to be met during the same period. Robin referred to the Getty Museum and in anticipation of the effect that its £29 million p.a., which had to be spent, would have. The Canova *Three Graces*, which no one looked at, was last valued at £3 million, so he was tempted to sell, but Woburn, he said, was not under threat. It was the middle range of houses at the moment which were rushing headlong towards disaster within a couple of years if recession and inflation continued. There the fall in attendances had been catastrophic. He

[1] Marquess and Marchioness of Tavistock.
[2] Duke and Duchess of Bedford, who had opted to quit Woburn Abbey to live in France.

agreed with me that the real problem would be the cataclysm ahead and the choice of what to save.

16 June. To Jan van Dorsten. Dekker and the Villa Maser.

We are deep in Dekker's *Shoemaker*. First night on Friday. Julia is in the theatre 10.15 a.m. to 11.30 p.m. all day and every day except Sundays. She looks ill with exhaustion. Twenty-one sets and a hundred costumes, and all through the workshops in eight weeks. I saw one of the previews last night. [John] Dexter has done wonders with this second-rate play, getting a lot of real character in, wonderful stage groupings, a lot of poignancy, a great sense of London and her society. It is on until the end of the year in repertory. Julia's simple treatment is truly Elizabethan. The London apprentices draw across painted cloths based on Elizabethan embroideries and tapestries, and the only 3-D set is a shoemaker's shop which is like a lump of Elizabethan England, so startling is its verity. Everyone is sitting in it making shoes exactly as they did!

This is our busiest time and we are very tired. Last week was heavy with a black-tie dinner for a hundred at the V & A on Monday, the King of Saudi Arabia's state banquet at Guildhall Wednesday, lunch for the V & A Council and a meeting Wednesday also, lunch with the Canadian High Commissioner and dinner for twenty with the Minister for the Arts. All on top of running the V & A. Thank God this week is slightly less frenetic. I am flat out on Elizabethan miniatures. A vast catalogue of two hundred of them is nearly finished. Momentarily I am off to Hatfield for three days' filming to introduce the BBC's *A Midsummer Night's Dream* in their Shakespeare series.

I had a marvellous eight days in Italy with the Friends [of the V & A], although doing twenty minutes off the cuff on the Renaissance idea of empire at 9.15 a.m. in the bus on the *autostrada* was testing. But I adore Italy and those villas are wonderful. Don't ever miss Maser [the villa Barbaro], the quintessence of Renaissance ideals. Very moving, tragic really, the centre hall filled with Veronese frescoes of music-making vanquishing the weapons of war. And yet [the Council of] Trent was going on over the hills and the end of a united Christendom and no reform – Protestantism was strong in the Veneto.

July. A change of policy on exhibitions.

I have inaugurated a massive change of museum policy as the cost of exhibitions has soared. We now spend £80 to £120,000 on the décor for each of them. Surely there will be attacks on this when the public

galleries are in such a mess? So the small exhibition gallery to the left of the main entrance will close next July and be demolished. Into it will go the shop, releasing the hall as a concourse area, caging exhibitions back to one major spectacle a year staged during the summer. Henceforth every penny available will be pushed towards refurbishing the permanent galleries, which now need addressing with urgency.

16 July. Dinner for the Michaels of Kent.

Jack Plumb gave a dinner for the Michaels of Kent at Brooks's. Julia did not want to go but we went to what was an odd assemblage of guests: Bamber and Christina Gascoigne, Raine and Johnnie Spencer, Kenneth Rose, Pamela Hartwell, Antonia Fraser minus Harold Pinter and others, about twenty in all.

Raine arrived after the royals, needless to say. Princess Michael was in Yves St Laurent and Antonia in Jean Muir. This was a flop of a dinner. Plumb is a disorganised host. No introductions were effected on arrival and we were all stuck at the table interminably, with no movement. The food and wine was unbelievably lavish. Jack, who was slightly manic by the end of the evening, stormed up to us and said, 'You don't leave before the royals,' as though we didn't know. On the way out he groaned about how dim the National Portrait Gallery was post my era and then said that the dinner had been arranged for Princess Margaret! Adding, 'You know the way to the "Headmistress" is through her sister,' a remark which staggered me.

22 July. Helmingham and the Tollemaches.

I went as I had promised to Helmingham for the day. I had not in fact been there for about fifteen years. Tim Tollemache[1] is, I suppose, now about forty or forty-two, slim with a clean-cut Guards officer face. Xa must be about thirty-five, upper class, horsey, and in love with children and country life. It's the world of the shoot and certainly not that of interior decoration or intellect.

As a house Helmingham has a certain quality, a Tudor red-brick courtyard house arising from a moat with drawbridges, the whole done over in the 1840s in the Elizabethan rookery-nook style. They have moved a few pictures around but really apparently not done much to the place. I would find it irresistible to be more iconoclastic. The entrance hall, cluttered with big-game-hunt rugs, huge cases of stuffed birds, Victorian Elizabethan furniture, stag-head trophies, halberds and

[1] 5th Baron Tollemache, married to Alexandra (Xa).

Tollemache portraits I longed to empty and rearrange for a start.

We walked around the garden in a thunderstorm, beautifully kept but lacking taste: beds of dahlias edged with alyssum and masses of bedded-out African marigolds. The walled kitchen-garden, however, was splendid, with great cross-walks of turf flanked with good herbaceous borders. Xa had attempted to create her own irregular garden bravely but it was a failure because you can't plant an irregular garden in relation to a formal house so I told her to plant her 'walls' of yew first, centred on the stable block, and suggested a walk of amelanchiers along the banks of the moat.

As usual, I gave out information on the pictures, all of which was scribbled down assiduously. I travelled back with Tim, off to Prince Charles's stag party at White's, which I heard broke up just past midnight.

In the evening Julia and I went to Gillian and William Rees-Mogg's drinks party to celebrate, belatedly, William's birthday on 14 July. I felt that he looked ten years younger, less harassed and in a cloud, although diminished now that he is no longer editor of *The Times*. He now lives on the board of GEC but really runs an antiquarian bookshop in Brunswick Square. The Rees-Moggs' children ran around acting as waiters and the mêlée was in the main political.

The summer.

We fled London on the eve of the Royal Wedding. We are indeed sunk beneath a marriage morass: T-shirts, mugs, tea towels, silver, plates, medals, Bibles, books – it cascades forth. So does the press: every glance, thought and look of both bride and groom are scrutinised and recorded. It is exactly as one predicted. As things get worse and worse the royalist cult accelerates. This event in a way leaves even the Silver Jubilee behind.

We were in Herefordshire for five weeks with the usual routine of sleep, writing, gardening, and putting the house in order to survive another winter. Suddenly the weather, after being cold and flooding down with rain until the end of July, improved and changed to brilliant sunshine. The garden is much advanced and I am snipping out the leaders of our many yew hedges which have now reached seven foot in height.

Undated but after 12 July. Ann Fleming.

Just before we left London Ann Fleming died. I wrote to her daughter

Fionn[1] and her answering letter prompts me to write. It was a heart-rending end, of cancer, but a quicker one than she was led to believe. She would go up and down and on some days would be marvellous, but the cruellest blow was blindness before the end.

I suppose that Ann must have been a terrible if memorable mother. I had written to Fionn that she was in a line of descent within British society of great hostesses from Lady Blessington down to Emerald Cunard. Blessed with considerable private means she occupied, certainly during the period when I knew her, from the late sixties on, the position of Emerald Cunard as a hostess and *animateur* of people. In appearance she was tall and commanding, almost gaunt to look at, with marvellous eyes. She looked as though she disapproved of everything and everybody as she presided over those gatherings, swooping from time to time as it were from her perch, cigarette in hand, her arm and hand movements at angles to her body in the manner of the twenties.

She was a woman of great loves and hates, as even I found out. Acid and sharp-tongued, she liked to be given as much as she gave, and nothing pleased her more than a verbal fracas at her table as two *éminences* would set out to demolish each other. Hers was never a card-index world like George Weidenfeld's, who entertained and continues to do so on a large and bewildering scale. In Ann's case there was a sense of admittance, of an accolade bestowed. It probably did not mean that she actually liked the person, rather that she was interested in observing them, or in what they said, or that they would prove an unexpected ingredient to confound others. But the gatherings did have the quality of a work of art which was peculiarly English, a salon over which she presided and mingled the likes of Diana Cooper with Roy Jenkins, John Sparrow with Princess Margaret, Francis Bacon with Stephen Spender, or Isaiah Berlin with the young Lord Dufferin. Partly political, partly literary, but less artistic and bound together by the chosen of the social scene, those picked on account of their wit or beauty.

Her relationship with Arnold Goodman was a mystery. It was constant from when I first knew her in 1968 and deepened. She always stayed with him in his Portland Place flat after Victoria Square had gone, and after a brief and predictably disastrous sharing of a flat with Pamela Egremont.[2] I would sense that the relationship became even

[1] Ann Fleming's daughter from her first marriage, to Lord O'Neill.
[2] Widow of John Wyndham, Lord Egremont.

closer after the death of Arnold's brother Theo, which he took hard. Was it purely platonic? He adored her and loved her. But everything about Arnold was decisive except, it seemed, his private life. I would guess that she removed that problem from him with her sense of decision. He had his 'wife', a dominant one, who would act as hostess and whose flow of observations on people and events would perpetually entertain him. At any gathering they always arrived and left together. I have not heard how he has taken it, but I suspect badly.

7 October. To Jan van Dorsten. Dame Frances Yates.

Frances Yates, the great Renaissance scholar, had been my supervisor as a postgraduate student at the Warburg Institute and a dominant force in my education and thinking. Her death marked the end of a tangled relationship.

You will no doubt want to hear how it all went on Monday at the funeral. It took place at Randalls Green crematorium at Leatherhead which I reached by train and taxi at about 11 o'clock. It was a beautifully planted modern crematorium with huge trees and shrubs landscaped in a contemporary manner but with a horrid chapel in the municipal style, concrete brick and rather cheap. I suppose that she had never expressed any wish about her end, but I cannot think that she would have liked this as a setting. However, gradually people turned up. Joe Trapp of course – what a marvellous man he is – he looked at me and said, 'I knew you'd come.' There had obviously been a worry as to whether there would be a reasonable show-up or not. There was. The usual Warburg [Institute] gang was there: Perkin Walker arrived very tottery, Gombrich I thought looking not too bad, a group from Claygate, neighbours who loved her (including a very nice young girl who called her daughter Astraea!) and the two women that ministered to her. I only met one of these, who was really sweet. Sydney Anglo came and, as we went in, I said, 'We should sit together,' which we did [we had been her students at the same time in the mid-1950s].

That chapel was awful, plywood and cheap velvet, awful. It was the usual service. By then the coffin had been carried in with lots of flowers which had to be ordered inevitably through a florist called Rita! I ordered a huge bouquet of virgin-white blooms and a card which read 'In tribute and with affection'. I would have loved to have carried a vast bunch of rosemary from the garden but no way. There's a dreadful treadmill about death these days and I had quite a struggle to avoid the flowers arriving in a plastic pot. However, to return...

The clergyman had obviously had talks to Frances about the faith, and he admitted that her mind was beyond his, which would not have been difficult I thought. But he did say he felt that she was trying to find her way back to the faith of her childhood. He should not have tried to claim her. By far the best moment was Joe's 'lump in the throat' and 'tears held back' short address, very moving and which said it all – the affection and the humour and the questing of the mind. Yes, that was good. Otherwise it was not, oddly enough, deeply moving. I suppose partly because one had grown away over the years and found one's own existence, although aware of an incalculable debt and affection and a caring for her (she *ate* bright young men, as you know ...). Even more, the setting was like a very bad Holiday Inn room. Having been to two funerals this year and about four memorial services I rank this effort down on my list, but then the Warburg and the University [of London] rarely have any sense of organised style and occasion. I just think that she deserved better. Afterwards we all went back to the local inn where well-meant frugal fare consisting of sausage rolls, biscuits and sandwiches, Spanish wine and coffee was produced.

No, I had no idea that she had fallen down or was ill or in a nursing home. Neither had Sydney Anglo, who kept on feeling guilty that he hadn't known and that he had not visited her in the nursing home. I told him not to lament because things like that did happen. She was in fact fine until the last week when she went downhill rapidly and only on the last day began not to recognise people. Over eighty one is living on borrowed time. And she had said what she had wanted to say in a magnificently rounded way. She was trying to put together a book on the Yates family but somehow I think that it was beyond her ... Looking back on it from a personal point of view the prodigal son had been received back! This was happy, because I knew that I was looked upon as a kind of write-off for years. Now I know that she would ask after me and in fact was really full of affection for me and saw that one had achieved something by a different path. To me she was always 'Miss Yates' and it was only last year that she signed her letters 'Frances' – so I think that meant something and was a signal. No, it wasn't a life cut off, it was one completed in a lucky way not always possible.

We are fine, very busy with every inch mapped in as always. Julia is doing a Kalman operetta in Kassel [*Die Czardas Fürstin*] which is nice. At the V & A things are going well at the moment, with massive developments all slowly moving forwards. The vast Gonzaga exhibition opens on 4 November, a terrific evening with the Prince and Princess of Wales, a great coup. It will be a stunning exhibition. Exhibitions

then go into retreat as I focus my energies on the interior of the building in the eighties. On 1 December the Boilerhouse opens [in the end that was delayed], the new mass-manufactured and -design artefacts museum financed by Conran of Habitat fame, a million-pound benefaction. By a stroke of luck I've laid my hands on the money to begin the vast task of redoing the galleries of British art. We start on the sixteenth century, now a mess, in December. Sorry we won't be in London when you come. There is so much to see. Don't miss *Quartemaine's Terms, Who's Afraid of Virginia Woolf?, Can't Pay, Won't Pay, The Mitford Girls* and yes, draw a breath, *The Sound of Music*. As you know I'm on the *Standard* Drama Panel so we live in the theatre for nothing.

We are now digging ourselves in for the winter. A new black cat has adopted us. Large and furry and affectionate, but Torte loathes him, so we have feline problems. We call him Muff.

31 October. Arts politics and excellence under siege.

Gordon Burrett, the Rayner Scrutiny man, came on a whistle-stop tour, very bright if doom- and gloom-laden. I write this entry in anticipation of the problems towards which we are heading. OAL cannot, I think, produce the goods that we have been led to believe. The crunch gets nearer and nearer as the vast building projects (in our case the Henry Cole building and the Theatre Museum) move to completion. In fact I would not be optimistic about the latter in light of the £5,000 million cuts the Cabinet are looking for at the moment. In a recent opinion poll with items listed in a questionnaire asking the public where the axe should fall, such projects came very high on everyone's list. Burrett placed the Museum within the broader perspective of the attack on excellence and its centres within our society, and how long they would be 'allowed' to survive in a populist culture that believed community arts drama was the equal of the National Theatre. Mrs Thatcher, I gather, is giving a dinner at Number 10 for the chairmen of the national collections. Certain things indicate to me that this is the opening of a dialogue along the lines of 'I will protect you from cuts if you charge'. The whole outlook is conditioned by what part of diminishing finite resources can be apportioned by politicians to 'excellence' in the form of our museums.

2 November. More arts politics.

Mary Giles[1] came to lunch and this was followed by our annual meeting over estimates with Mark Hodges and Kelvin English [all OAL]. Mark and I talked at length of the arts crisis and of the total inability of any minister to face up to reality. All of them had gone blindly soldiering on encouraging a long list of new projects which there was no satisfactory means of supporting. When I talked to the *Kaleidoscope* team the other day they said exactly the same thing. Every arts organisation was on the verge of bankruptcy but none would admit the gravity of their position publicly for fear of upsetting the Government/Arts Council and losing their grant. What ought to happen is a series of radical decisions putting the Arts on a firm basis of what we can actually afford. English National Opera and the Royal Opera House should merge, with the Ballet having Covent Garden; the National Theatre and the Royal Shakespeare Company should also merge. The Arts Council too needs radical reform. Over the whole field of the Arts certain projects should be folded or merge. Then there is the pro-liferation of ballet and opera companies in the regions, Welsh, Scottish, Kent, *et al.* All we do is reel from one year to the next with no decisions, just one cosmetic after another.

Paul Channon is an old friend, far easier to deal with than Norman St John-Stevas, but because he fell out with Mrs Thatcher and has now made his way back, he is terrified of ever upsetting her. Although notionally he has access to her and also to the Cabinet, in fact this is hardly true. The Arts are in reality cut off. He at least patched up his row with Peter Walker the other day in an attempt to get a chink of support in the Cabinet. Keith Joseph, who is Education, will be no ally as he believes that the Arts should not be subsidised at all. Paul is held back by trying to please and his reluctance ever to strike out in case he loses a foot forwards has made him a safe, unnewsworthy Minister. This, in turn, preys on him because he gets none of the glamour and clout of the *prima donna* heyday of Norman. He is not a good speaker but he has had no apparent training or help. He stands on one foot and perpetually takes his hand to his mouth. He has a speech to read and then he embroiders it himself but goes on too long and repeats himself. Of well meaning and good intentions there is never any doubt. The Civil Servants welcomed his appointment with 'alleluias' and perhaps one is beginning to see why. It is a drift back to Jack Donaldson, who was run by them. On the whole they are a pleasant lot this time after

[1] Personal assistant to the Minister for the Arts, and, later, a Trustee at the V & A.

the horrors of Ulrich and Spence but weak and vacillating, weather-cocks and paperers-over of cracks. They represent the 'limp along on crutches' syndrome rather than face up to the inevitable end if money is finite. It is votes that affect everything. No decisions are reached anywhere for fear of upsetting some section of the community and losing the next election. Democracy seems a system very ill-fitted for Britain in the 1980s.

4 November. The Prince and Princess of Wales and the Gonzagas.

The day of the opening of *The Splendours of the Gonzagas*. The vast lead-up to this, above all its inauguration by the Prince and Princess of Wales, endowed the whole occasion with an air of high expectancy. This was a tiring week with the battle for the V & A's finance and staff for 1982–3 and the Rayner Scrutiny going on at the same time. It began with a Friends viewing on the Monday evening with a huge turnout. The press view on the Tuesday was filled by no less than seven hundred and fifty of them and there was a long queue to get in. The problems with the Italians were endless, forever moving around the arrangements and changing personnel. Even when I was taking the Prince and Princess around the exhibition the dinner at the Italian Embassy was suddenly moved on half an hour, with the result that we had to tack on a huge tour round the Renaissance galleries.

On one thing the Italians insisted, and that was that a fifteen-minute early-seventeenth-century opera was performed by a company of twenty-nine before the Prince and Princess. Nothing could be done to prevent this happening, so in order to avert disaster I decided that a wand should be waved over the Raphael Cartoon Court which should be transformed into a setting worthy of a Renaissance court. So a huge stage was erected and scene-painters and set-dressers moved in. A vast canopy of bronze velvet patterned in gold was put up and two X-framed throne chairs in crimson velvet constructed. Before them spread the stage with its floor painted with sprays of flowers, and in the middle of which arose a fountain whose basin was filled with fruit and flowers tipped with gold. Cypress trees fifty feet high were brought in to decorate the court and the balcony opposite the stage had a carpet thrown over its ledge with garlands of fruit and greenery, again touched with gold, swagged along it.

It was a long day. I had to give a formal luncheon in the Poynter Room for the academics headed by the charmless *soprintendente* from Mantua, Ilaria Toesca. There were the usual last-minute screams, the staff of the Friends rushed to do flowers for me, and I personally tore

from one side of the Museum to the other bearing facsimile Renaissance silver rose bowls. It looked beautiful, but was only a curtain-raiser for the long fray ahead.

The Museum was shut at 4 p.m. and hordes of detectives, police and dogs combed the place. At 6 p.m. I was down in the front entrance hall as swarms of guests began to arrive. The Italians, as usual complaining, removed themselves off to a corner, huddled together and moaning about the cold. Michael Hartwell[1] [the exhibition was sponsored by the *Daily Telegraph*] turned up contrary to what Pam had said, which meant the arrangements for the chairs on stage had to be redone. However, the great moment at last came when Their Royal Highnesses arrived. There was a throng of police and applauding crowds outside but the protocol worked like clockwork: the Mayor and Mayoress on the pavement, Julia and I on the steps with John Physick, Les Smith and the Chief Warder behind. Inside the presentations were all lined up, with Pamela Hartwell looking awful in her usual violent pink ethnic robe and clanking artificial jewellery, and Ingrid Channon all glitter and with an amethyst the size of a gull's egg around her neck.

The Princess looked sensational, her dress cut straight across revealing the by now famous shoulders, but with a triple choker of pearls fastened with a diamond clip around her neck in the manner of Queen Alexandra. She has a clear complexion and lustrous blue eyes. Tonight she seemed a large girl in a billowing white dress full-skirted to the ground with a broad blue ribbon at the waist. More petticoats, however, Julia observed, were called for. How can I describe her? Well, after the event, I would categorise her as Eliza Doolittle at the embassy ball. Beautiful, in a way like a young colt, immensely well-meaning, unformed, a typical product of an upper-class girls' school. But she has so much to learn, which she will, unless she gets bored with it and it all sours. At the moment she has not learned the royal technique of asking questions. Nervous certainly, so I placed myself next to her and, as I promised Edward Adeane,[2] kept an eye on her the whole time. Her accent is really rather awful considering that she is an earl's daughter. Not an upper-class drawl at all but rather tuneless and, dare I say it, a bit common, as though it were the fashion to learn to talk down. That is what I meant by Eliza at the ball.

[1] Formerly Michael Berry, created Baron Hartwell in 1968, Chairman and Editor-in-Chief of the *Daily Telegraph* and *Sunday Telegraph*.

[2] Edward Adeane, Private Secretary to the Prince of Wales, was the son of Lord Adeane, former Private Secretary to the Queen.

He, in sharp contrast, is now immensely developed. Now thinner than ever not only physically but his hair as well. But he is incredibly easy and so much more assured and mature. Dignity, yes, but with a wonderful sense of humour and a great warmth of personality (which she has too). On the other hand I did not think that he looked after her enough.

So off we went up through the English Primary Galleries, past the Norfolk House Room, and marshalled ourselves for the grand entrance. I explained to her that as we swept into the Cartoon Court there would be a fanfare of trumpets from the balcony and that there were two throne chairs on which to sit. 'Like my wedding,' she said. At any rate it all went splendidly, much, I gather, to the astonishment of the assembled company. Speeches followed and I did a good one. HRH, now a very good speaker, spoke with plenty of fun but no silliness (hopefully his cult of the Goons from the 1950s has been buried) and then the Italian President, Fanfani, a tiny man like a barrel, gave a disastrous one. The lights then dimmed and the opera followed. It was not as bad as I had dreaded but it was too long and no one knew when it would end. It seemed to consist of endless wreath-bearing. Three singers were crowned and then two more threatened to advance on the royal party but mercifully laid their wreaths on the ground. Suddenly it was over.

Then came the exhibition with more presentations and one or two hitches. Always but always people vanish when you need them, but we survived, bar a couple of scene-painters in jeans and rags somehow having got in, much to the alarm of the detectives.

In the morning the Princess had gone to the State Opening of Parliament so that I was not surprised when Edward Adeane whispered that she would not be going on to the Embassy. How wise she was. It was a grand, stilted, interminable occasion. Julia and I were mal placé. I was flanked by the wife of some Mantuan official who spoke no English and the wife of an officer at the Embassy who did. She thought that I was some lowly member of the V & A staff. The food was really very good, every plate arriving as a still life, culminating in profiteroles topped by a Gonzaga ducal coronet in spun sugar. Afterwards we were incarcerated for more music in the *gran salone* above. As dear Sandy Glen, my beloved and best of all Council chairmen, said, 'The Triumph was worth the price.'

5 November. Aftermath.
It was announced today that the Princess of Wales is expecting a baby!

17 November. Paul Channon.
Paul Channon came to the V & A last week to give a lecture to NADFAS [the National Association of Decorative and Fine Art Societies] in the presence of the Duchess of Kent. The latter has aged, although she seemed quite sprightly but one imagines erratic, up and down. Her fair hair is still dressed in the bouffant style of the 1960s. Lots of pecks between her and Paul and George Howard.[1] She insisted, however, on sitting at the back of the lecture theatre which struck the audience as very odd. Paul gave the best speech I have ever heard him give, although the mannerism of his hand going up to his nose has now been replaced by clenching his fists and bashing them together which he did repeatedly.

We took Paul and Ingrid out for dinner à quatre after, which was tremendously happy. She is clearly not enjoying having endlessly to go around the regions and sit through badly played music. Paul is in a difficult position. Mrs Thatcher, Ingrid said, really did not like him because he represented money and privilege. Although the PM stated that he could have access to her there is little reality to this. There was a party for the Arts last week at Number 10 to which he wasn't even asked! He has no friends in the Cabinet. The media, after Norman St John-Stevas, has no interest in him. It is cruel because he is immensely hard-working and direct, but with no glamour. On the other hand he has not serenaded the arts scene over-much. We shall soon see whether he has been put in as an executioner.

At a dinner given by Hugh Leggatt last week he told Andrew Faulds, the Labour spokesman on the Arts, to attack him as hard as he liked. This corroborates the lack of influence.

18 November. A British Academy for the Arts mooted.
I went to a lunch at the National Theatre given by film-maker James Archibald ostensibly for a group who were advisers on arts sponsorship to the Institute of Directors. There was quite a good line-up, including Peter Hall, looking larger than ever with piggy eyes and long greasy hair, bright John Cox who has just taken on Scottish Opera and its huge overdraft, sculptor Liz Frink recovering from being in conversation with Norman St John-Stevas on the box, Sir Charles Groves, the

[1] Chairman of the BBC from 1980–3; created a life peer in 1982.

conductor, and someone whose name I've forgotten who was 'dance' on the Arts Council. And the Minister came with Mary Giles in tow.

The real reason for this gathering was to explore James's project for the equivalent to the Royal Society, but for the Arts. Paul Channon seemed unnerved and rather incredulous at the idea. The Royal Academy and the Royal Society of Arts were not to be upset. But James seems to have a hot line to some vast amount of money, premises and royal patronage. He is right. There is no equivalent in the Arts and the Arts have no united professional voice in that sense.

25 November. The Gala for the Prince and Princess of Wales.

We went to Covent Garden for a gala performance of *Romeo and Juliet* before the Prince and Princess of Wales. I really think that Covent Garden has lost any sense of occasion or style. The flowers around the Royal Box were poor and looped to no effect, nor were the baskets in the Crush Bar. There was no sense of entry, no fanfare or anything. There was just a gradual awareness that the Waleses were there and then the audience stood up, a pretty rackety lot some of them, reflecting the *bal masque* that they had had at the Savoy on Monday with Princess Margaret in a Carl Toms mask to which came, in the words of Ken Davison,[1] 'the dregs of Europe'.

The ballet had no magic and lasted interminably and at the close they sang 'God bless the Prince of Wales' rather feebly, clutching a piece of paper with the words on it. The gala programme was just a card with a reprint of an old one substituting the Prince and Princess for George V and Queen Mary! After, we were bidden for a drink in the Crush Bar. This was also a limp affair with the royals not organised or moved around enough. But it was amazing to see Marie Rambert, a minute 93-year-old, draped to the ground in fur.

7 December. The Italians fêted.

We gave a grand dinner for the Italians in the ceramic Gamble Room dressed overall, with candelabra and candles, greenery and damask, and very pretty it all looked. The main reason was to thank the Italians, headed by Ambassador Cagiati and his Valkyrie-like wife, for the Gonzaga exhibition. There were about seventy guests; drinks in the Morris Room, then dinner, then a viewing of the exhibition.

I sat between Caroline Gilmour and Xandra Dacre,[2] she trying to cal

[1] The Hon. Kensington Davison, Secretary of the Friends of Covent Garden.
[2] Hugh Trevor-Roper, the historian, had been created Lord Dacre of Glanton in 1979.

herself Lady Alexandra Dacre and Hugh telling her that it was wrong. At the moment she is giving the V & A all her couture dresses plus photos, etc. She's sweet, old and very pinched about the face, telling me that her son was married to the writer Angela Huth and of his odd experiences staying with Princess Margaret at Kensington Palace. Her father had proposed to her mother, then aged thirty-five, during a croquet match at Windsor Castle. Hugh, who owed his peerage to Mrs Thatcher, is now rather disillusioned. Mrs Thatcher and Mrs Shirley Williams both have his book *The Rise of Christian Europe* by their bedsides. Poor Xandra seems to have had short shrift herself from the PM and I really wondered whether they were enjoying Cambridge.

Ian Gilmour left at one point in the evening and returned. Later we learned that he had been to a secret meeting of fourteen Tory MPs who abstained from supporting Geoffrey Howe's economic package. No one looked really marvellous, although Raine Spencer, now thin again, looked pretty good in a short black velvet dress with a huge diamond brooch.

The dinner was in the aftermath of the national museum directors going to give evidence to the Select Committee and David Wilson telling them that unless the British Museum was maintained it would close in two years. This produced a flurry in the media who should have seen through him, overstating things as usual. It threw the V & A into the limelight once more as yet again our hopeless situation was referred to, still locked into the Civil Service.

New Year's Eve 1981. To Jan van Dorsten. Enter a Knight of the Realm.

By now you will have heard that I have been knighted, which was announced in the New Year's Honours List this morning and, which was very flattering, also referred to on two or three of the news programmes both on radio and TV. Yes, I confess to feeling a glow and in any case I've always been devoted to the monarchy and like the idea of knighthood and chivalry. One does feel that this marks a milestone of having stormed the Establishment because no Director has ever been knighted in his forties before, and indeed it is quite rare. I can only think of Peter Hall, Director of the National Theatre, getting it at my age. Everyone at the V & A, I understand, is thrilled and pleased which is even nicer. So enter Sir Roy and Lady Strong (who, knowing her, will, quite rightly, remain Miss Oman).

You will no doubt have heard that the Yates memorial will be on 22 January at the Warburg so you will miss that. Margaret Mann is to give

an address followed by one of her students, in this instance Sydney Anglo. I don't think it was correct to choose him but I knew that I would not be asked as I had made my own way and refused to be part of the cerebral salon. Australian radio, of all things, are doing a programme on her and I found myself giving an interview and saying all sorts of things about her that one hadn't really analysed before, mostly about the imbalance of her mind and her projection of her emotions into her work and on to her students. I think that I was perfectly fair and accurate, and the highly intelligent woman doing the programme said that I was the only person so far that she had talked to who had even attempted to essay that aspect, which explained so much. However, that's that ... I talked to Joe Trapp a bit about her treatment of me at times and he was staggered that I was not allowed to call her Frances until the year she died, when there seems to have been reconcilement and reconciliation. I've often thought, looking back on that strange relationship, that there was a tinge of envy on her part. Those years of studying under her were marvellous, the best, and her kindness and giving untold and remembered with such gratitude and affection, but why couldn't she let one go, let one follow one's own path and have one's own thoughts? No, that ability she lacked, and for years I couldn't bear to see her and have my mind smashed. And yet who was the more true? She always trained one to be independent in one's thoughts but if any of her students actually did pursue what she exemplified, she didn't like it. You were only 'in' if you were content to be sparks in her coronet. Sad really. However, I am to be bidden to choose a book from her library, which indeed I shall treasure, and I hope that wherever she is amidst the Dionysian hierarchies she will gaze down and recognise that in many ways I was the truest of all her students.

We have been in the grips of snow and ice for nearly three weeks, quite unprecedented. Now we have floods, and the garden in areas like a lake and bog. Awful. We are down here for a fortnight for Christmas and go back on 6 January. Lots of rest – sleep, sleep, and more sleep. My father-in-law came for Christmas and we looked after him well. He is eighty-one and having trouble with his eyes, cataract and a blind spot, which is sad. This year more than any previous one has filled me with how terrible old age is. Something like five memorial services and two funerals and endless instances of the problems of coping with the old and how totally arbitrary old age can be, how unfair. However, we must struggle on.

I must make a resolution to keep more diary entries next year. I always have kept a very patchy diary and looking back at it the other day I was struck by how fascinating it was. The early, late-sixties entries are halting, brief, but during the last few years I have kept to writing on the whole set pieces, giving the flavour of an event like a visit to Cecil Beaton or lunch at Clarence House. I was quite surprised how already they were history, describing appearances and tiny details visually and verbally.

The sun is shining now at this minute which is glorious and I look out on to the grand avenue, Elizabeth Tudor, and think of the carpet of golden daffodils to come. I've rung the Museum to get a 'thank you' card of some form printed. I had to cope with three hundred and fifty letters and telegrams when I became Director. Heaven knows what the knighthood will bring. So I've chosen to place Hilliard's full-length of Cumberland as Knight of Pendragon Castle on it, holding his lance and with Gloriana's glove in his hat – seems to sum it all up.

1982

All Change

The discovery through looking back at previous diary entries that they could be rather fascinating must have stirred something in me, for henceforth the entries are written in blank notebooks, foolscap in size, and no longer on odd sheets of paper. The diary running from 1975 to 1981 had been written on any scraps which came to hand, in the main on the reverses of redundant photocopies of my wife's costume designs for various productions. The size of the paper varied wildly but they all ended up in one large loose-leaf file. Now follows a series of neat bound volumes and, with the knowledge that they were more interesting and better written than I had thought, the length multiplies, although the principle of long set pieces and then interim blanket summaries of events continues.

This year seems the apposite one in which to let down the backcloth of the 1980s as it was to radically change the museum world as I had known it. We were on the road which led to the consumer museum. Such a development was a complete reversal of the post-war cultural concept of the funding and function of our great national institutions. Until then it was accepted as a given that they were basically sustained, however inadequately, by the State. Those in such institutions worked from the premiss that they were there to give the public what *they* thought was good for it. The role of the curator was first and foremost to be a scholar, to know about and collect objects within the orbit of his expertise. The supreme means of curatorial expression was the catalogue. The enemy, it would not be unfair to say, was the education department, which had the audacity to communicate on what they regarded as *their* objects to the public.

That, of course, is an over-simplistic view of what the museum world was up until the eighties. The dramatic change that followed was engendered quite simply by Government applying the financial thumb-screws. This began by cutting funds and forcing museums to raise money from the private sector. By 1990 the formula of matching pound for pound had become axiomatic for virtually any exhibition, gallery refurbishment, or new building project. Then charging came back on

ɔ the agenda with the National Maritime Museum leading the way. Government still funded the ongoing staff costs but that began to hange too. As museums were gradually granted flexibility as to how ɪey made use of their overall budgets, what was initially welcomed s a new freedom brought a sting in its tail. In the past there had been o flexibility allowed between the different financial subheads. When ɪat was gained it was at first extremely attractive but as salaries, ver which museum directors had no control, progressively spiralled pwards, more and more of the overall budget began to be eaten up by ɪem. By far the most expensive were those of the senior curatorial taff. By the end of the decade directors began to look at how they could ut that bill by reducing the number of senior appointments, but in ɔ doing they were striking at the foundations of any museum: its nowledge. Not long after I had left the V & A I was appalled to learn ɪat many people preferred to go to the saleroom experts for certain bjects because their expertise was now greater than that of the Ⅎuseum.

Simultaneously the amount of time and staff accorded to fund-ɪising, front-of-house management and events developed. One of the rime activities of a museum was now to be seen to be revenue-ngendering. As the Thatcher revolution switched from direct to ɪdirect taxation the role of the museum was to woo the pound from he public's pocket. For the first time museums were hit by customer ower. They could no longer ignore the public. The public had to be ttracted, enchanted and entertained. Perhaps in the nineties we see ɔo much of the downside of this shift in emphasis but in the eighties ː resulted in an enormous amount of dead wood being cut away and nabled directors to move things on, whether the curators liked it or ot.

All of this was apparent very early on in the new era. Unless the hallenge was met the primacy of knowledge was under threat. Time nd again this message was reiterated to the senior staff, that unless oncessions were made everything that the place stood for could go to he wall. Neither the message, nor the messenger, was welcomed. Ⅎost of the senior staff regarded the very notion of fund-raising with bhorrence, certainly as an activity which did not pertain to them. The)irector could get on with it. The new emphasis on consumer comfort ʋas met with hostility and derision. I remember standing in the front ntrance hall ordering it to be swept clear of clutter and inaugurating phase which can only be described as the glamorisation of the ⌐ & A. Amongst other things, two twenty-foot-high flower arrange-

ments by Kenneth Turner costing some £20,000 p.a. were part of the scheme. They looked stunning, but the curatorial staff were horrified and saw to it that the usual snide piece appeared in the *Times* gossip column.

But nothing was to stem the tide. By the close of the decade the incoming Director of the Natural History Museum sent his staff off to Disneyland as his first action. From the late sixties onwards the accent had been very strongly on education, but the shift was now to entertainment and a quality product. The Museum began to be available for hire for private dinners and parties, at a price. The shop and its merchandise became crucial, a treacherous path, for curators viewed any facsimile or use of the collections for commercial purposes as anathema. Catering moved centre-stage. At the V & A that was in the grip of the Civil Service in the form of an abomination called CISCO.[1] In the end we gained our freedom, but only at the price of finding a caterer who would fit out a new restaurant in the Henry Cole Wing. These changes affected scholarly output which in the past had automatically been printed as of right by HMSO. The stress was now on profitability and marriages with commercial publishers. During the 1980s the V & A raised £11 million from the private sector, quite an achievement, but it started with a huge disadvantage. It was a Government Department and had therefore never attracted much private benefaction compared with the huge inherited endowments of the National Gallery and British Museum which have seen those two institutions through difficult periods.

There was a new emphasis, too, on cleanliness in the galleries and the first moves towards making the exhibits less of a monument to curator-speak. Up until the eighties most of the energies of the V & A had gone into hugely influential exhibitions. These ceased in 1983 so that no one had any excuses for not putting every effort into the face-lift of the permanent public galleries. Until 1984, when the Trustees came in, we were still in the grip of the Property Services Agency of the Department of the Environment. Only when their hold was loosened could we bring in an outside consultant architect and develop and accelerate a new strategy.

The PSA have left an indelible mark on my mind, in the main for poor-quality work, nothing being completed on time and always forced to go to whoever gave the lowest tender for a job. In 1974, when arrived, I put them on to rebuilding the leaking roofs. I left in 1987 an

[1] Civil Service Catering Organisation.

they were still up there. As far as I know they still are. The PSA's prime role was to maintain the building, which they signally failed to do. This year, in August, there was an appalling flood. Several inches of rain fell in less than an hour. Gallons of water poured through into the North Court, the Restaurant, the Gothic Tapestry Court and the Cast Court. Even worse, parts of the Library were flooded. When I asked the PSA for a plan of the Museum's drainage system they could not produce one. They had no idea where the drains were.

No matter, for 1982 at least witnessed work start on the Theatre Museum in Covent Garden, not without the usual public wrangle, and there was a spectacular exhibition, *The Indian Heritage: Court Life and Arts under Mughal Rule*. But the most significant event was the Rayner Scrutiny. This was delivered in May and contained forty recommendations pertaining to the V & A of which by far the most important was that it should be devolved from Government. On 27 May it was announced in the House of Commons that separate legislation would be introduced to establish boards of Trustees for both the Science Museum and the V & A.

The New Year.
The year really began on 31 December when my knighthood became public. It was apparently on the midnight, seven o'clock, and eight o'clock news and, as we were at The Laskett, snowbound, I would never have known it had actually happened if it had not been for the last. Well, I suppose, sooner or later it was inevitable but it left no immediate impact, just a kind of deadness because when the moment was right it never came. That this was widely felt was reflected in virtually every other letter of congratulation, in which the words 'long overdue' recurred. One knows the reason for the delay. I fought the DES up hill and down dale during the period of the cuts to the V & A. On the blacklist I went. I would guess that this honour came in other ways.

But it was the aftermath that was cheering: the telegrams, letters, the bottles, the greetings and smiles of real joy and happiness of others. The V & A really lit up and I was given a surprise party with a burlesque 'masque' in which Lady V & A was rescued by her Knight. So many letters and cables. Princess Margaret was moved to put pen to paper and Queen Elizabeth at Clarence House commanded Martin Gilliatt to write. The most wonderful letter from Isaiah Berlin that encapsulated in three sentences what I had tried to achieve: scholarship and the communication of it to a wider public, the belief in quality and excel-

lence, and the effort to preserve public respect for it. And the letters from so many over the years from schooldays on, totalling in all some six hundred and eighty and incorporating an amazing roll-call of names. I answered each and every one.

10 January. Death of Pamela Hartwell.

I was rung at the office on Thursday 7 January by a *Telegraph* journalist, Kenneth Rose. It was, he said, urgent. When the call at last came through he said that Pam Hartwell would not last the day and that he had been asked by Michael to prepare an obituary notice for the *Telegraph*. I was stunned. In fact she died a day later but it all seemed so unreal. One had never associated Pam with ill-health, indeed like Lady Bracknell she seemed to regard health as one of the prime duties of life. When I came to read the obituaries they revealed that she had been fighting cancer for three years, which would coincide exactly with the time when Julia and I noticed a physical change in her appearance, a puffiness and a putting-on of weight. Yet no one knew. What extraordinary bravery and how utterly right that of all people she played even death her way.

When last we had lunch together shortly before Christmas she was as vibrant, strident, dominant and magnificent as ever, avid for all the gossip and intrigue, presenting me with a copy of Tom Hoving's[1] mischief-making book *King of Confessors*. That she was an extraordinary woman there can be no doubt. Her problem lay in the fact that her intellect had never been trained, doubtless something which can be laid at the door of her father, F. E. Smith. As a consequence her life was one long explosion of misapplied and frustrated energy as she bulldozed her way first as a political hostess, then as the presiding deity of British couture, and latterly as a lady of art. The result was an eternal unfulfilled restlessness as she pursued first this path, then that. This erratic progress was matched by her guest-list, which also speedily changed as people came on to it and as quickly came off it. Politics, fashion and art fell beneath her chariot wheels but she never actually displayed any deep knowledge of any of them. No amount of trudging around the galleries of Italy with John Pope-Hennessy, for instance, seemed to leave a flicker. Her houses were jam-packed with pictures and objects but they were there as decoration and bought taste; certainly nothing betrayed an original or idiosyncratic eye.

[1] Thomas Hoving, controversial former Director of the Metropolitan Museum of Art, New York, 1967–77.

So what was it about her that one found so compulsive? I think that it was her vitality and energy, which were on a terrific scale, and her appetite for people. Admittedly in the latter she was far less selective than Ann Fleming, rather a vacuum-cleaner in fact, sweeping into it anybody who happened to be 'in', although they were equally as soon 'out' if they failed to stay the course. I remember Xandra Dacre once at a Cowley Street party opining that she didn't know why they were there as they'd been cut off the list. But all those endless lunches and dinners and parties did perform a service. Pam stood firmly in a line of descent back to the eighteenth century, that of a great hostess bringing people together. They intrigued her and she needled out of them all she could. Liking them certainly didn't enter into it. And she was never happy at anyone else's party except her own. Many is the time we've seen her cornered into having to go to one, wafting her way along the line-up and sharply out the other side as quickly as she was able.

She could be appallingly rude. Once at Oving she asked A. L. Rowse to lunch and placed him to her right. There was a terrible fracas between them and he left immediately after. Her luncheon parties were the best, usually two round tables of eight in the new dining-room which she added to Cowley Street with grisaille decoration, rather oddly depicting City churches, by Felix Harbord. The lunches began in the drawing-room on the first floor with martinis and Bloody Marys and ended there with coffee. It was always a mix of politicians, publishing, art and the *beau monde*. But politics were the mainstay and art was always John Pope-Hennessy and myself, extending otherwise only to Graham Sutherland. Scholars or men of letters were certainly never part of the scene, apart from those of the ilk of Trevor-Roper or Noël Annan. Basically she was anti-royal which was an odd streak which must have gone back to something, but she always relished any possible derogatory gossip about them.

I remember Cecil Beaton describing seeing Pam dancing on a table when young as the prettiest thing he'd ever seen. I can believe that from old photographs and the ravishing Rex Whistler portrait. And once she must have had some dress sense for she was the mainstay of post-war revived British couture. But for as long as I knew her she always wore violent-coloured rather ethnic dresses and vast clanking gobbets of artificial jewellery. Like Diana Cooper she had had a face-lift, but rather less successfully, and there was a substantial amount of false hair.

I dread to think what she had been like as a mother. The youngest, Harriet, was virtually concealed as she grew older for fear of revealing

Pam's age. Her marriage to Michael, however, I always found touching. Whenever we stayed at Oving she would worry about when he was coming, how he would be when he did come, always bustling to see that food and drink were ready for him. Certainly no façade there that I could discern, although gossip had it that she had had affairs in the past including one with Malcolm Muggeridge of all people. But one doesn't know. I only fell out with her once and that was when John Pope-Hennessy poached her for the British Museum Trustees. I got Jack Donaldson to remove her from the V & A Council, but in time all that blew over and we were back on the list again.

Although she was fundamentally a man's woman she hit it off with Julia. Initially she treated her as a little wife, which didn't go down well at all. When we first stayed at Oving as a married couple Pam said, 'I'll go into Oxford with Roy,' to which Julia said, 'I'm coming too.' As we drove in the car, an ill-sorted bunch, the screen frosted up and Pam complained she couldn't see through it, at which point Julia leaned forward and said why not pull such and such a knob. From then on Julia began to be looked at in a different light: 'So practical,' Pam ejaculated, and even more so as Julia peered through the iron gates of All Souls and murmured that it was where she had been christened. Those expeditions with Pam were hilarious. There was no drive she wouldn't invade if she had set her mind on anything. What a zest for life! To die at sixty-seven is really cruel. I still can't believe it.

22 January. Dame Frances Yates remembered.
I stayed in London this Friday for the memorial meeting for Dame Frances Yates at the Warburg. In a way this rounded off one of the most profound relationships in my life. The lecture-room, painted a dreary puce and with brown curtains, was full. Many old faces and, of course, among them what was left of the old Jewish caucus of the original Institute, plus its later overlay from the forties and fifties. There were three speakers. Joe Trapp, the Director, read some autobiographical fragments written by her in 1980, not really very interesting except for the odd flash. After all it wasn't an interesting life in the emotional or physical sense, only in the mental. Gombrich did a brilliant *hommage* perceptive, appreciative of the toil, the erudition and the enthusiasm but tempered with caveats on the wildness and wilfulness upon which she could embark. Margaret Mann talked about her as a person, re inforcing the view of an existence which centred on a comfortable detached house and garden at Claygate, tea with good cake, looking out on to the tangled garden beyond. Nothing much there. Sydne

Victoria and Albert Museum
DONATELLO APPEAL

Please help to save
The Donatello Madonna
for the Nation – it will go abroad
if we are not able to buy it

The Eternal Begging Bowl

The Chellini Madonna, 1976

SOMETHING OLD, SOMETHING NEW

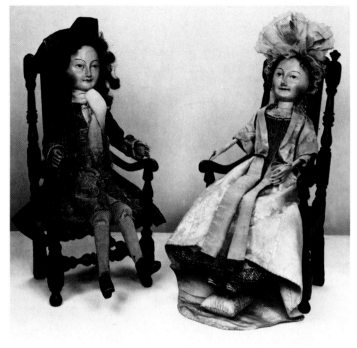

Patriotic Dolls

Lord and Lady Clapham, 1974

Going for Broke

The Lomellini ewer and basin,

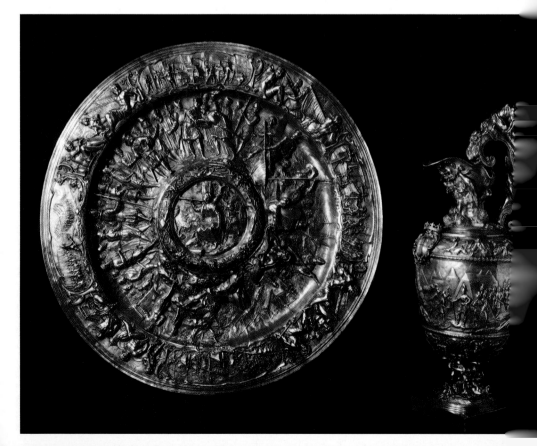

Cleopatra's Nightmare

Wellington's Egyptian Service, 1979

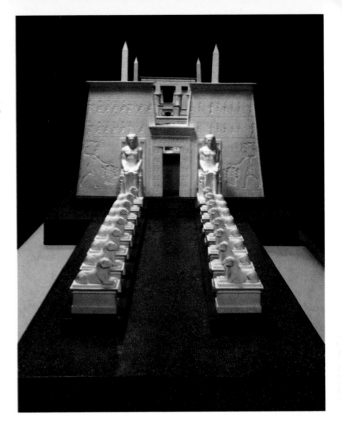

The Shock of the New

Robert Welch's Candelabra, 1980

Trendsetter

The Biedermeier Exhibition, 1979

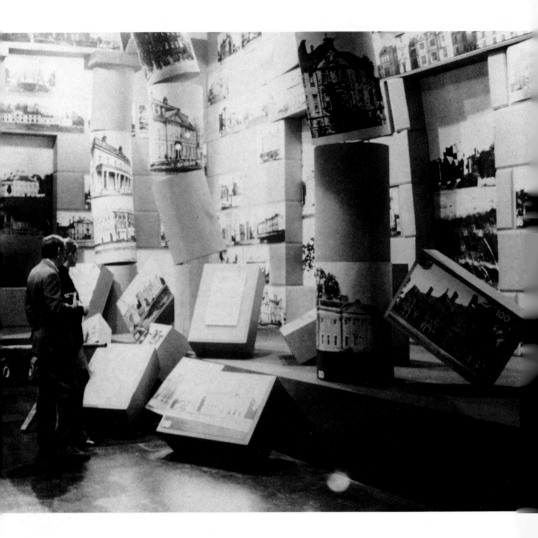

Milestone

The Destruction of the Country House, 1974

Millst

The Henry Cole V

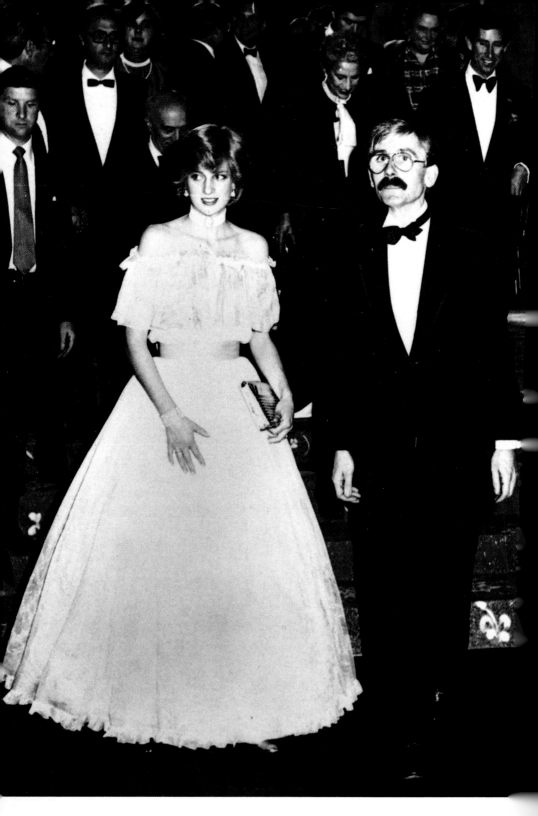

Glamorous Knight

The Princess of Wales leaves the Gonzaga Exhibition, 1981

Anglo as the 'student' caught quite a bit of the eccentricity of working for her, but the piece was too mannered in the wrong kind of way. I always thought that she loved music and what a shame that there was none. It was an affectionate occasion, warm and loving and, like so many university events, devoid of any style.

I cannot remember whether I have written of our relationship or not because it was me who in a way should have been the 'student' speaker. It all began in 1956. I had just got a First Class Honours Degree in History, much to everyone's surprise, and wanted to go on to do a thesis on portraits of Queen Elizabeth I. As an undergraduate I had attended the Optional Course on the Renaissance at the Warburg, which was held in the old Imperial Institute Building. Soon after the result was known I went for an appointment with its Director, Gertrude Bing. She had in fact lived with her predecessor as Director, the great Fritz Saxl, but that I did not then know. I was a shy, deeply introverted twenty-year-old and I vividly recall standing in the gloom outside their offices waiting to go in to see her. The offices were, in fact, rabbit hutches of plywood set within the old Victorian structure. As I stood there a door flung itself wide and a large lady appeared, her arms upraised, exclaiming, 'It must have something to do with Early Christian altars.' She swept out and shortly returned laden with huge tomes and went back into her office. That person, I was subsequently to learn, was Frances Yates.

I then went in to see Gertrude Bing, a plain, severe, German lady, crisp and very frightening. She stared hard at me and it was only later that I learned that she did this in the belief that she could read one's thoughts which, of course, she couldn't. In the room at the same time was the already famous E. H. Gombrich, who was only to take to me twenty years later. Well, I stumbled out a hymn about Gloriana, and Gombrich looked at Bing and said, 'Frances.' And that is how it all began.

One's earliest encounters with Frances Yates left a deep impression. I was quite overawed by this extraordinary woman. Legend already had it that she was the original of the dotty lady in Angus Wilson's novel *Anglo-Saxon Attitudes*. She must have been in her mid- to late fifties when I first knew her, large of build, wearing flat sensible shoes, always a straight skirt and jacket with a blouse or jumper on to which she usually pinned a little gold brooch of two birds. Her hair was already almost white, worn rather long, and she was always aware of its untidiness, from time to time hairpins falling out of it on to the floor. The structure of her head was leonine, no beauty, her features could

move from those of a hooded intensity with the gaze of a seer into the beyond, to ones invested with a kind of mad gaiety. Her eyes, which were pale blue-grey, were her best feature. At that period she chain-smoked Craven-A cigarettes in a holder which struck an unexpectedly sophisticated note. In attitude and appearance she belonged to that first generation of middle-class Englishwomen who had been allowed to have a university education (however odd hers was). She fits neatly into a gallery which includes Dorothy L. Sayers and Muriel St Clare Byrne. To be intellectual was equated with the affectation of a certain mannishness.

Our encounters in term-time were every Monday at 5 p.m. Punctuality was not her virtue and she had no compunction about leaving one standing outside her door for up to forty-five minutes. Once in the room one sat in a low chair and she swung on her desk chair, the smoke from her cigarette arising like incense around her. Early on she got the file of portraits of Elizabeth out of the photographic collection and we sat down to look at them together. Her flights of fancy would at times know no bounds. She would stroke ermine in a picture and mutter, 'Purity', or, if the Queen were holding a jewelled chain, wonder whether it was an allegory of Aristotelian justice as number and measure. She would suddenly embark on long expositions of sixteenth-century interpretations of the Apocalypse, once narrowing her eyes and bending down towards me, saying, 'You know, we've got to get to the bottom of this Whore of Babylon business.' Quickly she realised that I was not ready to do the portraits (nor, in retrospect, was she) and I was put on to Lord Mayors' Pageants for a term. These then had to be abandoned as someone else was found to be working on them. But her attitudes stuck. When confronted with a thesis on *Elizabethan Pageantry as Propaganda* I said, 'I can't do that, it's English literature,' to which the reply came, 'A trained mind can do anything. You take the book from the shelf and read it.' That was what was extraordinary.

While one's contemporaries at the Institute of Historical Research seminars were slogging away at recusants in Cheshire, MPs in the Parliament of 1581 or who did or did not pay Ship Money in Buckinghamshire in 1636, I was in full flight on triumphal arches, chariots, masques and ballets and, even more, leaping through them into music, theatre, poetry, the history of images and ideas, political and religious history, any tack to which the evidence led. The boundaries of knowledge widened dramatically. I was taught to think horizontally.

There were, however, differences of mind. I could not and never have escaped from my training as an historian. Documents could and still

do mean everything to me. Not only written but visual. This was Frances's weakness, for little of her work was ever really substantially based on manuscripts, and she never had any kind of critical visual eye. She never took kindly, however, to any form of criticism, no matter how mad her solution to any problem, she would stick to it. I remember her once giving a seminar on an Elizabethan portrait about which she was quite wrong. Amidst the uproar Gombrich could be heard saying, 'A loose dress always means a loose woman,' while Frances sat blankly reiterating, 'I'm right, I know I'm right.' When she wrote the Valois Tapestries book and I, as a shy student, pointed out to her that a drawing of Elizabeth I was a later insertion into her vital Lucas de Heere manuscript, she flew into a rage and next day I had a six-page letter from her as to why she was right. It was very difficult, as a lowly apprentice, to know what to do. She brought in Francis Wormald and we all met in the Manuscripts Department of the British Museum. The volume was fetched and Francis immediately said that I was right, pointing out how that page had been added.

This was an unattractive trait which manifested itself to me more than to others as I worked on material very close to her own ground. She wanted to dominate intellectually and on the whole only liked other people's ideas if they fitted in with, or expanded, her own. On the other hand she gave to her students. I was her twelfth since 1937, I believe, and one did see her and one did have one's eyes opened to so very much. She also took it on herself to find her students jobs. She fixed a fellowship for Sydney Anglo at Reading and heaved a sigh of relief that she did not have to think of me until 1959. Then she started getting to know Oliver Millar and trotted down to the National Portrait Gallery with the inevitable result.

Her knowledge of *le monde* was limited because she was hopelessly at sea in it. Always she spoke of toiling away in darkness on vast works and not seeking the limelight, with more than a swipe at Gombrich, something to which she returned from time to time. To me this always meant that she wanted stardom and, as she said, she was descended from two theatrical queens, Mrs Yates and Dame Nellie Yates, Queen of the Australian stage. It all fitted. I later began her on the progress to public honour, which she loved.

She was hopelessly impractical and her sister Ruby looked after her. How she found her way to the bus-stop let alone made a cup of tea I'll never know. There was instead this huge mind, unsullied by any of the conventional approaches and totally fearless at wading in. She was aware of this limitation over practicalities because she once described

to me how Fritz Saxl would sit at a typewriter composing a lecture on Mithras and then would get up and go into the next room and chair a committee saving the Institute. The latter she said she could never do. It was that account of Saxl which made me want to do both like that, too.

Shortly after the news of my knighthood Joe Trapp sent me her earliest copy of *The Faerie Queene* inscribed 'Frances Amelia Yates her book'. I know that small gift was symbolic and I at last wrote the letter to him that I had wished to write earlier – about my debt to her, her rejection of me, the years I needed to put myself together after that had happened, her perception and her blindness, her generosity and her meanness...

27 January. Charles Oman.

A time for gathering in. Never have I felt it so strongly as the deaths follow one upon the other. Yesterday my father-in-law, Charles Oman, died peacefully in his own bed at home at 2.15 p.m. Julia was there. This is the first time that I have been very close to death and seen the dead. All Julia and I felt was that his ending gave one the strength not to be afraid. As they wrote of Elizabeth I, he fell from the tree like a ripe apple. We saw a great machine nobly reach its end. The face was tranquil, more composed than in ordinary sleep. Once one understood that the crackle of heavy breathing caused him no pain, there was no fear in looking, in being lovingly present. I arrived as quickly as I could from the V & A after he had died and Julia took me up. The face was very pale, beautiful, the pallor heightening the bone structure, for he had been a handsome man with blue eyes and fair hair.

He was a very private man with few friends, indeed he did not like people. Overshadowed from birth by the aura and expectations of his father, he had to come to terms with falling short. Before he was sent to his preparatory school he did not stutter. So bullied was he that he was sent home bruised and beaten, but the parents put the 'dear boy' back on the train. He was never the same again. He failed to get the expected Winchester scholarship and failed to get a First at Oxford. I do not remember him ever referring to this period, but it must have been a very unhappy one. The result was to create a defensive cocoon, which he achieved and which worked for over half a century. He lived in a world of his own. Once he got into the V & A and alighted upon silver or, rather, was pushed into Metalwork he devoted his life to this narrow field. He knew it all and produced book after book. Convention demanded marriage, which he did, with Joan Trevelyan. Two children

were produced, above all the obligatory heir, but as the years went by Joan's role became more that of a housekeeper. They slept in separate rooms, never went anywhere together, and pursued their own existences. She gave him an organised home and meals. He appeared on time expecting to be fed and then disappeared into his study. He always believed that he had a happy marriage. It certainly suited him and it would never have crossed his mind that there was anything deficient about it. But there was. Joan Oman was the loser.

2 February. Pamela Harlech's new kitchen.

Dinner at David and Pamela Harlech's was in their new house. Julia was in Germany and so I went on my own. I arrived on the dot of 8 p.m. knowing that HRH Margaret was bidden and all the guests fell over each other at the door. HRH brought Derek Hart. As she was off to Mustique the next day we got away at 1 a.m., which was early for her. She was in fine fettle dressed in pale yellow embroidered with sparkle, a typical royal couture product. Even the opening line of negatives quickly subsided as we lurched into all the wrong subjects. No, she hadn't enjoyed the Gonzaga exhibition, the musical *The Mitford Girls* or the *Evening Standard* Drama Awards. She was anti Diana Cooper and pro the Crazy Gang. And so the conversation rolled on.

The refurbished house meant going through the dining-room to the drawing-room which was large and painted green, conventionally furnished with antiques from the Welsh house and *objets trouvés*. Visual originality was reserved for the kitchen, which we were shown after HRH had left. This is Pam's true domain, wonderfully organised and planned by her with a large central work bench that included chopping boards, areas for mixers, gas jets, trash cans, the lot. It would have been a happier evening in there, I thought.

3 February. The Royal College of Art.

I dined at the Royal College of Art. The Rector, Lionel March, is an impish, bright person, dedicated to brushing away the usual social cobwebs. So far he has done surprisingly well at the RCA and results must eventually come. The dinner was an innovation, a casual hotchpotch of students, staff and guests. I thought it a shame that they had not been given an opportunity to dress up, that the food was awful and also the flowers. These are details which should always be watched over. But the atmosphere was good even if it lacked Darwinian style. I

sat between Joanne Brogden[1] and a pretty Mexican girl finishing her degree. I was taken aback by Lionel March's *hommage* to me to which I had to reply off the cuff.

23 February. Farewell to Pamela Hartwell.

Pamela Hartwell's service was on a bright winter's day. The obligatory but unsympathetic St Margaret's, Westminster, was jammed with people. Black coats and hats I'd seen often before reappeared, and Lady Rupert Neville stood out wearing purple with a black veil over her head. It was difficult to see who was there as we were placed on the right in the ninth pew. Arnold Goodman was to Julia's left with the Thorneycrofts. Arnold whispered to Julia, 'Norman St John-Stevas looks as though he's been boiled.' He sat in front of us along with Evangeline Bruce and Roy Jenkins, who pushed his way in late, and Beryl Maudling in a wig and fur coat at the end of the row. Ahead stretched Paul and Ingrid Channon in the front pew, David Wilson in the second (he read the first lesson well but failed to wear a morning coat), Willie Whitelaw and Alec and Elizabeth Douglas-Home. The left-hand pews were filled with family, Michael Hartwell reading the second lesson. Gerard Irvine took the service, which was a colourless affair which the lack of an address only reinforced. There was no explosion, no extra touch, which would have captured her. It was all safe and rather dull, less ritual than routine. Two marvellous vases of flowers at the altar steps, however, she would have loved. One remembers Oving and Cowley Street being full of flowers.

At the end the family left by an east door and did not stand and receive at the west in the usual way. Rather a relief as it is always gruelling and no one knows quite what to say anyway. Up the aisle we all shambled almost falling over Dolly de Rothschild of Waddesdon and her friend, Miss Brassey. Outside the groups formed and re-formed in chatter and I fled back to the V & A. En route to the Underground I suddenly encountered Pamela's daughter Harriet Berry getting into a car. 'Your mother was incredible,' I said. 'She kept going like a flame-thrower to the end.' 'Well, at least it was short,' she replied.

3 March. The Barbican Centre opens.

The Barbican Centre was like a sleeping beauty. One was always aware that something or other was going on in the City but the sheer size of it was totally unexpected: a vast concert hall, huge theatre, studio

[1] Professor Joanne Brogden, Head of Fashion at the Royal College of Art.

theatre, cinema, restaurants and art gallery. The opening went like clockwork as far as we were concerned. We found our way to car park C as instructed, decanted ourselves along with a steady stream of other people in black tie and trailing dresses, and were put on a bus for the Centre. It seemed quite a long drive but after fifteen minutes it became apparent that we had gone more or less round in a circle. The whole affair was a terrific feat of organisation; thousands of people cramming every auditorium were moved this way and that, given endless drinks and finally a buffet supper. The Arts and City world were there in force, a plethora cascading over seemingly acres of concourse. One appreciated the space and facilities but did it have to be like a Holiday Inn? Garish in colour, splodgy orange ceilings and check carpets, and obtrusive signposting.

We were assigned to the concert, the hall of which was handsome, the Festival Hall in style moved on a little rather than a lot, the ceiling a forest of acoustic glass vases, the whole a celebration of wood with reeded decoration running behind the platform, the surprise of non-tip-up seats which were extremely comfortable to sit in. Claudio Abbado launched it with the overture to *The Mastersingers*, Beethoven's Fourth, Elgar's cello concerto and Ravel's *La Valse*. The atmosphere was good for music-listening, although the sound was too hard and sharp. We never got to see the inside of the theatre but bumped into Harold Pinter and Antonia Fraser, who thought the *Swansdown Gloves* so awful that they had migrated over to the concert. We also bumped into the Cassons at the end fleeing towards the doors, Reta saying that she never wished to come here again as they had sat frozen in the theatre.

The Queen came in pink, her hair growing into grey-white at the sides. For her it was an odd evening with half a concert followed by half a play. From her point of view two halves may have suited her better than enduring the whole of either. A *Time-Life* journalist rushed up and asked me what I thought of it all, to which I replied, 'Splendid but the test is to come. Is it a sixties idea reaching fruition in the eighties with no changes to meet new assumptions or expectancy? Or can it be adapted and reflect the back-to-basics of the present era?' The City is committed to £9 million p.a. just to keep it going. One wonders, after the first flurry, whether it has a future. Audiences in the recession are falling everywhere. The RSC is the best bet but I worry over the huge concert hall in view of the Festival Hall and the Albert Hall, not to mention the art gallery which has to compete with the Hayward and the Royal Academy plus a string of national museums. It will be interesting to watch.

We bumped into Alexander Glen, who had taken the Rayner Scrutiny man [Gordon Burrett] out to lunch and said that we would get everything we wanted if we were quiet. There was not much sign of any politician so Shirley Williams was rather a surprise, twice in a week because she was also at the Tate's dinner for the Landseer exhibition. She was wearing a curious dress with a bodice appliquéd with a piece of William Morris fabric and a border of the same at the hem. I saw another woman wearing exactly the same dress but a short version of it. No stunning dresses in fact bar two. George Howard arrived in a silk coat with gun-metal buttons escorting a young girl in a vast crimson paper taffeta crinoline in the Emmanuel style with an aigrette of the same in her hair. Zandra Rhodes sported *paniers*, her hair dyed various shades of purple, two eyebrows instead of the usual one, a bodice like a corset and her *paniers* supporting pleated sunbursts of gold.

9 March. I am knighted.

I was knighted today, an experience close to a school prize-giving. We drove and parked in the quadrangle of Buckingham Palace in brilliant sunshine. A huge dog sniffed the contents of the boot, in case we had a bomb in it, I suppose. Julia and I were split at the door and she eventually found herself a seat in the ballroom at the far end on one of the tiered seats in order to get a better view. The room was really rather chilly, the result perhaps of the royal economies we had been reading about. I went up the staircase one normally uses on state occasions into the first reception room with its green damask walls hung in the main with full-lengths by Alan Ramsay of George II's family and furnished with Boulle and Sèvres. There the knights and the solitary dame had been gathered for a rehearsal. A senior officer ran us through the drill twice with the kneeling-stool. This was certainly somewhat amusing, but when the time came no one actually failed to get it right. I was touched by the fact that members of the Household one knew all popped in just to wish me well: Peter Ashmore, the Master of the Household, John Johnston and 'Chips' Maclean, the Lord Chamberlain.

Everything as usual went like clockwork. We were marshalled in order (it was clear that they were getting towards the end of the alphabet at this investiture!) and then walked through the Picture Gallery past those receiving other awards, on across the end of the ballroom and looped around to the other side. Julia said that I looked like a dwarf amidst a series of very tall knights. We then queued until signalled to move towards the gentleman usher close to the Queen, who stood before a gilt chair placed at the front of the throne dais. John Johnston

passed her the awards on a cushion while to her right 'Chips' Maclean stood at a lectern calling the names. Behind were ranked the Yeomen of the Guard and Gurkhas. At the moment my surname was called I advanced, went towards the Queen, knelt, the sword catching the light as it passed from one shoulder to the other. I stood and bent forwards while her hand placed an order around my neck. As I inclined she said, 'I'm *very* pleased about this one, after *all* the work you've done.' I replied, 'I'm proud to be an Elizabethan knight, ma'am.' There was a handshake. I took a few paces back, bowed, and went out of the opposite door. It was over. I wonder whether it was different for Raleigh or Drake? Certain sensations must have been the same: the presence of the sovereign, the throne, kneeling, the flash of steel across the shoulders.

Back I went to sit in the ballroom and witness the remainder from afar. The music from the Guards band in the balcony was as I predicted, *My Fair Lady* and *The Sound of Music*. Could they not have risen to a little Mozart or Elgar? The Queen as usual incredible. It must be so boring for her to do six or more of these a year. No sign of this. Always a word, probably nothing much (that's the secret), a lot of nods, the face composed with momentary understanding and concern, then always released into a happy smile. Very particular care was always taken of any disabled person. This was especially noticeable in the case of those in wheelchairs or soldiers in a shattered state, having served in Northern Ireland. One noticed that all the forces walked so badly and the few women receiving awards were really a dishevelled lot. We had arrived at 10.15 a.m. and it was over at 12.15 p.m. We all stood, the national anthem was played as it had been at the start and the Queen left. A mêlée followed and Julia and I fled home to smoked salmon and a bottle of Dom Pérignon.

20–21 March. Royal Lodge again.

We were bidden by Queen Elizabeth once again to what I always refer to as the Royal Lodge Arts Festival. Times were changing and the old ranks thinning. David Cecil, a mainstay for years, was tending Rachel, who was dying of cancer. John Betjeman, another, now beyond much movement due to Parkinson's, was notably absent. For the last few years poor Martin Gilliatt had had somehow to get him upstairs and put him to bed. So Queen Elizabeth as ever has moved on, bringing in her friends of another generation to entertain: Sir David Willcocks, head of the Royal College of Music, as compère, Ruth Fermoy to play solo and occasional duets with him, a young clarinettist aged twenty

of a sparkling virtuosity, and the actress Celia Johnson just to read anything that she fancied.

We arrived at about 6.20 p.m. The flurry was exactly the same as before as our dilapidated vehicle joined the ranks of the superior cars in the forecourt. Our bags were seized upon. 'Please don't unpack them,' I implored. 'We will spend the weekend trying to find where everything is.' This time the injunction worked. As usual we went straight into the large drawing-room with its green-painted Regency Gothic architecture now lightened by huge vases of spring flowers. There she stood, not far from the drinks table. To describe Queen Elizabeth in her eighty-second year as remarkable would be an understatement. She seemed younger than ever. Arms extended in thrilled pleasure at our arrival. I presented her with my latest book, *The English Miniature*. 'Oh, I love miniatures,' she said, clasping it to her and promptly wanting to show it to everyone. The face seemed remarkably unlined, the hair as ever with combs tucked into it, which she has to push back in from time to time, and the same upright stance. And on her feet the whole time it seemed. She positively darted around the room. Sitting for her was less a means of rest than an opportunity to get her guests on the side to have a good gossip. 'Let's sit down,' she typically said to me. And off we went into a corner of the room where we regaled each other with all the chat.

It was a very happy party, much better and funnier than the time before. Fred Ashton, of course, looking pickled; John and Anya Sainsbury, Hugh and Reta Casson, inevitably, Hugh and Fortune Grafton, yet again inevitably. The routine was identical. Barely a minute to draw a breath for thirty-six hours. A new concession was that white wine was available which I stuck to on the Sunday after slugging myself with the lethal dry martinis the night before. Chatter, chatter, chatter, then to our rooms, Queen Elizabeth taking everyone. Fred Ashton later told me that once he had been sitting on the loo when the bathroom door was flung open by Queen Elizabeth who announced to the assembled tour, 'And this is Sir Frederick's bathroom.' Fortunately he had a dressing-gown on.

There is just about forty minutes allowed to bathe and change and then down again at about 8.30 p.m. to – yes, more drink, and dinner. The table looked wonderful with silver vases full of white and pale yellow chrysanthemums. The food as usual was country-house cooking from the thirties, items like a side salad of virtually uncut lettuce with cubes of beetroot on the top. I had Fortune Grafton on my left, not well, but in the aftermath of flu. At each meal there were eighteen and it was Ruth Fermoy's task to ring the changes in terms of placement

with Queen Elizabeth as mistress of the revels, undimmed, presiding and gesticulating at the head of the table. The ladies left and after a lull, during which Martin Gilliatt plays the role of host manqué, we followed. After dinner I remember sitting and chatting with Queen Elizabeth and Reta Casson when suddenly we all looked up and it was 12.45 a.m.

No sign of tiredness by HM, nor was there any flagging on the Sunday. 'She never takes a siesta,' said Ruth Fermoy. At nine I came down in my grey suit to breakfast with the men. I remember that last time I slightly wore the wrong thing. On Sundays the men appear be-suited for church. At 10.45 a.m. the church party assembled in the hall in which we found Queen Elizabeth in her raincoat popping back from having taken the corgis for their walk. There were two of them, one affable who rolled upside down for me and the other not to be touched. We walked to the chapel followed almost at once by Queen Elizabeth, immaculate in green hat and suit, in a vast Rolls-Royce. Julia, Fred, Celia Johnson and I were sent into the chapel while the Graftons and Sainsburys were pushed towards the royal pew door. The service was very dull with a very boring sermon by a Mr Treadgold which repeated the contents of the lesson which he had just read out. One caught glimpses in the pew of the Queen wearing huge glasses and the Duke of Edinburgh at the end looking totally uninterested.

Afterwards there was the usual presentation to them and off we all went to the Lodge for, inevitably, more drinks. The Queen wore a green coat and long black boots and a green pillbox hat with a black spotted veil to it, which was not attractive. Princess Margaret appeared seem-ingly from nowhere. I asked Ruth Fermoy why she wasn't at the Lodge. 'No room,' she replied. To this drinks *fête* came the Queen's agent plus daughter and the cleric plus family. The Queen is always, I find, very formidable and frightening and it is impossible to drift up to her. However, off they all went and lunch followed, ending at virtually 3 p.m.

The weak by then had gone to the wall, but most of us, headed by our intrepid hostess, piled into a series of cars for an expedition to Frogmore, laid on with me in mind. I'd never seen it. 'Oh, you have to!' And I must admit that it is extraordinary. In the first place it is bizarre that the Royal Family's only really private garden is a cemetery. I had no idea that it was so full of memorials. It is basically a landscaped area with a winding stream, a lake with an island, the whole planted with shrubs and trees. The mausoleum to Victoria and Albert looked gloomy on this dull March day, the light just about filtering in, catching too

much of the fast-peeling paintwork on the walls. The Marochetti of the pair is wonderful, touching, with her crowned head slightly inclined to his shoulder. There is a little flight of library steps to climb up and look at it. Into the chapel had been placed the Thorneycroft of Victoria and Albert as Anglo-Saxons banished from the Castle by George V, and a strange *art nouveau* monument to the Prince of Schleswig-Holstein, removed from St George's Chapel in the 1960s. On to the island we ascended, which is full of memorials to dogs and ladies-in-waiting, and up to the *tempietto* Queen Victoria built in memory of her mother, the Duchess of Kent, a full-length statue in white marble standing beneath a canopy of blue glass sprinkled with stars.

On next to Frogmore House. 'Who last lived here?' I asked. 'We did,' came the reply, recalling her honeymoon when there was electricity only in two of the rooms. It is a huge handsome house now in the grip of dry rot, being taken care of, which meant rooms had been emptied and that the whole place was a sea of crates packed with china and *objets*. Here, we were told, Queen Mary had assembled everything about the Royal Family and it was true; one passed dusty cabinets labelled, for example, 'Princess Amelia's china' or 'Models of the coronation robes'.

Back to the Lodge and tea, yes tea, which ran on to almost 5.45 p.m. when Martin Gilliatt said that drinks would be available again shortly. The room used for tea had been painted a pink colour with a framework of trellis, obelisks and grisaille views of the Lodge at different dates. It was not particularly pretty but I assume in the summer it is more a garden room with access to the terrace. By then Willcocks and the clarinettist had come. They had rehearsed all the afternoon while we were on our jaunt.

Up and changed and down by 6.30 p.m. in time for the Queen and Princess Margaret to arrive, the Queen in a blue blouse and brightly patterned skirt, Princess Margaret in an off-the-shoulder dress displaying her Mustique tan. There was a host of new arrivals: Garrett and Joan Drogheda, Robin and Rosemary Mackworth-Young, Martin and Gay Charteris, and a young equerry. We sat and the recital followed. The Queen was in enormous good humour, pulling the chairs forward, taking a squab cushion off one on which to place her drink. She, Queen Elizabeth and Princess Margaret all sat in the front row with the rest of us scattered behind. David Willcocks was all charm as the compère and the programme was both lyrical and amusing. There were wonderfully silly readings by Celia Johnson; the unattributed poems I found out later were by her. David Willcocks and Ruth Fermoy brought the

house down with a duet for a music master and pupil from the Victorian age which ended up with their hands crossed on the keyboard.

Afterwards there was more talk and at last the Queen relaxed and I smiled and said, 'Thank you for knighting me, ma'am,' and I described my role as the shortest knight, after which we had an hilarious conversation on investitures: fourteen a year, another hundred-and-eighty to do next week, don't ask more than one question, fatal, Prince Charles did, and the event went on two-and-a-half hours. Princess Margaret sat in recently because she will have to take over from Queen Elizabeth. 'Why do you keep bending?' she said. 'Have to, so that I can hang on the ribbons and badges.' The faldstool is weighted with lead and will give whoever lugs it to and fro a hernia. 'Must go now and give Philip his dinner,' and off she went and off we went to dinner where I sat next to Ruth Fermoy and discussed the enigma of Raine Spencer and how much the Princess of Wales had yet to learn. It was a very large dinner with a second table for the overflow, but it repeated the routine from the previous evening.

Queen Elizabeth really has such a warmth, such a zest for life, such a curiosity, a great actress playing a part and enjoying every minute of it. When I sat next to her at lunch she was planning her French trip. Couldn't go round the châteaux with Mitterrand in office so off to Paris instead to the Embassy. A whole day at Versailles was planned, a scheme to get to Malmaison, then what exhibitions would be on? Yet when I was describing my next Italian jaunt she had seen none of it except Florence years ago in pre-marital days. And then there was her fascination with my pocket calculator-watch: what was it? How did it work? Didn't they learn their tables any more? As usual we left in a haze of smiles and gratitude and a degree of wonder. One was reminded of Elizabeth I who, when the rest of the court was too ancient and persuading her not to go on progress, bid them stay put and the young up and go with her.

12 April. To Jan van Dorsten. Events of the winter.

I don't think that I've written since the eve of being knighted. All that went off like a bomb, really happy and cheering. Deluged with about 680 letters and cables. Amazing they were too, very touching and moving and only a handful stilted and mechanical. There is still a glamour about it and I couldn't help feeling it was glorious to be dubbed by Gloriana II and felt the light catch the blade of the sword as it passed from one shoulder to the other. But then I've always been a cavalier and a romantic.

That has been the bonus. The rest of the winter has been TERRIBLE. First appalling weather the like of which we have never seen. We were cut off here for five days with seven feet of snow on one side of the house and four on the other. It took us two days literally to dig ourselves out. Thank God the phone was not cut off or the electricity. An unheard of 23 degrees of frost wrecked the garden, instant death to precious trees and shrubs. I cannot tell you the horror of it all. It will take years to put it right.

Then we had to deal with the saddest event of all, my father-in-law died. In a way it was a good end and the closest I have ever been to experiencing death ... he has left me a precious legacy that it is not an awful thing, but a natural event, noble, calming, and in the end tranquil. Julia woke up the next day and turned to me and said, 'Now I am an orphan' – so you may imagine the rest. A great break had in fact occurred.

20 May. The French Embassy's fête for gardeners.

We are in the midst of the Falklands crisis,[1] so I felt that the de Margeries' *fête* in honour of the Chelsea Flower Show at the French Embassy was a bit like the Waterloo Ball. Style changes over the years in embassies. The last Ambassador was a flop and did nothing, but the Beaumarchais and the Courcelles who preceded him were masters of high style. The de Margeries' evenings are generally chaotic: buffet food and no placement. The result is tough on those who know few or none. It also fails to avert encounters between those who should be kept apart, and it means whole courses of food can be missed. There was a good sprinkling of doughty gardeners, English as well as French. Mollie Salisbury delectable as ever attired in her usual guise as the Woman in White, Debo Devonshire swagged in loops of pearl and sporting a gigantic diamond bracelet, Anne Rosse, a miracle at some vast age wearing a dress out of Beaton's Ascot scene of black slashed over white, twinkling with jewels. Blind as a bat, I don't know how she sees to put her *maquillage* on.

Julia and I joined a jolly ducal table with the Devonshires and Graftons. Andrew Devonshire was really not well, I felt, complaining of arthritic pains and his tunnel vision clearly no better. He embarked on barely audible monologues. Fortune Grafton on my right described

[1] Argentina had invaded the Falkland Islands and a British task force had been sent to reclaim them. The Foreign Secretary, Lord Carrington, accepted responsibility for the crisis and resigned, to be followed by Francis Pym.

Queen Elizabeth's visit to Paris with a nightmare dinner at the British Embassy of left-wing and communist members of the Government, for which none of them had been briefed. No visit to Versailles had been possible as it was being torn apart by security for the visit of President Reagan.

This was quite a gathering – Gibsons, Vereys, Lanning Roper, Peter Coats – Edward and Gill Tomkins, a joy to see, he telling of Michael Hartwell's tragic letter after Pamela died; John Cornforth, now employed as a consultant for our embassies; David Hicks, sharp as the etched wrinkles that make up his predatory face, explaining his plot for a vast video series on museums around the globe; Hugh Reay, a dandified figure from the late sixties, pinched in his responses and wearing a vastly dated white collar to his shirt ... We left at 11.50 p.m.

June. The Rayner Scrutiny.

This is the month of the Rayner Report. It appeared, a document of no great moment, riddled with cost-effectiveness: stop the Theatre Museum, return Ham and Osterley to the National Trust unless they can be made to pay, close Bethnal Green Museum unless it too can be made self-sufficient, collegiate management, rolling policy programmes and reviews, *et al.* Well, the important thing is that the Minister cut the Gordian knot by pronouncing on two points, the first that the V & A was to be a Trustee museum and secondly he would not introduce museum charges. So for the last few weeks we have been deep in Keepers' Meetings, reaching collective views on the forty recommendations which will/could affect us. A great deal of it is dead wood. I am grateful that over nine years I have moved the V & A in a direction where at least we can reach a sensible joint decision after debate. It took a long time, but it's here.

It is the summer of the *Indian Heritage* exhibition. Last week [2 June] we gave a dinner for seventy to celebrate this with Prince and Princess Michael of Kent as guests of honour, she endlessly moaning about shortage of cash as they are not on the civil list and, worse, subject to income tax. She still prides herself on being RC and can never get over the fact that her children have to be brought up C of E. One knew that the Queen was anxious over the Pope's visit from comments which had been made. The most significant moment was the papal visit to Buckingham Palace. I wonder what happened there? It must have been extraordinary to see four-hundred-and-fifty years of English history vanish. Whatever would Elizabeth I have thought?

***28 June. A disastrous* fête.**

The new American Ambassador gave a summer *fête* for a hundred-and-fifty. They had learned a lot over the last few months in terms of mix of people, placement, decoration and organisation. Mrs Lewis stood there to greet us looking a bit pinched. Where was the Ambassador? Oh, on the telephone. We bowled on, bringing up the rear with Fortune and Hugh Grafton, and crossed the returning Ambassador. We were to be entertained, we gathered, mercifully this time after dinner. The last time it had been before, piano-playing by an eighty-year-old American composer of musical comedy songs which seemingly lasted for hours. This time it was to be the comedian Benny Green and his wife on P. G. Wodehouse. We winced slightly at the blight to come later.

The large drawing-room with its green chinoiserie wallpaper looked as splendid as ever with yet another set of pictures, this time a swagger Gainsborough gent over the fireplace. There was quite a crush: Helen Adeane looking larger, so was Ronnie Grierson and his wife Heather whom we hadn't seen for a few years; Jayne Wrightsman in couture black, ashen-looking and drawn, Charlie being ill at home; Prudence Windlesham in crimson loops of Yuki drapes, a catastrophic dress revealing knobbly legs; David and Nancy Perth, he transparent, she with her neck in a halter. Our progress so far seemed more akin to hospital visiting than a *fête*. However, there were the fit: Hugh Grafton – would he like to be Chairman of the V & A Trustees? 'No.' 'How about Peter Carrington [Lord Carrington]?' I said. 'What a good idea.' I assailed the Minister [Paul Channon] on the same point.

Dinner came at last, very prettily done with a black-and-white marquee tacked on to the dining-room with round tables seating ten, and seemingly all the hired waiters in London in droves. I found myself next to Fleur Cowles, wearing dark glasses and a looped mound in shades of pink and plum. There is always something marvellous about her. It is extraordinary how this woman with her at times calculated entertaining is a bonus to life. This is offset by countless kindnesses, genuine affection and real taste. The Albany flat is like nothing else. We talked about Texas and its extravagances. Julia and I had flipped over for forty-eight hours two weeks ago. I tried to find out how Princess Michael paid her bills. Fleur and Tom are pretty close in there and HRH makes no secret ever about her financial woes.

At this point the Ambassador led off Princess Alexandra and we followed and then it happened. As predicted, the reading was a catastrophe. An echoing titter or two was uttered. At the back of the room we huddled, with everyone from the Channons to the Berlins itching

to go. How sorry I was for the performers. To be told that Wodehouse's characters were based on the old Duke of Devonshire *et al.* was greeted with a frosty silence. At the sound of the first clap we fled to the door.

18 July. Another campaign.

Rayner drags on. At the request of the Minister a public row is now needed in order to drum up the ammunition he needs to get the money out of the Treasury. It is an exhausting business reopening the campaign shop, as in 1977–8, with deluges of letters to newspapers, editorials and articles, all howling at the proposal to 'abandon' the Theatre Museum or 'close' Bethnal Green Museum. Paul is a good and considerate Minister but has no great influence higher up. Also one senses a fear of causing any affront in that area in case further advancement should be prejudiced. But here we are back again as in the days of the Socialist Government's cuts, with Hugh Leggatt's office playing its usual crucial role as a kind of 'posting office' for ideas we need to see in print under someone else's name. The *Standard* has taken up the cause of the Theatre Museum as a major campaign and, on the whole, I am optimistic about that one.

18 July. A friend remembered: Sylvia Lennie England.

Sylvia England died last Thursday. This year is full of too many deaths. The solicitor told me her most guarded secret. She was seventy-six. When a neighbour rang and told Julia on the Tuesday that she would not last much longer that evening I wept. Here was someone who in one aspect was a Dickensian caricature of decayed gentility, with her sing-song voice, her gangling look, her endless bags and handbags stuffed with papers. But she was a modest person with modest demands on life, which had treated her hard. Her father was bankrupted early so that she knew the travails of sudden hardship. So she began, after a short period of teaching, her long years as a researcher, becoming in the process a fixture in the North Library of the British Museum. Everyone knew her. She was a legend. Her permanent seat there was allowed to outlive their official abolition.

I met her around 1958 when I was a postgraduate student. She seemed exactly the same then. For years an 'affair', deeply mysterious, with an Italian writer dragged its weary way on. One always listened and never questioned. Was it an affair in the real sense? I doubt. He showered her with letters, nearly all abusive, for he must have been more than slightly mad, and every year there was a visit to him and his parents near Genoa. The lead-up to going, the dramas there, the recovery. Apart

from that it was up from Orpington and her bungalow to the Public Record Office and the British Museum, digging her way through the documents and books. Every entry into my office was always preceded with, 'Oh Roy, such treasures I have for you – such treasures!' And into the mound of transcripts and xeroxes we would plunge. A cultivated, widely read person, affectionate, loyal, brave, I shall more than miss her. I won't in the least be surprised if she haunts the North Library of the British Museum.

She was passionately devoted to the Renaissance (her only book was on the Massacre of St Bartholomew) and, as a result of her friendship with me, her estate endows an annual event at the V & A on that topic. She left me a few flower paintings and a charming chest of drawers with drawer knobs inlaid with mother of pearl. I think of her still.

31 August. To Jan van Dorsten. The repercussions of the Rayner Scrutiny.

It was a great loss for me when Sylvia England died of cancer in July at 76. I had no idea of her age but she knew her way around every document in the Public Record Office and was the mainstay of my research. I'm bereft without her and now have no one. I had known her for twenty-five years and really broke down and wept. Dickensian, yes, but a modest person trying to make the best of an existence with roots in long-vanished gentility. She was the sort of aunt that I always wish I had had, not that she would have liked to have been thought of as an aunt. But she was so loyal, so affectionate to me through so many troubles. Now the problem is to find a replacement but they don't exist. All one can say is that she died between books which I know is not a cruel joke but one that she would have appreciated.

The whole of the summer had been marred by the great V & A crisis when at last the Government report appeared. This has taken a terrible toll of me, although we are emerging triumphant. It contained recommendations for closing our branches, for shelving the Theatre Museum, endless cuts and cost effectiveness. After nine years I ask myself why is it that it is always the V & A and myself that have to bear these constant dreadful dramas. No one, but no one, in the museum world has ever gone through such tribulations as myself. The row raged on up and down every bit of the media for weeks and weeks, on through August wrecking what little break I had prayed for. On one day in July I just nearly broke down and wept on the office floor through sheer

nervous exhaustion. All I can say is that through infinite patience we have won and I have taken my colleagues with me as a team, but at a cost. The autumn will be full of battles as the unions muster to defy the removal of the V & A from Government, as the Bill is drawn up to go through Parliament (terrible problems over bequests, etc.), as we prepare financial estimates to deal with life on our own without built-in departmental help. And on top of that dry rot was found to run through six floors of the new wing [Henry Cole]. Everything has had to be torn down. Torrential rains flooded two major galleries, everything having to be removed at great speed, and now we are faced with closing the Library for six months because the roof is rotten.

It all sounds minus. But on the whole if it all works out it could be plus. There is more building work going on in the V & A than at any time since the 1950s. Even the floods meant that installations which were archaic had to be torn down, something which colleagues would normally have opposed tooth and nail, and which now they've gone they see how dated and threadbare they were. So my eighties will see the great scheme for changing the whole interior face of the Museum fall into place.

In the midst of all this I stupidly undertook to do the Miniatures exhibition. This I realise was a mistake and it is the straw breaking this particular camel's back...

I am so pleased that you kept all my letters. As you know, I have kept a very patchy diary – only since 1967 and the letters go back to 1959 and must be a mine of information. I have every intention later, much later, of writing more than one volume of memoirs, having seen quite a lot in my time and known nearly everyone who was anyone in the world of the Arts, theatre, fashion and *le monde*. I would dearly like, when you have a moment, a set of xeroxes to stick in a box and, of course, would pay for this to be done [his widow was to do this later]. Yes, you're right, times have changed. Time seems hardly to exist. The whole mood of the eighties is basically good if stability can be maintained. It is creative and forward-looking as the post-war vision fades and is seen not always to have worked. I have no regrets, only over some of the useless people it threw up in the 1960s who will be with us for ever. Our lives are mapped out months in advance. Every lunch is booked six to eight weeks ahead. The same applies to the evenings. The three days here are our lifeline, but they're working days. And when one was young one didn't have to think of six hundred staff or running a London flat, a house in the country with three-and-a-half acres of garden. If we see any of our real friends once a year privately

that is an achievement. Entertaining has vanished. Only one person has been here during the whole six weeks we have been down. It is so wonderful to be alone . . .

September. The summer.

A long gap during which a great deal has happened in the public sphere. The V & A campaign roared its way along with myself as an *éminence grise*. The *Standard* took up the campaign for the Theatre Museum which teemed its way through the media. Outrage too surrounded any idea of closing the branch at Bethnal Green. The result was that in the second week of August the Minister, Paul Channon, was able to announce their reprieve. I gathered later that the Theatre Museum was saved by Mrs Thatcher's own intervention in response to Paul's appeals to her. There were some tricky moments when the campaign veered dangerously the wrong way: personal attacks on Mr Burrett who had written the report above all. Alexander Glen was a tower of strength behind the scenes. Alexander Schouvaloff [Keeper of the Theatre Museum] and his 'scene' wife, Daria, had to be sat on as they pursued the wrong kind of publicity.

Looking at it as a whole one had learned a lot since the last public row and one had so many more contacts and influence, people who didn't even require levering into action. Within the V & A everyone pulled together and the business of taking them all through everything step by step paid off, although it tried my patience severely. The unions are still rampant, but I don't foresee them getting anywhere. OAL are, as a lot, rather confused and hopeless, failing to anticipate problems in the Bill which are obvious. On the whole it is less the Bill than the financial package to come out of it that worries me. The indications are that the 1983–4 estimates will be grim.

It was a tiring summer. But suddenly bits of the garden looked marvellous: the lion and the pinnacle [from my father-in-law's garden] were put up, the Rose Garden hedges I cut into buttresses at seven feet and I emptied and replanted the beds; the White Garden [Silver Jubilee] never trimmer or prettier, and I began to reclaim back other areas which had been devastated by the terrible winter.

August. The death of Marie Rambert.

The death of Marie Rambert has removed one of the great characters one has known. She was ninety-four and so determined to make her centenary that in her case death was less than welcome. She had however, never been right since her cataract operation earlier this year

We learned about the end from Astrid Zydower, who was closer to her than her daughter, but Astrid said that she was more like a mother to Marie Rambert. To her cremation went her son-in-law and Astrid, a decimated gathering of two. Later they returned and processed for the placing of the ashes in Ashley Dukes's[1] grave.

Marie Rambert was a woman of immense warmth, zest, energy and toughness. She also had a great sense of her own importance. When Astrid's head of her was presented to the National Portrait Gallery she sat by it holding court for the day. Whenever she made a public appearance out came the mink coat and, however old, she progressed through an assembly like a queen. Observation would indicate that there was no love lost between those ballet pioneers: Marie Rambert, Ninette de Valois and Fred Ashton. Marie Rambert was always a side-shoot, always not quite controllable, a little wayward. Like Sybil Thorndike she was, to the end, entranced and enthusiastic about the young and their contribution. She never gelled into a generation. She spanned them all and age was irrelevant. Her Lithuanian and Jewish origins, however, were. She always struck me as Eastern European, speaking with an accent and with a Slavic cast of face. It must have been a lonely existence in that murky house off Campden Hill, rooms of shadows with between-the-wars clutter and no sense of visual taste.

14 October. Marie Rambert's memorial service.
Marie Rambert's memorial service took place at St Paul's, Covent Garden, on a brilliant sunny day. It was packed, every seat and pew right to the back and the galleries with standing in the aisles. I could not help meditating on the fact that only Astrid and her son-in-law had seen her to the grave. It was one of those beautifully organised occasions when it is certain that something will go wrong. It did. No one had thought of the Piazza outside which had a hurdy-gurdy performing to great applause. Its raucous noise virtually drowned the speakers, of whom there were too many. Fred Ashton read a tribute, which was mostly about himself, badly, Gielgud read a sonnet, also rather badly, and redemption only came in the form of Alicia Markova,[2] who embraced the lectern and then us with a loving radiance and suddenly it was all joy as it should have been.

Ninette came last, very tottery in her eighty-second year, in her customary turban, helped to the lectern. I don't think that Mim and

[1] Husband of Marie Rambert.
[2] Dame Alicia Markova, *prima ballerina assoluta.*

Ninette can have got on but it was not a mean tribute, mostly about getting to know each other in old age, and there was one remarkable untold story. When both had been students at the Cechetti School but not really knowing each other, Diaghilev had cabled from Paris for a dancer. Ninette was asked to go. She was not happy about it, and left the school in a mental ferment. As she walked towards Leicester Square station she heard footsteps running after her. It was Mim Rambert, whom she barely knew. She rushed up and said, 'Oh, you will go, won't you? You *must* go.' This finally settled Ninette's mind, and we all know what followed.

December. The passage of the National Heritage Bill.

This had its second reading in the Lords. I went with a ticket from Edward Montagu.[1] Everything initially went smoothly until David Eccles's campaign to impose a British Library system (about which Paul Channon had warned me) erupted. It was prefaced by a disgraceful speech by Noël Annan, Chairman of the National Gallery and a Trustee of the British Museum, who proceeded to denounce the Trustee system with insinuating remarks as to the devious operations of museum directors and their staffs. This was followed by David Eccles, who took the cue to introduce the British Library system, hook, line and sinker. I left unnerved. However, in concert with Paul Channon, I wrote to thirty peers I knew asking them to speak or vote to prevent this amendment. David Eccles is rallying everyone he can for 14 December, the Committee stage. It is touch and go.

His amendments when they appeared were not as worrying as his speech, only one which states that Trustees shall co-opt two heads of department on to the Board. There are thirteen departments in the V & A. He cannot understand what the consequences would be. I talked to Paul again on the 7th and suggested that I write a personal letter to David Eccles. It went and it was very respectful. I hope that it might work. It would be fatal to push him into a corner. We need to make him retreat with honour.

26 December. To Jan van Dorsten. The last months of the year.

I cannot tell you how exhausting this autumn has been. One was just too near total collapse again by the time Julia drove me down [to The Laskett]. The finale was a week where you could have put a stopwatch by me as I went from one event to the next, at each one having to do

[1] Lord Montagu of Beaulieu, the first Chairman of English Heritage, 1984–92.

star turn, from hosting the Friends' party at Apsley with a speech, to a dinner for sponsors (another speech), a party for the *V & A Album* (another speech) [the *Album* was an innovation], my own Christmas party (no speech), filming a script at Chastleton on one of the [Shakespeare] sonnets (up at 5 a.m.), etc.

And that week, and before, the Bill to take the V & A out of Government in the Lords. Great danger that Lord Eccles's amendment to see that we had a British Library Board-type set-up would get carried. Never, but never, have the letters and phone calls showered out of my office to so many peers of the realm. I went down to the Lords and sat behind the Bar to see the amendment defeated and Eccles furious as loyal allies got up and made speech after speech to quell him. That was a test of connection and influence on a scale I had not attempted before, and all the more wonderful in that it was all done with nothing in the papers. And now I know that our finances for next year are good I heave a sigh of relief. Thank heaven that the Minister is an old personal friend and we got the largest increase of any institution, 12%. This will enable me to open the new wing (the Queen comes on 14 March to do this) and to recruit the administrative staff necessary for the great change which will be operable by October.

I have got the Chairman I wanted for the incoming Trustees, a great coup. Can't say who, but I'm very pleased and it will give great oomph and status to the new regime. With luck and the unions more co-operative I am hoping we may find a way to reopen the V & A on Fridays again by the end of the year. I suppose that one shouldn't blow one's own trumpet, but it does all seem to be fitting into place rather nicely considering the difficulties of the times ... There is a wonderful *camaraderie* in the place – that is what is so cheering – suddenly everyone realises what is being achieved and the excitement of it. I have waited a long time for this to happen, now it has.

As a symbol of staying to see it through I'm having my office done over in February in 1820s library manner. By the way I'm going to receive my first honorary degree from the University of Leeds in May. Lovely surprise that was ... As far as the exhibition [*Artists of the Tudor Court*] goes I've got all I want bar a few items from the Royal Collection. No scholar of the English Renaissance will ever see again such an array, nearly three hundred objects. Wonderful friends parting with things from their walls that they would never, but never, let go for anyone else, *Lucy Harington* and *Essex* from Woburn, the Hardwick Hall *Eliza*, the *Procession Picture* from Sherborne, etc. And the pick, but the pick, of the Buccleuch and Welbeck collections of miniatures.

No one, but no one, has ever seen those Welbeck miniatures since 1947. They are sensational. As you will see [Isaac] Oliver emerges as a great artist. The art historians won't like it [the exhibition], but who cares? Well, I've laid it to rest and I'm bored with it. I've opened the subject up and placed it into a broader historical perspective. Apart from proofs and a video film that's it.

It was sad to fell the beech avenue, fifteen feet high, after being killed by frost last year, but I've got twenty lime trees coming in March and I'm determined to have a great avenue of clipped limes on stilts as at Hidcote Manor. We've re-landscaped the front of the house, sweeping away the old path and herbaceous borders and paving a terrace along the front right under the windows but with small beds left for roses etc. to climb up. In front of that we've planted a yew hedge so that there is now a wonderful alley on arrival up to the fifteenth-century All Souls pinnacle.

This has been a year of deaths. Julia and I counted up fourteen in the last fifteen months, all people we know and most very well. I spend my life writing letters of condolence and in and out of services. This Christmas was just us, which was nice and quiet and lots of sleep which is what I need to build one up for 1983.

1983

State of the Art

With the return of the Conservative Government after the post-Falklands election triumph Thatcherism entered its heyday. This was the year that I was persuaded to join the Arts Council as Chairman of its Art Panel, and it was there that one saw the new impulses which were to end the post-war Welfare State cultural provision put into action. These were signalled less by the arrival of William Rees-Mogg as Chairman than by the appointment of Luke Rittner as Director-General. Luke had been the Director of ABSA[1] and his entry into 105 Piccadilly[2] epitomised a radical change of direction, one which no longer worked from a premiss of arts funding wholly by Government. Along with that came financial accountability and scrutiny as the principles of Rayner, already applied to the V & A, were now to be extended across the arts field and applied also to the major national performing companies.

In a year during which the Trustees came into office this was a heavy burden to bear but I felt that I owed it to Paul Channon, who had at last got the Museum out of the death-grip of the DES. Each meeting of the Council I recall demanded reading at least a hundred pages of single-spaced typescript, and many was the time on a Sunday evening that I was bowed over this as Julia kept telling me to get ready to go to London. What was always so extraordinary about the main Council was that only about three people on it were actually practising creative artists, the writer Marghanita Laski, Philip Jones of the Brass Ensemble and myself. When I looked up its composition in its early days, everyone of any importance creatively in the Arts had sat on it. Gradually the Arts Council became a monument to tokenism, political correctness, bureaucracy and, in the eighties, to accountants and businessmen.

Over the Art Panel I found no problem because the Director of Art was someone for whom I had the greatest respect, Joanna Drew. But it needed moving on. The problem there was how to get them to realise

[1] Association for Business Sponsorship of the Arts.
[2] Headquarters of the Arts Council.

that nothing was ever going to be the same again. What I made clear to Joanna from the start was that if it came to a battle on any major matter of principle I would fight for it but that I would not nit-pick. William Rees-Mogg I always felt had total confidence in my handling of the Department. He was hopelessly at sea in the visual arts, certainly anything remotely deemed contemporary or modern, but at least he had the modesty to recognise that. I knew that if it came to a major crunch he would listen to me, and so it proved.

By now I was on about a dozen external committees ranging from the British Council to that of the Royal College of Art, from Westminster Abbey to those connected with the Arts Council. I would always prefer to chair a meeting and consider my greatest achievement at the Arts Council was keeping the Art Panel meetings down to an hour-and-a-half. My predecessor had been David Sylvester and under him meetings began at 2 p.m. and tended to drift on to as late as 7 p.m. I swore that we would be over by 4.30 p.m. and we always were. In fact, I vividly remember my first Panel meeting when the Deputy Secretary-General arrived at 4 p.m. to find that I was nearing the end of the agenda. He couldn't believe it as he'd always timed his entrance to coincide with the conclusion of Matters Arising from the previous meeting.

Looking through my appointments diary I am appalled at all I never wrote about, but that applies throughout. On the whole what was written gives a fair picture of the general drift of one's life during a year which saw a marked upturn in one's fortunes. At last the Henry Cole Wing opened and, by the end of the year, the Trustees had come into office. It was a great stroke of luck to land Peter Carrington as the first Chairman. His benign presence eased what could have been a difficult passage, although like everyone who doesn't work in the arts world he never took in the warnings I gave him from the outset as to just how unpleasant it could be. But he was to learn that all too soon.

14 April. The opening months of the year: the Heritage Bill, the Cole Buildings opens, and the Arts Council.

I went down to the Lords on the great day of the passing of the Heritage Bill and sat behind the Bar. Eccles did not even take it to the vote, so well had one rallied the peers. The relevant Hansards contain all the speeches, the most notable one, on the nature of trusteeship, being made by Jeremy Hutchinson. It was a great test of rallying the forces and of anti-Eccles sentiment. But he did not give up easily and he, Pat Gibson, Noël Annan and David Perth went in delegation to Channon

petitioning him to alter the Bill. But I heard that they were confused as to what they actually wanted.

It is now in the Commons and I have done my homework on Phillip Whitehead,[1] et al. At this moment it is past the Committee stage, so it is all over bar the shouting. Meanwhile the rest of the Minister's pronouncements on the Rayner Report came out, deliberately released on Maundy Thursday so that no one would take any notice. They didn't. It's a feeble document pushing everything on to the incoming Trustees. As one expected, after the public row and the 'rescues' of last year, OAL don't want to know. Within the V & A the progress has been swift and in the right direction, with open collegiate discussion resulting in an agreed future management structure with a Deputy Director.

Then there was the opening of the Henry Cole Wing by the Queen. All of the V & A was there and all the wives were asked, which made it a joyous, wonderful occasion and great for morale. The wing has been well received with only attacks in the *Guardian* and the *Spectator*. On the whole, yes, it works but it's like the rest of the Museum, rambling, illogical and banked high with stuff. There's a lack of finish and the doors and some of the furniture are really awful, but at least it's done. Now within the main body of the Museum all Leigh Ashton's partitioning is beginning to be ripped out with great vistas and galleries revealed again as architecture, which is extremely exciting.

The week before Christmas I was rung by Paul Channon in the country several times. He was fuming about the Arts Council. Luke Rittner had been appointed by open competition and interview, the latter conducted by the heads of department as well as by William Rees-Mogg. The Council was in revolt over the appointment with a huge newspaper campaign, mostly via Roy Shaw[2] and especially in the *Guardian*, attacking Luke and his two O-levels. I was implored to go on the Council and be Chairman of the Art Department to help restore the balance. Paul Channon has done so much to help me that I said yes. This is a very tough assignment. It is a sea of bureaucracy, paper and committees. I had a very rough beginning. On the day of my first Panel meeting William Rees-Mogg summoned me to his office beforehand. He told me that I ought to know that negotiations were in progress to hand the Hayward Gallery over to the British Film Institute

[1] Television producer, Labour MP for Derby North, 1970–83; front-bench spokesman for the arts, 1982–3.

[2] Outgoing Secretary-General of the Arts Council. Knighted 1979.

in 1985. I was paralysed. How could I have been allowed to take on this job without being told that? It really was disgraceful. I said to William that I could not chair the Panel knowing that, and that Joanna Drew must be told. She was sent for and he had the decency to tell her. Later it firmed up to being March 1985 and so I sat and wrote to the Minister, with a copy to William, stating that I had been appointed on false pretences and that I did not think the Hayward closure was right, that it would be an enormous blow internationally and lead to outrage by contemporary artists. In due course I was summoned to the Minister's office. He and William were incarcerated together. I was called in and they caved in. I saved the Hayward, although few know this.

Afterwards I was angry. Angry that the Art Department and its policies had been so blinkered and unsuccessful that this move could even have been considered. It will need two terms of office to really change that Department. I like them, I love Joanna, but they are stuck back in the later sixties. Every single thing in fact is stuck. No decisions, no decisions about anything. Everything is always reported on and then there is another committee and yet another report to be written. The Department was devoid of identity and low in morale. They were doing too much and often badly.

18 April. The Mitchell Prize in Art History.

I arrived early at the Royal Academy and stood at the bottom of the stairs and was suddenly beckoned up by John Vaizey and so found myself in the pre-platform party. The prize was won by Hugh Honour and John Fleming for their book *A World History of Art*. Princess Michael was the guest of honour dressed as usual a bit over the top with a black choker ribbon round her throat and a dress whose upper part was later shed to reveal a strapless top. The prize is given by James Mitchell, a pale middle-aged American with a blond wig in late-sixties style. I was told that he had three of these. The ceremony was presided over by Marina Vaizey in a muddled, motherly way. Michael Jaffé, whom she stood in for, was absent due to gout and we were told how much wit we had missed. As far as I was concerned he never had much so we missed nothing. On the previous occasion in 1981 he spoke for twenty minutes eulogising John Pope-Hennessy, for some reason totally lost on the audience. Pope-Hennessy is one of the judges and so once more his ghost rode. Every speaker went on at length how it was no coincidence that it was his student who got the junior prize! Nor, might

[1] Rubens Scholar and Director of the Fitzwilliam Museum, Cambridge, 1973–90.

one add, was it coincidence that *A World History of Art* was promoted with a quote from him! We were told that next year there would be a prize for an art journalist or critic.

Afterwards we all moved out to the party and I was summoned to sit next to Harold Macmillan. At ninety he's pretty sharp but I'm always at my wits' end working up subjects to keep the monologue going. The last time we saw him was at Nico Henderson's[1] dinner for Betsy Whitney when Nico asked him to say a few words. Fatal. Macmillan has become like Dracula. He comes out at night to plague us, to take over any occasion and upstage everybody.

8 May. To Jan van Dorsten. Events of the early months.

Here we have been in a sea of water, rain, rain, and more rain. Everything is sodden. There has been only one weekend when the sun shone and then it was gorgeous. It has been, however, the most wonderful spring for flowers, the great avenue was thick with daffodils for over a month and we await the newly planted lime trees, twenty of them, to leaf for the first time. Pray to heaven that they last as that's the third planting so far. Banks covered with hyacinths and primroses, etc. And the Rembrandt tulips, which I'm crazy about, are beginning to come into bloom in the Rose Garden.

I think that I told you all the Arts Council dramas when we met. It is still a very great burden as one senses that the whole institution is in an ideological crisis. A *lot* of time goes on it, a day a week I reckon, committees, panels, consultations, lunches to give at the V & A to people, visits to the regions, *et al*. It could possibly be very creative and I've gone in with a no-holds-barred approach as I have nothing to lose. But the politics of it all and the petty internecine jealousies are terrible. And all that GLC left-wing stuff one has to cope with as I now run the Hayward Gallery.

However, the Queen's opening of the Cole Wing went off spectacularly well. She was in wonderful form. Everything went like clockwork – it was a great evening – happy, relaxed, a great family party for everyone in the V & A. From my point of view it has finally consolidated one's position and vindicated one's policies, which were always from the start long term. Now everyone sees everything fall into place and is exhilarated. Of course there are tracks of the Museum under scaffolding and there are teething problems in the new wing – the lifts

[1] Nicholas (Nico) Henderson, successively British Ambassador to Bonn, Paris and Washington, 1972–82; Trustee of the National Gallery, 1985–9. KCMG, 1972.

don't work – but that's minor compared with the overall strategy, which is moving forward with the support of the whole Museum. On 8 June the Dress Collection reopens after five years. I pray that it's a success. I believe it will be a rave. In early July comes the miniatures [the exhibition *Artists of the Tudor Court: The Portrait Miniature Rediscovered 1520–1620*]. I'm sure I'll be shot down but that's the price of fame...

The V & A Bill has gone through the Commons and is now back for a final wind-up in the Lords. Lord Carrington should be announced as Chairman any minute now, but we dread Mrs Thatcher going to the country which will possibly hold things up, just to plague us all, at the last minute. I hope that the Trustee set-up works through and internally we seem to be evolving very nicely with no dramas – just evolution. I am worried that they [the Trustees] will ask for too much and there is no staff or resources to meet such demands. Peter Carrington I like enormously and I'm thrilled to get him. He's a star, albeit a frustrated one, as being a lord has deprived him of ever becoming Prime Minister which he should have been. We shall see...

The rock of my existence is quiet in the country and the weekly exercise class I've gone to since I was thirty-one, but now Charlotte Gaffran who runs it is over eighty and how long will she last? She suggested that I took up running which I have and find it rather fascinating. Not much good at it yet but after my morning exercises I now run to the next village at about eight in the morning, pause to look at the fourteenth-century church in ruins, and then back. I can see that it will take me months to get to what is regarded as basic, that is to run non-stop for three miles at a time at least three days a week. Never thought I'd be doing this at forty-seven, but as I get older I'm a great believer in preventive medicine and anyway it's tremendously enjoyable because you can actually measure progress.

Life follows its usual pattern. I have a piece to do on what's wrong with modern garden design for the *Sunday Times*. *Vogue* came to draw and photograph me at length as the first of their series 'Men of Style'. That'll make a few enemies. I've had my office at the V & A redone in the grand manner which I love. In two weeks I'm off taking the Friends of the V & A around Renaissance gardens and must do my homework. No lunch vacant before 23 June which indicates the pressure.

Julia is a bit fed up but about to start on Glyndebourne and *Arabella*. This is my last year on the *Evening Standard* Drama Panel which is rather a relief. It has been a bit taxing trying to fit it all in. Because the Duchess of Kent has been ill my honorary degree at Leeds has been

delayed until July and now I've been made (another ceremony also in July) a Senior Fellow of the Royal College of Art. There's a huge profile of me due to appear in the *Observer*. God knows what it will be like, but it's quite a compliment as no museum director has ever entered into that series which usually covers major politicians, etc. Usually I avoid these things but the Press Office pressured.

16 May. The Arts Council savages Covent Garden.

An interesting meeting of the Finance and General Purposes Committee at the Arts Council. William Rees-Mogg has established the principle that representatives of the main national arts organisations should come before this Committee. Peter Hall and acolytes appeared with beating angels' wings and left with further haloes. The delegation from Covent Garden met with a very different reception. It was headed by Claus Moser[1] flanked by John Tooley and Denis Forman[2] and an administrative attendant. The paper that they had forwarded was very poor, badly written, and minus any sense of direction or reality. An indication of how unpopular they were can be measured by the fact that they were savaged for one-and-a-half hours on their lack of new productions, wrong priorities, audience profile, feeble efforts at education and touring record. Claus looked defeated from the outset. He was never in control of the debate, virtually at one point asking the Council to formulate a policy for him. In the aftermath of the disastrous *Manon* production one felt their unease. The star soprano Kiri te Kanawa, it seemed, didn't know her part, the chorus master was said to have been fired the next day, and the mediocre sets from Hamburg were shipped in at the last moment. There was not really a voice raised in their defence, apart from the fact that we all recognised the need for a prestigious opera house and appreciated the success of the Ballet.

After they left we were asked what we thought. I was beckoned to lead off and said that the rot was at the top and reflected the composition of the Board which was by no means a consumer's microcosm and that it, together with the management, lacked any sense of direction. Earlier I had drawn attention to the appallingly low morale in Covent Garden which was rotting the *esprit* of the workforce. The delegation struck one as rather helpless, arrogant and obsessed with money. Everything was put down to lack of it, not to lack of ideas. Marghanita Laski

[1] Claus Moser, economist, Chairman of the Royal Opera House, 1970–80. KCB, 1973.
[2] Denis Forman, with Granada Television from 1974 (deputy chairman, 1984–90); director of the Royal Opera House; knighted 1976.

perceptively summed up their attitude, citing the Covent Garden Proms when the seats are removed as it were for the 'poorer classes'. Why shouldn't they too sit to see grand opera? It will be interesting to see the upshot as a Rayner Scrutiny is busy at Covent Garden. I guess that it might well state that the Opera House is under-funded but I pray to heaven that it states that it is mismanaged and lacks direction.

That evening we went to Sadler's Wells Royal Ballet's *Swan Lake*, a much vaunted new production. It was a disappointment. Odette–Odile was danced by Galina Samsova, who did not even attempt the thirty-two *fouettes* which are *de rigueur* for any ballerina in Act II. With David Ashmole they formed a lacklustre couple with a lot of poor supporting dancing and an indifferent orchestra. The hacking about of Act II produced bizarre incongruities such as the Spanish dancers being part of von Rothbart's train.

20 June. William Rees-Mogg and Oliver Messel.

William Rees-Mogg came to lunch. I had asked him because I wanted to know what exactly he wanted to do with the Arts Council. He's a shy, very sweet man, a mixture of boyish glances hither and thither and then dignified weighty pronouncements. As one suspected, it is Tory radicalism in the Arts. 'In other words,' I said to him, 'we're out to convert all those people who are now buying their council houses.' 'Yes, that's it, an extension of the Arts in a providing sense and yet expecting them to contribute.' It is an intriguing challenge, a *renversement* in one sense of post-1945, the Tories now aiming to consolidate their view of society by drawing into the Arts the new skilled manual–meritocratic classes. Of course, it means a shift from the endless support of the *avant garde* which has bedevilled the Arts Council.

We ranged over many topics. I voiced my worry over Luke Rittner: 'They'll make mincemeat of him' ... but he's good and straight and very well meaning and extremely astute on money and no nonsense. Covent Garden inevitably surfaced after their débâcle before the Finance and General Purposes Committee. And then the problem of the profile [of the Arts Council]. This I have gone on and on about. The Council gets the brickbats and none of the bouquets. It has no sense of public relations or of getting any acknowledgement for what it has achieved. From my initial proposal we went on to formulate a plan for an annual BBC salute to achievement in the Arts and a prestigious evening launch.

The whole day had been blighted by the run-up to the Oliver Messel

exhibition. Tony Snowdon on the phone: had I seen the *Daily Mail*? No. I saw it later and it said that Tony was miffed that Princess Margaret was opening the show. Not true. No, I insisted, the speech had to be in the tent room. Then a letter by hand from Anne Rosse. She had wept all over the catalogue yesterday. Would she come? Wouldn't she come? Princess Margaret mercifully laid down the law: 'You must go to the Messel opening.'

The heat was stifling with no air-conditioning, leaving the ageing actresses and aristocrats melting, Dorothy Dickson, Elizabeth Welch, Anna Neagle and Ninette de Valois among them. The HRH gang were there in force – Carl Toms, Derek Hart, Milton Gendel, Jane Stevens, etc. Diana Cooper turned up on Patrick Procktor's arm complaining that I now cut her (not true!). There was a vast battery of photographers to get the photo they all longed for. Tony, having said that he'd just mingle with the crowd, did precisely what I thought he would. Immediately on HRH's entry he embraced her. Blaze of flashlights. In fact he's fascinated by her. Anne Rosse in trailing black taffeta acted as Queen Mother manqué.

11 July. The Theatre Museum cancelled again.
The aftermath of a really hectic fortnight. The Queen Mother came to inaugurate *Artists of the Tudor Court*, wonderful as always, so touching as she embraced Diana Cooper on entering the exhibition. I was able to present Joan Henderson, who started everything for me [my grammar school history teacher], to her at her request. But what was infuriating was to be rung up one hour before the opening and told that the Theatre Museum was cancelled yet again. There was no consultation by Grey Gowrie [Lord Gowrie, the Arts Minister in the aftermath of the election] with myself, Glen or Carrington. After ten years this is the end of the road. The decision evoked mass outrage, particularly in view of the fact that it had been saved last year via 10 Downing Street. I spent the whole weekend on the telephone. The trouble is we were an easy target in the post-Heritage Act but pre-Trustee period. Once more the Theatre Museum goes into the *Standard* as a campaign, once more letters stream to the newspapers, once more questions in the Lords and Commons. I can't go on with another ten years of this. It is either on or off. If off, we should stop collecting and hand back collections to their donors. It is the arrogance of Gowrie which astonishes me. The decision was the Minister's and he was warned about the row which would ensue.

12 July. Grey Gowrie.

Grey Gowrie came to lunch. Here was a pretty pickle of an event!
He is a curious saturnine fellow with a dark complexion as though
descended from Spaniards wrecked in the Armada. With a sudden lurch
we ranged hither and thither in a somewhat riveting way. He was
clearly on a hot line to the PM. Every other word was 'Margaret'. He
had not been pleased to be blasted by Peter Carrington on the telephone.
'You must re-educate him. He's not *au courant* with current Tory
thinking. She still rings him up over foreign affairs. She doesn't like
Pym and is unsure of Geoffrey Howe.' [Both were members of the
Cabinet.]

I made it clear that as far as I was concerned the Theatre Museum
had reached its final act and unless it definitely proceeded the curtain
would descend. He said that he would state in the Lords that evening
that if funds were available in 1984–5 it would proceed. And he threw
his hands around indicating the horrors which Nigel Lawson had dis-
covered after Geoffrey Howe and, to a degree, the ones he had found
post-Channon. Intimate secrets then began to be divulged which all
indicated dramatic and nasty times ahead. I didn't want to know, I'd
much rather not, but my bet would be that we would be winding up
the Theatre Museum in 84–5.

I said that of course Paul Channon had tackled none of the broader
issues. Everything was dealt with pragmatically. Every so often he
pulled out a notebook and scribbled down something I said. Notably,
this was never to record facts but only ideas and general observations.
The central dilemma is cash and how to make those who have it,
especially the 'new' classes, pay for Art and not to regard it any more
as part of the State handout. There was a torrent of questions which I
couldn't cope with. What should be done with the British Film Institute
swallowing £10 million for subsidising bad non-commercial films?
Should he remove the national companies' funding from the Arts
Council? How could the Arts Council be reformed? This all led up to
his stating that whatever our public stance, even a blazing row, this
would not affect private communication or advice to him on all topics
if he needed it.

13 July. Rudolf Nureyev.

We took Nureyev out to dinner. He had danced in Julia's *Swan Lake*
many times and was always sweet and appreciative to her. Julia thought
that he might be the man who would do her *Bal des Ardents* project
and oh, how she would love to do *Nutcracker* with him. It is always a

bit unnerving meeting a legend and he had, on account of an injury, been unable to dance *Spectre* the previous night. The company he was appearing with was one from Nancy and really of a second-rate awfulness, pounding their way through a programme called *Homage to Diaghilev* that would have made him turn in his grave. The great days are gone, but all the old fire and magic are still there, a unique spent quality aligned to an energy which could erupt into wild eroticism in *L'après-midi d'un faune* or exude the character of a passionate idiot in *Petrouchka*.

We owed this encounter to Nigel Gosling's widow, Maude, a tragic and sweet lady. The Goslings had looked after him for years, and now she is almost a mother. We managed to fend off any 'train', but he brought with him a highly intelligent young man called Robert Tracy who had just finished a book on Diaghilev's female dancers. Nureyev is not easy to describe but what was above all unexpected (it shouldn't have been) was his enormous natural intelligence. Of course, he knew the *Bal des Ardents*, he knew the illumination of the wildmen ablaze at the ball, he was excited but quickfire on the subject, thirty-five minutes he said, must use or adapt original medieval music, it would cost money – a spectacle – yes, but it was domestic in one way ... No good for the Paris Opera but an idea for the Opéra-Comique.

Glasses full of ice were perpetually brought for him, and this he placed into his wine. He had a passion for potatoes. More were sent for. Each one he picked up and peeled and relished. He looked old, but with a marvellous bone structure, his eyes sunk deep, his wispy hair, now thinning, brushed hither and thither in a gesture towards punk. The energy is enormous. Here is a night person who gets more excited and more alive as the clock moves past 1 a.m. Maude Gosling says that he will keep her awake till 3 a.m. Then he would read voraciously. At the moment he was reading Dostoyevsky in English because Nigel had told him to. Recently Maude had been taken aback when he passed on to her Bertrand Russell's *History of Western Philosophy*. The appetite knows no bounds. This is a remarkable man of an era, tremendously affectionate, almost childlike, then suddenly wild and incipiently violent, a spitfire intellect of darting response, tremendously spoilt and yet to those whom he loves, one senses, infinitely giving.

14 July. The Trustees are chosen.

Peter Carrington and I went to see Grey Gowrie about Trustees. Grey is in the Lord President of the Council's office in the old Admiralty

building, a Maples[1] kind of room with Churchill's map of the world in a shrine behind the desk. No problem over the Trustees. We ran down the list, all of us making the most outrageous comments, but we're home and dry with Peter Carrington, Jean Muir, Robin Holland-Martin, Terence Conran, Andrew Knight (slight flutter here because of his frostiness to Mrs Thatcher in the *Economist*), Marcus Binney, David Mellor, Christopher Frayling, Joel Barnett (much discussion here: 'He has no power in the Party,' Grey said, 'but the Labour Party's in ruins anyway'). We discuss Denis Healey, but not after what he says about Mrs Thatcher on the front bench, HRH Michael ('All the royals hate her'), and John Hale. Ian Hay-Davison is hit on, with the Theatre Museum in mind.

Grey had retreated even further over the Theatre Museum. Peter Carrington opened the subject by saying what I wanted him to say, that if the Theatre Museum proceeded and there were further cuts it would be the first to be shut. Grey had got the message and made it clear he would announce that it would actually proceed by next January at the latest. He seems to have learned a lesson, which he ought to have done, because it was rather short-sighted to have alienated so many potential allies.

16–17 July. The Laskett garden burgeons.

This has been the hottest of summers and I scorch myself brown catching every ray of sun. The rain which preceded it has resulted in bloom as never before, roses above all in abundance, the branches so heavy with flowers that they bend to the earth. In the garden the picture composes after a decade, and the main worry really is the mileage of hedge-trimming and pruning needed to sustain the effect. I go to the far side of the 'field' and cut the yew into a box and wire the leaders to form peacocks. The arbour and seat opposite are then clipped and cut back. They stand now virtually complete, but somehow my mind was full of how to tidy it up, how to cope with one's mistakes of over-planting and how to give it all a bit more finish. Alas, so much depends on cash and labour and we have neither.

Julia, after a bad patch with projects collapsing, is busy on Strauss's *Arabella* for Glyndebourne. I am redoing *Splendour at Court*, a big rewrite, as *Art and Power*. One feels very much in the aftermath of something, and I've not let the index cards on miniatures slip out of

[1] Maples had been a vast and popular furniture store in Tottenham Court Road which became a byword for a certain kind of taste.

my mind yet. All the reviews so far are very good but inevitably there's a feeling of anticlimax.

25 July. The Theatre Museum rescued.

The campaign in the newspapers for the Theatre Museum has not let up, the *Standard* understandably miffed that their successful one last year had been brushed aside. Norman St John-Stevas is uncontrollable as 'the Champion of the Theatre Museum', doing more harm than good in the newspapers and in the House. It can hardly give Grey Gowrie pleasure to have Norman come in delegation. However, Grey is clearly winded and he rang me about 6 p.m. to tell me where we had got. No, he couldn't go back on the £900,000 cut he had to make this year in building. Yes, he was committed to the Theatre Museum short of cataclysmic cuts from the Treasury. Now we had to manoeuvre forward. The GLC, under its present very Left aegis, had savaged his flank by saying that they would hold the lease on the same terms if £250,000 of Government money were spent in building by 1 April 1984. Real *Catch 22* stuff. But what did they mean by Government money? And here came the surprise. Grey had the £250,000, but he had got it as a private donation. I was stunned. Now it hung on whether the GLC would accept this in place of Government money. A voluminous cloak of secrecy was bidden to descend, and I await in wonder.

Late July. My first honorary degree.

Last Thursday (21st) I went to Leeds to have my first honorary degree conferred upon me. It was a very happy occasion. There were four of us: George Thomas, now Lord Tonypandy,[1] Imogen Holst,[2] Robert Rowe[3] and myself. We paraded in scarlet gowns trimmed with green, and wore Tudor bonnets. Each of us was presented and stood while a eulogy was read. Like everything in a regional university it was all a bit disorganised but very kindly meant. Keele have just decided to confer one on me too. I wonder if I will end up like Henry Moore with twenty?

[1] Labour MP for Cardiff West, 1950–83. Speaker of the House of Commons, 1976–83. Created Viscount, 1983.

[2] Scholar, musicologist and champion of her father, Gustav Holst.

[3] Director of Leeds City Art Gallery, 1958–83.

August, undated. To Jan van Dorsten. The summer.

We are now down here for August. July was very hectic with work pressure. The Miniatures exhibition opened and it all went very successfully. It looks absolutely beautiful, very restrained and chaste, the things sparingly displayed. All the reviews good so far, although I guess there will be a few stabs in the back by the end of it. Actually it is quite difficult to fault with all that historical and scientific research behind it. Dear A. L. Rowse was so touched to have my book [*The English Renaissance Miniature*] dedicated to him and gave it a rave in the *Standard* and there was another rave in *The Times*. At £18 a throw heaven alone knows who will buy it, but it is very well printed (Japan, needless to say). Nice shop-window displays of it and I went into Blackwells in Oxford and signed what copies they had left. The Queen Mother was absolutely sweet at the opening and adored it all. Very, very happy. The TV on it was perfectly OK considering the rush it was done in, although as the programme director normally does drama there is a fair amount of RS traipsing through rose bowers and actors in four-poster beds clutching miniatures to their bosoms. Heigh ho! Then there was a seemingly endless series of viewings [of the exhibition], including a huge black-tie dinner for the lenders with about eight butlers.

At the same time we are moving swiftly into Trusteeship. The new Minister for the Arts, Lord Gowrie, is an old friend from the swinging sixties when he wore his hair Afro and wrote poetry. That is a stroke of luck, plus the fact that I like him. From the point of view of the Museum it has been fortunate that I've been *persona grata* with the present regime. It has streamlined through a lot. Peter Carrington, the incoming Chairman, is, I need hardly say, a sharp cookie and very funny. So far all is well and hopefully the new Trustees will be announced soon. There will be a formal handover in October. There was one nasty fracas and that was over cuts to the arts budget midstream which led Grey Gowrie to chopping the Theatre Museum yet again – terrible row – a lot of intrigue is still going on. I think that with a little careful handling this might turn out to have been a stroke of luck. We shall see...

As a result of my article on the Chelsea Flower Show I was offered a weekly column in *The Times* on the leader page. After consulting I agreed to do a fortnightly one, at least have a stab – I can write on anything I like – rather extraordinary really. The huge *Observer* profile of me turned out to be very complimentary and the *Vogue* spread very funny with RS's listing off those who have style, with my favourite comment on Edna O'Brien: 'She's the nearest thing to one of Charles

II's mistresses still around.' Edna now asks me to find her her Charles II! The days here are peaceful with beautiful weather. Much hedge-clipping – early-morning run, breakfast, work, lunch, garden, cook, eat, sleep – what more can one want?

5 September. To Jan van Dorsten. Farewell to summer.

I really enjoyed the summer down here. Bar a very little, I've finished the rewrite of *Splendour*. Now it needs pulling together and tidying up. I've also enjoyed writing the fortnightly column for *The Times*, although it does unfortunately produce a mass of correspondence, so we're having to get a card printed saying 'Sir Roy regrets, etc.'

We had two visits to Stratford, much anticipated and both AWFUL: *Henry VIII* with Kurt Weill music and the tango at court; *The Comedy of Errors* – well – errors there were in plenty. Quite the worst season ever. There was modest socialising, in the main it seemed feeding Tory MPs and ministers. Never, but never, has the garden looked more glorious. Everyone who came was staggered by it and it really is rather extraordinary.

The V & A plugged on with endless dramas about the Theatre Museum, about which I could write a book but have never bored you with. This came to a most fortunate conclusion with an anonymous donor producing a quarter-of-a-million to start building it. So in our deepest recessionary hour RS has been seen to open a huge new wing and start a new branch museum. When I get back we're straight into the new Trustee set-up. Carrington is marvellous and so funny and indiscreet. Wonderful and, more to the point, he's gone down with the staff and one's colleagues. We expect a tough financial deal for '83–4, rumours of a 13% cut. God knows what will happen, but when it comes to cuts we are agreed, be dramatic and don't dodge it. The new Trustees are to be announced. Of course there'll be problems, but I'm too entrenched. It will be important to set up a framework that one's successor can work in.

I always dread the autumn. There is usually something ghastly. I am blessed by having one more member of my office staff and hopefully he will make a great difference. He is used to assisting Ministers. My career this year has gone through one of those sudden leaps and someone, but someone, must be there to draft, mark up what has to be read, *et al.* The pressures are enormous and there will be major battles to be fought, not the least the one to protect the visual arts from the performing arts lobby. It is awful to think of next week but never mind. I know in the next few months I have to go to an Arts Council

conference at Ilkley of all places, Bradford to open an Indian exhibition, and Malvern, and a speech in Oxford on historic houses. Somehow I'll get through it. At least one can make hay while the sun shines, or rather dimly glimmers.

It really is strange. The week after my birthday [23 August] always sees autumn come. I'm typing this to you looking out at strong winds bowing the trees with odd branches ripped off. This evening is our last 'summer's evening' *à deux* across the candlelight, with the Proms in the background and our darling cats, Muff and Torte, arranged looking on like tea cosies. No more magic till next year...

13 September. Back at the grind.
I have been back in the V & A a week. The atmosphere is full of economic gloom. Although we have been asked to compile estimates with a 5% increase, rumours have it that cuts are what the Treasury is investigating. A 5% increase anyway means in effect a cut. At the Arts Council I told Joanna Drew that if we had to cut she must be specific from the outset. Either name nothing or name the amputation but don't offer alternatives as it always causes unease and a bad atmosphere. The Theatre Museum is signed but I am still tremulous as we now learn £1 million is needed for the V & A's drains, which are in a state of total ruin.

28 September. Arts Funding and the Metropolitan Authorities.
Today the Trustees were announced from 10 Downing Street. They seem a punchy lot with a range of business interests built in. With Peter Carrington they come to thirteen in all, six from the former Advisory Council and six new ones. Out of the list only Joel Barnett and Ian Hay-Davison are unknown quantities to me.

Somehow the dramas now centre around the Arts Council, to which Grey Gowrie came today to lunch, and to sit in during part of a meeting. Saturnine and somewhat farouche, there was no good news here, just a reinforcement of the statement that there would be a low percentage increase. There was much talk around the table of the impossibility of dealing with the Arts on an annual basis. No leeway here, but it was a fair point to make. No one essayed the dramas ahead, the Priestley Report on two of the national companies and the abolition of the Metropolitan Authorities. The Priestley Report we know states that both Covent Garden and the Royal Shakespeare Company are under-funded, but money for them will only be got at the expense of other arts activities like the museums. It could lead to direct funding which

would pull the carpet out from under the Arts Council. There is a lot to be said for doing that and for establishing proper Boards of Trustees to run them, not the present hangers-on and time-servers they have now. The Metropolitan Authorities produce £24 million towards the Arts. How will a system be set up to guarantee this? Developments in Scotland already indicate that the local authorities won't step in. It demolishes overnight the Arts Council's 50/50 policy to encourage funding in the regions. It will be interesting to see whether the Arts Council survives this and, if so, in what form.

5 October. The Arts Council and direct funding.

Yesterday I came back from Manchester and was stunned to read in the *Telegraph* of William Rees-Mogg's denunciation of direct funding of the national companies as 'nationalisation'. What right did he have to pronounce on this? Later in the day I learned that at last week's meeting, after I had left, under Any Other Business someone said what happens if the article in the *Guardian* was right and the Priestley Report recommended direct funding? After a short discussion it was agreed that the Chairman should pronounce against it. I am the only person on that Council who has actually experienced direct funding. It is specious to argue, as *The Times* did yesterday in a muddled editorial, that the parallel with the museums was not valid. It is. Things like museum charges or the return of the Elgin Marbles are just as political as anything at Covent Garden or the National Theatre. And it's no use arguing that museums are free: we charge for virtually all our branches and for special exhibitions paid for by the taxpayer. I was really furious and tore off a letter to Rees-Mogg with copies to Rittner and Gowrie saying that I would resign on this unless new arguments were brought to bear in favour. The Council ought to shed those great performing institutions. No, the Arts Council can't bear to lose its unimaginative bureaucratic grip or the departments their power and free seats.

11 October. Back into the fold.

Last Wednesday I had lunch with Luke Rittner. 'Oh, William admires you so much,' he said. William's letter to me, brought by hand earlier, was a flow of 'You are one of the giants of the museum world ...' and so on. On Thursday I went to see Grey Gowrie and again it was 'You won't resign, will you?' So it looks as though I've been fixed. It is clear that William realises that he went too far and pre-empted a decision for what can only be a topic for a major discussion.

Lunch with Luke centred on how to streamline the Arts Council,

how to reduce the size of committees. This could only be done by developing the smaller Finance and Policy Committee and letting the main Council become a kind of ritual. It would take time. When Gowrie came, fifty-six people sat round the table.

Which brings me to my meeting with Gowrie last Thursday. From what he said he struck me as having arrived full of reforming zeal and already gone full circle, discovering just how parlous life in the Arts actually was. No, there was no more money. There might be a bit squeezed to meet one or two one-off horrors. He seemed too to have made up his mind against the direct funding of the four national companies, although Covent Garden and the RSC were initially to get more cash (at whose expense, I wondered). He was obviously weary of being lectured by William Rees-Mogg on economics, which struck me as an odd way to pass the time with the Chairman of the Arts Council. The £1 million needed for the V & A drains wasn't there but tactically if I came back in January it could be.

Week of 9 October. The Trustees take over and the Rectorship of the Royal College of Art.

This is the week that the Trustees take over the V & A. I hope that it will be a success. Peter Carrington seems to read nothing at all and the place is so complex that I wonder how long he can get by with the usual *bonhomie* and drollery and on-the-spot response. We shall see. The composition of the Board has been very well received.

So far I have not even recorded my presence on the committee to search for a new Rector for the Royal College of Art. This is chaired by Peter Byrom and there are only seven of us. I suppose for that intractable institution it has gone well, and silence so far has prevailed, but we were thrown by at last getting a list of nominees and finding that Byrom was among them! It now looks as though I shall have to chair this and Byrom will go. Like everything to do with the RCA it is really labyrinthine. The main push comes from John Hedgecoe, who wants Jocelyn Stevens.[1] One cannot honestly say that so far we have a spectacular list and who would want it anyway? It has sunk so low and there are so many problems. Byrom I don't think would be right, pleasant but vacillating. The meetings with him in the chair drag on and on with little structure.

[1] Wealthy journalist, noted for his innovative editorship of *Queen* magazine.

12 October. The Trustees begin in chaos.

This day should not pass without note, for the Advisory Council retired
and the Trustees came into power. All was happiness at the last meeting
of the Council and the luncheon was an enormous success. It looked
good with candles and silver and a placement and short speeches and
a presentation to Sandy Glen. How I shall miss him. What good fortune
that we were the team at the right time with the right people in the
Minister's office to get it all through. I was delighted that he was so
genuinely happy.

The Trustees' first meeting was very different, rather a shambles.
Carrington didn't stick to the agenda, never once referred to me, and
careered his way at juggernaut speed through everything. Nothing
mercifully too disastrous happened, but I must give thought as to how
to stage-manage these so that he does actually take in and act on what
he should. We retreated to my office to pick up the debris, and I was so
thrown and exhausted by it all that I sent for tea and chocolate cake to
aid recovery. On going through it we seemed in a reasonable state, but
the crucial actions over the abolition of the Metropolitan Authorities
he never even dealt with. This is interesting. The V & A has been
offered Kenwood and the Geffrye Museum. It was John Last of Liverpool
who had had a hand in working this out. I understand that Government,
including Mrs Thatcher, was just going to push the lot into the hands
of the local authorities, a terrible fate for these treasure houses. My
colleagues are instinctively against taking them, but their horizons are
usually prejudiced and narrow.

13 October. Farewell to Lord Civilisation.

I came out of Hugh Leggatt's to find that it was pouring with rain.
Mercifully Hugh usually keeps fifty umbrellas at the ready to provide
clients with protection, so I was handed one and made my way to the
Jermyn Street entrance to St James's, Piccadilly, for Kenneth Clark's
memorial service. Closing and shaking my umbrella I almost fell over
Hugh Grafton, who exclaimed, 'Bustle, bustle.' He, of course, must
have been representing the Queen Mother, while Jean Wills with him
represented Princess Margaret. Later, when they entered in procession,
Fred Ashton came for the Queen. The first time that he ever did this I
heard that he was quite thrown, as everyone bowed as he went by and
he couldn't understand why!

St James's is a clean, tidied-up sort of church with no mystery, no
atmosphere. It seemed not that full, only the centre pews and a sprink-
ling in the aisles, but no one in the galleries. Strange, in view of the

fame of the man. The make-up of the congregation was as one thought, but what was interesting was the absence of the power politicians which reflected the great change in the Arts since his period. It was an interminable service beginning at 3.30 p.m. and went on till 4.45 p.m. There was a biblical reading by Alan Clark[1] and a lovely one from Bacon's essay on learning by John Sparrow, but he was totally inaudible. The address was given by John Pope-Hennessy, who didn't look in a good state and clung to the rails of the pulpit stairs to heave himself into it. His voice is so terrible and the address was far too long. It wasn't about a human being at all, but one mind analysing another point by point, through every book, picture or TV series. It made me wonder whether on the Day of Judgment God would turn out to be an art historian and one would be raised or cast to oblivion according to the quality of one's articles in the *Burlington Magazine*. No reference to Jane [Clark] at all, no evocation of the warmth, charm and atmosphere that was the essence of the man.

That was followed by an endless chaconne by Bach played by Yehudi Menuhin and then, most surprising of all, an RC cleric appeared – we all thought to conduct the bidding prayers, but, no, he embarked on a long description of how K died a Christian and received communion and absolution. All of this quite bewildered me. Had he become RC on his last marriage or on his deathbed? The biographies will I am sure tell. It was not a happy or a sad occasion, just a ritual. As we left the publisher Jock Murray offered us tea at Murrays which we declined. Otherwise we, along with the rest of the Establishment in its old blacks from the back of the wardrobe, hurried away in the pouring rain.

21–23 October. The Arts Council Conference at Ilkley.

The third weekend in October was the occasion of a major Arts Council Conference at Ilkley. The arrangements for this gave a new dimension to exhaustion. We were ferried from pillar to post or, in this case, from conference-room to town hall to theatre to art gallery. On both days the buses carting us around never arrived back at the hotel till 1.30 a.m. The gathering was to carry through what William Rees-Mogg had discussed with me over lunch, bringing reality to the Arts Council. There can be no future in the present financial strait-jacket and the eternal annual cliff-hanging resulting in the butter being spread ever thinner with only occasionally a client ever cut. So we were all asked

[1] Son of Lord Clark; Conservative MP for Plymouth (Sutton) 1974–92 and junior Minister, 1986–92; historian and diarist.

to bring our package for the next five years, bearing in mind the needs of the country. I'd done this anyway for the Art Department: out of the Hayward, out of major shows, into the private and public patronage of artists and a new loan exhibition service. I do pray that all this happens.

The Arts Council is stuck. It is an awkward, shambling organisation, prejudiced and unbending, but with an odd streak of brilliance. The result of this survey and its decisions will obviously cause widespread dismay, but there is no way Gowrie, a dyed-in-the-wool monetarist, will ever produce a penny more. It is going to be quite a complicated game to see how this will work out. Is the Arts Council capable of it?

And, of course, we now have a new runner, the abolition of the Metropolitan Authorities. This is an ill-thought-through document, a carve-up for the Arts, to choose a random series of companies for Arts Council funding and a handful of museums for attachment to the nationals, the Walker and the Laing for the Tate, Kenwood and the Geffrye for the V & A and the Horniman for the British Museum. Whatever happens to those not 'rescued'? Are they all to be cast to the local authorities? What happens if they refuse? Will the nationals take the others on anyway?

26 October. Farewell to the American Ambassador.

On Wednesday last we went to lunch at Clarence House. It was to say 'Farewell' to the Lewises, a rather indifferent, well-meaning plastic pair. As usual Queen Elizabeth used it as a vehicle for a curious *mélange*. We'd been to many much better lunches there, ones with greater gaiety and sense of fun. She looked very white, we thought, and Alastair Aird said that her leg was still bothering her, although she stood as usual for ever.

It was a gathering of huge men. John Lewis is nearly seven feet and he was complemented by the British heavy gang: Lord Soames, Lord Whitelaw and Lord Astor. Norman St John-Stevas was one of the crew, although noticeably he spent most of the time in corners avoiding the big guns of his own party. I sat between Ruth Fermoy and Lady Whitelaw. There seemed no great gossip of any moment, although I collared Willie Whitelaw on the subject of the decimation of arts peers in the Lords. He took receipt. Julia sat next to that waspish Mark Bonham Carter,[1] who was vocal on everything: 'Awful flowers [chrys-anthemums]. I expect they'll be sent to Golders Green afterwards,'

[1] Liberal MP for Torrington, 1958–9; a director of the Royal Opera House, 1958–82, and first Chairman of the Race Relations Board, 1966–70. Created a life peer in 1986.

'Awful food' (it always is! Rissoles again!), 'awful china' (it wasn't). But it was odd to see butter placed in an earthenware crock amidst the silver and *biscuit* figures. Never mind, through it all Queen Elizabeth sparkled, full of affection, wanting to know all the gossip. At eighty-three to arrive from Scotland the day before and go straight into lunch for twenty the next day demands admiration. She was obviously so pleased with an article I had written about the pictures in Clarence House.

31 October. The Queen's House, and Mrs Thatcher thaws.

A rapid visit to the National Maritime Museum, Greenwich, to advise Richard Ormond, blissfully happy to be away from the National Portrait Gallery, on the Queen's House. It seemed to me that a very great deal was un-thought through.

Peter Carrington is determined to put the boot in on extracting money from the Government to put the V & A structurally in order. He toughened our letter to Gowrie. 'Mrs Thatcher is thawing towards the Arts,' he said. With the scenario ahead, may that thaw be a reasonable one.

8 November. Clive Tweedy and Widow Clark.

Clive Tweedy, a serious thirty-year-old and the new head of ABSA, came to lunch. There was much talk of how appalled he was by Grey Gowrie, who in Liverpool actually said that the abolition of the Metropolitan Authorities was going to be a down for the Arts with a £26 million shortfall which, he said, he wanted met from the private sector. ABSA at its best had never produced more than £8 million and it would be ridiculous for it to be seen to mop up a piece of purely political legislation.

Clive turned out to be a great friend of Steven Runciman and he recounted Steven's revulsion from Blunt, whose treachery he had known for a long time. I continue to be amazed by how many people seem to have known about it. He apparently said that only he and Fred Ashton were now left of a generation, all talented, all rich or who became rich, and all also homosexual, I assume?

That evening after the private view of the Dufy exhibition there was a buffet supper at the RCA and I looked after the widow Clark. She's enchanting, lively, with huge beautiful eyes. Her marriage to K, she said, had been all happiness. He was a shy man. He loved his food and would peer in at her in the kitchen, 'What are you cooking?' He would look after the bouquet for the table. Always she would have to say

'Don't pick that iris there!' But, of course, he would. His bedside in hospital had been full of flowers. He'd asked her to marry him after having had tea with her six times. Then he suddenly said, 'You and I should be joined.' She loved travelling with him to all his old haunts in France and Italy. He had provided her with a cottage at Saltwood. She had a little house also near her farm in Normandy. But oh, how she misses his library! What books! Wonderful first editions and French classics. The American writer Edith Wharton had apparently left him her library and he left it to Colin [Clark], who had sold it. Sadly she mused that not one of his children was bookish. When I told her some of what I had to cope with she exclaimed, 'K could never have done it!' How times change.

23 November. Trevor Nunn blows his top.

A busy month. The abolition of the Metropolitan Authorities drags on ... Grey Gowrie was heard to remark, 'Either I shall be a failure or a disaster,' a flash of wit which is irresistible. Peter Carrington has gone off on tour to Korea, Hongkong and New Zealand. Before he did Julia and I went to an hilarious dinner with him and Victor Rothschild.[1] I'd never met Victor before, a most extraordinary person, large, reptilian in many ways, quick, darting, with layers of meaning and counter-meaning to every word he uttered, however seemingly banal.

The Twentieth-Century Gallery opened to great applause and I gave a dinner for the Baring Foundation, who sponsored it, in the Morris Room. But by far the most interesting event was the appearance of Trevor Nunn and his RSC acolytes before the Finance and General Purposes Committee at the Arts Council last Monday. I had always wondered whether a monster lurked beneath that 1960s hair, beard, and Chinese eyes. It does. Marghanita Laski set the ball rolling by asking in her usual coy way, 'The aims of the company include the formation of a house style in acting, design, production. There is a moment', she droned on, 'when a style becomes a cliché. I think it now has.' Nunn was furious. A tirade followed. Anyone who dared make the slightest criticism was flattened. Rees-Mogg kept his head down and as this battle drew to its close after an hour, he raised it, after they'd gone, and said, 'Lucky Mr Priestley [of the famous report] wasn't around to hear that.' Arrogance had known no bounds.

[1] 3rd Baron Rothschild, Assistant Director of Research, Department of Zoology, Cambridge, 1950–70; Head of Central Policy Review Staff, 1971–74; then Chairman of N. M. Rothschild & Sons.

29 November. The offer of Kenwood.

I went with Michael Darby, the new Deputy Director, and Peter Wilson [my personal assistant] to see Mark Hodges at OAL over the abolition of the Metropolitan Authorities. Internally the V & A is against any of it, although I always bear in mind that they have been opposed to every major innovation or change I have ever made as Director, from the Associates and Friends to Trusteeship, from the V & A/RCA Course to the closure of Circulation. The Trustees seem so far that way inclined too. Hodges, who is a well-meaning man in his last weeks at OAL before retirement and who looks like a 1930s schoolteacher, revealed a truer state of play, which boiled down to some pretty low horse-trading. Frankly, down the plughole would go the Geffrye Museum, Rangers House, Marble Hill and Kenwood[1] if it came to it, but over Kenwood there was a degree of sticking. Contrary to what the Kenwood delegation believed, coming away from their meeting with the Minister, it was not OAL's intent to give it independence. Too small, it was said, and then we were asked on what terms we would take it on. This is a fine game of bluff, and on their side it boils down to how little they can get away with. It will be up to Peter Carrington to judge the stakes and squeeze as much out of Gowrie as he can for the V & A. We left bent on quantifying this. Although it was made clear that the Minister wouldn't like the flak from the Guinness family and the Hampstead literati he'd take it, if the worst came to the worst, and let Kenwood go to Camden.

6 December. The Directors' Conference.

The National Museums Directors' Conference, a colourless affair that used to happen once a year, now occurs twice. The Director of the National Gallery of Wales, Douglas Bassett, is the present Chairman, a sweet, limp soul, and we meet at the British Museum. I arrived early and was spotted by David Wilson, all huff and puff as usual, with the movements of someone off the dockside. Michael Levey appeared and we sat down and had coffee. The real news was the proposal by the National Maritime Museum, Greenwich, to introduce charges of £1.50 as from April 1984. No consultation, no courteous intimation. However, on studying that move, it was clear that Government had not yet agreed to let them have the gate money, an estimated £500,000.

[1] Lord Iveagh (formerly Edward Guinness) left Kenwood, a Georgian mansion on the edge of Hampstead Heath, in trust to the nation in 1927. The collection of pictures is notable.

The Museums Commission was denounced and David Wilson agreed with us that it ought to be swept away (which surprised me after all his courting of them). We then went up to the meeting which I certainly enlivened, but what struck me most was the ineffectuality of these people, their lack of political flair, their inability to pull together or display any real teeth, let alone bite.

7 December. David Hicks and Vivien Duffield.

Lunch with David Hicks at 92 Park Lane, part of the Grosvenor. David was angling for something, this time approval of his garden design for *Homes & Gardens* at the Chelsea Flower Show next year. He is such a shrewd businessman with his shop in Jermyn Street and a team of twenty designers working for him on the South Bank. At present he is deep in the inevitable Arab commissions, one for a royal yacht and the second to build a Palladian villa in the Algarve with seven-and-a-half acres of garden. He had the usual revelations about Princess Margaret, this time from someone who 'waited' on HRH from Mustique to the USA. Apparently no one had told the British Consul in Miami that she was passing through, with the result that she was shunted through what we all endure. Bad temper resulted. Much funnier was when she had to walk through the arch which registers metal which she set off jangling like blazes. No one knew what to do because it had been set a-singing by the antiquated metal-supported corsetry she wore beneath! More unpleasant was the account of the arrival of *Ritz* magazine with David Linley's comment on what he would least like as a Christmas present ('Dinner with Princess Michael'). United they stand, divided they fall.

We went to dine that evening with Vivien Duffield, the Clore heiress, and Jocelyn Stevens at 14 Cheyne Walk. Vivien is quite a character with an oval face, pointed chin and the lips of a Gaiety Girl. I fancy that she wears contacts and her lashes when they caught the light were spangled with glitterdust. She is definite, mixing considerable energy, flair and visual taste with a toughness and at times a vulgar streak. But she's a life-giver. Jocelyn still has remnants of being the blond macho of the 1950s and '60s but is now a little podgy, but with cascades of charm and intelligence.

It is rare these days to give a dinner for thirty-two. Jocelyn was a very good host but Vivien made no effort to introduce or move people around. I sat on her left at dinner with Lucy Snowdon on my left. Vivien had Brian Flowers on her right. He, like myself, was being got at over Jocelyn's wish to be Rector of the RCA. Vivien whispered to me, 'He's

hard work.' I said, 'Like pushing lumps of granite uphill.' Her life is divided between Switzerland and London, with four trips a year to Israel where she runs hospitals and schools and is even building a museum. She felt rather uninvolved in the Tate Gallery project [the Clore Wing] as she had no feeling, she said, for Turner or for modern art.

Lucy Snowdon and I exchanged Messel sagas. She is an odd kind of girl, thin with good eyes and an interesting nose. Apparently after the Messel opening at the V & A, there was a dinner at Kensington Palace, which almost never happened because Anne Rosse (now eighty-three) sat transfixed with emotion and refused to eat for hours.

1984

Carry on Carrington

This year in many ways was to be a turning-point, for in October for the first time I wrote of a restlessness, and I also began to put out feelers as to whether there was to be life after the V & A. On turning the pages of my jam-packed appointments diary I alighted upon an entry which in the long run was to signal what was to become part of a new phase of my life. On the afternoon of 4 February a young woman called Alison Cathie came to see me. She was a director of the publishing firm Conran Octopus and she said that she had two proposals for me to consider: the first was writing the diary of Elizabeth I for a year (I said that I'd rather shoot myself) and the other that I'd write a book on small-garden design. I replied that I wasn't a trained horticulturalist. That doesn't matter, came the reply, I hear that you have a very good garden. I said that I would think about it, but I was intrigued. Subsequently I rang Rosemary Verey[1] who immediately said that I should write the book, and that she would help me if I got stuck. I had no idea that this meeting was to be so significant, but it was. By the mid-1990s I had written five books on garden design, all of which remain in print and some half-a-million copies have been sold in six languages. The encounter was to prove a silver lining, but I could not have guessed it at the time.

1984 was the year of the arrival of the Trustees, whose initial impact was certainly stimulating. They were a mixed crew ranging from Jean Muir, the dress designer, to Christopher Frayling of the Royal College of Art, from stylish Princess Michael of Kent to the energetic Pamela, Lady Harlech. But there quickly emerged out of this *galère* those who applied to museums the same attitude that they brought to their business affairs. The two key players in this were Andrew Knight, editor of the *Economist*, and Sir Terence Conran, with the addition more or less of Ian Hay-Davison. Terence Conran used to refer to the museum collections as 'product', which sent a shiver down the spine, and to inquire eagerly as to how we were to 'market' it. Harnessed to

[1] Renowned plantswoman and one of the country's foremost garden writers.

setting up V & A Enterprises and the shop he was in his element, and made a valuable contribution. Otherwise sensitivities to an ancient and venerable institution and its traditions were sadly lacking. But in the first year of Trusteeship there were as yet only a few signs that the direction in which they wanted to go was to usurp the role of the executive.

Everything more and more boiled down to money, or rather lack of it. Carrington made a spirited start by rightly taking the Government to task for having under-funded the Museum for decades. 'It struck me', he said, 'that we needed as Trustees people who really knew about finance. We wanted people who cared about the Arts but could help us on the financial side as well.' The whole point of the business emphasis in the creation of the Trustees Board had been that they should be active fund-raisers for the Museum. That had been the optimistic hope of the V & A's staff, but it did not happen. Instead they made demands and spent money which was simply not there. Most had no idea of the penury of the staff. I recall Conran saying to me on my first visit to him, 'Tell your driver to set you down in such and such a place.' I replied that I would be coming by bus.

Carrington, however, was determined to fight Government for cash, and rightly so, for on coming out of it we were presented with a report on the state of the building which stated that some £26 million was needed for immediate structural repair. That fight went hand in hand with one to retain anything which came by way of revenue-engendering activity. Immediately, outside accountants were brought in (indeed one of them, Ronnie Gorlin, was soon put on the Board) to prepare a report on revenue potential, and by the close of the year the question of charges loomed large. In the case of the building something at least was exacted. The Government made £5 million available as the first 'instalment' towards the funds required for building works in the financial year 1984–5, more than double the sum allocated to any other museum or gallery. But it was a drop in the ocean and as each part of the building was probed, even more horrors came to light. The result was that not only was the roof still being rebuilt and the drains replaced, but it now emerged that the entire electrical system was in decay and overloaded. If any single item can be cited as evidence of wanton neglect by the Property Services Agency of the Department of the Environment, the Victoria and Albert Museum must surely be it.

The decision by the National Maritime Museum to introduce charges on 1 April was to prove a turning-point. I wrote in the *Financial Times* that month, in what I considered to be a significant article on the state

of play in the museum world, that this was a signal of a change in public mood, and indicative of things to come. 'In its crudest sense,' I wrote, 'it embodies a triumph of Thatcherite principles: that is, you get what you pay for.' I went on to trace this dramatic shift in funding, starting with the museum shops of the sixties followed, as the seventies unfolded, by a greater and greater emphasis on sponsorship:

> That has interlocked the national museums into the world of commerce as never before. Indeed, virtually no major exhibition can now be staged without a sponsor. In many ways this is a welcome development although it does painfully constrict the choice of subject. But it is not only temporary spectacles that require subsidy, it is also the permanent collections. Nearly every national museum now runs an appeal to reinstate galleries, looking to the private sector and to charities to achieve part if not the whole. Fund-raising organisations, formal or informal, are also an integral part of museum management which they certainly were not a decade ago. In short, an important bridge is in the process of being crossed because all this means that Government is no longer able to fund our national collections on the scale needed either to keep their fabrics in repair or their displays up to date...
>
> It is also noticeable ... that Boards of Trustees spend their time these days not haggling over works of art and other forms of acquisition but wrestling with the problem of money and how to lay hands upon it. Any analysis of the composition of Boards during the past ten years will also reveal a change in composition away from aristocrats, artists, collectors, connoisseurs and academics towards the recruitment of tycoons and men from the City...

Looking at all this a decade on, I can see why a certain disenchantment with the museum world was beginning to set in. This was not what I had entered it for, to be a full-time administrator and fund-raiser, with all the creativity and scholarship that used to epitomise the Director ideal sliced away from the role.

But there were bonuses. The Museum was assigned a large part of the old National Savings building in Blythe Road, Hammersmith, providing much-needed storage space rapidly filled by the Archive of Art and Design, which in the spring of the following year opened to the public for the first time. This was also the year of what I had billed as the last of the great exhibitions. I had inherited a scheme for a Rococo exhibition when I arrived in 1974. It was pleasurable that at last it should come to fruition, thanks largely to the sponsorship of the hotelier Lord Forte whose son was called Rocco (i.e., Rococo!). It was

not only beautiful but a major contribution towards the definition of a movement and a style. But I did not see how we could continue to spend over £200,000 each year on a major spectacle when those funds and the staff energies should be applied to lifting the Museum's public face. On that Carrington disagreed, but we were still as yet in the honeymoon period.

January and February.
A very dull beginning to the year. Preoccupations centre on the appalling financial situation at the Victoria & Albert. There is no money to embark on a single gallery refurbishment for 1984–5, just enough to progress with work in hand. The Trustees are rightly surveying all revenue-engendering activities. If the OAL gets Treasury sanction for the Museum to hold on to this income the change will be rapid. My package for handling the '84–5 estimates was adopted by the Trustees' sub-committees: a $12\frac{1}{2}$% cut to general expenses in favour of thirty-two new posts across the board in the administrative and curatorial grades. This will be a year of fast change, I think. Everything is questioned as to its cost-effectiveness. The Rococo exhibition is being billed as our last great show. How can we spend £200,000 on a three-month spectacle and not be able to run the Museum properly or even cope with the decay of the building?

15 February. Diana Phipps and the Windsors.
Diana Phipps is an original. She arrived wearing tinted glasses, trousers, a pale woolly, and suede boots like an Abraham Bosse cavalier, and with a fur coat made up of scraps of skins. Czechoslovakian in origin, she and her mother had fled in the post-war period and, after a life of vicissitudes, marriage into the Phipps family had ensured financial provision. A languorous *femme du monde*, a mistress of interior decoration done with a staple-gun, a linguist, and a woman who moves through what amuses her in international society but always avoiding bores. Now she is about to decorate Gore Vidal's flat in Rome and start on a second book on parties, beginning with the shooting parties her mother gave and then on through Palm Springs, New York, Paris and London.

I had no idea that she had known the Windsors so well. The Duchess took a shine to Harry Phipps, so they were doomed to *diner à quatre* followed by him playing bridge with Wallis, and Diana being landed with the Duke playing canasta ('You have to be really dim to play that'). He wanted to practise his languages. Diana groaned. He couldn't speak

French and he spoke German and Spanish with a mistake in every line. He also eulogised Hitler. It confirmed all one had feared.

19 April. *The Lady Torte de Shell.*

I loved the Lady Torte de Shell more than many, many human beings. She was feminine and capricious, offhand and then suddenly passionately maternal. She arrived over the fields eight years ago and decided that this was her home. Every morning she climbed up the wisteria and through the bedroom window to love me; a lick and a purr and a contented mound of fur encircled my head. She was so beautiful with green eyes, a little nose and face, exquisite markings with a preponderance of white fur, less ginger and a little black. She was 'my cat', although she loved Julia and would go to sleep in her arms after asking to be let in under the coverlet. The whole house was hers: the kitchen window-sill where she looked out and ate her breakfast, the logs in the garden on which she sunned herself, the geranium-embowered bay window in the Gothic sitting-room in which she slept in the warmth, so many places. She sat behind me in my writing-room by a radiator with her box behind it.

Oh, the tragedy of losing that little creature, the agony of every last day with the vet, the injections, the trays of food and milk, the tears shed over her as we knew that she could not live. Dearest cat, beloved Torte, tears fill my eyes as I write of you, most cherished of friends. Forgive me for the cry I uttered when I was told that your end was near and which you heard, and your face told all to me in the way of betrayal. You taught me stoicism and fortitude and nobility in the face of death. And dignity. How I wish that we could have spoken. How could we let you leave us on that last day and let you go, as you wanted to, over the fields to hide and die alone? Did you forgive us? You never resisted when we brought you back. We held you and we loved you to the end. And oh how we cried the cry of the bereaved. Now you sleep beneath spring flowers. We will never, never forget.

9 May. *Harold Acton revisited.*

It is like November in Tuscany today. An earthquake near Naples is blamed, but the skies are leaden, the rain falls and the bitter wind flattens everything and everyone, including the twenty Friends of the V & A I am escorting to see Harold Acton's garden on our tour of Tuscan villas. We were late due to gaining access to the Villa Demidoff in order to see Giovanni da Bologna's *Appenino*, an heroic sight, a

Blakean assault on God, this giant with his hand plunged into the pool behind him.

I rushed up the drive of La Pietra, the rain falling, a long straight avenue of cypresses. I removed my galoshes, rain hat and coat, and tidied myself up before ringing the bell. A large docile Alsatian sat dreamily behind the door. The one remaining male domestic appeared with a snappy pug at his heels and I was growled at and bitten all the way to the *salone*. Engulfed in gloom, it was an Edwardian Englishman's vision of an Italian villa. The nearest in atmosphere is the Isabella Stewart Gardner Museum in Boston, which sprang from the same impulse: pictures, gilt chairs, maiolica, china, ecclesiastical embroideries, bits of sculpture everywhere. Every movement becomes an act of navigation.

Harold looked remarkably well for nearing eighty, in fact the same as I always remembered him, though the Chinese-smooth hardness of his features had shifted towards emphasising the incipient baby-faced quality which had always been there. I waved a hand and told him that the Friends were happy looking at the garden (in fact they froze and weren't) and we talked. He looked forward to Princess Margaret's eightieth-birthday party for him on 9 July. She had such a marvellous voice on the telephone, he said, so kind, so thoughtful, and such a bad press. No, her stay last year was elsewhere, a hotel since bought by James Sherwood, the Orient Express millionaire, but it had not been a great success. She had complained about the food the whole time. None the less she was kept happy by morning visits to swimming pools. Her daughter came, so did the Weinbergs and Norman Lonsdale, the new 'walker' who 'looked like a Rhodesian farmer'. Everything as usual was arranged by Milton Gendel.

There were many moans about Anne Rosse, who pursued him with endless letters and calls. She was so old, he said, eighty-two or -three he hazarded, but with nothing to keep her going. All she talked about was the dead or the nearly dead and when she came she just sat. It was boring but it was also an index as to his own *joie de vivre*. He seemed to like my *Times* scribbles and the idea of putting them together in a book and getting Mark Boxer to illustrate them [these pieces appeared as *Strong Points*]. He continued to see Susannah Johnson, who was just about to produce a novel covered in four-letter words. He didn't like it and thought that it would cause a scandal. Her platonic affair with John Sparrow continued, although he had gone over to drink. We had just got going when the message came that the Friends were off. I gave him my garden renaissance book, Julia's love, and I went.

May. A retrospective.

I am writing this in a hotel room in Montecatini Terme. Almost five turbulent months have passed and so little diary to show for it! It would be difficult to reconstruct the period in detail but we passed through to Trustee status painlessly enough, and also the new strategy of the Arts Council emerged for what it was worth. In the case of the former, change is coming too fast, and an article I wrote in the *Financial Times* in April sums it all up. The shift is in expectancy. It is getting tougher and tougher and money scarcer and scarcer to find. I can see charging ahead. The ideology of the period is shifting and very fast. It is impossible for the Museum staff to keep pace with the whirlwind of change which is happening on all sides. Financial devolution in the V & A is forcing them, reluctantly, to think for the first time. A firm of accountants has produced a report on our revenue potential. We await the Minister's statement whether such revenue can be held on to or not. That will be the key pronouncement for 1984, for we are broke. Millions are needed to cope with the V & A and it will not all come from Government. There have been teething problems with the Trustees, although Carrington is good, direct, and only occasionally capricious.

In the case of the Arts Council it was another Hayward–Serpentine Gallery saga, but I emerged with both intact plus £500,000 to develop our regionalisation strategy. This is the windbag syndrome, just endless committees and papers. Joanna Drew as usual is irresolute, which throws all the load on to me which is very very tiring.

24 May. Princess Michael of Kent spills the beans.

Princess Michael of Kent came to the Prince's Trust sponsored concert at the V & A. She is always sharp and wildly indiscreet. What she said, however, didn't surprise me, which was the catastrophe of the Princess of Wales: droves of the household were leaving and then there was the terrible mother, Mrs Shand Kydd, who was a baleful influence. Poor Prince Charles who had bought Highgrove to be near his former girl-friends. Nothing was happy. Diana was hard. There was no pulling together, no common objectives, and it was misery for him. How long can it last? And Diana has become a media queen which only makes it worse.

'Prince Charles doesn't like me,' she chortled on, 'I'm regarded as the family's highest risk factor. In fact I'm devoted to him and it's not me who's the risk. The time bomb is Diana. Being rude to servants is the lowest thing you can do and she does it.' She then listed off the members of the private entourage who had gone. No one knows this. The Prince

is left increasingly isolated. The Queen is withdrawn. Not that the Kent family sounded that much united. In one sense she is a risk because I hope that she never tells just anyone this kind of gossip. On the other hand she is very bright and sharp, pinpointing characters neatly. Even her own chauffeur was spilling the beans to the *Daily Mail*, she lamented. But she, as always, worked hard, smiled, waved, and talked to everyone. The women that make up the Royal Family at the moment would make a fascinating study so disparate are they in looks, intellect and motivation.

30 May. The South Bank.

With abolition of the Metropolitan Authorities the South Bank, which included the Hayward Gallery and the two concert halls, had to be reconstituted into a new entity.

After an Arts Council meeting I saw William Rees-Mogg about the South Bank project. This was an initial discussion asking me how I saw it. I should record that I had registered my interest in the post of Director-General of the whole complex if there was to be one. By 1986, when all this would come into being, I would have directed the V & A thirteen years and I would be fifty-one. It would be time for a change. Luke Rittner came in, and together we hammered out a structure. The National Film Theatre, the Hayward Gallery, the National Theatre, the Festival Hall, all with Boards of Trustees. The overall South Bank Board would have a chairman and twelve trustees, four of whom would be the chairman of the institutional Boards. Great importance was attached to drawing in the boroughs, the conurbation of London as well as the regions and the great and the good 'Isaiah Berlin' types. As much funding as possible was to be channelled through the Arts Council to the South Bank Board in order to give it teeth. The National Theatre would of course try to cling to getting it directly from the Arts Council but at least the amount which used to go to them from the GLC would be redirected via the South Bank Board. The role of the South Bank Board and of its Director-General would embrace the whole of the site all community activities, publicity, the environment, the interlinking of activities, festivals, etc. It could be a very great opportunity for the Arts in London.

4 June. Assailing the Treasury.

We went in delegation to see Peter Rees, the Chief Secretary at the Treasury. He is a cheery kind of character, portly, red-faced, bespec

tacled, a trifle Pickwickian but sharp with it. There we sat, he flanked on one side by golliwog Gowrie, his hair all over the place, Richard Wilding, benign, Phipps, rodent-like, and his bright Treasury boys on the other. Carrington faced him with our contingent: Ian Hay-Davison, Andrew Knight, Robin Holland-Martin and John Last, along with myself and Michael Darby.

We presented our case, I thought, with panache. The place was falling down. Twenty-six million was needed to keep it standing. Government owed it to the incoming Trustees who had taken on a run-down institution. As I anticipated, there was a horse-trading element to this encounter, i.e., would we introduce charges? How about an appeal? Were we in a worse state than any other museum? Yes. Would we choose ourselves instead of the British Library? Yes. To be honest, everything boiled down to political muscle. Carrington has it. I think we'll get something out of this but in return for a further step up the Thatcherite alley.

5 June. Thatcherising the national museums.

The Directors' Conference at the British Museum had come round again, the usual lacklustre affair endured once or twice each year. The chairman is still Douglas Bassett of Cardiff, an affable, jolly kind of man but devoid of edge or muscle. We make an ill-sorted crew, not really loving each other: united we stand, divided we fall, and it's always been the latter for as long as I can remember. Grey Gowrie came and that made it for once interesting, for it shoved the contents of my *Financial Times* piece further along the path: the National Maritime Museum (which has already introduced charging), we were told, 'was on the beachhead'. This statement was surprisingly received with silence. Charges were then dwelt upon at length as being among the virtuous activities which might persuade the Treasury to open its purse a fraction wider. On we went through engendered revenue and surprisingly, too, horse-trading with the Purchase Grant. There is no doubt as to the general drift. What surprised me was the quiescent nature of the Directors.

31 July. Horstead Place and the Queen at Glyndebourne.

This was the fiftieth anniversary of the opera house, and the production of Strauss's Arabella *which Julia had designed was chosen for the occasion of the Queen's visit.*

Yesterday Mikki Neville came on the phone. Could we come to lunch

at Horstead? Well, we'd often been asked, the last time for a weekend with Princess Margaret, but never been in a position to accept. These were Mikki's last few weeks at Horstead. Daughter of the Earl of Portsmouth and the widow of Lord Rupert, the younger son of the Earl of Abergavenny, secretary to the Duke of Edinburgh, she is now fifty-eight. She seems always to have been close to the Queen, who has often stayed at Horstead. Mikki is a minor cult figure, short and compact of build with brown hair and eyes, her features somewhat sharp in repose and her voice with a slight crack to it. As she is not tall, one is always aware of her looking up with a quizzical sparkle. There is quite a lot of intelligence there. She is a renowned housekeeper; mistress of décor besides maintaining a good table. Everyone has copied Mikki Neville's sauce, which simply means mixing the mint sauce into the redcurrant jelly for roast lamb.

On this occasion the lunch was good rather than outstanding: rather disappointing gazpacho though the tomatoes in it were real and not tinned, cold meat with a home-made *salsa verde*, mixed vegetables, potatoes and salad, *crème brûlée* with Russian jam. Ah, that was a treat, mature crystallised strawberry. The house, due to moving, was in retreat. It is 1860s Puginesque Gothic, handsome outside in stone and brick, within the ginger-cat-coloured woodwork had been painted in shades of white. The most striking feature was the great corridor running the full length of the house, which was hung with portraits and carpeted all over to emphasise the width, and a marvellous Gothic staircase, with wallpaper in shades of white and grey which had been designed and printed for her by Martin Battersby. The huge double drawing-room was light, white and airy with glazed chintz curtains patterned with large bunches of flowers, the room a clutter of chairs, sofas and tables, piles of books and magazines and *objets*. It was not over-arranged but retained a lived-in and practical quality. The dining-room was Gothic, wallpapered in red, with Gothic dining-chairs and a mass of silver arranged in a pattern on the table. The real treat, however, was the garden, doors to which opened out on to a lawn which receded away and which was dotted with circular flower-beds, encircled by iron coronas painted white, directly in the manner of Repton. It was an informal, irregular, meandering garden, with picturesque walks and vistas taking one round to view the house from afar.

It was just a cosy lunch with Ingrid Channon and young Henry, an appallingly assured fourteen-year-old, but retaining the affectionate freshness of his father. Ingrid recorded their present lack of rapport with Peter Walker and how embittered he was. She was enjoying being

Trade Minister's wife, lovely trips, yes, but endless boring lunches and dinners.

Off we went for the great evening which, considering the lack of organisation which prefaced it, went off incredibly well. If the Queen has to go to an opera and she has to be 'forced' (there is no record of a voluntary visit) Glyndebourne is on her wavelength with its country-house atmosphere, comfortable neo-baronial décor, old clothes and dogs. When the Christies'[1] new puppy was held up to her she really lit up. Julia said that when the ladies went upstairs and she caught the Queen at certain angles she was now an old lady and looked older than her mother now at eighty-four. It is unfortunate that she still dyes her hair rather badly but she bowled along, dressed in bright pink chiffon, on the whole not at a loss for words. The atmosphere and the genuine applause really relaxed her and the opera did look and sound marvellous. It was a large party. There must have been twenty at dinner, for which the Christie silver gilt must have been got out of the bank, but it was a simple dinner served by the housekeeper and helpers. There were no hired domestics and this modesty struck a very good note. It was a real Glyndebourne mix with many members of what is known as the Chalk Circle: Peter Hall, larger than ever, eyes glinting, power-hungry, escaping the opening of *Götterdämmerung* at Bayreuth, part of his disastrous Ring cycle; Maria Ewing,[2] a pert wife number three, in many ways the same type as numbers one and two (she will ride him hard, I thought); Thomas and Henrietta Dunn, the Herefordshire contingent, staying at Horstead (Henrietta with Sussex roots); Anthony and Jane Lloyd, he chairman of the Opera House Trustees, a few Barings – money – and it didn't rain.

4 October. To Jan van Dorsten. Summer into autumn.

I can't think when you last had a long letter. The summer passed busily. The Rococo exhibition opened at the V & A. Trusteeship goes well, apart from difficulties over gallery planning: we now investigate whether or not to charge. The V & A like everything else is broke. All is money, money, money, and where to get it. It is a blood bath of fund-raising and pressure on Government and everyone out for themselves. Not pleasant. However, I did get my second honorary degree at Keele which was nice, bestowed by Princess Margaret, who is now an old

[1] Sir George and Lady Christie, owners of Glyndebourne. George is the son of its founder, John Christie, and his singer wife, Audrey Mildmay.

[2] American operatic soprano.

friend and who took me up to Keele and back on the royal plane, which was a very funny experience. What the effect on the university was of the recipient of the degree arriving on the arm as it were of the bestower I cannot imagine. That was happy.

Then down to The Laskett for August. Week one was rather dislocated because we had to come up to London for a night, two nights actually, because the Queen went to see Julia's *Arabella* at Glyndebourne. That was fun too. Her Majesty was in a good mood. I can't think what she made of it. As Julia had to stay there I was left alone in London which was a bit boring. However we then whizzed back to The Laskett. It was the usual summer life: hedge-cutting, gardening, lovely Proms on the radio, praying for rain (which at last came). We went up to London for a week in the middle of August, Julia to Glyndebourne for the recording of *Arabella*, me to the V & A for four very heavy days.

During August a major TV profile interview with Bernard Levin[1] went out, provoking a mass of fan mail and no less than three reviews from critics, admiringly hostile. They really don't like one to be clever and successful in this country. However, Levin only interviews the likes of Isaiah Berlin and Lord Rothschild, so one was cast into quite a league. What was sweet was the letter I got from Joe Trapp thanking me for my *hommage* to Frances Yates and then sending me the three volumes of her collected papers with its interesting biographical memoirs. I was touched.

Friends came and went and we ventured out occasionally to dinner. Otherwise good work and rest. Julia is frantically busy on *Nutcracker*, which hopefully will be her masterpiece. A huge task. The première is on 21 December with the Queen and Princess Margaret. Now we are back in London on the 'milk round' and over the October Trustees' Meeting, which was tough. The last three weeks have been very heavy not only with administration but state appearances. I gave what I consider was the best *fête* I have ever given in the Museum in honour of our sponsor [of the Rococo exhibition], Lord Forte, last week, a dinner for sixty in the Italian Cast Court. It was spectacular, all cleverly lit, round tables, flickering candles, an array of butlers, and I asked all of *le monde* that hadn't come to the dinner he gave to launch the Rococo...

I am now well into my second year as a *Times* columnist with no seeming flagging. It is amazing the reaction that the articles provoke

[1] Noted columnist on *The Times*; former drama critic; books include a seminal study of the 1960s, *The Pendulum Years*.

Such fun. My last one on the delights of fruit trees produced a flurry of letters and a box of medlars in the office. I would like to keep going up until sixty pieces when I might find fifty of them to make into a little Christmas book. I am so stunned that people seem to love them and amazed at my ability to write purely out of my brain box what are seen to be witty, nostalgic, perceptive pieces. The *hommage* to Sir Frederick Ashton resulted in my being asked to write his biography. [I didn't.] Also, which didn't occur to me, one is established in a much broader perspective in the public eye. I never write in those columns about museums or any of the work side. They are just me looking around. In a way they are in the tradition of the type of thing the Sitwells wrote in the thirties. It is so enjoyable putting together a little essay, for example, on passages and corridors one loves.

16 October. John Vaizey.

The memorial service for John Vaizey took place at St Mary-at-Hill, a Wren church not so far from the Monument, beautiful and untouched, its late-seventeenth-century furnishings virtually intact with a table altar, huge carved reredos, and box pews with facing seats in the aisles. As we approached it we were aware of squads of police. The Prime Minister was making her first public appearance in London after the Brighton bomb outrage.[1] We were all searched going in to what turned out to be a large gathering of the Establishment, which made one think how a bomb behind the altar could have achieved similar results.

Mrs Thatcher was pale but unruffled and without a hair out of place. It was a splendid service for a much loved man (we later learned that the funeral had been a great jamboree too). All the Vaizey children read a lesson, although only in their early teens, but did it very well with an exact observation of the punctuation. The address by Frank Field[2] was quite outstanding. One never really knew that John Vaizey was always in pain, or about his childhood misery with poliomyelitis of the spine. The spectrum across the political and intellectual worlds spoke of a man with polymathic interests. Marina seems to have taken it well and was totally composed, greeting everyone as we left. Probably she knew that this was likely to happen.

[1] On 12 October an IRA bomb had devastated the Grand Hotel, Brighton, where Mrs Thatcher was staying during the Conservative Party Conference. Her comment after narrowly escaping the wreckage was, 'Life must go on.'
[2] Labour MP for Birkenhead.

17 October. Wind of change.

The diary is very thin this year. I should have written much much more. Too much is happening. This is the first year when I have felt restless, a feeling that the V & A period is drawing to its close, but what next? That is the problem. It is not fleeing from problems, it is moving away from the *same* ones. Even my secretary admitted that nothing new came in any more. It was a recycling of the same old projects and problems. In other words, boredom. That is why the *Times* articles have been such a joy to do.

22 October. The offer of the South Bank.

It is curious that I should recently have put pen to paper on the subject of restlessness and that it was time to move on, for today the appointments diary read: '3 p.m. Arts Council – Sir William Rees-Mogg re South Bank.' I arrived not knowing what to expect, but rather expecting the usual dolours of the Hayward Gallery but, no, it was *à deux* with William. And so it unfolded. Government, I was told, would not accept a quango for the South Bank but only a set-up parallel to that of the Welsh and Scottish Arts Councils. This would have a chairman, a chief executive, a board and staff. The Chairman was to be Ronnie Grierson,[1] now about sixty-two, and whom I like, and I was to be the Chief Executive. It was to be funded by the Arts Council and Government was to give, William said, a 'dollop' of money for a huge South Bank festival in 1987. There were problems in that the GLC now would reveal nothing and were dishing out pay awards to their employees which would be embarrassing. Grierson wanted me sounded out on this 'marriage', which Grey Gowrie also knew about. The process would begin with Ronnie joining the Arts Council. Then he and I and Dione Digby[2] would be formed into a South Bank Committee with Richard Pulford[3] as full-time assistant. The chief executive post would have to go through the public motions but it was mine and I would have to be installed by the autumn of next year.

In a way it was difficult to take all of this in at one fell swoop. To my mind I should grab it and form it *ab initio*. It would give me a decade in a new post, a major post, a vast challenge to draw together all the elements of the South Bank. I know that I can't go on for twenty-two years in all at the V & A. This is the natural moment for the break

[1] The businessman Sir Ronald Grierson. Knighted 1990.
[2] Lady Digby, Arts Council committee member, 1982–6. DBE, 1991.
[3] Deputy Secretary-General of the Arts Council, 1979–85.

I don't underestimate the task. Also there would be political problems. It is unlikely that Labour would ever get back next time. At the most there would be an alliance of them and the SDP/Liberals or Tories and the same. Once something is abolished it is generally not put back. The task is a positive one. At the moment the South Bank exists as a series of small separate institutions. There is no overall 'animation', no roots into the London boroughs which need to be put down and, in addition, there must be a lot more popular activities. But the ingredients are there.

In a way it comes perhaps a year too early as far as the V & A is concerned but opportunity must be seized by the forelock. By the autumn of next year the V & A ought to be in a better structural state than now. No one is indispensable, but I can't think who could do the job. But then I would.

12 November. Mrs Thatcher at the Lord Mayor's Banquet.

This old warhorse continues unabated, a formidable parade of costume, a cascade of wigs, aldermen's gowns, judges' robes and bishops' gaiters, with men in orders and ladies who have exhumed the family tiara from the bank vaults. The custom of being announced and presented to the new Lord Mayor and Lady Mayoress standing in tableau at the end of the library must be unique. On either side sit City dignitaries and guests who applaud newcomers as they advance either on their own or preceded by beadles bearing wands of office up to the dais. I had not noticed before the spectacle of the judges arriving as a phalanx, their trains carried behind them. At the banquet, when the Lord Chancellor spoke, they all put their wigs on again. There was a notable round of applause for Geoffrey Howe and a standing one for the Prime Minister as they entered. She looked initially somewhat bent and certainly had put on weight. Nevertheless it was interesting to see how she immediately transformed herself for a major public appearance. Suddenly her neck returned. She seemed taller and the years slipped from her. I felt the hand of Ronnie Millar[1] at work in her speech with its mass of quotes from everyone from Shakespeare to Mark Twain. It ranged far and was delivered in a spirit of Churchillian rhetoric, dealing with the fundamentals of a society based on democracy and the rule of law, both under threat from the miners, *et al*. There was another tremendous standing ovation.

[1] Ronald Millar, playwright, screenwriter who had written speeches for Margaret Thatcher since she became leader of the Conservative Party. Knighted 1980.

21 November. George Strong.

The telephone rang at about 8 a.m. this morning. It was Derek, my eldest brother. Father had died in the night. He had not got up and Mother, seeing the light still on in his room, went in, at first thought him asleep and then realised that he was dead. I remember saying to Julia years ago, 'Don't think that I will shed a tear when this happens and I shan't feel any guilt about it.' I was right. When I think recently how I wept after having suddenly seen that remarkable man, Anthony Wagner,[1] blind, it marks the degree as to how far I remained totally unmoved by the news.

How could it be otherwise? He was never interested in any of us. He had barely addressed a word to me for the last twenty-five years. Home in retrospect was largely hell, and all one regrets is that one didn't get away from it soon enough. Everything revolved around him. My early years were all of a pattern. In deprived wartime he always had his egg-and-bacon breakfast. We didn't. He always had to have his piece of steak for supper when he came in from work. We stood and watched. He always had what he wanted on the radio. We listened. He would always eat on his own. Indeed Mother cooked in relays. He would shout, 'Mabel, Mabel,' and she would rush panic-stricken to the kitchen. 'Where's the mustard/salt/sauce, etc?' The particular item would only be ten feet away in the larder or just behind him on the gas stove. But he would never move. He taunted her through life: 'Why are you reading?' 'Haven't you got a wartime job yet?' 'Look at Mabel's teeth' (when the poor thing had lost one at the front). It was never-ending. Until the 1960s she was given £2.4s.6d. a week with which to feed and clothe herself and three boys. Yes, I did know what poverty was. Some days we would sit trying to rake together the pence for the fare to Enfield or Palmers Green and a one-shilling-and-ninepenny seat at the cinema.

He had no interest in any of his children that I can ever remember. He might have done when we were very young. Certainly he had no idea that they ought to be brought up. Year in and year out we trembled, awaiting his return from work. On went the old pink dressing-gown and out came the whisky. He sat by his drop-leaf desk in the corner of the sitting-room with the radio by him. Piles of dirty handkerchiefs were to hand for he suffered badly from asthma. Indeed he was always 'ill'. No one, but no one, was ever as ill as he was, but he went on till

[1] Anthony Wagner, Garter King of Arms since 1978; Trustee of National Portrait Gallery, 1973–80. KCVO, 1961; KCB, 1978.

his ninetieth year. All my memories are of him being ill, of us having to be quiet, leave the room, or carry things up and down stairs as he sat huddled in bed.

I think that he only ever took me out two or three times on my own, and that would be fishing on a Sunday morning, which I loathed. I remember making at school a small pouch for him to keep his tobacco in for Christmas. He dismantled it virtually before my eyes in order to use the piece of chamois leather as a duster. All through the war and after he had boxes of black-market chocolates which he kept in a cupboard. He would cheerfully eat one in front of us, or give one to one child and none to the others. Only once did my mother ever get him to go to a parents' evening at Edmonton County Grammar School. I recall coming home clutching a very good report and advancing to show it to him. He pushed it away unread.

My only memory of 23 Colne Road was of life under a dictatorship, my mother sitting, sometimes weeping, in the kitchen. Everything but everything she said was prefaced with, 'But don't tell your father.' For fifty-five years this went on. Only in the last twenty did she get her own back when he had to depend on her. Then she turned and became ironically *his* old self. But even then she ran round him still, crippled as she was with arthritis. What he needed always had to be fetched, carried, cooked. What a marriage! I always remember Aunt Elsie [Bryer] revealing that the engagement had been broken and that she had been sent as an emissary to patch it up. As a teenager I could never understand why in other homes I visited the family did things together like eat, go out, go on holiday. The husband and wife would be loving to each other and to their children. None of that ever came my way.

For a time I hated him. I use that word deliberately. As I grew up I suddenly saw him for what he was, and for what he had done to my mother and to all of us. I hated him for that. In one's teens it was all bottled up. How could it have been otherwise? From time to time it would explode in violent rages when I had endured some awful humiliation. I have never but never felt anger, rage and resentment so deeply, so bitterly, as I did in my early teens.

I blamed him too for what I had become: 'Mother's boy'. For years as I grew into manhood I took his place. I went everywhere with her even into my early twenties. It was all so wrong, and when I achieved the break, my mother never quite recovered from it. On my marriage it was total. But it should never never have been allowed to happen in the first place.

And, yes, I was ashamed of Colne Road. I dreaded anyone I knew

coming there. Father would always deliberately say the wrong thing. The person concerned would then be torn to pieces afterwards. Only as life passes and happiness comes can one have the true measure of unhappiness. Worse than that, only when one matures and sees good homes and good parenthood can one's own childhood be placed into context. God knows, my mother really did what she could. Yes, she loved us boys all, she cooked, laboured, went to work, subsidised us, and really believed in our education, but it was at a price. We were to be *her* boys. No one was good enough for us, none of us should ever marry. The attitude was primeval. As I married last, for years I was held up as an example: 'Roy's sensible,' she would proclaim...

But to return to my father. What did life mean to him? Did he enjoy it? One tries to look with compassion at any human being. I suppose he got pleasure out of some things: fishing and the garden. The terrible thing is that I cannot think of one human gesture he ever made to anyone. I can't think of any help or kindness towards anyone either. It frightens me to write this, but I really can't. I never recall one gesture of love towards my mother. Even birthdays and Christmas were reduced to a few pound notes handed over and an entry in his ledger. Never a kiss, a bunch of flowers, or a box of chocolates. And never a surprise gift. She sounded almost girlish when I spoke to her after he had died. I'm hardly surprised, but it's a false dawn.

31 December. The Nutcracker *Gala at Covent Garden.*

The first night of *Nutcracker* was a triumph. I have never 'supported' Julia through such a hectic, frustrating run-up to a production, in the main beleaguered by lack of time, only ten months, the inertia of the production manager, and the poverty of direction at the Opera House. It was so very beautiful, the first half an early-nineteenth-century Biedermeier vision of Christmas with the great tree, a toy fort, and a doll's house, the dresses so pretty with layers of lace over muslin and ribbons, the great spectacle of the tree growing from six to thirty feet in three dimensions spangled with candles before our eyes and to the astonishment of the audience. There was a magical sleigh drawn by an angel who guided Clara and the Nutcracker through the sky and the Land of Snow to the Kingdom of Sweets. The second act opened with baroque angels standing in the clouds, passing candles one to the other to light the voyagers on their way. Then they passed through a grotto to be greeted by little pages and guided to the Kingdom, a dazzling scene based on an eighteenth-century sugar table decoration. Dowell and Collier danced superbly and, at the close, we saw the clockmaker

Drosselmeyer's shop lifted up into a star-spangled sky encircled by angels.

It was the gala to end all fund-raising galas, raising £600,000 in one evening for the NSPCC. It was also the Royal Family's Christmas outing. The Queen sat through it po-faced as though studying race-horses. Then there was Prince Philip, who is not interested, Prince Andrew who just came, and the two who really enjoyed it, Princess Margaret, who embraced Julia, and the Queen Mother, who, on hearing of it all from us, had asked herself along and was so enraptured that she broke ranks and said, 'I have to see Julia,' which, much to their surprise, she did. Once they had gone only HRH Margaret was left and a raving crowd of the very very rich with a lot of rather good dresses, jewels and tiaras. Men had been persuaded to wear white tie too. The food and drink was nothing but pink champagne and vodka, with caviar in large bowls, smoked salmon, scrambled eggs, and blinis.

The formidable Vivien Duffield had orchestrated the charity side of this event and ranged around on people like a chain-saw seeking new victims to despatch. Turquoise was not a colour for her.

December. The Glory of the Garden becomes the Agony.

Last week we had the first meeting of the South Bank sub-committee. What came out was alarming and I record here that at Lord Howard's memorial service I indicated to William Rees-Mogg that the likelihood of my being interested in the directorship of it was becoming increasingly remote. In the first instance it looks desperately under-funded. Also there is no real control over anything except the Festival Hall, the Queen Elizabeth Hall, the Purcell Room and the Hayward Gallery. The only immediate idea to emerge was to change the Queen Elizabeth Hall into something other than a concert hall. The Festival Hall was over-staffed on a huge scale, something like three times the number of people needed and no Director. The open-door policy was very expensive and could not be gone back on. No information was available and the GLC threatened to incinerate the files. Nine unions would have to be contended with. How this gruesome reality can be matched with a vision of a new Vauxhall Gardens God knows. William Rees-Mogg's idea that an arts festival could be arranged by 1986 was hopelessly ill-informed and conceived.

Meanwhile back at the Arts Council the cash for the Arts for 1985–6 caused understandable outrage (as indeed it has with all the museums). Luke and William seem to me to have been taken for a ride by OAL. They have got the Arts Council to pledge itself to a regional programme

in *The Glory of the Garden* [the policy statement] by a pruning overall, and not got the money to implement it. All that has been dished out is a million for the regional development, leaving a 1% or 2% increase for the rest which means certain death or amputation for others. I was vocal as others were on the absurdity of this policy. We were embarking on new imaginative but wholly uncertain ventures which would only consume more money in the long term and, at the same time, leave the hard core of our clients in poverty or, in the case of some, like English National Opera, facing closure.

1985

Trapped

This was a year where I seemed to move from disaster to disaster. Having striven to free the V & A from Government I now found myself at the mercy of an intractable and capricious Board of Trustees. What happened so eroded me that I wrote very little and what there is traces a saga only of one misery piled on another. In July my Dutch correspondent suddenly died at the age of fifty-two, leaving a wife and two young daughters. An old friendship had gone out of my life and the letters cease. We had our last evening together on 17 April when I took him to see *The Bartered Bride* at ENO after he had been to the dedication of a plaque in memory of Sir Philip Sidney in St Paul's Cathedral. He had spent his academic life pursuing the Shepherd Knight and his friends in the old Europe of the Renaissance. It was a curiously appropriate last visit.

This year I felt under attack and intensely vulnerable, caught in a trap from which there seemed to be no escape. The decision to move on had already been taken the previous year, before any of the appalling troubles with the Trustees began. I was fifty in August and I recall looking back and saying did I want the next twenty-five years of my life, if they were to be granted, to be like the previous ones? The answer was a resounding 'No', not because one was incapable of running the V & A but because I had said what I had to say about that great institution and needed the stimulus of a new challenge. There were also parts of my creativity that had not been used and life was finite.

The most controversial event of the year without doubt, not only for the V & A but for all the national collections, was our introduction of what were called voluntary donations. As the Director, it was my task publicly to carry out what was a Trustees' decision. My own view was that it would have been far better to have gone for a nominal fixed entrance fee for everyone but with certain exemptions. I was overruled, and left to put together some kind of intellectual case for this unsatisfactory way of engendering revenue. On 3 October I stood up before the massed array of the press and other interested parties and gave one of the speeches of my life. The fact that we were going to introduce

such a system may not have been liked but no one spoke up and challenged any of the arguments I advanced. Indeed my most endearing memory of that horrendous occasion was of Sir Ernst Gombrich, opposed to any charge for museums or galleries, coming up to me and saying that if an argument had to be made to do this terrible thing I had made the only one which could be made. That comment meant more to me than any other.

So much of what we were embarking upon had already been set in train anyway by the National Maritime Museum, but with them it was never national news. In the case of the V & A and myself it always was, and we were hounded all the way. At the time, what I said was greeted with horror by the media and the rest of the museum profession. It would seem appropriate to record the drift of that speech for its contents over a decade on form the everyday assumptions of anyone who now runs a museum.

Its theme was that henceforth museums would have to be consumer-oriented: 'Museum-visiting is more often than not associated with some form of discomfort or deprivation. It is also connected with dirt, dust, indifference and closure. The criteria that any of us would apply, without thinking, to an evening at the theatre or in a good hotel are thought not to apply.' Up until recently, I continued, the great national collections had been in the enviable position of being able to exist without taking the consumer much into consideration: 'On the whole we have given the public what they think they should have ... The old concept that a museum opened its doors and that was that has gone for ever. We live in a society where what we offer has to be lined up against what others have to offer. The alternatives to museum-visiting and the information gained through it are far greater than forty years ago. The public expect a quality product and, to be brutal, we do not give it. We delude ourselves if we think that we do. Whether museums like it or not they are now right down in the marketplace.' What was striking, I pointed out, was that the Museum of the Year Award generally was given to a museum in the private sector: 'They have to be consumer-orientated and cost-effective or else they would not survive.' Living through the 1990s, where the keyword for museums and all arts organisations has been marketing, I would modestly cite myself as a prophet of what was to come. But no one thanked me at the time for the message.

Nothing was helped by the fact that Peter Carrington was Secretary-General of NATO, flying around the world for most of the time. When he took on the chairmanship, he, of course, had no idea that this would

happen. In addition, in spite of my frank warnings as to the true nature of the museum world, he had not taken in just how dreadful it could be, and indeed was. The weakness he showed in the face of the machinations of the 'heavy gang' was as much as anything due to the fact that he simply hadn't the time to apply to the job. Later that year he recruited a deputy chairman, Sir Michael Butler, who had been our Ambassador to the European Union. I should add that I was fully aware that such a huge change in the Museum's governance would not settle down into a routine overnight. It would take several years in fact. For all I know it is still going on.

The real tragedy was that the Board had been brought in as essentially a fund-raising one and yet its members raised hardly a penny. What was raised was largely achieved by Julie Laird of the Associates, occasionally assisted by one of the more committed younger members of staff like Joe Earle, who did much to facilitate our drive for reinstating the Japanese Gallery. Instead the Trustees embarked on grandiose schemes which there was not the capital to implement. But it was not all doom and gloom, for this year Sir Michael Hopkins was appointed the Museum's Consultant Architect with a brief to draw up a strategy covering the entire site, and building on what had so far been achieved. He and his wife were an enormous bonus, giving us a vision and an architectural expertise which up until then had been entirely denied while we were wrapped into the Government system. That was a huge step forwards out of the dead hand of the PSA and the design-oriented Trustees, Conran, Jean Muir and David Mellor, were at their rare best. Negotiations were also set in train to set up what was to be V & A Enterprises with the creation of a new shop and an investigation of all revenue-engendering potential. And, thanks to Luke Rittner, I found an excellent caterer in Michael Millburn, who not only produced the capital to fit out a new restaurant but actually opened it by the end of the year.

But there was little real joy in this year. Indeed, in it might be read how the reasons I wanted to work in museums in the first place vanished from my life. Everything was now administration and money. Acquisitions, once the focus of any committee serving a museum, were pushed aside as virtually irrelevant. Certainly, knowledge and scholarship as the Museum's core activities were marginalised. But there were moments of delight and spectacle. On 4 June the Friends staged a Regency Ball at Osterley to raise funds. In spite of torrential rain it was a memorable occasion. Great care was taken over the costumes and rehearsals were held for the period dances. My fanciful

and mercurial young assistant, Stephen Calloway, came with me to Bermans [theatrical costumiers] and together we saw to it that I cut an elegant figure in a silver-grey frock-coat and knee breeches. Nor should I fail to mention the film about the photographer, Fox Talbot, which I made with Harlech Television and which won several prizes. It was paradise to escape to Lacock Abbey even for a couple of days and film, cast as the White Rabbit wearing a white suit and a huge straw hat, drifting through rooms seemingly permanently engulfed by a smoke machine in overdrive. But without doubt the most spectacular event of the year was the fashion show by Gianni Versace. New doors open in life as old ones close. He walked into my office on 4 June, a shy man, but the rapport was instant. The fashion show on 2 October was high glamour with a barrage of media coverage. If I was slowly sinking – and it was a year of savage personal press attacks – at least I was going to go down with all flags flying.

10 January. To Jan van Dorsten. Into a new year.

This was to prove to be my last letter to him.

I can't think where I left the Strong saga. It was a very heavy and vaguely depressing autumn. I felt terribly fed up after eleven years of the V & A and haunted by the thought that all I had to look forward to was eleven more years of the same old people and the same old problems, insurmountable sums of money needed to put right a crumbling building. It will all come out in the memoirs but a change of job was in the offing (it still is if I want it), paid more, and I was tempted. No one knows this and, please, you must never let anyone in England know. However, I seem to have suddenly got a rather marvellous second wind in 1985, got over a mental block and now feel set for another very creative period at the V & A. I am suddenly bolstered by the knowledge that all the Trustees go in September [they didn't], so that changes can be made and the very difficult ones eliminated, and also by the appointment of two heads of department from outside. That has been a bold move, but the place needs new blood and new ideas to meet new challenges, new demands. I am sick to death of them recycling the 1950s.

Autumn was *Nutcracker* at Covent Garden. Even I was green with exhaustion from that. It is a wonderful production (mixed reception), beautiful to look at, set in Biedermeier Nuremberg, a perfect evocation. A great charity gala opening with virtually the whole royal waxworks. The Queen in a bad mood (dramas about Prince Henry's christening).

The Queen Mother had asked herself along – we'd told her all about it and she wasn't going to miss it – broke ranks and rushed to speak to Julia. Princess Margaret threw her arms around Julia and kissed her with delight. I suppose it all went well. I've now seen it four times and it really has settled in.

This meant that we did not get down here until 21 December and inevitably we both collapsed with 'flu colds. We saw no one, which was heaven. We slept and slept and slept...

March. A year of problems.

This continues to be, as I thought it would be, a difficult, negative year. There was a bonus visit to the University of California at San Diego where I lectured on Henry, Prince of Wales, which went well, at a very high-powered conference on drama and society in the Renaissance. What amazed me was how my work was followed and how they wanted to know about the books and not the V & A. What I wrote was read avidly and (together with Stephen Orgel) I am regarded as one of the founders and founts of the new historicist movement in English literature studies.

The *Times* pieces were stopped at number thirty-nine in February. Thames & Hudson are publishing thirty-seven of them, arranged in groups, put together as *Strong Points* as a Christmas book. I have a real affection for these non-academic pieces of writing and had a very nice letter about them from the editor of *The Times*.

The V & A was hell all through February with the knowledge that finance will be spiralling ever downward from a 3% to a 2.8% increase by 1988–9. There were about twenty finance meetings and no sign of any pot of gold. We'll get through 1985–6 but after that we may have to do something radical, very radical. There was a terrible Trustees' Meeting in February in which Carrington allowed Terence Conran and Andrew Knight to behave like Victorian mill-owners. They want power without responsibility and have no feeling or sympathy for the terrible problems of the public sector. Mercifully the lot go in September, or rather could. I am, however, doubtful whether Carrington will, in fact, axe the worst. Meanwhile the Museum continues to be a sea of scaffolding and nothing ever seems to be finished. Charges in the manner of the Metropolitan Museum of Art, New York, will be introduced this year, the first of an across-the-board attempt to extract money from its users. It will not be liked, but the Museum in its Welfare State phase has reached its end. Better by far to face up to the fact.

25 March. I sit for my portrait to Polly Hope.

Polly Hope, the textile artist, is one of life's originals. Enormously tall, white-haired and in her fifties, her face well scrubbed, she was encased today in a blue padded jump suit. Her studio is in Spitalfields, a haven after having been soaked getting there, picking my way past East End rag-trade shops, in the main catering for the Indian community, their windows ablaze with glittering saris.

The studio, which she shares with Theo Crosby with whom she lives, is its own concealed world: a courtyard dotted with assorted sculptures, including her maquette of Edward Lear, a garage studio for Theo's sculpture (he started late in life, Polly said, and he could be good by seventy if he gave up everything else) and also for hers, which are ceramic. The sculptures stood here and there, with a kiln in the corner (the afternoon was to be haunted by the electrician, who never appeared, to put that right).

And then there was the studio proper. This consisted of a vast ground-floor textile store, all in meticulous order, with a bathroom and loo above, a marvellous studio-room, a dining-room, kitchen, and a gallery sitting-room–bedroom. Like all artists' living areas it was totally original. We sat in the gallery on a 1930s revival sofa with chairs scattered with linen cushions embroidered with crinoline ladies, the type of pattern given away with women's magazines in the twenties and thirties. Lacquered chinoiserie Chippendale chairs sat around a scrubbed wood dining-table. The large studio was empty, but had a vista to a handsome neo-classical sofa with, to one side, a dottier sofa of her own invention which was like a little building of fabric bricks over which textile plants serpentined. Sewing-machines stood in serried ranks beneath the windows. We drank, consumed a good soup and a spinach cheese pastry Greek dish. Happiness spread over us as we talked of work, of friendship, of the necessity for privacy, of the choices as one gets older, all the easier, in a way, as life must have focus in the face of less time.

But why was I there? The Textile Department wants a Polly Hope. Polly wanted to do a portrait of Roy. It was a lovely idea. She wanted information, so I sent her a dossier of facts and loves: Gloriana, writing, gardening, running, the V & A, etc. Polly showed me the plan, which was a delight: a half-length in which I stand holding the V & A in my hands, wearing my Sasha Kagan knitted waistcoat. By my side sits Muff holding the Shakespeare Prize medal in one paw. My knighthood is hung around my neck. Behind, in the middle, an apple tree arises flanked by views of the garden and the whole is embowered with old

roses hung with trophies, which we talk about: a picture of Elizabeth I, my running shoes, some cooking implements, and a Valentine for JTO. Then comes the shock: a life-mask. I've been softened up with good food and talk and abundant white wine. I take off my coat, tie and shirt, put on an old shirt of Theo's and lie full-length on the floor and resign myself to being Vaselined and laden with plaster-soaked bandages. But animals come to the rescue. Debussy, the tailless black cat, isn't interested, but the Siamese loves me and curls up on my stomach. I stroke him, while the whippet can be heard bounding around with excitement. And then suddenly it's over. We rushed down to the bathroom and I washed my hair. Never experienced anything like this before. We laughed, and I sat for Polly to sketch my eyes.

She has a rare talent. At one end of the studio there hung her full-length of her son in his Eton suit. Elegant and gangling, standing in a flower-sprigged landscape, he had the sunshine of a blown-up Elizabethan miniature.

27 March. Plotting the South Bank.
The South Bank Working Group is surely one of the few pleasures the Arts Council affords. We meet at GEC's ghastly, mean headquarters where even the quality of the coffee declines the lower the floor. Ronnie Grierson is a lovable whizz of a person. International life is second nature to him, leaving him uneroded and benign. It was a great idea to get him in. Richard Pulford is one of the few brains in the Arts Council, with a bird-like swooping intellect. Dione Digby is Rees-Mogg's loyal handmaiden, her approach to the South Bank is akin to a marchioness who has discovered that the servants' hall is in revolt. Unlike the Arts Council we rush through business. The minutes say nothing, while in fact we bandy names around and intrigue or speculate on the commercial development and transformation of the site. Everything is money, money, money. That is the bore but a vast package is being cobbled together, which means embarking on a development in order to raise funds, and a network of connection is evolving: Max Rayne, Jeffrey Sterling (essential for Patrick Jenkin and Mrs Thatcher), Janet Morgan, Simon Rattle, Joanna Lumley, Thomas Chandos, George Weidenfeld, Ed Streator (US cash), etc. I think the honeymoon will end soon.

24 April. Deadlock with the Trustees.
This is an odd, interim year, when one phase as it were ends and another begins, but the latter has not got fully under way. We find

ourselves progressively involved in deadlock with the Trustees. It is difficult to pinpoint where this went wrong. On 22 April the Trustees had a special meeting at Apsley House for which the papers were carefully prepared, in the main by me: the Act's remit, the decisions taken during their first year, a diagram of the structure of responsibility, the role of the Director as Accounting Officer, *et al.*, proposals for what we should achieve in the period 1985–90.

It was unfortunate that the moderates like John Last, John Hale and Joel Barnett couldn't come. This left those who were that way inclined ready for obliteration by the heavy gang. It started with an oration by me lasting half an hour, going over this material and then into the difficulties: their inability to recognise the boundary between a board of trustees and a board of directors, the reconciliation of their decisions with the Director's responsibilities to Parliament as the Accounting Officer. I performed, I knew, fluently and well but one sensed that all was lost when Conran from the outset seemed never to listen and, I noticed, yawned and leaned backwards. We withdrew. What went on we know not but they emerged at 1.15 p.m. very ashen and quiet. Carrington looked mashed up, Jean Muir subdued and only a little giggly, most not wanting to speak to each other. They had clearly been told to say nothing as to what had gone on, but it was evident that there had been a blood bath in there.

Over lunch Conran behaved like a *sansculotte* triumphant. I put before them again the superb bust by Roubillac of Lord Chesterfield. 'What do we want work by that foreigner for? I know someone who can make a copy of that, so that you'd not notice the difference. Why can't we share it with the National Portrait Gallery and shunt it to and fro?' Thus Terence Conran. This is a man of achievement; yet he's no intellectual and I suppose I make him feel inferior and so as usual he bullies his way through, with all cudgels thumping. My response is not to be drawn, and certainly not to sink to his level of outright rudeness, which continued to flow throughout lunch. So my ploy is always to be witty and informative, deliberately parrying hither and thither.

But what was it all about? God knows. A piece of paper was indeed typed and read. It didn't mean anything really. It left my colleagues and I marooned, unloved, unthanked, shattered and threatened. The relationship between us had snapped. How is one to handle it? In my view one can only throw it back at them. Otherwise we will continue to be blamed for everything they want not being produced at once. If that is the corporate feeling, I'm not doing one thing without one of them there. They will then be tarred with their own brush.

I feel worried about those close to me, for they feel threatened to the degree that it is the intention of the Trustees to throw them out. It is essential to take stock, behave impeccably and act in a way that they cannot fault. It is curious. I have the advantage of the Arts Council and my book projects to keep me happy in some aspects. They don't. One just has to grin and bear it.

9 May. The aftermath of the Apsley meeting and William Waldegrave.
The last ten days after the meeting at Apsley have been a very rough ride. I've now found out what happened. Terence Conran apparently let rip with a fifteen-minute tirade against me in a violent outburst. Well, truth will out, and it is sad to be the victim of such naked rage. I have avoided and shall avoid any passage of arms. There is no point. I've no quarrel. As Julia said, one will get blow-ups like this from time to time and that's what you expect from 'trade'. Sad, because it was me who brought him into the V & A. I have never crossed him, never been other than helpful. I suppose that I must embody so much that all his money can never buy.

But I learned he had been at the receiving end of a series of letters from a member of staff. That is really nasty. I feel very ill-used indeed. So now we don't do one thing without referring it to a Trustee. That's OK. They'll get bored with it in the end. Christopher Frayling it was who told me what happened and it was not pleasant. I must keep my head down but...

Meanwhile the show struggles on. William Waldegrave[1] came to lunch, thinner than ever, a good intellect and an ambitious politician with his prospects slipping as he sees that he would be ready for top office only after the next election. We ranged over most arts things. He, like me, was uneasy about Rees-Mogg at the Arts Council. It had not been a success. It's no use putting in there someone who feels uncomfortable with art and who, when Peter Hall comes to see him, only talks economics! That is unbelievable.

If the organisational review at the Arts Council goes through and dismembers the Art Department I shall fight to get it hived off and joined to the Crafts Council. That could prove a very good solution. Grey apparently has begun to prise open the Treasury on the subject of tax incentives for arts support but it sounds a weary, long path. I was asked to think of a new chairman for the Royal Fine Art Commission.

[1] Conservative MP for Bristol West; Minister of State for the Environment and Country-side, 1985-7, to be followed by other Cabinet posts.

Conran has been canvassed. Needless to say I put the boot in that one! He confirmed me in my view of Ronnie Grierson. There'll be eighteen months of explosive activity and then collapse. Thought must also be given as to who replaces William Rees-Mogg. It is only eighteen months off.

13 June. A really dreadful Trustees' Meeting.
Trustees' Meetings have developed into very unpleasant affairs. Initially they were just staff-bashing ones but, as I have now mastered the technique of involving them up to the neck in what they are interested in, they now bash each other. They have proved a real collection of weathercocks. They don't even remember from one meeting to the next what they agreed or said. Today John Hale did a complete U-turn on admission charges, so did Carrington. He realised what a failure he'd been. He hardly seems engaged in the place, although too much of a gentleman to make his exit from it as a failure. He was completely flattened by Grey Gowrie, who told him that Getty had given the National Gallery £50 million. In the taxi back from White's he said he had been a failure. He has. So have all the Trustees.

The closed session they had must have been rough as they were subdued when we joined them and they had clearly been slanging each other. Peter Carrington had also slammed at them for producing no money and made the two who raised money for themselves or others, Conran and Princess Michael, into a new fund-raising committee. It was the usual wretched meeting. Nothing but bitter and rude complaints, just short of abuse. No word of gratitude to anyone, none. It left me deeply depressed. One just has to learn to detach oneself from the crudity of it all.

18 June. An unwarranted attack.
After a weekend of trying to cope with the V & A on the telephone picking up the debris, I returned to Monday's *Evening Standard*, which had a whole-page spread on the theme 'Has the Strong magic gone?', lunging into the dreariness of the Museum, its sad displays, filthy restaurant, lack of signposting, *et al*. No one else attracts these pieces, and they could as easily have been written about the National Gallery, the British Museum or the Tate Gallery. It just so happens that we were alighted upon. In a way I'm not surprised, for there is no doubt that for the next eighteen months we have to go through a major dislocation in building terms in order to put things right. Michael Darby [the Deputy Director] proved a hopeless emissary to the press. I could have

hit him for what he said. Everything is at its worst: rows and delays with the PSA, curatorial inertia, Trustee interference, and lack of commitment in areas. Delays on everything. No one single control over the whole building. Everything goes back to the PSA. Disaster follows disaster. Nothing is ever finished, never on time, the work is inferior and the cost unbelievable. No doubt the Royal Fine Art Commission will throw out the quadrangle scheme [the Pirelli Garden] and one more blow will fall.

What irritates me is that it was about two years ago that this great series of works began: the Henry Cole Wing, the restoration of the Cast Court, the redisplay of the Dress Collection, the restoration of the Italian Cast Court and the front entrance hall. Then there is to follow in sequence the Medieval Treasury, the Japanese Gallery, the Indian Gallery, the reopening of the vista laterally across the V & A. A new restaurant in fact opens in September. What more can I do? . . .

In fact all these works went on to be done, only the Indian Gallery followed under my successor.

22 June. The Getty gift.
I rang Adrienne Corri[1] to ask her to *Ariadne* while Julia was in Spoleto and also to catch up on her art gossip. Needless to say I screamed about the Getty gift to the National Gallery. Adrienne was a friend of Paul Getty, and even more of his daughter-in-law, Talitha. Grey Gowrie was at Eton with Paul junior and that was the key link. The original amount was £20 million and not £50.

24 June. Aftermath of the attack and a Bernini.
Someone was put up to that *Evening Standard* article. Its author wrote a very curious letter to the Deputy Director in which he referred to the fact that he had never seen me, but that he had been warned not to 'as the executioner should not meet the eyes of his victim'. I have never known a journalist in a letter to admit so much. Three evening issues of the *Standard* have carried letters all pro me. Very unusual.

Well, we are to get the *Cardinal del Pozzo* by Bernini. Simon Howard[2] wrote today offering it to the V & A. I understood from Hugh Leggatt that it will be offered for £3 million. The Heritage Memorial Fund is

[1] Actress, who first appeared in Jean Renoir's film, *The River*, based on a novel by Rumer Godden.
[2] Son of Lord Howard and heir to Castle Howard.

likely to cough up the amount and Gowrie, as usual, is to be covered in glory.

20 *August. Carrington wants to go.*

Three days before my half-century. This has been a really ghastly year. Julia has only had Menotti's[1] *The Consul* to do for a pittance with no prop-up. That has left her low, although a visit to Menotti in Spoleto cheered her. We were also cheered by our cruise around Britain and up to Bergen and the fiords. I had to lecture, but we were very well treated with a penthouse and every luxury, which was bliss and very happy.

Carrington came to see me today, very low and mopy, probably because someone has written a book attacking him. We are now at the end of the road. He knows that he has been a flop. He was so good at the start, marvellous at the charm, the up-front, beaming and a-twinkle. But this year it has all been beyond him. He caves in every time to the heavy gang. He was completely overruled by them at the last Trustees' Meeting when he was forced to accept hard-line voluntary donations. He sits there listless and flapping around, with no edge and not an original thought and no help at all. He is a fair-weather prodigy. He wants to get out by Christmas and push in Sir Michael Butler, whom I don't even know.

Summer. In and out of Vogue.

The saga around *Vogue* started in July when I was asked to judge a *House & Gardens* competition. I knew that they had been searching for a new editor for *Vogue* so when Bernard Laser[2] appeared I asked him what was happening. 'No one,' was the reply. Charles Wintour's[3] daughter in New York was offered it, but no job with a comparable salary and prospects could be found for her husband in this country. Suzy Menkes[4] had been talked to. Beatrix Miller had said, 'What we want is a young Roy Strong.' I said, 'What's wrong with an old Roy Strong?' That suddenly moved the conversation in the direction of a serious meeting and talk. I told Julia, who said that when Beatrix had come to dinner with us and said what she wanted was a man to succeed her she was thinking of me. Julia had not told me at the time but she knew that sooner or later *Vogue* would be offered to me, and this is the

[1] Gian-Carlo Menotti, Italian-born American composer and founder of an international music festival in Spoleto.

[2] Condé Nast executive.

[3] Journalist and long-time editor of the *Evening Standard*.

[4] Fashion editor of *The Times*.

first time that Julia has ever said that a job was right.

Next day I was due to lunch at *Vogue* and arranged to see Beatrix before. I told her of the conversation and said that I was serious but only if she thought that it was right. She lit up, was thrilled, and said that only Tony Snowdon or I could do the job and how she couldn't bear to see it go to someone she didn't respect.

The next step was breakfast with Bernard Laser at the Connaught about a week later. That certainly went very well. I didn't leave him with any illusions that I was a museum monk. He's very bright. I believe that I have 85% of the ingredients they want but on a wider scale than they have ever had. There is not one magazine Condé Nast run in this country into which I could not have an input. From the social connections to the 'eye', to the knowledge of photographers and familiarity with everything going on, I must be pretty unrivalled. But it requires a leap of the imagination by the owners of Condé Nast in New York and even more of the Chairman for Europe, Daniel Salem. It is very difficult to predict how this one will run. No one, but no one, knows except Julia, Beatrix and Bernie Laser. Beatrix rang today and said that there was another stumbling-block and that Bernie would ring me next week.

Unlike the South Bank job I feel very composed about this. I don't feel any sense of major dramatics. Maybe this is a good sign. It would be very foolish to expect the job and prejudge the issue. One must only sit it through. A lot will depend on the reaction up the line to what must be a most unlikely and intriguing candidate. Even if it doesn't come off one will have learned a lot. The time for a move is right and I really believe that if this fails I must gently alert certain people to think that I am available, and not a V & A fixture.

[Added later:]
All of this fell through because of the pressure of the European Chairman, Salem, and Alex Liebermann in New York to put in Anna Wintour, who suddenly became available and was in-house at American *Vogue*. After the event I felt curiously un-upset about it.

15 October. Disillusionment and the Bernini.
This year continues its weary way. *Strong Points* was published last Monday. It is the only book that I have ever written for which there is to be a Foyle's Literary Luncheon, a platform performance at the National Theatre, and an interview on *Bookshelf*. That might perhaps give some lift to what, as predicted, is a most strenuous and difficult autumn. I

have no Deputy Chairman and Carrington is nowhere to be seen. It has already appeared in the media that he is to go. The V & A has been left rudderless for all of this year. The staff have no confidence in the Trustees at all. Why should they? The Trustees barely appear, do not support or appreciate them, and naturally they feel disillusioned and embittered and resentful about people who make sweeping decisions affecting them without any evidence of care or thought for them. All the indications now are that 'admissions' will have a stormy ride. Even that some of the Trustees are trying to dodge. It is their policy and they have to argue it out with the public and the media. It is not my role. When it comes to the interface they all want to slip away. The Board has changed its remit to A. Y. Grant [the firm investigating the introduction of charges] no less than sixteen times in three months. The lack of *esprit* and confidence is very worrying and they are totally indifferent to, or oblivious of, it.

The marvellous lump of white marble we call the *Cardinal del Pozzo* by Bernini now sits in my office, indeed has done for six weeks, while emissaries from the National Art Collections Fund, the National Heritage Memorial Fund and the OAL come to see it. Our package so far is £500,000 over two years and the NACF came through with a quarter-of-a-million. A few odds and sods might get that up to £1 million which leaves £2 million for the NHMF and Government to fight out. Martin Charteris saw the bust as his weapon to up the Fund's finances, so that all we do is wait and see how the bashing goes. I would think that we could get it in the end but I will not do an appeal.

7 October. The South Bank Board is launched.

The Monday before last this curious new body was launched at the British Film Association in Piccadilly. I don't really think that Ronnie Grierson should ever be let loose in public. Although we all sighed a sigh of relief that he stuck to his script, he exudes a combination of Mr Fixit with the predatory smile of the Cheshire Cat. The media were anti and the conference was a flop. Hardly surprising, because there was nothing to say. No, we had not got the money, nor did we have any inkling that Government would produce it. Grierson is a big tough man but he really must begin to respect the decencies of public life and stop offering to resign every time he doesn't get his own way. He must also stop telling the Board who is going to get particular jobs before he even sets up the so-called open competitions for them.

4 November. *The launching of Voluntary Admissions.*

The press conference went off smoothly with over four hundred present and a largely rabid audience was silenced as I spoke. On the whole the media have gone along with our policy, which is some small triumph because until I sat down and wrote that speech the Trustees had no policy. On the day it began there was the usual rent-a-picket from the left wing, the 'stars' [including the playwright Colin Welland] were photographed by the media and went. It all blew over, bar leaflets and

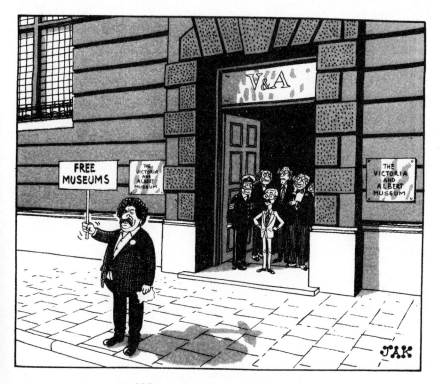

"I'd like to see someone trying to get into
one of his plays for nothing!"

stickers, by midday. I did a stream of TV, radio and press. The irony at the end of the day was that £700 was taken! I'd have been glad to get £150 after all those demos. The firm who arranged it were very satisfied. It went off in a way far exceeding expectations. The barrage of media on the V & A must leave every other museum gasping.

11 November. Truth will out.

The media petered out at the weekend in an explosion of radio and TV. More interesting was the long talk I had with Mary Giles on Sunday. Yes, there had been a strong move to get rid of me by a group of Trustees earlier this year. Gowrie too, I was told, wished this to happen and to put in a former V & A museum assistant who now worked for the Getty Museum. 'He was no friend to you,' Mary said. Mary, however, had got on to Alexander Glen who rang Carrington who is supposed to have put a stop to it. This has been a bitter year, full of devious and wretched people. Over donations, my speech put the whole policy together. The Trustees had none and would have been torn to shreds. It was me who had to carry the whole thing. No Trustee lifted a finger, let alone rang me to sympathise.

1986

The Decision

To all intents and purposes I was the victim of my own success. A meteoric career was suddenly seen to lead to a dead end. I needed to move and change direction but to where? The only parallel career had been Kenneth Clark's, but he'd been a millionaire and not an impoverished scholarship boy. I needed a job and an income. For the first time in my life I found myself suddenly cornered, not knowing how to get out. One by one any avenues of change within Government service closed; I was foolish enough to cherish a belief that those who had raised me so high might have taken some interest in my fate but I was mistaken. And then there was one's own vanity, which demanded that whatever happened there should be a progression to something appropriate. In retrospect it was extremely foolish of me to have turned an eye towards the National Gallery but in the circumstances understandable. It was, after all, my predecessor Sir John Pope-Hennessy's one unfulfilled ambition to be its Director. Mercifully the messages were negative and in the event they made a brilliant appointment in Neil MacGregor. But for me when that door closed any further life within the museum profession was effectively at an end.

Of course, I did hope that something else might have come my way but in the Thatcher era the time when those who had achieved in the Arts were accorded appointments had passed. Instead Government looked to the world of business, and the Deputy Secretary to the Minister for the Arts made it clear to me that I must nurse no hopes in that direction. So the great leap into the unknown had to be made. In that, the debt to my wife can never be repaid. She recognised that my creativity and the V & A had parted company and the strain was telling. She never once tried to persuade me to do anything but make the leap, knowing not what lay in the abyss beyond, whether in fact I could make a living, or how it would affect our circumstances.

Anyone who has had to make a decision such as this knows that it is never an easy process. In my case it was protracted, but once finally taken was never looked back on or regretted. I recall exactly the moment when it became irrevocable. On Tuesday 21 October I was

flying back from Venice, having taken a group of the V & A Friends on a cultural tour. Julie Laird, the Organising Secretary, by then a trusted friend, also came. On the plane talking it over the havering stopped, and I said that immediately on my return I would sit down and write to Peter Carrington. That I did, asking him to respect my confidence, which he did. I cannot fault Peter in his handling of my departure. Our relationship had started so well but it became ill-starred. Perhaps, I thought, it was my fault and it would have come to greater fruition with another Director. He once said that the trouble with me was that I was 'a museum director and a character' and that wasn't allowed. No one was to know of my decision to resign until the New Year, and the secret was kept. I knew that in order to make my exit I would have to deliver all the refurbishment schemes in hand in the galleries, inaugurate the Italianate Pirelli Garden in the quadrangle, open the Theatre Museum, and reopen the main Museum on Fridays. All of this by the close of 1987, when I left, had been achieved.

In a sense I'd had enough. I'd loved museums since childhood, but now progressively they came to pay tribute less to the god of knowledge than to that of mammon. The art historical and museum world with all its internecine jealousies and perpetual intrigues increasingly palled. How wonderful it would be not to be every other art journalist's perpetual whipping-boy, not to deal with up to a hundred files a day pouring through the office, not to forever appeal to the rich for money or to those in Government who might influence this or that, not to raise money, not to deal with intractable and ignorant Trustees, not to be expected always to do a star turn, speak, charm and entertain. Later, after I had left, I found myself sitting next to the remarkable writer Anita Brookner at dinner. She had once been at the Courtauld Institute of Art and part of that world. Virtually her opening comment to me was, 'You have always been the victim of envy.' But later came the more significant exchange. I said to her that I didn't think that I could face writing art history again. She looked at me with those extraordinary eyes and said, 'But that's wonderful. For the first time in your life you're free.' How often that sentence has returned to my mind and how grateful I have since been for its articulation, thanks to that chance encounter.

I was indeed to be free but before emancipation there lay ahead eighteen months of business which had to be finished. I was not as yet demob happy. No one within the art world or the Museum itself had any inkling of the scenario ahead and that my reign, if such it had been was drawing to its close. For those outside I must have still seemed ar

exotic bird in a gilded cage when I was in fact trapped in one of iron with apparently no gate through which to escape. The absence of the correspondence to my late Dutch friend, and the introspection which set in, means that there is little to read of the rhythm of country life which still went on. The diary drifts increasingly towards being an agony column.

As a corrective, I turned the pages of the three volumes of scrapbook for 1986 and they tell a far happier story, a side that should not be forgotten. In the New Year's Honours Julia was given a CBE, a great distinction for a theatre designer. In May I made my first visit to Gianni Versace at his villa on Lake Como and told him how he should rearrange his garden, a signal of the life to come, reinforced in September by the publication of *Creating Small Gardens*, which attracted huge coverage. Perhaps it was the eccentricity of a national museum director producing such a book, but the fact that ten years on it is still in print in six languages and that a quarter-of-a-million copies have been sold is testimony that it must have filled a genuine need. And what I consider to be one of my finest academic books was published, *Henry, Prince of Wales and England's Lost Renaissance*. There was also the conference on British design at Aspen, Colorado, where again I spoke on garden design. At the V & A the first of a succession of rabbits began to be pulled out the hat, for on 12 November the Medieval Treasury opened, the start of the series of openings which no one as yet knew signalled my departure.

14 January.

There is no doubt about it, 1985 was what is known as a 'bad year'. We just moved from drama to drama. The last three months nearly finished me off, a blaze of publicity as I, single-handed, carried through a very controversial policy. I have no doubt that it will not be long before I am proved to be right. There are stirrings on all sides of those who will follow. The pickets are still outside the V & A. What I cannot gauge is how much it has damaged one's reputation. In terms of Government and the Trustees there is no doubt but that it has upped it.

This entry, however, is to chronicle something which may never happen. For more than a year I have written that my work at the V & A has come to an end. It will finish on 23 April 1987 when the Theatre Museum opens [it was actually to be later]. A new and unexpected door opened with the rumours of Michael Levey's retirement from the National Gallery. I love that gallery and believe that I could do the job there very well. Julia agrees. Even before his retirement on 1 January

1987 was made official I had spoken to William Rees-Mogg, who said 'Yes' to being a referee and that he knew Stuart Young on the Board. I wrote to Arnold Goodman and to Martin Charteris asking them. Then last Monday, 6 January, came an unexpected lunch with Peter Carrington. He was at his best as I opened my heart to him. I recited my closing litany: thirteen years and the final acts – the Henry Cole Wing, the National Heritage Act, the Five-Year Plan [the strategy to redisplay the collections adopted by the Trustees], Donations and the Theatre Museum. His reaction was absolutely a hundred per cent. It was astonishing how at once he grasped my dilemma and the impossibility of continuing for up to twenty-seven years here. He rang me yesterday saying that he had written to Jacob Rothschild and would also write to Nico Henderson, Isaiah Berlin and to Richard Luce.[1]

Meanwhile last Thursday [9 January] Richard Wilding, of OAL, came to lunch. He was very straight and, as Carrington agreed, I told him. He again was quite extraordinary. He perceptively said that once someone realised that they had reached a finale it was self-fulfilling. Yes, he supported a move too, and clearly held me in high esteem. It will be interesting to see what happens. Mercifully my name is the only one not floated publicly so far for this job. The Trustees of the National Gallery are trying to persuade the Civil Service Commission to let them advertise to include the United States. I can't see an American Director of the National Gallery appearing, for instance, before the Reviewing Committee objecting to the export of a picture to the US. I could offer a way out for everyone. My feeling is that I will know quite soon about this. I feel strongly that even if rebuffed by Jacob Rothschild I should still put in, as those Boards should be fair, and one's curriculum vitae and achievement which I had to cobble together are pretty remarkable.

15 January.
I went to see Arnold Goodman for breakfast. Nearly all of it centred on the National Gallery and I received very good advice. Arnold warned me that whatever I did I must never put myself in a position of being known to have been rejected as it would prejudice my chances of any other post. Very wise. He thought that I would be marvellous for it, yes, the V & A was a more important museum, the National Gallery more prestigious. However, it could only move if Jacob Rothschild

[1] Richard Luce, Conservative MP for Shoreham, 1974–92, was Minister for the Arts 1985–90. Vice-Chancellor of the University of Buckingham since 1992. Knighted 1991.

made the first move, so that I could say that I was approached by the Chairman. He thought it dotty to appoint an American and that my disadvantage would be that I was too powerful. It was important that my name be casually dropped to Jacob Rothschild and he would sound it out *en passant* with Isaiah Berlin and Grey Gowrie. I said that Peter Carrington had written all over the place and that I could not control him. He thought that Ronnie Grierson was important both for Jacob Rothschild and for his influence with Mrs Thatcher. He also thought it important that I had an academic referee (Julia thought of Gombrich). I returned to the Arts Council and caught Ronnie Grierson. There it rests. It will either move or die the death this week or next. I don't think that I have done anything to compromise myself other than be seen to float my name.

23 January. The Bernini saga.
This is a rum story. Listed by the V & A as the third greatest piece of sculpture left in private hands next to the Donatello [the *Chellini Madonna*] and the Michelangelo tondo, it was offered to the V & A for £3 million by Simon Howard. Three million was needed by the Howards to put the estate in order subsequent to George Howard's death. We were told that it had been valued at £7.2 million and that, allowing for tax, etc., it was ours for three, a stupendous sum. Most of last autumn was spent thrashing around on this: £500,000 over two years from the V & A, £250,000 from the NACF, £10,000 from the Pilgrims, £100,000 from the Associates of the V & A, etc. We've now reached £1,125,000. Everything hung on the NHMF, which was 'broke'. We learned this week, after pressing hard for details on the Howard lawyers since last September, that the bust had never been valued and that the £3 million came out of Simon Howard's head. We are now back to square one with only a week to go to raise the money. Informal contacts with the salerooms indicate a much lower price.

28 January. Bernini again.
Today a valuation came through from Sotheby's which confounded the idea that it should be a lower one. It was for £7,500,000 which, with a tax liability at 60% and the *douceur*, gave a price of £4,250,000 to the V & A. We circularised the Trustees immediately, advising them against proceeding with the negotiations. We cannot 'put all our eggs into one basket', as we do not have the resources of a fine art museum and have a responsibility for design across the board. Having got this out on the 27th there was a sudden reversion by the Howards back to £3 million!

Once more we had to inform the Trustees. It will not, however, affect the main issue.

29 January. Henry Moore's altar.

I gave evidence at a Consistory Court at St Mary-le-Bow in favour of Henry Moore's circular altar at St Stephen Walbrook. It is a beautiful artefact placed beneath the dome and enhancing Wren's spatial values, essentially those within the tradition of the Renaissance centralised church. I was grilled for three-quarters of an hour, in particular by the pedantic man conducting the case against the altar remaining. Confrontations like this do great harm to the conservation movement. As I stated in my written evidence: 'There is a fair balance to be kept between conservation and mummification.' In cases like this, that is not being observed.

10 February. More on the Bernini and Voluntary Donations.

We heard that the National Gallery of Scotland has decided to go for the Bernini. It will be interesting to follow the fate of this one. The odds are that at £7 million it will go abroad. Last week the unions did their worst, demonstrating to the television cameras on the third anniversary of the introduction of Voluntary Donations. There was a lot of bad newspaper coverage on the halved attendance figures. I was dragged out of the Lord Privy Seal's Office to do the one o'clock news and also lunch with the Minister for the Arts for BBC TV news. Having embarked on this course, the Trustees must be seen to stick to it, however unpopular. It is a worry that it has been savaged, even by the *Mail* and *Telegraph*.

The budget arrived from OAL for 1986–7. It is not good news apart from the change to Grant-in-Aid with a run-over of 2% on general expenses and one of 10% on annual receipts. Otherwise as far as I can make out from the oceans of paper it is only £300,000 more at the optimum. There is no doubt that this Government is starving museums. It is difficult to be loyal as we spiral in agony into poverty. One feels helpless.

13 February. Star-crossed.

Yesterday, Ash Wednesday, must represent a new low as our ill stars stay beaming down on us. Denys Sutton's vitriolic editorial in *Apollo* demanding my resignation appeared, and was pressed into my hands so was an anti-V & A editorial in the *Burlington Magazine*. Someone in the PSA had leaked Pirelli's sponsorship [of the quadrangle garden

to the *Standard* and I came home to find that Julia was not doing the *Winter's Tale* with the director Terry Hands.

Odd about strokes of ill-luck. By now, after a groan, I just laugh. How the V & A will survive the summer I don't know, with massive building disruption hand in hand with a campaign to attract visitors. The print media, Labour, and the unions are solidly against us. The pickets outside are now in their fourth month. On the other hand we are on target for cash, the building programme is now really moving, and anything on television or radio is favourable. No, the key is to have alienated the whole arts press, which is a very tiny interconnected group. I must just sit it out. I said to Christopher Gibbs, who came to lunch, I am doing all the *unpopular* things that have to be done in the late eighties in the same way that I did all the *popular* things that had to be done in the late sixties.

19 February. Bernini again and Richard Luce.

Brian Lang[1] has been in contact with me, off the record. Timothy Clifford[2] has asked the NHMF for £1.5 million. Lang knows that if we had been granted that amount we could have bought the Bernini and is working hard to that end. I pointed out that we had said and written nothing to indicate that we were not still in the running.

Richard Luce, the Minister for the Arts, came to lunch. He is a shambling, straight-up-and-down kind of man, with a lot of careful thought going on behind that face. He reminded me of Paul Channon but a bit more cerebral, and no sign of the almost devious glamour of Gowrie or the high camp of Norman St John-Stevas. He seemed impressed by all we were up to, indeed he definitely was. Suddenly he felt very at home over lunch and let his hair down about the immovable attitudes of the art establishment. There is no doubt but that this granite quality worried him or that he was shocked by the squalid backbiting of this world. He really was concerned as to how to shift views from a set belief in the eternal handouts, in light of the fact that the basis of funding and indeed the whole arts philosophy had changed.

In the evening I went to address the Tory Back-Bench Committee on the Arts and Heritage. About a dozen appeared, but interesting ones. I made them rather ashamed that they had not been more vocal in support of the V & A. I put my case over punchily and left feeling

[1] Dr Brian Lang, Secretary of NHMF, 1980–7; Chief Executive and Deputy Chairman of the British Library since 1991.
[2] Director, National Galleries of Scotland since 1984.

that I was the hero of the hour and, whether I was or not, I needed the 'lift'.

23 February. Bernini drags on.

More pieces towards the Bernini saga. After we had been forced to withdraw, Scotland made a bid in the form of Timothy Clifford. He had recently caused his usual media stir by attempting to buy for £7 million Mantegna's *Lamentation over the Dead Christ*, sold to the Getty Museum. By this time Timothy Clifford had alienated so many people north and south of the Border that this was a lost cause before it had even started, plus other factors such as the eleven Mantegnas already in the National Gallery, the condition of the picture, and the ridiculous price. When he failed to get that, he said both in the newspapers and on television that he would persuade those who had promised to donate to switch their gift to the V & A and the Bernini. He then swiftly denied this.

At any rate when we heard that Scotland was after it, and that Timothy Clifford had rung Simon Howard, arrangements were made to send the bust to Edinburgh. No sooner had we done this than two journalists informed the Sculpture Department that the Trustees of the National Gallery of Scotland had declined to purchase it so we sent it back to Castle Howard.

The appalling fact is that the public statement by those Trustees was apparently deliberately false, for they decided to raise the money behind the scenes. All of this came to the surface last Thursday when I was rung from the Arts Office and told that Government had passed over to the NHMF £105 million. That was a cruel stroke of fate, because if it had come some four weeks earlier none of what has ensued need ever have happened. On the advice of Brian Lang of the NHMF I had already reactivated our case and subsequent to the announcement I rang round to pursue it. Sir Peter Wakefield of the NACF who had pledged £250,000 nearly dropped the receiver in horror when I told him Scotland's official line but it was clear that they had already made over their money there I sent him this in writing, for I had written also to Martin Kemp, who is a V & A and National Gallery of Scotland Trustee.

So this week no one knows what will happen. Much will depend on Simon Howard, but I guess even more on the NHMF, who do not love Clifford after his onslaught against them over the Mantegna, but who must publicly do the right thing. I also got Carrington to ring Martin Charteris [the Fund's Chairman]. It is touch and go . . .

10 March. The Bernini chase.

The next move in the Bernini saga was for me to write to Simon Howard asking for the bust to be re-offered, as Scotland had turned it down. It was a very carefully worded letter recalling the dilemma which we had found ourselves in, that none of this would have happened if Government had come through with the money a month before, and reminding him in quotes of Scotland's withdrawal and of all Castle Howard owed to the V & A. It was a very good letter and difficult to wriggle out of. It went Datapost and Simon Howard sat on it for a week trying to put together a reply. When it arrived, it was a bland and cryptic two paragraphs, the second congratulating us on the Pirelli Garden sponsorship, the first saying that the door was at present closed as the bust was on offer to 'another body', not named. We all know that this is the National Gallery of Scotland.

11 March. Further twists in the saga.

There is a new twist in the Bernini saga. Carrington and Charteris talked on the telephone and from this it emerged that the NHMF won't give more than £1 million so that the proposal now is to look for joint ownership: £1 million V & A and £1 million Scotland and £1 million NHMF. This would certainly confound the art world and highlight the inadequacy of the funding of any institution to cope with works of art on this scale.

26 March. Yet more.

I rang Brian Lang to find out what had happened over the Bernini and was told that Scotland would not play ball on a division of the Bernini bust between the two institutions. Lang had even been to see the Chairman of the Scottish Board. He admitted that it was a squalid saga. He went on to indicate, and a later call from Lord Charteris suggest, that if we could raise £1,725,000 we would be offering in excess of Scotland and he would hope that the Fund would give £1,250,000. We had already cobbled together £1,600,000 with authority from the Trustees and, Carrington being submerged in crises abroad, I got clearance from Michael Butler. It meant mortgaging £700,000 from the 1987–8 Purchase Grant but that could be got round by buying it in stages or by the NHMF agreeing to 'loan' us the money until we paid them back.

27 March. The end of Bernini.

On Maundy Thursday I was rung by Lang directly after the NHMF meeting, saying that after a long and terrible meeting and the most difficult decision that they had ever made they felt duty bound to offer the £1.25 million to Scotland, who now had to raise the rest to fill the gap. Lang said that they had hoped to offer me some good news. Mercifully I am stoic. But what a week.

It was one which opened with the devastating flooding of a crypt store and a barrage of media, thousands of objects marooned in four feet of water, a major conservation rescue, visits by Ministers, etc. The V & A is never, never out of the news, the spotlight never moves as we make our way from one drama to the next. Yes, I think stoic is the right word. We're on track but it has been a perfectly horrible few months. How the Bernini will end I don't know.

9 April. A vitriolic attack.

The Sunday before last there was what I thought was a really filthy attack on me in the *Sunday Times* by the Arts Editor. The latter had hawked the commission around asking Simon Tait[1] and then Marina Vaizey to write it. Both refused. It is depressing. Carrington was furious and his reply is to be published. All the same the endless onslaught is debilitating. On the other hand, no other Director has been photographed by everyone from Beaton to Brandt or caricatured by everyone from Lancaster to Scarfe! Still, to be blamed for everything and have one's achievements ignored is appalling, let alone the personal abuse.

22 April. The Queen's Sixtieth-Birthday Gala at Covent Garden.

Carrington replied to the *Sunday Times* article. I drafted it, but he put me in as 'a man of vision and an outstanding scholar'. On 14 April we came out of the Bernini run. I really felt that we had been treated very badly.

On the 21st we went to the Queen's Sixtieth-Birthday Gala at Covent Garden. The flowers were rather horrid, fussy pink garlands and loops of blue ribbon tied in bows. In a way we were an adjunct to a TV spectacular with a mixture of linking readings by Judi Dench and Paul Eddington, bits of *Romeo and Juliet*, *Daphnis and Chloë*, *Rosen-kavalier*, *Birthday Offering*, et al., interlaced with solos by Jessye Norman, Carreras and Domingo, who looked fat and florid. There was also an ethnic quota in the form of a Gospel Band. The real coup

[1] Former public relations officer, Victoria and Albert Museum.

however, was Fred Ashton's *pièce d'occasion* with which the evening opened, a *pas de deux* inspired by a glimpse of the two little princesses playing when they were children, like a Dorothy Wilding photograph brought to life. All the world and his wife were there, including the whole Royal Family, and Martin Charteris agreed with me when I said to him at the end: 'She enjoyed it more than she thought she would.' We went after to a buffet supper given by Adrian Ward Jackson,[1] stuffed with familiar faces, where I learned from Vivien Duffield that the Tate was opening its new wing on the same day as we were to open the Theatre Museum and from Jocelyn Stevens[2] that the RCA wing will not seemingly come our way.

23 April. One door closes.

When Carrington came in on Monday I thought that it was time that something was communicated [about the National Gallery]. He said, 'I don't think that this will happen.' So I replied, 'That to me means that something has been said which people are reluctant to communicate.' He said, 'Jacob Rothschild says that it won't go down with the Trustees.' In an odd way I don't really mind. Three times I have attempted to move in the last two years. There is no future in fuelling frustration. I, in fact, feel very perky at the moment. The books are appearing, new intellectual directions are being cultivated and a lot of good things are in the pipeline for the V & A. And, as one gets older, one gradually moves towards being the person longest upon the scene, however irritating that may be. I have already been a director of two national collections, longer, I think, than anyone else in this century and twice as long Director of the V & A as anyone since 1945. Non-frustration is a good resolution...

8 May. Bernini buried.

Last evening I went to Dulwich Art Gallery for a reception. I saw Brian Lang and said, 'I'm glad to see that the Bernini sank without trace.' He replied: 'Martin Charteris leaked Scotland's acquisition of it deliberately to the *Guardian* so no one else would touch it.' I was contacted last Friday by my office which had been rung by Christopher Gibbs to warn me that Getty had given £200,000 towards Scotland buying the bust. Thus ends a squalid saga.

[1] Art dealer and a friend of Diana, Princess of Wales.
[2] Rector and Vice Provost of Royal College of Art from 1984 to 1992, when he became Chairman of English Heritage. Knighted 1996.

19 May. The Chelsea Flower Show.

We ended up going with Prince Michael of Kent through the unlooked-for intercession of Rosemary Verey. The sun shone and we arrived at Kensington Palace to find that the other members of the party were Mikki Neville and Norman St John-Stevas. I said to Norman how sorry I was that he was leaving the House, to which he replied that he was not leaving the House but the Commons, indicating I suppose a peerage in June! How he'll love it. He's very mellow these days. Princess Michael was in America and doing what was never revealed. Prince Michael is an amiable chap with his affectionate sheepish face and kindly eyes peeping out of a sea of beard. At any rate he took Julia and me into his car, to our surprise, and off we went, with outriders driving on either side of the road.

On arrival we were faced with a line-up. However, in we got, only to be very shortly aware that other royal posses were circling: the Queen, Princess Alice, Princess Anne and Princess Margaret. Prince Michael's real interest was not in flowers but mini-tractors and circular saws. It was, in fact, the best show for years with an interesting literary garden based on a passage in *Jane Eyre*, all divided up into little plots, a topiary display with spirals and pyramids, an eighteenth-century garden, good for its plants but kitsch Georgian, and what was called a Fabergé garden with huge standard bays with twisted trunks costing £1,500 each imported from Holland. We all finally foregathered in the tent where drinks were served and we sat around at little tables. There was a comic side to this because every time we settled we all had to stand for yet another member of the Royal Family. Looking around the tent one realised what a narrow world it was, all those members of the Household, gentlemen and ladies-in-waiting looking vaguely identikit, the men with their pressed suits and the women in their underplayed dresses or suits.

Off we went back in the car. When we went past Kensington Gardens Prince Michael said that the Long Avenue had been felled in the last war so that in a pre-helicopter era a plane could be got in to rescue the King!

28 May. Mrs Thatcher, Norman Tebbit and the Hamlyns.

As we approached 28 Upper Phillimore Gardens I said, glimpsing the minibus which had carted the police, I bet that the Prime Minister is there. As we left the party I warned Julia: 'If you continue to go in that direction you'll knock Mrs Thatcher over.' The party concerned was

given by Evelyn and Victoria de Rothschild[1] in a house furnished with a variant of *gout Rothschild*, the drawing-room into which we descended as though lifted from a country house with horse pictures in the main banked up its walls and a roaring log fire. French windows were flung open on to a terrace and the garden was planted as an optical illusion, a curve into the distance suggesting endless walks beyond and all only in white and green.

The Cabinet was heavily in evidence: Nigel Lawson looking more and more like George IV in decay, and pinch-faced Norman Tebbit[2] whom I bearded and discomfited by introducing myself and saying, 'You and I are the only people in public life with this one thing in common. We went to the same grammar school.' Tony Snowdon was there on his own looking less haggard than of late, so was Hugh Casson, who at seventy-five seems to have taken on a new lease of life post the RA. Fred Ashton was interesting on the little ballet he did on the two princesses for the Queen's sixtieth. The two students from the Royal Ballet School were never told what the ballet was about until the very last moment in order not to inhibit them. I had a chat with Mary Soames,[3] a four-square woman with her father's jaw, who had just completed the biography of the most boring Duke of Marlborough ever and was going on to do a book on her father's penchant for painting. All I could remember was Rab Butler's[4] anecdote about when Churchill was asked about his vivid colour range and the reply came that it was the butler who laid out his palette for him! I suggested that she might ask Hugh Casson to write an essay on them as pictures.

From there we moved on to Paul and Helen Hamlyn[5] in their Gropius house in Chelsea for a dinner on the grand scale for about sixty, tables scattered through the house and along the terrace, over which a marquee had been built. There was an army of domestics. Lobster was piled high in the centre of each table to start with, walnut bread had been flown in from France, *quails véronique* followed, then an amazing range of cheeses and a miraculous chocolate cake with a cascade of

[1] Evelyn de Rothschild, Chairman of N. M. Rothschild & Sons Ltd. Knighted 1989.

[2] MP for Chingford, 1974–92; Chairman of the Conservative Party, 1985–7. Created a life peer in 1992.

[3] Daughter of Sir Winston Churchill and wife of the Tory politician Lord Soames; Chairman of the Royal National Theatre Board, 1989–95. DBE 1980.

[4] R. A. Butler, Conservative MP; Chancellor of the Exchequer 1951–5. Created a life peer in 1971.

[5] Paul Hamlyn, wealthy publisher and benefactor and supporter of the Social Democratic Party.

raspberries. The Hamlyns must be very rich, as Paul had given Helen for her fiftieth birthday a Foundation and we were celebrating the exhibition it had just staged in the V & A's Boilerhouse of design artefacts for the elderly. It was a good exhibition, a great change from other trade shows which had led the establishment downhill so rapidly in the last two years.

The Hamlyns are great supporters of the SDP [Social Democratic Party] and so the Owens, David and Deborah, were there. I always like her, sharp, very American, very open, bright and practical. He is always trying to look the part of a future PM and not succeeding and is totally humourless. The rest was a raging mob of designers and people of the ilk of Terence and Caroline Conran. It was such a contrast to the previous party. For some odd reason I was placed between Deborah Owen and Julia. We were never introduced to everyone at the table but the person on Paul's left seemed to own half Covent Garden. On Julia's right there was Bernard Nevill, the textile designer, like an excited owlish schoolboy because the next night he would at last occupy his house at Fonthill. Not *the* Fonthill, he firmly said, but another nearby. He'll make a marvellous Caliph.

1 June. The media goes in reverse.
At last the colour supplement article on me by Peter Dunn appeared in the *Sunday Times*. It was rather a revelation. Julia said it was a resurrection. The sources were very well informed and mysterious. I never knew that Pope-Hennessy was literally against my appointment from the start. He really is a double-dealer. I have his letter in reply to mine, telling me to put in, after overtures from him via Pamela Hartwell. Whoever told Dunn that I detested my father and who was the distinguished art critic who saw how my career has been blighted because of rejection by the museum homosexual network, thereby incurring formidable enemies?

2 June. Bryan Magee and the Princess of Wales.
Bryan Magee came to lunch, an ex-SDP MP, now returned to academic life but engaged in a fifteen-part television series on the history of philosophy. He had read the piece and thought it very good. I was intrigued as to how he pinpointed Pope-Hennessy's regime as like David Webster's at Covent Garden. It was curious that that generation of homosexuals pre the Act were almost always ambitious outsiders who got in, their qualities being an alignment of snobbery, malice and intrigue.

In the evening we went to Osterley for a ball to celebrate the 600th anniversary of the treaty of England with Portugal. There was a huge raving swarm of fifteen hundred, just anyone who could buy a ticket. It was a cheap ball, I thought, at £60. We were, however, sidetracked amidst *les grands* and placed in an Adam room with the two top tables, in the main diplomats and ambassadors and wives of Latin extraction wearing dresses like demented parakeets.

I found myself at the Princess of Wales's table, too distant to speak, between Lady Camoys of Stonor and the Brazilian Ambassadress. It was interesting to study the Princess after a few years for a length of time. The freshness and bloom had gone that she had on the V & A Gonzaga evening in 1981, when there was a shy softness about her. Now she was thinner and sharper of feature with a hard jutting chin-line and hair lacquered to the point of snapping. She doesn't hold herself well and her dress was rather sleazy with huge puff sleeves. The evening was chiefly notable for the pyrotechnic display of the Portuguese Riding School, the baroque era relived. When the dancing began we fled.

17 July. The Mynotts.

The painters Lawrence and Gerald Mynott took me out to lunch. I was very touched. There they sat like Tweedledee and Tweedledum in matching Tyrolean suits, very well turned out and fresh. Lawrence had been a beau of Diana Cooper's in old age. He had been sweet to her, just talking to her and then looking at TV until she revived again. How those two worshipped their heroes – Beaton, Messel, the Sitwells, Rex Whistler. I was amazed by them. Lawrence virtually told me, why go on with it? You, he said, should be You, high profile and giving, and not strangled by that Museum. Out of the mouths of babes, I thought. How enormously perceptive they were. They saw me wasted.

13 August. Richard Wilding.

I came up to London for two days. Richard Wilding[1] came to lunch. He said that everything had gone wrong with the National Gallery appointment but that he had the highest confidence that Neil Mac-Gregor (recently appointed as Director) would bring it off. I wonder. This was what is known as a significant lunch as I asked him point-blank what OAL saw as my future. The answer to that was that they didn't. Nothing was ever to come my way. As I remarked to him,

[1] Head of Office of Arts and Literature, 1984–8.

'You've had your pound of flesh.' Any future for me, I was told, lay in the private sector.

In a funny sort of way I knew that this would be the reply anyway. It is, however, useful to have it articulated. There will be no public advancement of any sort, so one might as well know and get on with life rather than set one's sights in directions it is a waste of energy even to contemplate. One now knows exactly where one stands. It comes back to what it always has been: 'Follow your own star' . . .

November. I decide to resign.

After much heart-searching I sat down and wrote to Peter Carrington saying that I would go from the V & A at the close of 1987 and would he be instrumental in securing conditions from OAL? His reaction was good. He said that if I was to have another career I had to do it now. Richard Luce was coming to stay with him in Brussels. Luce did, and for two evenings, 12 and 13 November, they discussed it. Luce agreed to achieve what was required. We now wait. I feel that nothing will change my desire to exit. Carrington wants to land me something and is pursuing the chairmanship of the South Bank Board after Grierson. My decision, I believe, is right. Those I trust all say so too. It has been a tremendous decision to make. I have to make it or else I will bitterly regret it always . . . I now long for it to happen.

1987

Exit Stage Right

From the moment my resignation was made public it was as if some terrible weight had been lifted from me. The effect it had can be measured in the diary entries for this year which are over twice as long and are full of the kind of brio which recalls earlier, more expansive days in one's career. The announcement produced a huge onrush of letters, all too generous, but the ones which stick in the mind are those from creative people who realise the brevity of life and how one must never betray that creativity, and from those in the profession who admired the bravery of throwing security and status to the winds to follow another destiny.

Although the media never really retreated from its hymn of condemnation, everything somehow came together to make one long finale of openings and grand events. The Conran Boilerhouse gave way to our own exhibition gallery dedicated to this century; the galleries of Art and Design in Europe and America from 1800 to 1900 opened; so, on 23 April, did the Theatre Museum in Covent Garden. That had been bequeathed to me as a poisoned chalice. Now it was up and running, although I was only too well aware of the problems it would face in the future. When Cecil Beaton's secretary Eileen Hose died in the summer some 8,000 negatives plus a large collection of vintage prints came, forming Beaton's Royal Portrait Archive. That I look upon as a monument to a friendship. Then Michael Hopkins & Partners presented their masterplan for the building, a comprehensive programme for the restoration and development of the entire site which would take the Museum into the next century. On 6 November the newspapers carried a picture of me peeping around the entrance doors to the Museum as we swung wide again our gates on Friday, after closure for nearing a decade. All in all it wasn't a bad exit, and for those who would still detract I would ask them when they next go to the Museum to bear in mind that epitaph of Sir Christopher Wren's: *Circumspice*. There are few areas of it devoid of my imprint. Recently someone remarked to me how the Strong era was already definable but mercifully spared me the definition.

My mind, released, was already moving on to other things. But there were some touching farewells. Just before Christmas, party followed party. Farewell to the Friends, who gave me a facsimile of Rysbrack's bust of Shakespeare which I look at in our conservatory, farewell to the Associates who presented me with a plaque sculpted by Simon Verity in which my profile sits between that of Victoria and Albert. I did, as I promised them, build a temple at the end of a great vista. The plaque is on the back wall of it. Either side are busts of Queen and Consort. On a summer's evening we have a glass of wine there, and recall all those years, both happy and sad, at the V & A. The staff collected for a present and asked me what I wanted. I said for the quadrangle to be filled with snowdrops each springtime to lift the heart of every visitor and also everyone who worked within that great institution. They were planted by the bane of my life, the Property Services Agency, and died. I was told that a large file existed on the subject, and although crocuses are supposed to have replaced them no one has ever asked me back to see what commemorates my era each time that spring comes again. I only wish that they had, as nothing would give me greater delight. The Trustees held a grand dinner in the Italian Cast Court in the style which I would have wished. All the women who came wore their most glamorous clothes and jewels, 'For you' as they said, and I was touched. They realised that I had always stood for style and a sense of occasion. Princess Margaret made up a group and came to see the Museum one evening. The next day she rang me to thank me and said, 'I brought them to show them what a wonderful job you had done.' I will always remember that kindness.

People often ask me if I regretted the decision to leave. I never have except once and that was when, at the close of a somewhat drunken dinner *à deux* with a bright young BBC radio producer, he told me that I shouldn't have. I asked him why. The reply was because I represented all of them up there and by resigning I lost my power base. That was the only occasion when I felt that I had perpetrated an act of betrayal because I had always striven to represent 'all of them up there' and now I no longer could. For that I can only beg forgiveness.

11 February. My resignation is made public.
The Trustees met at Apsley House on 26 January. I must say that I resented not being able to tell them myself, but Lord Carrington had decreed otherwise, so I waited without like a footman. I had arranged that simultaneously the despatch riders would leave the V & A for Fleet Street. There was, however, a botch-up here. Uniquely the Minister had

issued a statement praising my virtues which reached the journalists' desks before the actual release, so much was the confusion. Our press release was good and truthful. What I gather was mishandled by Lord Carrington was the money side. I will be left with little and there was no reason why that should have gone to the Board at all.

When the moment came I entered and spoke with true zeal from the heart, not reiterating the contents of the press release but stating two things, the first on the mental and physical exhaustion ensuing from twenty-one years of directing and the second that I had truthfully nothing more to give the V & A. It seemed to go well. Mercifully Conran couldn't come and Andrew Knight had resigned. After an hour I left and went back to the V & A.

The heads of department had meanwhile been gathered into my office for a drink. They were utterly astonished when I told them. My announcement was received with just a deep silence. There was a solitary expression of good luck from the Keeper of the Indian Department. It was all rather strange, I thought. After that the media was let loose. We had taken the decision to be available for that day only and that on the morrow, Tuesday, there was to be nothing, and no interviews were to be given before the end of the year. So I did Channel 4 news, the BBC PM programme, LBC and BBC Breakfast TV. The next day it swept its way through the national press with a picture and centre page in *The Times*, the front page of the *Guardian*, where it was stated that I was going because I was 'bored', a picture and story in the *Independent*. That all seemed to go very well, and certainly no national museum director has ever made such a spectacular exit. But inevitably the nasties surfaced, including a small and disagreeable piece by Godfrey Barker in the *Telegraph*, but by Thursday even Brian Sewell in the *Standard* had embarked on repentance. The previous week there had been a vicious piece by him on 'Where Sir Roy went wrong'. Now, in an article by Valerie Grove, Sewell implored me to reconsider my decision. In that piece I was billed as a national monument and as a prophet without honour. Needless to say, having put the curtain firmly down the Sundays had to rake around as best they could. The *Observer* did a piece on 'Star of the V & A quits' with a caption which read 'Soft heart and bravura style' but the *Sunday Times* went in for a fully fledged half-page of vitriol in key with their consistent policy. There were really awful contributions to it from a whole phalanx of those one had crossed, Anna Somers Cocks,[1] Elizabeth Aslin,[2] Alexander

[1] Member of the Victoria and Albert Museum staff; later editor of *The Art Newspaper*.
[2] Head of Bethnal Green Museum of Childhood.

Shouvaloff, *et al.* It was very damaging and vile but, I suspect, counter-productive. It is interesting that Lord Carrington had got wind that they were going to write that my relationship with him had been a disaster and that I had been forced to resign, all totally untrue. He had rung them and flailed at them and stopped that.

Then came the onrush of letters. It was very noticeable that my move was received by the museum world with a total *froideur*. But otherwise, yes, wonderful letters above all from creative people. Then also came the offers, every newspaper and magazine hungry for pieces and three publishers after my autobiography. There is no doubt but that it had caused a stir in the dovecotes. We went to an Arts Party at 10 Downing Street and certainly Mrs Thatcher was clued up on it. She had read my garden book! She is odd.

20 February. The Serpentine Gallery.

Breakfast at the Arts Council with William Rees-Mogg and Luke Rittner about the Serpentine Gallery. William revealed his deep hostility to the Tate and their doctrinaire view of art and wants a chairman for the Serpentine not of that kind. We agreed to Grey Gowrie. I pointed out the proximity of the RCA gallery and the possibilities as a focus for young artists and for older ones who worked outside the current trend. OAL I was told was bereft that I am going and somehow I had to be kept at the centre in the Arts. So I alone have been extended for a further two years on the Council. The *Independent* made overtures for me to write arts leaders.

24 February. The search for a new director begins, and the Theatre Museum.

We bumped into Peter Hall, Maria Ewing and child outside Poons, the Chinese restaurant in Henrietta Street. 'We're leftovers from the sixties,' Peter ragged. I said, 'Speak for yourself.' Peter then said that he had been working on his exit for four years. I said that I had for three.

Yesterday *Gloriana* [an update of my 1963 book on the portraits of Queen Elizabeth I] was published and I did *Start the Week* with an odd *mélange* of writers and theatricals including Larry Adler with that beastly mouth organ and a literary lunch at the English Speaking Union. It all went off very well. Denys Sutton's final swiping editorial was trailed in the *Times* gossip column, but who cares really? I learned that there was a large amount of international coverage of my exit all through the German newspapers and it even appeared in New Zealand!

Last week's Trustees' Meeting confirmed their hopelessness. Once again the fund-raising Trustee problem came up, year four on this one, and still no solution, so we're back once more to square one. We are now in the interim period where I almost hate going into the place. The pressure of work is huge but the weeks slip by. We will be into March next week. The search for a new director, under the aegis of Michael Butler, Ian Hay-Davison, Jean Muir and David Mellor, is risible.

The *V & A Album* this year will be put together as an *hommage* to me. It is good to get the last fourteen years between hard covers and I put together for it a chronology of what had happened *vis-à-vis* the V & A. Carrington is concerned that I won't have an office and a secretary and, when asked by him, I said that I would not say 'No' to another job.

Late February. Theatre Museum crisis.
Throughout this period there has been the saga of Alexander Schou-valoff and the Theatre Museum, one which dates back to October last. The relationship with Alexander has proved fatal. In many ways he had been an imaginative head of department, but I find him impenetrable. One's worry about the state of the Theatre Museum, coming up sup-posedly to opening, was so bad that he was asked to produce a flow chart as to how he would achieve opening it. He failed to, and four days later had a heart attack in the Garrick Club. What was reported to me by those involved in the project and from those brought in to rescue it was deeply disturbing. It would never have opened in time. The archive, for a start, turned out apparently to be twice the size it was thought to be and it wouldn't fit in. It seemed to me to be in complete chaos; the Gielgud exhibition had not even got a list of exhibits, as far as I could establish. The area for the storage of costume did not even meet the standards demanded by conservation. The catering facility was com-pletely inadequate. The theatre sight-lines left much to be desired, and so the weary list went on. Mercifully, Santina Levey [Head of Textiles and Dress] was moved sideways and rescued the situation.

18 March. The Duchess of York.
I bumped into Pat Gibson, who reminded me that when interviewed for the V & A in 1973 and asked how long I would stay I had said that I would move on at fifty.

I went to see the Duchess of York at Buckingham Palace. There she was in a small office with a secretary lady-in-waiting on the top floor in the old nursery suite. This had all arisen because she had heard

from Bill Heseltine [the Queen's Private Secretary] that I was to do a television series on the royal gardens and she saw a book in it. So did I, so that was soon settled. She is strikingly refreshing, direct and intelligent, a huge bonus I would have thought. No beauty at all, but good Sloane Street features with large eyes. Her mission, she said, was to be youth and the Arts, especially in the north of England, but, she added, the invitations never came. I said that I would do what I could to help. I said that it was a shame that no member of the Royal Family had a house in the north, to which she replied that the Civil List wouldn't pay for it. She was, she announced, York Enterprises and there is no doubt that they must make a living and she will be the one to do it. That was how the royal gardens came up because, pre-marriage, she had been with Burton Publishing and the *Antique Collector* had asked her to do a book on the royal gardens and then I popped up.

The lady-in-waiting looked up and asked how Muff [our cat] was, which was sweet. 'Who's Muff?' the Duchess said, and so I told her. 'Is he a big 'un?' she said. 'Yes, as big as this table,' I indicated. We all roared. .

1 April. The opening of the Clore Gallery.

The rain fell as though Noah and his ark were due. Julia and I went to two of the openings, the first of which, very select, was in the afternoon, with about a hundred and fifty and the Queen to open it. Her Majesty was dressed as usual to be seen, in red with a red boater with a feather askew to one side. She wore her glasses the whole time, which may have brought her a sense of relief because she was able to see everything and everybody, although vanity is not part of her make-up. Vivien Duffield [Charles Clore's daughter] was resplendently swathed in claret with a pair of Cartier diamond clips at her neck given her by Jocelyn, with a blue 1930s revival hat which was pulled down low over her forehead.

The speeches were short and notable for the fact that the Queen referred only to Turner and not to the benefaction, and for the Chairman Richard Rogers'[1] attack on Government funding, which was bad form. Richard and Rose Luce visibly twitched as he did it. As usual a great deal of business could have been done in a very short time, for the galleries were full of everyone whom one couldn't usually get hold of. There were, however, notable absences on both occasions, such as the

[1] Award-winning and innovative architect (Lloyd's headquarters in the City of London). Knighted 1991.

Directors of the British Museum and of the National Gallery, but due to what I know not.

The evening opening took the form of a reception at 8.30 p.m., a time which normally signals sustenance, but on enquiring practically everyone established that it only meant nibbles. We were bidden in black tie none the less. Nancy Perth, on to the same ploy, rang and asked us to dinner before, so we went. I love her dearly and in spite of the fact that dinner turned out to be tinned soup and a plate of prosciutto with a roll, there was a bottle of 1953 vintage champagne to compensate.

The rain never abated. Soaked, we at last got to the Tate where some of the throng were already fleeing before the fireworks. We saw neither a glass, nor nibbles, nothing. All had vanished by 9.30 p.m. and there were still two hours to go. Here was the same list of people as the afternoon but expanded to a thousand, all parading around in the main complaining that the colour of the walls was wrong and that the pictures were hung too low. This time Vivien was swathed in black velvet with loops of pearls. She seemed happy and I thanked her. After all no one else has given a new wing to a national collection and the building has style and presence, although a bit Schinkelesque with dolly-mixture colours. Certainly the entrance is like a temple and made me think that I would bump into Papageno. The pink handrails, used to contain lighting, were like radiators but the main galleries were of gracious if not grand proportions with beige walls and carpet. The reserve display, however, on porridge paper with reddish-purple emulsion paint was definitely tacky. And too many Turners. Whoever wants to see every scribble and quick slosh? We see here the apogee of the Turner cult which began with Gowing's exhibition at the Tate twenty years before.

Compared with twenty years ago I was struck by how few people looked extraordinary. Fashion now is so unimaginative. There was certainly an explosion of shoulders, the wider for women the better, and a great amount of beadwork and glitter in the art deco vein. Men are very dull these days. Timothy Clifford in a green velvet smoking-jacket with black frogging just looked a curiosity. The look otherwise is sharp and shiny with hair well gelled, shirt with a wing collar, and immaculate blacks, but no bizarre opulence compared with such a gathering ten or twenty years ago.

11 May. The directorship.

Jim Close [my administrative right-hand man] rang me on Sunday and asked me *vis-à-vis* the short list of the V & A. It was a very thin field with no one outstanding, no great scholar or personality. The initial short list for round one of the interviews was Elizabeth Esteve-Coll (the V & A's Chief Librarian), John Morley (Head of Furniture and Woodwork), Edmund Capon (Art Gallery of New South Wales), Julian Spalding (Manchester City Art Gallery), Richard Marks (Brighton City Art Gallery), Patrick Boylan (Leicester), Alan Borg (Imperial War Museum), Malcolm Rogers (National Portrait Gallery). Borg has by far the best track record and I wrote to Carrington, as he asked my views, and told him that I thought Borg was the best. His background was the Courtauld, Princeton, the Tower, the Sainsbury Centre. He knows how to run a national collection, had raised money for a new wing and was favoured by this Government. Capon has been too long out of Britain and away from all the changes.

3 June. The race for the directorship.

At the May Trustees' Meeting in the closed session they were told the final short list: four internal: Jonathan Ashley-Smith, Elizabeth Esteve-Coll, John Morley and Joe Earle; and five external: Alan Borg, Richard Marks, Julian Spalding and Patrick Boylan. There was huge lobbying done by Sir John Hale, with support from Ronnie Gorlin, that Timothy Clifford should be invited. They were rounded on by the rest. It was left that everything would be reconsidered if an appointment was not made. Later John Hale wrote to Carrington with a list of those who should be invited and no less a group than Pat Gibson, Grey Gowrie and Martin Charteris lobbied as to why Gervase Jackson-Stops was not on the list. What has he ever done other than cobble together *Treasure Houses of Britain*? The intrigues around this are extraordinary. So far the newspapers have laid off, although the *Sunday Times* on 31 May ran a piece with most of the wrong people listed, including Timothy Clifford and Christopher Frayling. What is interesting is the awareness that it is not a nice job. The *Financial Times* ran a piece by Colin Amery which began to appreciate my contribution.

4 June. Overtures from Sotheby's.

Grey Gowrie came to see me and everything took a different direction. Sotheby's seem to be after me. He was concerned about its cultural profile in terms of education, publications, exhibitions, *et al*. Also no

one had quite replaced Sir Philip Hay. The conversation was quite unexpected and I needed time to think.

5 June. More on Sotheby's and the quest for a director.

I rang Grey Gowrie, who wanted to ring me. I put to him the idea of being the director of cultural events and activities for Sotheby's, bringing together education, exhibitions and publications besides offering my expertise on British pictures and miniatures. We settled on two-and-a-half days a week, i.e., half my time in return for a salary, an office and a secretary. Meanwhile Felicity Bryan [my literary agent] was negotiating with Andreas Whittam-Smith [editor of the *Independent*] for an exclusive. I would give up writing for the *Financial Times* which is, I feel, a natural break. I rang Rees-Mogg and said that I would come off the Arts Council as it would otherwise be too inhibiting to write.

I heard that the final short list for the V & A was Edmund Capon, Elizabeth Esteve-Coll, Julian Spalding and Richard Marks. I was very surprised that Borg was knocked out. I gather that many talked themselves out of the job. The most-overheard word on the candidates was 'lacklustre' and Jean Muir was seen to leave looking ashen.

9 June. More on the directorship.

Peter Carrington rang and wanted my view on the short list. Apparently Elizabeth Esteve-Coll had shone out. How would people take it if we appointed her? I said that people would be intrigued. Above all her integrity had struck them. Also, I pointed out, the learning curve would be little as she's been part of the senior management team for a couple of years. Peter Carrington said that I should say 'Yes' to Grey's offer.

I sat next to Princess Margaret at lunch at the Antiques Fair at Hammersmith. Apart from her trip to China ('I'd got my eye in in respect of Chinese art,' she said, 'from my grandparents' – apparently both George V and Queen Mary and also on the Glamis side). What was interesting was that she told me that I had been on the *tapis* for the Royal Collection, but as its structure was to be changed it was pointed out that I could not be asked to be Number Two. Sad that...

15 June. The general election.

The relief felt at the result of the election should be recorded. Like 1974 one felt nervous. This time the elements on the extreme Left could signal the end of the society we know. No such extreme elements on the Right. None the less the landslide to the Conservatives was a surprise. Good news for Britain but not for the Arts.

17 June. Robert Armstrong and 'The Weak who follow Strong'.

Sir Robert Armstrong, the Cabinet Secretary, came to lunch on 15 June. He is a man for whom I have an enormous admiration. He too is on his way out, having promised to see Mrs Thatcher through her next election which he has. He quite understood my desire to move and he said had it been a hung Parliament he would have stayed because it would have presented new problems instead of a rerun of the last eight years. The nub of it at the close was did I wish to be among 'the Great and the Good'? My own view was that I had to make a living first and, yes, but only if it was a chairmanship or a vice-chairmanship...

On 16 June Michael Butler followed me to my office and sat like a child listening to what I thought of the short list. Unless she mucks it up Elizabeth will have it, which would certainly give me great pleasure. Capon was no good at his first interview, very thin; Spalding of no great importance; Marks rather dull and too reflective. There was a piece in the *Standard* which he was fuming on about, 'The Weak who follow Strong', saying that the Keepers didn't want any of them. As usual: 'trouble up at mill'. All I could do was point out the long tradition of unpleasantness which was at the core of the V & A.

The new shop looks terrific with an upward curve of takings. It has been designed by David Davies of the Next shops. More alterations have been done to the front entrance hall. I moved the two splendid Antonio Corradinis over so that they face the visitor on arrival and they look marvellous. All very satisfactory.

29 June. The Pirelli Garden.

Last week I think was a triumph. The beloved Queen Mother came on the Tuesday. Monday was the Pirelli evening. Signor Leopoldo and a bevy of women arrived. I sat between two, and there was dinner for fifty in the Italian Cast Court with all the silver, candles and the best catering. I have never seen the V & A look more spectacularly beautiful, the great vistas magically lit and decorated with huge floral arrangements.

Leopoldo Pirelli was a fit, bronzed man of any age between sixty and seventy-five. He was visibly very moved, having come expecting a dreary evening but instead it was a feast. The climax was leading Signor Pirelli's party into the garden in darkness and letting him press a series of switches which put on the floodlighting and the fountain, at which there was great applause. It made me gratefully think of all those who had seen this through so loyally: Tom Northey of Pirelli, Lord Thorneycroft, its UK chairman, Julie Laird, the Works people, in par-

ticular Douglas Childs, the designer. They made it all worth while because it had taken fourteen years to achieve. Always there had been the battle over the cherry trees, even when I had a design by Russell Page back in 1979. Sad.

The Queen Mother evening was a great treat. The Royal Engineers lined the route through the Medieval Treasury and the garden was kept empty except for Signor Pirelli. She advanced and they shook hands. Then there were baroque fanfares from the balcony and all the doors were flung open and the party flooded out into the garden. It was a great evening. I felt very happy and proud. Everything looked marvellous, the whole Museum so different . . .

7 July. A new director for the V & A.

Last Wednesday the interviews for the directorship took place. Carrington showed me the score cards and it was a close-run thing between Edmund Capon and Elizabeth Esteve-Coll. Elizabeth got it. She owed it not only to her own character and directness but to the lack of the need to learn. It would be an easy run-in, with support by me. I feel very pleased at the result. The media took it on the whole very well and so did the Museum. She will be very different. There's no glamour, style or flair there, but there's integrity, purpose, sense and affection. For what the V & A needs I believe that she will fit the bill, and build on what has gone before.

22 July. Plans for the future.

We seem to have reverted to what June was, with floods of rain everywhere. Last Saturday it was public that I was to write for the *Independent*, done very low key as I requested. I feel that that will be interesting. I wrote to Richard Luce resigning from the Arts Council and to the *Financial Times* saying that I would be coming out of that. On the whole things seem calm apart from a sharp attack in *Punch* by Alastair Sampson, who runs an antique shop in the Cromwell Road, provoked by my speech at the *Antique Collector*'s dinner, in which I indicated that the V & A may be forced to charge the trade for its expertise.

27 July. The Beaton Bequest and the Chinese fête.

This summer Eileen Hose, Cecil Beaton's secretary, made over to the Museum his archive of royal photographs. This gift, I know, owed much to my friendship with him. She died shortly after.

On Sunday news of the gift of the Beaton royal photographs hit the *Sunday Times*. It had been leaked. Nikos Stangos [of Thames & Hudson] rang and asked me to write a book on them, to which I agreed. I wrote to Eileen.

I am genuinely worried about the V & A as no funds have been raised for anything to happen after I've gone. I see a long dreary gap beckoning. The Trustees have done nothing. David Mellor is coming out, which is a relief.

I feel that things should gradually slip Elizabeth's way as I disengage. There is no point in having any more rows or confrontations.

Last Thursday the National Trust and the V & A jointly hosted an Anglo-Chinese evening at Osterley with Princess Alexandra. Although the skies were leaden it went very well. People came and had their picnics. There were stands and booths with food and novelties, and a pavilion on the lake with Chinese boats including rather a bad dragon one. After dark there were jugglers and flares, a children's choir from Hongkong, a never-ending dragon dance and a huge firework finale. I sat between HRH and the actress Gayle Hunnicutt, HRH opining about the media. Join the club, I thought. They are vile. How hurtful to the Queen, with attacks on the Princess of Wales, etc.

28 July. Saltaire Mill.
On the Tuesday we went in delegation to look at Saltaire Mill, Bradford, with the possibility of establishing it as a South Asian Arts and Crafts Centre. The whole project of decentralising the V & A goes back through my directorship. This one arose about 1977–9, when Robert Skelton came to see me about another mill with the Indian Collections in mind. It could not have happened at a worse moment. After Robert became Keeper of the Indian Collections I gave him a brief to start thinking about the ethnic minorities in the UK. The Bradford link then began to develop. Exhibitions like *Petals of a Lotus, Indian Hats, et al.* went there, but now the idea is to establish a permanent outstation.

The mill looked like the Escorial, vast and monolithic, but around it there was a Victorian ideal village made up of delightful small terraces, houses and shops, interspersed with handsome public buildings: a library, a church, a dining-hall, etc., and a huge open space. It is a wonderful setting and if we bring it off it could be very lively, because the rest of the mill will be filled with shops and restaurants. The bounding enthusiast for this is the purchaser, Jonathan Silver, a dark, striking-looking 37-year-old with designer stubble and Levis. Our delegation did a huge up-front with everyone, both the city and the Asian

community. I feel hopeful that this could come off as it links in with the drive to renew the inner cities. Also the funding could be mixed: EEC, English Heritage, the Council, commercial and sponsorship. [Sadly, this project did not proceed.]

7 August. *En vacances.*

The summer holidays began with a feeling of exhilaration and exhaustion. The thought of the *vita nuova* being now so near has been intoxicating. For so long we have seen so few friends and this summer I was determined to be more social than we had been for utterly years. Every summer within my memory there had been V & A crises by telephone, things to be written for them from speeches to reports, things which had to be done for them. The tentacles from South Kensington dangled over The Laskett. But here we were accepting invitations and issuing them.

On Saturday, on the spur of the moment, we were asked to Whitfield by George Clive. He had Grey and Nietie Gowrie, along with Iris Murdoch and her husband John Bayley, staying. Lady Mary Clive, George's mother, is a Pakenham, a woman not without intellect and a scribbler. *The Day of Reckoning* is a delightful book. I sat on her right and found that she hadn't written a public line for years, ever since her publishers turned down a book on the cloister life of the Emperor Charles V, which was hardly surprising. Now, she said, she sat and wrote about people she knew but not to be revealed until after her demise. Really she seemed ten years younger than the last time that we went. Iris is a character and I was amazed to learn that she couldn't even type, but wrote everything in longhand. The Bayleys had left Church Stretton and moved into Oxford. John is a lovable old teddy bear, rather vague, podgy, with balding head and unkempt, unpressed clothes, resembling the proverbial mobile bundle. Julia very much took to him this time. George Clive had been at Eton with Grey.

On the morrow they came as a delegation to see the garden. That caught us off our guard because they wanted to see the house too and it was in a mess, but so what. They were whizzed round the lot. Grey, as we came out of my book-stacks, suddenly said, 'It won't work,' by which he meant the proposal that I should be a non-executive director of Sotheby's. 'They told me in New York that all the things you would do were part of my job.' This seemed more than casual, although I took it on the shoulder. At least four weeks ago he had promised to ring me in ten days. 'I think that I can come back to you with something else,' he added. I am not sure that I want that something else...

On Monday we voyaged to lunch with Princess Michael at Nether Lypiatt, just outside Stroud. Rosemary Verey was there. It was a beautiful day and the house was equally stunning, a miniature version of Ashdown, a perfect late-seventeenth-century house, all of a piece, tall and splendid, with noble windows still full of old glass. As there were only two guest bedrooms it certainly cannot be called large. And she had done it very well and comfortably, the dining-room at ground level with light green textured paint on panelling covered with Meissen flower plates, the huge staircase well stencilled in ochre on yellow in a large damask pattern by Lynn Le Grice. Apart from a factotum who had married the nanny there was no sign of living-in staff, and when someone grand comes the royal footmen are shipped down from London. For such an impoverished princess much money must have been lavished on the decoration of the house.

Princess Michael never, but never, stops talking. We left exhausted. It is strange that she really has no taste for garden design and Rosemary's efforts to help seem to have borne little fruit. A huge rose maze had been planted, just thousands of bushes every colour of the rainbow in raised beds with a gravel path, but of little effect because they were not set off by anything giving the maze vertical height or the foil of evergreens. A hugely expensive green lawn tennis court had just been put in and the entire grounds floodlit, although that might have been done for security. It seemed a lonely life, remote and isolated. One wondered what she did all day. She speaks to her domestics in the same way that she does to everyone. We were submitted to a never-ending flow, invariably leading back to the fact that they were not on the Civil List and cars and helicopters were not provided so they couldn't accept invitations outside London. How the Prince had never received an honour. Would I bear this in mind. Meanwhile she seemed set on assailing the Prime Minister when she came to lunch next Saturday that I ought to be made a peer. Whatever next? None the less it was our first alfresco meal in this country this year, very pleasant, at a damask-covered table with good soup and veal cutlets and an abundance of raspberries. In a way she seems to have made her own prison. I cannot imagine her making conversation with the locals or going to the Women's Institute.

By the time that we got to the garden at Barnsley to collect the box hedging we were really knocked out. Never mind, Rosemary Verey is one of life's real enhancers, the garden of unbelievable loveliness and joy. It is always wonderful to tour it and suggest ideas and alterations, this time the resiting of a statue of her by Simon Verity, fast disappearing

through the lush growth of shrubbery. And then we had dramas because we were shown what *Homes and Gardens* intended to use for the article on our garden, and it was very upsetting. This, in the end, resolved itself when mercifully the close-up of a bust in a yew hedge was dropped and Jerry Harpur's wonderful vista of the Jubilee into the Rose Garden was put in. Rosemary is moving out of the great house and the cottage joined to it is being transformed for her, including a conservatory with Ionic pillars which will be very splendid.

20 September. Job prospects.

Now I am back for the last few weeks before my exit. It was wonderful to announce that we would reopen to the public on Fridays on 6 November. Last week Carrington had a frisson that I should be Surveyor of the Queen's Pictures as a result of the post appearing in the *Sunday Times*. Carrington rang David Airlie. As one thought, my name had been a runner but I was too grand and, as he said, 'unspoken'. I had too public a profile. Carrington told me that he had been offered the chairmanship of Christie's and I told him to take it if he was happy with trade. Carrington sadly seems to have ended up as the great non-deliverer, perhaps not helped by the fact that he is a man who likes too much to be liked.

28 September. Maurice Saatchi and the Prince of Wales.

Carrington was miffed that Mrs Thatcher won't ask Maurice Saatchi[1] to be the V & A's fund-raising Trustee and wrote a furious letter to her. Catford[2] rang him and said that Saatchi's handling of the election was not the cause. There was something else which could not be put on paper and which might blow over in three months. Carrington said that he would discover what when he goes to Number 10 on 23 October.

Today Jules Lubbock[3] came to see me about the Prince of Wales. Via Lubbock I warned the Prince off forming an advisory group on architecture. It would be too *parti pris* and members could be got at or seduced. There was a need to open up the subject and talk to a wider group based on a safe caucus. Rod Hackney[4] was out. He had used the Prince of Wales's name too much and had no discretion. Lubbock and

[1] Advertising guru and adviser to the Conservative Party, responsible for Tory election campaign posters. Created a life peer, 1996.

[2] Sir Robin Catford, Secretary for Appointments to the Prime Minister and Ecclesiastical Secretary to the Lord Chancellor, 1982–93. KCVO, 1993.

[3] Dr Jules Lubbock, University of East Anglia, architectural historian and writer.

[4] Architect; President of the Royal Institute of British Architects, 1987–9.

Colin Amery[1] were 'in'. I find this set-up bewildering. To focus on architecture and to be seen to be involved is fatal. To be seen to take a lively, 'learning' interest across the board is quite different. The Prince of Wales hates the 'nobs' and the sycophants, is very puritanical and is very much his father's child. To listen, learn and respond and advise always seems to me to be the right role. It is fatal to pretend to be expert when one is not, but the inspired question as the 'superior' common man is a correct role. They seemed so isolated.

10 October. The aftermath.

Jules Lubbock rang to convey the gratitude of the Prince of Wales's secretary Sir John Riddell. Apparently four of us were asked to form this group: Jacob Rothschild, John Sainsbury, Michael Podro[2] and myself. We had all given the same advice: Don't form a consultative group as there would be questions in the House and do spread a wider net. The only one out of line was John Sainsbury, who needless to say proffered his services as an adviser.

The rise of John Sainsbury is something to wonder at. One can't help admiring the way in which he has made his way up from groceries. Interestingly their charity, the Linbury Trust, is sponsoring a competition for young theatre designers at the Theatre Museum. Neither Julia nor I can ever remember seeing John Sainsbury in anything other than the opera house. It transpired that why the plays chosen to be designed were so strange was precisely because they were the only ones he knew. They pursue the royals avidly and I fear that he may go the way of the Mosers on this now he has got the Royal Opera House. Certainly he got off to a very bad start there by sitting on his Greek island and letting the strike of the opera chorus run on. No one, but no one, has supported the management on this. Public sympathy was wholly in favour of the chorus, who are very ordinary semi-detached folk struggling to make a living. That was solved only by Jeremy Isaacs[3] locking the door and refusing to allow the Board out until they had settled it. That bodes well for him.

[1] Architectural writer and critic for the *Financial Times*.

[2] Professor Michael Podro, Professor of Art History, University of Essex.

[3] Board member, Royal Opera House, Covent Garden; appointed General Director in 1988.

Early October. Canada.

We had an exhilarating week in Canada, three days in Winnipeg and three in Toronto. I gave the 75th anniversary Founder's Lecture in Winnipeg which was a huge success, and Julia and I worked like blazes beneath the prairie skies. It is a remarkable city in the middle of nowhere but with a ballet, an orchestra, a theatre, and an art gallery. Toronto positively sparkled compared with twenty years ago. It has become a most handsome city, vibrant with life and cash. We suffered there from too many academics – 'My interest is *Astrophel and Stella* or *prospettiva* in *seicento* Venetian painting' – which got me down. It confirmed that two or three days is more than I can stand of it, and that it was right to have turned down US academic offers.

12 October. In pursuit of Beaton and the royals.

Was this life after the V & A? I began by going to the gym for a workout, something I've been doing now for three years two or three times a week. It has been of huge benefit, although I still feel the effects of having fallen down running in Herefordshire in July. Thence to Sotheby's to see the Beaton Collection, as the great project is a book on Beaton's royal portraits to be out in time for next Christmas. It was to have been written with Eileen Hose, now it will be in memory of her. Sotheby's offices are squalid and decrepit, the archive literally a cupboard stuffed with junk in which one crouches. The sitters' books only began in 1940 and then are confusing, with two series of sitters listed under date. Some, however, are undated and there are those which just read 'Royal'.

From thence to Tommy Nutter's in Savile Row where I chose two suits and two ties, which was a pleasure; then on to the Garrick for lunch which began lonely and then soon picked up with the arrival of Ken Davison and Milton Shulman.[1] I had no idea as to what disasters had struck Charles Wintour since he had left the *Standard*. Everything he got involved in apparently folded, including something called *Working Woman* which swallowed £100,000 of his own capital. Judi Dench is to get the Actress of the Year award for Cleopatra. Quite right too. I said to Ken Davison that we looked forward to the party for the Mosers on Wednesday *after* the *Nozze* (judging from the reviews).

I then took a taxi to 65 Lexham Gardens to Cecil Beaton's young biographer, Hugo Vickers. Here's a charming, wide-eyed person, a kind of Hooray Henry Eton aesthete, tall with a very sensuous lower lip.

[1] Drama critic, *Evening Standard*, 1953–91.

The flat is on two floors and almost reminded me of photographs of Edith Sitwell's flat. It was full of strange pieces from the Edward James sale: Edwardian mock Chippendale chairs painted cream and picked out in gold in the twenties manner, little sofas upholstered in dolly-mixture-coloured satin and lots and lots of pictures: a Bérard of Beaton, a Tchelitchew, Beaton photographs, Stephen Tennant. The whole place was saturated in a between-the-wars milieu.

In addition Hugo has had a royalist cult since his early teens. A cupboard was thrown open to reveal hundreds of royal cuttings books. Peeress's robes hung on the walls or were used as coverlets, royal Christmas cards were left propped up, and there was a very good library of royal hagiography. We went upstairs and I saw the hideous boxes with the xeroxes of Beaton's diaries and I read out the dates of the sittings. Only some have stuff but not all, none for the very early ones, alas! But I gathered some good stuff on the later ones. The trouble with Beaton is that he wanted to be a friend of the Royal Family and never realised that one can't be, and hence, in the end, he disliked being treated like a servant. By 1968 he even dipped his pen in venom on the Queen.

We lingered over his two bookcases. It was odd how many biographies of Princess Marina had been written, not one true. Queen Mary disapproved of her consorting with Noël Coward, and Philip Hay was, 'tis said, one of many lovers. Poor lady, one felt. Naughtily, the biography of Hélène Cordet was shelved next to biographies of Prince Philip. I left happy and went to the V & A and cleared the immediate heaps and met Julia at ENO to see the most terrible *Pearl Fishers*, directed and designed, or rather ruined, by Philip Prowse.

23 October. The Chinese Export Gallery and the Canary Wharf development.

A very busy week. The Duchess of Kent came on Tuesday to open the Chinese Export Gallery. I have never seen the V & A looking more marvellous. The marble entrance hall was decorated with huge vases of evergreens and pink and mauve feathers. Beneath the dome there was a circle of pale yellow to creamy-white flowers dotted with candles and, beyond, there was the vista to the Pirelli Garden fountain floodlit. This gallery marked the completion of the eastern arm of the Long Corridor which bisects the Museum, the first time that it has been seen since about 1945. It looked magnificent, in spite of the troubles over finishing it, the lighting and, most terrible of all, the dropping of a mandarin statue whose head was severed.

The Duchess was so much younger and less fraught than I remembered her. She is a remarkable woman. I always find her burst of confidences to me odd and touching. Suddenly as we walked through she turned and told me how she had gone to see Jacqueline du Pré[1] as she lay dying the day before, and had been with her almost to the end. She had been a friend. Daniel Barenboim[2] told her to stay, but an hour before the end she withdrew. Had she, she asked me, done the right thing? In my mind there was no doubt. Of course she had for she had left those two together for one of the most private moments any marriage must endure. We turned, and off we went to do all things official.

Gerald and Cecily Godfrey, who had paid for the gallery, are sweet people but the dinner for forty they gave at Claridge's went sadly awry. Apart from the eight courses we had to drag through, no one had checked that the place cards were in order and they weren't. It was chaos. We took it as best we could and all would just about have been all right if the newly ennobled Lord St John – Norman [St John-Stevas] – hadn't decided to come late, after we had been seated, and when he had already said that he wasn't coming. I got up and said, 'Oh Norman, you're there between a princess and a duchess,' knowing his predilections, but oddly this wasn't acted on and he was wheeled around and placed between curators as my heart sank into my boots. Apparently he behaved terribly and left after the third course. Early in the evening, on hearing his title, I had said that the only St Johns I knew were Earls of Bolingbroke. 'Oh,' he said, 'we're vaguely related a long time ago.' That took my breath away as I had always understood that his St John was adopted by him at his confirmation.

Yesterday Nigel Broackes,[3] who is a good thing, kindly toured me around the Docks. He is so proud of what he has done there and I don't blame him. He's a great chunk of a man with an enormous warmth and an X-ray mind. I think that we are always puzzled as to why we get on with each other, but we do. I've been approached by Olympia & York to act in some sort of capacity as an adviser to the Canary Wharf development which is why he took me round. He had told me that I should only do it if I got a year's contract. I always feel a little bewildered by this world and its ways, not mine but I must learn from them ...

[1] Gifted young cellist who died of multiple sclerosis aged forty-two.
[2] Pianist and conductor, at the time married to Jacqueline du Pré.
[3] Nigel Broackes, member of V & A Advisory Council, 1980–3. Chairman of Trafalgar House, 1969–92, and subsequently president. Knighted 1984.

I've suddenly become aware that I am a highly marketable commodity.

29 October. Too many dinners.

A week of dinners. We kicked off with the Friends of the Israel Museums at the V & A on Monday. Princess Alexandra and her husband Angus Ogilvy came. It was interminable, with a sale of fifty items conducted by Melanie Clore before dessert and an after-dinner speech by Paul Johnson, a Roman Catholic, which was a twenty-minute crash history of the Jews. The Raphael Cartoon Court looked wonderful, with autumn flowers and leaves.

It was Princess Alexandra again on Tuesday in a different dress but just as adorable, this time for the Diego Rivera exhibition at the Hayward Gallery which was attended by the usual organisational chaos, the evening being enlivened by Rivera's last wife and mistress not ever having to meet. It ended with dinner at the Mexican Embassy; a nice ambassador in a faded and rather grubby grand house in Belgrave Square.

Wednesday was the grand *fête* of the week to celebrate the Ferragamo exhibition. The whole Ferragamo family was there plus every *principessa* that they could lay their hands on. The V & A looked fantastic with the garden and fountain floodlit, everyone in couture clothes, and the Raphael Cartoon Court transformed yet again, this time *all'italiana* with huge swags of greenery up the walls like pillars, vast arrangements like box topiary exploding at the centre. There was an endless dinner with the chefs flown in from Italy to cook the risotto and bear it in in procession. After dinner Ann Murray sang and Georg Solti played the piano. My neighbour was Princess Pia di Savoia, who divided her time between Versailles and Palm Beach, rather a vapid life I thought but odd crumbs were fascinating. One year of the war was passed with an Irish nanny in the Pitti Palace. It all went on for ever and the last guests were turfed out at 2 a.m.

Dinner number four was on the following evening after going to the Ferragamo private view at the V & A and also a party elsewhere in the Museum, after which I went on to Ronnie Grierson's dinner at the South Bank for the Princess Royal. I am not sure what this dinner was about. The Princess was splendid, no beauty but very definite, a mix of her father and Queen Mary but with a bit of fun. Otherwise the speeches sank into a sea of Jewish jokes by Arnold Weinstock[1] and Peter Ustinov.[2]

[1] Arnold Weinstock, businessman, managing director of GEC since 1963. Created a life peer in 1980

[2] Actor and writer.

A great opportunity was missed as there was no visionary speech by Ronnie or sense of why the event had been held. I sat next to Arnold Goodman, who said what a good miss the National Gallery had been for me, and now I realise that he was right.

2 November. The Arts Council Art Department.

My last meeting of the Art Panel. They were very sweet and gave me a small drinks party afterwards and Luke Rittner said a few fair words. Well, I don't think that I've written much about this so now I do. Five years in all I've spent, not easy ones, doing this. In respect of the Art Department I went in with three objectives: to save and revivify the Hayward Gallery, to get contemporary art and creativity into the regional museums and galleries, and to get people to buy new art.

I think that I can feel some satisfaction at having brought most of it off. I saved the Hayward Gallery early on; the exhibitions there have been generally much more box-office oriented, and I have seen and will see through its total devolution to the South Bank Centre. The *Glory of the Garden* policy I am immensely proud of. Everyone at the Arts Council recognises it to have been hugely successful. It is wonderful to visit those regional galleries and see them bursting with life. That has been a terrific step forward and must be built on. Over encouraging the purchase of contemporary art the last paper to go to Council has a lot to do with that, as well as with artists as small businessmen.

I feel pleased at having got Sandy Nairne[1] to succeed Joanna Drew. He is, I believe, a fine person. He looks forward. Joanna tended to look back and would only move when I chivvied her. But I cannot fault her, a most remarkable woman, although at times too much into the thought mode of an earlier period. Sandy was there today and so the final leap was made.

12 November. A last glimpse of the Arts Council.

Billesley Manor is three miles outside Stratford-upon-Avon on the Worcester road. It is now a hotel and seems to be a Rookery Nook mock-Tudor kind of place, with awful carpet and beams and phoney tapestries and armour. Olde Englande, I suppose. This is an Arts Council 'think-tank' in the aftermath of the Minister announcing a generous dollop of cash and a three-year rolling budget. It is, however, the last meeting but one I shall attend. What a motley crew! I eyed the forty-

[1] Director of the Art Department, Arts Council, 1987–92; Director of Public and Regional Services at the Tate Gallery since 1994.

three people who sat round the table and groaned. Rees-Mogg always allows debate about the minor points and clearly has fixed the larger ones, and spins them through quickly or whips them away altogether.

It is an odd *galère* of untold prejudices and emotions which have nothing at all to do with what is being discussed but about human nature. Around that table there is metropolis versus the regions, north versus south, awful class clashes, sexual influences as the gays gang up and their molls preside. I was struck by it all so forcefully this morning and how these irrelevant things actually affected their attitudes and decisions. It is a kind of watershed, for the chairmanship is coming up and there are four to five vacancies on Council. The whole thing could dramatically change character. I got out of it by the afternoon when I was driven to Oxford to give a lecture to Green College.

22 November. The last Trustees' Meeting.

Last week saw the last Trustees' Meeting, a reasonably calm affair at which I averted a threatened obituary notice at the close. Elizabeth is now faced with Carrington going next year to chair Christie's, but looking round the Board most of the horrors have gone. An attempt was made to purchase a Girtin watercolour for £350,000 which was quashed. It prompted from me an impassioned plea that the V & A really must strengthen those collections which made it different from the other national collections and not the same.

That day we should have had the State Banquet given by the Italian President for the Queen and assembled worthies in the V & A, but he cancelled his visit. So no state dinner for us. It was sad not to see a second banquet at Buckingham Palace. But Prince Charles came to the Theatre Museum on Tuesday, his arm having been twisted by John Sainsbury; who had sponsored a competition for new stage designers. He still seems boyish, and there's a lovely sensitivity and humour there. More, he had been to Enniskillen where the terrible bomb outrages had taken place that morning and in the evening he seemed to end whooping it up with Diana for his birthday at Annabel's. Some energy therefore.

24 November. The Queen's Christmas broadcasts.

I went to Brooks's for The Club, a dinner which turned out to be for eight. I mostly spoke to David Attenborough,[1] who was interesting on the topic of the Queen's Christmas broadcasts. Each year he comes up with an idea which is presented and usually lapped up. Last year it was

[1] Broadcaster and naturalist; former Controller BBC2.

set in the Royal Mews. This year he had suggested the crown glittering and then the Queen. They loved it but David went abroad, came back, and discovered that it was off. 'What about Fiji?' was the cry. He agreed with me that these broadcasts should be very ordinary, almost rather dull, in the George V tradition with a minimum of clever hype. The person who really messed things up was the Duke of Edinburgh, who always threw a spanner in the works. That links in exactly with my current work on Beaton where the Duke of Edinburgh also figures as the 'enemy'.

25 November. Grillions celebrates.

The 175th anniversary of Grillions[1] at Brown's Hotel. I have never seen such acres of old mottled flesh gathered together in one place for a long time: as William Whitelaw said, two Archbishops of Canterbury, two Field Marshals and three private secretaries to the Queen, and so the list went on. The average age must have been about seventy, but a great number were over eighty, so that William Waldegrave and I brought the average age down, which at fifty-two was quite surprising. The turn-out of sixty-four was large and we dined at six tables with bad food and worse speeches. Roy Jenkins, who came with a temperature of 102 to give his, really shouldn't have bothered. It was a potted history of the club put together by someone for him, and mainly consisted of dates and statistics since 1812.

I sat between the eighty-year-old Lord Plowden, who was the man responsible for upper Civil Servants being badly paid, and David Windlesham. Plowden was fascinating on the decline of interesting recruitment to the lower ranks of the Civil Service and its eventual consequences. Principals leave, he said, because on their salary it is not possible to afford a family.

2 December. The best of friends.

Last Thursday the Queen Mother gave one of her lunches for about sixteen of us: Fleur Cowles and Tom Meyer, the new Lord Chancellor, Lord Mackay, the new Lord St John, Sir Nicholas Goodison and wife, the Dean of St Paul's and wife plus a few Household. It was much less stiff than usual, Queen Elizabeth draped in turquoise, an amazingly bright 87-year-old, was anxious for all the news, wanting to come to the V & A before I went, which I can't see working.

This time, after lunch, I went up and asked whether she had a Beaton

[1] Grillions, a dining club to which one is elected.

photograph which she would sign and give me. The usual lovely wave
of the hands and twinkles of pleasure in the eye and, 'Oh, what a goo
idea – we must look ...' in that lilting rather sing-songy voice. On
always realises that one flirts with her and age is totally irrelevan
She's terribly good at getting around the room and took Julia off to
sofa to hear all about *The Best of Friends* and John Gielgud and ho
our poor cat was. 'Oh, you must come to Royal Lodge again ...' Inspire
by my little gardening books she was scribbling plans for a new garde
on the site of a tennis court at Royal Lodge. One loves the bravura o
it. One always leaves in a haze of happiness and realises that when th
time comes what a great miss it will be.

Yesterday Martin Charteris came to lunch. He's a wily and cann
seventy-four, now sadly getting deaf and I had to raise my voice rathe
loudly. Still he battles on with the NHMF for another eighteen month
and with Eton till 1990 when he will be seventy-seven, a good inning
We roared with laughter about everyone and he's very funny as alway
He confirmed that the Lord Altrincham article in 1955[1] was the rea
watershed for the post-war monarchy and how years after he ha
actually thanked Lord Altrincham for the terrific service he had don
He also confirmed that there was a shift from Beaton to Snowdon bu
he was very surprised when I told him that Beaton's diaries reveale
how he felt 'crushed' by the Palace by 1960. He loved Cecil and wa
obviously a great influence on his use. He emerged rightly very pro th
Queen, very pro the Princess Royal as we all are, pro Prince Charle
said that he had only ever shaken Princess Diana by the hand, pr
Princess Margaret, so we agreed on the ratings, worried about th
younger ones. He stressed the need to put the mystery back as the
have been virtually 'stripped naked'.

10 December. Over-exposure to royalty.
Yesterday would have gladdened Chips Channon:[2] one king, tw
queens, two princes and one princess. That mix came about in th
evening, firstly through the Prince and Princess of Wales coming t
present the prizes for ABSA at the V & A on its tenth anniversary. Th
was my last royal occasion at the Museum, involving standing on th
steps and receiving them. The Museum looked spectacular with th

[1] John Grigg, Lord Altrincham, had written an article critical of the monarchy in th
National Review which aroused a storm of controversy.

[2] Sir Henry ('Chips') Channon, MP and socialite, father of Paul, whose published diari
revelled in crowned heads.

entrance arches encased in swags of Christmas evergreens as a swirling still life, in which nestled baskets full of fruit and nuts and silver-winged cherub heads. Chaos reigned as eight hundred guests piled in to reveal cloakroom pandemonium. The Prince looks increasingly Hanoverian with his eyes high on his face, a long nose which flares somewhat at the nostrils, a heavy jawline and imminent double chin. I kept on thinking of George II and Poor Fred.[1] Julia noticed a scar on his face. She is very, very thin and was in a little navy-blue suit, very tall, with all freshness sunk beneath an abundance of unnecessary make-up and hair lacquered to bounce.

It all went off with a degree of brio in the Raphael Cartoon Court, where the sound system left much to be desired. As I bid them farewell he said that he was very sorry that I was going and what was I going to do? The answer included Canary Wharf, at which point he said, 'I remember. I wrote to you today and want to talk to you in the New Year.'

We rushed from this at breakneck speed to the Danish Embassy for a dinner for the Queen of Denmark at which the King and Queen of Greece were also present. The residence is at the top of their block in Sloane Street and it was an interesting instance of old furniture and pictures looking elegant in such a sharply twentieth-century interior. The evening was a bit of a bore and I couldn't work out why we were there. I was next to our hostess and to a Mrs Heyman, wife of a QC, a rectangular hunk who lived in Sussex organising shoots and who had no interest in anything, food, gardening, travel, the Arts ... I gave up. The other guests were as far as I can remember Lady Elizabeth Anson, looking ill (as midnight chimed she whispered to me, 'How can I get out? I have to go to the office for two hours' work'), Delia and Oliver Millar (she fell asleep after dinner), Paul and Marigold Johnson (having polished off Gloriana and the Jews he is now writing a tome on the intellectuals), Peter Schaffus (Danish dancer and the new Director of the Festival Ballet, which is greatly improved, apart from his psychological *Nutcracker*), the Greeks and Dame Anne Warburton, another hunk with a sharp intellect and much flashing of the teeth (ex-Ambassador in Copenhagen and now heading a minor educational establishment in Cambridge).

The Queen of Greece looks so unlike her sister, much shorter and small featured. The Queen of Denmark is hugely tall with an oval face, her small tight lips low on it and her hair smoothed back in loops to

[1] Frederick, Prince of Wales, eldest son of George II.

the back of her head. She has no taste in dress at all but did wear one good jewel. Much movement of an angular kind and tossing of the head. She smokes like the proverbial chimney. Her husband I hardly glimpsed. As midnight neared, a card-table was set for bridge and I could see that we were in for an all-nighter and felt how terrible those evenings must have been in minor courts in the eighteenth century, where courtiers and household were held in thrall in some dismal gathering. Julia, however, got at the lady-in-waiting and explained that I was off on Concorde for New York at the crack of dawn, so we managed to escape.

The Queen of Denmark is thoroughly anglophile. (It seems that all European royalty are, real or ex, which must go back to Queen Victoria, English nannies, exile or education here.) She was a Cambridge-educated archaeologist and certainly is a woman of bright intellect and, unlike many of the British royals, one can have a constructive conversation with her, and even disagree. At least one wasn't caught in that drift towards passive sycophancy which can so easily take place with royals.

The King of Greece looks like a middle-range American executive. I could only catch snatches of his conversation with Paul Johnson, in the main never forgiving Nixon (I think) who protected the Generals and a long saga on their violation of human rights.

11 December. Canary Wharf.

This offer arrived from out of the blue. A letter came from Olympia & York, the huge Canadian international property developers, asking whether I would act as a design consultant. In retrospect I learned that the suggestion had been made by Alan Kilkenny of Graylings, their PR firm. It had been pointed out to them that, being a Canadian firm with five American architects, they needed a UK input. Nothing happened on this until I met Ron Soskolne, their design chief, over breakfast in Toronto in October. I liked the concept of the scheme enormously. It is grand, bold and formal. The booklet with imaginary pictures of it finished, however, was very disappointing. But the notion and its potential appealed to me.

On return I rang Nigel Broackes. He has always had a soft spot for me and the feeling is mutual and he seemed much amused and said of course I should do it, that my name would be such a coup for them ... Nigel took me round the whole Docklands area, puffing a cigar in the front of his grey Rolls-Royce and purring with pleasure, as well he might, at the resurrection of this vast eight-square-mile scene of deso-

lation. It was an odd mixture. I can see how people said why wasn't there a masterplan, but it would never then have happened at all. As it is, it is a mixture of restored old warehouses, post-modernist buildings and constructions for businesses, restored yuppie old houses, acres of crumbling decay, eruptions of deadly council housing (over 80% of the population live in this, mainly the real East End working class, left from the days when we had a port) and occasionally a church with a spire.

Canary Wharf has quite a history and I have been brought in post Olympia & York buying out the previous developers. The project is to build what can be described as the Docklands 'downtown' area, a huge formal working and retail centre which would act as a focus for the whole, in the same way that London falls into areas like Kensington, Chelsea, the West End and the City. The concept includes a grand series of formal squares and circuses, high-rise buildings constructed with linking design modules. All of this can happen without reference to anyone as the Docklands is a development zone.

And this is the final entry for 1987. The diary for 1988 opens with the sentence: 'This should open with many entries not written. Hélas!'

PART THREE

POSTSCRIPT

1996

1996

Postscript

A decade has passed and a new life has been made. I could not return to the old one. In the final days before I left the V & A my successor looked at me and said, 'This place has traumatised you.' 'Yes,' I said, 'it has.' 'Everything they have done to you they will now do to me.' The reply was in the affirmative.

I write this looking through my writing-room window out on to the great cedar of Lebanon which holds the house in its mighty arms. In the distance I can see May Hill, which divides Herefordshire from Gloucestershire. The fields in the foreground are in the first flush of the greens of spring. Below that noble tree, on the front lawn, spreads what we call the glade, presided over by a statue of Flora, her arms bearing a cornucopia of stone blossoms. But today the fitful sun catches drifts of flowers at her feet, flecks of honey, lemon, ochre, sky-blue and pale purple. On the other side of the house Julia, I know, will be at her drawing-board, our two cats curled up in nests close to her. We will meet at lunch, something always to look forward to.

Wherever my eye falls, the room is garlanded with the artefacts of memory: David Hockney's quick profile of me taken that weekend at Reddish with Beaton and, not far from it, a sketch by Cecil of a vase of flowers standing in his 'Lady Windermere's Fan' room. Up over a cupboard for stationery hangs David's wedding present to us, given at a party Lindy Dufferin sweetly held to mark that event. Tucked behind the glass doors of the Gothic bookcase which holds my collected works I glimpse the Matteo de Pasti medal of Sigismundo Malatesta, a Christmas gift to me from my father-in-law, Charles Oman, and also the Shakespeare Prize medal from 1980. Just above the phone there is a Cecil photograph of the Queen Mother from the famous 1939 sitting in which she clasps a lace parasol beneath the great Waterloo Vase, the one she signed for me in the aftermath of that Clarence House lunch in 1987. On another wall my eye catches the framed certificates of honorary fellowships and degrees as well as Nicholas Georgiadis's design for Nureyev's costume in *Nutcracker*. And there is Carola Oman's solid Victorian partners' desk in the middle of the room, at

which I still write. And, of course, there are portraits, Lelyesque ladies and an eighteenth-century gentleman who nestles beneath a sketch by Bryan Organ for the portrait of me now in the National Portrait Gallery, recalling the days when Lesley Blanch dubbed me 'Sir Portrait'. Close to the pile of books to be used for the work in hand there is a back view of that busybody Sir Henry Cole, whose successor I was for fourteen years in the middle of this century. I wonder what he would have made of it all?

And dotted and propped up everywhere there are photographs of Julia and of our cats, both past and present. Julia happy picnicking at Glyndebourne, Julia peering through the branches of an apple tree laden with fruit, Julia doing her patchwork or embracing a cat. Outside spreads that paradise which we created together, the garden. I feel tranquil and secure. Can anyone ask for more?

The Reverend Wenceslas Muffby
by Michael Leonard

INDEX

Abbado, Claudio, 311
Abel Smith, Henriette Alice, Lady, 216–17
Aberconway, Christabel, Lady, 29–31
Abercorn, Anastasia Alexandra, Duchess of, 89–90
Abercorn, James Hamilton, 5th Duke of, 89–90
Acton, Sir Harold: RS's first meeting, 45–6; Sutro lunch, 45–6; personality, 46; Rosses' parties, 64, 230, 360; RS's visits to La Pietra, 100–1, 125, 359–60; at Covent Garden, 164; Hartwell lunch, 181; response to *Children of the Sun*, 181; Princess Margaret's parties, 205, 360
Adam, Robert, 145
Adams, Christine, 86, 87
Adams, Kingsley, 6, 86
Adburgham, Alison, 12
Adeane, Edward, 291, 292
Adeane, Helen, Lady, 48, 320
Adeane, Michael, Baron Adeane of Stamfordham, 48, 291n
Ades collection, 223
Adler, Larry, 410
Agnews, 91
Aird, Captain Sir Alastair, 28, 175, 206, 276, 349
Airlie, David Ogilvy, 13th Earl of, 90, 421
Airlie, Virginia (Ginnie), Countess of, 90, 170
Aitken, Jonathan, 9, 55
Albert Hall, 311
Alexandra, Princess: at Albert Hall, 8, 23; at Buckingham Palace, 90, 172, 173; *American Art* visit, 175; Queen Mother's eightieth birthday, 262; Buccleuch eightieth birthday, 268; American Ambassador's dinner, 320; Anglo-Chinese evening, 418; Friends of Israel Museums dinner, 426; Diego Rivera exhibition, 426
Alexandra, Queen, 19, 195
Alice, Princess, 268, 402
Alington, Lady Mary, 114
Alington, Napier Sturt, 3rd Baron, 114
Althorp, Northants, 17, 190
Altrincham, John Grigg, 2nd Baron, 430
Amery, Colin, 414, 422
Amery, Julian, Baron Amery of Lustleigh, 113
Amies, Sir Hardy, 55, 81, 90, 269
Amis, Sir Kingsley, 207–8, 208n
Ancaster, Gilbert Heathcote- Drummond-Willoughby, 3rd Earl of, 191

And When Did You Last See Your Father?, 199, 222
Andrew, Prince, 218, 373
Anglesey, Marjorie, Marchioness of, 64
Anglo, Professor Sydney, 286–7, 296, 304, 307
Annan, Gabriele, Lady, 122
Annan, Noël, Baron Annan: Hugh Thomas's birthday party, 24; Fleming parties, 69, 122, 303; Sainsbury party, 202; Heritage Bill, 326, 330
Anne, Princess Royal, 90, 155, 172, 191, 402, 426
Anne of Denmark, Queen, 33
Anne Marie, Queen of Greece, 431–2
Annenberg, Leonore, 61, 89, 94, 106
Annenberg, Walter, 61, 89, 94, 106
Annigoni, Benedetto, 58
Annigoni, Pietro, 9, 42–3, 48, 51, 52, 56–60
Antique Collector, 412, 417
Apollo, 52n, 83, 396
Apsley House, 136–7, 326, 382, 408
Archibald, James, 293–4
Argyll, Margaret, Duchess of, 114, 257
Armstrong, Robert, Baron Armstrong of Ilminster, 416
Arnold, Sir Malcolm, 97
Art and Power, 340
Art Newspaper, The, 409n
Arts Council: photographic committee, 137; theatre exhibition, 142; Shaw's position, 149–50; reform suggestions, 289, 338, 345–6; role, 329, 333; Art Panel, 329–30, 427; Covent Garden problems, 335–6; arts funding debate, 344–5; Ilkley Conference, 343–4, 348–9; new strategy, 361; *The Glory of the Garden*, 373–4, 427; organisational review, 383; RS's extension, 410; RS's resignation, 415, 417; RS's last Art Panel meeting, 427; Billesley think-tank, 427–8
Arts Office: RS's brief on V&A appointment, 138, 145; Donatello roundel, 156; V&A funding, 161, 235; Leicester conference, 191; creation, 232
Arundel Castle, Sussex, 188
Ashcombe, Wiltshire, 40, 251
Ashcroft, Dame Peggy, 35, 267n
Ashley-Smith, Jonathan, 414
Ashmole, David, 337
Ashmore, Sir Peter, 216, 312

Ashton, Sir Frederick: wartime experiences, 25; social life, 27, 35, 268, 279; Hockney portrait, 36; farewell to Royal Ballet, 79; *Month in the Country*, 87, 164, 235; Rambert training, 102, 325; *Enigma Variations*, 102–3; OM, 202; at Royal Lodge, 211, 314–15; relationship with Queen Mother, 215, 314–15; Messel thanksgiving, 229–30; Covent Garden triple bill, 240–1; appearance, 261, 268; Queen Mother's eightieth birthday, 261; Sibley-Dowell *pas de deux*, 271, 278; represents Queen, 347; Runciman on, 350; *hommage* to, 367; royal *pas de deux*, 401, 403

Ashton, Sir Leigh, 6, 134–5, 152, 170, 233, 331

Aslin, Elizabeth, 177, 409

Aspen, Colorado, 393

Association for Business Sponsorship of the Arts (ABSA), 200, 232, 329, 350, 430

Association France-Grande-Bretagne, 155

Astor, Judy, 62

Astor, Michael, 62

Astor, William Waldorf Astor, 4th Viscount, 349

Attenborough, Sir David, 428–9

Auden, W.H., 35

Augustus, Elector of Saxony, 192

Avedon, Richard, 119

Ayer, Sir A.J., 39, 103

Ayer, Peter, 80

Bacon, Francis, 34, 58, 97, 122, 285

Baddeley, Hermione, 197

Baddeley, Rev. William, 197

Bagnold, Enid (Lady Jones), 215

Bailey, David, 27, 46, 53, 80, 85, 90

Baker, Dame Janet, 236

Balanchine, George, 103

Balcon, Jill, 105–6

Balfour ciborium, 250, 269, 271

Balfour of Burleigh, Robert Bruce, 8th Lord, 257

Banham, Mary, 182

Barber, Richard, 81

Barbican Centre, 310–12

Barbirolli, Sir John, 97

Barenboim, Daniel, 425

Baring Foundation, 351

Barker, Godfrey, 409

Barnett, Joel, Baron Barnett, 340, 344, 382

Baryshnikov, Mikhail Nikolayevich, 265

Bassano, Jacopo da, 277

Bassett, Douglas, 352, 363

Bates, John, 269

Bath, Alexander Thynne, 7th Marquess of (earlier Viscount Weymouth), 244

Bath, Henry Thynne, 6th Marquess of, 244

Bath Festival, 41

Battersby, Martin, 70, 364

Bayley, John, 419

Baynes, Keith, 21

Bazeley, Chris, 108

BBC, 84, 143, 216, 282, 336, 396, 409

Beardsley, Aubrey, 33

Beatles, the, 32

Beaton, Baba, 123

Beaton, Sir Cecil: diaries, xiii; friendship with RS, 7, 123, 176, 250–3; photographs of RS, 8, 271, 400; social life, 10, 12, 13, 38, 55–6, 104, 113–14; sartorial influence, 11; exhibition of portraits, 13, 26–8, 72; stories, 18; Reddish weekends, 19–21, 38–40, 77–8, 123, 251–2, 437; portrait by Hockney, 38–40, 251; photograph of Princess Margaret, 57; Bailey film, 80, 90; Cooper friendship, 90; photographs of RS and Julia, 94; in New York, 101; *Masque of Beauty* exhibition, 108; V&A collection, 117; stroke, 151–2; old age, 165, 167, 242–3; archive sale, 165; collection of dresses, 181; Foyles Literary Luncheon, 203; death, 250–3; funeral, 253–4; sale, 254, 266; memories of Pam Hartnell, 303; influence, 405; Collection, 423; relationship with Royal Family, 424, 430

Beaufort, David Somerset, 11th Duke of, 110

Beaumarchais, Jacques de, 168, 175, 196, 318

Beaumarchais, Marie-Alice de, 168, 175, 196, 318

Beaumont, Hugh, (Binkie), 113–14

Beckwith, John, 177

Bedford, John (Ian) Russell, 13th Duke of, 108–9, 114, 218, 281

Bedford, Nicole, Duchess of, 108–9, 114, 121, 218, 281

Beith, Alan, 151

Bell, Quentin, 22, 35

Bell, Vanessa, 21–2

Belvoir Castle, Lincs, 279–80

Beningborough Hall, Yorks, 4, 97

Bennett, Alan, 64

Benney, Gerald, 174

Benton, Lady, 110

Berenson, Marisa, 85

Berger, Helmut, 85

Berlin, Aileen, Lady, 12, 181, 320

Berlin, Irving, 253

Berlin, Sir Isaiah: Waverley lunch, 12; Gendel funeral, 112; Hartwell lunch, 181; Yates DBE, 196, 198; influence, 196, 200, 362, 394, 395; Fleming gatherings, 285; letter on RS's knighthood, 301; American Ambassador's party, 320; Levin interview, 366

Bermans, 61, 201, 378

Berners, Gerald Tyrwhitt-Wilson, 14th Baron, 240

Bernini, Gian Lorenzo, 271, 385, 388, 395, 401
Berry, Harriet, 303, 310
Bertin, Rose, 67
Bethnal Green Museum of Childhood, 137, 177, 319, 321, 324
Betjeman, Sir John: social life, 13, 181, 213; theatre going, 37; biography, 109n; on *Spirit of the Age*, 146; eyesight, 175, 207, 211; ill health, 182, 211, 213, 313; *Archie and the Strict Baptists*, 202
Biagio, Rebecca, 20
Biffen, John, 268
Billesley Manor, Warks, 427–8
Billington, Rachel, 88n
Bindoff, Professor, S.T., 5
Bing, Professor, Gertrude, 305
Bingham, Andrew, 110
Bingham, Caroline, 110
Binney, Marcus, 139, 198, 340
Birk, Alma, Baroness Birk of Regent's Park, 149, 188, 189, 257
Birkenhead, Robin Smith, 3rd Earl of, 181
Birley, Sir Oswald, 35
Birley, Rhoda, Lady, 35
Birtwell, Celia, 80, 152
Bishop's Frome Rectory, 111
Blake, Robert, Baron, 228
Blanch, Lesley, 79–80, 438
Blanche, Jacques-Emile, 21, 64
Blandford, John Spencer-Churchill, Marquess of, 55
Blessington, Lady, 285
Blum, Maître, 139
Blunt, Anthony, 246–7, 270, 350
Bologna, Giovanni da, 359
Bonham Carter, Mark, Baron Bonham-Carter, 349–50
Bonhams, 207
Bonington, Chris, 95
Bonington, Richard Parkes, 75
Bookshelf, 387
Booth, Dr Graham, 9
Borg, Dr. Alan, 414, 415
Borrie, Michael, 7
Boughton House, Northants, 76–7, 146, 190, 246
Bowen, Elizabeth, 69, 97
Bowes-Lyon, David, 174
Bowhill, Selkirk, 220
Bowness, Sir Alan, 267
Bowness, Sarah, Lady, 267
Box, E. (Eden Fleming), 167
Boxer, Arabella, 40
Boxer, Mark, 40, 60, 360
Boylan, Patrick, 414
Boyle, Edward, Baron Boyle of Handsworth, 200
Brabazon Brabazon, Hercules, 15, 89
Brandes, Lawrence, 235, 260, 266, 268, 269
Brandt, Bill, 227, 270–1, 400
Brewster, Kingman, 203

Brewster, Mary Louise, 203
Brighton, RS's house, 85, 94, 103, 104
Bristol, Hans Schubart Memorial Lecture, 151
British Academy, 197
British Council, 53, 67, 330
British Film Association, 388
British Film Institute, 332, 338
British Library, 363
British Museum: soirée, 42; Pope-Hennessy Directorship, 116, 150, 163–4; Jaffé appointment, 176; conference on regions, 195; funding, 295, 300
British Rail, 192
British Theatre Museum, 138
Britten, Benjamin, Baron Britten, 63, 182
Broackes, Sir Nigel, 425, 432–3
Brockhall, Northants, 17
Brogden, Professor Joanne, 310
Brommelle, Norman, 134
Brookner, Anita, 392
Brown, Caroline, 84
Brown, Carter, 139
Brown, Lancelot ('Capability'), 227
Bruce, David, 41, 93
Bruce, Evangeline, 27, 41, 77, 93, 310
Brudenell, Marion, 190–1, 268
Bryan, Felicity, 415
Bryer, Elsie, 371
Buccleuch, Jane, Duchess of, 146, 220–1
Buccleuch, John Montagu Douglas Scott, 9th Duke of (earlier Earl of Dalkeith), 220, 221
Buccleuch, Mary (Mollie), Duchess of, 77, 220, 261, 268
Buccleuch, Walter Montagu-Douglas-Scott, 8th Duke of, 77, 95, 220
Buccleuch miniatures, 327
Buckingham Palace, 9, 69, 89–90, 170–3, 312–13
Buckle, Richard: celebration lunch with, 4; Diaghilev exhibition, 6; Beaton friendship, 7, 27, 151; Beaton exhibition, 26, 28; Beaton party, 80; Museum of Theatre Art, 86; Beaton's funeral, 253
Bulmer, John, 245
Burghley House, Lincs, 190, 204, 279–81
Burgoyne, General John, 98
Burlington Magazine, 176, 225, 348, 396
Burman, Peter, 198
Burrett, Gordon, 273, 288, 312, 324
Burton, Baroness, 113
Burton, Hal, 253
Burton, Richard, 95
Burton Publishing, 412
Butler, Sir Michael, 377, 386, 399, 411, 416
Butler, R.A. (Rab), Baron Butler of Saffron Walden, 202, 403
Byatt, A.S., 14, 221–2
Byatt, Charles, 221
Byatt, Miranda, 221
Byrne, Muriel St Clare, 306

Byrom, Peter, 346
Byron, Annabella, Lady, 24
Byron, George Gordon, 6th Baron Byron of Rochdale, 24, 117, 137
Byron Society, 137

Caccia, Anne, Lady, 261
Caccia, Harold, Baron Caccia, 261
Cagiati, Andrea, 294
Cagiati, Sigrid, 294
Cairns, David, 164
Callaghan, Audrey, Lady, 169, 173, 218, 237–8
Callaghan, James, Baron Callaghan of Cardiff, 169, 173, 217, 220, 237–8, 261
Calloway, Stephen, 378
Calthrop, Gladys, 27
Camoys of Stonor, Elisabeth, Lady, 405
Canaletto, 109
Canary Wharf, 425, 431, 432–3
Canova *Three Graces*, 281
Capel family, 64
Capon, Edmund, 414, 415, 416, 417
Carlisle, Esmé, Countess of, xiii
Carlton Terrace, 88
Caro, Sir Anthony, 44
Carpenter, Lilian, 155
Carreras, José, 400
Carrington, Peter Carrington, 6th Baron: Foreign Secretary, 238, 318n; Chairmanship of V&A Trustees, 320, 330, 334, 342, 344, 347, 379, 382, 384, 386, 390; Theatre Museum, 337, 340; Gowrie relationship, 338, 340, 350, 352; selection of Trustees, 339–40; RS's opinion of, 342, 343, 346, 347, 361, 386, 392; V&A funding issue, 350, 352, 356, 358, 363, 384; NATO commitment, 376–7; leaving V&A, 386, 388, 421, 428; RS's departure and future career, 394, 395, 401, 406, 408–10, 411, 421; Bernini saga, 398, 399; RS's successor, 415, 428
Carritt, David, 55, 153
Carroll, John, 13–14
Carter, Ernestine, 54
Carter, Jake, 54
Cartland, Dame Barbara, 73n
Casson, Sir Hugh: NPG plans, 88; drawings, 114, 217; President of RA, 164; RA Dinners, 170, 191, 258; *Tonic for the Nation* show, 182; Michelangelo tondo, 237; Clarence House lunch, 277; Barbican opening, 311; at Royal Lodge, 314–15; Churchill book suggestion, 403
Casson, Reta, Lady, 277, 311, 314–15
Casson Conder, 98
Castle, Barbara, Baroness Castle of Blackburn, 50–1, 62
Catford, Sir Robin, 421
Catherine of Braganza, 77, 239
Catherine the Great, Empress, 67, 68
Cathie, Alison, 355

Cavendish, Lady Elizabeth, 174–5, 202, 211
Cazalet, Thelma, 215
Cecil, Lord David, 174–5, 211, 213, 214, 253, 313
Cecil, Rachel, Lady David, 174, 211, 214, 253, 313
Cecil, Robert, 54
Cecil, Rose, 214
Cezanne, Paul, 31
Chalfont, Alun Gwynne Jones, Baron, 71
Chandos, Thomas Lyttelton, 3rd Viscount, 381
Channel 4, 409
Channon, Sir Henry ('Chips'), 16n, 60, 430
Channon, Henry, 364
Channon, Ingrid: *Vogue* party, 27; Kelvedon weekend, 40; *Elizabethan Image*, 47; Kelvedon party, 76; at Beaton film party, 80; Gendel funeral, 112; Downing Street party, 113; Lindsay House entertaining, 205, 215; Covent Garden gala, 264; Buccleuch party, 268; *Princely Magnificence*, 270; Gonzaga exhibition opening, 291; life as Minister's wife, 293, 365; Hartwell memorial, 310; American Ambassador's party, 320; Neville lunch, 364–5
Channon, Paul: *Vogue* party, 27; Kelvedon weekend, 40; *Elizabethan Image*, 47; Kelvedon party, 76; at Beaton film party, 80; Downing Street party, 113; V&A cuts, 260, 266–7; Covent Garden gala, 264; Buccleuch party, 268; *Princely Magnificence*, 270; Minister for the Arts, 274, 277, 289, 293, 294, 321, 324, 329, 331, 397; speech making, 289, 295; V&A lecture, 293; Hartwell memorial, 310; American Ambassador's party, 320; Heritage Bill, 326
Chappell, William, 265
Charles I, King, 53, 89, 206, 277
Charles II, King, 206
Charles, Prince of Wales: NPG Trusteeship question, 59; Organ portrait, 79; Longford party for, 88–9; appearance, 89, 292; Buckingham Palace party, 90; State Opening of Parliament, 155; christening, 228; Mayer Concert, 236; Queen Mother's eightieth birthday, 262; wedding, 284; Gonzaga exhibition, 287, 290–2; at Covent Garden, 294; investitures, 317; marriage difficulties, 361–2; advisory group, 421–2; Theatre Museum visit, 428; ABSA prizegiving, 430–1; appearance, 431
Charleston, 21–2
Charlotte, Queen, 217
Charteris, Gay, Lady, 89, 213, 316
Charteris, Martin, Baron Charteris of Amisfield: Annigoni portrait viewing, 59; dinner with, 89; at Royal Lodge, 213, 316; Provost of Eton, 213, 430; National

Heritage Memorial Fund, 257, 388, 398, 399, 430; Queen Mother's eightieth birthday, 262; Bernini saga, 388, 398, 399, 401; National Gallery Directorship question, 394; RS's successor question, 414; lunch with RS, 430

Chatsworth, Derbys, 204, 279

Chellini Madonna, 145, 153–4, 223, 395

Chelsea Flower Show, 318, 342, 353, 402

Cheshire, David, 140

Chesterfield, Philip Dormer Stanhope, 4th Earl of, 382

Childs, Douglas, 417

Cholmondeley, Lady Caroline, 109

Cholmondeley, George, 6th Marquess of, 177

Cholmondeley, Sybil, Marchioness of, 62–3, 177, 214, 228

Christian Science Monitor, 56

Christie, Sir George, 365

Christie, Harold, 77

Christie, John, 365n

Christie, Julie, 9

Christie, Patricia (Mary), Lady, 365

Christie's, 91, 153, 206, 421, 428

Churchill, Sir Winston, 122, 403

Churchill Memorial Lecture, 155, 158

Civil Service Catering Organization (CISCO), 300

Clandeboye, Co. Down, 10–11, 36, 44–5

Clarence House, 174–5, 205–6, 229, 264, 276–8, 349–50

Clark, Alan, 348

Clark, Colette, 278

Clark, Felicity, 253, 254

Clark, Jane, Lady 165, 348

Clark, Kenneth, Baron Clark: career, 3, 391; Buckingham Palace party, 90; *Civilisation*, 111; V&A Advisory Council, 135; V&A lecture, 165; old age, 165, 207; V&A lobby, 200; autobiography, 202; second marriage, 202; Nicolson memorial service, 226; V&A Friends launch, 233; memorial service for, 347–8, 391

Clark, Nolwen, Lady, 207, 350–1

Clark, Ossie, 34, 80, 152

Clary, Prince and Princess, 206

Clifford, Timothy, 397, 398, 413, 414

Clive, George, 419

Clive, Lady Mary, 419

Clore, Melanie, 426

Club, The, 428

Coats, Peter, 16, 27, 60–1, 229, 264, 319

Cochran, C.B., 240–1

Coggan, Donald, Baron Coggan, 213

Coke, Sir Robin, 257, 258, 260

Cole, Sir Henry, 438

Colefax & Fowler, 190

Colin, Pamela, *see* Harlech

Collier, Lesley, 265, 372

Conner, Angela, 122, 200, 245

Connolly, Cyril, 34

Conran, Caroline, Lady, 404

Conran, Sir Terence: V&A Trustee, 340; Board meetings, 355–6, 379, 382–3, 409; fund-raising role, 356, 384; design strategy, 377; relationship with RS, 382–4; Hamlyn dinner, 404

Conran Foundation, 249, 269, 288

Conran Octopus, 355

Constantine II, King of Greece, 431

Contemporary Arts Society, 54

Cooper, Lady Diana: RS's first meeting, 12, 13; Beaton friendship, 12, 152, 253; appearance, 16, 70, 108, 152, 194, 215, 253–4; social round, 16, 27, 29, 63–4, 71, 92, 93, 94, 215, 277, 285; face lift, 23, 303; Loelia Lindsay story, 56; at Covent Garden, 63–4; childhood memories, 64; surprising lunch with, 70; luggage, 93; Trefusis story, 125–6; Fabergé exhibition, 194; admirers in old age, 215, 405; Beaton funeral, 253–4; Queen Mother's eightieth birthday, 261; Princess Margaret's opinion of, 309; Messel opening, 337

Cooper, Douglas, 30

Cooper, Duff, 1st Viscount Norwich, 12n

Cooper, Samuel, 16

Coote, Jean, 100

Coote, Merritt, 100

Cordet, Hélène, 424

Cormack, Sir Patrick, 151

Cornforth, John, 72, 139, 149, 268, 319

Corradini, Antonio, 416

Corri, Adrienne, 385

Costume Museum, Bath, 24–5

Costume Society, 24

Cottesloe, John Fremantle, 4th Baron, 179

Council of Europe, 53

Courcel, Geoffroy, Baron de, 318

Courtauld, Sir Samuel, 30

Courtauld Institute of Art, 250, 392

Courts, David, 173

Coutts Bank, 277

Covent Garden, Royal Opera House: Royal Box, 48, 63, 180; *Eugene Onegin*, 87; status, 87; *La Bohème*, 120; gala, 121; seat prices, 142; Wilson's opinion of, 154; *A Month in the Country*, 158, 164–5, 264; *Fledermaus*, 197; *Sleeping Beauty*, 201; Queen Mother's Birthday Gala, 262, 264–5; ENO merger proposal, 289; *Romeo and Juliet*, 294; mismanagement, 335–6; funding, 344, 345, 346; Queen's Birthday Gala, 400–1; chorus strike, 422

Cowan, John, 186

Coward, Sir Noël, 27, 424

Cowles, Fleur, 176, 206–7, 277, 320, 429

Cox, Angela, 85

Cox, John, 293

Cox, Sir Trenchard, 136, 147, 233

Crafts Advisory Council, 162

Crafts Council, 383

Cranborne, Hannah, Lady, 174
Cranborne, Robert Cecil, Viscount, 174
Cranborne, see also Salisbury
Cranborne Lodge, Dorset, 77–8, 168
Craven sale, 33
Craxton, John, 29
Creating Small Gardens, 393
Crewe, Quentin, 10, 28, 69
Crewe, Susan (née Cavendish), 69, 80
Crichel, Dorset 20, 40
Croome Court Library Room, 145
Crosby, Theo, 380, 381
Crown Commissioners, 119–20
Crown Estates, 88
Cult of Elizabeth, The, 185
Cunard, Maud Alice (Emerald), Lady, 285

Dacre, Alexandra, Lady, 268, 294–5, 303
Dacre, Hugh Trevor-Roper, Baron, 228, 294–5, 303
Daily Express, 43
Daily Herald photographic archive, 85
Daily Mail, 32, 51, 59, 62, 337, 362, 396
Daily Mirror, 56
Daily Telegraph, 243, 291, 302, 345, 396, 409
Dalhousie, Margaret, Countess of, 174
Dalhousie, Simon Ramsay, 16th Earl of, 174
Danvers House, Culworth, 99, 103–4, 110, 111
Darby, Michael, 352, 363, 384–5
Dartmouth, Gerald Legge, 9th Earl of, 90
Dartmouth, Raine, Countess of, see Spencer
Darwin, Sir Robin, 170
Daumier, Honoré, 200
David, Gerard, 104
David, Gwenda, 207
Davidson, Ken, 201
Davies, David, 416
Davies, Sir Martin, 112
Davies, Sue, 137
d'Avigdor Goldsmid, Rosy, Lady, 108
Davis, Sir Colin, 41
Davison, Kensington, 294, 423
Day-Lewis, Cecil, 105–6
Day-Lewis, Jill (Balcon), 105–6
Daylesford, 228
de Bellaigue, Sir Geoffrey, 270
de Bellaigue, Sheila, Lady, 270
Deene Park, Northants, 190
de Gaulle, General Charles, 213
de Heere, Lucas, 307
Dekker, Thomas, 275, 282
de L'Isle, Margaret, Lady, 261
de L'Isle, William Sidney, 1st Viscount, 71–2, 77, 261
della Robbia, Luca, 150
de Margerie, Bobbie, 276, 318
de Margerie, Hélène, 276, 318

Dench, Dame Judi, 400, 423
Denny, Robyn, 44
de Nobili, Lila, 103
Department of Education and Science (DES): Special Grant question, 17; NPG site, 74; V&A funding, 134, 189, 235; cuts, 160–1, 188, 195, 235, 301; V&A status, 199, 200, 210, 216
Department of the Environment (DOE), 85, 187, 189, 249
Derain, André, 264
Derby, Earls of, 91
d'Erlanger, Edwina Louise Pru, 181
Desert Island Discs, 50, 52
Design Museum, 249
Devlin, Bernadette, 50
Devonshire, Andrew Cavendish, 11th Duke of, 53, 63, 279, 318
Devonshire, Deborah, Duchess of, 63, 318
Dexter, John, 120, 282
Diaghilev, Sergei Pavlovich, 6, 241, 326, 339
Diana, Princess of Wales: Organ portrait, 79; wedding, 273, 284; Gonzaga exhibition opening, 273, 287, 290–2; appearance, 291, 405; pregnancy, 293; at Covent Garden, 294; role, 317; marriage difficulties, 361–2; media treatment, 418; husband's birthday, 428; ABSA prizegiving, 430
Dickson, Dorothy, 230, 337
Digby, Dione, Lady, 368, 381
Ditchley Conference (1975), 150, 158
Domenichino, 90
Domingo, Placido, 400
Donaldson, Frances (Frankie), Lady, 201, 215, 261, 268, 276
Donaldson, John Donaldson (Jack), Baron Donaldson of Kingsbridge: V&A cuts, 182–3, 188, 195, 216, 255; personality, 183, 200, 255, 289; Mentmore case, 189; lifestyle as Minister, 201, 215; replacement, 255; Queen Mother's eightieth birthday, 261; Weidenfeld gathering, 276; V&A Council, 304
Donatello, 145, 153–4, 156, 158, 163, 165, 395
Donne, John, 87
Donohoe, Jimmy, 105
Dors, Diana, 107
d'Orso, Luigi, 270
Dotrice, Roy, 38
Douglas, Lord Alfred, 21
Douglas-Home, Alec, Baron Home of the Hirsel, 310
Douglas-Home, Elizabeth, Lady, 310
Dowell, Sir Anthony, 240, 265, 271, 278, 372
D'Oyly Carte, Dame Bridget, 154
Drake, Fabia, 48
Drake, Sir Francis, 91
Drayton House, Northants, 18–19

Drew, Joanna, 149, 329–30, 332, 344, 361, 427

Drogheda, Garrett Ponsonby Moore, 11th Earl of: at Covent Garden, 48, 63, 264; Fleming party, 122; at Royal Lodge, 213, 316; US tour, 246; Queen Mother's eightieth birthday, 261, 264; Buccleuch party, 268

Drogheda, Joan, Countess of, 63, 213, 261, 264, 268, 316

Drumlanrig Castle, Dumfriesshire, 221

Drummond, Sir John, 146

du Cann, Sir Edward, 200

Duff, David, 114

Dufferin and Ava, Belinda (Lindy), Marchioness of: appearance, 10, 34; Clandeboye shooting party, 10–11; *Vogue* party, 27; party for Duncan Grant, 34–5; Morocco trip, 36–7; artists at Clandeboye, 44–5; Rosses' party, 65; Plunket introduction, 75; wedding party for RS and Julia, 437

Dufferin and Ava, Maureen, Marchioness of, 161

Dufferin and Ava, Sheridan Hamilton-Temple-Blackwood, 5th Marquess of, 10, 34, 65, 75, 285

Duffield, Vivien, 353–4, 373, 401, 412–13

Dukes, Sir Ashley, 325

Dunluce, Alexander McDonnell, Viscount, 34

Dunn, Henrietta, Lady, 365

Dunn, Mary, Lady, 39

Dunn, Peter, 404

Dunn, Sir Thomas, 365

du Pré, Jacqueline, 425

Düsseldorf, Künsthall, 150

Earle, Joe, 249, 377, 414

Easton Neston, Northants, 17–18, 190

Eccles, David, 1st Viscount Eccles: museum charges policy, 53, 81, 87; Mary Tudor portrait funds, 94; views on society, 149–50; influence, 200; Heritage Bill, 326, 327

Eccles, Sybil, Lady, 149

Economist, 340, 355

Eddington, Paul, 400

Ede & Ravenscroft, 155

Edmonton County Grammar School, 5, 51, 371

Edward VII, King, 101, 195

Edwards, Matilda, 247

Egremont, John Wyndham, 1st Baron, 285n

Egremont, Pamela, Lady, 122, 285

Elgar, Sir Edward, 115

Elizabeth I, Queen: 'Ditchley Portrait', 13, 49; *The Elizabethan Image* exhibition, 33–4; Hilliard portrait, 145; Warwick Castle portrait, 207

Elizabeth II, Queen: lunch at Buckingham Palace, 9; Annigoni portrait, 9, 42–3, 48, 51, 52, 58–60; Henrietta Maria portrait, 16–17; Beaton photographs, 26, 27; Plunket tiara story, 75; Buckingham Palace *fête* (1971), 90; clothes, 95; Country House show, 143; State Opening of Parliament (1975), 155; Downing Street dinner, 166; State Banquet for the French, 171–3; National Theatre opening, 179–80; Silver Jubilee, 192–4, 198; Fabergé exhibition visit, 199; Windsor, 212, 217–19; Mayer centenary concert, 236; *Japan Style* visit, 298; Queen Mother's eightieth birthday, 262, 264–5; RS's knighthood, 312–13; Royal Lodge arts festival, 315–17; Henry Cole Wing opening, 331, 333; son's marriage, 362; Glyndebourne visit, 363–4, 365, 366; *Nutcracker*, 366, 373, 378; sixtieth birthday, 400–1; Chelsea Flower Show, 402; Clore Gallery opening, 412; Christmas broadcasts, 428–9

Elizabeth, Queen, the Queen Mother: Beaton lunch, 12, 13; Beaton show, 27, 28; *Elizabethan Image* exhibition, 47; seventieth birthday, 76; Palace party, 90; Clapham appeal, 137; Country House show, 143; State Banquet for the French, 171; Clarence House lunches, 174–5, 205–6, 276–8, 349–50, 429–30; *Tonic for the Nation* exhibition, 182; at Covent Garden, 202; Royal Lodge arts festival, 212–13, 313–17; Channon dinner, 215; Kent wedding party, 229; Ham House visit, 238–9; Weinstock wedding, 246; eightieth birthday, 261–2; Buccleuch eightieth birthday party, 268; RS's knighthood, 301; *Artists of the Tudor Court* opening, 337, 342; *Nutcracker*, 373, 379; Pirelli Garden opening, 416–17; Beaton photograph, 430, 437

Elizabeth R, 94, 101, 103

Elizabethan Image, The (1969 exhibition), 33–4, 46–7, 50, 51

Elizabethan Institute, 22

Ellison, Clifford, 13

Ellison, Gerald, Bishop of London, 247, 261

Emery Reves Collection, 139

England, Sylvia Lennie, 321–2

English, Kelvin, 289

English Heritage, 326n, 419

English Icon, The, 33, 50

English Miniature, The, 314

English National Opera, 256, 289, 374, 424

English Renaissance Miniature, The, 342

English Speaking Union, 410

Enthoven Collection, 138

Erté, 112, 261, 268

Esher, Christian, Lady, 90

Esher, Lionel Brett, 4th Viscount, 90, 207, 208

Esteve-Coll, Dame Elizabeth, 414, 415, 416, 417, 437

Euston, James FitzRoy, Earl of, 45
Evans, Dame Joan, 145
Evening Standard, 64, 70, 120, 176, 288, 309, 321, 324, 334, 337, 341, 342, 384–5, 397, 409, 416, 423
Ewing, Maria, 365, 410
Eworth, Hans, 95
Exeter, David Cecil, 6th Marquess of, 280
Exeter, Diana, Marchioness of, 280

Fahy, Everitt, 153
Fanfani, Amintore, 292
Faulds, Andrew, 293
Feather, Alice, Lady, 90
Feather, Vic, Baron Feather, 90
Ferens Lectures, Hull, 98, 100
Fermoy, Ruth, Lady: family stories, 63, 206; at Royal Lodge, 212, 313, 314–17; with Queen Mother, 229, 278, 315; Clarence House lunch, 349
Ferragamo family, 426
Festival Hall, 311, 362, 373
Feydecheva, 68
Field, Frank, 367
Field, John, 87
Financial Times, 223, 227, 242, 356, 361, 363, 414, 415, 417
Firmstone, Christopher, 46, 108, 182
Fischer, Freddie, 203
Fischer, Rosemary, 203
Fish, Michael, 30
Fitzalan-Howard, Margaret, Lady Michael, 174
Fitzalan-Howard, Lord Michael, 174
Fitz-Gerald, Desmond, 17–18
Fitzwilliam, William Wentworth- Fitzwilliam, 10th Earl, 153
Fitzwilliam Museum, Cambridge, 3
Fleetwood-Hesketh, Peter, 72
Fleming, Ann: gatherings, 11, 62, 69, 122, 285, 303; *Vogue* party, 28; Kelvedon weekend, 40–1; personality, 40–1; Goodman friendship, 48, 181, 285–6; Hartwell parties, 71, 181; Beaton film party, 80; appearance, 122, 181, 228, 241, 268, 285; Rothermere funeral, 228; death, 284–5
Fleming, John, 100, 124–5, 332
Fletcher, Dr John, 52
Flockinger, Gerda, 173
Florence, Medici exhibitions, 257
Flowers, Brian, Baron Flowers, 353–4
Fonteyn, Dame Margot, 16n, 79, 103, 254
Foot, Jill (Craigie), 122, 166
Foot, Michael, 122–3, 166, 279
Forain, Jean-Louis, 200
Forbes, Hon. Sir Alistair (Aly) Granville, 63
Forbes, Bryan, 90
Forbes, Nanette, 90
Ford, Sir Brinsley, xiii, 29–31, 216
Ford, Colin, 85, 107

Ford, Joanna, Lady, 29
Forgan, Liz, 162, 176, 259
Forman, Sir Denis, 335
Forster, E.M., 24
Forte, Charles Forte, Baron, 357, 366–7
Forte, Sir Rocco, 357
Fowler, John, 95–6, 203
Foyles Literary Luncheon, 202, 387
Fraser, Lady Antonia: gatherings, 11, 23, 29; Byatt introduction, 14; appearance, 16, 23, 54, 88, 179; Cloth of Gold ball, 54–5; Tussauds dinner, 62; Beaton film party, 80; Longford gatherings, 88, 110, 179; Weidenfeld gatherings, 91, 276; Phipps house party, 93; *Masque of Beauty*, 108, 109; Pinter relationship, 222, 276, 283; Plumb dinner, 283; Barbican opening, 311
Fraser, Benjie, 278–9
Fraser, Flora, 278
Fraser, Sir Hugh: Beaton film party, 80; Longford gatherings, 88, 110; Weidenfeld gatherings, 91, 276; Phipps house party, 93; separation from wife, 222, 276; Melchett supper party, 278–9; children, 278
Fraser, Natasha, 279
Frayling, Professor, Christopher, 250, 340, 355, 383, 414
Freemantle, Chloë, 100
Freemantle, Richard, 100
Freud, Lucian, 122
Freyberg, Ivry, Lady, 92
Frick Collection, New York, 153
Friends of the Israel Museums, 426
Frink, Dame Elisabeth, 293
Frogmore, 315–16
Fry, Roger, 21

Gaffran, Charlotte, 334
Gainsborough, Thomas, 76, 217, 219, 267–8, 320
Gaitskell, Anna Dora, Baroness Gaitskell, 62
Garbo, Greta, 26
Gardner, Dame Helen, 14, 459
Garland, Madge, (Lady Ashton), 167
Garland, Patrick, 48
Garner collection, 223
Garnett, Angelica, 37
Garnett, David, 34
Garrick Club, 52, 423
Gascoigne, Bamber, 283
Gascoigne, Christina, 283
Gatacre, P.V., 24, 29
Gatacre, Teresa ('Tizzy'), 24, 29, 55
Geffrye Museum, 347, 349, 352
Gendel, Judy, 11, 29, 112–13
Gendel, Milton, 11n, 29, 176, 337, 360
George II, King, 312
George III, King, 206, 219, 277
George IV, King, 212
George V, King, 59, 415, 429

George VI, King, 212, 214
George of Hanover, Prince, 219
Georgiadis, Nicholas, 49, 278, 437
Getty, Paul, 16, 108, 114, 384, 385, 401
Getty, Paul Jr, 385
Getty Museum, 390, 398
Gibb, Bill, 269
Gibbons, Grinling, 219
Gibbs, Christopher, 11, 44, 253, 254, 397, 401
Gibson, Dione, Lady, 238, 264, 319
Gibson, Patrick, Baron Gibson: Advisory Council Chairman, 135; influence, 150, 200; V&A campaign, 200, 210, 215, 222; Queen Mother's Ham House visit, 238; Queen Mother's Birthday Gala, 264; French embassy fête, 319; Heritage Bill, 330–1; RS's appointment, 411; RS's successor, 414
Gielgud, Sir John, 47, 325, 430
Giles, Mary, 256, 289, 294, 389–90
Gilliat, Sir Martin: Waverley dinner, 92; Queen Mother's entourage, 175, 206, 229; at Royal Lodge, 212, 315, 316; Queen Mother's Ham House visit, 239; RS's knighthood, 301
Gilmour, Lady Caroline, 237–8, 246, 294
Gilmour, Ian, Baron Gilmour of Craigmillar, 238, 295
Giscard d'Estaing, Valéry, 173
Gladwyn, Cynthia, Lady, 113
Glen, Sir Alexander: Chairman of Advisory Council, 216, 292; fund-raising role, 232; Gonzaga exhibition, 292; Rayner Scrutiny, 312; support for RS, 324, 390; Theatre Museum issue, 337; presentation to, 347
Glendevon, Elizabeth, Lady, 28, 276
Glendevon, John Hope, 1st Baron, 28, 188, 276
Gloriana, 410
Gloucester, Brigitte, Duchess of, 170, 172, 219, 262, 268
Gloucester, Prince Henry, Duke of, 76
Gloucester, Prince Richard, Duke of, 95, 155, 170, 172, 219, 268
Glyndebourne, 225, 261, 334, 340, 363–5, 366
Godfrey, Cecily, 425
Godfrey, Gerald, 425
Golding, William, 97
Gombrich, Sir Ernst (E.H.), 3, 286, 304, 305, 307, 395
Gone, Going, Going: The Fate of the Country House (TV programme), 140, 143
Goodison, Judith, Lady, 429
Goodison, Sir Nicholas, 429
Goodman, Arnold, Baron Goodman: Ann Fleming friendship, 48, 181, 285–6; Museum of Theatre Art, 86; Annenberg lunch, 89; Beaumont encounter, 113;

Sutherland portraits, 119, 200; Conner head, 122, 200; appearance, 123; personality, 123; V&A campaign, 200, 202, 210, 215, 222; ABSA, 232; Queen Mother's Birthday Gala, 264; Hartwell memorial, 310; National Gallery Directorship advice, 394–5, 427
Goodman, Theo, 286
Gordon, Charles, 86
Gorlin, Ronnie, 356, 414
Gosling, Maude, 339
Gosling, Nigel, 339
Gowing, Sir Lawrence, 106, 413
Gowrie, Grey Hore-Ruthven, 2nd Earl of: Theatre Museum issue, 337, 340, 341, 342; appearance, 338, 342, 397; V&A Trustees, 339–40; Arts Council, 344, 345–6, 349; relationship with RS, 342, 345, 390; on private sector funding, 350, 383; wit, 351; Kenwood question, 352; museum charges policy, 363; South Bank project, 368; Getty gift, 384, 385–6; National Gallery Directorship question, 395; Serpentine Gallery, 410; Sotheby's suggestion, 414–15, 419; Laskett visit, 419
Gowrie, Nietie, Countess of, 419
Goya, Francisco de, 65
Grafton, Fortune, Duchess of, 113, 239, 276, 314, 315, 318, 320
Grafton, Hugh FitzRoy, 11th Duke of, 113, 238–9, 314, 315, 318, 320, 347
Graham, Ted, Baron Graham of Edmonton, 151
Grant, A.Y., 388
Grant, Duncan, 13, 21–2, 34–5
Gray, Eileen, 234
Greater London Council (GLC), 73, 74, 333, 341, 362, 373
Green, Benny, 320
Green, Kenneth, 106
Green, Martin, 181
Green College, Oxford, 428
Grierson, Heather, Lady, 320
Grierson, Sir Ronald: Italian house, 99; American Ambasssador's party, 320; South Bank Board, 368, 381, 388, 406; RS's opinion of, 381, 384, 388; influence, 395; dinner for Princess Royal, 426–7
Griffiths, Evelyn, Lady, 247
Griffiths, Hugh, Baron Griffiths, 247
Grillions dining club, 429
Grimond, Jo, Baron Grimond of Firth, 62
Grimsthorpe, Lincs, 191
Gromyko, Andrei Andreevich, 166
Grove, Valerie, 409
Groves, Sir Charles, 293–4
Guardian, 29, 151, 163, 331, 345, 401, 409
Guinness, Mariga, 122
Gunn, Sir James, 9, 212, 214, 219
Guyatt, Professor Richard, 9, 207

Gwynne, Nell, 95

Hacket, Bill, 173
Hackney, Rod, 421
Hale, Sir John, 340, 382, 384, 414
Hall, Sir Peter: background, 4; *Figaro*, 87; *Inigo Jones* review, 120; Shakespeare Prize, 254; appearance, 293, 365; knighthood, 295; Arts Council meetings, 335, 383; marriage, 365, 410; career, 410
Ham House, 160, 238–9, 319
Hambleden, Patricia, Dowager Viscountess, 55, 206
Hamburg: Staatsoper, 98–9, 120; Künsthall, 150; Shakespeare Prize, 263
Hamilton, Sir Denis, 121, 170
Hamilton, Sir James, 199, 216
Hamilton, Hamish, 34
Hamilton, Olive, Lady, 121
Hamilton, Yvonne, 34
Hamlyn, Helen, 403–4
Hamlyn, Paul, 403–4
Handel, George Frederic, 8, 15, 23
Hands, Terry, 397
Hanks, Nancy, 89
Hans Schubart Memorial Lecture, 151
Harbord, Felix, 303
Harding, Charles, 256
Hardwick Hall, 327
Hare, Augustus, 64
Harewood, George Lascelles, 7th Earl of, 86, 87
Harlech, David Ormsby Gore, 5th Baron, 27, 205, 309
Harlech, Pamela (née Colin), Lady, 28, 46–7, 55, 63, 205, 309, 355
Harlech Television, 378
Harmsworth family, 91
Harper's, 56, 178n
Harpur, Jerry, 421
Harris, John, 120, 139, 233
Harrison, Elizabeth, 108
Harrison, Sir Rex, 108
Hart, Derek, 205, 214, 270, 309, 337
Hartnell, Sir Norman, 90, 95
Hartwell, Michael Berry, Baron, 71, 105, 167, 291, 302–4, 310, 319
Hartwell, Lady Pamela (Berry): general election parties, 71, 231; American Embassy party, 89; Buckingham Palace party, 90; Wrightsman party, 105; RS's appointment to V&A, 118, 404; V&A Advisory Council, 135, 304; work for V&A; Oving weekends, 139, 303–4; lunch for Acton, 181; Beaton on, 243; Beaton funeral, 253; Plumb dinner, 283; Gonzaga exhibition opening, 291; death, 302–4, 310, 319; personality, 302–4; appearance, 303; memorial service, 310
Hastings, Elisabeth (Lizzie), Lady, 153
Hastings, Sir Stephen, 153

Hatfield House, Herts, 282
Hawarden, Lady, 137
Haworth-Booth, Mark, 138
Hay, Sir Philip, 168, 415, 424
Hay-Davison, Ian, 340, 344, 355, 363, 411
Hayes, John, 107, 128
Hay's Wharf, 85
Hayward Gallery: photographic exhibition, 85; status, 311; RS's involvement, 332, 333, 349, 361, 368, 427; South Bank project, 362, 373; Diego Rivera exhibition, 426
Head, Antony Head, 1st Viscount, 77–8, 276
Head, Lady Dorothy, 77–8, 276, 277–8
Healey, Denis, Baron Healey, 166, 187, 219, 261, 340
Healey, Edna, Lady, 261
Heath, Sir Edward, 76, 90, 113, 133, 168, 247
Hecht, Alfred, 122
Hedgecoe, John, 207, 346
Heinz, Drue: husband's post, 106; appearance, 108; sponsorship, 140, 175, 232; Russell dinner, 176; Princess Margaret's stay, 205; Whitfield dance, 226
Heinz, Henry John II (Jack), 106, 140, 175, 176, 226, 232
Helmingham Hall, Suffolk, 283–4
Helpmann, Sir Robert, 79
Hemmings, David, 94
Henderson, Joan, 5, 337
Henderson, Sir Nicholas (Nico), 333, 394
Hendy, Sir Philip, 25, 72, 112
Henrietta Maria, Queen, 16
Henrik, Prince, 431–2
Henry, Prince, 378
Henry, Prince of Wales and England's Lost Renaissance, 393
Hepworth, Dame Barbara, 267n
Hereford Cathedral, 263–4
Heritage Group, 151
Herschorn, Doris, 134, 145
Herschorn miniatures, 134, 145, 223
Heseltine, Sir William, 412
Hesketh, Alexander Fermor-Hesketh, 3rd Baron, 18
Hesketh, Kirsty, Lady, 18
Heyer, Georgette, 222
Heyman, Mrs, 431
Hicks, David, 268, 319, 353
Hidcote Manor, 328
Hill-Adamson albums, 98, 99, 121
Hilliard, Nicholas, 91, 145, 297
Hillier, Bevis, 109, 182, 259
Historic House Owners Association, 139
History Today, 51
Hitler, Adolf, 359
HMSO, 300

Hockney, David: paintings, 10, 34, 152; social life, 28, 34–5, 44–5, 80, 87, 91; portrait of Beaton, 38–40; sketch of RS, 38, 39, 437; Webster portrait, 97; V&A petition, 183; *Magic Flute*, 225
Hodges, Mark, 289, 352
Hodgkin, Sir Howard, 44
Hodgkinson, Terence, 135, 148
Hogarth, William, 74
Holland-Martin, Robin, 232, 340, 363
Holman Hunt, Diana, 94
Holst, Gustav, 341n
Holst, Imogen, 341
Homes & Gardens, 353, 421
Honour, Hugh, 100, 124–6, 332
Hood, Peter, 95
Hood, Samuel Hood, 6th Viscount, 144, 216
Hope, Polly, 380–1
Hopkin, Mary, 28
Hopkins, Sir Michael, 377, 407
Hordern, Sir Michael, 180
Hornby, Sir Simon, 135
Horniman Museum, 349
Horstead Place, 364–5
Hose, Eileen: on Beaton, 123; role at Reddish, 151–2, 165; Beaton's health, 151–2, 242; Beaton collection, 167, 407, 417–18; Beaton's funeral, 253; death, 407
Hoskins, John, 16
Houghton Hall, Norfolk, 177, 178
House & Garden, 60, 386
House of Commons Select Committee, 147
Hoving, Thomas, 302
Howard, Elizabeth Jane, 71, 207–8
Howard, George, Baron Howard of Henderskelfe, 293, 312, 373, 395
Howard, Mrs Greville, 98
Howard, Simon, 385, 395, 398, 399
Howe, Geoffrey, Baron Howe of Aberavon, 268, 295, 338, 369
Howell, Georgina, 152
Hudson, Thomas, 8, 15
Hume, Cardinal Basil, 261
Humphries, Barry, 11n
Hunnicutt, Gayle, 94, 418
Hussey, Marmaduke, 168
Hussey, Lady Susan, 168
Hutchinson of Lullington, Jeremy Hutchinson, Baron, 267, 330
Hutchinson of Lullington, June, Lady, 267
Hutt, Rev. Cannon, David, 93–4

Illustrated London News, 7
Independent, 409, 410, 415, 417
Inigo Jones: The Theatre of the Stuart Court, 120
Institute of Historical Research, 306
Irvine, Rev., Gerard, 93–4, 310
Irving, Sir Henry, 32
Irwin, John, 173

Isaacs, Jeremy, 422
Isham, Sir Gyles, 18
Iveagh, Edward Guinness, 1st Earl of, 352n

Jackson, Adrian Ward, 401
Jackson, Glenda, 46
Jackson, Robert, 92
Jackson-Stops, Gervase, 414
Jaffé, Michael, 135, 176, 332
Jaffé, Pat, 176
Jagger, Bianca, 221
Jagger, Mick, 28, 80
James, Edward, 424
Japan, 211, 227
Japan Foundation, 248–9
Jebb, Julian, 29
Jefferies, Judith, 46
Jellicoe, George Jellicoe, 2nd Earl, 169
Jenkin, Patrick, Baron Jenkin of Roding, 381
Jenkins, Hugh, Baron Jenkins of Putney, 149, 163, 216
Jenkins, Dame Jennifer, Lady Jenkins of Hillhead, 62
Jenkins, Roy, Baron Jenkins of Hillhead, 62, 285, 310, 429
Jenkins, Simon, 120
John, Augustus, 21, 206, 277
John Lewis, 55
John Paul II, Pope, 319
Johnson, 'Babs', (Georgina Masson), 124
Johnson, Dame Celia, 314, 315, 316
Johnson, Cornelius, 64
Johnson, Hugh, 167
Johnson, Marigold, 431
Johnson, Paul, 426, 431, 432
Johnson, Richard, 37
Johnson, Susannah, 360
Johnston, Sir John, 312
Jones, Inigo, 34, 53, 120
Jones, Philip, 329
Jones, Sir Roderick, 215n
Joseph, Sir Keith, 268, 289
Julian of Norwich, Dame, 261

Kaftal, George, 100
Kagan, Sasha, 380
Kahn, Otto, 13n
Kaleidoscope, 289
Kasmin, John, 44
Kaye, Elizabeth, Lady, 96
Kaye, Sir Emmanuel, 96
Keele, University of, 341, 366
Kelvedon Hall, Essex, 40, 76
Kemp, Martin, 398
Kempson, Rachel, (Lady Redgrave), 204
Kennedy, Jackie, see Onassis
Kennedy family, 50
Kensington Palace, 205, 270, 402
Kent, Edward, Duke of, 155, 172, 173, 219, 229, 247, 260

Kent, Katharine, Duchess of: wedding dress, 117; State Opening of Parliament, 155; lunch for Empress of Persia, 168; health, 168, 173, 334; State Banquet, 172; Queen's Silver Jubilee, 193–4; Windsor visits, 219; Michael of Kent wedding party, 229; appearance, 247, 293; Chinese Export Gallery opening, 424–5; du Pré's death, 425

Kent, Prince Michael of, 78, 228, 283, 319, 402

Kent, Princess Michael of: marriage, 228; appearance, 262, 332; Plumb dinner for, 283; *Indian Heritage* dinner, 319; finances, 319, 320, 420; religion, 319; Royal Academy dinner, 332; Gowrie on, 340; Linley on, 353; V&A Trustee, 355, 384; on Princess of Wales, 361–2; Chelsea Flower Show, 402; Nether Lypiatt lifestyle, 420

Kent, William, 26, 30

Kenward, Betty ('Jennifer's Diary'), 154, 178, 248

Kenwood, Hampstead, 347, 349

Kenyon, Lloyd Tyrell-Kenyon, 5th Baron: RS's appointment as Director of NPG, 3–4; Chairmanship of Board of Trustees, 3, 6, 11, 26; royal contacts, 9, 12, 59, 85; farewell dinner, 10; relationship with RS, 10, 11, 29; Beaton exhibition, 28; National Gallery relations, 74; Derby miniatures, 92; RS's appointment to V&A, 119

Kenyon, Leila, Lady, 28

Keppel, Alice, 101, 195

Keswick, Sir John, 175

Kilkenny, Alan, 432

King, Professor, Anthony, 181

Kinnaird, Lady, 92

Kitaj, Ralph, 34

Kitson, Penelope, 108

Kneller, Sir Godfrey, 85, 108

Knight, Andrew, 340, 355, 363, 379, 409

Kyle, Keith, 103

Kyle, Susan, 103

Lacey, Robert, 207

Lacock Abbey, Wilts, 378

Laing Museum, 349

Laird, Julie, 233, 377, 390, 416

Lambton, Antony, Viscount, 169n

Lamerie, Paul, 77

Lamport Hall, Northants, 18

Lancaster, Anne (Scott-James), Lady, 113

Lancaster, Mark, 38

Lancaster, Sir Osbert, 98, 99, 113, 120, 400

Lancaster Gate, RS's flat, 7, 15

Land Fund, 189, 204

Landseer, Sir Edwin, 217, 219, 312

Lang, Brian, 397–400, 401

Lansdowne, Polly, Marchioness of, 94, 149

Lantz, Robbie, 119

Larkin, William, 98

Lasco, Peter, 216

Lasdun, Sir Denys, 135

Laser, Bernard, 386, 387

Laskett, The, Much Birch, Herefordshire: purchase, 114–15; Casson drawing, 114; history, 115; move to, 120, 126; building work and décor, 124, 126–7, 199, 227, 255; garden, 146–7, 158–9, 164–5, 178, 191, 195, 198–9, 208–9, 223, 226–7, 235, 240, 255, 263, 266, 297, 324, 333, 340; refuge, 223; under snow, 234; life at, 242, 366, 437–8; Brandt photographic session, 270

Laski, Marghanita, 329, 335–336, 351

Last, John, 347, 363, 382

Lategan, Barry, 56

Lauder, Estée, 106

Laver, James, 152–3

Lavery, Sir John, 59

Lawrence, Gertrude, 152–3

Lawrence, Sir Thomas, 15

Lawson, Nigel, Baron Lawson of Blaby, 15, 91, 103, 338, 403

Lawson, Vanessa, Lady, 15, 91, 103

Laye, Evelyn, 230

LBC, 409

Lear, Edward, 380

Lee, Jennie, Baroness Lee of Asheridge, 22–3, 26, 47, 122

Lee, Laurie, 54

Leeds, University of, 327, 335, 341

Lees-Milne, James, 204

Leggatt, Sir Hugh: support for NPG, 8, 42; friendship with RS, 8, 84, 347; Annigoni portrait, 9, 42–3, 59; Kenyon farewell dinner, 10; Henrietta Maria miniature, 17; museum charges issue, 87–8; Derby miniatures sale, 91; Donatello roundel, 156; Pope-Hennessy resignation story, 163; V&A campaigns, 216, 321; NHMF, 257; speech writing for Princess Margaret, 258; Channon Arts position, 293; Bernini bust story, 385

Leggatt Bros., 91

Legh, Laura, 246

Le Grice, Lynn, 420

Lehmann, Rosamond, 106, 201

Leighton House, 138

Lely, Sir Peter, 206, 277

Lennon, John, 51

Leslie, Anita, 106

Leslie, Charles Robert, 219

Lever, Diane, Lady, 264

Lever, Harold, Baron Lever of Manchester, 149, 170, 200, 264, 279

Leverson, Ada, 23

Levey, Sir Michael, 192, 195, 256, 352, 393

Levey, Santina, 411

Levin, Bernard, 366

Lewis, John, 320, 349

Liberace, 98

Lichfield, Lady Leonora, Countess of, 205
Lichfield, Patrick Anson, 5th Earl of, 80, 205
Liebermann, Alex, 387
Lightbown, Ronald, 250
Linbury Trust, 422
Lindsay, Loelia, Lady, 55–6
Lindsay, Sir Martin, 56
Linley, David Armstrong-Jones, Viscount, 218, 270, 353
Liotard, Jean-Etienne, 18
Listener, The, 240
Lister, Moira (Vicomtesse d'Orthez), 95
Liszt, Franz, 89
Llewellyn, Roddy, 205, 214, 217, 220–1, 224, 241, 270
Lloyd, Anthony, Baron Lloyd of Berwick, 365
Lloyd, Geoffrey, Baron Geoffrey- Lloyd, 151
Lloyd, Jane, Lady, 365
Lohmeyer, Birgitte, 150
Lomellini family, 136
Lomellini ewer and basin, 136, 223
Longford, Elizabeth, Countess of: NPG Board, 11, 26, 45, 74; NPG readings, 14; Beaton show, 28; appearance, 48, 62, 108; drinks party for Prince Charles, 88; Charteris dinner, 90; dinner with, 110; V&A Advisory Council, 135; seventieth birthday, 179
Longford, Frank Pakenham, 7th Earl of, 28, 88, 90, 110
Longford Castle, Wilts, 81–2
Longleat, Wilts, 244–5
Lonsdale, Norman, 360
Losch, Tilly, 8
Louis XVI, King, 19
Lousada, Patricia, Lady, 201
Lowe, John, 136
Lubbock, Jules, 421, 422
Luce, Sir Richard, 394, 397, 406, 412
Luce, Rose, Lady, 412
Lucie-Smith, Edward, 176
Lumley, Joanna, 381
Luxon, Benjamin, 225
Lympany, Dame Moura, 113, 164

Macclesfield, George Parker, 7th Earl of, 74
Macclesfield, George Parker, 8th Earl of (as Viscount Parker), 74
McEwen, Rory, 205
MacGregor, Neil, 391, 405
Mackay, James, Baron Mackay of Clashfern, 429
Mackenzie, David, 211
Mackworth-Young, Sir Robin, 9, 17, 90, 213, 219, 270, 316
Mackworth-Young, Rosemarie, Lady, 270, 316

Maclean, Charles ('Chips'), Baron Maclean, 173, 312
Macmillan, Harold, 1st Earl of Stockton, 70, 121–2, 197, 333
MacMillan, Sir Kenneth, 87, 103, 241, 278
Madame Tussaud's, 55, 61–2, 223, 255
Magee, Bryan, 404
Mainstone, Madeleine, 184
Malatesta, Sigismundo, 437
Malraux, André, 23
Mann, Margaret, 295–6, 304
Mantegna, Andrea, 398
Marble Hill, 352
March, Lionel, 309–10
Margaret, Princess: theatre going, 37; personality, 47, 156–7, 191, 256, 353; Elizabethan Image visit, 47; Organ portrait, 52, 79; Beaton photograph, 57; social life, 65, 69, 89, 90, 110, 155–7, 175–6, 205, 212, 214, 220–1, 226, 246, 285, 309; marriage, 86, 89, 158, 166–7; Trusteeship question, 97; Judy Gendel's funeral, 112; Acton photograph of, 125; Country House show, 143; French visit, 155–8; Mustique, 158, 201, 214, 309, 353; separation, 166–7; State Banquet, 172, 173; National Theatre opening, 180; Queen's Silver Jubilee, 194–5; at Covent Garden, 201, 241, 366; Windsor, 212, 217–19; illness, 224; divorce, 224; Messel service of thanksgiving, 229; Beaton on, 243; St John-Stevas, 256; Royal Academy Dinner, 258; Queen Mother's eightieth birthday, 262, 264–5; Princely Magnificence visit and dinner, 270; Spotlight exhibition, 279; Savoy bal masque, 294; RS's knighthood, 301; Royal Lodge festival, 315–17; Messel exhibition opening, 337; Miami airport story, 353; Acton's eightieth birthday party, 360; RS's Keele degree, 365–6; Nutcracker, 366, 373, 379; Chelsea Flower Show, 402; V&A visit on RS's resignation, 408; Antiques Fair, 415
Margrethe II, Queen of Denmark, 431–2
Marie Antoinette, Queen, 19, 62, 67, 192
Marie Feodorovna, Empress, 67
Marina, Princess (Duchess of Kent), 26, 233, 424
Marini, Marino, 97
Markova, Dame Alicia, 325
Marks, Richard, 414, 415, 416
Marlborough, John Spencer- Churchill, 10th Duke of, 94
Marlborough, John Spencer- Churchill, 11th Duke of (as Marquess of Blandford), 55
Marten, Marianna, 20, 40, 253, 268
Marten, Toby, 20, 40
Mary I, Queen, 94, 95
Mary, Queen, 195, 316, 415, 424
Mary, Queen of Scots, 103, 145

Mason, James, 108
Massine, Léonide, 264
Masson, Georgina, 124
Maudling, Beryl, 55, 310
Maudling, Reginald, 55
Maugham, W. Somerset, 177
Mayer, Sir Robert, 236
Medici, Marie de', 171, 192
Melchett, Sonia, Lady, 278
Mellor, David, 340, 377, 411, 418
Menkes, Suzy, 386
Menotti, Gian-Carlo, 386
Mentmore, Beds, 186–9, 223
Menuhin, Diana, Lady, 268
Menuhin, Yehudi, Baron Menuhin of Stoke
 d'Abernon, 41, 236, 268, 348
Merton, John, 220
Messel, Oliver: *Sleeping Beauty*, 35;
 Rosenkavalier, 61; sister, 64n, 164;
 Acton friendship, 101; Princess Mar-
 garet's Mustique house, 158; influence,
 201, 405; Elizabeth Tudor head, 214;
 service of thanksgiving, 229; Covent
 Garden boxes, 264; V&A exhibition,
 336–337; stories, 354
Messel, Thomas, 229
Messel Collection, 279
Metropolitan Museum of Art, New York,
 82, 379
Meyer, Tom, 429
Michael Hopkins & Partners, 407
Michelangelo tondo, 153, 237, 395
Michelmore, Cliff, 244
Midsummer Night's Dream, A (TV
 production), 282
Mildmay, Audrey (Lady Christie), 365n
Millais, Sir John Everett, 206, 277
Millar, Delia, Lady, 431
Millar, Sir Oliver, 3, 9, 16, 239, 307, 431
Millar, Sir Ronald, 369
Millburn, Michael, 377
Miller, Beatrix: Beaton photographs of RS,
 8; friendship with RS, 8, 32, 116, 178,
 269; RS's work for *Vogue*, 8; Harlech
 dinner, 47; party for Lesley Blanch, 79–
 80; flat, 79–80; Beaton film party, 80;
 appearance, 113; *In Vogue* party, 152;
 Beaton funeral, 253, 254; successor at
 Vogue, 386–7
Miller, Jonathan, 191
Miller, Kitty, 110, 243
Milne, Taylor, 87
Milstein, Nathan, 113
Milstein, Thérèse, 113
Ministry of Works, 96
Mitchell, James, 332
Mitford, Diana, 36n
Mitterrand, François, 317
Mlinaric, David, 55
Mobil Oil, 232
Monnington, Sir Thomas, 98
Monroe, Marilyn, 27

Montacute House, Somerset, 4, 97, 151
Montagu of Beaulieu, Edward Douglas-
 Scott-Montagu, 3rd Baron, 326
Moore, Doris Langley, 24–5
Moore, Henry, 183, 200, 202–3, 216, 222,
 341, 396
Morgan, Janet, (later Lady Balfour of
 Burleigh), 381
Morley, John, 414
Morpeth Terrace, RS's flat, 15, 89
Morocco, painting trip, 36–7
Morrell, Lady Ottoline, 114
Morris, Roger, 173
Morris, William, 312
Mortimer, Raymond, 34, 78, 177
Moser, Sir Claus, 168, 202, 335, 422, 423
Moser, Mary, Lady, 168, 202, 422, 423
Mosley, Sir Oswald, 36n
Mount Offham, 75
Mountbatten, Louis, 1st Earl Mountbatten
 of Burma, 14, 76, 143, 219, 221
Moyne, Bryan Guinness, 2nd Baron, 34, 36
Muggeridge, Malcolm, 304
Muir, Jean: work, 80, 113, 276, 283; Royal
 Academy Dinner, 258; V&A Trustee,
 340, 355, 377, 382, 411, 415
Mulholland, Olivia, 175
Mullaly, Terence, 34, 60, 79, 80
Mulley, Fred, Baron Mulley, 168–9, 182–3,
 188
Munnings, Sir Alfred, 277
Murdoch, Dame, Iris, 69, 419
Murray, Ann, 426
Murray, Jock, 120, 201, 348
Museum of the Performing Arts, 138
Museum of Theatre Art, 86
Museums Association, 145, 192
Museums Commission, 64n, 74, 353
Mynott, Gerald, 405
Mynott, Lawrence, 405

Nairne, Alexander (Sandy), 427
Nash, Paul, 110
National Art Collections Fund (NACF),
 220, 388, 395, 398
National Association of Decorative and
 Fine Art Societies, 293
National Gallery: Directorship, 3; NPG
 relations, 52–3, 72–4; Harewood Titian,
 87–8; conference on regions, 195; endow-
 ments, 300; Getty gift, 384, 385; Direc-
 torship question, 391, 393–5, 401, 405
National Gallery, Canada, 146
National Gallery of Scotland, 396, 398,
 399, 401
National Gallery of Wales, 352
National Heritage Bill, 255, 256, 326, 330
National Heritage Memorial Fund
 (NHMF), 256–7, 269, 385–6, 388, 395,
 398–400, 430
National Maritime Museum, 85, 299, 350,
 352, 356–7, 363, 376

National Museum Directors' Conference, 352–3, 363
National Museum of Film and Photography, Bradford, 85
National Museum of Wales, 85
National Photographic Record, 64, 97–8
National Portrait Gallery: RS's career at, 6–7, 128–9, 307; *Winter Queen* exhibition, 6; RS's appointment as Director, 3–4, 7; Board of Trustees, 6, 11, 26, 45, 64, 71, 73–4, 83–4, 91, 97; Beaton retrospective, 13, 26–8, 32, 72; lunchtime readings, 13; portraits of the living, 14, 119; finances, 14–15, 33, 65, 91; use of film, 32, 52; Tudor Room, 51; cartoon exhibition, 52; Pepys exhibition, 52, 80–1, 117; National Gallery relations, 52–3, 72–4; site question, 72–4, 98, 119–20; Pereja portrait, 81–2, 83–4; entry charges, 88; Contemporary Portrait Collection, 97; *Masque of Beauty* exhibition, 107–8; Richard III exhibition, 119; RS's leaving party, 141; conference on regions, 195; Warwick Castle portrait of Elizabeth I, 207
National Slide Library, 248, 274, 275
National Theatre: opening, 179–80; *Shoemaker's Holiday*, 275; recession effects, 279, 288, 289; lunch at, 293; politics, 345; South Bank Board, 362; *Strong Points*, 387
National Trust: NPG relationship, 3, 97, 98; Chairman, 64n, 97; restoration work, 96; historic houses handover question, 160, 319; Fowler memorial service, 203; Anglo-Chinese evening, 418
National Union of Public Employees, 234
Natural History Museum, 300
Neagle, Dame Anna, 337
Nevill, Bernard, 80, 404
Neville, Mikki, Lady Rupert, 257, 277, 310, 363–4, 402
Neville, Lord Rupert, 277
New Statesman, 187, 188, 216
Nicholson, Ben, 267n
Nicolson, Benedict, 24, 126, 176, 225–6
Nicolson, Sir Harold, 24n, 126
Nicolson, Nigel, 24n, 126
Nijinsky, Vaslav, 16
Nixon, Richard M., 432
Noland, Ken, 44
Norfolk, Anne, Duchess of, 247
Norfolk, Miles Francis Fitzalan- Howard, 17th Duke of, 247
Norman, Jessye, 400
Northey, Tom, 416
Northumberland, Lady Elizabeth, Duchess of, 171
Northumberland, Hugh Percy, Duke of, 171
Norwich, Duff Cooper, 1st Viscount, 12n
Norwich, John Julius Cooper, 2nd Viscount, 261
Nott, Sir John, 268
Nunn, Trevor, 351
Nureyev, Rudolf, 16, 103, 193, 194, 202, 338–9, 437
Nutter, Tommy, 423

Oberon, Merle, 20
O'Brien, Edna, 80, 342–3
Observer, 335, 342, 409
Office of Arts and Libraries (OAL): V&A reports, 259–60, 274; V&A status, 267; Balfour ciborium, 269; Rayner Scrutiny and Report, 274, 288, 331; Heritage Bill, 324; Kenwood issue, 352; V&A funding, 358, 396; Arts Council relationship, 374; Bernini bust, 388; RS's position, 405–6, 410
Ogilvy, Sir Angus, 426
Oldham, Felicity, Mrs, 133
Olympia & York, 425, 432–3
Oliver, Isaac, 91, 280, 327
Oliver, Peter, 91
Olivier, Laurence, Baron Olivier, 180
Oman, Carola (Lady Lenanton): NPG Trustee, 8, 11; introduction to Georgina Masson, 124; Byatt meeting, 222, death, 224–5; desk, 224–5, 227, 437
Oman, Charles: V&A Metalwork Department, 37, 117, 135; gift to daughter, 37; sister's death, 225; Laskett visits, 266, 296; old age, 296; death, 308–9, 318; gift to RS, 437
Oman, Joan, 120, 308–9
Oman, Julia Trevelyan: *Enigma Variations*, 37, 93, 102–3, 115, 164, 165; first impressions of RS, 37; *Brief Lives*, 37–8; Russia trip, 65–9; *Eugene Onegin*, 65, 87; Kelvedon party, 76; Pepys exhibition, 80–1; marriage, 83, 92–4; honeymoon, 98–9; married life, 101–3; Covent Garden work, 120; mother's death, 120; Canada trip, 146; *A Month in the Country*, 158, 164–5, 182, 235, 264, 265; *Importance of Being Ernest*, 170, 174, 178, 193; *La Bohème*, 170; *Die Fledermaus*, 197, 199, 208, 211; *Papillon*, 205; Tussaud's, 223; forty-eighth birthday, 225; Royal Designer for Industry, 227; *Swan Lake*, 246, 255, 257, 271, 274, 275, 278, 338; *Hay Fever*, 255, 257; Orangery, 255; Queen Mother's eightieth birthday gala, 262; *Wild Duck*, 271; *Shoemaker's Holiday*, 275, 282; *Die Czardas Fürstin*, 287; Hartwell friendship, 304; father's death, 308–9, 318; RS's knighthood, 312–13; *Arabella*, 334, 340, 363–4, 366; Nureyev meeting, 338–9; *Bal des Ardents*, 338–9; *Nutcracker*, 366, 372–3, 378–9; *The Consul*, 386; RS's career change, 391; awarded CBE, 393
Oman family, 93

Onassis, Jackie Kennedy, 110–11
O'Neill, Fionn (Mrs. Morgan), 285
O'Neill, Hugh, 122
O'Neill, Raymond O'Neill, 4th Baron, 62
Oppenheim, Sir Duncan, 232
Organ, Bryan, 52, 79, 86, 89, 438
Organ, Elizabeth, 86
Orgel, Stephen, 120, 379
Ormond, Richard, 26, 45, 85, 350
Orton, Joe, 79
Osterley Park House, 160, 319, 377–8, 405, 418
Oudry, Jean-Baptiste, 63
Oving House, Bucks, 139, 303–4, 310
Owen, David, Baron Owen, 203, 207, 404
Owen, Deborah, Lady, 203, 207, 404

Page, Russell, 233, 417
Pajou, Augustin, 136
Pakenham, Catherine, 44
Pakenham, Michael, 55
Pakenham, Thomas, 88n
Palmer, Samuel, 227, 234
Palmer, Tony, 98
Parker, George Parker, Viscount, 74
Parkinson, Norman, 271
Parr, Catherine, Queen, 15, 17, 23
Pasti, Matteo de, 437
Pater, Walter, 202
Paul, Tsar, 67
Paul VI, Pope, 213
Paul Mellon Center for British Art, 116
Pavarotti, Luciano, 120
Pembroke, Henry Herbert, 17th Earl of, 253
People Past and Present (lunchtime readings), 13, 85
Pepys, Samuel, 30, 52, 80–1, 117
Percival David Foundation, 197
Persia, Farah Diba, Empress of, 168, 169
Perth, David Drummond, 17th Earl of, 88, 119, 174, 320, 330
Perth, Nancy, Countess of, 88, 100, 174, 320, 413
Peter I (the Great), Tsar, 67, 69
Philip, Prince, Duke of Edinburgh: Buckingham Palace lunch, 9; BM soirée, 42; State Opening of Parliament, 155; Healey relationship, 166; State Banquet for French, 171; Queen's Silver Jubilee, 194; at Windsor Castle, 217–19; appearance, 217; relationship with sister-in-law, 221; Mayer concert, 236; Thatcher story, 247; Queen Mother's eightieth birthday, 262; Windsor weekends, 315; at Covent Garden, 373; biography, 424; role, 429
Phillips, Captain Mark, 155, 191
Phipps, Diana: Fleming lunch, 41; Cooper lunch, 70; Beaton film party, 80; Weidenfeld gathering, 91; party, 92; décor, 92, 358; Este villa house party, 93; Beaton

funeral, 253; appearance, 358; Windsor stories, 358–9
Phipps, Harry, 358
Phipps, Jack, 41
Phipps, Lady Sybil, 95
Physick, John, 147–8, 291
Pia di Savoia, Princess, 426
Picasso, Pablo, 31, 138, 223
Pick, Frank, 227
Pile, Sir William, 169
Pinter, Harold, 4, 222, 254, 276, 283, 311
Piper, Sir David, 3, 6, 7, 17, 71, 87
Piper, John, 25, 182, 216, 222
Piper, Myfanwy, 182, 203
Pirelli, Leopoldo, 416–17
Pitt-Rivers, Michael, 39
Plas Newydd, Anglesey, 30
Plendell, Leo, 187
Plomer, William, 63
Plomley, Roy, 52
Plowden, Edwin Noël, Baron Plowden, 429
Plumb, Sir J.H. (Jack), 88–9, 105, 110, 283
Plunket, Patrick Plunket, 7th Baron: Clandeboye shooting party, 11; Annigoni portrait showing, 59; personality, 75, 76; Mount Offham open house, 75–6; guests, 77; Buckingham Palace party, 89, 90; Judy Gendel's death, 112; catalpa gift, 191
Podro, Michael, 422
Pope-Hennessy, James, 101, 117
Pope-Hennessy, Sir John: lunch party, 45; social life, 45, 77, 134; relationship with RS, 53, 117, 150, 158, 174, 404; appearance, 77, 117; brother, 101, 117; Directorship of V&A, 116–17, 127, 136, 147–8, 181; leaves V&A for BM, 116, 118, 128, 147; personality, 116–17, 127–8, 147; *Chellini Madonna*, 153; resignation from BM, 163–4; to USA, 197; Friends of the V&A, 233; Hartwell friendship, 302, 303, 304; influence, 332–3; Clark memorial service, 348; National Gallery ambition, 391
Pope-Hennessy, Dame Una, 117
Porter, Marguerite, 265
Predera, Joe, 113–14
Priestley, J.B., 42, 202
Priestley Report, 344–5, 351
Prince's Trust, 361
Prior, James, Baron Prior, 238
Priory Farm, Balscote, 111–12
Private Eye, 52, 55, 151, 256
Procktor, Patrick: appearance, 27, 34, 38, 69, 80; manners, 41; Beaton funeral, 253; Messel exhibition opening, 337
Profumo, John, 20–1
Property Services Agency (PSA): V&A responsibilities, 232, 300–1, 377, 408; problems with, 249, 300–1, 385; neglect of V&A, 300–1, 356; Pirelli sponsorship leak, 396
Proust, Marcel, 222

Prown, Jules, 116
Prowse, Philip, 424
Pulford, Richard, 368, 381
Punch, 60, 417
Purcell Room, 373
Pym, Francis, Baron Pym, 318n, 338

Queen Elizabeth Hall, 373
Queen Mary College, 5
Queen's House, Greenwich, 350
Quennell, Joan Marilyn, Lady, 105, 122
Quennell, Sir Peter, 122

Radnor, Jacob Pleydell-Bouverie, 8th Earl of Radnor, 137
Radnor, Margaret, Dowager Countess of, 81–2
Radziwill, Lee, Princess, 27
Rambert, Dame Marie (Mim), 101–3, 278, 279, 294, 324–6
Ramsay, Alan, 312
Ramsey, Rt. Rev and Rt. Hon Arthur Michael, Baron of Canterbury, 45
Ramshaw, Wendy, 173
Rangers House, Greenwich, 98, 352
Rankin, Lady Jean, 28
Ratcliffe, Michael, 146
Rattigan, Sir Terence, 276
Rattle, Sir Simon, 381
Rayne, Max, Baron Rayne, 9, 381
Rayner, Derek, Baron Rayner, 273, 274, 319
Rayner Report, 331
Reagan, Ronald, 106, 276, 319
Reay, Hugh Mackay, 14th Lord, 319
Redcliffe-Maud, Jean, Lady, 169
Redcliffe-Maud, John Maud, Baron, 169–70
Reddish House, Wiltshire, 19–21, 75, 151–2, 165, 167
Redgrave, Vanessa, 38
Redon, Odile, 21
Rees, Peter, Baron Rees, 362–3
Rees-Mogg, Gillian, Lady, 284
Rees-Mogg, William, Baron Rees-Mogg: State Banquet for French, 173; on Blunt, 246–7; birthday drinks party, 284; career, 284; Chairman of Arts Council, 329–30, 331–2, 335, 336, 348, 374, 383–4, 410, 428; Hayward Gallery issue, 331–2; personality, 336; funding policy, 345; Nunn explosion, 351; South Bank project, 362, 368, 373; successor at Arts Council, 384; National Gallery Directorship question, 394
Reeve, James, 92
Regional Arts Councils, 149
Reid, Jean, Lady, 54, 94, 267
Reid, Sir Norman, 46, 54, 94, 192, 267
Reinhardt, Max, 13
Rembrandt, 58
Renaissance Garden in England, The, 239–40, 272
Renoir, Pierre Auguste, 30, 31, 104, 106

Renton, David, Baron Renton, 151
Reviewing Committee for Works of Art, 237
Reynolds, Graham, 134
Reynolds, Sir Joshua, 75
Rhodes, Zandra, 258, 312
Richard III, King, 119
Richards, Margaret, 133
Richardson, Samuel, 30
Riddell, Sir John, 422
Rigg, Dame Diana, 180
Ritchie, Charles, 69
Rittner, Luke: Arts Council appointment, 329, 331, 336; career, 329; lunch with, 345–6; South Bank project, 362; Arts Council funds, 374; caterer recommendation, 377; Serpentine Gallery, 410; RS's farewell drinks, 427
Ritz magazine, 353
Rivera, Diego, 426
Robbins, Iris, Lady, 264
Robbins, Jerome, 87
Robbins, Lionel, Baron Robbins, 72, 200, 201, 264
Roberts, Keith, 107
Robertson, Barbara, 41
Robertson, Bryan, 34
Robespierre, Maximilien de, 61
Robson, Dame Flora, 14, 90, 222
Rochefoucauld, Duchesse de, 157
Rockingham Castle, Northants, 190
Rodin, Auguste, 137
Rogers, Malcolm, 414
Rogers, Richard, Lord Rogers, 412
Rogers, Samuel, 30
Rolling Stones, the, 36
Roper, Lanning, 319
Rose, James Anderson, 224
Rose, Kenneth, 283, 302
Rosebery, Albert Edward Primrose, 6th Earl of, 188, 189
Rosebery, Eva, Dowager Countess of, 186, 189
Rosebery, Neil Primrose, 7th Earl of, 186–7, 188, 189
Rosse, Anne, Countess of: *Vogue* party, 27–8; party for Harold Acton, 64; at Covent Garden, 164; Kensington Palace party, 205; son's marriage problems, 205; Messel memorial service, 229–30; appearance, 229, 318, 337; Messel exhibition, 337, 354; old age, 360
Rosse, Michael Parsons, 6th Earl of: party for Harold Acton, 64; National Trust, 64n, 97; Standing Commission, 97, 180; V&A Advisory Council, 135; at Covent Garden, 164; V&A cuts, 180, 181; Kensington Palace party, 205; Messel memorial, 230
Rothenstein, Sir John, 46
Rothermere, Esmond Harmsworth, 2nd Viscount, 94, 228, 231

Rothermere, Mary, Lady, 94, 228, 253
Rothschild, Dolly de, 310
Rothschild, Sir Evelyn de, 403
Rothschild, Jacob Rothschild, 4th Baron, 394–5, 401, 422
Rothschild, Leopold de, 63
Rothschild, Victor Rothschild, 3rd Baron, 181, 351, 366
Rothschild, Victoria, Lady, 403
Roubiliac, Louis François, 136, 382
Round House, Chalk Farm, 79
Rowe, Robert, 341
Rowse, A.L., 51, 303, 342
Roxburghe, Lady Mary, Duchess of, 177, 268
Royal Academy: Hill-Adamson photographs sale, 98; Gothic exhibition, 139; Turner show, 142; *Tonic for the Nation* show, 182; dinners, 191, 258–9, 332; Michelangelo tondo, 237; Japanese exhibition, 249; status, 311
Royal Ballet, 79, 240–1
Royal Collection, 16, 327, 415
Royal College of Art: V&A links, 162, 163, 401; Rectorship offer, 207, 208; joint MA course with V&A, 249–50, 267, 270, 352; dinner at, 309–10; RS's involvement, 330, 346; RS Senior Fellowship, 335
Royal Court Theatre, 278
Royal Fine Art Commission, 74, 383–4, 385
Royal Lodge, The, 211–13, 313–17
Royal Shakespeare Company (RSC), 289, 311, 344, 346
Rubens, Peter Paul, 34, 70, 75
Runcie, Robert, Baron Runcie, 261–2
Runciman, Sir Steven, 48, 69, 135, 350
Runciman of Doxford, Katherine, Lady, 247
Runciman of Doxford, Walter Runciman, 2nd Viscount, 247
Russell, Aliki, Lady, 176
Russell, Bertrand, 339
Russell, Georgiana, 244
Russell, Sir Gordon, 227
Russell, John, 34, 60
Russell, Sir John, 176
Russell, Ken, 38
Russia, 65–9
Rutherford, Dame Margaret, 13, 14
Rutland, Charles Manners, 10th Duke of, 279–80
Rutland, Frances, Duchess of, 280
Rutland, John Manners, 7th Duke, 64
Rutland, Violet, Duchess of, 64
Ryan, Ned, 270
Ryan, Nigel, 215
Ryan, Mrs. J. Barry (Nin), 13, 92, 104–5, 123

Saatchi, Maurice, 421

Sackville-West, Eddie, 5th Baron Sackville, 78
Sackville-West, Vita, (Lady Nicolson), 24n, 126
Sadler's Wells, 278, 336
Sainsbury, Anya, Lady, 164, 180, 314, 315
Sainsbury, John, Baron Sainsbury of Preston Candover, 180, 201, 314, 315, 422, 428
Sainsbury, Lisa, Lady, 201
Sainsbury, Sir Robert, 201
Saint, Andrew, 187
St Albans, Charles Beauclerk, 13th Duke of, 95
St John-Stevas, Norman, Baron St John of Fawsley: V&A campaign, 200; Channon dinner, 205; at Royal Lodge, 211, 212; Minister for the Arts, 235, 255–5; spending cuts, 238; personality, 255–6; NHMF, 257; V&A disestablishment campaign, 260; Buccleuch party, 268; Arts departure, 274, 277; successor at Arts, 274, 289, 293; Fraser- Melchett supper, 279; Frink interview, 293; appearance, 310, 397; Theatre Museum issue, 341; American embassy party, 349; Chelsea Flower Show, 402; title, 425; Clarence House lunch, 429
St Laurent, Yves, 283
St Paul's Cathedral, 261–2
Salem, Daniel, 387
Salisbury, Elizabeth, Marchioness of, 70, 71
Salisbury, Mollie, Marchioness of, 78, 168, 253, 318
Salisbury, Robert Cecil, 6th Marquess of, 78n, 168
Salisbury, Robert Gascoyne-Cecil, 5th Marquess of, 70, 71
Saltaire Mill, Bradford, 418–19
Salzburg, 178
Sampson, Alastair, 417
Sampson, Anthony, 207
Sampson, Sally, 207
Samsova, Galina, 336
Samuel the Prophet, 30
Sandford, Rev. John Edmondson, 3rd Baron, 226
Sargent, John Singer, 63, 89
Saudi Arabia, King of, 282
SAVE, 139–40, 189
Savoy Theatre, 154
Saxl, Fritz, 305, 308
Sayers, Dame Dorothy L., 306
Scarfe, Gerald, 131, 400
Schaffus, Peter, 431
Schlesinger, Peter, 35–6, 39–40, 80, 87
Schouvaloff, Alexander, 138, 324, 409, 411
Schouvaloff, Daria, 324
Science Museum, 160, 161, 168, 301
Scofield, Joy, 214
Scofield, Paul, 214

Scott, Bobby, 94
Scott, Gay, 94
Seago, Edward, 190
Searle, Ronald, 207
Serpentine Gallery, 361, 410
Seurat, Georges, 31
Sewell, Brian, 409
Seymour, Lynn, 202
Shakespeare Prize, 254, 255, 258, 263, 266
Shand Kydd, Frances, 361
Shaw, Norman, 182
Shaw, Sir Roy, 149–50, 331
Shawe Taylor, Desmond, 78
Sheldon, Gilbert, 247
Sherborne Castle, Dorset, 151, 327
Sheridan, Richard Brinsley, 75
Sherwood, James, 360
Shirburn Castle, Oxon, 74
Shore, Peter, 189
Shulman, Milton, 423
Sibley, Antoinette, 271, 278
Sickert, Walter, 31, 35, 64, 89
Sidney, Sir Philip, 34, 375
Sieff, Nicole, 108
Sielern, Countess, 93
Silver, Jonathan, 418
Simpson, Wallis, see Windsor, Duchess of
Sinden, Donald, 274
Sitwell, Dame Edith, 8, 12, 61n, 405, 424
Sitwell, Georgia, Lady, 61, 110
Sitwell, Sir Osbert, 30, 31, 61n, 405
Sitwell, Sir Sacheverell, 61, 110, 405
Six Faces of Royalty (TV series), 103, 111
Six Famous Portraits in Fifteen Minutes, 32
Skelton, Robert, 418
Sleep, Wayne, 201
Smiley, Sir Hugh, 253
Smiley, Nancy, Lady, 253n
Smith, F.E., 1st Earl of Birkenhead, 302
Smith, Sir John, 257
Smith, Les, 291
Smith, Matthew, 21, 43
Smith, Sir Thomas, 136
Snap: Instant Image '71, 85
Snow, C.P., Baron Snow, 97
Snowdon, Lucy, Countess of, 279, 353–4
Snowdon, Antony Armstrong-Jones, 1st
 Earl of: theatre going, 38; Elizabethan
 Image opening, 47; mother, 64n, 65, 205;
 Rosses' party, 65, 65; appearance, 80,
 403; Organ portrait, 86; marriage prob-
 lems, 86, 158; Buckingham Palace party,
 90; State Opening of Parliament, 155;
 separation, 166–7, 194; divorce, 224;
 Royal Designer for Industry, 227; Messel
 service, 229; Beaton on, 243; second mar-
 riage, 279; Messel exhibition, 337; Vogue
 editorship question, 387; work, 430
Snowman, Kenneth, 194
Soames, Christopher, Baron Soames, 349
Soames, Mary, Lady, 403

Soames, Nicholas, 176
Society of Antiquaries, 53, 145
Solti, Sir Georg, 426
Somers Cocks, Anna, 409
Somerset House, 138, 144
Soskolne, Ron, 432
Sotheby's: V&A work, 136; Beaton archive
 sale, 165; Mentmore sale, 188; royal
 Millais purchase, 206; Bernini bust valu-
 ation, 395; RS position, 414–15, 419;
 Beaton Collection, 423
South Bank Board, 388, 406
South Bank project, 362, 368–9, 373–4,
 381
Spalding, Julian, 414, 415, 416
Sparrow, John, 12–13, 112, 285, 348, 360
Spectator, 7, 15, 107, 331
Spence, Sir Basil, 182
Spence, John, 186, 188, 204, 216, 235, 290
Spencer, Edward (Johnnie) Spencer, 8th
 Earl, 17, 18, 30, 73n, 190, 257, 268, 283
Spencer, Frances, Countess, 206
Spencer, Raine, Countess (earlier Countess
 of Dartmouth): RS's first meeting, 73;
 appearance, 73, 121, 268, 295; American
 Embassy lunch, 89; Buckingham Palace
 party, 90; lunch with, 92; Spencer mar-
 riage, 190; NHMF, 257; Plumb dinner,
 283; Fermoy discussion, 317
Spender, Lizzie, 11
Spender, Natasha, Lady, 1n, 41, 69
Spender, Sir Stephen, 11n, 27, 29, 41, 69,
 285
Spirit of the Age (TV series), 143, 145–6,
 152
Splendour at Court, 120, 340, 343
Spurling, Hilary, 7, 15
Squire, Geoffrey, 133–4
Standing Commission on Museums and
 Galleries, 97, 180, 183, 216, 274
Stangos, Nikos, 418
Stanley, Venetia, 11n
Staples, Doris, 5
Start the Week, 410
Steer, Philip Wilson, 89
Stefanides, John, 112
Steinberg, 'Babe', 106
Steinberg, Jack, 106
Stern, Isaac, 236
Stevens, Alfred, 145
Stevens, Jane, 28, 171, 270, 337
Stevens, Jocelyn, 28, 346, 353–4, 401, 412
Stewart, Douglas, 85
Stirling, Jeffrey, 381
Stone, Reynolds, 202
Stopford Sackville, Lt. Colonel, Lionel, 18
Stoppard, Tom, 180, 254
Stratford-upon-Avon: 1963–4 Shakespeare
 exhibition, 6, 186; readings, 13–14;
 Henry VIII and Comedy of Errors, 343
Strathcona and Mount Royal, Donald, 4th
 Baron, 41

Strathcona and Mount Royal, Lady Jane, 41
Streator, Edward, 381
Strong, Brian (RS's brother), 49
Strong, Derek (RS's brother), 50, 370
Strong, George Edward Clement (RS's father), 4–5, 50, 370–2
Strong, Mabel Ada (née Smart, RS's mother), 4–5, 50, 370–2
Strong, Sir Roy: childhood, 4–5, 49–50; education, 5–6, 305–7; work at National Portrait Gallery, 6–7, 128–9; appointment as Director, 1–2, 7; appearance, 7, 8, 11, 32, 53, 184; clothes, 7, 11–12, 23, 25, 33, 54–5, 61, 77, 79, 423; Beaton photograph, 8, 271; Hockney sketch, 38, 39, 437; Organ portrait, 91; proposal and wedding, 92–4; gardening, 96, 120, 146–7, 158–9, 164–5, 191, 195, 198, 199, 208–9, 223, 226–7, 235, 240, 263, 266, 297, 324, 333, 355; honeymoon, 98–9; house, 114–15; Directorship of V&A, 116–19, 127–9, (see also Victoria and Albert); income, 134, 208, 223, 258, 356; domestic life, 185, 241–2, 323, 437–8; cats, 185, 272, 276, 288, 344, 359, 437, 438; eighth wedding anniversary, 240; Brandt photograph, 270–1; ill health, 274–5; knighthood, 295, 301–2, 312–13, 317; Chairman of Art Panel, 329–30; gardening books, 355; father's death, 370–2; ; decision to leave V&A, 391–2, 406; question of future career, 391, 393–5, 401, 405–6; resignation from V&A, 406, 407–10
Strong Points, 360, 379
Strongpoints (radio talks), 240
Stubbs, George, 8, 74, 219
Suffolk Collection, 98
Summerskill, Shirley, 149
Sunday Mirror, 28–9
Sunday Times, 50, 52, 54, 64, 107, 156, 229, 259, 334, 400, 404, 409–10, 414, 418, 421
Sutherland, Cathy, 202–3
Sutherland, Graham: Queen's portrait question, 12; Winn collection, 43; retrospective exhibition, 107, 203; Goodman portraits, 119, 200; Churchill head, 122; personality, 202–3; marriage, 202–3; Shakespeare Prize, 254; Hartwell invitations, 303
Sutherland, Dame Joan, 8, 23
Sutro, Gillian, 20, 45, 48
Sutro, John, 20, 45, 48
Sutton, Denys, 34, 52, 80, 83–4, 396, 410
Sylvester, David, 330

Tagg, Alan, 117, 151
Tait, Simon, 400
Talbot, William Henry Fox, 378
Talleyrand, Charles Maurice de, 197
Talon, William, 174–5, 239, 276

Tate Gallery: 1969 Elizabethan Image exhibition, 33–4, 46–7, 50, 51; Friends of the Tate, 54; Goodman portrait, 119; conference on regions, 195; Gainsborough exhibition, 267–8; Landseer exhibition, 312; Clore Gallery, 354, 412–13
Tavistock, Henrietta, Marchioness of, 176, 280, 281
Tavistock, Robin Russell, Marquess of, 176, 281–2
Taylor, Elizabeth, 95
Tebbit, Norman, Baron Tebbit of Chingford, 5, 403
te Kanawa, Dame Kiri, 206, 335
Tempest, Marie, 25
Templer, Sir Gerald, 26, 45, 73, 97
Tennant, Lady Anne, 166, 179, 205, 220, 229, 270
Tennant, Colin, 3rd Baron Glenconner, 155–7, 205, 220, 270
Tennant, Stephen, 424
Terry, Dame Ellen, 14
Thames & Hudson, 379
Thames TV, 216
Thatcher, Sir Denis, 154, 181, 247, 258, 277
Thatcher, Margaret, Baroness Thatcher of Kesteven: Eccles on, 149; Civil Service decimation, 161; décor, 169; Russell dinner for, 176; appearance, 176; husband, 181, 247; Vaizey opinion, 196; St John-Stevas relationship, 212; meeting with RS, 231; public sector cuts, 236, 268, 276, 288; Gilmour relations, 238, 241; NHMF, 257; RA dinner speech, 258; Queen Mother's eightieth birthday, 262; RS encounter at Clarence House, 277; museum charges issue, 288; Channon relationship, 289, 293; Trevor-Roper peerage, 295; Theatre Museum, 324; general election, 334; Gowrie relationship, 338; V&A Trustees, 340; Metropolitan Authorities abolition, 347; Arts policy, 350; Vaizey memorial service, 367; appearance, 367, 369; Lord Mayor's Banquet, 369–70; South Bank project, 381; influence with, 381, 395; National Gallery Directorship, 395; Rothschild party, 402; Downing Street party, 410; Armstrong relationship, 416; Saatchi relationship, 421
Thaw, Eugene, 153, 156
Theatre Museum: project, 136; Somerset House proposal, 138, 144; Covent Garden site, 144, 235; RS's achievement, 271; inauguration, 274; prospects, 288; work on, 301; Rayner Report, 319, 321, 322; campaign for, 324, 337, 341; Gowrie policy, 338, 340, 342; prospects, 343, 344; opening, 392; opening, 401, 407; crisis, 411; competition for designers, 422; Prince Charles' visit, 428
Thomas, Frances, 106

Thomas, George, 1st Viscount Tonypandy, 341

Thomas, Hugh, Baron Thomas of Swynnerton, 23

Thompson, Nicholas, 207

Thorndike, Dame Sybil, 14, 108, 325

Thorneycroft, Carla, Lady, 310

Thorneycroft, Peter, Baron Thorneycroft, 310, 416

Thornton, Peter, 134, 139

Thorpe, Jeremy, 113

Throope Manor, Bishopstone, Wilts, 78

Thynne, Christopher, 255

Time, 62

Times, The, 7, 60, 83, 146, 153, 157, 180, 187, 197, 200, 210, 216, 223, 246, 284, 300, 342, 343, 345, 360, 367, 368, 379, 410

Times Literary Supplement, 50

Tippett, Sir Michael, 41

Titian, *Death of Actaeon*, 87–8

Toesca, Ilaria, 290

Tollemache, Alexandra (Xa), Lady, 283–4

Tollemache, Timothy Tollemache, 5th Baron, 283–4

Tomkins, Sir Edward, 155–6, 158, 175, 319

Tomkins, Gillian, Lady, 155, 157–8, 175, 319

Toms, Carl, 201, 214, 294, 337

Tooley, Sir John, 87, 335

Tooley, Patricia (Patsy), Lady, 87

Townsend, Peter, 214

Tracy, Robert, 339

Tradescant, John, 168

Trapp, Professor Joseph, 286–7, 296, 304, 308, 366

Tree, Michael, 165

Tree, Penelope, 27, 46, 80, 80

Trefusis, Violet, 101, 125–6

Tregoning, Gay, 59

Trevelyan, Humphrey, Baron Trevelyan, 163

Trevelyan family, 93, 122

Trevor-Roper, Hugh, *see* Dacre

Trevor-Roper, Patrick, 78

Tudor and Jacobean Portraits, 33

Tudor-Craig, Pamela, Lady Wedgewood, 119

Turnbull & Asser, 77

Turner, Kenneth, 59, 108, 246, 299–300

Tweedy, Clive, 350

Tynan, Kathleen, 28, 55

Tynan, Kenneth, 28, 55, 71, 79

Ullbricht, John, 14

Ulrich, Walter, 199, 216, 238, 290

University of California, 379

Ure, Caroline, Lady, 109

Ure, Sir John, 108–9

Usill, Harley, 14

Ustinov, Sir Peter, 426

Utrillo, Maurice, 106

Vaizey, John, Baron Vaizey, 196, 200, 241, 332, 367–8

Vaizey, Marina, Lady, 196, 241, 332, 368, 400

Valois, Dame Ninette de (Madame), 229, 241, 278, 325–6, 337

van de Velde, Willem, 63

Van der Dort, 16

van der Kemp, Florence, 157

van der Kemp, Gerald, 157

van Dorsten, Jan: marriage, 240; death, 375; RS's correspondence with, xiv, 3, 4, 7, 8, 11, 13, 14, 22, 28, 46, 50, 64, 74, 93, 100, 103, 111, 123, 126–7, 140–3, 146–7, 158, 164, 170, 178, 185, 197, 208, 222, 227, 239–40, 255, 257, 262, 266, 271, 274, 286, 295, 317, 322, 326, 333, 342–3, 365, 378

Van Dyck, Sir Anthony, 34, 104, 206

Vaughan, Will, 46

Velásquez, Diego de, *Juan de Pareja*, 81–2, 83–4

Verey, David, 319

Verey, Rosemary, 319, 355, 402, 420–1

Verity, Simon, 420

Vermeer, Jan, 104, 219

Verrio, Antonio, 219

Versailles, 156, 157, 158

Versace, Gianni, 378, 393

Vickers, Hugo, 253, 423–4

Victoria, Queen, 85, 219, 220, 277

Victoria and Albert Museum (V&A): Byron exhibition, 24, 134, 141; Berlioz show, 46; Dickens exhibition, 69; loans to NPG, 85; Directorship, 116–19, 127–9, 133–5; Advisory Council, 135; Keepers' Meetings, 135–6; Theatre Museum, *see* Theatre Museum; Henry Cole Wing, 136, 138–9, 144, 211, 235, 236, 288, 323, 330, 331, 333, 385; finances, 136–7, 144–5, 160–1, 298–300, 356–8, 361, 365–6, 379, 418; Photographers' Gallery, 137–8; Regional Services, 138, 145, 148, 180, 183, 188, 235; Indian Collection, 139; Craft Shop, 139; *Destruction of the English Country House (1875–1975)*, 139–40, 142–3, 198, 239; staff relations, 146, 147–8, 160–2, 176–7, 184, 186, 270, 382–3; Department of Museum Services, 148; government cuts, 160–1, 178, 180, 182–3, 185–6, 235, 257, 259–60, 263, 266; *The Makers*, 162–3; *The Land* photographic show, 165; *Fashion* show, 165, 166; *American Art 1750–1800*, 175; Keepers' Meetings, 177; Minton show, 178; Regional Services closure, 180, 183, 188, 235; Friday closing, 189–90, 235, 407, 421; Fabergé exhibition, 194–5, 197–8, 199, 239; *Change and Decay* exhibition, 198; Ludwig of Bavaria exhibition, 198, 227; Archive of Art and Design, 211; *Giambologna* exhibition, 227, 234; *The Way We Live Now* exhibition, 227;

Victoria and Albert Museum—*cont*
sponsorship, 232; *Vienna in the Age of Schubert*, 232, 233, 234; *The Garden*, 232, 233, 239, 254; Friends of the V&A, 233, 257, 282, 326, 334, 359–60, 377, 390, 408; North Court plans, 235; Post Office Building, 235, 236; Regional Services re-establishment, 235–6; *Princely Magnificence* exhibition, 248, 267, 269, 271, 274; *Japan Style* opening, 248; Primary Galleries, 249, 269, 271, 274, 292; Boilerhouse Project, 249, 269, 288, 407; MA course, 249–50, 267, 270, 352; *Splendours of the Gonzagas*, 273, 287, 290–2, 294, 309; Trustee status, 273, 301, 327, 339–40, 342, 343, 344, 346, 347, 352; *Spotlight* exhibition, 279; Rayner Scrutiny, 288, 290, 301, 311, 319, 322–3; flood, 301, 323, 344; *Indian Heritage*, 301; RS's knighthood, 301; dry rot, 323; *Artists of the Tudor Court*, 323, 327–8, 334, 337, 342; Dress Collection, 334, 385; Board of Trustees, 210, 339–40, 344, 347, 352, 355–6, 361, 363, 375, 378, 379, 381–3, 384, 386, 388–90, 428; Twentieth-Century Gallery, 351; V&A Enterprises, 356; Archive of Art and Design, 357; Rococo exhibition, 357–8, 365, 366–7; delegation to Treasury, 363; voluntary admission charges, 375–6, 389, 396; Japanese Gallery, 377, 385; Cast Court, 385; Indian Gallery, 385; Pirelli Garden, 385, 392, 396, 399, 416–17; Bernini bust, 385, 388, 395–6, 397–400; Medieval Treasury, 393; galleries of Art and Design, 407; Royal Portrait Archive, 407, 417–18; RS's resignation, 407, 408–10; *V & A Album*, 411; RS's successor as Director, 414–15, 417, 418, 428, 437; Chinese Export Gallery, 424
Vidal, Gore, 358
Vienna, Burgtheater, 170, 178
Vile & Cobb, 145
Vilmorin, Louis de, 23
Vlachos, Helen, 16
Vogelpoel, Pauline, 34, 53–4, 94
Vogue, 8, 27, 57, 243, 253, 269, 334, 342, 386–7

Wade, Robin, 140
Wagner, Sir Anthony, 154n, 370
Wagner, Gillian, Lady, 154–5
Wakefield, Sir Peter, 398
Waldegrave, William, 383, 429
Waldheim, Kurt, 217
Walker, Perkin, 286
Walker, Peter, Baron Walker of Worcester, 113, 151, 226, 238, 289, 365
Walker, Robin Caspar, 226
Walker, Tessa, Lady, 113
Walker Museum, 349
Wall, David, 201

Wallace Collection, 135
Walls Lectures, 142
Wan, Barney, 80
Warburg family, 263
Warburg Institute, 3, 6, 198, 286–7, 304–5
Warburton, Dame Anne, 431
Ware, Isaac, 136
Warner, Sir Fred, 249
Warner, Marina, 80, 89, 276
Warner, Simone, Lady, 249
Warwick, Charles Greville, 7th Earl of, 207
Warwick, David Greville, 8th Earl of, 207
Warwick, Frances, Countess of, 106
Warwick Castle, Warwicks, 207
Waterfield, Hermione, 37
Waterhouse, Sir Ellis (E.K.), 3
Watson, Sir Francis, 122
Watson, William, 197
Waugh, Auberon, 23
Waugh, Evelyn, 123
Waverley, Ava, Viscountess, 12–13, 92
Webb, Kaye, 207
Webster, Sir David, 97, 404
Wedgwood, Dame Veronica, 16, 264
Weidenfeld, George, Baron Weidenfeld of Chelsea: gatherings, 11, 91, 196, 206, 276, 285; appearance, 23; *Vogue* party, 28; fiftieth birthday party, 33; Sutro supper, 46; Cloth of Gold ball, 55; Hartwell election party, 71; Beaton film party, 80; Phipps parties, 92, 93; Wrightsman party, 104–5; Fleming party, 122; Sutherland memoirs, 203; Beaton funeral, 253; South Bank project, 381
Weidenfeld, Sandra Payson Meyer, 28, 80, 91, 93, 105
Weill, Kurt, 343
Weinberg, Anouska, Lady, 360
Weinberg, Sir Mark, 360
Weinstock, Arnold, Baron Weinstock, 426
Weinstock, Simon, 246
Welbeck miniatures, 327
Welch, Elizabeth, 337
Welch, Robert, 250
Weldon, Jill, 47, 80, 113
Wellington, Arthur Wellesley, 1st Duke of, 65, 137
Wellington, Valerian Wellesley, 8th Duke of, 237
Wellington family, 237
Wells, Dee, 39, 103
Wells, John, 55, 122
Welsh Arts Council, 85
West, Dame Rebecca, 42, 207–8
West Green House, 96
Westminster, Loelia, Duchess of, *see* Lindsay
Westminster Abbey, 330
Weston, Dame Margaret, 160
Weston Hall, Northants, 110
Wharton, Edith, 351
Wheldon, Sir Huw, 150

Whistler, Rex, 30, 79, 278, 303, 405
White, Professor John, 250, 267
White, Paul, 95
Whitehead, Phillip, 331
Whitehouse, Pauline, 46
Whitelaw, Cecilia, Lady, 349
Whitelaw, William Whitelaw, 1st Viscount, 310, 349, 429
Whitney, Betsy, 333
Whittam-Smith, Andreas, 415
Wilde, Oscar, 21, 23
Wilding, Dorothy, 401
Wilding, Richard, 363, 394, 405
Wilkie, Sir David, 219
Willatt, Sir Hugh, 89
Willcocks, Sir David, 313, 316
William, Prince, 70, 273
Williams, Rev. Austen, 90
Williams, Charles, Baron Williams of Elvel, 177-8
Williams, Mrs Harrison, 101
Williams, Marcia, Baroness Falkender, 71, 166
Williams, Neville, 197
Williams, Shirley, Baroness Williams of Crosby: Minister for the Arts question, 149; Education Secretary, 180-1, 182-3, 186; appearance, 181, 312; Arts cuts, 188, 204; RA dinner, 191; British Academy dinner, 197; V&A Trustees, 210, 216; Dacre book, 295
Wills, Jean, 347
Wilmcote Church, 83, 93-4
Wilson, Sir Angus, 36, 69, 305
Wilson, Sir David, 192, 268, 295, 310, 352-3
Wilson, Harold, Baron Wilson of Rievaulx, 71, 94, 154, 166
Wilson, Mary, Lady, 173
Wilson, Peter (of Sotheby's), 90
Wilson, Peter (RS's personal assistant), 352
Wilton House, Wilts, 204, 243
Windlesham, David, 3rd Baron, 429

Windlesham, Prudence, Lady, 320
Windsor, Duchess of, 101, 105, 139, 358-9
Windsor, Duke of, 101, 105, 358-9
Windsor Castle, 76, 216-20
Winn, Godfrey, 43-4
Winnipeg, Founder's Lecture, 423
Wintour, Anna, 386, 387
Wintour, Charles, 386, 423
Woburn Abbey, 108, 177, 218, 281-2, 327
Wodehouse, P.G., 320
Wolfe, Teddy, 94
Wolfson, Leonard, Baron Wolfson, 269
Wolfson Foundation, 91, 249, 269, 271, 274, 275
Woman's Hour, 29
Wood, Christopher, 94
Woodhouse, Davina, 205
Wormald, Professor, Francis, 3, 307
Worsthorne, Sir Peregrine, 103
Worth, Irene, 12, 20, 47, 253
Wren, Sir Christopher, 407
Wright, Willy, 138, 161
Wrightsman, Charles, 104-5, 110-11, 117, 118, 320
Wrightsman, Jayne, 104, 110-11, 117, 118, 181, 320
Wyndham, Violet, 23

Yale University, 98
Yates, Dame Frances: RS's referees, 3; RS's studies under, 6; influence, 14; DBE, 196, 198; Byatt on, 222; funeral, 286-7; memorial, 295-6, 304-8; RS's *hommage* to, 366
Yates, Ruby, 307
York, Sarah, Duchess of, 411-12
Yorke, Lady Victoria, 109
Young, Stuart, 394
Yuki, 269, 320

Zoffany, John, 219
Zuckerman, Solly, Baron Zuckerman, 270
Zydower, Astrid, 86, 101-2, 278, 325

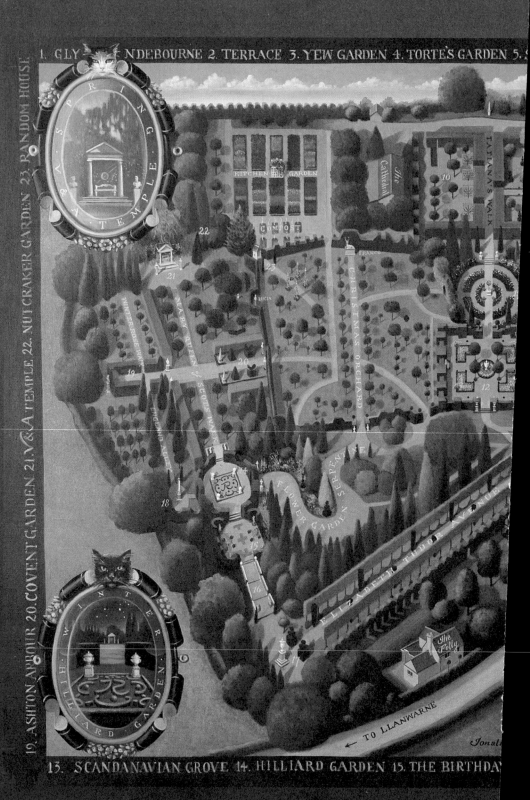

13. SCANDANAVIAN GROVE 14. HILLIARD GARDEN 15. THE BIRTHDA~

'A bird's eye view (by Jonathan Myles-Lea, 1995) of the garden we created over twenty years, a paradise into which I could escape from the dolours of public life. All our cats are commemorated here.' ROY STRONG